EXPRESSIONISM
Art and Idea

EXPRESSIONISM
Art and Idea

Donald E. Gordon

YALE UNIVERSITY PRESS
New Haven and London

Publication of this book has been aided by a grant from The Millard Meiss
Publication Fund of the College Art Association of America.

MM

Designed by Susan P. Fillion and set in Helvetica type by The Composing
Room of Michigan, Inc.
Printed in the United States of America by Federated Lithographers-Printers,
Inc., Providence, Rhode Island

Library of Congress Cataloging-in-Publication Data

Gordon, Donald E.
 Expressionism: art and idea.

 Bibliography: p.
 Includes index.
 1. Expressionism (Art)—Germany. 2. Arts, Modern—20th century—Germany.
3. Expressionism (Art)—Influence. I. Title.
NX550.A1G63 1987 709'.04'042 86-9188
ISBN 0-300-03310-9

The paper in this book meets the guidelines for permanence and durability of
the Committee on Production Guidelines for Book Longevity of the Council on
Library Resources.

10 9 8 7 6 5 4 3 2 1

Contents

Illustrations

FIGURES

1. Ferdinand Hodler, *The Dispirited,* oil on canvas, 1892. Bayerische Staatsgemäldesammlungen, Neue Pinakothek, Munich

2. Gustav Klimt, *Medicine,* oil on canvas, 1900–01. Österreichische Nationalbibliothek, Vienna. (Permission of Galerie Welz, Salzburg)

3. Erich Heckel, *Portrait of Friedrich Nietzsche,* woodcut, 1905. (Copyright Erich Heckel Estate, Hemmenhofen)

4. Ernst Ludwig Kirchner, illustration for *The 1001 Nights,* woodcut, 1905. Brücke-Museum, Berlin. (Courtesy Galleria Henze, Lugano)

5. Max Pechstein, poster for the "First Neue Secession Exhibition," color lithograph, 1910.

6. Wassily Kandinsky, sketch for *Composition VII, no. 1,* 1913. Sammlung Felix Klee, Bern. (© ADAGP, Paris/VAGA, New York, 1985)

7. Franz Marc, *Animal Destinies,* oil on canvas, 1913. Öffentliche Kunstsammlung, Kunstmuseum Basel.

8. Oskar Kokoschka, drawing for *Murderer, Hope of Women,* ca. 1909. Graphische Sammlung, Staatsgalerie Stuttgart.

9. Otto Dix, *Friedrich Nietzsche,* [lost], 1912. (Photo Courtesy of Otto Dix Archiv)

10. George Grosz, "In Memory of Richard Wagner," 1921. Illustration from *Ecce Homo,* number 60. (Estate of George Grosz, Princeton, New Jersey)

11. Edvard Munch, *Madonna (Loving Woman),* lithograph, 1895–1902. Oslo Kommunes Kunstsamlinger.

12. Edvard Munch, *Evening on Karl Johan Street,* oil on canvas, 1892. Oslo Kommunes Kunstsamlinger.

13. Ernst Ludwig Kirchner, *Street, Dresden,* oil on canvas, 1908. Collection, The Museum of Modern Art, New York. Purchase. (© Dr. Wolfgang and Ingeborg Henze, Lugano)

14. Erich Heckel, *Girl with Doll,* oil on canvas, 1910. Private collection, USA. (Courtesy Serge Sabarsky Gallery)

15. Ernst Ludwig Kirchner, *Bathers Throwing Reeds,* color woodcut, 1910. Sprengel Museum, Hannover. (Courtesy Galleria Henze, Lugano)

16. Alfred Kubin, *Stampeding Horses* (From *The Other Side*), ca. 1908.

17. Franz Marc, *Yellow Cow,* oil on canvas, 1911. Solomon R. Guggenheim Museum, New York. (Photo Robert E. Mates)

18. Oskar Kokoschka, poster for *Murderer, Hope of Women,* color lithograph, 1909. Collection, The Museum of Modern Art, New York; Purchase.

19. Gustav Klimt, *The Kiss,* oil on canvas, 1908. Osterreichische Nationalbibliothek, Vienna. (Permission of Galerie Welz, Salzburg)

20. Egon Schiele, *Cardinal and Nun,* oil on canvas, Kallir 156, 1912. (Courtesy Galerie St. Etienne, New York)

21. Emil Nolde, *Dance around the Golden Calf,* oil on canvas, 1910. Staatsgalerie Moderner Kunst, Munich. (Nolde-Stiftung Seebüll)

22. Emil Nolde, *Christ among the Children,* oil on canvas, 1910. Collection, The Museum of Modern Art, New York. Gift of Dr. W. R. Valentiner. (Nolde-Stiftung Seebüll)

23. Emil Nolde, *Mary of Egypt* (triptych), oil on canvas, 1912. Hamburger Kunsthalle. (Nolde-Stiftung Seebüll; photo © Ralph Kleinhempel)

24. Emil Nolde, *Crucifixion,* from *Life of Christ,* oil on canvas, 1912. Bayerische Staatsgemäldesammlungen, Munich. (Nolde-Stiftung Seebüll; photo © Ralph Kleinhempel)

25. Emil Nolde, *The Prophet,* woodcut, 1912. Los Angeles County Museum of Art, The Robert Gore Rifkind Center for German Expressionist Studies.

26. Ludwig Meidner, *Apocalyptic Landscape,* oil on canvas, 1912–13. Nationalgalerie, Staatliche Museen Preussischer Kulturbesitz, Berlin. (Photo Jörg P. Anders, Berlin)

27. Wassily Kandinsky, *Paradise,* watercolor, 1911–12. Städtische Galerie im Lenbachhaus, Munich. (© ADAGP, Paris/VAGA, New York, 1985)

28. Franz Marc, *The Unhappy Tyrol,* oil on canvas, 1913–14. Bayerische Staatsgemäldesammlungen, Staatsgalerie Moderner Kunst, Munich.

29. Egon Schiele, *Self-Seers II (Death and the Man),* oil on canvas, Kallir 129, 1911. (Courtesy Galerie St. Etienne, New York)

30. Oskar Kokoschka, *The Tempest,* oil on canvas, 1914. Öffentliche Kunstsammlung, Kunstmuseum Basel.

31. Oskar Kokoschka, *Bach Cantata,* from *O Ewigkeit, Du Donnerwort (Bachkantate),* color lithograph, 1914. (Los Angeles County Museum of Art, The Robert Gore Rifkind Center for German Expressionist Studies)

32. Erich Heckel, *Two Men at the Table,* oil on canvas, 1912. Hamburger Kunsthalle. (Copyright Erich Heckel Estate, Hemmenhofen; photo © Ralph Kleinhempel)

33. Erich Heckel, *Glassy Day,* oil on canvas, 1913. Bayerische Staatsgemäldesammlungen, Staatsgalerie Moderner Kunst, Munich. (Photo Artothek)

34. Robert Delaunay, *Circular Forms, Sun and Moon,* oil on canvas, 1912. Collection Stedelijk Museum, Amsterdam.

35. August Macke, *Bathing Girls,* oil on canvas, 1913. Bayerische Staatsgemäldesammlungen, Staatsgalerie Moderner Kunst, Munich.

36. Ernst Ludwig Kirchner, *Eternal Longing* (illustration for Petrarch's "Triumph of Love"), woodcut, 1918. Galleria Henze, Lugano.

37. Erich Heckel, *Roquairol,* tempera on canvas, 1917. (Copyright Erich Heckel Estate, Hemmenhofen)

38. Ferdinand Hodler, *Love,* 1908. Kunsthaus, Zurich.

39. Egon Schiele, *The Embrace,* oil on canvas, 1917. Österreichische Galerie, Vienna. (By permission of Galerie Welz, Salzburg; Fotostudio Otto)

40. George Grosz, *Dedicated to Oskar Panizza,* oil on canvas, 1917–18. Staatsgalerie Stuttgart. (Estate of George Grosz, Princeton, New Jersey)

41. Karl Schmidt-Rottluff, *Christ on the Road to Emmaus,* woodcut, 1918. (Courtesy, Museum of Fine Arts, Boston, Arthur M. Knapp Fund)

42. Max Beckmann, *The Night,* oil on canvas, 1918–19. Kunstsammlung Nordrhein-Westfalen, Düsseldorf. (© ADAGP, VG Bild-Kunst, 1985; photo Walter Klein)

43. Hans Pleydenwurff, *Hofer Altarpiece, Descent from the Cross,* oil on wood, fifteenth century. Bayerische Staatsgemäldesammlungen, Alte Pinakothek, Munich.

44. Max Beckmann, illustrations to the drama *Ebbi,* etchings, ca. 1920. (Courtesy Dr. Peter Beckmann, Murnau)

45. Bruno Taut, *Cathedral Star,* from *Glass Architecture and Alpine Architecture* (New York: Praeger, 1972)

46. Caspar David Friedrich, *The Cathedral,* oil on canvas, ca. 1818. Sammlung Georg Schäfer.

47. Lyonel Feininger, *Cathedral of Socialism,* woodcut, 1919. (Courtesy of the Busch Reisinger Museum, gift of Mrs. Lyonel Feininger)

48. Lovis Corinth, *The Red Christ,* oil on canvas, 1922. (Reproduced by permission of Thomas Corinth, New York; photo Artothek)

49. Vincent Van Gogh, *Rising Moon: Haycocks,* oil on canvas, 1889. State Muséum Kröller-Müller, Otterlo, The Netherlands.

50. Erich Heckel, *Sunset,* oil on canvas, 1907. (Copyright Erich Heckel Estate, Hemmenhofen)

51. Henri Matisse, *The Blue Nude,* 1907. The Baltimore Museum of Art: The Cone Collection, formed by Dr. Claribel Cone and Miss Etta Cone, Baltimore, Maryland.

52. Ernst Ludwig Kirchner, *Girl under a Japanese Umbrella,* 1909. Kunstsammlung Nordrhein-Westfalen, Düsseldorf. (Courtesy Galleria Henze, Lugano; photo Walter Klein)

53. House beam, Palau Islands, nineteenth century, painted and carved wood. Ethnographical Museum, Dresden.

54. Ernst Ludwig Kirchner, *Exotic Scene,* postcard (postmarked June 20, 1910). Altonaer Museum, Hamburg. (Courtesy Galleria Henze, Lugano)

55. Karl Schmidt-Rottluff, *Two Female Nudes,* painted wood relief, 1911. Brücke-Museum, Berlin. (© ADAGP, Paris/VAGA, New York, 1985; photo Henning Rogge, Berlin)

56. Ajanta caves, India. A lady and servants, Cave xvii. (From John Griffiths, *Paintings of the Buddhist Cave-Temples of Ajanta, Kandesh, India,* London, 1876)

57. Ernst Ludwig Kirchner, poster for the "MUIM-Institute," color woodcut, 1911. (Courtesy Galleria Henze, Lugano)

58. Wassily Kandinsky, *Riegsee Village Church,* oil on canvas, 1908. Von der Heydt-Museum, Wuppertal. (© ADAGP, Paris/VAGA, New York, 1985)

59. *Mary with the Son of God,* Bavarian glass painting. (From Langheit, ed., *Der Blaue Reiter,* Munich: Piper Verlag, 1965 ed.)

60. Children's drawings illustrated in *Der Blaue Reiter,* 1912.

61. Gabriele Münter, *Girl with Doll,* oil on cardboard, 1908–09. Milwaukee Art Museum, Collection of Mrs. Harry Lynde Bradley.

62. Wassily Kandinsky, *Mountain,* oil on canvas, 1909. Städtische Galerie im Lenbachhaus, Munich. (© ADAGP, Paris/VAGA, New York, 1985)

63. Paul Gauguin, *Tahitian Women Bathing,* oil on canvas, 1891–92. The Metropolitan Museum of Art, Robert Lehman Collection, 1975.

64. Franz Marc, *Blue Horse II,* 1911. Kunstmuseum, Bern, Stiftung Othmar Huber, Munich.

65. *St. George,* Bavarian glass painting. Bayerisches Nationalmuseum, Munich.

66. Wassily Kandinsky, *St. George,* glass painting, 1911. Städtische Galerie im Lenbachhaus, Munich. (© ADAGP, Paris/VAGA, New York, 1985)

67. Wassily Kandinsky, cover of the *Almanach der Blaue Reiter,* color woodcut, 1911–12. Städtische Galerie im Lenbachhaus, Munich. (© ADAGP, Paris/VAGA, New York, 1985)

68. Vincent Van Gogh, *Madame Roulin and Her Baby,* oil on canvas, 1888–89. Philadelphia Museum of Art, Bequest of Lisa Norris Elkins.

69. Oskar Kokoschka, *Ludwig von Janikowsky,* oil on canvas, 1909. Knize Collection, USA. (Courtesy Serge Sabarsky Gallery)

70. Gustav Klimt, *Family (Mother with Children),* oil on canvas, 1909–10. Österreichische Nationalbibliothek. (Permission of Galerie Welz, Salzburg)

71. Egon Schiele, *Dead Mother I*, oil on wood, Kallir 115, 1910. (Courtesy Galerie St. Etienne, New York)

72. Pablo Picasso, *Head of a Woman (Fernande)*, bronze, 1909. Collection, The Museum of Modern Art, New York; Purchase.

73. Bohumil Kubišta, *Saint Sebastian*, oil on canvas, 1912. National Gallery, Prague.

74. Claude Monet, *Bend in the Epte River, near Giverny*, 1888, oil on canvas. Philadelphia Museum of Art, The William L. Elkins Collection.

75. Christian Rohlfs, *Birch Forest*, 1907. Museum Folkwang, Essen. (Courtesy Mrs. Helene Rohlfs)

76. Max Pechstein, *Evening in the Dunes*, oil on canvas, 1911. Leonard Hutton Galleries, New York. (Photo Otto E. Nelson)

77. Edouard Manet, *Déjeuner sur l'herbe*, 1863. (Musée d'Orsay, Paris.) Alinari Art Resources, New York.

78. James Ensor, *Intrigue*, 1890. Koninklijk Museum, Antwerp.

79. Yoruna tribe (Munduruku, Brazil), shrunken trophy head. Museum für Völkerkunde, Berlin.

80. Kalabari Ijo, Hippopotamus mask, wood, pigment. Raymond and Laura Wieglus Collection.

81. Emil Nolde, *Masks*, oil on canvas, 1911. Collection, The Nelson-Atkins Museum of Art. Gift of the Friends of Art.

82. Cameroon tribe, headdress Ekoi, wood, leather, and mixed media. Staatliches Museum für Völkerkunde, Munich.

83(a–d). Karl Schmidt-Rottluff, *The Four Evangelists*, painted over brass relief, 1912. Brücke-Museum, Berlin. (© ADAGP, Paris/VAGA, New York, 1985)

84. Raymond Duchamp-Villon, Cubist house, 1912. Building destroyed.

85. Ludwig Meidner, *Corner House (Villa Kochmann, Dresden)*, oil on canvas, 1913. Sammlung Kirste, Recklinghausen.

86. Georges Minne, *Bather I*, bronze, 1899. The Robert Gore Rifkind Collection, Beverly Hills, California.

87. Wilhelm Lehmbruck, *Kneeling Woman*, cast stone, 1911. Collection, The Museum of Modern Art, New York. Abby Aldrich Rockefeller Fund.

88. Mathias Grünewald, "Crucifixion" from the Isenheim Altarpiece. Musée Unterlinden, Colmar. (Giraudon/Art Resource)

89. Max Ernst, *Crucifixion*, 1913. Museum Ludwig, Cologne. (Photo Rheinisches Bildarchiv)

90. Anonymous, child's drawing, *Snowball Fight*. From Georg Kerschensteiner, *Die Entwickelung der zeichnerischen Begabung* (Munich, 1905), pl. 95.

91. Paul Klee, *Children as Actors*, ink and pencil on paper, 1913. Paul Klee Stiftung, Kunstmuseum, Bern. (© COSMOPRESS, Geneva, ADAGP, Paris/VAGA, New York, 1985)

92. Robert Delaunay, *Windows on the City*, 1912–13. Musée national d'art moderne, Centre Georges Pompidou, Paris.

93. Franz Marc, *Deer in the Forest II*, oil on canvas, 1914. Staatliche Kunsthalle, Karlsruhe.

94. Gino Severini, *Self-Portrait with Monocle*, 1912. Musée national d'art moderne, Centre Georges Pompidou, Paris. (© ADAGP, Paris/VAGA, New York, 1985)

95. Otto Dix, *Self-Portrait as Mars*, oil on canvas, 1915. Deutsche Fotothek, Dresden.

96. Umberto Boccioni, *Forces of a Street*, oil on canvas, 1911. Private collection, on loan to Kunstmuseum Basel.

97. George Grosz, *The Big City*, oil on canvas, 1916–17. Thyssen-Bornemisza Collection, Lugano, Switzerland.

98. Philipp Otto Runge, *Morning* (small version), oil on canvas, 1808. Hamburger Kunsthalle. (Photo © Ralph Kleinhempel)

99. Erich Heckel, *Ostend Madonna* [lost], oil on canvas, 1915. (Copyright Erich Heckel Estate, Hemmenhofen; Foto Marburg)

100. Caspar David Friedrich, *Large Enclosure (Evening on the Elbe)*, 1832. Staatliche Kunstsammlungen, Dresden.

101. Emil Nolde, *Marsh Landscape (Evening)*, oil on canvas, 1916. Öffentliche Kunstsammlung, Kunstmuseum Basel. (Nolde-Stiftung Seebüll)

102. Gabon Fang tribe, wooden head in two views. (From Carl Einstein, *Negerplastik*, 1915, nos. 16–17)

103. Karl Schmidt-Rottluff, *Three Kings*, woodcut, 1917. Collection, The Museum of Modern Art, New York; Purchase.

104. Court of Benin, Nigeria, bronze plaque. Museum für Völkerkunde, Staatliche Museen Preussischer Kulturbesitz, Berlin. (Photo Dietrich Graf)

105. Heinrich Campendonk, *The Tiger*, woodcut, 1916. Bayerische Staatsgemäldesammlungen, Munich.

106. Albrecht Dürer, *The Fall of Man (Adam and Eve)*, engraving, 1504. Museum of Fine Arts, Boston. (Courtesy, Museum of Fine Arts, Boston; Centennial Gift of Landon T. Clay)

107. Max Beckmann, *Adam and Eve*, 1917. Private collection, USA.

108. Stalactite vaulting, Alhambra Palace, Granada, Spain.

109. Hans Poelzig, *Grosses Schauspielhaus*, Berlin, 1919. (Photo courtesy of the Akademie der Künste, Berlin, architecture collection)

110. Constantin von Mitschke-Collande, *The Time Is Ripe*, woodcut, 1919. Los Angeles County Museum of Art: The Robert Gore Rifkind Center for German Expressionist Studies

111. Hermann Warm, Walter Rohrig, and Walter Reimann, designers, still from Robert Wiene's film, *The Cabinet of Dr. Caligari*, 1919. The Museum of Modern Art/Film Stills Archive.

112. Ngombe tribe, Congo, female fetish figure, painted wood. Museum für Völkerkunde, Staatliche Museen Preussischer Kulturbesitz, Berlin.

113. Max Pechstein, *Moon*, painted wood, 1919. Location unknown.

114. Polynesian cult figure, "God of Fishermen." Staatliches Museum für Völkerkunde, Munich.

115. Paul Klee, *Portrait of the Artist*, drawing, 1919. Location unknown. (© COSMOPRESS, Geneva, ADAGP, Paris/VAGA, New York, 1985)

116. Tung-fang-so, Chinese porcelain longevity figure. (Nolde-Stiftung Seebüll)

117. Emil Nolde, *Still Life (Rider and China Figures)*, oil on canvas, 1920. (Nolde-Stiftung Seebüll; photo © Ralph Kleinhempel)

118. Philipp Otto Runge, *Parents of the Artist*, oil on canvas, 1806. Hamburger Kunsthalle. (Photo © Ralph Kleinhempel)

119. Otto Dix, *Portrait of the Artist's Parents*, 1921. Öffentliche Kunstsammlung, Kunstmuseum, Basel.

120. Karl Schmidt-Rottluff, *Am the Child of Poor People*, woodcut, 1905. Brücke Museum, Berlin. (© ADAGP, Paris/VAGA, New York, 1985)

121. Käthe Kollwitz, *March of the Weavers*, etching, 1897. The Robert Gore Rifkind Collection, Beverly Hills, California.

122. Paula Modersohn-Becker, *Kneeling Mother and Child*, oil on canvas, 1907. Private collection, West Germany.

123. Lyonel Feininger, *The Manhole, I (Infanticide)*, 1908. Location unknown. (© ADAGP, Paris/VAGA, New York, 1985)

124. Emil Nolde, *At the Wine Table*, oil on canvas, 1911. Bayerische Staatsgemäldesammlungen. (Nolde-Stiftung Seebüll)

125. Ernst Ludwig Kirchner, *Manifesto of Künstlergruppe Brücke*, wood or

1937. Oskar Kokoschka-Dokumentation Pochlarn, Austria. Museum of Modern Art, New York. (© COSMOPRESS, Geneva, 1985)
175. Constant Permeke, *Engaged Couple (Les fiàncés),* 1922. Musées royaux des Beaux-Arts de Belgique, Brussels.
176. Frits von den Berghe, *Birth (Naissance),* oil on canvas, 1927. Emanuel Hoffmann-Foundation, Kunstmuseum Basel.
177. Albin Amelin, *Murdered Woman,* 1928. Nationalmuseum, Stockholm.
178. Aldo Renato Guttuso, *Crucifixion,* oil on canvas, 1941. Galleria del Milione, A. Della Ragione Collection, Milan.
179. Chaim Soutine, *Hill at Céret,* oil on canvas, 1922. The Israel Museum, Jerusalem.
180. André Masson, study for stage design for Cervantes, *Numance,* ink on paper, 1937. Collection, The Museum of Modern Art, New York.
181. José Clemente Orozco, *Prometheus,* fresco, 1930. Pomona College, Claremont, California.
182. José Clemente Orozco, *Katharsis,* fresco, 1934. Museo del Palacio de Bellas Artes, INBA, Mexico.
183. Mark Rothko, *Self-Portrait,* oil on canvas, 1936. Solomon R. Guggenheim Museum, New York. (By permission of the Estate of Mary Alice Rothko)
184. Abraham Rattner, *Clowns and Kings,* oil on canvas, 1944. Collection of Esther Gentle Rattner, New York.
185. Jack Levine, *Gangster Funeral,* oil on canvas, 1952–53. Whitney Museum of American Art, New York. (Photo Geoffrey Clements)
186. Jackson Pollock, *Birth,* oil on canvas, 1940–41. Estate of Lee Krasner Pollock. (Photo Bruce C. Jones)
187. Pablo Picasso, *Girl with Cock,* oil on canvas, 1938. Private collection on loan at the Kunsthaus, Zurich. (© SPADEM, Paris/VAGA, New York 1985)
188. Jackson Pollock, *Bird,* oil and sand on canvas, 1941–42. Collection, The Museum of Modern Art, New York. Gift of Lee Krasner Pollock in memory of Jackson Pollock.
189. Tlingit fringed blanket, Chilkat. Collection Esther Gottlieb, New York.
190. Adolph Gottlieb, *Eyes of Oedipus,* oil on canvas, 1941. (Courtesy of Adolph and Esther Gottlieb Foundation, New York © 1981)
191. Mark Rothko, *Number 26,* oil on canvas, 1947. Formerly in the Betty Parsons Collection, New York.
192. Willem de Kooning, *Light in August,* ca. 1946. Teheran Museum. (Courtesy Xavier Fourcade, Inc., New York; photo Bruce C. Jones)
193. Chaim Soutine, *Woman in Red,* oil on canvas, ca. 1922. Collection Dr. E. M. Bakwin, Chicago.
194. Willem de Kooning, *Woman, I,* oil on canvas, 1950–52. Collection, The Museum of Modern Art, New York; Purchase.
195. Adolph Gottlieb, *Blast, I,* oil on canvas, 1957. Collection, The Museum of Modern Art, New York, Philip Johnson Fund.
196. Francis Bacon, *Painting,* oil and tempera on canvas, 1946. Collection, The Museum of Modern Art, New York; Purchase.
197. Asger Jorn, *Suicide's Counselor,* 1950. Collection of Erling Koeford, Copenhagen.
198. Georg Baselitz, *Family,* oil on canvas, 1975. Mary Boone Gallery, New York, and Galerie Michael Werner, Cologne.
199. Anselm Kiefer, *To the Unknown Painter,* oil emulsion, woodcut, shellac, latex, straw on canvas. Carnegie Museum of Art, Pittsburgh. Gift of Richard M. Scaife and A. W. Mellon Acquisition Endowment Fund, 1983.
200. Sandro Chia, *Dionysus' Kitchen,* oil on canvas, 1980. Marx Collection, Berlin.
201. Julian Schnabel, *Head (for Albert),* oil on canvas, 1980. Emmanuel Hoffmann Foundation, Museum für Gegenwartskunst Basel.

COLORPLATES

1. Franz Marc, *Animal Destinies,* oil on canvas, 1913. Öffentliche Kunstsammlung, Kunstmuseum Basel. (Colorphoto Hans Hinz, Basel)
2. Oskar Kokoschka, poster for *Murderer, Hope of Women,* color lithograph, 1909. Collection, The Museum of Modern Art, New York; Purchase.
3. Arnold Schoenberg, *The Red Stare,* oil on canvas, 1910. Städtische Galerie im Lenbachhaus, Munich. (Photo Artothek)
4. Egon Schiele, *Cardinal and Nun,* oil on canvas, Kallir 156, 1912.
5. Emil Nolde, *Wildly Dancing Children,* oil on canvas, 1909. Kunsthalle zu Kiel. (Nolde-Stiftung Seebüll)
6. Ludwig Meidner, *Apocalyptic Landscape,* oil on canvas, 1912–1913. Nationalgalerie, Staatliche Museen Preussischer Kulturbesitz, Berlin. (Photo Jörg P. Anders, Berlin)
7. Oskar Kokoschka, *The Tempest,* oil on canvas, 1914. Öffentliche Kunstsammlung, Kunstmuseum Basel. (Colorphoto Hans Hinz, Basel)
8. Erich Heckel, *Glassy Day,* oil on canvas, 1913. Bayerische Staatsgemäldesammlungen, Staatsgalerie Moderner Kunst, Munich. (Photo Artothek)
9. Max Beckmann, *The Night,* oil on canvas, 1918–19. Kunstsammlung Nordrhein-Westfalen, Düsseldorf. (© ADAGP, VG Bild-Kunst, 1985; photo Walter Klein)
10. Otto Dix, *Pregnant Woman,* oil on canvas, 1919. Galerie Valentin, Stuttgart. (Reproduced by permission of Otto Dix Stiftung)
11. Max Pechstein, *Give Us This Day Our Daily Bread,* plate 5 from *The Lord's Prayer,* hand-colored woodcut, 1921. Los Angeles County Museum of Art. (Purchased with Funds Provided by Anna Bing Arnold, Museum Acquisitions and Deaccession Funds)
12. Lovis Corinth, *The Red Christ,* oil on canvas, 1922. (Reproduced by permission of Thomas Corinth, New York; photo Artothek)
13. "Music of Wagner," from A. Besant and C. W. Leadbetter, *Thought-Forms,* 1908.
14. Wassily Kandinsky, *Mountain,* oil on canvas, 1909. Städtische Galerie im Lenbachhaus, Munich. (© ADAGP, Paris/VAGA, New York, 1985)
15. Christian Rohlfs, *Birch Forest,* 1907. Museum Folkwang, Essen. (Courtesy Mrs. Helene Rohlfs)
16. Max Pechstein, *Evening in the Dunes,* oil on canvas, 1911. Leonard Hutton Galleries, New York.
17. Emil Nolde, *Marsh Landscape (Evening),* oil on canvas, 1916. Öffentliche Kunstsammlung, Kunstmuseum Basel. (Nolde-Stiftung Seebüll; Colorphoto Hans Hinz, Basel)
18. Otto Dix, *Portrait of the Artist's Parents,* 1921. Öffentliche Kunstsammlung, Kunstmuseum Basel. (Colorphoto Hans Hinz, Basel)
19. Paula Modersohn-Becker, *Kneeling Mother and Child,* oil on canvas, 1907. Private collection, West Germany.
20. Ernst Ludwig Kirchner, *Street, Berlin,* oil on canvas, 1913. Collection, The Museum of Modern Art, New York. Purchase. (© Dr. Wolfgang and Ingeborg Henze, Lugano)
21. Oskar Kokoschka, *Fan for Alma Mahler,* 1914. Museum für Kunst und Gewerbe, Hamburg. (© COSMOPRESS, Geneva, 1985; photo Karin Kiemer, Hamburg)
22. Ernst Ludwig Kirchner, *Schlemihl's Encounter With the Shadow,* reproduction after color woodcut, 1915. Los Angeles County Museum of Art. Purchased with Funds Provided by Anna Bing Arnold, Museum Acquisitions Fund, and Deaccession Funds. (© Dr. Wolfgang and Ingeborg Henze, Lugano)

23. Jackson Pollock, *Bird,* oil and sand on canvas, 1941–42. Collection, The Museum of Modern Art, New York. Gift of Lee Krasner Pollock in memory of Jackson Pollock.
24. Willem de Kooning, *Woman, I,* oil on canvas, 1950–52. Collection, The Museum of Modern Art, New York.
25. Francis Bacon, *Painting,* oil and tempera on canvas, 1946. Collection, The Museum of Modern Art, New York; Purchase.

26. Sandro Chia, *Dionysus' Kitchen,* oil on canvas, 1980. Marx Collection, Berlin. (Photo Bevan Davies)
27. Julian Schnabel, *Head (for Albert),* oil on canvas, 1980. Emmanuel Hoffmann Foundation, Museum für Gegenwartskunst, Berlin.

Preface

In January 1984 Donald E. Gordon submitted his manuscript for *Expressionism: Art and Idea*. Fortunately, he learned informally of its acceptance prior to his death on April tenth of that year. Still to be handled at the time were the revisions recommended by the Press's outside reader, and the bibliography, illustrations, and index, none of which had been completed. It was my decision, with the concurrence of Judy Metro of Yale University Press, to undertake and/or supervise the completion of the project myself. Using the many resources open to me due to the abundant goodwill left as a legacy by my husband, we began the work. His colleagues at the Frick Fine Arts Department at the University of Pittsburgh were warmly supportive and made their facilities available to me unstintingly. To Kathryn Linduff, the department chair and a former student of Don's, I owe a particular debt for her care and kindness.

The first task was to evaluate and integrate the suggestions made by the final manuscript reader, Victor Miesel. Lucy Embick Kunz, a doctoral candidate of Professor Gordon's, undertook that assignment as well as the organization of a system of identifying and tracking down over two hundred works of art for illustrations. Since Don had left only a checklist specifying artist, title of work, and date, discovering the present location of each work of art was a complicated puzzle. Without Lucy's steadfast efforts, both here and in Germany, I could not have completed this endeavor. With the help of Linda Hicks and Matthew Roper of the Frick Fine Arts Department staff, Penny Cyd Lazarus, a graduate student, and Elizabeth Prelinger, then of the Museum of Art, Carnegie Institute, we started the international search, writing requests in English, receiving replies in German, French, Italian, and Norwegian. Information which would have been at Don's fingertips or in his head took us more than a year to locate. Mark Haxthausen, of the University of Minnesota, kindly agreed to verify our findings by double-checking the problematic illustrations. A grant from the University of Pittsburgh Research and Development Fund cleared the way for the final processing.

Since I had revised the footnotes, I also began compiling the selected bibliography. Rich Gordon organized the index, continuing a tradition he started at age ten, when indexing his father's Kirchner book. Tom Gordon has helped in many ways, including translating from German, proofreading, heavy hauling, and just being there.

In addition, I would like to thank Anne W. Gordon, Oxanna S. Kaufman, and Ray Ann Lockard of the Frick Fine Arts Library; Joan

Weinstein, the new specialist on German expressionist art at Pitt; Martine Sheon for her sensitive suggestions; and Elaine A. King, art historian and curator at Carnegie-Mellon University, whose knowledge of both the subject and myself proved invaluable.

Finally it must be said that Don did not have the luxury of time to carry out the thorough revision any writer savors while wrapping up a creative endeavor—finding the last primary source, the better turn of phrase, a particularly exquisite clarification. Don looked on this as a seminal work, hoping that future scholars would find bones to pick and areas to explore at greater depth. Since it was our desire to make the end product completely his, we hope the reader will take the given circumstance into account and benefit from the final work of a distinguished and dedicated scholar.

The papers and Expressionist library of Donald E. Gordon are available for research purposes at the Frick Fine Arts Library at the University of Pittsburgh.

Joan Morse Gordon
Pittsburgh, Pennsylvania
1987

Introduction

To understand the problem with which this book began, the reader must first be familiar with an unlikely set of circumstances. He or she must conceive not a close-knit art school but a vaguely defined art "movement" whose participants began their activity independently, in five or six German-speaking cities, regions, or even countries, only to be tagged by art critics with a foreign label which, in a country drifting toward war, came gradually to be colored by nationalistic hyperbole. The reader must further imagine yet another group of artists, on the average younger than the first and working now in wartime and postwar styles and social conditions, to whom art critics gave the exact same label—thus forcing some members of both the earlier and the later groups to disclaim any connection with the tag that had been foisted on them. And finally the reader must accept the fact that by the time that same label came to be used in the United States, its Germanic associations were forgotten and it was limited instead to meanings of "emotion" and "feeling"—meanings which had been only peripheral to the original use of the term. Once the reader has grasped this situation, he or she will understand much of the history of the label "Expressionism."

Faced with this situation, the student of the subject might be tempted to consider the label as one of the great failures of modern art criticism and might wish to limit the damage to later scholarship by returning to the word its earliest meanings. This at least was my hope in 1966 in publishing a study on the word "Expressionism."[1]

By the time I had begun work on this book, however, I had readily adopted a practical approach. Throughout the text I planned to use the word "Expressionism" pragmatically to mean simply what Expressionists do, while in a separate chapter I would present the several definitions of the term and, as necessary, the arguments against them. This indeed I have done. But in considering the art and its history over the years I pondered whether there might not exist some common denominator after all, some unifying idea of Expressionism that would prove relevant to the different kinds of Expressionist art. Thus was born the underlying concept of this book, which I will refer to as Expressionist art *and* idea. Needless to say, I was not concerned with identifying some "essence" of Expressionism, capable of abstract definition; as Georg Lukács was the first to point out, this is where Expressionist criticism went wrong in the first place. Instead,

the Expressionist idea would have to emerge directly from the art historical material.

The book comprises a series of exploratory probes. I must stress the word "exploratory," for the subject is extensive. A recent bibliography on German Expressionist art numbers 4,259 items through the year 1972, yet does not include architecture, film, music, or literature.[2] Another listing, the 18-volume *Index Expressionismus,* does include these media, but its computer-collated entries comprise the 37,000 magazine articles published only through 1925 in Germany alone.[3] When one adds the collected works of literary Expressionists, the recent studies on Expressionist artists, and the entire bibliography on non-German Expressionism, the quantity of work produced is mind-boggling. Rather than seeking to be definitive, in sum, the book will achieve its purpose if it succeeds in formulating some of the ways Expressionist art embodies the vanguard aesthetic of modern art and the social and cultural history of its time.

The separate chapters do not provide a continuous historical survey but rather a series of more or less independent investigations into Expressionism's intellectual milieu, iconography, style, social psychology, and art criticism. Therefore my coverage is both broader and narrower than is common in art texts of this type. It is broader in that, for an art without a center, careful circumnavigation is necessary to establish boundaries. Because there is not a defining "essence," Expressionism's relation to Romanticism or to Cubism or to Dada must, at various points, be examined. The coverage is narrower in that the central chapters of the book are devoted not to art in general but to art works in particular. Certain paintings are analyzed for their specific implications of style or content. As a result, even though individual works cannot be considered exhaustively, they each become the vehicle by which broader judgments are achieved.

Despite the fact that Expressionism has no center, for the purposes of this book I have followed the traditional view that Expressionism was primarily, but not exclusively, German. Expressionist tendencies certainly existed in Europe before 1914 and in both Europe and America afterward. But I tended from the start to see Expressionism as typical—and indeed revelatory—of modern German culture as a whole. I considered the German production the key to the entire phenomenon.

But the chronological limits of Expressionist art were more difficult to establish. In his pioneering study of *German Expressionist Painting,* Peter Selz included the Secessions from the turn of the century—Berlin's Impressionism, Munich's Jugendstil, Vienna's Klimt—but ended the movement, essentially, with the First World War.[4] This led to an anachronism: the movement in painting seemed to flourish during the prewar decade 1905–14, while that in literature flourished during the period 1910–23. Of course, once a "second wave" of Expressionist art was widely recognized, the inconsistency disappeared.[5] Today we see Expressionist art, despite the fact that it originated earlier, as essentially contemporary with the literary movement. Thus I had grounds to date the visual arts of German Expressionism from about 1905 to about 1923.[6]

Nevertheless there remained the question of Expressionism's exact relation to its Impressionist and Symbolist precedents. Did the movement include its turn-of-the-century sources, or did it somehow react against them? This is an insoluble question, like that of the priority of the chicken or the egg. Yet it led me to postulate a principle of "reactivity" as an essential key to the Expressionist puzzle. According to this principle, the artist takes his initial inspiration from the immediate past but then actively transforms or, in fact, negates it.[7] The principle helped explain why Expressionists took inspiration from Gauguin, Van Gogh, and Munch and yet remained, themselves, German. Moreover, the notion of apparent acceptance and yet rejection promised to explicate other aspects of modern German culture, especially its youth movements and generation conflicts.

This clue, slight as it was, permitted me to address the nature of Expressionism's primary intellectual content. On one level this was easy. Art movements often reflect important ideas of their time: witness Impressionism and the optical science of Eugène Chevreul, Cubism and the non-Euclidian geometry of Henri Poincaré, Surrealism and the depth psychology of Sigmund Freud. Why should not Expressionism embody the vitalist philosophy of Friedrich Nietzsche? After all, an American observer had written in 1910 of "Nietzsche's definition of an ascendent or renascent art, . . . the product of an over-plus of life and energy, not of the degeneracy of stagnant emotions, . . . an attempt at expression."[8] Expressionism was, in its origins, precisely such a "renascent art" full of "life and energy."

But the problem with this reading was that it represented only one half of Nietzsche, the optimistic half. There was also the pessimistic Nietzsche described more recently: "To some he has been primarily the man who diagnosed the decadence and imminent collapse of western civilization, while others have seen in him and his philosophy the embodiment of the very nihilism for which he professed to supply a remedy."[9] How could he advocate both renascence and decadence? More importantly, how can Expressionism be an art of both renewal and decline?

The short answer to these questions is that he did, and it is. The very content of Expressionist art, like that of Nietzsche's teachings, depends fundamentally on antithesis or contradiction. The reactive principle is at work in the formation not only of Expressionism's style but also of its meaning.[10] Moreover, though twentieth-century Expressionism contains immeasurably more contradiction than did nineteenth-century Romanticism, the very notion of antithesis is rooted in northern Romanticism rather than Latin Classicism.[11] Finally, even Expressionist emotion—in the form of the "new pathos"—is dualist; pathetic feelings are those involving sympathy and suffering, affirmation and pity. This is why, it seems to me, the prime emotional state of Expressionism is tension, ambiguity, ambivalence. Expressionist dualism defines such typical themes as the vital and decadent city, or the self as suffering hero.

This finding sheds light, in turn, on the problem with which we started, namely German Expressionist chronology. For the prewar

movement was on balance optimistic, the post-1914 development pessimistic. The very textbooks and exhibition catalogues on the subject reflect this difference: for example, Selz's 1957 study of pre-war Expressionism is sanguine, while Rigby's 1983 study of the war and postwar movement is bitter.[12] And yet the fact is that both halves of the movement contain their opposites. The period around 1912 saw apocalyptic images—the destruction that must precede new creation—while the period around 1918–19 saw images of the "new man," in other words depictions of rebirth following death. In its three phases, then, German Expressionism certainly begins with the promise of renewal (1905–10), but soon achieves in its greatest masterpieces an optimistic/pessimistic tension (1910–14) before ending in a grim standoff between latent hope and manifest despair (1914–23).

If part of Expressionism's –"idea" is ambivalence, however, the content of its art is both intellectually and socially based. Does this suggest a link between Expressionism and Nazism? Victor Miesel points out that Expressionists were Germany's "war generation," even the "same generation" as the future Nazis.[13] But it would be better to stress the half-generation difference: Kandinsky, Nolde, Kirchner, and Kokoschka were born between 1866 and 1886, but Hitler, Goering, Hess, and Goebbels between 1889 and 1897. All were affected by the 1914–18 war, and younger Expressionists were actually contemporaries of older Fascists. But Expressionism and Nazism originated in response to different historical situations: the former in the fin-de-siècle, the latter in the postwar era. Thus in one case cultural decadence prompted a radical cultural revival while, in the other, military defeat fostered a radical militarist party. Still, what we see in both cases is a youthful rebellion or reaction against events intolerable to the rebels yet generally accepted by the older generation. In this sense there was not an ideological but a structural similarity between the two revolts: as Expressionists reacted against Wilhelmian culture circa 1905, so would Nazis react against the Weimar Republic circa 1920 and against Expressionism itself circa 1935. What linked German art and politics was not necessarily a folkish ideology—this remains to be examined—but rather a repeated recourse to rebellion.

Ambivalence, reactivity, rebellion: these are properties of German modern art and culture which constitute the Expressionist "idea." Do they also reflect aspects of the German national character? It has been suggested that depth psychologists and Expressionists were simultaneously investigating the self. They were all proceeding from outer description to inner experience or, as Alessandra Comini has it, "from façade to psyche."[14] Yet the discoveries of Freud and Jung (like those of Einstein and Bohr) were not generally known before 1918; Expressionist dualism was rarely described, in its time, in terms of the conscious and unconscious mind. Instead, the German character had traditionally been reflected in that Romantic image of split personality, the doppelgänger; the problem of the German psyche, it appeared to me, was identity confusion. Expressionist art, often created for Jewish patrons or dealers, provided an opportunity to examine the closely related questions of "Germanness" and "Jewishness."

Proceeding further in this direction, I found I could not limit the Expressionist properties of ambivalence, reactivity, and rebellion to German art and social psychology alone. To what extent, I wondered, do they characterize modern German Wissenschaft as well? The evidence is inconclusive, yet Expressionists were remarkably aware of recent developments in science, social science, and pseudo-science—fields in which German-speaking investigators led the world. Indeed Expressionism's dualist aspect seems to complement such relativistic concepts as evolution/dissolution, matter/energy, and instinct/intellect—concepts which reformulate or react against those of leading British and French positivists a few decades before. In this sense the Expressionist idea helps to define a scientific paradigm. It may mark yet another discontinuity in the episteme of Western culture, distinguishing a "post-modern" science from the "modern" (for example, nineteenth-century) science defined by Michel Foucault.[15]

It is at this point that the book begins, with a study of the intellectual milieu in which Expressionist artists matured. Yet the book ends with discussion of a broader question still. To what extent does Expressionist art contribute to twentieth-century art as a whole? From the 1900s when a "cult of Nietzsche" arose in France and Italy,[16] to the 1940s when "Abstract Expressionism" dominated art in the United States, to the 1980s when "Neo-Expressionism" reappeared throughout the West, what was once a German itch has required worldwide scratching. Through analysis of the Expressionist idea in Germany, that is, we can now recognize the post-Nietzschean, post-mimetic, post-Victorian, and post-industrial dimensions of modern art and culture.

My work was begun in 1973–74 with the aid of a fellowship from the American Council of Learned Societies, and completed ten years later with a briefer scholarship from the Robert Gore Rifkind Foundation. In between my work has profited from the advice and criticism of my colleagues John Bowlt, Wolf-Dieter Dube, Charles Haxthausen, Reinhold Heller, Donald Kuspit, Victor Miesel, R. C. Washton Long, Linda Nochlin, Theodore Reff, Leopold Reidemeister, Mark Roskill, William Rubin, Gert Schiff, Peter Selz, Jiri Šetlik, Martin Urban, and O. K. Werckmeister, and from the contributions of my students Lucy Embick, Ann Gibson, Sara Gregg, Piri Halasz, Julia Rowland Myers, and George Rugg. To all of them, and above all to my wife Joan, I express my deepest gratitude.

Donald E. Gordon
Christmas, 1983

EXPRESSIONISM
Art and Idea

1.
Intellectual Milieu

Art has just gone through a long period of aberration caused by physics, chemistry, mechanics, and the study of nature. Artists, having lost all of their savagery, having no more instincts, one could even say imagination, went astray on every path.

PAUL GAUGUIN

1.1. ART AND SCIENCE, HOPES AND FEARS

Friedrich Nietzsche once wrote that "It is not the victory of science that distinguishes our nineteenth century, but the victory of scientific method over science." Scientific method is objective, impersonal, rational, and is to be distinguished from a true search for knowledge which is instinctual: "Scientific integrity is always ruptured when the thinker begins to reason. . . . Genius resides in instinct; goodness likewise. One acts perfectly only when one acts instinctively." Elsewhere Nietzsche distinguishes science from the subjective values that one "imports" into it: "Ultimately, man finds in things nothing but what he himself has imported into them; the finding is called science, the importing [is called] art, religion, love, pride."[1] These views suggest Nietzsche's ambivalence toward science. He valued the search for knowledge—as much the philosopher's task as the scientist's—but he deplored the dehumanizing aspect of the modern scientific enterprise.

Moreover, Nietzsche viewed contemporary science with special skepticism, and was particularly disturbed by the reduction of science to a search for causes—whether efficient cause (as in "cause-and-effect") or final cause (as in "teleological reasoning"). Thus he spoke against the physics of his day: "It is perhaps just dawning on five or six minds that physics . . . is only an interpretation and ex-

egesis of the world (to suit us, if I may say so!) and *not* a world-explanation; but insofar as it is based on belief in the senses, it is regarded as more. . . . Eyes and fingers speak in its favor, visual evidence and palpableness do, too; this strikes an age with fundamentally plebian tastes as fascinating, persuasive, and convincing." He also argued against contemporary physiology, decrying the notion of self-preservation as organic life's "cardinal instinct." Nietzsche felt that self-preservation was but an indirect result of life's will to power—"a living thing seeks above all to *discharge* its strength"—and so he warned against the "superfluous teleological principles" of scientists for whom deadly ends justified ruthless means. Against such modern scientism he upheld the example of Plato's Socrates: "In this overcoming of the world, and interpreting the world in the manner of Plato, there was an enjoyment different from that which the physicists of today offer us—and also the Darwinists and anti-teleologists among the workers in physiology, with their principle of the 'smallest possible force' and the greatest possible stupidity."[2]

From here it was but a small step to the belief that modern scientism was a sign of decadence, that the modern world defined by nineteenth-century science was in decline. As Nietzsche put it, "our desire, even our will for knowledge, is a symptom of tremendous

decadence. . . . That science is possible in the sense that is cultivated today is proof that all elementary instincts . . . no longer function." To this he added that the "nihilistic trait" of the natural sciences was "causalism, mechanism," and of history "fatalism, Darwinism."[3] Nietzsche's position is, once again, ambivalent. Physics, physiology, evolutionary biology, history exist and have a right to exist as sciences. Yet the scientific method employed by these disciplines—whether called causalism or materialism, mechanism or positivism—was considered both faulty in itself and symptomatic of the decadence of its age.

Nietzsche's views are significant for two reasons. First, his critique of late-nineteenth-century science can be taken as a prediction of the more relativistic sciences of ensuing decades—atomic theory, quantum mechanics, depth psychology—which are no longer causal or mechanistic in the earlier sense. His foresight fed his posthumous reputation early in the twentieth century. Second, Nietzsche's ambivalence toward science was nevertheless based upon an intimate working knowledge of those very sciences he scorned. To call him an "irrationalist" or a "subjectivist" is to overlook the fact that he first had to understand the rational and objective aspects of nineteenth-century science before arguing against them. Ambivalence does not mean outright rejection. Instead it signifies fascination tinged by revulsion, affirmation hand in hand with negation.

What Nietzsche sowed, Expressionists reaped. Like him, Expressionist artists participated in the scientific learning of their age and yet opposed its materialism and its positivism. Like the philosopher, the painters saw a renewed vigor of art as the best antidote for the sickness of science. And like the great "Yea-sayer," Expressionists achieved optimism only in the face of despair. In Franz Marc's words: "Science works negatively, *au détriment de la religion*—what a terrible confession for the spiritual work of our time."[4] If German Expressionism is to be understood as a coherent movement at all, then it must be seen as inhabiting an intellectual milieu of ambivalence.

In his pioneering study of the German movement Peter Selz has written that "Expressionism can be more fully understood if it is seen in relation to the relativistic and subjective trends in modern psychology, the sciences, and philosophy—trends of which many of the Expressionists were acutely aware." Expressionist artists, most of whom were well educated, not only read Nietzsche, but also followed the latest developments in the sciences, social sciences, and pseudo-sciences of their day. Indeed, had a second *Blaue Reiter* almanach followed the original of 1912, it would have gone further into these areas. As Wassily Kandinsky later recalled, "My immediate plans for the next volume of the *Blaue Reiter* were to put art and science next to one another: origins, realization through various work processes, purpose." Even Emil Nolde, who was often skeptical of book learning, borrowed from the language of the Social Darwinists to describe the Negro culture of New Guinea in 1914. "All that matters is the law of the stronger," Nolde wrote. "During these months I have frequently been forced to think of the Spaniards and their blind, reckless extermination of Central American culture."[5]

If Expressionists followed Nietzsche in criticizing the science of their era, they also agreed with him that objective knowledge had to yield to subjective creation. In Nietzsche's words: "Our religion, morality, and philosophy are decadent forms of man. The counter-movement [is] art."[6] Yet in preferring art to science, Expressionist painters could hardly assume that the decadence of learning meant the vigor of the arts. Far from it—German Expressionists readily proclaimed the sickness of German art around 1900. Indeed it is significant that Expressionism first arose not in literature or music but in the mediums of painting and printmaking, mediums that had not particularly prospered in nineteenth-century Germany. It was precisely in the greatest area of decline that artists found the greatest prospects for renewal.

Despite Nietzsche's criticism, German science had flourished from Fechner and Haeckel to Roentgen and Mach, even before the breakthroughs of Freud and Einstein. And in philosophy and music, in literature and architectural design, German contributions in the last quarter of the nineteenth century were universally recognized as significant. Only in the visual arts, particularly in the medium of painting, did informed Germans by the turn of the century acknowledge French priority. In this acknowledgment lay the promise of new beginnings; precisely in the ground where decay was greatest lay the best seed for future growth. It is impossible to describe the Expressionist phenomena without first confirming the weakness of pre-Expressionist German painting.

Quite revealing is a letter written by Ernst Ludwig Kirchner at the end of his life:

> Did you know that as far back as 1900 I had the audacious idea of renewing German art? Indeed I did, and the impulse came to me while looking at an exhibition of the Munich Secessionists in Munich. . . . Indoors hung these anemic, bloodless, lifeless studio daubs while outside was life itself, noisy and colorful, pulsating in the sun. . . . I learned a great deal from an exhibition of French Neo-Impressionists . . . [and from] the Rembrandt drawings in the Munich Kupferstichkabinett. . . . I wanted to express the richness and joy of living, to paint humanity at work and at play in its reactions and interreactions and to express love as well as hatred. . . . That great poet, Walt Whitman, was responsible for my outlook on life. During my dismal days of want and hunger in Dresden, his *Leaves of Grass* was and still is my comfort and encouragement.[7]

Kirchner's letter reflects the enthusiastic and energetic side of German Expressionism, the utterance of *joie de vivre* by means of art, the stress on sheer vitality in painting, above all the renewal of a medium that had attracted few major talents in Germany for generations. But the idea of renewal also carried with it the antecedent notion of decline. The Expressionist was well aware of a danger his predecessors had encountered, the risk of bloodlessness and lifelessness

that well-meaning older artists could not avoid. Wassily Kandinsky felt the same way as late as 1909:

> When I returned to Munich a year ago, I found everything still in the same place. And I thought: this really is that fairy kingdom in which pictures sleep on the walls, custodians in their corners, the public with their catalogues in their hands, the Munich artists with their same broad brushstroke, the critics with their pens between their teeth. And the buyer, who in former times went indefatigably with his money into the secretary's office—he too, as in the story, has been overcome by sleep on the way, and left rooted to the spot. But one of my old friends told me: "They're waiting for something," "Something's got to happen," "Everyone who knows about such things realizes it can't go on like this," etc.[8]

That long-awaited "something" turned out, of course, to be a vital and forward-looking kind of painting. Yet a sleep had to precede the awakening. The youthful and optimistic art is somehow unthinkable without the prior debilitating tradition.

But more than just the medium of painting had atrophied. For Expressionism was a cumulative reaction to many different intimations of decline: to an imagined decrepitude in society, a supposed running down of the cosmos, and an alleged decay in the culture. It was a universal fear of degeneration that prompted a utopian hope for regeneration—that hope which is necessarily if variably present in all art called Expressionist. Indeed the very magnitude of Expressionist optimism can only be measured against its starting point in despair. This tension creates ambivalence, and the two together describe the "emotion" which viewers commonly observe. As an art of ideas Expressionism often pitted a more or less irrational antithesis against a rational thesis, thus reflecting the "traditional German tension between intellect and anti-intellectualism."[9]

Expressionism can be described most broadly and simply as a response to the fear of decline. Such a description permits otherwise disparate art forms to be unified, not according to some elusive quality of content or style, but by an underlying attitude of hoped-for revitalization. Central to the Expressionist enterprise was reciprocity: hope as answer to fear, decline as prerequisite for renewal. Reciprocal thinking determined the movement's historical development, promising health as antidote to sickness, but also threatening exhaustion for youthful energy. But before we can outline the historical phases in the evolution of Expressionist art at the end of this chapter, we must first sketch the movement's pre-history. Only by doing so in some detail can we sense the seriousness of the problem to which Expressionism was the response.

1.2. DEVOLUTION IN SOCIETY

Art historians used to think of the early modern period as a time of uninterrupted progress. And progress there was from the 1850s to the 1900s: from Realism and Impressionism to Fauvism and Cubism. But these same decades also witnessed a pervasive mood of despair. After the failures of revolutionary hopes in 1848 and 1871 a profound pessimism emerged among intellectuals in western Europe.

This despair is evident in the early Symbolist plays of Maurice Maeterlinck published around 1890. His characters, in Wassily Kandinsky's words, "are souls searching in the mist, threatened with suffocation, over whom hovers a dark invisible power. Spiritual darkness, the uncertainty of ignorance, and fear of ignorance is the world his heroes inhabit. . . . The darkening of the spiritual atmosphere, the destroying but guiding hand—and the desperate fear it instills—the lost path, the leader gone astray, all are clearly reflected in these works."[10] In The Blind an old priest leans against a gigantic oak, seemingly asleep, while on either side are arrayed six sightless men and six sightless women. They are waiting for their leader, who had brought them to this island forest, to return to them—since they do not know their way. The men must resemble the figures in Ferdinand Hodler's 1892 painting The Dispirited (fig. 1), submitting forlornly to "an unavoidable, hopeless fate."[11] For, in the Maeterlinck drama, the leader-priest has in fact died, and his charges are left with no exit from their island, no escape from their predicament.

Other Symbolist works provide similar messages. In Edvard Munch's Evening on Karl Johan Street (fig. 12), the anxious figures have been described as confronting "not us, at whom they seem to stare, but some awful interior vision." And of Gustav Klimt's Medicine (fig. 2), a critic noted that Hygeia can only "salve" the "profound suffering" that life brings with it "from the cradle to the grave." What is missing in all these works is a faith in some meaning to existence. Alternatively, what is present is a faith in the malevolence of destiny: "In these plays [Maeterlinck wrote], faith is held in enormous powers, invisible and fatal. No one knows their intentions, but the spirit of the drama assumes they are malevolent. . . . Destinies which are innocent but involuntarily hostile are here joined, and parted, to the ruin of all, under the saddened eyes of the wisest, who foresee the future but can change nothing in the cruel and inflexible games which Love and Death practice among the living. . . . To the problem of existence no reply is made except by the riddle of its annihilation."[12] Kandinsky argued that Maeterlinck's achievement was to transform the outer or material gloom into an inner or spiritual creation: "The word is an inner sound." Thus Munch manipulated the frontality of figures, Klimt their sensuality, and Hodler their "parallelism"—all in order to change the disaster of life into the triumph of art.

Such pessimism was not in principle nationalist, as it had been in Germany after the Napoleonic defeats of 1808, but was more diffuse and culturally conditioned. For these fears arose amid the most far-reaching and unsettling discoveries of modern science, from the biology of Darwin and Spencer to the physics of Clausius and Kelvin. Where the romantic sensibility could still be excited by the exploits of a Wellington or a Byron, the later insecurity was augmented by the seeming complicity of nature itself. Pseudo-political in origin, the new despair was usually expressed in pseudo-scientific terms.

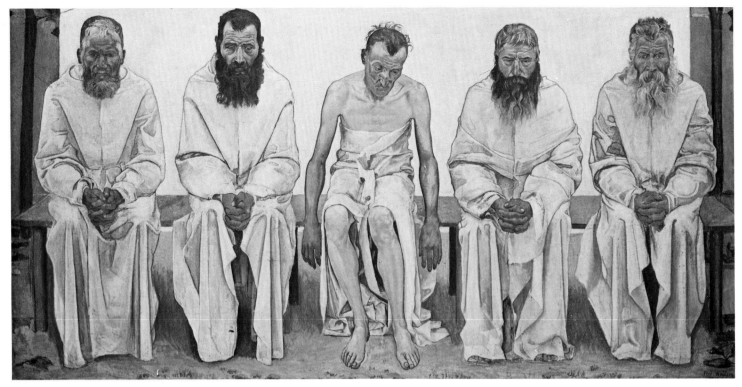

1. Ferdinand Hodler, *The Dispirited,* oil on canvas, 1892. Bayerische Staatsgemäldesammlungen, Neue Pinakothek, Munich.

There is a distinction, then, between the "romantic" pessimism of Schopenhauer and the "naturalist" nihilism of the later Nietzsche.[13] Schopenhauer's thought still rested on German idealist premises, while Nietzsche, after his break with Wagner, started with the evolutionary position of modern science. In fact the Darwinist period in European science corresponds with the Nietzschean period in German philosophy; in both there was a gloomy fascination with the contending forces of progress and decline. If Nietzsche rather than Darwin exercised the greater influence on Expressionists, it was because he alone could extrapolate from nineteenth-century fears a twentieth-century imperative.[14] Nietzsche's importance for Expressionism was precisely his *double* insistence on the reality of decline and the necessity of renewal.

Cultural pessimism was initially more pervasive in France and England, however, than in the newly unified German empire. The aborted revolutions of 1848 had spawned contradictory estimates on the chances of social betterment. In Karl Marx's view, society was bound to improve so long as it continued to give economic and political power to ever broader masses of people. Once the middle class had captured power from the aristocracy, it was inevitable, according to Marx, that it would eventually pass from the bourgeoisie to the proletariat. But in the view of conservative observers, the failure of revolution only confirmed modern hopelessness. In the estimate of Arthur de Gobineau, in fact, civilization's best days lay in the past. Only young societies are healthy; older ones become decrepit and die: "The fall of civilizations is the most striking and, at the same time, the most obscure of all the phenomena of history. . . . We moderns are the first to have recognized that every assemblage of men, together with the kind of culture it produces, is doomed to perish. . . . Societies perish because they are degenerate, and for no other reason. . . . The word *degenerate,* when applied to people, means (as it ought to mean) that the people has no longer the same blood in its veins, continual adulterations having gradually affected the quality of that blood."[15] Writing in 1853, Gobineau found the white race superior to yellows and blacks and praised the younger "Aryan elements" of northern Europe over the older "Roman" peoples to the south. But his fanciful racial theories paled before a pessimism so profound that his book ended in fatalistic gloom: "What is truly sad is not death itself but the certainty of our meeting it as degraded beings. And perhaps even that shame reserved for our descendents might leave us unmoved, if we did not feel, and secretly fear, that the rapacious hands of destiny are already upon us."[16]

Gobineau's gloom, if not also his racism, became characteristic of conservative social thought in France. In 1857, for example, Bénédict Morel focused on urbanization as the cause of modern ills; his findings were published as a *Treatise on the Physical, Intellectual and*

Moral Degeneration of the Human Species. And forty years later the sociologist Gustave Le Bon found the great civilizations of the past replaced by a faceless plebian crowd: "On the ruins of so many ideas formerly considered beyond discussion, and today decayed or decaying, of so many sources of authority that successive revolutions have destroyed, this power [of the crowd], which alone has arisen in their stead, seems soon destined to absorb the others. While all our ancient beliefs are tottering and disappearing, while the old pillars of society are giving way one by one, the power of the crowd is the only force that nothing menaces."[17]

But what must be stressed is that the mood of despair gripped not just a few intellectuals after the twin failures of the 1848 revolution and the 1870–71 Franco-Prussian War. Instead it spread inexorably outward from France, infecting popular opinion on much of the continent. As Henry Adams observed in 1910, "every reader of the French and German newspapers knows that not a day passes without producing some uneasy discussion of supposed social decrepitude; falling off of the birthrate;—decline of rural population;—lowering of army standards;—multiplication of suicides;—increase of insanity or idiocy,—of cancer,—of tuberculosis;—signs of nervous exhaustion, of enfeebled vitality,—"habits" of alcoholism and drugs,—failure of eyesight in the young—and so on, without end."[18]

Contributing to this mood were the Social Darwinist warnings about social decline emanating from England. Charles Darwin himself was responsible, however indirectly, for focusing attention not only on the beginnings of societies but also on their end. Life proceeded, according to his evolutionary theory, by struggle and biological destruction. This was clear from the Malthusian passages in his pioneering study of 1859, *On the Origin of Species by Means of Natural Selection:* "A struggle for existence inevitably follows from the high rate at which all organic beings tend to increase. . . . [In looking at nature, it is necessary] never to forget that every single organic being around us . . . lives by a struggle at some period of its life; that heavy destruction inevitably falls on the young or old, during each generation or at recurrent intervals."[19]

Still, the "species" of Darwin's famous title were domestic animals and birds, not human beings. It was Herbert Spencer in 1865 who first described the progress of *man* as a survival of the fittest. In his *Social Statics* Spencer pointed to "the stern discipline of nature which eliminates the unfit"; he argued further that "without war the world would still have been inhabited only by men of feeble types, sheltering in caves and living on wild food."[20] To be sure, Spencer also maintained that war was counterproductive, and that in higher civilization progress depended less on the competitive nation than on the heroic individual.[21]

So it fell to Darwin, after all, to give a dire warning about the "degeneration" of the weaker races of man in his *Descent of Man and Selection in Relation to Sex* (1871):

With savages the weak in body or mind are soon eliminated; and those that survive commonly exhibit a vigorous state of

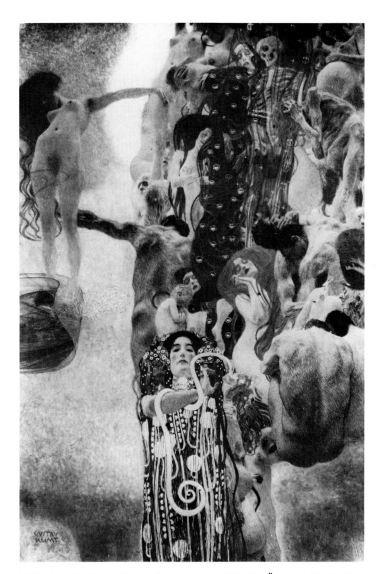

2. Gustav Klimt, *Medicine,* oil on canvas, 1900–01. Österreichische Nationalbibliothek, Vienna.

health. We civilized men, on the other hand, do our utmost to check the process of elimination; we build asylums for the imbecile, the maimed, and the sick; we institute poor-laws; and our medical men exert their utmost skill to save the life of every one to the last moment. . . . Thus the weak members of civilized societies propagate their kind. No one who has attained to the breeding of domestic animals will doubt that this must be highly injurious to the race of man. It is surprising how soon a want of care, or care wrongly di-

rected, leads to the degeneration of a domestic race; but excepting in the case of man himself, hardly anyone is so ignorant as to allow his worst animals to breed.[22]

If the lesson of life was adaptation and change, in Darwin's view, then the absence of evolution brought with it the risk of devolution.

Given the evolutionary struggle as model, and such passages of Darwin and Spencer as cited above, the Social Darwinist viewpoint emerged as a central theme in European thought of the 1880s and 1890s. Mutually contradictory ideas like "brutal individualism" and "class struggle," "imperialist sentiment" and "eugenics," were all tagged with the Social Darwinist label.[23] Yet most agreed with Benjamin Kidd, who argued, in his *Social Evolution* (1894), that collective and material values were the highest values:

> It is not intellectual capacity that natural selection appears to be developing in the first instance, but other qualities contributing more directly to social efficiency, and, therefore, of immensely more importance and potency in the social evolution which mankind is undergoing. . . . [Viewed from the evolutionary standpoint,] the record of the past 150 years must be pronounced to have been almost exclusively disastrous to the French people. Not only have they withdrawn worsted at almost every point from that great rivalry of races which filled the world in the eighteenth century, but their decadence continues within their borders [due to a declining birth rate].[24]

What Kidd wrote in 1894 about France, Charles Morris in 1895 had to say about China and India: due to the "national isolation" of the one and the "mental isolation" of the other, "deterioration . . . is sure to set in when progress halts." Moreover, nationalism and imperialism were fully justified by racism, according to the British biologist Karl Pearson in 1900: "If you bring the white man in contact with the black . . . [y]ou get superior and inferior races living on the same soil and that coexistence is demoralizing for both. They naturally sink into the position of master and servant, if not admittedly or covertly into that of slave-owner and slave. Frequently they intercross, and if the bad stock be raised the good is lowered."[25]

The most pernicious aspect of Social Darwinist ideas was that they were pseudo-science masquerading as science. Even when authors did not call on the great man's name directly, they traded on the high reputation which the natural sciences had come to enjoy in Darwin's generation. Pearson was a biologist; Morris's article was published in *Popular Science Monthly;* and Kidd's book, with the key word "evolution" in its title, sold some 250,000 copies.

In Germany, however, there was a sharp division of opinion on social decline in general and Social Darwinism in particular. For example, Ernst Haeckel, Germany's leading evolutionist, tended to reverse the English emphasis. According to his *History of Creation* (1873), exposing weaker infants could strengthen species health while modern medicine and warfare could weaken it, but these were

cases of what was called "artificial selection." Haeckel reserved Darwin's term "natural selection" not for brute struggle but instead, remarkably, for *intellectual* survival and progress: "[With humans,] this struggle for life will ever become more and more of an intellectual struggle, not a struggle with weapons of murder. The organ which, above all others, in man becomes more perfect by the ennobling influence of natural selection, is the *brain*. The man with the most perfect understanding, not the man with the best revolver, will in the long run be victorious; he will transmit to his descendents the qualities of the brain which assisted him in the victory." Haeckel already saw a continuity between the physical/material and the intellectual/spiritual aspects of life, a continuity he went so far as to consider an identity. This explains his theory of "monism," which related even intellectual activity to "physical" or "mechanical" causes.[26] By the 1890s, as we shall see, he thought that "divine" energies could also be physically demonstrated (see section 1.7).

The philosopher Friedrich Nietzsche shared the Darwinist concern with social devolution, but he made two original and essentially ameliorative arguments: (1) that the key survival struggle was intellectual rather than physical (the Haeckel position), and (2) that decline was but a prerequisite for renewal (the Expressionist position).

Nationalism and racism were of little concern to Nietzsche. He preferred the age of Enlightenment to the age of Bismarck, and he often admonished Germans to become "good Europeans." The decay that did bother him, however, was not that of Africans or Frenchmen but of contemporary Germans. As early as *Human, All-too-Human* (1878) he attacked the materialism and amorality of the early post-unification era and described how weak individuals can infect a whole community. But in entitling his essay "Ennoblement through Degeneration," he argued that it is the function of sickness to engender health: "Precisely in this wounded and weakened part the whole structure is *inoculated*, as it were, with something new. . . . Those who degenerate are of the highest importance wherever progress is to take place; every great progress must be preceded by a partial weakening."[27]

More problematic is Nietzsche's discourse "On War and Warriors" in *Thus Spoke Zarathustra* (1883): "And if you cannot be saints of knowledge, at least be its warriors. They are the companions and forerunners of such sainthood. I see many soldiers: would that I saw many warriors! 'Uniform' one calls what they wear: would that what it conceals were not uniform! You should have eyes that always seek an enemy—*your* enemy. . . . You should love peace as a means to new wars—and the short peace more than the long. To you I do not recommend peace but victory. Let your work be a struggle. Let your peace be a victory!" There can be little doubt that Nietzsche wanted to be understood in a Darwinist sense. "Struggle" and "war" were precisely the processes by which the fittest survived; elsewhere he even out-Darwinned Darwin on the subject of eugenics.[28] But there can be equally little doubt that Nietzsche was here using the concept of war metaphorically. These are warriors of "knowledge," not uniformed soldiers. It is "your" enemy, not the state's enemy, that must

be fought; *Zarathustra*'s following section actually satirizes the state as "The New Idol." And indeed the search for knowledge and self-knowledge is an intellectual, rather than a physical, struggle.[29] As did Haeckel, Nietzsche implies that the Darwinian struggle in man has passed from the realm of physical force to that of knowledge and intellect.

Fifteen years later Houston Stewart Chamberlain, a German writer of English birth, introduced yet another variation on the theme of decline by grafting Darwin's ideas of "breeding" onto Gobineau's fantasies of race. Chamberlain's thesis, in *Foundations of the Nineteenth Century* (1899), was that modern society involved a confrontation between two incompatible groups: the Jewish and the German peoples. Of the two the Jews were allegedly a racial mixture of Semitic, Syrian, and Indo-European types, while the pure Germanic race originally comprised not only Germans but also Celts and Slavs. The crux of Chamberlain's argument was that the Jewish racial mix was somehow impure, but that the Germans could safely intermarry across the face of northern Europe. On the one hand, with the Jews "the crossing of incompatible types leads . . . to sterility and monstrosity" while, on the other hand, "by crossing with each other Germanic peoples suffer no harm—rather the reverse; but when they cross with aliens they gradually deteriorate."[30] Despite the inconsistency and absurdity of Chamberlain's ideas they were advocated by influential groups within Wilhelmian Germany. Indeed Kaiser Wilhelm II became the racist's chief champion: "he himself read Chamberlain's [book] to his sons, and caused it also to be distributed among the officers of the army, while a rich endowment made possible the placing of free copies of the work in many libraries and associations."[31]

Pernicious as his central argument undoubtedly was, Chamberlain could also firmly deny the inevitability of Germany's social decline. For he saw Darwin's struggle for existence as affecting only individuals, not the species. In his words, "Progress and Degeneration can only be applied to the Individual, never to the Universal." It followed, then, that nineteenth-century Germans could still be "in process of development," and that "it will only be after hard work that we shall succeed as a united whole in reaching that stage upon which Hellenic, Roman, Indian and Egyptian cultures once stood."[32]

Thus the German approach to Social Darwinism was mixed. Haeckel saw human evolution as an intellectual/spiritual progress, while Nietzsche interpreted devolution of the part as a step to evolution of the whole. And for Chamberlain, both progress and decline were processes involving less the race than the individual.

Another development of Darwinist science was an extrapolation from racism to sexism. Just as "superior and inferior races . . . sink into the position of master and servant" (Charles Morris), so do male and female individuals. If the *stronger* animal prevailed in evolutionary struggle, that animal was normally male. From here it was but a short step to a belief in female "inferiority." Darwin's first contribution was to classify all sexuality as unwilled, as "instinctive"; such an action was one "performed by an animal, more especially by a very

young one, without any experience," or else it was "performed by many individuals in the same way without their knowing for what purpose it is performed."[33]

The nature of sexual instinct was defined not so much in the *Origin of Species*, however, as in the later *Descent of Man and Selection in Relation to Sex*. For in 1859 Darwin merely commented that "A hornless stag or spurless cock would have a poor chance of leaving offspring." But in 1871, especially in an essay "On the Extinction of the Races of Man," he tended to blame human females for weaknesses in sexual selection. But Darwin was doubly mistaken: first, in assuming that human races were "species" and second, in believing that *human* evolution proceeded by men's struggle for helpless women. Thus, in the latter essay, he attributed to sexual causes the "extinction" of blacks confronted by whites. On the one hand he argued that barbarian males could not stand "competition" from civilized males, and that they therefore—like the hornless stag—could not effectively breed. And on the other he maintained that the females of the dying races displayed sexual "profligacy" or maternal "neglect," or else that they for unknown reasons—like certain breeding stock—simply became barren themselves.[34] Still ignorant of immunological factors involved in adaptation, Darwin reasoned from insufficient evidence that nature favored civilized men over primitive men and women. In this, of course, he shared the racist and sexist assumptions of his time.

Darwin's most serious error, however, was in popularizing the pseudo-scientific notion of female physical and mental inferiority. He started unobjectionably enough, in *Origin of Species*, by distinguishing sexual selection from natural selection. Selection by sex depended "not on a struggle for existence," he wrote, "but on a struggle between the males for the possession of the females; the result is not death to the unsuccessful competitor, but few or no offspring." But in the *Descent of Man* (1871) Darwin generalized from animal breeding patterns to those of humans. To be sure, as Darwin pointed out, there were really *two* kinds of sexual selection: not only the stick of brute force but also the carrot of aesthetic attraction. In the second kind, where the male developed beautiful plumage or song, it was actually the female that makes the selection. Nevertheless "with mammals," wrote Darwin, "the male appears to win the female much more through the law of battle than through the display of his charms."[35]

As he brought his evolutionary account up to the nineteenth century, Darwin's sexism became obtrusive. Just as Helen's capture once caused the siege of Troy, for example, so now among Australian aborigines "the women are the constant cause of war." Moreover, Darwin insisted, even in modern civilization women are physically weaker and mentally inferior: "The chief distinction in the intellectual powers of the two sexes is shown by man's attaining to a higher eminence, in whatever he takes up, than can woman—whether requiring deep thought, reason, or imagination, or merely the use of the senses and hands. . . . We may also infer from the law of the deviation from averages . . . that if men are capable of a decided pre-eminence over women in many subjects, the average of mental

power in man must be above that of women."[36] What had started as an evolutionary explanation of male aggression here ended as a sexist justification for female inferiority and submissiveness. Given the great authority of Darwin's writings and their rapid translation into all the major Western languages, it is understandable how evolution theory, which is scientific, came to be bolstered by a belief in male supremacy, which is not.

After Darwin's death the misogynist argument was accepted by scientists from Krafft-Ebing to Freud and also by philosophers from Nietzsche to Marinetti. Nietzsche stated his position, once again, in *Zarathustra*. Man might evolve from worm and ape but, meanwhile, woman was to be kept in her place. Is it better to be trapped by a murderer or by a lascivious woman, Nietzsche asked, and he provided his own answer: "You are going to women? Do not forget the whip!" Meanwhile Richard von Krafft-Ebing classified female sexuality as abnormal in his *Psychopathia Sexualis* (1886). "It is certain," the Viennese doctor stated, "that the man that avoids women and the woman who seeks men are abnormal." Moreover, he added, in contrast to man's "powerful natural instinct," woman's "sexual desire is small." Another landmark was Paul Julius Möbius' study *On the Feeblemindedness of Women* (1900), which achieved an eighth edition in only seven years. "Instinct makes woman like an animal," Möbius wrote, "dependent, secure, and serene." And Otto Weininger's *Sex and Character,* first published in 1903, reached its sixth edition in only two years. Among other uncomplimentary remarks Weininger wrote that "there is not a single woman in the history of thought . . . who can be truthfully compared with men of fifth- or sixth-rate genius." Then, in 1905, came Sigmund Freud's *Three Essays on the Theory of Sexuality.* Here female inferiority was explained not biologically but psychologically: "The assumption that all human beings have the same (male) form of genital is the first of the remarkable and momentous sexual theories of children." And finally, in Filippo Marinetti's *Second Futurist Manifesto* (1909), republished in Berlin in 1912, warfare is glorified as a valorous occasion for escape from the despised female. "What do women matter to us," Marinetti asked, "these domestics, these invalids and sick ones with all their clever advice?"[37]

Despite such widespread and allegedly scientific belief in female inferiority, however, contrary views were also voiced. John Stuart Mill had pointed out the "serfdom" of marriage in *The Subjection of Women* as early as 1869, while in his later novels Theodor Fontane pilloried the "double standard" by which women were outlawed for practicing a sexual license freely granted men.[38] And the leader of the German Social Democratic party, August Bebel, argued in *Woman and Socialism* (1887) that "the whole trend of society is to lead woman out of the narrow sphere of strictly domestic life to a full participation in the public life of the people." Perhaps ignorant of Darwin's actual views, Bebel claimed that "Darwinism, as all genuine science, is eminently democratic." Thus he was free to proclaim woman's intellectual equality: "Woman is to take up the competitive struggle with men in the intellectual field also. . . . Already has wom-

an brushed aside many an obstacle, and stepped upon the intellectual arena,—and quite successfully in more countries than one." There followed an inventory of women's accomplishments, from superiority in coeducational classes in American universities to the invention of major labor-saving devices.[39]

While scientists and pseudo-scientists upheld the position of male superiority, others—including most Expressionists—insisted on male-female equality. But in doing so, they opened themselves to the charge of being "degenerate" or "pathological" (see sections 1.4, 2.1).

1.3. DISSOLUTION IN THE COSMOS

There was yet another whole dimension, however, to Europe's fascination with decay. Warnings of social decline were now complemented by theories of cosmic dissolution. Where Darwinists could describe the end of a race, other scientists could conceive the end of the world.

Between 1850 and 1851 the Second Law of Thermodynamics was formulated by Rudolf Clausius and William Thomson (later named Lord Kelvin).[40] The Law was then restated by Clausius in 1854 as a function of entropy, and was finally refined by Ludwig Boltzmann in 1884 in terms of statistical probability. In contrast to the First Law, which asserts the conservation of the total *quantity* of energy in a closed system, the Second Law addresses the *quality* of this energy and recognizes the fact that, though energy is always conserved, it may become unavailable for useful work. In naming such a system's non-productive energy "entropy," Clausius gave the Second Law its well-known definition: "The entropy of an isolated system never diminishes." In G. J. Whitrow's description:

> Every reversible change occurring in a closed system will leave its total entropy unaltered, for the gain of entropy in one part of the system will be balanced by its loss in the other part. But every irreversible change in the system will increase its entropy. Irreversible changes occur when heat passes of its own accord from one part of a system to another that is at a lower temperature. In general, any spontaneous change in the physical or chemical state of a system will lead to an increase in its entropy. No spontaneous change will occur when the entropy is at a maximum, . . . and the system will then be in a state of stable thermodynamic equilibrium.

Boltzmann's contribution was to see this final equilibrium state as one of maximum probability. But he maintained that entropy was always only a statistical concept: fluctuations from equilibrium *could* arise, on a galactic scale, spontaneously. Nevertheless it was not Boltzmann's but rather Clausius' belief that was widely accepted, namely that increased entropy was the fate of the cosmos. Indeed Clausius concluded that "the universe is tending toward a state of

'thermal death' in which the temperature, and all other physical factors, will be everywhere the same and all natural processes will cease."[41]

New arguments soon arose for the notion of cosmic decay, albeit in philosophy rather than in physics. In England Herbert Spencer articulated his view in the *First Principles* of what he called his "synthetic philosophy," a book published in 1864, modified in 1867, and pushed to its definitive state in 1875. In effect, Spencer proposed that wherever there was progress there must also be decline, that whatever "evolution" created "dissolution" would destroy: "The processes thus everywhere in antagonism, and everywhere gaining now a temporary and now an enduring predominance the one over the other, we call Evolution and Dissolution. Evolution under its most general aspect is the integration of matter and concomitant dissipation of motion; while Dissolution is the absorbtion of motion and concomitant disintegration of matter."[42]

Spencer's principle of dissolution had nothing in principle to do with natural selection. Instead it was concerned with homogeneity and heterogeneity; differentiated forms sink back into undifferentiated ones upon the death of organisms and of societies. But just as evolutionists depended upon fossil geology and the nebular hypothesis to refute the biblical account of six-day Creation, so Spencer saw the principle of Dissolution at work across the entire history of material existence.

And not only Spencer. Haeckel too, in his *History of Creation* (1873), emphatically denied the existence of any "purpose in nature"; the Darwinist "struggle of All against All" meant "everywhere a struggle and striving to annihilate neighbors and competitors." In his famous *Riddle of the Universe* (1899) Haeckel's pessimism assumed cosmic proportions. "Humanity is but a transitory phase," he wrote, "the true proportion of which we soon perceive when we set it on the background of infinite space and eternal time." Again, thanks to the recent findings of astronomy and physics, "our earth shrinks into the slender proportions of a 'mote in the sunbeam,' of which unnumbered millions chase each other through the vast depths of space." Yet Haeckel stopped short of endorsing that universal heat-death which Clausius' theory of entropy had predicted. Since monist philosophy merged material with spiritual processes, and since the latter were infinite, Haeckel concluded that the cosmos was eternal. "There is neither," he wrote, "beginning nor end of the world."[43]

Another writer who certainly *did* believe in the death of the cosmos was the French thinker André Lalande, who published *Dissolution Opposed to Evolution in the Physical and Moral Sciences* in 1899. Lalande, like Spencer, saw the principles of evolution and dissolution as determining the chances of life. In this he opposed his dualism to Haeckel's monism which, whatever else its faults, had at least advocated a "religion of science." But he also used Spencer's antinomy against itself—by giving the ultimate priority to decay and not to growth. Here Lalande depended on Clausius. It was the physics of entropy rather than the biology of evolution that was binding: "In a word, if evolution is defined [following Spencer] as the transition from homogeneity to heterogeneity, and if dissolution is defined [following Clausius] as the reverse, then there is not any doubt that the general law of the material world—within which all partial evolutions are fortuitous accidents—consists on the whole of dissolution."[44] The universe was doomed to reach a standstill. Its stars would burn out, its energy would suffer heat-death, and its vitality would reach a gray continuum of lifelessness.

Lalande followed the view of Arthur Schopenhauer, the renowned philosopher of pessimism, that nature's blind, ceaseless activity or Will formed "the essence of things."[45] So it is not surprising that Lalande's thesis of 1899 confirmed the conclusion Schopenhauer had reached in his *World as Will and Representation* (1819): "We must not even evade [nothingness], as the Indians do, by myths and meaningless words, such as reabsorption in *Brahman,* or the *Nirvana* of the Buddhists. On the contrary, we freely acknowledge that what remains after the complete abolition of the will is, for all who are still full of the will, assuredly nothing. But also conversely, to those in whom the will has turned and denied itself, this very real world of ours with all its suns and galaxies, is—nothing."[46] Given the vogue for Schopenhauer in fin-de-siècle Paris,[47] it is likely that the German's philosophy of pessimism triggered the Frenchman's dark faith in "dissolution." Indeed, despite the presence of the respected word "evolution" in the title of Lalande's book, his ideas were at best pseudo-science pretending to the dignity of science.

1.4. DEGENERATION IN THE CULTURE

Social decline and cosmic dissolution were serious matters, but they were relatively abstract; before the 1890s they were remote from popular concern. Quite different, however, was the matter of cultural degeneration. For the middle-class public was often aware of the latest spectacle in literature or art; it was all too sensitive to charges by conservative critics that contemporary culture was in the process of decay. Knowing this, certain French writers of the 1880s even named themselves "Decadents."

The cult of decadence began with Charles Baudelaire's *Fleurs du mal* (1855). His "Voyage to Cythera," for example, in contrast to Antoine Watteau's Rococo painting on that theme, focuses not on sensuous love but on putrescence and decay: "Ferocious birds perched on their fodder / Destroy with rage a hanged man already ripe. / Each plants its impure beak, like a tool, / In every bloody nook of this putrefying rot." Théophile Gautier first called Baudelaire "decadent" in his introduction to the 1868 edition of *Les fleurs du mal,* but it was Paul Bourget who based a "theory of decadence" on Baudelaire's example in his *Essay on Contemporary Psychology* (1883). A distinguished member of the Academie de France, Bourget conceived his theory according to a quasi-Spencerian view of organic decay. Society was like an organism, in his view: an organism which must, in order to survive, contain and yet rigidly dominate each organ of constituent cells:

If the energies of the cells become independent, the organs which compose the total organism will likewise cease to subordinate their energy to the total energy, and the resulting anarchy will constitute the decadence of the whole. The social organism does not escape this law. It enters into decadence as soon as individual life is aggrandized under the influence of comforts acquired and inherited. The same law governs the development and decadence of that other organism which is language. A style of decadence is that where the unity of the book is distorted by giving way to the independence of the page, where the page is distorted by giving way to the independence of the phrase, and the phrase by giving way to the independence of the word.[48]

Bourget's definition was soon appropriated by Nietzsche—no longer for Baudelaire but for Wagner, whose work the mature Nietzsche had come to despise. As he put it in *The Case of Wagner* (1888): "If anything in Wagner is interesting it is the logic with which a physiological defect [leads to] . . . a crisis in taste. For the present I merely dwell on the question of *style.*—What is the sign of every *literary decadence?* That life no longer dwells in the whole. The word becomes sovereign and leaps out of the sentence, the sentence reaches out and obscures the meaning of the page, the page gains life at the expense of the whole."[49] Thanks to Nietzsche and his forerunners, Expressionists understood that epochal style had succumbed to decadence. As Franz Marc put it in 1912: "the artistic style that was the inalienable possession of an earlier era collapsed catastrophically in the middle of the nineteenth century. There has been no style since. It is perishing all over the world as if seized by an epidemic." Still, the first visual artist actually to be *praised* for a sensitivity to cultural decline was Edvard Munch. As early as 1890 he had been called one of the "Decadents"—"the children of a refined, overly civilized age."[50]

Cultural decay was often acknowledged by modernists of the 1890s, who could justify their own roles by appeal to the Realist doctrine, *il faut être de son temps.* But decadence was anathema to conservative observers who looked longingly to the past; particularly in Germany, critics pointed to cultural sickness with scorn. Paul de Lagarde made these remarks in his *German Writings* (1886): "Our speech has ceased to speak, it shouts; it says 'cute,' not 'beautiful,' 'colossal,' not 'great'; it cannot find the right word any more, because the word is no longer the designation of an object, but the echo of some kind of gossip about the object. . . . [W]e shall all sink into nothingness: for the capital resources of our intellectual life, which we possessed in 1870, have been nearly exhausted in this last period of our history, and we are face to face with bankruptcy."[51] And Julius Langbehn began his nationalist tract of 1890, *Rembrandt as Educator,* with the familiar refrain: "It has by this time become an open secret that the intellectual life of the German people today finds itself in a condition of gradual, some might say rapid, decay. . . . The great celebrities in the different provinces [of the arts] are dying out: *les rois s'en vont.*" Allegedly at fault was "the democratic, levelling, atomising spirit of the century" and an educational model "that is scientific and wants to be scientific; yet the more scientific it is, the more uncertain it becomes." Langbehn's solution was to champion the "claim of the homeland" on art: "A centralisation, sharpening, and hypnosis of all intellectual life into a single center, as in Paris, leads to shattered nerves. . . . The Germans' wandering spirit, which now loafs around artistically in all the regions of heaven and earth, must once again be tied down to the soil of the *Heimat:* the Holstein painter should paint Holsteinian, the Thuringian painter Thuringian, the Bavarian Bavarian—through and through, inwardly and outwardly, objectively and spiritually." The clock must be set back; a balance must be struck between nature and idea, external ugliness and inner grace, color and drawing: "The return to Rembrandt is here simultaneously a stride forward to the future."[52]

Lagarde's 1886 book was reprinted in 1891 and 1903, but it was Langbehn's 1890 text that became an instant best-seller: 60,000 copies were printed in the first year, and there were forty printings in the first two years alone. Fritz Stern, who records these facts, sees both books as trading on the nationalists' discovery of cultural decline; in looking backward to imagined German models, they fostered a "politics of cultural despair." But the discovery was not limited to nationalists alone. For example, the vanguard critic Hermann Bahr commented on literary Decadence in the early 1890s, calling it "the practice of highly refined, wilting, sickly nerves."[53] And the Jewish medical doctor Max Nordau catalogued *every* recent cultural product of England, France, Russia, Scandinavia, and Germany as examples of decline. He gave his two-volume study of 1892–93 the sensational title of *Entartung* (*Degeneration*).

Nordau's list of degenerate cultural movements ran the gamut from "Mysticism" (Pre-Raphaelites, Symbolism, Tolstoy, the Wagner cult) to "Ego-Mania" (Parnassians, Decadents, Aesthetes, Ibsen, Nietzsche), and on to "Realism" (Zola, French Naturalists, Young Germans); even Impressionism was included. Moreover, the doctor couched his attack in psychiatric jargon and thus made it seem scientific when it was not: "From a clinical point of view somewhat unlike each other, these pathological images are nevertheless only different manifestations of a single and unique fundamental condition, to wit, exhaustion, and they must be ranked by the alienist in the genus melancholia, which is the psychiatrical symptom of an exhausted central nervous system. . . . We stand now in the midst of a severe mental epidemic; of a sort of black death of degeneration and hysteria, and it is natural that we should ask anxiously on all sides, 'What is to come next?'"[54] Nordau espoused a liberalism of a nineteenth-century kind, believing in "progress through order, will, and rationality" in George Mosse's words; his was an essentially middle-class morality. A Darwinist, he envisioned "a time when evolution had advanced far enough for men to live together in solidarity without coercion by the state." But in the meantime mental discipline was required, the kind of discipline that the bourgeoisie traditionally failed to find among practicing artists.[55]

Nordau dedicated his book to Cesare Lombroso, author of *Genius and Insanity* (1863), which had just appeared in French translation in 1889.[56] And he credited Bénédict Morel with having formulated the concept of degeneracy in mental disease in 1857. But where Lombroso had studied mainly criminals and what he called "graphomaniacs" or "semi-insane persons who feel a strong impulse to write," Nordau speaks of such qualities as "moral insanity," emotionalism, and pessimism or self-abhorrence. And where Morel had originally attributed degeneracy to poisoning by alcohol, tobacco, and tainted foods, Nordau now stressed "residence in large cities" and "fatigue" caused by the fast pace of urban life. Nordau's survey was unusual, in fact, in providing statistical evidence for the recent growth of liquor consumption, urban population, railroad and postal traffic, newspaper and book publication. Industrial man allegedly worked "five to twenty-five times" harder than he had fifty years earlier. Still, for artists suffering nervous exhaustion, neither "Socialism nor Darwinism" provided escape.[57]

Following Lombroso, Charcot, Krafft-Ebing, Magnan, and other believers in psychopathic classification,[58] Nordau tried to define the abnormal trait or traits in each writer or artist he discussed. Thus Tolstoy's *Kreutzer Sonata* shows feelings "the normal man never experiences toward his wife"; Wagner is "an erotic (in a psychiatric sense)," his lovers reflect "a form of sadism"; while Zola is "affected by coprolalia ["muck-talk"] to a very high degree." Another example of Nordau's approach was his attribution of "*nystagmus,* or trembling of the eyeball," to Impressionist painters. A yet more insidious suggestion was that Berlin's Society for Ethical Culture should serve as "the voluntary guardian of the people's morality"; only in this way could resistance be mounted against "the filth-loving herd of swine, the professional pornographers."[59] The two latter ideas were picked up and amplified some four decades later by another would-be art critic, Adolf Hitler (see section 5.3).

But at the turn of the century Nordau's concern with pornography was also widely shared. Thus the Swiss hygienist, Dr. August Forel, offered a section on "Art and Pornography" in his 1905 textbook on *The Sexual Question:* "There are few great artists, but thousands of charlatans and plagiarists. Many of those who have never had the least idea of the dignity of art pander to the lower instincts of the masses and not to their best sentiments. In this connection, erotic subjects play a sad and powerful part. Nothing is too filthy to be used to stimulate the base sensuality of the public. . . . In these brothels of art, the most obscene vice is glorified, even the pathological."[60] And art critics, such as this one in 1911, greeted Expressionist art with similar concerns, sometimes even with similar language: "The [Dresden] pictures cannot be topped for the futility of their drawing. They are nothing but harshly colored daubs by some kind of cannibals or other. . . . What we noticed last year about those Russians [from Munich], namely that they treat the females in their pictures as vulgar, is true of the Germans to a much higher degree. What is presented to us here has the poisoned air of the darkest dens of vice of any metropolis, and is evidence of a spiritual niveau on these painters' part that can only be considered pathological."[61] For reasons to be examined later, the divorce was complete between Expressionist art devoted to sexual themes and that bourgeois "morality" defended by the doctors Forel and Nordau.

Nevertheless *Degeneration* remains very much of its time. It parallels Langbehn's 1890 tirade against "Zolaism," for example, and it even cites Nietzsche's 1888 attack on Wagner.[62] It is ironic that after citing Nietzsche in this way, Nordau proceeds to a lengthy critique of Nietzsche himself. And yet the pages on the German philosopher are among the most convincing of the book; Nordau demolishes Nietzsche's "sadistic" aspect not by medical diagnosis but by logic and common sense. At issue is Nietzsche's contrast, in the *Genealogy of Morals* (1887), between the rapacious "blond beast" as representative of an "Aryan, conqueror race" and the Judeo-Christian tradition which marks "the slave revolt in morality." Nordau offers this rejoinder: "But is it, then, true that our present morality, with its conceptions of good and evil, is an invention of the Jews, directed against 'blond beasts,' an enterprise of slaves against a master-people? The leading doctrines of the present morality, falsely termed Christian, were expressed in Buddhism six hundred years prior to the rise of Christianity. Buddha preached them, himself no slave, but a king's son, and they were the moral doctrines, not of slaves, not of the oppressed, but of the very masterfolk themselves, of the Brahmans, of the proper Aryans."[63] He then enumerated a number of Buddhist doctrines, such as the Hindu saying "Because he has pity on all living creatures, therefore is a man called Ariya [elect]." The argument was elegant and persuasive.

Hungarian by birth and Austrian by training, Nordau lived for many years in Paris—the center of Western pessimistic thought. But compared to both the French- and German-speaking worlds, the English were more sanguine. Indeed the earliest rebuttals to Nordau were both by Englishmen. In a witty polemic of 1895, *The Sanity of Art,* George Bernard Shaw touched lightly on the inability of degeneracy to withstand "the stream of progress," yet he also mentioned forces which can "bring us back to barbarism after a period of decadence like that which brought imperial Rome to its downfall." Shaw's link of decadent ends with primitive beginnings—possibly drawn from Nietzsche—was one that Expressionists would use later. But the idea was also central to Alfred Hake's 1895 response to Nordau. For Hake simply accepted Nordau's view that modern culture destroyed established values. Nevertheless, he argued, such destruction had to precede renewed construction. "The axe must precede the plow," he wrote, "because the forest cannot co-exist with the wheatfield."[64] In this way, as the title to Hake's book indicated, the proper sequel to *Degeneration* would be *Regeneration.*[65]

1.5. NIHILISM IN MORALITY—AND ITS OVERCOMING

Friedrich Nietzsche became insane early in 1889 and did not die until 1900. During the entire decade of the 1890s, then, he did not take part in the controversies generated by Kidd and the later Haeckel, by

Chamberlain and Lalande, by Langbehn and Nordau. So when Elizabeth Förster-Nietzsche published extensive "studies and fragments" in 1901 as the first of her brother's "posthumous works," *The Will to Power: Attempt at a Revaluation of All Values* came as a voice out of the grave. It must have been startling to read a fundamentally new approach to the problem of decline with which Europe had been grappling for years, and yet one based on notes written thirteen to eighteen years earlier. Just as startling must have been the appearance of the second edition of *The Will to Power* in 1906, for it now contained twice as much material as the first: 1,067 sections to the earlier 483. And a final surprise was the appearance in 1908 of Nietzsche's long-suppressed autobiography of 1888, entitled *Ecce Homo*.[66] Nevertheless, though these books heavily influenced advanced artists after 1900, their ideas still belonged to the Darwinist era.

After devolution in society, dissolution in nature, and decadence in culture, Nietzsche now offered as the root of all such imagined decay the concept of nihilism in morality. This is how *The Will to Power* begins:

> Nihilism stands at the door: whence comes this uncanniest of all guests? Point of departure: it is an error to consider "social distress" or "physiological degeneration" or, worse, corruption, as the *cause* of nihilism. Distress, whether of the soul, body, or intellect, cannot of itself give birth to nihilism (i.e., the radical repudiation of value, meaning, and desirability). Such distress always permits a variety of interpretations. Rather: it is in one particular interpretation, the Christian-moral one, that nihilism is rooted.

It was the "death of God," the loss of spiritual values in a secular society, that created the nihilistic mood of pessimism and hopelessness. Moreover, Nietzsche's preface, by displacing nihilism from the present to the future, made both the problem and its solution a matter for twentieth-century concern:

> What I relate is the history of the next two centuries. I describe what is coming, what can no longer come differently: *the advent of nihilism*. . . . [F]or this music of the future all ears are cocked even now. For some time now, our whole European culture has been moving as toward a catastrophe, with a tortured tension that is growing from decade to decade restlessly, violently, headlong, like a river that wants to reach the end. . . .
>
> [M]ake no mistake about the meaning of the title that this gospel of the future wants to bear. "The Will to Power: Attempt at a Revaluation of All Values"—in this formulation a countermovement finds expression, regarding both principle and task; a movement that in some future will take the place of this perfect nihilism—but presupposes it, logically and psychologically, and certainly can come only after and out of it.[67]

Despite a militarist or collectivist overtone, the will to power was concerned with "values" in the individual. Neither the state nor Christianity, neither Socialism nor any other shared ideal or abstraction, could rescue a person from the meaninglessness of modern existence; these were all gods that fail. Instead it is the individual man or woman who must become strong enough to *be* an individual, who must develop a new morality—to wit, the morality of self-reliance. The "power" necessary to transcend a sense of nothingness was the power of self-realization, self-revaluation. And the person who would embody this will to power was announced, in *Thus Spoke Zarathustra*, as the *Uebermensch* or "Higher Man." That person was a creative individual, a poet, an artist, a seer.

He was also, of course, Nietzsche himself. Nietzsche opens *Ecce Homo* with a chapter titled, egoistically, "Why I Am So Wise": "Apart from the fact that I am a decadent, I am also the opposite. . . . Looking from the perspective of the sick toward *healthier* concepts and values and, conversely, looking again from the fullness and self-assurance of a *rich* life down into the secret work of the instinct of decadence—in this I have had the longest training, my truest experience; if in anything, I became master in *this*. Now I know how, have the know-how, to *reverse perspectives*: the first reason why a 'revaluation of values' is perhaps possible for me alone." And he ends *Ecce Homo* with a chapter titled, just as egoistically, "Why I Am a Destiny":

> I contradict as has never been contradicted before and am nevertheless the opposite of a no-saying spirit. I am a bringer of glad tidings like no one before me. . . . For all that, I am necessarily also the man of calamity. For when truth enters into a fight with the lies of millennia, we shall have upheavals, a convulsion of earthquakes, a moving of mountains and valleys, the like of which has never been dreamed of. The concept of politics will have merged with a war of spirits; all power structures of the old society will have been exploded—all of them are based on lies: there will be wars the like of which have never yet been seen on earth. It is only beginning with me that the earth knows *great politics*.[68]

In this last passage we note the ambivalence, once again, in the concept of "war." As he did in *Zarathustra*, Nietzsche implies a brute struggle in the Darwinist sense while also identifying that struggle as a fight involving values (see section 1.2). The future "great politics" will be an intellectual struggle of ideas, a "war of spirits."

But before we can comprehend Nietzsche's egoistic "truth," we must first understand his notion of "nihilism." In rooting nihilism in a "Christian-moral" interpretation, first of all, he clearly wanted to give it more a philosophical than a political meaning. Ivan Turgenev, who popularized the concept of political nihilism in *Fathers and Children* (1862), is not named in Nietzsche's work.[69] The same is true of Max Stirner, whose polemic *The Ego and His Own* (1845) has been aptly characterized as "nihilistic egoism."[70] Yet circumstantial evidence suggests that Nietzsche knew Stirner's writings very well indeed.[71]

In their total denial of the values of idealism and altruism, in fact, the two men are strikingly similar. As R. W. K. Paterson has observed: "Both thinkers cast their unique and total choice on the present world of finite reality, rejecting with deliberate finality every type of transcendent, other-worldly solution which philosophy and religion have proposed. . . . For both Nietzsche and Stirner, therefore, life is essentially self-assertion—choice, resolution, and action—and both men are accordingly fascinated by that artistry of the will which creates and is created by the self-mastery of the individual.[72] Moreover, Stirner's egoism, like Nietzsche's, arises precisely from a sense of nothingness. In Stirner's own words:

> God and mankind have concerned themselves for nothing, for nothing but themselves. Let me then likewise concern myself for myself. . . . If God, if mankind, as you affirm, have substance enough in themselves to be all in all in themselves, then I feel that *I* shall still less lack that, and that I shall have no complaint to make of my 'emptiness.' I am not nothing in the sense of emptiness, but I am the creative nothing, the nothing out of which I myself as creator create everything. . . . You think at least the "good cause" must be my concern? What's good, what's bad? Why, I myself am my concern, and I am neither good nor bad. Neither has meaning for me.
>
> Every higher essence above me, be it God, be it man, weakens the feeling of my uniqueness, and pales only before the sun of this consciousness. If I found my affair on myself, the unique one, then my concern rests on its transitory, mortal creator, who consumes himself, and I may say: I have founded my affair on nothing.[73]

And finally, although neither Stirner nor Nietzsche advocated *any* political system, both were linked from the 1890s on in the literature of anarchism. Just after *The Ego and His Own* went into a second edition in 1892, for example, Stirner's American disciple Benjamin Tucker declared that "anarchists . . . are egoists in the farthest and fullest sense." And no less a figure than Emma Goldman, an American activist of the Expressionist generation, believed that Nietzsche's anarchism lay in his elitist self-centeredness: "his aristocracy was neither of birth or of purse; it was of the spirit. In that respect Nietzsche was an anarchist, and all true anarchists were aristocrats."[74]

What most concerns us here, however, is Stirner's claim that "I am the creative nothing, the nothing out of which I myself as creator create everything." For this is the source, I believe, for Nietzsche's two key assertions in the preface to *The Will to Power:* (1) that "nihilism" will generate its own "countermovement," and (2) that a revaluation of values will come not only *after* nihilism but "*out of*" it. The will to power can arise only in the post-Christian man or woman who has *lost* the illusory powers which state and religion had once seemed to grant. The very descent into the abyss of nothingness must precede the ascent up to the new values of self. In both Stirner

and the later Nietzsche, in short, we find those models of reciprocal thinking which we believe central to Expressionist thought: the hope as answer to the fear, decline as prerequisite for renewal (see section 1.1).

Nietzsche was always, to be sure, a philosopher; such notions as sickness and decline were for him primarily modes of thought. By the word "nihilism," in fact, he shows his century's fear of decline to be a fear of *imagined* decline; today we judge the age of Wundt, Pasteur, and Edison more positively. Only as a philosopher of *inner* values can Nietzsche be understood properly. But even such a philosopher carries the weaknesses of his strengths. Though claiming to disregard "social distress" and "physiological degeneration," he could nonetheless evoke the Social Darwinist panaceas of war and eugenics. Focusing on the "logical and psychological" effects of the will to power, he did not see its imperialist and fascist potential. Such blindness was not unknown among his disciples, anarchist, Expressionist, and Nazi alike.

Yet it was *as* a philosopher that Nietzsche offered Expressionists the key concept of "countermovement," namely the notion that denial only confirms that which is denied. In Freud's terminology of 1925, "Negation is a way of taking cognizance of what is repressed." Later observers have also confirmed the negative aspects of negation, the reactionary potential of rebellion. Karl Mannheim put it this way in 1929: "For even in negation our orientation is fundamentally centered upon that which is being negated, and we are thus unwittingly determined by it." And Siegfried Kracauer observed in 1947: "Not unlike the old Expressionist tyrant films . . . , the [Weimar] youth films affirm fixation to authoritarian behavior precisely by stressing rebellion against it. Young rebels frequently develop into old tyrants who, the more fanatical they are as rebels, the more relentless they are as tyrants."[74] The risk in the revaluation of values is that the *old* beliefs—nihilism, decay, decline—can still dictate the revaluation.

The Nietzsche of *Zarathustra* (1883), *The Will to Power* (1901), and *Ecce Homo* (1908) was concerned with "finite reality," in Paterson's phrase, rather than with "other-worldly solution[s]." Even the youthful Nietzsche can be partly understood in this light. In *The Birth of Tragedy* (1872), for example, the twenty-eight-year-old had advanced not just an abstract principle of "Dionysian intoxication" but also the more substantive interaction of the Dionysian and the Apollonian, the irrational and rational, together.[75] Nevertheless, by the 1880s Nietzsche had turned against his earlier allegiance to Wagnerian notions of redemption through art. The change is marked by a shift in *The Birth of Tragedy*'s subtitle, from "The Spirit of Music" in 1872 to "Hellenism and Pessimism" in 1886, and also by the "Attempt at a Self-Criticism," which precedes the original "Preface to Richard Wagner" beginning in 1886. This later Nietzsche was the shaper of German Expressionist thought—not so much the Wagner-inspired romantic who thought that "art represents the highest task and the truly metaphysical activity of this life" (1872), but more the unillusioned realist whose self-imposed task was "to look at science in the perspective of the artist, but at art in [the perspective] of life" (1886).[76]

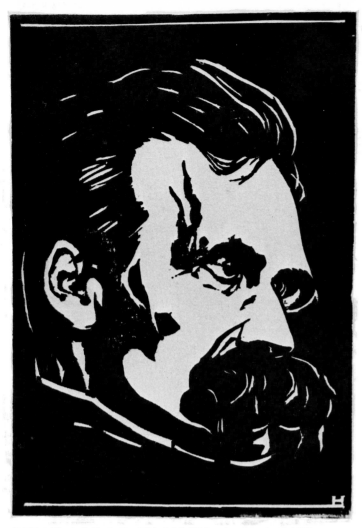

3. Erich Heckel, *Portrait of Friedrich Nietzsche*, woodcut, 1905.

1.6. NIETZSCHEAN RENEWAL IN EARLY MODERN ART

Shortly after 1900 two teenagers at the Chemnitz Gymnasium, Erich Heckel and Karl Schmidt (later Schmidt-Rottluff), met at a literary club. The written word was as important for them as was the painted image; for Heckel, indeed, literature was so engrossing "that for a long time he was undecided as to whether he should become a writer or a painter." Upon first meeting Ernst Ludwig Kirchner at the latter's Dresden apartment in 1904, it was Heckel who climbed the stairs "declaiming aloud from *Zarathustra*." And it was Schmidt-Rottluff, during *his* first meeting with Emil Nolde in Alsen in 1906, who spoke about Nietzsche and Kant, among others.[77] Meanwhile in Dresden Heckel, who was not quite twenty-two, and Schmidt-Rottluff, who was still twenty, joined with Kirchner and his friend Fritz Bleyl, both twenty-

five, to found the Artists' Group "Bridge" (*Künstlergruppe "Brücke"*). They drew their name from the prologue to *Thus Spoke Zarathustra:*

> Man is a rope, tied between beast and Higher Man—a rope over an abyss. A dangerous across, a dangerous on-the-way, a dangerous looking back, a dangerous shuddering and stopping.
>
> What is great in man is that he is a bridge and not an end: what can be loved in man is that he is an *overture* and a *going under*. I love those who do not know how to live, except by going under, for they are those who cross over. I love the great despisers because they are the great reverers, the arrows of longing for the other shore.[78]

Further homage to Nietzsche was paid by Heckel in a woodcut portrait from 1905 (fig. 3); the Brücke was founded on 7 June of that year.[79]

The Dresden artists kept a house-book which they inscribed *Odi profanum vulgus* ("I hate the plebeian crowd"), following Nietzsche's *Birth of Tragedy*.[80] In it Kirchner drew erotic scenes from *The 1001 Nights* (fig. 4), beginning that celebration of sex through art which was to become the Brücke's hallmark. In this too they followed Nietzsche's example, as stated in *The Will to Power:* "[E]verything perfect and beautiful works as an unconscious reminder of . . . this aphrodisiac bliss (Physiologically: the creative instinct of the artist and the distribution of semen in his blood). The demand for art and beauty is an indirect demand for the ecstasies of sexuality communicated to the brain."[81]

These words demonstrate that the principle of sublimation—for example, the transposition of instinctual urges into socially acceptable art—was already recognized (though not yet named) by Nietzsche.[82] Indeed for Kirchner, who owned two copies of *The Will to Power,* the principle of sexual sublimation through art was self-evident. As he once put it, "The love which the painter brought to the girl who was his mate and partner was transmitted to the carved figure, was refined in the environment of the picture, and in turn mediated the particular chair- or table-form out of the lifelong pattern of the human figure." And for Emil Nolde, briefly a Brücke member but never an intellectual, Nietzsche's insistence on the instinctual basis of art was equally self-evident: "The painter doesn't need to know much; it's fine if, led by instinct, he can paint as confident of his goal as when he breathes or walks."[83] Nietzsche's ideas were as influential with the Berlin Neue Secession as they were with the Dresden Brücke: understandably so, since the Dresden artists helped found the Berlin group. An iconographically interesting example of this influence is Max Pechstein's Poster for the "First Neue Secession Exhibition" (fig. 5). Although Pechstein lived chiefly in Berlin from 1908 on, he maintained his membership in the Dresden association he had joined in 1906. His color lithograph poster actually subsumes *both* of the Nietzschean impulses we have mentioned. The forthright nude girl with flaming hair is a reminder of Nietzsche's belief that art should suggest the "aphrodisiac bliss" of sex. But the bow and arrow in her

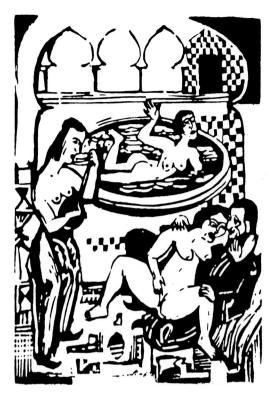

4. Ernst Ludwig Kirchner, illustration for *The 1001 Nights,* woodcut, 1905. Brücke-Museum, Berlin.

rate in its sound, just like a hymn to new creation which follows the destruction."[86]

In any number of Blaue Reiter paintings, such as the sketch for *Composition VII, no. 1* (fig. 6), Kandinsky devises a Nietzsche-like creation by catastrophe. To be sure, specific themes and the entire analogy between abstract painting and musical sounds are derived not from Nietzsche, but from the "spiritual science" of Theosophy (see sections 2.4, 3.3). Nevertheless, even a first impression of Kandinsky's imagery confirms the transformative principle which Nietzsche had called "destruction, change, becoming."

Even earlier, in his book *On the Spiritual in Art,* written by 1910 though unpublished until 1912, Kandinsky paraphrased a passage from Nietzsche's *Ecce Homo.* Where Nietzsche predicted a "war of spirits," confronting truth with "the lies of millennia," Kandinsky de-

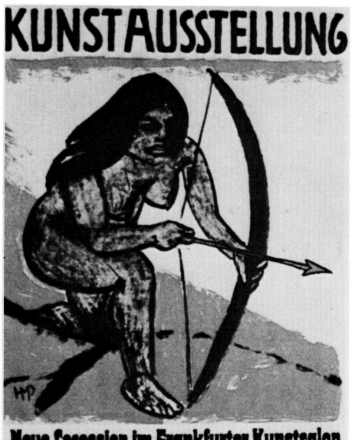

5. Max Pechstein, poster for the "First Neue Secession Exhibition," color lithograph, 1910.

hand, aimed across an empty margin, seems also to be a coded symbol for the Neue Secession's leading contingent, the Brücke. Thus the overall image implies the new group's exalted mission in breaking with the established Berliner Secession. The young artists, using sex as a vehicle, were to be "the great despisers [as] the great reverers, the arrows of longing for the other shore."[84]

The Dresden Brücke and the Berlin Neue Secession served as models for the Munich group called the Blaue Reiter ("Blue Rider"), where artists were also steeped in Nietzschean thought. But here the emphasis was less on sex in art than on what may be called creation through destruction. Nietzsche articulated this principle, once again, in *The Will to Power:* "The desire for destruction, change, becoming, *can* be the expression of an overfull power pregnant with the future (my term for this, as is known, is the word 'Dionysian'): but it can also be the hatred of the ill-constituted, disinherited, underprivileged, which destroys, *has* to destroy, because what exists, indeed existence itself, all being itself, enrages and provokes it."[85] And Wassily Kandinsky reflected this principle in his *Reminiscences* (1913): "Each art work arises technically just as the cosmos arose—through catastrophes, like the chaotic instrumental roar at the end of a symphony that is called the music of the spheres. . . . A great destruction with an objective effect is also a song of praise, complete and sepa-

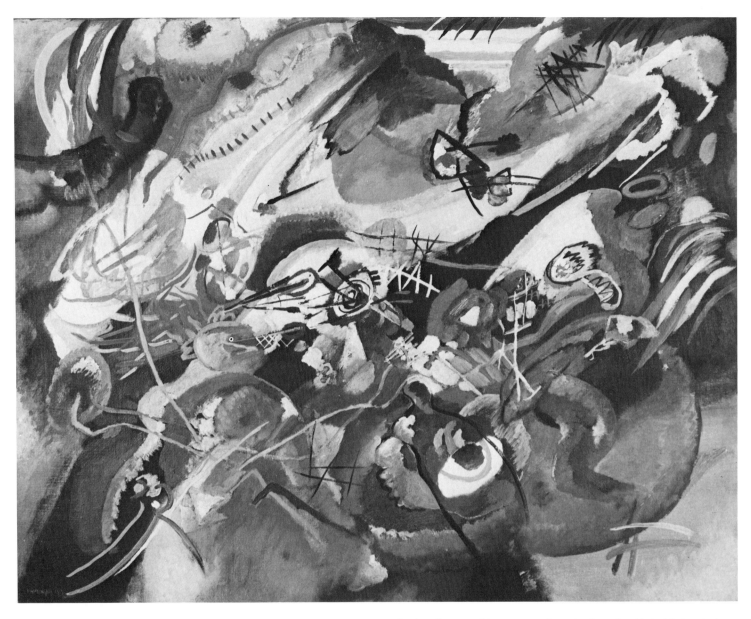

6. Wassily Kandinsky, sketch for *Composition VII*, no. 1, 1913. Sammlung Felix Klee, Bern.

scribes a similar struggle as a "Spiritual Turning-Point." And where Nietzsche embellished his prediction with word of "upheavals" and "a convulsion of earthquakes," so Kandinsky adorned his by describing an "enormous tower [which] lies in ruins" and yet another convulsion: "The old, forgotten cemetery quakes. Old, forgotten graves open, and from them arise forgotten ghosts." Moreover, Kan-

dinsky climaxes this passage by referring directly to Nietzsche's re-valuation of values: "When religion, science, and morality are shaken (the last by the mighty hand of Nietzsche), when the external supports threaten to collapse, then man's gaze turns away from the external toward himself."[87]

Kandinsky's co-founder of the Blaue Reiter, the Munich painter Franz Marc, was also converted to the Nietzschean notion of creation through destruction. At least this is the conclusion to be drawn from the titles of such paintings as *Fighting Forms* (1914), *Wolves (Balkan War)* (1913), and *Animal Destinies* (fig. 7, plate 1). Indeed in choosing

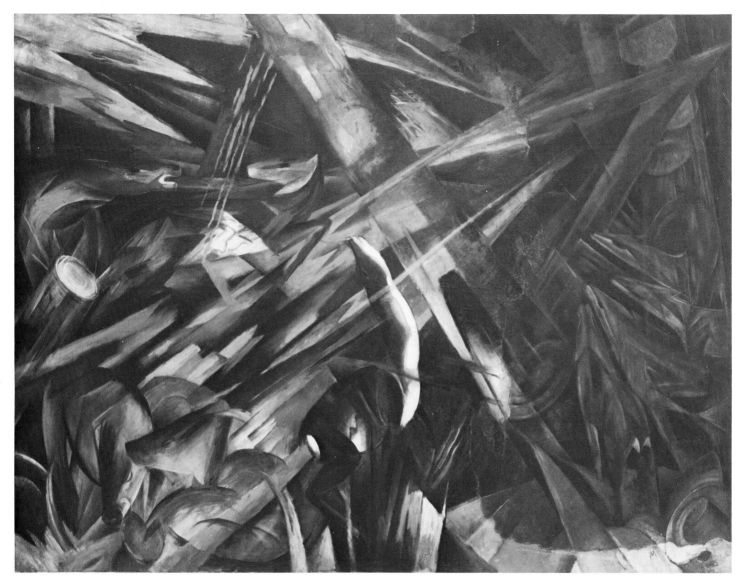

7. Franz Marc, *Animal Destinies,* oil on canvas, 1913. Öffentliche Kunstsammlung, Kunstmuseum Basel. (See also plate 1)

the word *Schicksale* for the latter title—meaning "fates" or "destinies"—Marc alludes to Nietzsche's usage in the *Ecce Homo* chapter "Why I Am a Destiny." The forest animals whom Marc had earlier seen as carrying the "glad tidings" of instinctual renewal were now considered beasts of "calamity." In the world of animals rather than that of men, Marc here envisions that moment in Nietzsche's prediction "when all power structures of the old societies will have been exploded."[88]

Marc's borrowings from Nietzsche are more numerous than those of the Russian-born Kandinsky. His 1912 remark about the decline of style recalls Nietzsche's (and Bourget's) definition of "decadence" (see section 1.4). And at the outset of 1911, in a letter reporting his study of African art, Marc expressed the Nietzschean wish that he and his friends "become ascetics" in order properly to profit from the primitive encounter. As Nietzsche had put it in *The Will to Power*, a stronger race maintains its self-control before African "barbarians" by means of "asceticism of every kind."[89] Elsewhere in the 1911 letter, but even more clearly in a wartime essay on "The Secret Europe," Marc endorses Nietzsche's famous advice that Germans become "good Europeans."[90]

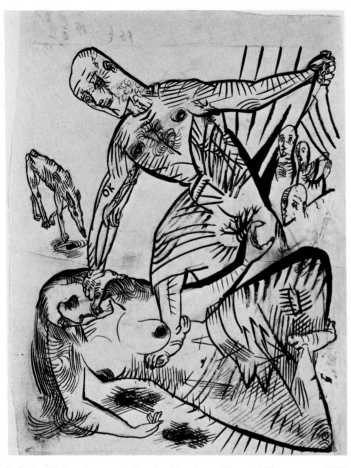

8. Oskar Kokoschka, drawing for *Murderer, Hope of Women*, ca. 1909. Graphische Sammlung, Staatsgalerie Stuttgart.

The first wave of Nietzsche's posthumous influence crested not only in Dresden, Berlin, and Munich, but also in the Austrian capital of Vienna. Here the element of cruelty in Expressionist art derives not so much from its practitioners as from its sources. In Oskar Kokoschka's drawing for the drama *Murderer, Hope of Women* (fig. 8), for example, a knife-wielding man and a victimized woman are depicted: he reaches for her neck while she gropes for his sex. Both drama and drawing were published in Berlin in 1910, but the play was first performed in Vienna in 1909, partly as a comment on Heinrich von Kleist's *Penthesilea* (1800) and partly as a sequel to August Strindberg's *The Father* (1888). It was in the Strindberg drama that the sexes, in a Darwinist trope, were said to descend from "two different species [of] apes"; accordingly, "love between the sexes" was conceived as "a battle" (see section 2.2). But in the Expressionist version Kokoschka also draws on Nietzsche. The very glorification of murder

in the title, and particularly the notion that the weak must "hope" for deliverance from the strong, evokes the Nietzschean distinction in *The Will to Power* between master and slave moralities: "I teach the No to all that makes weak—that exhausts. I teach the Yes to all that strengthens, that stores up strength, that justifies the feeling of strength." Kokoschka's understanding of the situation is captured in his later remarks: "Now God had abdicated, and with him had gone the divine order of the *Civitas dei*. Nietzsche had announced this in his *Will to Power,* and had found madness in his own heart."[91]

Nietzsche's influence extended to many other Expressionists or Expressionists-to-be. He is mentioned twice in Emil Nolde's account of the 1906–12 years and was the subject of an Otto Dix sculpture in 1912 (fig. 9).[92] Max Beckmann cited Nietzsche in his diary as early as 1903, while the title of his "Thoughts on Timely and Untimely Art" (1912) recalled Nietzsche's *Untimely Meditations* (1873).[93] And George Grosz's satirical drawings seem to illustrate Nietzsche's maxim from *Ecce Homo:* "negating and destroying are conditions for saying Yes."[94] Grosz even borrowed Nietzsche's title for a 1923 portfolio of 100 drawings called *Ecce Homo*—one of which satirizes the German burgher's nostalgia for the sentimental Teutonisms of Wagner (fig. 10). The author of *The Case of Wagner* would surely have approved.

The philosopher's impact on the Expressionist generation was, in short, profound. Reading his words fed a "thirst for action," in Theda Shapiro's view, an appetite that was politically liberating: "It was Nietzsche who taught the young that their parents' soft but uneventful lives were undesirable and who gave them a thirst for action. . . . Some painters-to-be first went through a period of anarchism. Others discovered art and anarchism simultaneously. Still others adopted and expressed beliefs that were not specifically anarchist but left-wing and radical." Like Marx, Stirner, Dostoevsky, Kropotkin, and others, the later Nietzsche offered this generation a critique of materialist society and a faith in the individual's ability, through self-realization, to transform that society.[95]

Yet Nietzsche's influence was almost as great in prewar France as it was in Germany. As Ellen Oppler has observed, the emergence of French Fauve painting owed much to a "cult of Nietzsche." French translations of the German thinker appeared under the imprint of the Mercure de France: *Ainsi parlait Zarathoustra* in 1898 and 1901, *Par delà le bien et le mal* in 1898 and 1903, *La volonté de puissance* in 1903. Jules de Gaultier's second Nietzsche monograph, partly prompted by the latter translation, came out in 1904. Meanwhile André Derain mentioned Nietzsche in a 1901 letter to Maurice Vlaminck; Guillaume Apollinaire discussed Nietzsche in a 1904 article; and the Nietzschean character of Pablo Picasso's art from 1901 to at least 1907 became evident.[96] Thus Nietzsche's stress on the instinctual basis of art, so important for the Dresden Brücke, finds an echo in a statement by Vlaminck: "It takes more courage to follow one's instincts than to die a hero's death on the field of battle." And the Nietzschean stress on Dionysian destruction, so influential for the Munich Blaue Reiter, is reflected in Picasso's remark that "A picture

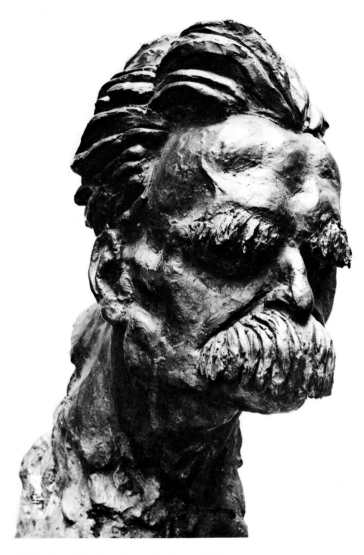

9. Otto Dix, *Friedrich Nietzsche*, [lost], 1912.

10. George Grosz, "In Memory of Richard Wagner," 1921. Illustration from *Ecce Homo*, number 60.

used to be a sum of additions. In my case a picture is a sum of destructions."[97]

In addition, one finds references to Nietzschean philosophy in advanced French painting. Toward the end of 1908, for example, the American critic Gelett Burgess interviewed nine artists he called "The Wild Men of Paris": in the Fauve camp Chabaud, Czobel, Friesz, Herbin, Matisse; and in the Cubist group Braque, Derain, Metzinger, Picasso. In his article of 1910 Burgess commented: "Whether right or wrong, there is . . . something so virile, so ecstatic about their work that it justifies Nietzsche's definition of an ascendent or renascent art. For it is the product of an overplus of life and energy, not of the degeneracy of stagnant emotions. It is an attempt at expression, rather than satisfaction; it is alive and kicking, not a dead thing, frozen into a convention."[98]

This is the kind of criticism, stressing artistic renewal as "expression," that led to the 1911 exhibition of most of these French artists in Berlin as "Expressionists" (see section 5.1). It is also the kind of Nietzschean viewpoint that has suggested "a [close] relationship between all the major schools of the period—Fauve, Brücke, Cubist, and Blaue Reiter."[99] Finally, it is the common ground in Nietzsche that explains certain affinities between early modernism in France and Germany and the early stages of Futurism in Italy. In the Futurist foundation manifestos of 1909, for example, Filippo Marinetti advanced the Nietzschean principle of creation by destruction in such admonitions as the anti-retrospective "Burn the museums" and the anti-sentimental "Kill the moonlight." Marinetti's alternate title for his movement, "Dynamism" instead of "Futurism," might have made his Dionysian purpose even clearer.[100] As it was, Luigi Boccioni and Gino Severini, two of the leading Futurist painters after 1909, were brought together by "their mutual enthusiasm for Nietzsche."[101]

Nietzsche placed his faith in art, it appears, because he despaired of the prospects for science and social science. Science seemed helpless, he wrote, to oppose the abstract imperatives of moral doctrines. "Residues of Christian value judgments are found everywhere in socialistic and positivistic systems," he claimed; therefore he condemned "[t]he nihilistic consequences of contemporary natural science (together with its attempts to escape into some beyond)."[102] These words, though unpublished until 1901, were actually written shortly before Nietzsche became insane in 1889; he had assumed that nihilism would evolve for two centuries before a "countermovement" would occur. Yet the renewal he sought was already beginning in his own day. It was certainly evident to observers of the 1890s. What is most important, however, is that the countermovement began in attitudes expressed by scientists themselves.[103]

In his Romanes Lecture of 1893, for example, Thomas H. Huxley essentially agreed with Nietzsche that evolution was amoral. Purely evolutionary success depended upon animal instincts, upon man's "cunning," "his ruthless and ferocious destructiveness when his anger is aroused." Nevertheless, Huxley continued, there is a morality in social evolution unknown in biological evolution: "After the manner of successful persons, civilized man would gladly kick down the ladder by which he has climbed. He would be only too pleased to see 'the ape and tiger die.' . . . In fact, civilized man brands all these ape and tiger promptings with the name of sins; he punishes many of the acts which flow from them as crimes; and, in extreme cases, he does his best to put an end to the survival of the fittest of former days [for example, to modern outlaws] by axe or rope."[104]

As a result, Huxley argued, one must admit nature's cruelty—"the thief and the murderer follow nature just as much as the philanthropist"—and yet also seek to overcome it: "Social progress means a checking of the cosmic process at every step and the substitution for it of another, which may be called the ethical process; the end of which is not the survival of those who may happen to be the fittest, in respect to the whole of the conditions which obtain, but of those who are ethically the best. . . . [Ethical evolution] is directed, not so much to the survival of the fittest, as to the fitting of as many as possible to survive. It repudiates the gladiatorial theory of existence." In words that were to be echoed more than once by post-Nietzschean thinkers, Huxley insisted in his remarks on *Evolution and Ethics* that man's further progress depended on the conversion of instinct into intelligence:

> Let us understand, once for all, that the ethical progress of
> society depends not on imitating the cosmic process, still
> less in running away from it, but in combating it. . . . Fragile
> reed as he may be, man, as Pascal says, is a thinking reed:
> there lies within him a fund of energy, operating intelligently
> and so far akin to that which pervades the universe, that it is
> competent to influence and modify the cosmic process. In
> virtue of his intelligence, the dwarf bends the Titan to his
> will. . . . The intelligence which has converted the brother of

the wolf into the faithful guardian of the flock ought to be able to do something towards curbing the instincts of savagery in civilized men.[105]

A different approach to the same problem was taken by Henri Bergson in his *Creative Evolution* (1907). He too wanted to compare "instinctive" to "rational" behavior and he found them, indeed, intimately related: "There is no intelligence in which some traces of instinct are not to be discovered, more especially no instinct that is not surrounded by a fringe of intelligence." But where Huxley affirmed the superiority of intelligence, Bergson affirmed the reverse: "Intelligence, in so far as it is innate, is the knowledge of a *form;* instinct implies knowledge of a *matter.* . . . There are things that intelligence alone is able to seek, but which, by itself, it will never find. These things instinct alone could find; but it will never seek them. . . . We are [intellectually] at ease only in the discontinuous, in the immobile, in the dead. The intellect is characterized by a natural inability to comprehend life." Bergson's concept of the life impulse—*l'élan vital*—in fact depended on irrational rather than rational factors. The vitalist principle was *natura naturans* rather than *natura naturata;* it was creative, generative, even divine:

> Now, if [nebula formation] is going on everywhere, whether it
> is that which is unmaking itself or whether it is that which is
> striving to remake itself, I simply express this probable
> similitude when I speak of a center from which worlds shoot
> out like rockets in a fire-works display—provided, however,
> that I do not present this center as a *thing,* but as a
> continuity of shooting out. God, thus defined, has nothing of
> the already made; He is unceasing life, action, freedom.
> Creation, so conceived, is not a mystery; we experience it in
> ourselves when we act freely.

Not surprisingly, just as Huxley had rebutted Social Darwinism's gloomy view of society, so Bergson now countered Lalande's pessimistic view of the cosmos: "Besides the worlds that are dying, there are without doubt worlds that are being born. [Nor does] the death of individuals . . . seem at all like a diminution of 'life in general.' . . . Everything is *as if* this death had been willed, or at least accepted, for the greater progress of life in general."[106] Philosopher rather than scientist, Bergson nonetheless intended his *élan vital* to evoke a new and more life-centered kind of science.

The two positions outlined above were mutually contradictory. Huxley feared the irrational and so valued intellect over instinct; Bergson welcomed the irrational and so preferred instinct to one-sided intellect. The contradiction reappeared a few years later in the disagreement between Sigmund Freud and Carl Jung. In *The Interpretation of Dreams* (1900), for example, Freud insisted on the sovereignty of intellect in the human mind. The "primary process" indeed embodied instinctual wishes and aggressions, but the more logical "secondary process" had to develop out of—and yet contain and repress—the more irrational kind of thought. In Jung's *Transformations and Symbols of the Libido* (1911–12), on the other hand,

"fantasy-thinking" was given priority over logical thought: "Through fantasy-thinking, directed thinking is brought into contact with the oldest layers of the human mind, long buried beneath the threshold of consciousness."[107]

Nevertheless, despite this disagreement, Freud and Jung both described instinctual thought as possessing primitive qualities. For Freud dreams were regressive. They were to adult thought what "primitive weapons [like] bows and arrows" had once been to adult societies. And for Jung fantasy-thinking was mythic, permitting one to agree with Jacob Burckhardt's notion that every classical Greek had embodied "a little bit of Oedipus" and every German citizen "a little bit of Faust."[108] Moreover, both psychoanalysts credited Nietzsche with the key insight that dreams contain "some primaeval relic of humanity" (Freud) or the "atavistic element in man's nature" (Jung).[109] Indeed, since the work of neither psychologist was known to Expressionist pioneers, it is to Nietzsche that the Expressionist concern with dreams should be attributed.[110]

But the Polish-born Stanislaus Przybyszewski, Nietzsche's earliest cultural interpreter in Berlin, understood that the issue of instinct versus intellect was a matter not only of biological or psychological truth but also of cultural renewal. Still a medical student in 1890, Przybyszewski developed a personal view of evolution before becoming a confidant of the painter Edvard Munch and the dramatist August Strindberg in Berlin in 1892.[111] Earlier that year he devoted his first publication to a study *On the Psychology of the Individual,* of which the first part was titled *Chopin and Nietzsche.* Beginning with Darwin's stress on selection by sex, Przybyszewski nevertheless believed more in sexual attraction than in sexual aggression. Though starting with Nietzsche's praise of instinctual sex, in fact, he actually possessed a greater respect for women (cf. section 1.4). Most importantly, however, he insisted on intellectualizing sex in a way that Darwin and Nietzsche had not; to the crass materialism of Zolaesque Naturalism he opposed the "synthetist ideal" of the emerging Symbolist movement. Przybyszewski's views are epitomized in a typically breathless passage:

> Also accessible to art in this macrocosmic view [exemplified by *Zarathustra*] . . . will be The Sexual: that never-satiated lust which displays only the eternal joy of creation, everlasting self-affirmation, and a big "yes" to all the will's instincts for personal immortality, for propagation; those spasms of passion, considered as the deepest instinct of life, as the holy way to life's future, to life's eternity; that relation of the sexes, viewed as the most ancient biological law according to which among insects the male in contrast to the female obtained the suppler shape and wings; among birds the male the magnificent feather adornment and the fuller larynx; and, among the highest of the mammals, man his individualized, finely articulated body and brain, and woman her padding of adipose tissue and liveliness of spinal cord reflexes. Only in such a view lie the endlessly fertile germs that will spread a new art, an art so endlessly different from

that tedious Naturalism with its shabby, lifeless "corners of nature."[112]

Przybyszewski here converts raw sex into an artistic ideal of the creative mind. This is more than mere sublimation, for the transformation occurs through the conscious decision of the idealist artist. Notably free of nihilist overtones, Przybyszewski's remarks provide a major blueprint for post-Nietzschean—and Expressionist—renewal.

The intellectualization of sex was one accomplishment of turn-of-the-century thought. Another, closely related, was the conversion of science into faith. The English evolutionists, of course, had been non-believers. Huxley in fact coined the term "agnostic"—opposing the church's "gnosticism"—to describe his stand. And even Darwin, reticent on the topic in England, finally informed a German colleague that since his fortieth birthday in 1849 "he believed nothing, not having been able to find any proof for this belief [in God]." This was also the position of the more philosophical champion of evolution, Herbert Spencer, whose *First Principles* (1875) was primarily concerned, as we have seen, with the material principles of "evolution" and "dissolution" (see section 1.3). Yet Spencer's agnosticism complemented his materialism. His book's two parts were titled "The Unknowable" and "The Knowable," and his cosmological constants of Matter, Motion, and Force were discussed in the second category. Only at the end of his text did Spencer remark that *each* of the "antithetical conceptions of Spirit and Matter" was to be considered "but a sign of the Unknown Reality which underlies both."[113]

The issue was perceived differently, however, by the German evolutionist Ernst Haeckel. In Haeckel's view, Spencer's spirit/matter duality had to yield to a higher conceptual unity. Although he called this conceptual approach "monism" as early as 1873, it was not until the 1890s that Haeckel made a systematic attempt to bridge the gap between religion and science (see section 1.2). His failures in this endeavor are less important than the fact of the attempt itself.

Haeckel's opening salvo on the matter/spirit front was his 1892 essay on *Monism,* which was subtitled "The Confession of Faith of a Man of Science." Here he proposed a physical demonstration of the existence of God—by means of an illusory entity known as ether. Haeckel's argument was based on the claim that "ether" plus "mass" equaled "substance." The latter was a philosophic construct yet it was also, by analogy with known scientific laws, deemed eternal: "Immortality in a scientific sense is conservation of substance, therefore the same as conservation of energy as defined by physics, or conservation of matter as defined by chemistry."[114] But in addition Haeckel saw ether, as *opposed* to mass, as a deity, that is "the mobile cosmic ether as creating divinity, and the inert heavy mass as material of creation." By identifying ether with "spirit" and with the functions of "electricity, magnetism, light and heat," he described it as "dynamic" and "continuous"—although possibly "not composed of atoms." As a result he believed that ether was "no longer hypothetical" and that the ether-deity was susceptible to scientific proof. By a simple electrical experiment he even claimed to see—*mirabile dictu*—"the vibrating ether" itself![115] Nevertheless,

despite Haeckel's citation of reputable scientists, the very existence of ether had recently been brought into question. His conception of an ether-god, like his physics in general, was decidedly pseudo-scientific.[116]

Perhaps he recognized this belatedly, for in *The Riddle of the Universe* (1899) Haeckel did not repeat his claim. Although continuing to call his spurious law of substance "the supreme and all-pervading law of nature," he now conspicuously failed to identify either it, or its constituent ether, with God. On another front, however, Haeckel continued to proclaim the identity of matter and spirit. Building on a theory of the "cell-soul" he had developed in 1866, Haeckel now believed in the intelligence of matter and the "mechanism" of soul: "The great progress of anatomy, physiology, histology, and ontogeny has recently added a wealth of interesting discoveries to our knowledge of the mechanism of the soul. If speculative philosophy assimilated only the most important of these significant results of empirical biology, it would have a very different character from that it unfortunately presents." What this meant, however, was that the soul was an aspect of matter. Haeckel therefore scoffed at the notion of its immortality: "If, then, the substance of the soul were really gaseous, it should be possible to liquify it by the application of a high pressure at a low temperature. We could then catch the soul as it is 'breathed out' at the moment of death, condense it, and exhibit it in a bottle as 'immortal fluid' (*fluidum animae immortale*). By a further lowering of temperature and increase of pressure it might be possible to solidify it—to produce 'soul-snow.' The experiment has not yet succeeded."[117] Despite his position as Germany's leading Darwinist, in sum, Haeckel made an imaginative attempt to bridge the gap between science and religion. Given the popularity of *The Riddle of the Universe,* with the 1899 edition running to 16,000 copies, an inexpensive English edition selling 30,000 copies in 1902, and the 1903 *Volks-Ausgabe* reaching readers of even the most modest means, we may be sure that Haeckel's thesis was known to future Expressionist writers and artists. What they made of his effort to imbue matter with spirit remains to be seen.

An even more speculative response to Darwin was the syncretistic doctrine of Theosophy, inaugurated by Helene Blavatsky in *Isis Unveiled* (1877) and then expanded in *The Secret Doctrine* (1888). In her earlier book Blavatsky, too, used the notion of ether to unify traditional religion and modern science. For she attributed all of nature's "magical possibilities," from "Zoroastrian sacred fire" down to "Edison's Force and Professor Graham Bell's Telephone," to "The Universal Ether." More importantly, she cited Huxley, Haeckel, and Darwin himself with some degree of approval: "Modern science insists upon the doctrine of evolution; so do human reason and the 'secret doctrine,' and the idea is corroborated by the ancient legends and myths, and even by the Bible itself when it is read between the lines. . . . The antediluvian ancestors of the present elephant and lizard were, perhaps, the mammoth and the plesiosaurus; why should not the progenitors of our human race have been the 'giants' of the *Vedas,* the *Volüpsa,* and the Book of *Genesis?*"[118]

By the time of her 1888 book, Blavatsky had read her scientific sources more exhaustively. She even took from Haeckel's *History of Creation* the idea of the sunken continent of Lemuria, in the Indian Ocean, which had supposedly been the antediluvian "cradle of the human race." But what annoyed Blavatsky the most was Spencer's categorical separation of spirit from the evolutionary process of matter:

> Suppose an Occultist were to claim that the first grand organ of a cathedral had come originally into being in the following manner. First, there was a . . . production of a state of matter named organic protein. Then, under the influence of incident forces, . . . [it] slowly and majestically evolved into and resulted in new combinations of carved and polished wood, of brass pins and staples of leather and ivory, wind-pipes and bellows. After which, having adapted all its parts into one harmonious and symmetrical machine, the organ suddenly pealed forth Mozart's *Requiem*. . . . What would Science say to such a theory? Yet, it is precisely in such wise that the materialistic *savants* tell us that the Universe was formed, with its millions of beings, and man its spiritual crown.[119]

To be properly understood, she argued, evolution theory had to be complemented by religious symbolism drawn from Indian and other creation myths. Blavatsky's *Secret Doctrine* of 1888 strangely complements, in fact, Haeckel's *Riddle of the Universe* of 1899. For where the latter described the material evolution of spirit, the former traced the spiritual evolution of matter.[120]

Indeed, since Haeckel had tried all along to reconcile science and religion, his biological findings might even be considered the "first chapter of Theosophy, or spiritual science." Such at least was the conclusion of Germany's leading theosophist, Rudolf Steiner, in an undated lecture on "Haeckel, the Riddle of the Universe, and Theosophy." In this lecture Steiner took a key step by undermining Darwin in favor of Blavatsky and Haeckel. For he disputed the central Darwinist assumption that man "descends" from the ape. He believed instead that both ape and man were descended from a common primitive being, compared to whom the ape was a comedown but from whom man had worked his way up. Moreover, it was the human *soul,* already present at the time of the common ancestor, that made the difference. The "better" of these primitive beings could "submit themselves to the soul's process of higher education," while the "more inferior" could not. "Thus," he concluded, "today's human soul has a soul-ancestor, just as the body has its bodily ancestors."[121] Where Darwin had once traced the evolution of species, Steiner now traced the evolution of souls.

Earlier Steiner had also addressed himself to Nietzsche's views on instinct, once again championing and then undermining them. Steiner's *Friedrich Nietzsche* (1895) was one of the early German appraisals of the German philosopher after Przybyszewski's study. Here man is discussed as an essentially instinctual being: "virtue,

justice, knowledge, and art . . . are means through which the human instincts can develop according to their nature." Zarathustra teaches us to live not by "ideals" but by "nature": "To live according to nature is healthier than to chase after ideals which, allegedly, do not stem from reality. The man who disdains impersonal goals and seeks the purpose and meaning of his existence in himself . . . Nietzsche places higher than the selfless idealist."[122]

Nevertheless, despite all this, Steiner argues that instincts must be augmented by what he calls "moral imagination":

> Only he who has moral imagination is truly free, for man must act by *conscious* motivations. And if he can't produce these himself, then he must accept them for external authority or from tradition speaking in him in the form of a voice of conscience. The man who merely gives in to his sensual instincts behaves *like an animal;* the man who puts his sensual instincts in the service of alien thoughts acts without freedom; only that man who creates for himself his own moral goals behaves freely. It is the moral imagination that is missing in Nietzsche's writings. . . . [I]t is an absolute necessity that this concept be inserted into the Nietzschean world view. Otherwise it would perpetually be open to this criticism: Indeed Dionysian man is no slave of tradition or of the "otherworldly will," but he is still *a slave of his own instincts.*[123]

Nietzsche's self-centered arguments against the false morality of collective ideas are here undone by a call for yet another morality.

Steiner finally found the post-Nietzschean morality he was seeking in the teachings of Theosophy. Without here entering into the various categories enumerated in his *Theosophy* (1904)—for example, the three "worlds" and the seven "regions" known to "supersensible knowledge"—we can note the reappearance of old Christian ideals under new guise. Steiner's entire Theosophical program seems but a system, in fact, by which the body's orientation toward matter becomes the soul's achievement of mind. The Christian virtue of charity reappears in the principle of "sympathy": "The fifth stage of the soul world," for example, is one where "sympathy with others has already reached a high degree of importance." And the Christian aversion to bodily function surfaces in such other passages as this: "A man is the more perfect, the more his soul sympathizes with the manifestations of the spirit. He is the more imperfect the more the inclinations of his soul are satisfied by the functions of his body."[124] Steiner's Theosophical doctrine, for all its "scientific" claims, actually reincorporates aspects of Christian morality brought into question by Darwin and Nietzsche.

Theosophy was a spiritual substitute for materialist science, and we know that Munich Expressionists adopted some of Steiner's ideas.[125] But they did not denigrate hard science, on this account, at all. Instead, as is clear from the catalogue introduction to the second Blaue Reiter exhibition in February 1912, they respected the exemplary effect of *any* law, whether religious or scientific, for the further progress of art:

> One can explain it through divine plan or through Darwinist theory. Not this is important here, but rather the clear effect of a law. Whether in the world of ants or in the world of stars, nature fascinates us in two ways. The first is known to every human being: the "infinite" variety, the "unlimited" richness of natural form: elephant, ant, spruce-tree, rose, mountain, flintstone. The other is known to the informed person: the adaptation of form to necessity (the trunk of an elephant, the jaws of an ant). . . . Nature creates form for its own purpose; art creates form for its own purpose.[126]

Now freed of what Huxley had called its "gladiatorial" implication, evolutionary science had some philosophical implications for art.

But this was even more true of the latest developments in physical science. For in the years around 1905 two events occurred which brought into question the entire Newtonian world view upon which nineteenth century physics had been based. The first was Albert Einstein's postulation of a theory of relativity, one which finally rejected "ether" as the medium for the transmission of light and which thus denied any mechanical or material limits to the laws of electromagnetism.[127] The second was Ernst Rutherford's experimental proof of 1903, soon elaborated by Arnold Sommerfeld and Niels Bohr, that the atom "is only a tiny but massy point around which revolve clouds of much lighter particles."[128] As a result of these developments, the notion of fixed or immutable "matter" disappeared from the fundamental assumptions of modern science. As Einstein later stated, "We may therefore regard matter as being constituted by the regions of space in which the field is extremely intense. . . . There is no place in this new kind of physics both for the field and for matter, *for the field is the only reality*" (emphasis added). Or, in Bohr's formulation, "Isolated material particles are abstractions, their properties being definable and observable only through their interaction with other systems."[129]

German Expressionism came to fruition before Einstein's relativity theory became known to the public (in 1919), and even before Bohr had demonstrated the exact orbits electrons can take around the atomic nucleus (in 1913). Nevertheless, in *Concerning the Spiritual in Art,* written by 1910, Kandinsky already realized some of the implications of Rutherford's experiments. Indeed, it was the physicists like Rutherford who occupied the highest level of knowledge at the "Spiritual Turning-Point": "There we find other professional men of learning who test matter again and again, who tremble before no problem, and who finally cast doubt on that very *matter* which was yesterday the foundation of everything, so that the whole universe rocks. The theory of the electrons, that is, of waves in motion, designed to replace matter completely, finds at this moment bold champions who overstep here and there the limits of caution and perish in the conquest of the new scientific fortress."[130] Kandinsky here drew upon one of the most advanced ideas of his time.

In his *100 Aphorisms* (1915) Franz Marc, too, looked for a transformation of material into spiritual values: "Some day they will surely prove the identity of world history and natural history, just as they will recognize the unity of physics and psyche in the sense that physics goes into psyche without remainder—and not the reverse, as the clumsy mistake of materialism would have us believe." Moreover, Marc foresaw a post-Nietzschean transformation of mere will into creative knowledge:

> Schopenhauer glorified the victory of will over representation. In our hands it will change into the victory of *knowledge* over representation. The good European creates exact thinking, thinking that lies beyond representation, matter and fashion, and shows familiarity with the absolute—without Schopenhauer's wish to pass away into nothingness.
>
> The revaluation of Nietzsche's will to power into a knowledge about power—after long wars which we fight under Nietzsche's banners, and which we still must fight; this will be our faith, our epoch, Europe's epoch.

The "technical conquest of the world" leads only to the ironic wonders of "martial science" which force humanity back to the age of the cavemen. In contrast to this technical science there is a "Pure Science" which is "our European conscience." It is this conscience, Marc adds, that "we must obey."[131]

As this survey suggests, then, a "revaluation of values" was well under way after 1890. Impersonal positivist method was yielding to an interest in inner subjective values. Philosophically, it was a shift from materialism to idealism; culturally, from science to art. Such at least were the changes in concern from evolution to ethics, instinct to intellect, matter to mind. To be sure, post-Nietzschean renewal could readily depart from the path the philosopher had marked. It could veer toward just that type of cerebral abstraction against which Nietzsche had warned; it could sacrifice phenomenological description to Kantian universals.[132] Nevertheless, in this post-Nietzschean (and Expressionist) revaluation, the emphasis shifted not only to subjectivity but also to questions of authenticity in the individual. Vague collective concepts gave way to concrete issues of personal psychology; nihilism yielded to the hope for self-realization, self-creation.

1.8. PHASES OF THE GERMAN MOVEMENT

But there is still more to the matter than this. For the entire idea of decline and renewal—as evoked in the later Nietzsche's notion of "countermovement"—had an afterlife in Germany far longer than in any other country. Partly because of the rigidity of Wilhelmian society before 1914, partly because of German battlefield failures afterward, the entire Expressionist period was haunted by an oppressive fear—to wit, that the desired rejuvenation and revitalization might not, after all, occur. If through negation one is "fundamentally centered upon that which is being negated," in Karl Mannheim's words, then the risk is great indeed that those who would live by the sword of renewal might yet die by the sword of decline (see section 1.5).

For the fact is that Darwinist science and pseudo-science had not suddenly lost their validity; they continued to point not just to evolution in the past but also to devolution in the present. And in Germany around 1900, so recently unified economically and politically, it was precisely in the area of culture that decay seemed especially inevitable. Moreover, Anglo-French writers and artists had a weapon more effective than that available to Germans. Thanks to Henri Bergson's popular *Creative Evolution* (1907), those west of the Rhine could affirm that optimistic principle of vitalism, the *élan vital,* which was always ready to recreate that which had decayed. Nature itself, operating through man and his creations, provided the vitalist impulse for art (see section 1.7).[133] German writers and artists, by contrast, had to rely on the Dionysian principle, a principle partly rooted in pessimism and tragedy. They remained dependent not on Bergsonian vitalism but on Nietzschean "revaluation"—a concept considerably less efficacious or certain.

Under the circumstances, then, Nietzsche's notion of creation through destruction must have been particularly unsettling for Germans. As one Expressionist after another began to conjure up images of death or decay, it was sometimes unclear whether the disaster was being rejected or approved. Just so, for example, did Ludwig Meidner describe his *Apocalyptic Landscapes* of 1912: "I feared such visions, yet the final results gave me an especially warm feeling of satisfaction, a slightly Satanic joy." Similarly, Hermann Bahr, earlier an objective observer of German culture, by 1916 was swayed by the same doubts that artists were experiencing. Indeed Bahr's book on *Expressionism* provides an especially ambivalent view of modern, godless existence:

> All that we experience is but the strenuous battle between the soul and the machine for the possession of man. We no longer live, we are lived; we have no freedom left, we may not decide for ourselves, we are finished, man is unsouled, nature is unmanned. A moment ago we boasted of being her lords and masters and now she has opened her wide jaws and swallowed us up. Unless a miracle happens! That is the vital point—whether a miracle can still rescue this soulless, sunken, buried humanity. . . . Never was happiness so unattainable and freedom so dead. Distress cries aloud; man cries out for his soul; this whole pregnant time is one great cry of anguish. Art too joins in, into the great darkness she too calls for help, she cries to the spirit: this is Expressionism.[134]

By the early postwar years there were important areas of German science and pseudo-science where pessimism swallowed up earlier hopes. One such case was Oswald Spengler's *Decline of the West,* begun in 1911 but first published in 1918, where the idea of progress was fundamentally denied: "The future of the West is not a limitless tending upwards and onwards for all time towards our present ideals, but a single phenomenon of history, strictly limited and defined as to form and duration, which covers a few centuries. . . . What the myth of

Götterdämmerung signified of old, its irreligious form, the theory of Entropy, signifies today—the end of the world as completion of an inwardly necessary development." Another such case was Sigmund Freud's *Beyond the Pleasure Principle* (1920), which postulated a "death instinct" as complement for the "sexual instinct" Freud had described in 1905.[135] The tendency to self-destruction which Spengler attributed to whole civilizations Freud now located within each human psyche. What Nietzsche's generation had feared—decay and decline—now came to seem like reality. And what Nietzsche could still see as creation *through* destruction now came to seem like an instinct for destruction alone.

Yet so far as the German Expressionist movement was concerned, renewal was always the outcome of decline, creation always the goal of destruction. Freud's friend Oskar Pfister described Expressionism, in fact, as just this kind of progress through regress. "Regression is the inevitable stage of transition of every forward movement," he declared. "Every step on the road to progress is possible only through the detour of such a regression (cf. Jesus, the Reformation—really a Retromation—, Rousseau's *retour à la nature*, Tolstoy's return to peasant life, etc.)."[136] Published in 1920, Pfister's book was titled *Expressionism in Art: Its Psychological and Biological Basis*. Pfister here recalls Nietzsche's conclusion, in *Human, All-too-Human* (1878), that "every great progress must be preceded by a partial weakening." We recall Nietzsche's additional remarks about countermovement on that occasion: "Those who degenerate are of the highest importance wherever progress is to take place. . . . Precisely in this wounded and weakened part the whole structure is *inoculated,* as it were, with something new" (see section 1.2).

Expressionist historiography embodies this principle of countermovement, it appears, but in the context of German cultural history from 1890 to 1920, which moved from despair to increasing hope—and back again. The history of Expressionist art describes a similar dialectic, not of transcendence but of self-canceling opposites. Nietzsche's metaphor of inoculation is in fact the key to understanding the movement's three successive phases, except that the phases describe a progress not of the patient but of the disease.

In turn-of-the century England, France, Italy, and Germany, first of all, there had been an infection in the body social, an infection we have called a "fear of decline." This was the pre-Expressionist situation. But by means of invigorating Expressionist impulses across Europe—titled variously "Fauve," "Brücke," "African," "Futurist"—the body's immunological processes were brought into play, antibodies were sent to the disease site, and the healing process we call "renewal" ensued. This was the procedure of early Expressionism from about 1905 to 1910—a procedure so automatic that the infection itself often went unrecognized.

Gradually in 1910–11 and uniquely in Germany, however, new evidence of malaise appeared—politically in the Moroccan crisis and culturally in new concerns about Apocalypse and the end of the world. There arose the danger of epidemic in the body social. The danger was countered by inoculation with disease virus or, more precisely, with those toxin-antitoxins we call "decay/revitalization" and "destruction/creation." This was the situation of mature Expressionism from about 1910 to 1914, where the immunological reaction was body-wide and where the cure was a hair of the very dog that bites. The potentially toxic virus became a working partner in prewar Expressionist hygiene. The work of art embodied an optimistic/pessimistic tension.

The late Expressionist period of the war and Weimar years (1914–23) constituted a ragged and uneven stage of the sickness. The war itself, of course, marked a failure of the immunological process: the prospect of devolution was now epidemic across a continent. The defenses of the body social had been breached, the dangers of "decay" and "destruction" were quite real. But there were also moments of remission, even illusory cure. The Bolshevik revolution of 1917 in Russia, the "frozen" revolution of 1918–19 in Germany, the passive resistance in the Ruhr in 1923, all prompted hopes for renewal which were, one after the other, dashed. This was Expressionism's so-called "second wave." During this phase the art work embodied at best a pessimistic/optimistic tension.

After the currency reform of the 1923–24 winter, the Expressionist movement ceased to exist. It was followed by a direction called Neue Sachlichkeit, whose translation "New Objectivity" suggests the sobriety of this era and the end of all hope for renewal. In half a decade Weimar Germany achieved a material stability and a spiritual emptiness such as Wilhelmian Germany had known in its time. The world that German Expressionists bequeathed to their successors was as devoid of inner values as had been the world which Nietzsche bequeathed to his. It was a world in which man, as both bridge and abyss, could only swim by sinking. It was a world of *Uebergang* through *Untergang,* of "crossing over" by "going under."

This outline of Expressionism's three phases tells us something about its successor movements in other countries. Once Expressionist historiography embraced both exuberant and pessimistic positions, Expressionist art criticism could encompass similarly contradictory qualities—from, say, emotionalism in content to vitalism in color. There are a number of "Expressionisms," in short, to be accounted for, ranging from the Nazi view of Expressionism as simply the most recent type of "degeneration" in art to the Belgian view of Expressionism as the art of refugees displaced by war, or the French view of it as the art of Jews alienated from society. And finally there is the view of Americans who, on the threshold of a later war, saw it as a more positive art of social change and self-assertion. Even after the end of the German movement, then, Expressionist art had something to say not only about German culture but also about the human condition of twentieth-century man.

2.
Iconography

The imaginative life of mankind obeys a very simple law: it lives on antithesis.

WILHELM WORRINGER

2.1. SEXUAL AND SPIRITUAL LIBERATION

In the bitter turn-of-the-century struggle between science and religion, contradictory positions became firmly entrenched. Spiritual values were both drastically weakened and rigidly reinforced, while bodily functions were both privately investigated and publicly tabooed. Centrally concerned with sexual and spiritual liberation, Expressionist art nonetheless reflects the contradictions of the times.

Between them, David Friedrich Strauss' *Life of Jesus* (1835) and Darwin's *Origin of Species* had undercut the authority of both the New and the Old Testaments. Clergymen in Germany, as elsewhere, were accordingly willing "to abandon the mystical and intuitive elements of the Christian tradition and to sacrifice doctrinal positions." Simultaneously, however, German Evangelism became more rigid in opposing issues of liberal social concern. "As in Luther's day," Gordon Craig has written, "the Protestant Church put its faith in princes and enjoined upon its members the doctrine that it was their duty to believe in God and remain true to the demands of their calling and leave politics to their rulers."[1]

Meanwhile sexuality emerged as an important topic for biological and psychological appraisal and yet also as a disruptive force that required social limitation. In Michel Foucault's summary: "Sex was a means of access both to the life of the body and the life of the species. It was employed as a standard for the disciplines and as a basis for regulations. This is why in the nineteenth century sexuality was sought out in the smallest details of individual existences; it was tracked down in behavior, pursued in dreams; it was suspected of underlying the least follies, it was traced back into the earliest years of childhood; it became the stamp of individuality—at the same time what enabled one to analyze the latter and what made it possible to master it." Nevertheless, the danger of sexual discourse was its potential for anarchic lawlessness. Suppressed in society through a network of codes and laws, sexual topics could be depicted in art only through indirection. It was safer to decry "erotic subjects" altogether and to accuse the painters of such subjects of "pander[ing] to the lower instincts of the masses and not to their best sentiments."[2]

Thus described, the German cultural situation at the end of the nineteenth century can best be defined as Victorian. Of course German cultural criticism lacks the word "Victorian" in its vocabulary, and thus has no term to evoke the "middle-class respectability, prudery, bigotry"[3] obtaining in England during Queen Victoria's long reign (1837–1901). Yet Wilhelmian society was certainly Victorian in the

sense that it was class-conscious, ostentatiously Christian, and intolerant of sexual mores not practiced in the middle-class home. Indeed Victorian values in Germany were among those that Nietzsche had sought to transform. This is so much the case that if Expressionist revaluation can be called post-Nietzschean, it can justifiably be called "post-Victorian" as well.

Victorian values were enforced in the church, in the home, and above all in the school—in the *Gymnasium* or *Realschule* where middle-class youngsters were prepared for the university. Here the teacher's authority went unchallenged although his ignorance of his charges' concerns was great. Frank Wedekind's drama *Spring's Awakening* was set in such a school and focuses upon the unfortunate consequences of an adolescent tryst. These included the death of the pregnant girl, apparently from a bungled abortion, and the suicide of an intelligent boy who was already sick of life. The petty-bourgeois conspiracy to hush up matters sexual, especially when they concerned the young, can be seen by the fact that *Spring's Awakening*, though published in 1891, went unperformed until 1906. Nevertheless, the issue of schoolboy suicides had already become a national scandal. Indeed, "in the last twenty years of the nineteenth century no fewer than 1,152 adolescents thus took their own lives."[4]

It was in the context of such Victorian sensibility that Expressionist art and culture proved so liberating. It is possible to see Expressionism as a "revolution," as an inchoate or muddled rebellion against German bourgeois society—a rebellion with both socialist and fascist implication.[5] But before the revolution was political it was familial; it was a protest by adolescents against the ignorance, intolerance, and materialism of their parents and teachers. In opposing the Victorian code, Expressionism was a "revolt against the constrictions of middle-class conformity, sterile religiosity, [and] conventional morals."[6]

No study exists of the family and school backgrounds of future Expressionist artists, but the matter was important enough to them to prompt bitter comments both artistically and verbally. In a 1949 triptych, from the end of his life, Max Beckmann still remembered a boy furtively drawing a nude in a classroom while another boy was forced to stand in a corner with arms raised. During his schooldays the young Ludwig Meidner was so obsessed by punishment that he did a drawing, *Kill the Flesh* (1902), depicting Christian monks flagellating themselves. In his autobiography George Grosz recalled the "Protestant officers" who were his teachers, and the "controlled fury" with which one of them would rap a heavy signet ring against the boy's head. Oskar Kokoschka recorded in his autobiography a decision to commit suicide if he failed his *Realschule* exam and lost a scholarship. Even the peasant boy Emil Nolde, the first of his family to quit the farm for the city, remembered a religion class at school when the sexton confiscated his drawings and burned them in the oven. And Ernst Ludwig Kirchner, although the son of a well-educated chemical engineer, still smarted from "the dark heritage of fanaticism in the generation of Brandenburg ministers on my father's side."[7] In becoming Expressionist artists, some of them at quite youthful an age, these men were to some degree reacting against an unusually repressive adolescent environment.

The case of Edvard Munch, in this regard, is instructive. Though Norwegian by birth and Symbolist by stylistic inclination, he was one of the first to attempt the overthrow of Victorian values. Munch felt the restrictions of a middle-class Protestant home, headed by a devout father, where death had taken away the boy's mother (when he was five) and older sister (when he was fourteen). In repressing the erotic impulses of adolescence and early manhood, however, he also made diary notes and, eventually, sketches about matters of intimate concern. By the 1890s he was able to externalize both his sexual and spiritual experiences in a series of paintings he called a "Life Frieze." The Frieze was exhibited in Berlin (1902), Leipzig (1903), Christiania (Oslo, 1904), and Prague (1905); its sections were titled "Seeds of Love," "Flowering and Passing of Love," "Life Anxiety," and "Death."[8] The works had a powerful effect on future Expressionists. In Prague, as Emil Filla later wrote, "Munch's work had exploded in the hearts of young artists and had so deeply affected them that they felt as though all their hopes had suddenly come true."[9] Nevertheless, though the Frieze helped launch Expressionism, its iconography was deeply pessimistic. Its themes were still dictated by Symbolist attitudes.

As the secular son of a religious father, Munch was profoundly affected by the implications of Darwinist science. After the dying father had sent a Bible to Paris "to save his son's threatened soul," the young Munch wrote a few words at the end of 1889 that managed to link love, death, and the "sanctity" of religion: "A strong naked arm, a tanned powerful neck—a young woman rests her head on the arching chest. She closes her eyes and listens with open, quivering lips to the words he whispers into her long flowing hair. I would give form to this as I now see it, but envelop it in a blue haze. These two in that moment when they are no longer themselves but only one of thousands of links tying one generation to another generation. People should understand the sanctity of this and take off their hats as if they were in church." Munch clarifies his meaning in a commentary to his *Madonna* painting of 1893 and lithograph of 1895–1902. The lithograph, also known as *Loving Woman* (fig. 11), depicts a hollow-eyed nude framed by an ornamental pattern of swimming spermatozoa. An image of a fetus appears lower left, near the nude's lower torso. Love is linked, in Munch's words, both to death and to renewed life: "A corpse's smile. New life shakes the hand of death. The chain binding the thousand dead generations to the thousand generations to come is linked together."[10]

By calling his subject *Madonna* and by wanting people to respond to an image of love "as if they were in church," Munch hoped to embellish eroticism with all the traditional trappings of religion. But on the other hand, by focusing on sperm and fetus, the artist changes the Christian subject into a secular symbol of merely physical generation. In the image itself, religious reference is lacking. As Reinhold Heller notes:

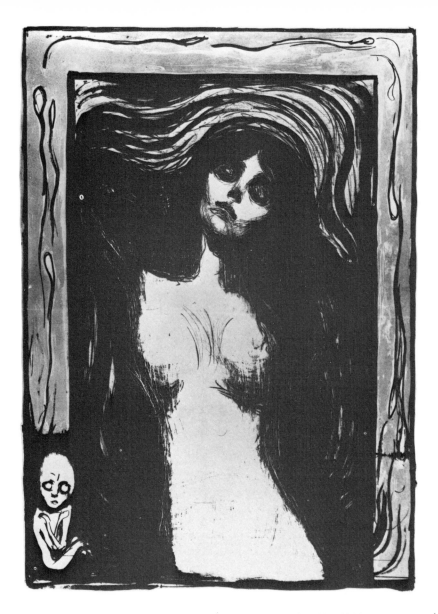

11. Edvard Munch, *Madonna (Loving Woman)*, lithograph, 1895–1902. Oslo Kommunes Kunstsamlinger.

The problem which Munch posed himself was . . . how to present [his] thoughts of immortality to an age whose faith in science and evolution had replaced the faith in its Christian heritage. Darwin's theories introduced Munch to a new concept of immortality, totally reversing the immortality of which St. Paul wrote (I Corinthians xv, 22): "For as in Adam all die, even so in Christ shall all be made alive." The new immortality was founded specifically in Adam, and empha-

sized the continuation of human terrestrial life rather than an everlasting extra-terrestrial salvation or condemnation.

Munch's position remained, in short, both Darwinist and skeptical: the "new" immortality belonged to the species, not at all to the individual. Only through progeny, through copulation and birth, could mankind assure continuity into the future. Meanwhile onto woman, the very vehicle for this continuity, Munch projected his own inner despair. He gives her a "corpse's smile" and the "hand of death."[11]

We understand how Munch's *Madonna* seemed liberating to young artists: it dared to bring taboo topics like copulation and gestation to public view. Yet despite such refreshing frankness, Munch's

message is fundamentally pessimistic.[12] It is this which links him to the nihilism of Nietzsche's time, not yet to Expressionist revaluation.

Another painting in Munch's Life Frieze was his *Dance of Life* (1899–1900; not illustrated).[13] The painting is somber in mood, symbolizing the progress from youth to age and from love to death. The irony in Munch's title is that the "dance of life" is but another form of the medieval dance of death. A similar irony informs other pre-Expressionist works such as *La Ronde* (1896–97), written by the Viennese author Arthur Schnitzler.[14] Here too, in ten dialogues between successive pairs of lovers, an entire dance of life is encompassed. From a Prostitute at the periphery to a Young Wife and Husband at the play's center, the dance is one where no person remains faithful to any other. Indeed, at the end, when the Count is paired with the Prostitute whom we met at the outset, the circle is closed and Schnitzler's black humor is revealed. A third example is the 1905 woodcut cycle *Two People* by the future Expressionist Kirchner. Though depicting a pair of lovers as did Richard Dehmel's 1903 poem of the same name, Kirchner's cycle departs from Dehmel's idealized narrative to end with ominous images of *Temptation* and *Separation*.[15] Like Munch and Schnitzler, the young Kirchner still inhabited Nietzsche's world of pessimistic "nihilism."

Unlike them, however, Kirchner and his Dresden Brücke friends sought an Expressionist "countermovement." In just this way did Kirchner employ Munch's *Evening on Karl Johan Street* (1892) in composing his own *Street, Dresden* in 1908 (figs. 12, 13).[16] Kirchner's purpose is to show not just Munch's fin-de-siècle city with its aura of decadence, but also the bustling modern city with its trams and women shoppers. A pink street, bright green face tones, orange outlines squeezed from the tube—all are Fauve elements designed to make Symbolism look outdated.[17] Yet there are similarities between the two works. The anxious expressions of the pedestrians in *Karl Johan Street* are echoed in the nearest woman in the Dresden *Street*. Indeed the latter figure's staring eyes and clutching hand even evoke the "corpse's smile" and "hand of death" which Munch had attributed to the woman in *Madonna*. Despite protestations,[18] Kirchner at some level wanted the Munch connection to be seen—in order to stress his conversion of a gloomy attitude into a gayer one. If we call Munch's image nihilist and Kirchner's a revaluation of values, then precisely in Nietzsche's sense does this early Expressionism mark a movement counter to Symbolism—namely "a movement that . . . [takes] the place of this perfect nihilism—but presupposes it, logically and psychologically, and certainly can come only after and out of it."[19]

The shift from a Darwinist to a Nietzschean context was only the first step, however, in the formation of Brücke iconography. The second and more radical step was the espousal of a hedonistic eroticism which surpassed even that of Nietzsche himself. In a later discussion we shall identify Fauve and Oceanic precedents for Kirchner's *Girl under a Japanese Umbrella* (fig. 52; 1909). But here we may point out the painted screen above with four small nudes—including on the left a girl bending to expose her buttocks and, center right, a male figure

with genital erection. Such sexual frankness was rare in early modern art. It was due not just to Nietzsche's discovery of art as sexual sublimation, nor even to Przybyszewski's intellectualized praise for a sex-based art (see secs. 1.6, 1.7).

Instead, it was the American poet Walt Whitman who first prompted the Brücke artists' public celebration of sexual activity. Kirchner considered *Leaves of Grass* his "best friend" during the Dresden years.[20] Throughout *Leaves of Grass* are passionately written verses in which the sexual "urge" is given direct expression:

> Urge and urge and urge,
> Always the procreant urge of the world.
> Out of the dimness opposite equals advance, always
> substance and increase, always sex,
> Always a knit of identity, always distinction, always a breed
> of life.
>
> I and this mystery here we stand.
> Clear and sweet is my soul, and clear and sweet is all that is
> not my soul.[21]

Other verses evoke the sheer physical attraction existing between people:

> Undrape! You are not guilty to me, nor stale nor discarded,
> I see through the broadcloth and gingham whether or no,
> And am around, tenacious, acquisitive, tireless, and can
> never be shaken away.
>
> I am the mate and companion of people, all just as immortal
> and fathomless as myself.
> They do not know how immortal, but I know.[22]

That Kirchner should have been drawn to Whitman is not too surprising. Shortly after the Brooklyn poet's death in 1892, the Berlin writer Johannes Schlaf called Whitman Nietzsche's "new man"; in a review of 1899 Schlaf even took Whitman to embody Przybyszewski's "Individual" and Max Stirner's "Ego and His Own."[23] Moreover, once Schlaf's German translation of *Leaves of Grass* became available in 1907, Whitman became a model for the entire Expressionist generation and a precedent for the "new pathos" in German Expressionist literature.[24]

Given Whitman's verses, the frank eroticism of Kirchner's *Girl under a Japanese Umbrella* seems perfectly natural. With the achievement of a Whitmanesque kind of sexuality, the Brücke finally rejects both the elitism and the male chauvinism of the Darwin-Nietzsche milieu. For when Whitman writes that he sees through "broadcloth and gingham" he evokes the erotic potential of *both* male and female bodies. Auto-eroticism, heterosexuality, homosexuality—all are equally possible and equally guiltless. It is not the female alone who is the passive object of male desire. Instead Whitman sees *every* human being as a sensuous being: male and female, self and other, equally.[25] Indeed when we turn in the Kirchner painting from back-

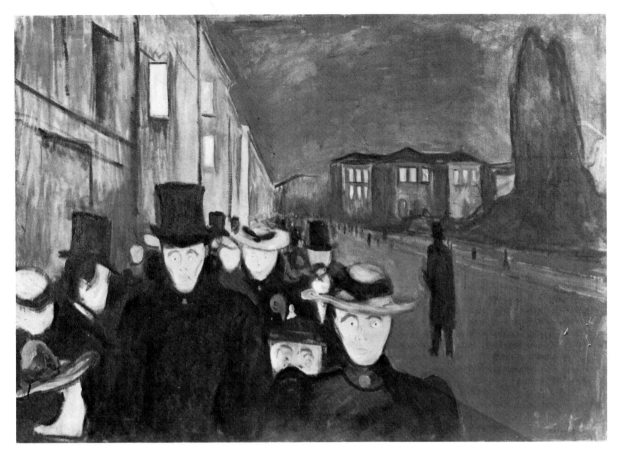

12. Edvard Munch, *Evening on Karl Johan Street*, oil on canvas, 1892. Oslo Kommunes Kunstsamlinger.

ground screen to foreground nude we are aware of a subtle sexual encounter. Though the girl has her legs closed and carries an ornamental parasol, the delicacy of her pose is belied by the challenge of her stare. She seems less a model posing impersonally for the painter than a seductive female actively inviting his sexual response.[26] She is in fact Doris Grohse, nicknamed "Dodo," whom Kirchner recalled so fondly that he later began a lengthy diary with his recollections of her: "Your fine, spontaneous delight in love; with you I experienced it totally, almost at the risk of my career. Still, you gave me the power of speech over your beauty."[27]

For the Brücke artists even children possessed a healthy eroticism—again, not as passive objects of adult desire but rather as alert and sensuous beings with a polymorphous playfulness appropriate to their age. This is the case with Erich Heckel's *Girl with Doll* (fig. 14). The model is the eleven-year-old Fränzi who, with her thirteen-year-old sister Marzella, posed for the Dresden group with their mother's permission.[28] What Heckel does is to catch the naturalness

of an uninhibited child, playing with her doll like a little girl yet posing in the nude like a grown-up woman. The ambivalence of the image is intentional. By emphasizing both the nipples and the lips with touches of the same red he has used for bodily outlines, Heckel stresses a sexual potential otherwise denied by the imagery of youth and innocence. Yet the innuendo is not that of debauched virginity, as has been suggested,[29] but rather that of the child "playing" the adult.

Perhaps the Brücke's greatest shift in erotic emphasis after 1908 was from Nietzsche's view of sex as masculine and intellectual to Whitman's view of sex as essentially democratic. Where Nietzsche had measured the artist's instinct by "the distribution of semen in his blood" and his sex by desires "communicated to the brain," and where even Przybyszewski had idealized sexuality as the very antidote to the Naturalists' "corners of nature," Whitman saw himself more simply and directly as "the mate and companion of people." This is how the Brücke artists saw themselves in their communal bathing-and-painting excursions to the Moritzburger Lakes, outside Dresden, during the summers of 1909, 1910, and 1911.[30] Max Pechstein recalled their sense of community on the 1910 trip, which he shared with Heckel and Kirchner, Fränzi, Marzella, and perhaps other models: "Early in the morning we painters would set off, loaded

13. Ernst Ludwig Kirchner, *Street, Dresden,* oil on canvas, 1908. Collection, The Museum of Modern Art, New York. Purchase.

with our heavy gear, while the models would follow behind with pockets full of things to eat and drink. We lived in absolute harmony; we worked and we swam. If a male model was needed as [compositional] counterweight, one of us three would jump into the breach."[31] In a color woodcut from the 1910 trip, Kirchner's *Bathers Throwing Reeds* (fig. 15), there is evidence of just this kind of sensuous comradery. Rather than stressing sexual distinctions, the print understates them by the merest nuance of bodily curve or angle. And despite a male figure's erect genital, that figure's boisterous play with a nearby nude seems less an erotic encounter than part of a communal game. Despite its frankness, in sum, Brücke eroticism seems today to be inoffensive and largely true to life. But in opposing the moral taboos of the period, both in displaying the sexes as equal and in evoking sexual arousal at all, Brücke art was severely criticized in

its time (see sec. 1.4). In retrospect the subversiveness of Brücke sexuality is apparent, for it affirms a powerful solidarity of youth against all forms of Victorian hypocrisy.

The nude was not a major theme of Blaue Reiter art, and so the Dresden interest in sex yielded to a Munich concern for instinct in general. Here too, however, a Darwinist attitude emerged early—especially in the work of the Austrian-born story-teller and illustrator Alfred Kubin. Kubin took his first ideas on instinct from Arthur Schopenhauer, whom he had read around 1900. "The genital organs are . . . subject merely to the will, and not at all to knowledge," Schopenhauer wrote. "In this respect they were worshipped by the Greeks in the *phallus,* and by the Hindus in the *lingam.*"[32] Phallus-worship also appears in Oskar Panizza's *Council of Love* (1895), a drama Kubin later illustrated (see sec. 2.6). But Kubin also seems to have been impressed by Rudolf Steiner's insistence, in his *Friedrich Nietzsche* (1895), that "[t]he man who merely gives in to his sensual instincts behaves *like an animal*" (emphasis Steiner's).[33] In any event Kubin reflected these sources in his 1909 novel *The Other Side:*

14. Erich Heckel, *Girl with Doll,* oil on canvas, 1910. Private collection, USA.

To [the mob], the organs of fertility were not symbols of secret delights and powers; instead they were grossly reverenced as gods, in whom alone all hope was now placed. The greatest of all mysteries, the secret of the blood, was likewise disclosed, and therein lies madness. This may well have been the cause of the destructive release of the instincts. . . . And like the onset of a storm, the sexes fell upon each other. Nothing was exempt, neither family bonds nor sickness nor youth. No human creature could extricate himself from the elemental drive; with bulging, greedy eyes, all sought a body to embrace. . . . They were automatons, machines, that had been set in motion and left to their own devices—their spirits must have been elsewhere. . . . *Only animals could roar that way.*

In another passage of *The Other Side,* illustrated by a drawing of *Stampeding Horses* (fig. 16), Kubin described the fury of instinct-driven animals themselves: "They reared, standing straight up in the air, and threw their riders. With piercing whinnies, they stampeded in a wide circle around the Great Square. . . . The horses, seemingly endowed with supernatural strength, had gone berserk."[34] This is still

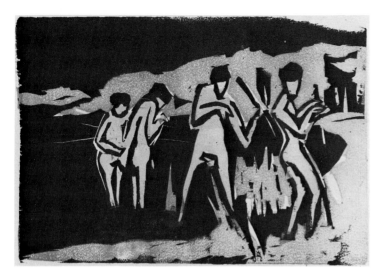

15. Ernst Ludwig Kirchner, *Bathers Throwing Reeds,* color woodcut, 1910. Sprengel Museum, Hannover.

a Victorian and Darwinist approach to instinct, stressing the brutish behavior that arose in evolution's struggle for life.

But there soon emerged a post-Victorian position, articulated this time by Nietzsche among others: "Genius resides in instinct; goodness likewise. One acts perfectly only when one acts instinctively. Even from the viewpoint of morality, all conscious thinking is merely tentative, usually the reverse of morality. . . . It could be proved that all conscious thinking would also show a far lower standard of morality than the thinking of the same man when it is directed by his instincts." In these remarks from *The Will to Power* (1901), Nietzsche turns the tables on Darwin: rather than mere animality, instinct is a kind of unconscious intelligence. Independently or not, Henri Bergson made this point explicitly in his *Creative Evolution* (1907): "instinct is also knowledge at a distance."[35] With this approach, both Nietzsche and Bergson came perilously close to a Neo-Romantic "retreat from reason." Instinct became that life-force in man, that natural impulse or *élan vital,* which also animated the trees and fertile earth, the clouds and starry heavens.[36] Instinct operated in man, benignly, as God allegedly did in nature.

Franz Marc was groping toward this view of instinct when he described the "animalization of art" in a letter of April 1910: "I am seeking . . . a feeling for the organic rhythm in all things, a pantheistic empathy into the shaking and flowing of the blood in nature, in trees, in animals, in the air. . . . I see no happier means to the 'animalization or art,' as I would like to call it, than the animal-picture. Therefore I treat it accordingly."[37] Marc embodied this viewpoint in such paintings as the *Yellow Cow* (fig. 17) and the *World Cow* (1913; not illustrated).[38] Perhaps he had in mind Goethe's remark about

"the nourishing principle which runs through all nature, which preserves the world," a principle which symbolized for Goethe "the omnipresence of God."[39] But in the earlier painting "animalization" still signified a merely lyrical and rhythmical union with the surrounding trees and hills. The *Yellow Cow* is as sentimental as Kubin's *Stampeding Horses* were vicious, yet she, too, is "instinctual." She signifies a kind of universal maternal instinct—bovine, rocking, nurturing—but without the mundane realities of flies, disease, and dung.

2.2. EROTICISM AND SUFFERING

Yet another post-Victorian source presaged the earliest Expressionist developments in Vienna. This was August Strindberg's tragedy of 1888, *The Father.* Strindberg's innovation was to turn Darwin's "struggle between the males" for dominance in evolution into a middle-class battle between the sexes for power within the family:

CAPTAIN: . . . You want power over the child, but you want me to stay on to support the family.
LAURA: Power—yes. What has all this life and death battle been about but power?
CAPTAIN: . . . Do you hate me?
LAURA: Yes, at times! When you're a man!
CAPTAIN: That's like race hatred! If it's true we are descended from apes, at least it must have been two different species.[40]

Compared to Munch and Przybyszewski, who were both Symbolists when he met them in Berlin in 1892, the Swedish Strindberg in 1888 was still a Naturalist following in the path of Ibsen. His attitude toward sex was, accordingly, less intellectualized and more observant of routine domestic behavior.[41] Nevertheless, his imaginative reinterpretation of Darwinist science offered a key insight into sexual psychology that Expressionists would later make use of. This was the notion that domestic harmony between the sexes required less a Victorian insistence on male strength than an "unmanly" admission of male vulnerability:

LAURA: . . . Why, you're crying, man!
CAPTAIN: Yes, I'm crying, although I'm a man. But does a man not have eyes? . . . Is he not fed with the same food, hurt with the same weapons, warmed and cooled by the same winter and summer as a woman? If you prick us, do we not bleed? If you tickle us, do we not giggle? If you poison us, do we not die?
CAPTAIN: And when I thought I saw you despising me for being unmanly, I wanted to win you as a woman—by being a man.
LAURA: Yes, but that was your mistake. The mother, you see, was your friend, but the woman was your enemy. And love between the sexes is a battle. And don't think I gave myself! I didn't give. I took—what I wanted.[42]

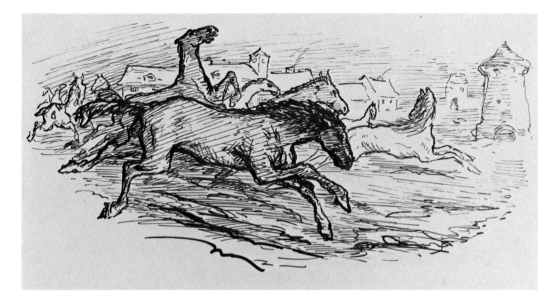

16. Alfred Kubin, *Stampeding Horses* (From *The Other Side*), ca. 1908.

Strindberg anticipates Expressionism in insisting not only on sexual equality but also on the tensions that that equality creates.

Twenty years later the Viennese artist and dramatist Oskar Kokoschka wrote a brief play deriving partly from Strindberg's *Father,* and partly from Heinrich von Kleist's tragedy *Penthesilea* (1800).[43] This was Kokoschka's *Murderer, Hope of Women,* conceived in 1907, first performed in Vienna in July 1909, and now recognized as the earliest German Expressionist drama.[44] Like the Greek warrior and Amazon queen in Kleist's work, Kokoschka's two figures destroy each other through love and war. But where Kleist's Achilles died before Penthesilea did and where Strindberg's Captain's death left Laura victorious, Kokoschka's anonymous "Man" outlives his equally anonymous "Woman." The weaker sex must "hope" for deliverance, even in death, from the strong. Here, and only here, is the Nietzschean meaning of Kokoschka's message (see sec. 1.6).

In other respects, however, the instinctual forces invoked by Kokoschka far exceed those of his models. Where Kleist describes male bragging and female swooning at length, for example, Kokoschka uses sado-masochistic imagery for the female's surrender to the cruel male:

WOMAN: Why do you bind me, man, with your gaze? Ravening light, you confound my flame! Devouring life overpowers me. O take away my terrible hope—and may torment overpower you.
THE MAN: enraged. My men, now brand her with my sign, hot iron into her red flesh.

And where Strindberg notes the simian dimension to human sex and the maternal dimension to female love, Kokoschka caricatures both:

THE MAN: . . . Who nourishes me?
WOMAN: covers him entirely with her body; separated by the grille, to which she clings up in the air like a monkey.
THE MAN: Who suckles me with blood? I devour your melting flesh.

Furthermore, where neither Kleist nor Strindberg actually portrays physical brutality, Kokoschka assuredly does. After the maimed woman has inflicted a gash in the man's side and placed him in a cage, it is his turn to get even:

THE MAN: stands uprightly now, pulls open the gate, touches the woman—who rears up stiffly, dead white—with his fingers. . . . The torch goes out and covers everything in a shower of sparks. He stands on the highest step; men and women who attempt to flee from him run into his way, screaming. . . . He walks straight towards them. Kills them like mosquitoes and leaves red behind. From very far away, crowing of cocks.

In ending the play on such a gory note Kokoschka stresses a certain primitivism of imagery that departs equally from his Romantic and Naturalist sources.

And yet those last three words of the drama do not evoke savagery but instead the imminence of a new day, if not indeed of Resurrection. For Kokoschka's hero, carrying a gash in his side like Christ and caged in a tower inscribed with a large white cross, is here visited in his tomb by the woman—addressed once, incidentally, as "virgin"—just as Jesus was once lamented by the three Marys. Death for these

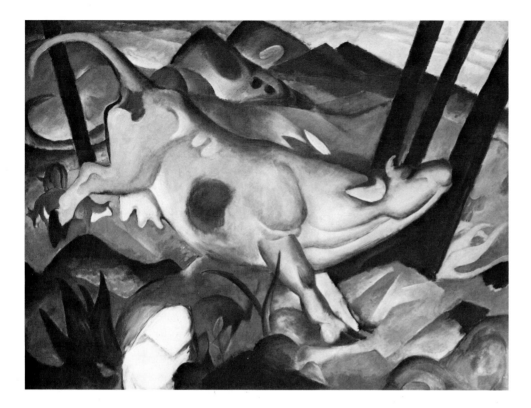

17. Franz Marc, *Yellow Cow,* oil on canvas, 1911. Solomon R. Guggenheim Museum, New York.

protagonists, as for any believing Christian, was to be followed by rebirth and eternal life. In Expressionist iconography multiple and even conflicting dimensions co-exist—from Victorian to post-Victorian, from the Nietzschean to the Strindbergesque, and from the primitive to the Christian.

This is clear from Kokoschka's major illustration to this drama, the poster for *Murderer, Hope of Women* (fig. 18, plate 2). Here the female's function is not erotic at all. The two figures are not lovers; their bodies do not face one another. The sexual characteristics are hidden or, in the man's case, omitted altogether. The woman, instead, is oddly maternal: her silhouette encloses his cramped body, while his skin is pink and glistening like that of an infant. Moreover, she is also vaguely Christian: his left elbow hooks onto her white arms as does the Good Thief's on the crossbar of his cross. Yet the image recalls not only a Crucifixion but also, and more closely, a Pietà in which the virgin Madonna cradles her both mortal and immortal son. One thinks in this regard of Michelangelo's very late *Rondanini Pietà*.[45] Indeed Kokoschka himself confirms the predominance of death in the poster: "The man is blood-red, the color of life. But he is lying dead in the lap of a woman who is white, the color of death."[46]

Yet despite this dominance, Kokoschka is concerned with both the themes of love and death. It is not a physical but an ideal love, he writes, a Christian *"charisma,"* a "love as spiritual grace," which can transcend the reality of death. Since one is born dying, as it were, charismatic love is one's surest cure. "The Passion is the eternal story of man," he explains. "Even the miracle of Resurrection can be understood in human terms, if it is grasped as a truth of the inner life: one does not become human once and for all just by being born. One must be resurrected as a human being every day."[47] In its combination of clinical detail and Christian imagery, in sum, the 1909 poster suggests the dilemma confronting religious faith in the age of science.

One of the hallmarks of Viennese Expressionism, here inaugurated by Kokoschka, was to be a cunning confusion of sexual and spiritual values. Another Austrian Expressionist concerned with these values was the composer and painter Arnold Schoenberg, whose musical Expressionism emerged during the 1909–11 years, at just the moment he gave up Neo-Romanticism in favor of that atonality which later became the twelve-tone, serial system. Indeed if Expressionism in music "communicates its deep-seated anxieties through chromatic congestion and atonal dispersion,"[48] then we can identify the three Schoenberg works that constitute his earliest Expressionist achievement. These are: *Erwartung* or *Expectation*, opus 17 (a half-

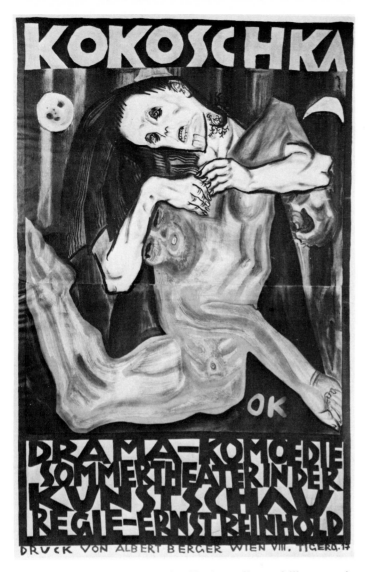

18. Oskar Kokoschka, poster for *Murderer, Hope of Women*, color lithograph, 1909. Museum fo Modern Art, New York; Purchase (See also plate 2)

hour work written in only seventeen days during the summer of 1909); *Die glückliche Hand* or *The Golden Touch,* opus 18 (begun in 1910 but not completed until 1913); and the *Sechs kleine Klavierstücke* or *Six Piano Pieces,* opus 19 (dated 1911). *Erwartung* is a monodrama for orchestra and single voice in which the tonalities of instrument and song are purposely permitted to diverge and conflict. *Die glückliche Hand* is a drama for three voices and chorus in which *Sprechgesang*—a spoken or uttered song—is pioneered. And the *Klavierstücke* introduce into the piano repertory alone the dissonance or

atonality which had just been used for voices and instruments together. These pieces show, in the words of René Leibowitz, "a well-nigh delirious enthusiasm in the midst of the wealth of chromatic material released by the suspension of the tonal system."[49]

But what they also show is the composer's creative response to a tragic personal crisis. In November 1908 the twenty-five-year-old painter Richard Gerstl, after conducting an affair with the composer's wife Mathilde, had committed suicide.[50] The three voices of *Die glückliche Hand* reportedly mirror the real-life triangle, while *Erwartung*'s "pathos of loneliness" apparently reveals the composer's own sense of loss.[51] It is suggestive that *Erwartung* was composed during precisely the summer weeks of 1909 when *Murderer, Hope of Women* was being performed. The Schoenberg piece exactly parallels Kokoschka's play, as Carl Schorske has noted: "It chronicles a murderous love, only this time in the form of the search of a deranged woman for her lover—murdered by her, or by a rival for this love? We do not know." Moreover, just as Kokoschka in 1909 identified his tormented hero with Christ, so Schoenberg in his 1912 song cycle *Pierrot Lunaire* identifies *his* suffering protagonist with Christ "by a related religious symbolism: that of the Mass."[52]

Schoenberg's progress from suffering to spirit had an important way station not in religion, however, but in occultism. The detour occurred not in music, but in such paintings as *The Red Stare* (plate 3, 1910). Schoenberg's source was probably a 1908 watercolor titled *Expression* (not illustrated) by the Belgian Symbolist Léon Spilliaert commemorating occult experience.[53] The Belgian work depicts the trance of a medium, pupils dilated into orbs of light and irises contracted into thin dark rings, attempting contact with the dead. In the Austrian painting, of course, these dark-ringed, white-orbed pupils are made horrific by the addition of reddened eye sockets and a lopsided grimace. It is as if we are seeing the ghost called forth from the afterworld, not the medium who is doing the calling. Arguing in favor of this interpretation is the painting's hallucinatory quality: the disembodied head floats before a hazy and impenetrable void. Moreover, we can even guess the head's identity. Might it not be the ill-starred Gerstl, who had painted together with Schoenberg during the summer of 1907? While a summer houseguest, after all, he had still been the composer's friend. It is at least plausible to believe that in *The Red Stare* Schoenberg has conjured up the shade of an erstwhile friend and protégé from that hellish inferno reserved for adulterers and suicides. As had Kokoschka before him, Schoenberg seems to find in the solace of spirit a welcome countermovement for the sufferings of sex.

In mid-1910, when Kokoschka moved to Berlin to contribute to Herwarth Walden's newly founded *Sturm* magazine, Expressionist ties between the German and the Austro-Hungarian capitals were quite close. Indeed *Der Sturm* was datelined "Berlin and Vienna" during its first two years.[54] It is likely, then, that topics published in the Berlin journal would be of interest to advanced artists in Vienna as well. One such topic was Przybyszewski's two-part essay on "Sex" which Walden published in the autumn of 1910. "In the beginning

was sex," the Polish-German author began, and he continued in the same sacrilegious vein:

> Sex longs for godliness! . . . And so sex is the androgynous "Father-Mother" of all that is, that was, and that will be. . . . May I say what my [idea of] beauty is? It is the feeling of burning rapture which lets me forget everything all around, which blinds my eyes but opens all the wider the windows of my soul; it is the feverish flight of my whole being in an orgasm of all my spiritual powers, the cold thrill which courses through me. . . . Certainly, I admit that centuries will pass before man can purge himself from the dirt, before he can celebrate the ascension of the pure, of the sanctified sensual pleasures and experience a rebirth in beauty through—sex![55]

It was this substitution of sex for God and for man's spiritual destiny that seems to have profoundly affected the third great innovator of Viennese Expressionism, Egon Schiele.

Schiele was only twenty in 1910 when he freed himself from an early dependence on his Symbolist mentor, Gustav Klimt (figs. 70, 71). And in that year he began a series of painted nudes that suggested a concern for sexual taboo and repression. Not only did he depict his sixteen-year-old sister Gerti in the nude, but he also portrayed himself in a state of genital excitement and yet with restrained or anxious arm gestures (figs. 139, 140). In such exploration of "the theme of masturbation-compulsion-guilt," according to Alessandra Comini, there was an overtone of masochism: "Also familiar was . . . the substitution of pain for pleasure, with its attendant punishments of hallucinations or mutilation—not necessarily expressed by castration or mangling of the offending organ, but through proxy dismemberment of other body extremities. Schiele, whether in sincerity or simulation, seems to have been clearly aware of this aspect, and it is interesting that he only applied such suggestions of punishment to himself."[56] In such a frame of mind, Schiele late in 1910 must have welcomed Przybyszewski's positive and permissive equation of "sex" with "godliness."

In a 1911 letter Schiele also expressed a similar viewpoint. He said he wanted people to experience his sensual art as "an enlightening religious revelation."[57] Moreover, a friend later suggested that "his religiosity, internalized almost to the point of mysticism, occasionally drove him spontaneously into eroticism, into an eroticism ranging from the sentimental to the outrageous."[58] Between 1911 and 1914, in fact, Schiele created a number of erotic works with religious associations, as well as many religious subjects with erotic overtones. At their best, however, such paintings shattered the Symbolist unity advocated by Przybyszewski and offered instead an Expressionist disjunction or contradiction in attitude.

Schiele's *Cardinal and Nun* is typical of these paintings (fig. 20, plate 4). On one level it can be seen as a reaction to Klimt's *Kiss* (fig.

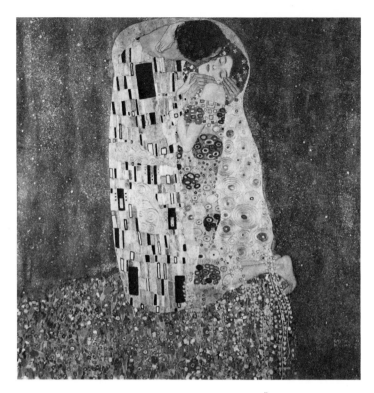

19. Gustav Klimt, *The Kiss,* oil on canvas, 1908. Österreichische Nationalbibliothek, Vienna.

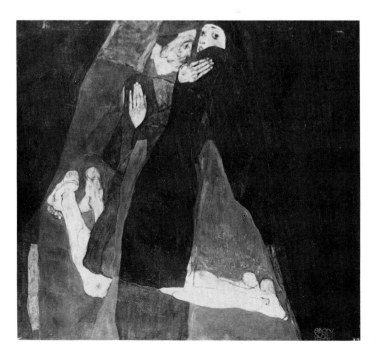

20. Egon Schiele, *Cardinal and Nun,* oil on canvas, Kallir 156, 1912. (See also plate 4)

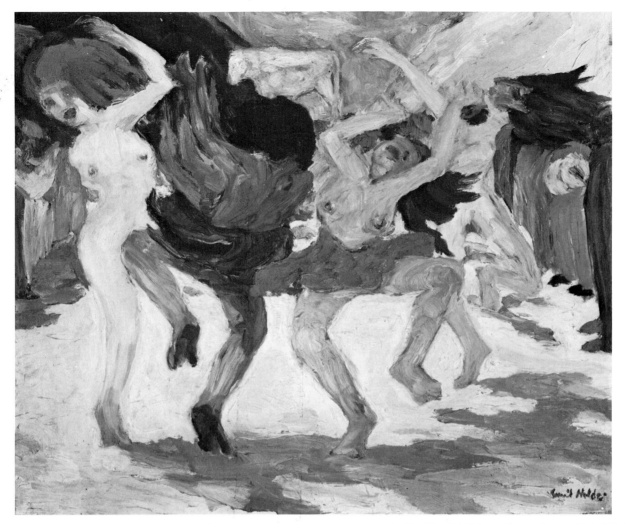

21. Emil Nolde, *Dance around the Golden Calf,* oil on canvas, 1910. Staatsgalerie Moderner Kunst, Munich.

19), for it opposes the notion of sexual embrace as ethereal state of mind with one involving a more urgent and even grotesque emotion. Yet it is not a "deliberate parody" of the Klimt, as has been proposed.[59] Created only months after Schiele's brief imprisonment in 1912 on a trumped-up charge of immorality, *Cardinal and Nun* attacks instead the spurious "spirituality" of Austrian society and its religious institutions.

Indeed, at a deeper level, the painting offers a conflict in meaning between sexual encounter and spiritual epiphany. It takes its origin from a little-noticed detail of the Klimt prototype, namely the fact that the woman, in being engulfed by the man's embrace, has fallen to her knees. Prompted by this compositional device—absent incidentally in the Stoclet Palace frieze from which Klimt's painting derives—Schiele had the happy conceit of placing both figures in the kneeling position of prayer. From this conceit, in turn, the Expressionist's further transformations derive. He presents not just beautifully gowned aesthetes but Roman Catholic votaries, not just gentle hands but bony legs, not just a kiss but also a furtive grimace. The result is a Nietzschean image of contradiction, a religious image of prayer and sacrilege and yet a carnal evocation of bliss as well. Depicting Przybyszewski's "sanctified sensual pleasures," Schiele yet echoes that author's admission that modern man was still mired in the dirt.

2.3. EXPRESSIONIST RELIGIOUS RENEWAL

If Expressionism in Vienna began with Kokoschka's conversion of sex into spirit in the summer of 1909, then Expressionism in Berlin originated with Emil Nolde's similar initiative beginning the same summer.

For it was then that the North German painter turned from an art of sensuous subjects, partly prompted by his brief Brücke membership 1906–07, to produce his first two religious paintings; in the year 1910 there were many more.[60] We can trace the thematic shift by comparing the hedonistic *Wildly Dancing Children* of 1909 with a compositionally related religious work, the *Dance around the Golden Calf* (plate 5 and fig. 21).

Nolde's *Wildly Dancing Children* is among the greatest tributes to the vitality of youth that the twentieth century has produced. The ring of joyously jumping girls, hair flying and skirts blurred, is an image of reckless, instinctual release. The motivation is Nietzschean. Ever since 1906, when Karl Schmidt-Rottluff had spoken to Nolde of "Nietzsche and Kant and great men of this kind," the untutored Nolde must have equated the instinctual and the sensuous with the Dionysian impulse. But in conceiving *Dance around the Golden Calf* in 1910, Nolde apparently considered other Nietzschean concepts. Of course he knew the Old Testament story (Exodus 32: 2–20) in which Moses brought down the Commandments for his people only to discover their forbidden idol-worship. But he probably also knew Nietzsche's statement, first published in 1895, that "all the values in which mankind at first summarizes its highest desideratum are *decadence values*. I call an animal, a species, an individual depraved when it loses its instincts, when it chooses, when it *prefers*, what is harmful to it." And he almost certainly knew Nietzsche's view from *Zarathustra* that sensuality was a contradictory force, a drug for the masses but a joy for the elite that could master it: "Voluptuousness: only for the wilted, a sweet poison; for the lion-willed, however, the great invigoration of the heart and the reverently reserved wine of wines."[61]

Nietzsche's remarks, from the posthumously published *Anti-Christ,* had been directed at Christianity itself, allegedly a sentimental bourgeois religion which favored "everything weak, base, ill-constituted." But in his 1910 painting Nolde redirected the attack toward a different target, namely Judaism. Still, though Nietzsche would not have approved such anti-Semitism,[62] Nolde had the authority of Scripture in pointing to Jewish decadence. For in the *Golden Calf* he depicts idol-worshipping Jews, a community that has violated its own Commandment. Thus he presents them as the embodiment of "decadence-values," as a once-vigorous people that has "[lost] its instincts" and which, as a consequence, "prefers what is harmful to it." In the end *Dance around the Golden Calf* both resembles and departs from *Wildly Dancing Children*. Like the precedent painting, the voluptuous dance evokes "the great invigoration of the heart"; unlike it, however, the Jewish dance embodies "a sweet poison for the wilted."

Although Darwinist and Nietzschean in his emphasis on instinct, Nolde opposed these sources in championing religious renewal. Why, then, did he decide to do religious paintings in 1909? For an answer I would look to the milieu in which the decision occurred, namely that of the Berlin Secession which elected Nolde to membership in that very year.[63] Ever since exhibiting with the Secession in 1907, in fact, Nolde was apparently annoyed with the kind of religious art the Berlin organization displayed. For example, the Naturalist approach of Max Liebermann's *Jesus among the Rabbis* (1879), shown in 1907, prompted Nolde to do a more ecstatic version in his *12-Year-Old Christ* (1911). In 1909 Nolde was presumably offended again, this time by secular versions of further biblical themes shown at the Secession that spring: Lovis Corinth's lascivious *Susanna in the Bath* and Max Beckmann's stage-like *Resurrection*.[64] Would it not have been natural for Nolde, a devout Christian, to react to these "nihilist" paintings by creating more convincing ones of his own?

In any event, he did so. And now at last, free of literary or philosophical influence, Nolde rediscovered an atavistic or "primitive" impulse within himself. In the *Christ among the Children* (fig. 22), for example, there is an innocence and naiveté that stemmed from the artist's own childhood: "The notions of a boy from long ago, who during the long winter months used to sit every evening reading and being deeply moved by the Bible, were reawakened. There were pictures here, as I read, of the richest Oriental fantasy. They kept whirling up in my imagination until, long afterward, the grown-up man and artist could paint them as if in dream-like inspiration."[65] This autobiographical element may be seen in the eager, glowing expression on the children's faces, so "deeply moved" by the encounter, and also in the exotic features of the adult apostles on the left, filled with "Oriental fantasy."

And in another religious work of the period, this time a triptych of 1912 entitled *Mary of Egypt* (fig. 23), Nolde externalized another

22. Emil Nolde, *Christ among the Children,* oil on canvas, 1910. Collection, The Museum of Modern Art, New York. Gift of Dr. W. R. Valentiner.

aspect of his personal and private motivation. Mary's story is an odd one. A prostitute in the port of Alexandria (left panel), she was converted to Christianity by a picture of the Virgin in Jerusalem (center panel), before dying in the desert and being buried by St. Zosimus and his lion (right panel). Thus the narrative presents quite literally that transformation of sex into spirit that we saw occur in Nolde's art, more figuratively, from 1909 to 1910. The reason for Nolde's attraction to the theme is not far to seek, however. For he describes his own puberty as a time when sexual anxiety at the glances of "the half-grown girls with their beautiful, mild eyes" gave way to religious ecstasy: "After school, . . . driven by thoughts and vague feelings, I would sometimes take a lonely walk in the country. In a high cornfield, seen by no one, I lay down with my back pressed to the ground and my eyes closed, with my arms stretched out stiffly. And then I thought, 'So lay your Savior Jesus Christ when the men and women took Him down from the cross.' And then I turned myself over, dreaming with problematic faith that the whole wide, round, wonderful earth was my beloved."[66] Without benefit of the erudite theories of Nietzsche or Freud, Nolde by the end of tenth grade had understood religion to be a sublimation of sex.

Nevertheless in identifying himself with Christ Nolde had also identified himself, willy-nilly, with the Jews. They were a strong, primitive people, and the religious works evoked this Semitic strength:

> They had arisen completely according to my own instinct, with the human types as Jews—Christ and the apostles too, as they indeed had been—and with the apostles as simple Jewish country people and fishermen. I painted them as strong Jewish types, for those who professed Christ's revolutionary new doctrine were certainly not weaklings. . . . It seemed quite remarkable to me that for decades I was threatened and attacked simultaneously from two opposite sides. It takes an iron strength of character to remain quiet when a painter on the one hand is persecuted by Jews because he paints them as Jews, and on the other is attacked by Christians because they want to see Christ and the apostles painted as Aryans.[67]

In Nolde's larger-than-life *Crucifixion* (fig. 24), the centerpiece of a nine-part *Life of Christ* cycle, the Savior is given red hair according to Jewish tradition. Moreover, the famous *Prophet* woodcut (fig. 25) displays such features as beetle-brows, hirsute cheek, and slightly hooked nose, which are not Aryan but Semitic in character.

If there is an inconsistency in Nolde's position it is this: he admired Jewish strength but decried what he perceived as Jewish decadence. Believing the ideas on racial purity of H. S. Chamberlain (see sec. 1.2), Nolde advocated Zionist "reunification" and "the founding of a Jewish state in a healthy, fertile part of the world." But he felt himself offended by a Jewish "girl-chaser" who once bragged to him of his conquests, and he concluded that "Jews are different people than we are."[68] In retrospect it appears that Nolde created his re-

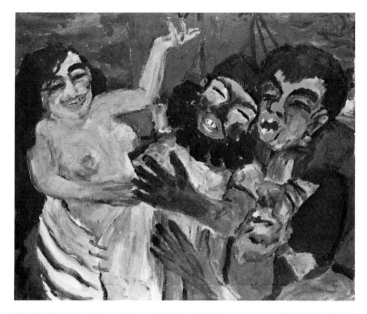

23. Emil Nolde, *Mary of Egypt* (triptych), oil on canvas, 1912. Hamburger Kunsthalle.

ligious art not only as a sublimation for sexual anxiety but also as a compensation for anti-Semitic feelings.

A second Berlin Expressionist who exploited biblical iconography was himself Jewish, namely Ludwig Meidner. In a series of *Apocalyptic Landscapes* from 1912 and 1913, such as the one from the Berlin National Gallery (fig. 26, plate 6), Meidner depicts the end of the world as prophesied in the Book of Revelations. Unique to this painting, however, is the male nude sprawled voluptuously in the left foreground. What could this passive, open-legged figure have to do with Apocalypse? While not answering our question directly, Meidner's description of his reaction to Apocalypse suggests a certain degree of masochistic feeling, of a "dog" seeking its "master." "Covered with sweat," Meidner wrote, "I fancied myself like a dog with panting lips who covers miles and miles on the chase in search of its master—in this case a successful oil painting covered with apocalyptic disaster. I feared such visions, yet the final results gave me an especially warm feeling of satisfaction, a slightly Satanic joy."[69] There is much additional evidence for Meidner's masochism, from the previously mentioned 1902 drawing of religious flagellants called *Kill the Flesh*[70] to the title of a 1918 book which can be translated *The Sea of Stars at My Neck*.[71] Indeed Meidner once admitted to occasional "masochistic moods" and even recalled being drawn as a young man to the "grotesque events" in Krafft-Ebing's *Psychopathia Sexualis,* a book giving detailed description to cases of masochism and other unorthodox sexual practices.[72] To this catalogue of self-revelation must be added, finally, Meidner's published accounts of his own passive bisexuality and of his yearning for suicide.[73]

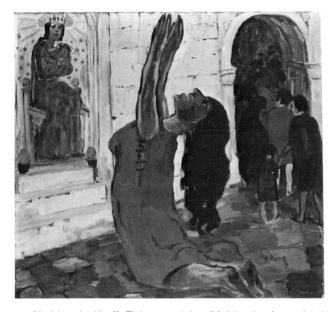

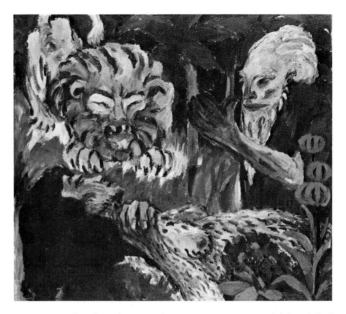

Nothing in Krafft-Ebing explains Meidner's *Apocalyptic Landscape,* but another well-known book from the turn of the century describes a series of masochistic fantasies linking bisexuality, suicide, and the end of the world: Dr. Daniel Schreber's *Memoirs of a Nerve-Patient,* published in 1903.[74] Schreber had been a distinguished jurist before his hospitalization in 1894, and his forensic skills were useful both in marshalling the evidence of his illness and in finally winning his 1902 release from the sanatorium. Although he was a widely educated man, having read among other sources Ernst Haeckel's *History of Creation,* his fascinating account describes the delusions of a madman. Among his early symptoms, for example, he reports the fantasy that the world was being destroyed because of his own special link to God: "[V]ery early on there predominated in recurrent nightly visions the notion of an approaching *end of the world,* as a consequence of the indissoluble connection between God and myself. Bad news came in from all sides that even this or that star or this or that group of stars had to be 'given up'; at one time it was said that even Venus had been 'flooded,' at another time that the Cassiopeia (the whole group of stars) had had to be drawn together into a single sun, that perhaps only the Pleiades could still be saved, etc., etc." Moreover, the step required to counter this cosmic emergency was nothing less than his own sexual transformation:

> In such [a catastrophe], in order to maintain the species, one single human being was spared—perhaps the relatively most moral—called by the voices that talk to me the "Eternal Jew." . . .[He] had to be *unmanned* (transformed into a woman) to be able to bear children. This process of unmanning consisted in the (external) male genitals (scrotum and penis) being retracted into the body and the internal sexual organs being at the same time transformed into the corre-

sponding female sexual organs, a process which might have been completed in a sleep lasting hundreds of years, because the skeleton (pelvis, etc.) had also to be changed. A regression occurred, therefore, or a reversal of that developmental process which occurs in the fourth or fifth month of pregnancy, according to whether nature intends the future child to be of male or female sex.

Since Schreber reports his "female genital organ" to be only "a poorly developed one,"[75] it appears that his sex change was in principle reversible—a bisexualization rather than a castration.

The influence of Schreber's 1903 *Memoirs* on Meidner's *Apocalyptic Landscape* a decade later seems likely. Of course Meidner has invented the storm upper left, the reduction of civilization lower right to the condition of campfire and tepee, and the suggestion in the center of humanity's rush, lemming-like, to the sea. And there are additional factors, from Expressionist poetry to Futurist rhetoric, that contributed to Meidner's theme (see sec. 3.5). But this languidly posed nude, displayed so oddly at the end of the world, seems dependent upon Schreber's story. He seems very much in the process of being "unmanned."

2.4. THEOSOPHY AND THE THIRD KINGDOM

In Munich during the Blaue Reiter years there were apparently at least two contradictory images of spiritual renewal. The first we have touched on earlier: it was a Nietzschean, essentially apocalyptic, metaphor of creation through destruction. Catastrophic events were meant to stand for the spiritual epoch that would follow (see sec. 1.6). But the second was an exactly contrary image of that spiritual epoch itself. It was a peaceful and joyous world of pleasure. The distinction

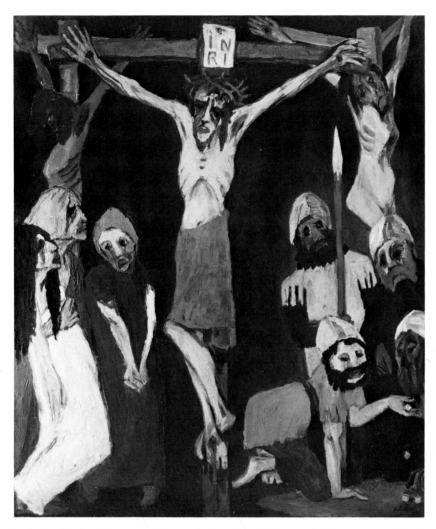

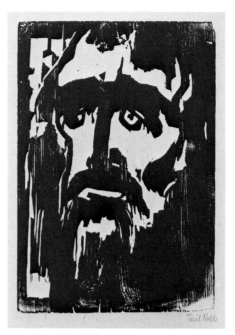

25. (above) Emil Nolde, *The Prophet*, woodcut, 1912. Los Angeles County Museum of Art, The Robert Gore Rifkind Center for German Expressionist Studies.

24. (left) Emil Nolde, *Crucifixion*, from *Life of Christ*, oil on canvas, 1912. Bayerische Staatsgemäldesammlungen, Munich.

between the two images rests precisely on the difference between strife and harmony.

For the Russian-born Wassily Kandinsky the first of these images of spiritual regeneration was undoubtedly the earliest: he connected apocalyptic imagery with Nietzsche's name in his *Concerning the Spiritual in Art* (1912), a book written by 1910. But how did he come to link the Bible's apocalyptic tradition with Nietzsche's notion of "Dionysian destruction"? Nietzsche, after all, had *denied* a similar link in the concluding sentence of *Ecce Homo* in 1908: "Have I been understood?—Dionysos versus the Crucified." And Nietzsche had contrasted the two notions even more forcibly in *The Will to Power* of 1901: "The god on the cross is a curse on life; Dionysos cut to pieces is a *promise* of life: it will be eternally reborn and return again from destruction."[76]

For the answer to this question I would look to the Munich performance of a play by the French mystic Édouard Schuré, *The Drama of*

Eleusis, as staged by Rudolf Steiner beginning on 19 May 1907.[77] In Schuré's recreation of the Eleusinian mysteries, the character of Dionysos is made to prefigure Christ when he describes the red flecks in his hair as "the drops of my blood shed for thee." Moreover, Schuré finds that the essential idea unifying Christ and Dionysos is the idea of love through suffering:

DIONYSOS: . . . Though the Titans rent me limb from limb, I did not forget thee. They tore away my flesh, cast my body to the tigers and my head into the pit; but ever did my flesh, my heart and my head, cry out: Persephone! Persephone![78]

And finally Schuré, expanding on the mere mention of Dionysos in his earlier Eleusis reconstruction,[79] relates the myth of Dionysos to the notions of Demeter's hellish descent and ascent in the myth of Demeter and Persephone:

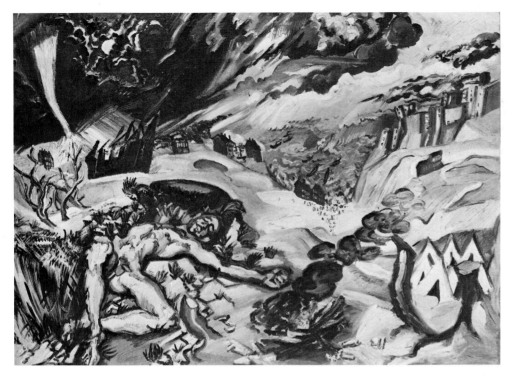

26. Ludwig Meidner, *Apocalyptic Landscape,* oil on canvas, 1912–13. Nationalgalerie, Staatliche Museen Preussischer Kulturbesitz, Berlin. (See also plate 6)

TRIPTOLEMOS: When the grain is sown, the earth covers it over and no one sees it any more; but with the warm breath of spring there appears the green sprout which ripens into golden ears. If Demeter causes the corn to germinate in the soil, she must also bring back into her light the souls of men who descend into the underworld. Wherefore hope sings in my heart like the lark in my path.[80]

The single concept unifying all these ideas is one which Schuré later called "progress by struggle": "With Dionysos there breaks into art, poetry and the theater . . . the idea of the necessity of grief, of progress by struggle, of the purification of the soul by suffering. At first, Dionysos alone represents this idea, but soon it multiplies in endless ways."[81] What Schuré has done, in short, is to describe the same Dionysian principle as Nietzsche had a quarter century before, namely the notion of crossing over by going under, of *Uebergang* through *Untergang.*

It is not clear whether Kandinsky in 1907 actually witnessed Schuré's play, but many of his Munich friends could have discussed it with him.[82] In addition, the French drama had a profound effect on Steiner, its producer, and it was Steiner who influenced Kandinsky. For after publishing his general handbook on *Theosophy* in 1904, Steiner began lecturing on the Christian gospels in 1906. By June of

1908 in Nuremberg Steiner began a series of thirteen lectures on *The Apocalypse,* in which the seven "epochs" of Theosophical doctrine were integrated with biblical chronology: the fourth epoch destroyed by flood, the fifth epoch—ours—to be destroyed by apocalypse, and the sixth and seventh epochs to yield finally to a spiritual or "astral" realm.[83] In the text for these lectures Steiner wrote: "The Apocalypse of John prophetically points to the cycle of human evolution lying between the great upheaval upon our earth which the legends of various peoples describe as a flood, and geology the glacial period, on the one hand, and that event which we designate as the War of All against All on the other. In the epoch between these two events lies everything prophetically referred to in the Apocalypse—that book which reveals to us the beings of past ages in order to show what is to fire our will and our impulses for the future."[84] Here we find the final flowering of Darwinist thought, namely the pessimistic depiction of human history as a "struggle for life"; Steiner's very language of apocalypse was taken from a passage in Haeckel's *History of Creation* (1873): "If we contemplate the common life and the mutual relations between plants and animals (man included), we shall find everywhere, and at all times, the very opposite of that kindly and peaceful social life which the goodness of the Creator ought to have prepared for his creatures—we shall rather find everywhere a pitiless, most embittered *Struggle of All against All.*"[85] Given the combined wisdom of Nietzsche and Schuré, Haeckel and Steiner, Kandinsky cannot be blamed for concluding that bestial material existence must inevitably if violently yield to a better but spiritual one. **43**

There were other sources supporting this belief as well. For as a Russian, Kandinsky must have been aware of the eschatological mood among intellectuals in his native land. After Russia's defeat by Japan in 1905, Andrei Bely wrote that year on "Apocalypse in Russian Poetry" and Viacheslav Ivanov published an ancient prophesy that a "new epoch" of 490 years' duration was just beginning; by 1909 Bely believed that "we are standing at the border between two great periods of human evolution" and Alexander Benois felt that "God nears, and the earth already moans."[86] By 1909, when Steiner began to invoke the name of Russian thinkers, and by 1910, when Russian intellectuals were fully aware of Steiner's ideas,[87] Kandinsky must have seen repeated signs in both Munich and Moscow that apocalypse was imminent.[88]

In any event, in 1909–10, while writing *Concerning the Spiritual in Art,* Kandinsky departed from the harmonious and decorative principles that had guided his art during the previous decade. Setting Nietzsche to music, as it were, he wrote that the "harmony" of the age was one of "antitheses and contradictions." "Harmony today rests chiefly on the principle of antithesis," Kandinsky wrote, and so even musical "discord" and "ugly" dance movements could be considered "beautiful."[89] And from 1910 to 1913 he introduced a "hidden imagery" of violence into his seven major *Compositions.* In the climactic *Composition VII, no. 1* (fig. 6), in fact, he depicted "a vast and definitive catastrophe for humanity."[90] More specifically, individual elements have been identified with "the Last Judgment," "the Deluge," and also with "the Garden of Love."[91]

This last theme requires explanation, however. It is possible that Kandinsky, following Schuré, still thought of the pagan principle of love through suffering; though rent from limb to limb, after all, the mythical Dionysos had still persevered in his romantic quest. But it appears that the theme stems from a different iconographic tradition altogether. This is the theme of the Third Kingdom or Third Revelation.

The concept enters the pre-Expressionist literature through Henrik Ibsen's drama *Emperor and Galilean,* published in 1873 but first performed in Leipzig (1896) and Berlin (1898). What was involved was a synthesis of worldly and otherworldly power:

"JULIAN THE EMPEROR: Emperor-God, God-Emperor. Emperor in the kingdom of the spirit, and God in that of the flesh.
MAXIMUS THE MYSTIC: That is the Third Kingdom, Julian! . . . Logos in Pan, Pan in Logos.
JULIAN: Maximus, how comes he into being?
MAXIMUS: He comes into being in the man who wills himself."[92]

Ibsen had drawn his concept from the notion of the Third Revelation, as originally advanced by the twelfth-century monk Joachim of Flora, who had perceived world history as "the progress of revelation through an age of God the Father, an age of God the Son, and a final age of God the Spirit."[93]

Ibsen's image of the unified flesh-in-spirit was immediately adopted by Johannes Schlaf in an influential book published in 1900 called *The Third Kingdom* (in German, *Das dritte Reich*), which was subtitled "A Berlin Novel." In Schlaf's view the carrier of the Third Kingdom—Ibsen's "man who wills himself"—was equated with Nietzsche's Higher Man and with Przybyszewski's Individual. But he was also equated with the resurrected Christ. The "mystical idea" of the Third Kingdom was "forced" into consciousness, Schlaf wrote, by "readings in the Apocalypse and in the Gospel of St. John"; Christ's prediction of His second coming (John: 12–16) was even cited in full. Thus the "slow and gradual birth of a new type of living creature" was ordained not only by biological evolution but also by Christian doctrine.[94]

Schlaf's Third Kingdom of 1900 was quite different, of course, from Hitler's Third Reich of 1933; the earlier title carries the connotation of mythic "kingdom" rather than geopolitical "empire." The Hohenzollern empire (1871–1918), following that of the Hohenstaufens in the Middle Ages, was already known as Germany's *second* Reich, and at the turn of the century the Third Kingdom had only a spiritual, not yet a political, sense. When the writers Heinrich and Julius Hart formed a "New Community" in 1900–01, their pamphlets were titled *Kingdom of Fulfillment,* and the "Communitys'" members included such later Expressionist authors as Gustav Landauer and Erich Mühsam.[95]

Felix Holländer, who wrote the other popular book—the 1902 novel *The Way of Thomas Truck*—to take up the idea of the Third Kingdom, was also a member of the "New Community." For Holländer the desired goal was to be achieved by faith in Scripture. Redemption was possible not for Socialists or Anarchists, he argued, but for Christians; the Gospels were man's "ultimate and highest knowledge." Holländer too quotes from the Gospel of St. John, this time from those verses (3:6–7, 14–15) where Christ teaches "Ye must be born again." But Holländer also gives the Joachimite prophecy a secular twist by twice interpreting the Third Kingdom as a "kingdom of joy," to be achieved through the sublime performance or experience of music.[96]

Yet another vehicle for the Joachimite vision was Dmitri Merezhkovsky's description of a "Third Revelation," published in Paris in 1907. His was a more Hegelian formulation: "The third and last moment [of the evolutionary process], the moment announced right now, is the revelation of the Spirit. This will unite the revelation of the Son with that of the Father. . . . The Old Testament is the revelation of God in the World. The New Testament, that of the Son, is the revelation of God in Man, of God-Man. The Third Testament is the revelation of God in Humanity, of God-Humanity."[97] Merezhkovsky's divine principle, like that of several other Russian Symbolists, tended to focus on the sexual act. The concept has been called "Love as salvation."[98] In both the German tradition of Holländer and the Russian tradition of Merezhkovsky, the prophecy of a harmonious and joyous spiritual realm departs directly from the biblical tradition of violent apocalypse.

It is in Merezhkovsky's language that Kandinsky himself championed the Third Kingdom in his *Reminiscences* (1913): "[Concern-

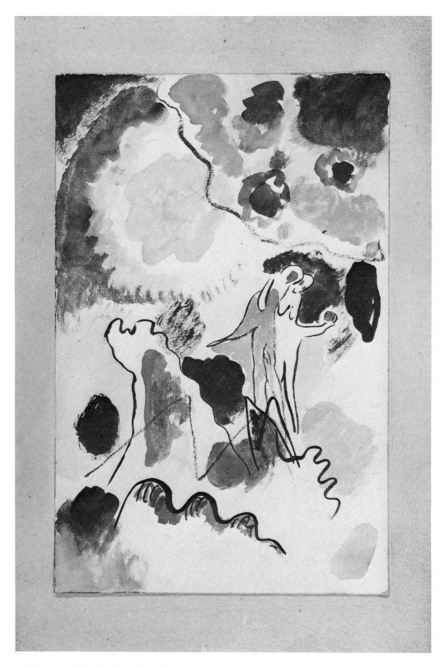

27. Wassily Kandinsky, *Paradise,* watercolor, 1911–12. Städtische Galerie im Lenbachhaus, Munich.

ing] that great kingdom which we can only dimly divine, today is the great day of one of [its] revelations. . . . Here begins the great ep-

och of the spiritual, the revelation of the Spirit: Father—Son—Spirit. . . . Would the New Testament have been possible without the Old? Would our era on the threshold of the 'third' revelation be conceivable without the second?"[99] And it is in such paintings as *Paradise* (fig. 27) that he introduced the sublime imagery of redemptive love. Depicting Adam and Eve in Eden, the watercolor nevertheless

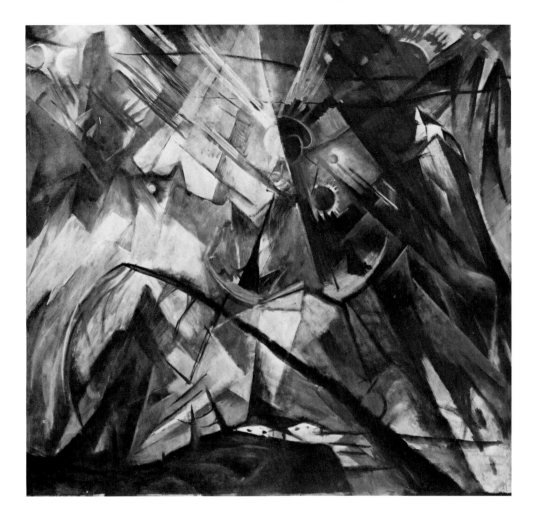

28. Franz Marc, *The Unhappy Tyrol*, oil on canvas, 1913–14. Bayerische Staatsgemäldesammlungen, Staatsgalerie Moderner Kunst, Munich.

visualizes a variation on Genesis. For although Eve holds the apple of knowledge, there seems to be no punishment threatened by the ineffectual snake below. Indeed, in related works titled *Garden of Love* from these years, the serpent is compositionally isolated from the embracing lovers.[100]

Comparing the *Paradise* of 1911–12 with the 1913 sketch for *Composition VII, no. 1* (figs. 27, 6), we find that Kandinsky has indeed stressed "antithesis and contradictions." According to R.-C. Washton Long, for example, *Paradise* denies by its color the harmony affirmed by its composition. "Although pastel colors predominate in the watercolor," Long writes, "the couple have their feet rooted in muddy gray and a maroon brown (the Theosophical colors for materialism). . . . In this work, Kandinsky used the color black in a cloud-like oval patch next to the apple to suggest a threatening force, perhaps the expulsion from Eden." And in the 1913 sketch images of destruction are redeemed by a single image of creation. Through close analysis of related drawings and studies, Long identifies the diagonal yellow patch upper right as a vestige of the Last Judgment's "golden trumpet" and a white shape with four red figures lower right as a "tiny boat" set on the blue sea of the Deluge; but in the lower left corner are the red and purple outlines of the Garden of Love's reclining "couple."[101] This last motif is once again a reminder of the paradise that will issue from apocalypse.

Allowing for differences of age, nationality, and iconographic sources, Franz Marc evolved a surprisingly similar outlook to that of Kandinsky. This is obvious when we compare the previously discussed *Yellow Cow* of 1911 with the 1913 *Animal Destinies* (figs. 17, 7, plate 1). In the earlier painting Marc is still idealizing his animals, feeling a kind of "pantheistic empathy" into their Neo-Romantic, rhythmical forms (see sec. 2.1). And in the more apocalyptic work we

find a destruction of the decadent and materialist world, a kind of post-Nietzschean "war of spirits" (see sec. 1.6). Although Marc is neither as subtle nor as contradictory as his Russian-born friend, *Animal Destinies* offers another example of denial/affirmation. Only here the iconographic source is not the Bible, much less the Norse Eddas, but rather a passage apparently drawn from the Hindu Vedas: "And all existence is flaming suffering."[102] Inscribing this phrase on the back of the canvas, Marc nevertheless had other words in mind as the work's original title: "The trees show their rings, the animals their veins."[103] And the painting confirms the latter words. On the belly of a green horse upper left Marc has painted a white triangle which reveals red lines of blood. Elsewhere Marc depicts either sawed-off tree trunks or, especially on the right, trees that have become transparent enough to reveal their oval-shaped cross-sections. What he shows us, then, is a destruction of the material world, the world of "flaming suffering," and simultaneously the creation of a more ideal and spiritual realm where flora and fauna have become transparent and dematerialized. Whether or not the four young deer on the right symbolize the purer, more spiritual race to come, *Animal Destinies* relieves its images of horrible catastrophe with cryptic signs of spiritual transcendence.

A similarly direct confrontation is the subject of Marc's *Unhappy Tyrol* (fig. 28). Featuring a scythe-like tree thrust up diagonally from the lower right, the painting memorializes the ethnic strife between Italian- and German-speaking peoples that had enflamed the region during the 1912–13 Balkan Wars. Like *Animal Destinies,* then, *Tyrol* is a pessimistic painting conceived in somber blues, reds, purples, and greens. Unlike the animal painting, however, the landscape introduces several areas of a bright and glowing yellow—a color Marc had articulated in a letter of 1910 as "the feminine principle, placid, cheerful and sensuous."[104] This hue is intended to be a joyous if secular counterweight to the gloom otherwise dominating the composition. But Marc must have thought his mood still too somber, his meaning still too subtle. For after exhibiting the work late in 1913, he added a figural image right in its center: a haloed Madonna, holding her infant and standing on an arc-like moon shape. Clearly the Madonna cannot evoke apocalyptic despair, as has been argued.[105] Instead she embodies a feeling of solace and hope.

2.5. DEATH AND TRANSCENDENCE

A concern for catastrophe and redemption was not at all limited to Berlin and Munich during the immediate prewar years. In Vienna Egon Schiele explored his own self-image with increasingly destructive implications. The 1911 painting *Self-Seers II,* also titled *Death and the Man* (fig. 29), certainly displays a morbid fascination with death. It is a visionary painting, seeming to conjure up a ghost from the dead, and is in this respect the sequel to Arnold Schoenberg's "visions" of 1910 (see plate 3) which were exhibited and widely discussed in Vienna in 1911.[106] Like Schoenberg, in fact, Schiele at this time was dabbling in theosophy, writing in 1911 of "my astral light"

and in 1912 of an "astral light" that "pours forth in orange or other colors."[107] On the other hand, however, the fact that the work is a self-portrait is ominous. Seeing *oneself* beyond the grave is, in principle, suicidal. Schiele draws on a long and honorable German tradition: first, on the "doppelgänger" theme in the writings of E. T. A. Hoffmann and Rilke, and second, on the "death and the artist" theme of Böcklin and Corinth. But his depiction of himself raises the danger, in Alessandra Comini's words, of a potentially schizophrenic "personality crisis."[108] The danger is only averted by the foreground figure's crossed arms, which refer, symbolically, to the Christian cross of redemption. But that figure's hallucinatory stare, augmented by the echo of his sightless "double," produces a powerful feeling of anxiety and despair.

Another Viennese painting incorporating a self-portrait, *The Tempest* by Oskar Kokoschka (fig. 30, plate 7), is also concerned with death and transcendence. The two subjects are Kokoschka and Alma Mahler, whose husband, the composer Gustav Mahler, had died in 1910. As the artist later wrote, the painting "shows me, with the woman I once loved so intensely, in a shipwreck in mid-ocean." But it shows more than this. In Alma's recollection, for example, "he painted me in storm and mountainous swells, I lying calmly, trustfully clinging to him—expecting all help from him who, with despotic face and radiant energy, calms the waves!" And the painting confirms the differences in expression: Alma serene and Oskar, if not "despotic," then certainly tense and anxious. We are reminded of his depressed emotional state in the months preceding the painting. After a lover's quarrel early in 1914, Alma reports, the artist "had painted his studio all black. The two halves of the room were illuminated by a red and blue light. The black wall was full of sketches, made with white chalk. He himself was in a peculiar and extremely dangerous state." She adds that shortly afterward he painted a large fresco, now lost, "which showed me in a ghostly brightness pointing to heaven, while he appeared standing in hell enveloped by death and serpents."[109]

In such a depressed mood *The Tempest* was conceived, yet the artist managed to make it nonetheless a powerfully positive and radiant painting. It is as if death itself could be faced, so long as it could be shared with the loved one. But this heroic and romantic notion was hardly original with Kokoschka. He had borrowed it from Richard Wagner's famous opera of 1859, *Tristan and Isolde;* indeed the very title of *The Tempest* seems to echo the last words of Wagner's text:

In the billowy surge,
in the ocean of sound,
in the World Spirit's
infinite All,
to drown now,
descending,
void of thought—
highest bliss!

The theme of love-in-death or *Liebestod* had been the leitmotif of their affair. On the very evening in 1911 that they had met, Kokoschka **47**

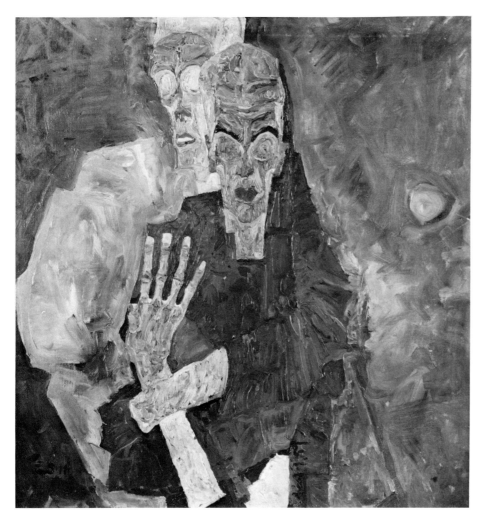

29. Egon Schiele, *Self-Seers II (Death and the Man)*, oil on canvas, Kallir 129, 1911.

recalled, Alma "took me to the piano in the next room, where she played and sang—for me alone, she said—Isolde's *Liebestod*."Almost four decades later Kokoschka still associated her with Wagner's opera. As he wrote her in 1949: "You are still the wild creature, just as in those days when you were first carried away by *Tristan and Isolde* and used a quill to scribble your observations on Nietzsche in your diary."[110]

Kokoschka depicted himself and Alma once again in 1914, this time in the roles of "Fear" and "Hope" in a series of lithographs illustrating the *Bach Cantata: O Ewigkeit, Du Donnerwort* (fig. 31). In the second of these lithographs, the figure of Fear stands trembling beneath Bach's moving text: "O eternity, Thou word of thunder, / O

sword that pierces the soul, / O beginning without end, / O eternity without time." Later in the series Fear is threatened by death while Hope consoles him. The two together listen to the solemn words of the Holy Spirit, as taken from the Book of Revelation (14: 13): "Blessed are the dead, the dead / which die in the Lord from henceforth; / Blessed are the dead which die in the Lord."[111]

The Tempest and the *Bach Cantata* were created early in 1914, well before the outbreak of war in August of that year. Nevertheless, the artist's depressed mood and longing for death were only heightened by the war. They continued in a painted *Fan* he gave to Alma Mahler and in the autobiographical *Knight Errant* of 1915 (figs. 142, 143, plate 20), where Kokoschka anticipated his own serious injuries in battle.

One of the surprises in German Expressionist art is that the Brücke artists, too, occasionally turned to religion for artistic inspiration. In fact their move from Dresden to Berlin in 1911 coincided with a gener-

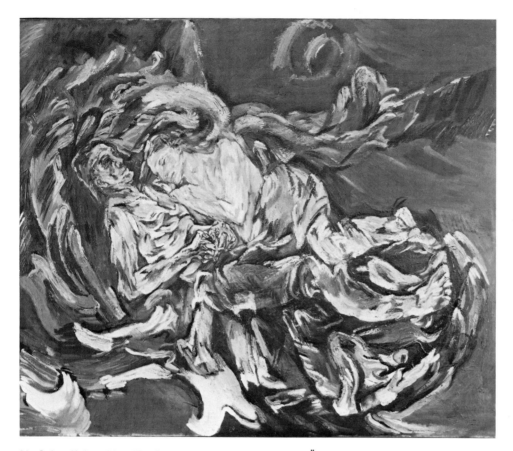

30. Oskar Kokoschka, *The Tempest,* oil on canvas, 1914. Öffentliche Kunstsammlung, Kunstmuseum Basel. (See also plate 7)

al shift toward religious sentiment in some Berlin circles. Not only were Nolde's religious paintings being discussed and Meidner's apocalypse scenes about to begin, but Wilhelm Worringer had focused renewed attention on the German spiritual tradition in his 1910 *Form Problems of the Gothic* (see sec. 3.5). In this milieu Schmidt-Rottluff created a *Four Evangelist* relief (fig. 83), while Kirchner and Heckel conceived a towering *Madonna* for the chapel of the 1912 Sonderbund exhibition in Cologne.

Circumstantial evidence nevertheless suggests that Heckel had rejected orthodox religion and was now seeking a more personal, post-Christian mode of religious expression. If so, he could have easily taken his cue from Nietzsche's *Will to Power:* "These 'states of redemption' in the Christian are mere variations of one and the same diseased state—interpretations of the epileptic crisis by a certain formula supplied, not by science, but by religious delusion. . . . [Previous practice] held a man to be cured when he abased himself before the cross and swore to be a good man. But a criminal

who . . . does not slander his deed after it is done has more *health of soul.* The criminals among whom Dostoevsky lived in prison were one and all unbroken natures. Are they not worth a hundred times more than a 'broken' Christian?"[112] It seems likely that, starting with such passages as this, Heckel soon familiarized himself with the Dostoevsky sources Nietzsche had read, especially his *Notes from the House of the Dead* (1861–62), *Notes from Underground* (1864) and,[113] in view of Nietzsche's mention of "epileptic crisis," *The Idiot* (1868).

Whatever the motivation, however, Heckel based several figure compositions of 1912 on Dostoevsky's writings and then created several landscapes in 1913–14 in a quite different manner— crystalline in form and transcendent in mood.[114] There is a contradiction in spiritual meaning between these Heckel works, a contradiction between Nietzschean resignation and post-Nietzschean revaluation. Yet a similar opposition is to be found, I believe, in Dostoevsky. Pitting earthbound submission against heavenly aspiration, the contradiction emerges in Dostoevsky's concept of an "acute consciousness" induced by suffering.

In *Notes from Underground,* for example, the Russian author contrasted what may be called inauthentic and authentic existence. He **49**

31. Oskar Kokoschka, *Bach Cantata,* from *O Ewigkeit, Du Donnerwort,* lithograph, 1914. Los Angeles County Museum of Art, The Robert Gore Rifkind Center for German Expressionist Studies.

introduced as "the antithesis of the normal man" what he named as "the man of acute consciousness," to wit, that man who is compelled to "hate or love, if only not to sit and twiddle [his] thumbs." Continuing the contrast, Dostoevsky ridiculed the materialist and positivist mentality that had produced England's Crystal Palace of 1851. Then, to the rational logic of the philistine mind he opposed the irrational need for authentic caring:

> I admit that two times two makes four is an excellent thing, but if we are to give everything its due, two times two makes five is sometimes a very charming thing too. . . . As far as my own personal opinion is concerned, to care only for prosperity seems to me positively ill-bred. Whether it's good or bad, it is sometimes very pleasant, too, to smash things. Suffering would be out of place in vaudevilles, for instance; I know that. In the "Crystal Palace" it is unthinkable; suffering means doubt, negation, and what would be the good of a

"crystal palace" if there could be any doubt about it? And yet I am sure man will never renounce real suffering, that is, destruction and chaos. Why, after all, suffering is the sole origin of consciousness. . . . [And] consciousness, for instance, is infinitely superior to two times two makes four.

Though Nietzsche is Dostoevsky's worthy successor, Dostoevsky himself stands for the Christian tradition of original sin represented by Augustine and Pascal; his remarks on multiplication even evoke Luther's dictum "reason is a whore."[115] Nevertheless, his notion of higher "consciousness" through suffering is an especially mystical and modern formulation. And he took this notion still further in his 1868 novel *The Idiot.*

It is *The Idiot* that Heckel chose to paraphrase in his 1912 painting *Two Men at the Table* (fig. 32). Depicted is that moment when the innocent Myshkin is confronted by his would-be assassin, Rogozhin. The knife between them is ominous, yet it points to a painted Christ before Resurrection; in this way the authenticity of suffering in the seated prince is suggested. Both the criminal and his victim possess a Nietzschean "health of soul." But Prince Myshkin is also an epileptic, an "idiot" attuned to his inner mental state rather than to the "two times two makes four" of the outer world. As a result, because of his inner-directed sensibility, he can face Rogozhin's attack with equanimity.

What Myshkin has learned through his suffering, of course, is heightened consciousness. An epileptic attack can bring, in Dostoevsky's words, an unheard-of ecstasy: "What does it matter that it is an abnormal intensity, if the result, if the minute of sensation, remembered and analysed afterwards in health, turns out to be the acme of harmony and beauty, and gives a feeling, unknown and undivined until then, of completeness, of proportion, of reconciliation, and of ecstatic devotional merging in the highest synthesis of life?"[116] Myshkin's conclusion—"Yes, for this moment one might give one's whole life!"—confirms that for one experiencing such ecstasy, death holds no peril. This is the post-Christian equivalent to the Resurrection signified by the canvas on the wall in both novel and painting. It is this contradiction, between masochist submission to suffering and mystical attainment of joy, that Heckel has learned from Dostoevsky.

Two Men at the Table cannot fully contain its intended message, however; only Myshkin's vulnerability is communicated, not quite his mysticism. Perhaps this is why Heckel returned to the other half of Dostoevsky's original comparison: the "crystal palace." For by now the notion of crystal architecture had lost that association with English rationality which it had possessed in Dostoevsky's day; for Heckel, as we shall see, it signified nothing less than transcendent consciousness itself!

Heckel chose to explore this issue in a group of works including the *Glassy Day* (fig. 33, plate 8) and the 1914 etching *Park Lake* (not illustrated). They focus on nature's shimmering, prismatic, and otherworldly forms. Such an approach to nature was probably prompted, in the first instance, by Wilhelm Worringer's views on the transcen-

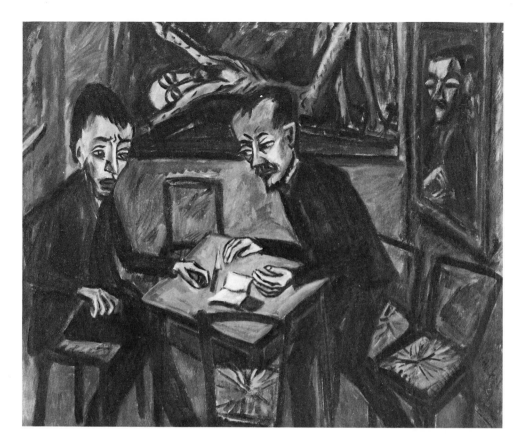

32. Erich Heckel, *Two Men at the Table,* oil on canvas, 1912. Hamburger Kunsthalle.

dental nature of abstraction. For in his *Abstraction and Empathy* of 1908 Worringer had argued that nature must be "de-organicised" to achieve a state of timeless and "crystalline" perfection:

> Thus all transcendental art sets out with the aim of de-organicising the organic, i.e. of translating the mutable and conditional into values of unconditional necessity. But such a necessity man is able to feel only in the great world beyond the living, in the world of the inorganic. This led him to rigid lines, to inert crystalline form. He translated everything living into the language of these imperishable and unconditional values. For these abstract forms, liberated from all finiteness, are the only ones, and the highest, in which man can find rest from the confusion of the world picture.[117]

Heckel achieves this "transcendental" mood by reducing all of organic nature to hard-edged and rectlinear forms. Angular shapes are used for rocks, hills and clouds, while prismatic reflecting shapes appear in sky and water like so many pieces of fragmented or splintered glass. Only the sculpturesque nude in the foreground of *Glassy Day* embodies the curving, living forms of organic nature, while in the *Park Lake* etching even the human figure is eliminated. When we consider Heckel's style not only generically "abstract" but specifically "Cubist" as well, we sense the way in which German Expressionists interpreted Cubism as a "striving towards a final unity."[118]

In addition to Worringer, however, there is another source which might have helped to prompt Heckel's transcendental image.[119] This is Wenzel Hablik's folio of twenty etchings called *Creative Forces,* which was exhibited in Berlin's Sturm Gallery in May 1912.[120] While walking in the Alps Hablik had had a vision of crystalline "clouds" and "pinnacles" which had seemed godlike to him. He described the vision in his introductory note to the folio: "I saw the shiny crystal, saw it extending in luminous vapors, saw the space before me envelop itself in thunderous clouds from which glittering pinnacles broke forth and separated. One thought moved mountains, one thunderous word hammered stars out of their orbits and, like the strong arms of the gods, it reached deep, deep into unlimited space, creating, forming with unbridled, eternal strength."[121] Hablik's etchings, first published in 1909, were still conceived in a linear Jugendstil manner and

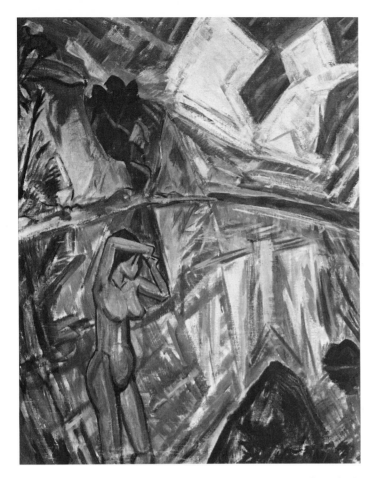

33. Erich Heckel, *Glassy Day,* oil on canvas, 1913. Bayerische Staatsgemäldesammlungen, Staatsgalerie Moderner Kunst, Munich. (See also plate 8)

sages from Goethe, including one from his "Trans-Optical Colors": "Mirrors hither, mirrors thither, / Double setting, something special, / While between them, darkly resting, / Essence of the world—a crystal."[124]

It is important to note this iconography of transcendence when comparing German Expressionist with French Cubist or Orphist painting. Thus it is true enough that the small circular shapes in August Macke's 1913 *Bathing Girls* derive directly from Robert Delaunay's 1912 *Circular Forms, Sun and Moon* (figs. 34, 35). But going beyond the formal similarity, we know that Delaunay was concerned with the "simultaneous" qualities of light (see sec. 3.6), while Macke seems committed to the transcendent or spiritual implication of what Worringer had called "inert crystalline form." Where Delaunay's image floats and shimmers like so many reflections and refractions of light itself, Macke's figures seem monumental and architectonic like structures of some kind of sublime architecture. Even this distinction, however, does not go far enough. For Macke is painting not so much bathers or architecture as he is the subjective experience of joy or bliss. As he had stated in the *Blaue Reiter* almanac of 1912: "Man expresses his life in forms. Each art form is an expression of his inner life. The exterior of the art form is its interior."[125] The Romantic roots of Macke's attitude are legion: "The language of the heart is the only one that is universal" (Constable); "poetry [is the] representation of the spirit, of the inner world in its totality" (Novalis).[126] Whether in Romanticism or in Expressionism, such attitudes constitute an "aesthetics of inwardness."[127]

But historically, once the aesthetics of inwardness was married to an iconography of transcendence—without further reference to the realities of sex or death—then Expressionist tension and contradiction finally yielded to the Romantic sublime. This point was first reached with Kandinsky's momentary interest in the newly revived notion of a mystical Third Kingdom. With Macke's harmonious and wholly lyrical *Bathing Girls,* however, that threshold on the path away from Expressionism was finally crossed. Indeed for Macke the Expressionist renewal of art, so urgently desired just a few years before, had now come to pass.

2.6. WARTIME SINNERS AND SAINTS
Closer examination of both erotic and religious experience suggests, however, that the path of devotion never runs smooth. Ambivalence is always present: sex involves animality, Eden the Fall. It was the war that prompted new awareness of such ambivalence. Careers were aborted: Kandinsky as an "enemy alien" fled Germany in August 1914, Macke died in France in September, and Marc fell at Verdun in March 1916. Most Expressionists were in uniform: some were wounded, others were invalided out of the service (see secs. 3.7, 4.5). More importantly, though, the war forced artists not just to withdraw inward but also to face the facts of real existence.

This conflict between inwardness and facticity, between exalted ideals and existential realities, characterizes much later Expressionist art. In the sexual sphere a revealing example is Kirchner's 1918

so were remote from Heckel's style. Nevertheless, they initiate a widespread interest in glass and crystal imagery among later Expressionist artists and architects. In addition to Heckel's 1913 *Glassy Day,* there were Lyonel Feininger's 1913 paintings in a prismatic, quasi-Cubist style, and also Bruno Taut's Glass Pavilion at the 1914 Werkbund exhibition in Cologne. Dedicated to Taut was Paul Scheerbart's *Glass Architecture* (1914), which called for the end of "the city as we know it" and its replacement by "a glass culture," "a new glass environment [that] will completely transform mankind."[122]

A number of precedents have been proposed for such glass and crystal imagery, including the stained glass employed in Gothic cathedrals, the jeweled Grail temple described in various legends, and also the biblical setting of the heavenly throne before "a sea of glass like unto crystal" (Revelation 4: 6).[123] Among Romantic sources numerous descriptions by Novalis have been cited, as well as pas-

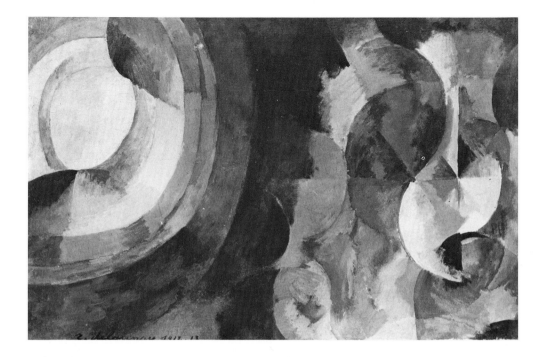

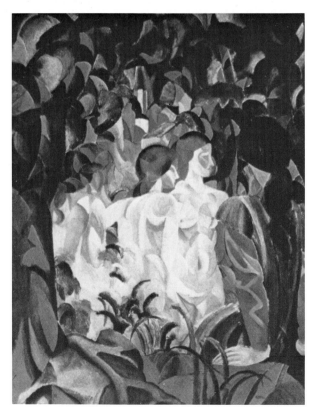

woodcut cycle of Petrarch's "Triumph of Love" and its concluding image of *Eternal Longing* (fig. 36). A 1912 version of the theme, with its hedonistic depiction of nude lovers amidst palm trees,[128] has been forgotten. The 1918 cycle is somewhat closer to *Two People* of 1905, where the physical embrace or *Union* falls midway between the hopeful *Longing* and the despairing *Separation* (see sec. 2.1). Nevertheless, the pre-Expressionist works with their Jugendstil borders narrate an obvious story; *Longing* in that cycle merely depicts a man on a hill, looking to the sky. In *Eternal Longing* (1918), by contrast, the two lovers are separated below by a single-eyed primitive mask, a "symbol of the secret which eternally governs the relation between man and woman."[129]

Such an image hardly accords with Petrarch's affirmation of love's secular triumph on earth. Instead, it embodies Kirchner's subjective view of the male/female tie. In *Eternal Longing* the two figures are locked in each other's gaze yet separated by a heavy white vertical emerging from the mask; they are unified yet isolated, both two and one. Kirchner offered a positive interpretation for the woodcut. It symbolizes, he wrote, "the inseparable union in coexistence [Nebeneinander], maintained by mutual respect." But as Günther Gercken has pointed out, such longing can never be fulfilled in reality for it "founders against the limits of the ego."[130] And Kirchner showed a lifelong

34. (top) Robert Delaunay, *Circular Forms, Sun and Moon,* oil on canvas, 1912. Collection Stedelijk Museum, Amsterdam.

35. (left) August Macke, *Bathing Girls,* oil on canvas, 1913. Bayerische Staatsgemäldesammlungen, Staatsgalerie Moderner Kunst, Munich.

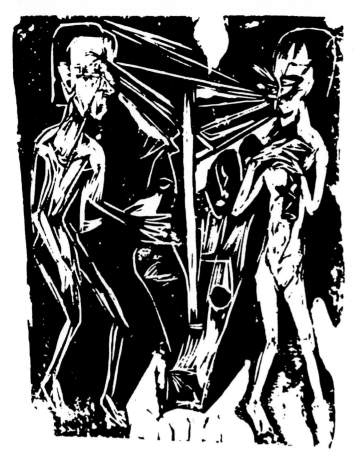

36. Ernst Ludwig Kirchner, *Eternal Longing* **(illustration for Petrarch's "Triumph of Love"), woodcut, 1918.**

intermediate conditions between male and female—sexual transitional forms. . . . The fact is that maleness and femaleness are like two substances combined in different proportions, but with neither element ever wholly missing. We never find, so to speak, solely a man or a woman. . . . We may recall the mythical personification of bisexuality in the Hermaphriditos, the narrative of Aristophanes in the Platonic dialogues, or in later times the suggestion of a Gnostic sect (Theophites) that primitive man was a 'man-woman.' "[132] Weininger's explanation of bisexuality was quantitative: "For true sexual union it is necessary that there come together a complete male (M) and a complete female (F), even though in different cases the M and F are distributed between the two individuals in different proportions." If we substitute for M and F the male and female hormones still unknown in Weininger's day, we see that his theory had much to recommend it. For it purported to explain the attraction between mature women and young men (and not only, as Darwin assumed, between nubile girls and older aggressive males), and also why the attraction between members of the same sex was normal (and not abnormal, as claimed by Krafft-Ebing and Freud).[133] The book reached a sixth edition by 1905 and a tenth by 1912.

Of course Weininger took back in the second part of his study what he had given in the first. Although every human being was allegedly part M and part F, he now assigned a value of "1" to M and "0" to F! The result was a mammoth denigration of woman; she was as vile as devil or Jew.[134] But a less obvious result was the denigration of any male who was part female; Weininger had painted himself into a corner. In proving his own partial femininity and also the unredeemed evil of that femininity, suicide was the only way out.

Kirchner's concern with his own part femininity began in 1915–16—at just the time, coincidentally, when mental duress led him, too, to consider suicide. These concerns did not come from reading Weininger, so far as we know. Instead they arose during the nervous breakdown that had put an end to his military service. Nevertheless, there is a parallel with Weininger in Kirchner's bisexual ambivalence: on the one hand he questioned·his masculine identity, and on the other he compared himself with evil women.

In his 1915 self-portrait as *The Drinker* (not illustrated) the artist wears a colorful striped scarf and pointed high-heeled shoes, possibly borrowed from his dancer-mistress Erna. Meanwhile a drawing mirror-image of this portrait has been identified as either a likeness of the artist wearing Erna's dress or, more likely, as *Erna Seated at the Table;* in any event, its "remarkably androgynous traits" have been noted.[135] In another 1915 painting called *Dance between the Women* (not illustrated), the dancer is given a sexually ambiguous hair mass and a semicircular female breast. Yet the dancer's pose derives from a photograph of a man (in women's shoes) dancing nude in Kirchner's studio; that man has been identified both as a homosexual friend, Hugo Biallowons, and also (though less likely) as Kirchner himself.[136] Later, in 1916, Kirchner wrote to his patron Botho Gräf, also a homosexual, that he had become more concerned with "psychic" than with "physical" penetration into the female nude: "The less

ambivalence toward Erna Schilling, with whom he lived from 1912 until his death in 1938 but whom he never married.

Equally revealing is the fact that in *Eternal Longing* the man and woman resemble one another so closely. Their relationship is less physical than mental; in the 1918 cycle images of *Conquest* are succeeded by examples of *Selflessness* [Entselbstung]. The process of "making selfless" is described by Gercken as follows: "The specifically masculine and feminine properties must be transcended; man and woman must each unify in himself or herself the feeling and sensitivity of both sexes. For Kirchner a prerequisite for becoming fully human, and thereby also for creating art, is the broadening of psychic discrimination into the essence of countersexuality."[131] If this reading is correct, then Kirchner was seeking some kind of psychic androgyny.

A possible source for this notion was the 1903 text *Sex and Character,* published by the twenty-three-year-old Otto Weininger a few months before committing suicide. For according to Weininger androgyny was the *normal* human condition: "There exist all sorts of

I was myself physically interested, which started quite early as a consequence of my frame of mind, the better and more frankly could I penetrate into the other and portray her." During this entire period, however, sexual ambiguity was not merely benign. Late in 1915 Kirchner compared himself as conscripted soldier with a jailed cocotte: "New draft calls of the reserves stay close at my heels and who knows when they will stick me in again and then one can't work anymore; one is more afraid of that than any prostitute." By 1916 the identification with whores was complete: "Like the prostitutes I painted am I now myself."[137]

In the end the 1918 woodcut of *Eternal Longing* has an existential, even pathological dimension. The parallel is less with Romantic ideas of Herder or Hölderlin, as has been mooted,[138] than with subjective feelings of persecution, self-mutilation, self-castration (cf. figs. 145, 146). The forbidding and grimly distorted mask is alone a sufficient clue to Kirchner's real fears about androgyny. But two other prints in the *Triumph of Love* cycle also help to explain that clue. In *Woman's Conquest of Man* the female triumphs over the male's resort to force; she stares him down through an enormous masklike face and frightening, hollow eyes. Moreover, multiplied behind her are the equally spooky faces of her female ancestors—a conception of female dominance in human evolution that Kirchner shared with Strindberg and Munch.[139] And in the print called *Man's Selflessness* where, if anyplace, Kirchner's nobility of purpose should have been made clear, we find instead reminders of mere bestiality. For here, as the male visualizes the female in bed with another man, his jealousy is palpable. Looming between his head and the offending couple are a phallic giraffe and a springing lion—surely intended to symbolize their animal lusts.

When Erich Heckel learned in 1917 of the sufferings of his former colleague Kirchner, he portrayed his friend as one of the great antiheroes of Romantic literature, *Roquairol* (fig. 37). The eyes are infinitely sad, the brow wrinkled, the chin slack. The whole upper body is bent, leaning listlessly toward a setting sun. And Kirchner's left arm, elbow sprouting disjointedly from the shoulder, describes a swooping diagonal; the purposelessness of this gesture suggests madness. By the title Heckel indicates Captain Charles Roquairol, the protagonist of Jean Paul Richter's *Titan: A Romance*. For Richter had called Roquairol a "suicidal madcap," and had described his ambivalent appearance as a knight on horseback: "A pale, broken-down face, glazed over with long inward fire, stripped of all youthful roses, lightening out of the diamond-pits of the eyes under the dark, overhanging eyebrows, rode along in a tragic merriment, in which the lines of the veins were redoubled under the early wrinkles of passion. What a being, full of worn-out life!"[140] While Heckel's portrait evokes the demonic overtones of the Romantic character, it lacks the idealist sensibility of Romanticism. In portraying the suffering of a fellow Expressionist, it is in fact more existential allegory than literary illustration.

A similar distinction can be observed between Ferdinand Hodler's 1908 painting of *Love* and Egon Schiele's *Embrace* of 1917 (figs. 38,

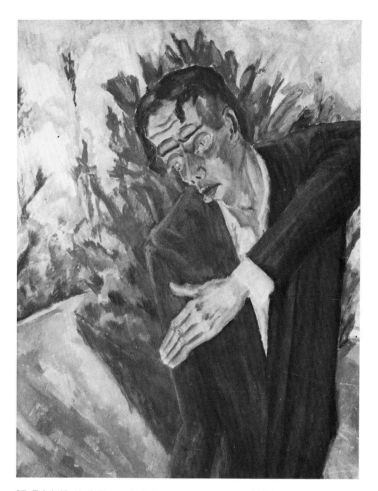

37. Erich Heckel, *Roquairol,* tempera on canvas, 1917.

39). Hodler's Symbolist purpose is suggested by his wish to pick the ideal "moment" in a human pose or gesture: "My compositional goal is to achieve a harmonious accord which touches on especially harmonious examples in nature. I choose the moment in which the limited order of our existence is revealed as it appears in nature."[141] Here Hodler gives us the moments of longing and intimacy, of a yearning for love and its consummation. It is typical that the moment of intimacy is not especially physical. In the absence of genital contact the symbolism of *Love* consists in the framing of joined heads by two pair of gymnastically contorted and overlapped arms.

Schiele takes his cue from this Symbolist pose, as he did earlier with Klimt (see figs. 19, 20). Heads and upper torsos are framed by encircling arms in the Schiele as in the Hodler, while genital involvement is avoided. But Schiele also employs some aspects of Hodler's left-hand man as well; this is his original contribution. For in *Embrace* **55**

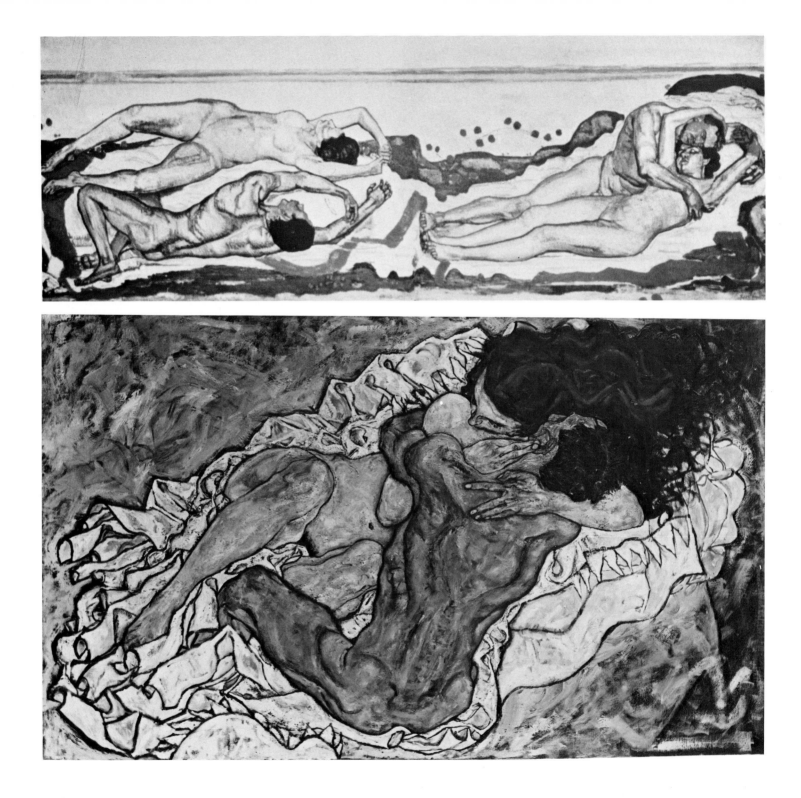

the woman pulls her legs up and the man with muscular biceps is seen from behind, not unlike Hodler's "yearning" man. Thus the Expressionist work combines *both* moments of the Symbolist one, with remarkable tension and contradiction. Hodler's "before" and "after" become Schiele's "during," but the result is less love than its frustration. The woman's nose presses into her shoulder as if she were biting her flesh, while the man's head stretches away from his shoulder as if he were breaking his neck. Rather than inviting embrace the woman places her elbow, forbiddingly, against his chest; two rigid fingers evoke not a caress but a cutting shears. The effect of Schiele's embrace is nervous, electric, unyielding. It promises not just the ideal harmony of release but also the real discord of further physical exertion.

It can be argued that Kirchner, Schiele, and their peers depicted sex as a form of social protest. Where the public sought ideal love in art, Expressionists also gave them love's fears and frustrations. But if explicit sex violated public decorum, then blasphemous sex could undermine religious morality. Nietzsche intimated this by praising Cesare Borgia in his *Anti-Christ* (1895): "I behold a spectacle . . . [that] would have given all the gods of Olympus an opportunity for an immortal roar of laughter—*Cesare Borgia as Pope*. . . . Am I understood? Very well, *that* should have been a victory of the only sort *I* desire today—: Christianity should thereby have been *abolished!*"[142]

Nevertheless, the inventor of blasphemous sex as social protest during the 1890s was Oskar Panizza, one of Germany's great satirists. Trained as a doctor and psychiatrist, Panizza achieved his first notoriety with an earnestly argued satire on a recent papal encyclical. *The Immaculate Conception of the Popes* (1893) was immediately confiscated by the courts, as was an 1894 book claiming "666 Theses and Citations" against Rome. Then in 1895 appeared a "Heavenly Tragedy in Five Acts," *The Council of Love*, in which Panizza attributed the invention of syphilis to the Devil and God as punishment for the sins of the Borgia Pope, Alexander VI, and the entire population of Naples in 1495:

MESSENGER: . . . Dogs and black-cocks have their times of rut, but the Neapolitans are animals all year long; the entire city is a seething cauldron of passion; Italy is the most love-mad among the peoples of Europe, but Naples is to Italy what Italy is to the other peoples; the siege has intensified the drunken frenzy of the sexes to the point of madness; no age is given indulgence, no youth is shown mercy; phalluses of immeasurable size are led through the streets as deities in solemn processions, accompanied by roundelays of young girls, and are worshipped as omnipotent idols. And in Your Church I saw the priest at the altar with a venal prostitute. . . .
GOD: I will smash them![143]

For this effort Panizza was tried for blasphemy, convicted, and jailed for a year. In 1898 there followed the *Psychopatia [sic] Criminalis*, titled after Krafft-Ebing but devoted to modes of legal persecution; and the 1899 verse collection *Parisiana*, in which Emperor Wilhelm II was named the "public enemy of humanity and its culture." Panizza was jailed again in 1901 for six months, including six weeks in an asylum, and then, following increased hallucinations and a suicide attempt, was finally declared insane—with his own consent—in 1904.[144]

For Germans of the Expressionist generation, Panizza was an exemplary model. Kurt Tucholsky once called him "the cheekiest and boldest, the wittiest and most revolutionary prophet of his country while he was still in his right mind." Alfred Kubin executed nine pen drawings for a 1913 edition of *The Council of Love*. And the young George Grosz, only twenty when Kubin brought Panizza to Expressionist attention, memorialized the mad author in his 1917–18 painting *Dedicated to Oskar Panizza* (fig. 40). Grosz may even have had in mind Panizza's Neapolitan description, for he called his own assembly "a throng of possessed human animals" and he showed that throng led by a cleric.[145] Still, Panizza's procession paraded lust and sin where Grosz's depicted stupidity and piggishness. Though Grosz would later be tried for blasphemy himself, following the precedents of Strindberg, Ensor, and Panizza,[146] his main target was not the church. Instead the faith that Grosz blasphemed was Germany's bourgeois faith in "moral" values. In this respect Grosz remained, late in the Expressionist period, a committed heir of Nietzsche.

Another protest against bourgeois religious values was Karl Schmidt-Rottluff's 1918 woodcut series devoted to *Christ,* including *Christ on the Road to Emmaus* (fig. 41). The latter's graphic properties can be attributed to the medium: black trees against white sky, light heads against dark hills or striated ground. But the depicted saints also violate traditional religious representations: foreheads break out in stripes, hair masses become prickly, heads are broken into ugly facets, and even Christ's pupils are cockeyed—one white and one black. Still, before we attribute such distortions to some kind of abstraction-for-abstraction's-sake, much less to the artist's lack of piety, we should note that he called several paintings of the immediately succeeding years "Numinous Pictures."[147] This suggests that Schmidt-Rottluff's meaning is associated with the notion of the "numinous" advanced by Rudolf Otto in his 1917 study of *The Holy*.

Otto's search for authentic religious experience had taken him around the world in 1910–11 to Africa, the Near East, India, the Orient, and to Indian reservations in America. He finally determined that the core of spiritual feeling lay in a contradictory phenomenon he defined as "numinous consciousness":

38. (top left) Ferdinand Hodler, *Love,* 1908. Kunsthaus, Zurich.

39. (bottom left) Egon Schiele, *The Embrace,* oil on canvas, 1917. Österreichische Galerie, Vienna.

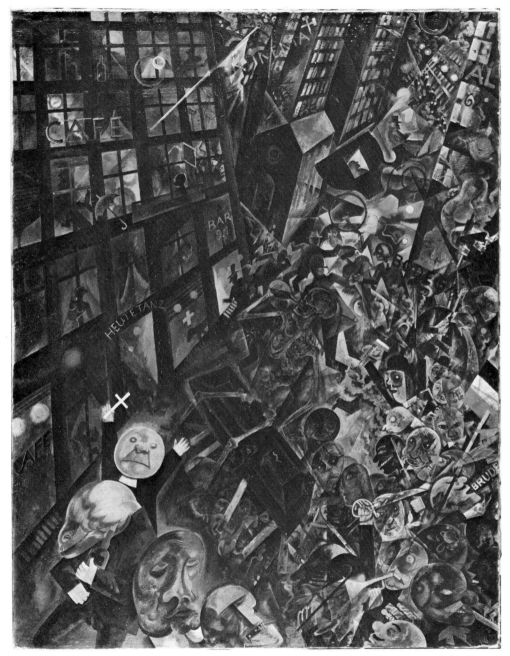

40. George Grosz, *Dedicated to Oskar Panizza,* oil on canvas, 1917–18. Staatsgalerie Stuttgart.

These two qualities, the daunting and the fascinating, now combine in a strange harmony of contrasts, and the resultant dual character of the numinous consciousness . . . is at once the strangest and most noteworthy phenomenon in the whole history of religion. The daemonic-divine object may appear to the mind an object of horror and dread, but at the same time it is no less something that allures with a potent charm, and the creature, who trembles before it, utterly cowed and cast down, has always at the same time the impulse to turn to it, nay even to make it somehow his own.[148]

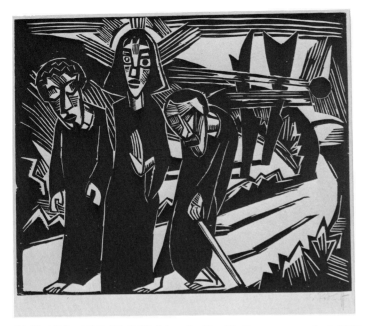

41. Karl Schmidt-Rottluff, *Christ on the Road to Emmaus,* woodcut, 1918.

In this context Schmidt-Rottluff's figures are truly numinous. It is precisely the contrast of "the daemonic-divine" that the artist introduces into his skewed and abstracted personages. In *The Way to Emmaus* it is Christ's two-toned eyes and nature's hurtling black comet that prompts the observer to experience "horror and dread." Only after such negative experience can a positive acceptance ensue.

A similar black orb appears at the top of an enormous *Resurrection,* over eleven by sixteen feet in size, on which Max Beckmann worked from 1916 to 1918 but which he finally left incomplete (not illustrated).[149] The painting is enigmatic, with large figures above and smaller ones below, yet with no clear vertical ascension; it is a strangely earthbound Last Judgment. The artist also included himself, his wife at that time, Minna Tube, their son Peter and several of his friends in a trench lower right, thus conveying further an autobiographical meaning. And indeed this latter aspect reveals a likely source for Beckmann's black sun, namely a nightmare the artist had experienced just before his nervous breakdown and military discharge in mid-1915. "Last night I had another world destruction dream," he wrote home to his wife. "By now probably my twentieth. The two of us on a broad street, a kind of mountain road, which seems to recede up an endless hill. In rushed flight from something or other. In the infinite vaults one saw remarkably ray-shaped clouds . . . [with] strange black cores which revolved at an enormous distance."[150] Despite a kind of dreadful fascination not unlike Otto's notion of the numinous, Beckmann's *Resurrection* seems ultimately more pessimistic.

Beckmann's pessimism became only more profound as the war dragged on. This is seen from his *Creative Confession,* written late in 1918 although unpublished until 1920:

> The war now approaches its sad end. It hasn't changed my idea of life, but only confirmed it. I daresay we have hard times ahead. But just now, even more than before the war, I feel the need to be among my fellow men. In the city. This is where our place is now. We must take part in the great misery to come. We must expose our heart and our nerves to the ghastly cries of poor deluded mankind. Precisely now we must place ourselves as close as possible to people. The only thing that can to some extent motivate our existence—otherwise, strictly speaking, superfluous and selfish—is that we give people a picture of their fate. This one can do only if one loves them.[151]

This gloomy mood is also found in Beckmann's exactly contemporary painting of *The Night,* inscribed lower left with the dates "August 1918–March 1919" (fig. 42, plate 9). Nevertheless, the artist's *Confession* displays an odd disjunction between a cynical view of life as "superfluous and selfish" and a sentimental fellow-feeling for "poor deluded mankind." Do we not sense this disjunction in *The Night* as well? The cynicism may be seen in the clinical detail with which the male and female victims are depicted, with blackened foot and twisted arm and with tied wrists and open corset, respectively. And the sentiment seems to reside in the extinguished and burning candles which together suggest, according to traditional religious symbolism, that life, at least, goes on.

Beyond this there is little agreement, however, on the painting's meaning. Günter Busch sees "murder and torture, rape and unspeakable vileness," while Peter Selz evokes the assassinations of Karl Liebknecht and Rosa Luxemburg in January 1919. But Friedhelm Fischer goes beyond the physical to speak of "metaphysical dread," while Marcel Franciscono finds reason to question "whether we are looking at a scene of torture at all."[152]

Fischer's argument depends upon Beckmann's conversion to gnostic belief by "around 1918," when he called his pictures "a reproach against God for everything he did wrong." By 1920, Fischer reports, Beckmann even wanted to strangle the Creator to learn why He had "contrived all these tortures for [His] creatures." Such Job-like protest is not necessarily gnostic, however. On the one hand the gnostic religion of the second century A.D. *had* divorced an alien and otherworldly God from this earth's pointless and godless existence. But on the other hand gnostics saw the individual "self" as a bridge to that alien God, as a light damped in material darkness which yearned for the larger spiritual light. As Hans Jonas has written: "Never before or after had such a gulf opened between man and the world, between life and its begetter, and [had] such a feeling of cosmic solitude, abandonment, and transcendental superiority of the self taken hold of man's consciousness. . . . [Yet] the self is kindred only to other

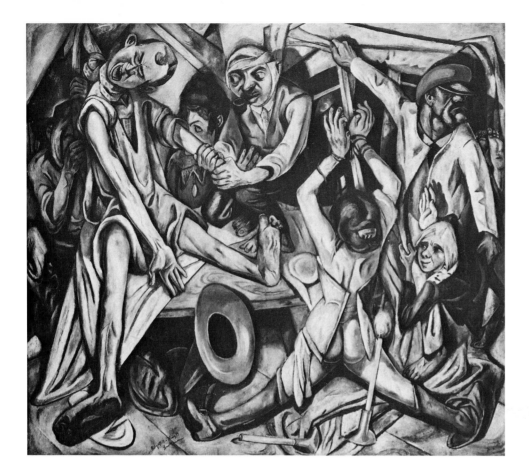

42. Max Beckmann, *The Night,* oil on canvas, 1918–19. Kunstsammlung Nordrhein-Westfalen, Düsseldorf. (See also plate 9)

human selves living in the world—and to the transmundane God with whom the non-mundane center of the self can enter into communication." To be sure, we might argue that Beckmann's "love" for his "fellow men," as professed in the *Creative Confession,* can embody the gnostic self's relatedness to "other human selves."[153] But in the painting of *The Night* such relatedness is hard to find. The sense of man's "abandonment" overwhelms any indication of a "transmundane God"; it is a picture weighing heavily on the gloomy side of a pessimistic/optimistic scale.

If there is any optimism in the painting at all, in fact, it is expressed not in gnostic but in traditional Christian terms. This was the discovery of Marcel Franciscono: "*The Night* . . . is not a 'narrative' of torture but a symbolic structure of broader and more general import. Like the dwarfed crucified Christ in His mother's lap in late medieval carvings who is a man but is also meant to remind us of His baby innocence,

Beckmann's imagery is adjusted ever so slightly to allow for a complex of meanings. These are certainly guided by the context of a scene of torture, but they are not fixed within it."[154] In Franciscono's view *The Night* depends upon a fifteenth-century *Descent from the Cross* by Hans Pleydenwurff or his workshop (fig. 43), since the strap used to lower Christ from the cross in the late Gothic work resembles the scarf used to lower Beckmann's male sufferer.

I say "lower" because the half-hidden figure extreme left can be both hanging *and* releasing the screaming man. In a similar manner the pipe-smoking man with bandaged head resembles as much a doctor setting an arm as he does a torturer breaking it. Even the partly disrobed woman, despite her spread-legged pose, might merely be leaning her braceleted wrists together without their being, in fact, tied. The gramophone, the dog, and the woman in red seated quietly above—all further this interpretation: the scene is a domestic interior in which a rough board has been set up as a temporary work surface. Here the victims have been brought for emergency medical care.[155]

Moreover, the male sufferer, like the subject of the Pleydenwurff altar, is also presented as a Christ-figure; the palm and soles are turned out, as if to display their stigmata. In this sense the crossed

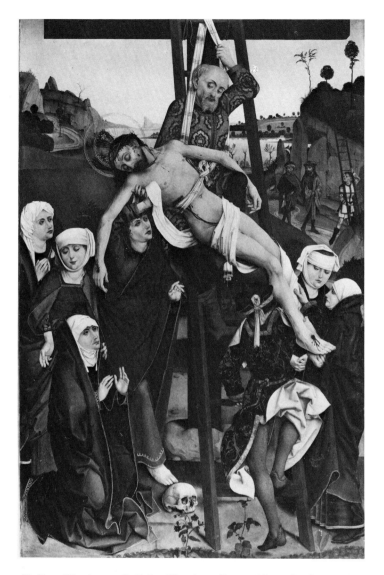

43. Hans Pleydenwurff, *Hofer Altarpiece, Descent from the Cross,* oil on wood, fifteenth-century. Bayerische Staatsgemäldesammlungen, Alte Pinakothek, Munich.

beams above also have a Christian connotation.[156] Even though the 1918–19 oil derives from a 1914 etching of a brothel murder, in short, it also sounds a note of Christian charity. Nevertheless, the work remains, in the end, a quasi-Gothic morality tale. Intended to symbolize the earthly condition, *The Night* is totally removed from heavenly "day."

Beckmann's essential pessimism may also be seen in his 1924 farce *Ebbi,* written and illustrated with six etchings around 1920. The middle-aged merchant Eberhard, nicknamed Ebbi, is inspired by the painter Johanna to become a poet. "A poet needs to be neither rational nor moral," he claims, thereby divorcing creative freedom from bourgeois rectitude. In the *Ebbi* etching illustrated here (fig. 44), Beckmann shows the heavy-jowled merchant to be comical as he describes his new life to his uncomprehending wife and friends. And Ebbi *is* comical, whether describing his office existence "getting one hemorrhoid after another" or evoking the poet's loss of his muse: "Empty, empty, empty: gone is the fire! She took it with her." But then Johanna is comical too, leading Ebbi to a bordello to show him "the abyss of existence," and then arranging for them to rob a friend's house: "You *must* do evil. It is precisely a matter of diverting you from your soft and virtuous path so that you suffer torments and remorse, so that you have conflicts like any true poet."[157]

Thanks to Beckmann's irony, this is pseudo-Nietzschean farce. Both the middle-class burgher *and* the immoral artist are scorned and made fun of. Nietzsche's lesson of renewal is rejected; creation and destruction are deemed equally absurd. As Ebbi returns to his middle-class milieu at the final curtain, the meaningless of the dance of life, of virtue and sin, is revealed. Like Schnitzler's *La Ronde* a generation before, Beckmann's *Ebbi* describes an empty and nihilist society.

2.7. REVALUATION OF VALUES

At the opposite extreme from these Beckmann works are the utopian statements, of seemingly unlimited optimism, which followed the armistice in November of 1918. Expressionism's final phase produced several of these, each possessing a hothouse luxuriance, a force-fed faith, which suggested that the movement's days were numbered. Such statements were especially prevalent in the fields of architecture and architectural criticism.

The utopian mood arose in the last year of the war, following the Bolshevik revolution in Russia (November 1917) and the consequent peace treaty between the Soviet government and the Central Powers (April 1918). The ideas of socialism and peace became inextricably intertwined in German consciousness. The very communal forces that had previously supported military adventurism and homefront sacrifice were now yoked to a faith in social transformation and postwar rebuilding. As Kurt Junghanns has written: "The idea of the unavoidability of catastrophe was slowly linked with the notion of a great turning-point, a powerful coming awakening to an existence with new relations between men and with novel forms of art and architecture."[158] In this mood the "transcendental" interests of such prewar creators as the artists Hablik and Heckel, the novelist Scheerbart and the architect Taut (see sec. 2.5), became almost generation-wide.

During the winter of 1917–18 and on through the summer of 1918 Bruno Taut prepared the plates for a projected publication called *Alpine Architecture.* Comprising thirty ink-and-wash illustrations, each with hand-printed text, *Alpine Architecture* envisioned gran-

44. Max Beckmann, illustrations to the drama *Ebbi*, etchings, ca. 1920.

diose projects sometimes bordering on science fiction; for example, three of the book's five sections were titled "The Crystal House," "Alpine Building," and "Astral Building." Plate 12, under "Alpine Building," was captioned in part: "NATURE IS GREAT, ever beautiful, an eternal creatrix, from atom to mountain range. Everything is ever NEW CREATION. We too are her atoms and follow her command—in creating. To admire her idly is sentimental. LET US CREATE IN HER AND WITH HER AND LET US DECORATE HER!" Illustrated were mountain peaks adorned with "glassy-white crystals" and forest valleys relieved by towering vertical spikes, each concrete-framed and made of white milk-glass—tipped and ornamented ruby-red—"lit from within to glow at night."[159]

Taut's Plate 26, in the section "Astral Building," was captioned simply *Cathedral Star* (fig. 45). Like the other plates in this section with such titles as "Cavern-star with suspended architecture" or "Systems within systems—Worlds—Nebulae," *Cathedral Star* fuses two orders of magnitude. Sketched in the center in delicate line and shimmering reflections is a many-spired church. But the entire crystalline structure is made to glow in an ink-black sky, surrounded by planets, comets and nebulae. Where earlier Expressionists had been content to imagine a cosmic yet disembodied "consciousness," Taut now visualized the Expressionist architect literally building among the stars! When *Alpine Architecture* was published in 1919, it set the tone for the times.

Yet this was just the beginning of Taut's visionary activity. Also published at this time were his pamphlet for Berlin's Working Council for Art entitled *A Program for Architecture* (Berlin, December 1918); a book on utopian urban planning called *The City Crown* (Jena, 1919); another book, often contradicting the latter, titled *The Dissolution of Cities* (Hagen, 1920); and even an "architectural drama" with symphonic accompaniment called *The World Architect* (Hagen, 1920). Exemplifying Taut's approach are two elements embodying sexuality and spirituality. In *The Dissolution of Cities* he drew a solar-energy power station in the form of "phallus and rosette" in order both to fuse nature and architecture and to reactivate the "ancient wisdom" that "complete openness in sexual matters [leads to] the overcoming of instinct through itself."[160] And one of the features of the urban center visualized in the *City Crown* (1919) was to be a church containing a "Pillar of Prayer" and an antipodal "Pillar of Suffering," both to be carved by Karl Schmidt-Rottluff.[161]

Taut's literary sources, in addition to Scheerbart, whom he had greatly admired since 1914, now included the German philosopher Nietzsche and the Russian anarchist Kropotkin. It was the Nietzsche of *Zarathustra*, the Nietzsche who had based his Higher Man in the mountains and who used the mountain as a symbol of man's coming self-realization, who informed Taut's *Alpine Architecture* most directly.[162] Yet Taut's approach was also post-Nietzschean as well. For in grasping for the crystal heavens, Taut wilfully ignored Nietzsche's insight that "it is with man as it is with the tree. The more he aspires to the height and light, the more strongly do his roots strive earthward, downward, into the dark, the deep—into evil." Here Taut's authority

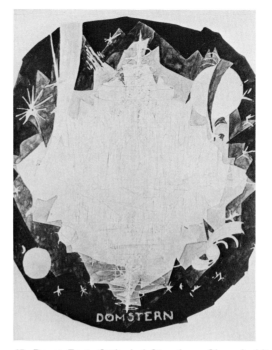

45. Bruno Taut, *Cathedral Star*, from *Glass Architecture and Alpine Architecture*.

was Peter Kropotkin, the Russian thinker who had rebutted the two central theses of Social Darwinism: "Darwin's [really Spencer's] law of the survival of the fittest he countered with the principle of mutual aid in nature and history. Against Malthus' theory of the arithmetical progression of food production and the geometrical progression of population increase he put forward the idea that, given the right kind of social organization, agricultural output could be stepped up sufficiently to keep pace. . . . It was Kropotkin's ideas, from the abolition of the state right down to the electrification of household technology, that Taut illustrated in *The Dissolution of Cities*."[163] In these utopian sketches, Taut completely fused a creative with a social vision.

Also in 1919 Taut went on to organize a round-robin exchange of letters, carbon copies, and photostats among some fourteen architects and painters. The exchange was called "the utopian correspondence," while the group itself was soon dubbed the Glass Chain; in 1920 Taut began publishing excerpts from the correspondence in his short-lived magazine *Frühlicht* (or "Dawn"). Typical of the Glass Chain's rhetoric was this passage from a 1919 letter by the architect Hans Scharoun: "Our work is the ecstatic dream of our hot blood, multiplied by the blood pressure in the millions of our fellow human beings. Our blood is the blood of *our* time, of the possibilities for expression in our time."[164]

46. Caspar David Friedrich, *The Cathedral,* oil on canvas, ca. 1818. Samm-lung Georg Schäfer.

In addition to Taut there were others intent on radical architectural renewal. Quite influential was the critic Adolf Behne, particularly in his 1919 book *The Return of Art.* Behne saw the French style of Cubism as a spiritual style, as one appropriate for *all* the arts: "[Cubism is] a secret striving towards a final unity. . . . The Cubists reveal a will towards a higher unity through the feeling of world-love that resounds ceaselessly out of its finest works." Moreover, Behne too saw glass architecture as a means of post-Nietzschean revaluation: "Therefore the European is right when he fears that glass architecture might

47. Lyonel Feininger, *Cathedral of Socialism,* woodcut, 1919.

become uncomfortable. . . . Only where comfort ends does human-ity begin. . . . Glass architecture rules out the dull vegetative state of jellyfish-like comfort in which all values become blunted and worn, and it substitutes a state of bright alertness, a daring activity, and the creation of ever fresher, ever more beautiful values. . . . Glass archi-tecture is going to eliminate all harshness from the Europeans and replace it with tenderness, beauty, and candor."[165]

Behne and Taut had much in common. Together they had helped organize the Working Council for Art (Berlin, November 1918), and were among the group's first officers. The title *Arbeitsrat* or Working Council was chosen to evoke the notion of *Arbeiterräte*—workers' councils or "soviets"—by which workers were represented in Com-munist Russian government. In principle, all "intellectual workers" in the different crafts and professions belonged to the Working Council for Art, without regard to specialization or advanced training. This can be seen in one of the Council's programs, the "Exhibition for Un-known Architects," organized by Walter Gropius and opened in April 1919. Even men without architectural background were invited to submit projects, and some non-professionals like Hermann Finsterlin

were discovered in this way. In addition, the painters César Klein (once with the Neue Secession) and Johannes Molzahn (soon to join the Novembergruppe) exhibited visionary projects in Cubist/ Expressionist styles.[166]

But Gropius himself became a leader of late Expressionist art through yet another utopian project, also announced in the month of April 1919. This was described in Gropius' *Proclamation of the Weimar Bauhaus*. "Let us create a *new guild of craftsmen*," Gropius wrote, "without the class distinctions which raise an arrogant barrier between craftsman and artist. Together let us conceive and create the new building of the future, which will embrace architecture *and* sculpture *and* painting in one unity and which will rise one day toward heaven from the hands of a million hand workers like the crystal symbol of a coming new faith." It is important to stress that during its opening years from 1919 to 1922 the activities of the Bauhaus were essentially Expressionist. As one observer has commented, "It is all very weird— . . . the Gropius of Fagus [starting] an Expressionist guild."

Given its utopian context, in fact, we can better understand the woodcut cover to Gropius' proclamation, the so-called *Cathedral of Socialism* by Lyonel Feininger, along with its Romantic source in Caspar David Friedrich's painting of *The Cathedral* (figs. 46, 47). In first publishing this comparison, Robert Rosenblum saw the Feininger as the last in a series, begun by Friedrich, "in which a Gothic façade is seen in frontal symmetry as a symbol of triumphant spirit and aspiration. . . . [Friedrich] transforms these monuments of religious architecture into transcendental emblems, free from the laws of engineering and gravity, and borne by heavenly light."[168] Even in its Cubist style, which Behne would see as a Romantic "striving towards a final unity," Feininger's woodcut perfectly embodies that visionary quality which Gropius called a "crystal symbol of a coming new faith."

Feininger's *Cathedral of Socialism* thus fuses two Neo-Romantic traditions: the heritage of the Gothic, increasingly treasured after 1914, and the fascination with crystalline Cubism and Orphism that had emerged just before the war. We recognize a marriage, once again, of an aesthetics of inwardness and an iconography of transcendence (see sec. 2.5 above). For both Macke in 1914 and Feininger in 1919 the path *away* from Expressionism now lay open.[169] But this is not surprising in Feininger's case. For his original artistic motivation had not been Expressionist renewal at all. Instead, as he had written as early as 1905, he had always been seeking a kind of sublimely Romantic vision:

Reflecting windows—no one ever suggested this to me; it is all mine. . . . Even as a little boy in the country, I used to love them. That will be a whole series of pictures! Sunset, all in gold and violet half tones, and in one spot, right in the very far distance, half hidden by trees, two or three rows of windows facing west that throw the gold of the sky back like spears—transposing the whole image into indescribably

beautiful tones. In the already dying eastern sky—the "good night" sky—there are suddenly pieces like jewels out of the sun-drenched, glowing western sky, just put there quite frankly and daringly—to me this violent confrontation of two different skies always held some mysterious beauty.

Somewhat like Nolde, then, the mature Feininger drew on subjective childhood experience—in this case, an American childhood in New York and Connecticut where he had lived until he was sixteen. His love for the sublime in nature had led him to seek, in Rosenblum's words, "the sacred in the modern world of the secular."[170]

In addition to the Working Council for Art and the Bauhaus, the early postwar months also saw the formation of the Novembergruppe ("November Group"), an organization led by the painters Max Pechstein and Georg Tappert. Johannes Molzahn exhibited with this group, but not before he published his own utopian proclamation in September 1919, *The Manifesto of Absolute Expressionism*. These were several of Molzahn's sentiments: "Out of ruins and fragments we prepare our work; doing battle, we want to force our way to the stars. There is no I—nor YOU—anymore. Everything—purpose, goal—inhibits flowing ETERNITY."[171]

And finally, in Dresden, the Gruppe 1919 ("1919 Group") was founded by a group of painters including Otto Dix. Caught up in the utopian fervor of the moment, Dix made his visionary statement in the form of a painting known today simply as *Pregnant Woman* (plate 10). But it is evident that the woman stands astride a cow, while her eyes, breast, and raised left hand contain the stars of a deep blue firmament. The reference is probably to the "dairyland goddess of the cow, Ninhursag"—a Sumerian goddess who was "equally present in the heavens above, in the earth beneath, in the waters under the earth, and in the womb."[172] Nevertheless, it is unlikely that Dix wants the figure to be interpreted literally. Understood mythically, however, she becomes a mother goddess of universal scale, known even in the arts of Neolithic man.[173] And so she too exemplifies the visionary rhetoric of late Expressionism, by symbolizing nature as the "eternal creatrix" and the vehicle for "worlds" and "nebulae" (Taut, 1919).

These sentiments and art works are part of the long awaited "revaluation of values," a culmination of German Expressionist hopes over the previous dozen years. This was supposedly a renewal of art and architecture, of man and society; an alleged new dawn following the long night of death, destruction, and despair. Yet the renewal remained strangely abstract. It did not address itself to ways and means, to issues of technique and ideology, by which myths were to become realities. As Karl Scheffler put it, in reviewing a book by the Working Council for Art: "all this is not a beginning; it is the end, it is the last stage of collapse; this generation is as yet incapable of creating a sound modernity. In this book several artists and authors have dealt with utopias, mostly architectural utopias. Should one imagine that they would be realized and that one would have to live in such a cultural center of the future, one begins to look for a rope to hang oneself.[174] The dream of transcendence was a Romantic dream, in

short, not Nietzsche's tough-minded remaking of the German spirit. It was suddenly modish escapism, not moral catharsis.

It is impossible to avoid the suspicion that Otto Dix understood this fact very well. His *Pregnant Woman* borders on caricature: one breast descends to just above the buttocks, while an arc behind the head describes a superfluous marriage veil. Moreover, the painting would have nothing to do, if taken literally, with Dix's post-1919 iconography—which leans heavily toward images of satire and corruption (cf. fig. 167). Like several other Dix works from 1919, in short, this one displays an "ambiguous meaning."[175] However unintentionally, Dix manages to satirize precisely what he seems to praise.

The situation is only a bit different with Max Pechstein's 1921 woodcuts to *The Lord's Prayer*. In *Give Us This Day Our Daily Bread* (plate 11), to be sure, there is no attempt to caricature the four men around a table. Cap and dark shirts identify the men as workers, and the emptiness of the table suggests the poverty of their diet; the theme goes back to the 1885 *Potato Eaters* by Vincent Van Gogh. Nevertheless, there is something grotesque in treating the four adult men as if they were so many chicks in the nest, looking up with expectant lips for the proffered worm from their mother. It has been said of these Pechstein woodcuts that "[his] Expressionist style does not arise out of an inner urge for creative analysis but is laid on, superimposed on the material."[176] Pechstein's Expressionist iconography, too, is superimposed rather than being integral to the theme. The stretched necks and grimacing heads of the two lower men accord not at all with the flat and stylized shapes of their bodies. And the smiles of the two upper men absolutely deny the rough poverty of the scene. The view of religion that is presented to us here is one of sentimentality, not strength; an infantilization of the worker rather than his transfiguration.

Perhaps the only authentic religious subject to come after Schmidt-Rottluff's 1918 *Christ* cycle, and certainly one of the last great spiritual statements of the German Expressionist movement, is *The Red Christ* by the sixty-four-year-old Lovis Corinth (fig. 48, plate 12). Less than half the size of a *Crucified Christ* in a 1910 altar triptych (not illustrated),[177] the 1922 work is considerably more vital in expression, active in pose, and dramatic in coloration.[178] Why should this be so? Indeed why should Corinth's lifelong German Impressionist style give way, after his sixtieth birthday, to a powerful Expressionism at all? One answer is that Corinth was belatedly influenced by Kokoschka's recent work;[179] but this does not fix the shift in 1918 rather than before. More germane is Corinth's own explanation of a psychological change he experienced in the latter year. For he apparently felt the fall of Germany's second empire as a loss of part of his own identity: "I have spoken, written, and interceded on behalf of German art and before the world war I was convinced that German art would surely outshine the French in excellence. . . . [But] just as in childhood I had lived through the Hohenzollern dynasty and the rise of Prussia [to German leadership], nay, still more than this, just as with full consciousness as a man I had experienced the government as the only greatness, so [with the fall of that government] was the

48. Lovis Corinth, *The Red Christ*, oil on canvas, 1922. (See also plate 12)

ground pulled out from under my feet."[180] Corinth wrote these words in 1922, the same year that he painted *The Red Christ*.

As with Max Beckmann's slightly earlier *Resurrection* and *Night*, then, there is an autobiographical dimension to Corinth's Expressionism. We even find similarities in facial features and in lighting between *The Red Christ* and two *Self-Portraits* of 1922 and 1923.[181] Also possible is a visionary process not unlike that by which Corinth later conceived his 1925 *Ecce Homo* (not illustrated).[182] Just as in the latter year he believed he had met Christ in the form of a beggar and had wanted to kneel before him,[183] so the 1922 painting may have been activated by a similar vision originating in "the sorrowful ego."[184] But even if *The Red Christ* is not visionary in this literal sense, it is certainly the result of the artist's self-identification with the man of sorrows.

Given this sense of personal suffering, however, the painting's color and facture are all the more surprising. For the sky is a multi-

colored turquoise, yellow, red, and violet, while the paint is applied in brushy impastos and rapid scumbling strokes. The richness of surface belies the somberness of theme, as if the subject were not a bloody icon but a sensuously painted nude. And Corinth himself at about this time confirmed the underlying sensuality of his style: "Just as music in man and in birdsong originates strictly speaking only in sexual feeling, so painting too is purely sensuous expression. I can perhaps say that purely as a painterly concept eroticism is the most elevated and the most difficult to master. . . . Precisely because it . . . signifies an art of pure sensation, it must for this very reason call forth something noble and exalted in every human being."[185] If a contemporary critic was right in basing Corinth's art in an "animal lust for painting,"[186] then *The Red Christ* achieves its extraordinary tension precisely by its sensual approach to matters religious. The painting is a truly Expressionist, not a romantic, revaluation of values. Like numerous earlier works in the German movement, it seeks the security of spirit in the vagaries of flesh.

2.8. THE LESSONS OF CONTRADICTION

In retrospect it can be said that among the primary motivations of German Expressionist artists was the wish to *épater le bourgeois,* to surprise the staid sensibilities of the nineteenth-century Victorian mind. The challenge took two forms: first, an overthrow of the sexual mores of the German middle-class family and, second, an attack on the religious values of the German Christian tradition. The Expressionist challenge was successful on both counts. By the beginning of the Weimar Republic in 1919, if not before, traditional German values had been rudely shattered. In barely a dozen years Expressionism had created a new agenda for advanced art—an agenda which included the radical problems and opportunities raised by post-Victorian sexual liberation and by post-Christian religious experience.

But while Expressionists deserve much credit, it is clear that their initiatives depended upon the philosophic, scientific, and literary ideas of the previous generation. These ideas were intrinsically ambivalent. They were the product of a Europe-wide period of transition known variously as Symbolist, Neo-Romantic, and Post-Impressionist. The transition was between old, fixed traditions and new, untested values in many fields of social and cultural endeavor. Moreover, the ambivalence of these ideas arose precisely from uncertainty whether it was good or bad that traditions should crumble, good or bad that innovations should occur so rapidly in so many areas at once. Expressionist art came into existence at just this juncture between renewal and decline, between a feeling of beginning and a sense of an ending.[187] For every Whitman there was a Weininger, for every Steiner a Schreber, for every Kropotkin a Panizza. And just behind them loomed the great exemplars of cultural contradiction— Nietzsche and, to a lesser extent, Wagner and Dostoevsky, Ibsen and Strindberg.

If Expressionism is an art of ideas, however, it distinguishes itself from other ideational art movements in one particular respect. This is its ambivalence or contradiction in matters of content. For Expressionist art does not evoke ideas unequivocally; when it does, in fact, it is no longer Expressionist. Thus we would argue that Hodler, Munch, and Klimt remained Symbolists in most of their work. Even where one of their paintings may contain several different meanings (biographical, emotional, literary), these meanings significantly reinforce one another.[188] We have seen how several works by these artists reflected Maeterlinck's fascination with death, for example (figs. 1, 2, 11, 12); to the extent that these paintings did not admit true ambivalence they did not *enter* the Expressionist movement at all. In a similar manner we have suggested that Expressionist artists may discover, in unequivocal content, a way *out* of the movement. They stand on the verge of Neo-Romanticism, for example, when they yield to the awe of the sublime. Just so did Macke respond to Delaunay and Feininger to Friedrich (figs. 34–35, 46–47) and, in such responses, leave Expressionism behind.[189]

Expressionism without ambivalence, it now appears, is impossible. This is why the Expressionist art work does not simply "embody" or "reflect" ideas. Instead it provides an emotional attitude *toward* ideas that effectively "interiorizes" or "relativizes" them. Though attitudinal boundaries are never entirely clear, we may distinguish three such Expressionist responses to precedent ideas: (1) the exaggeration or satirization of a source, usually by enlarging one of its unstressed implications (the "caricatural" attitude); (2) the partial negation of a source, usually by reversing or undermining it in some respect (the "reactive" attitude); and (3) the contrast of antithetical meanings, usually by playing off different sources against one another (the "contradictory" attitude). It is these three attitudes, separately and in combination, that seem to determine the iconography of German Expressionist art.

Caricature is not necessarily Expressionist, though as "a projection of an inner image" it is often associated with Expressionism.[190] We have seen the caricatural attitude at work in Kubin's distortion of Schopenhauer and Steiner (fig. 16), in Kokoschka's brutalization of Strindberg (fig. 18), in Meidner's pastiche on Schreber (fig. 26), in Grosz's satires on Panizza and Wagner (figs. 40, 10). But we have also seen the attitude emerge in one artist's treatment of another, as in Dix's apparent satire on the utopian Taut or in Pechstein's exaggeration of an image by Van Gogh (plates 10, 11). There is an active or even aggressive intention to the caricatural attitude,[191] although the subject matter being dealt with—for example, Meidner's or Pechstein's—may be in part passive or even masochistic.

The principle of reactivity has been defined as "a two-stage process in which dependency is followed by self-assertion."[192] Thus the reactive attitude is exemplified in Kirchner's partial reversal of Munch's pessimism or in the same artist's idealization of a theme treated grimly by Weininger (figs. 12, 13, 36). It is also seen in Schiele's ironic undermining of the idealism of Klimt and Hodler (figs. 19, 20, 38, 39). The attitude is prominent in Kokoschka's complex

responses to major themes by Wagner and in Beckmann's largely secular reactions to his fifteenth-century religious source (figs. 30, 31, 42, 43). It is important to stress that while the reactive attitude is subjective, it is not on that account predictable: as the cases of Kirchner and Schiele suggest, the reaction to gloom may be a partial idealization while the response to idealism may be a partial irony.

The contradictory attitude, though the most difficult to demonstrate conclusively, is probably the key to the other two. Starting with the Nietzschean antithesis between "nihilism" and "countermovement," in other words, the Expressionist must have felt the need to oppose precedent views by satirizing, idealizing, or otherwise reversing them in his own work. The process was all the simpler when authoritative sources themselves disagreed—as was so often the case around 1900. Thus Marc's view of "animalization" may well pit Goethe against Darwin, while Nolde's view of religion contrasted Nietzschean instinctuality with the merely naturalist narratives of Berlin Secession painters (figs. 17, 23, 24). Meanwhile Kandinsky sought to contain the strife of Steiner and the concord of Merezhkovsky, and Heckel tried to bridge Dostoevsky's message of suffering with German views of transcendence (figs. 6, 27, 32, 33). For Schmidt-Rottluff the contradiction between the daemonic and the divine was found within the writings of Otto alone, while for Taut it was Darwinist struggle versus Kropotkin's principle of mutual aid (figs. 41, 45).

Of course, if the three attitudes of ambivalence helped dictate Expressionist iconography, there is the possibility that they also helped determine Expressionist style, and even Expressionist politics or social psychology. The defining of Expressionist attitudes, elementary though these definitions may be, is only the first step toward an understanding of Expressionist creativity. It is to the more complex issues of style and psychology that we now turn in ensuing chapters.

3.
Style

Generally the wish to repeat the past has prevailed over the impulses to depart from it. No act ever is completely novel, and no act can ever be quite accomplished without variation.

GEORGE KUBLER

3.1. SELF-DISCOVERY THROUGH SELF-SURRENDER

In earlier chapters Expressionism was described as post-Nietzschean and post-Victorian; it now must be defined as Post-Impressionist as well. Expressionism comes not only after and out of Impressionism, but is also to some extent its countermovement. French Impressionism was the model for the German movement's independence of vision, its departure from academic norms, and its revitalization of brushstroke and color. But the very word "Expressionism" came into common use as a counterweight to the label "Impressionism"; it signified subjective and not scientific qualities, inner rather than outer values (see sec. 5.1). Like Fauvism or Futurism, Expressionism originated as a particular direction—the German direction—within European Post-Impressionism.

Nevertheless, Expressionist style can be described not only antithetically but also parenthetically. Expressionists themselves saw their art as transitional, as lying between the great styles of the past and those yet to come. In this sense Expressionism connotes less an anti-Impressionism than a kind of momentary "non-style": "But the artistic style that was the inalienable possession of an earlier era collapsed catastrophically in the middle of the nineteenth century. There has been no style since. It is perishing all over the world as if seized by an epidemic. Since then, serious art has been the work of individual artists whose art has had nothing to do with 'style' because they were not in the least connected with the style or the needs of the masses. Their works arose rather in defiance of their times. They are characteristic, fiery signs of a new era."[1] Franz Marc's words manage to define Expressionism as an in-between stage, as successor to Western mimesis and as anticipation of a coming spirituality but as a confirmation of neither. Still, even such a transitional art must possess its own style; even if not based in the "needs of the masses," Expressionist style reflects many common assumptions of German vanguard artists at the end of the Wilhelmian era.

What Marc meant, I think, is that Expressionism was opposed not so much to style as to form, and to innovation as defined by form. As Marc put it in 1915, artistic success rested on feeling rather than form: "One has only to listen to one's own conscience—he who honestly asks will be told when the feelings that he expressed in his paintings were genuine and when he contented himself, frivolously, with empty formalistic shapes." Or again, as Paul Klee wrote in 1920, Expressionist formal problems are secondary because they are rooted in Expressionist content: "these are very important formal issues,

crucial to wisdom about form, but not art in the highest sense." Or finally, as Werner Haftmann later affirmed, Expressionists were in danger of formlessness: "They indulged in rhetoric and neglected form." It would be pointless to look for formal innovation per se in Expressionist art. When we find a Divisionist use of color or a Futurist grid of force-lines, we may usually find their precedents in non-Expressionist sources. With D. H. Kahnweiler we can agree that Expressionists tended to misread the "constructivist distortion" of Cubist pictures as a kind of "expressionist distortion."[2] The most that can be said from a formalist point of view is that Expressionists were borrowers from other styles of art and that Expressionist style is thus, in this sense, eclectic.

In another sense, however, Expressionist borrowing is the very hallmark of Expressionist style, and the key to understanding it. Writing in 1911, Wilhelm Worringer actually elevated stylistic dependency to a central position in German art history from Dürer to the Expressionists:

> If I understand Vinnen correctly, it is not the great classic Impressionists like Manet, Monet and Renoir from whose influence he would protect German art, but rather the so-called young Parisians who proceed from Cézanne, Van Gogh and Matisse in the search for a new mode of artistic creation. . . . [But] let me comment briefly on the national aspect of the question. He who is really knowledgeable about his Germanness, who is familiar especially with the historical evolution of German art, and who knows that given our congenital difficulty and uncertainty with sensual instincts it is not traditional for us to find a direct way to our own artistic form, he knows that we always have to take our cue from abroad, that we must always first surrender and lose ourselves in order to find our own self. From Dürer to Marées that has been the tragedy and greatness of German art, and he who would cut our art off from the dialogue with other art worlds would renounce our own national tradition.[3]

Worringer here uses a Nietzschean turn of phrase: self-discovery through self-surrender as a kind of *Uebergang* through *Untergang*. But his meaning is clear, namely that German modern art would find its style only through interaction with that of other nations.

This tells us something fundamental about German Expressionism. Stylistically speaking, there is a void at the center. Kandinsky knew this. And that is why he was willing to condone stylistic borrowing so long as it expressed each artist's "inner truth" or "internal necessity":

> I must be precise here. It is often considered a crime and fraud by critics, by the public, and often by the artist, to use the forms of others. This, in fact, is only true when the "artist" uses these forms without an inner necessity and creates a lifeless, dead, spurious work. If in order to express his inner impulses and experiences, an artist uses one or another

"borrowed" form in accord with inner truth, he then exercises his right to use every form *internally necessary* to him—a utilitarian object, a heavenly body, or an artistic form created by another artist. The whole question of "imitation" is also far from having the importance attached to it by the critics. The living remain. The dead vanish.[4]

What Kandinsky called inner necessity we have now identified as the reactive principle: dependency followed by self-assertion. The Expressionist used existing forms rather than inventing new ones. He proceeded not by the imitation of a source but by a transformation of it, in other words by a reactive process of simultaneous acceptance and partial modification or rejection.

We have already encountered Expressionist reactivity in the relation of Kirchner's *Street* to Munch's *Evening on Karl Johan Street* (figs. 12, 13). The sharply foreshortened ground plane is made steeper but also painted a bright pink; the disturbing eyes stare out of more handsome faces; and the dark, flowing contours are now accentuated by ribbons of red paint squeezed from the tube. Other examples in which the reaction takes the form of caricature include Kokoschka's 1909 *Poster* in relation to Michelangelo's *Rondanini Pietà,* and Beckmann's 1918–19 *Night* in relation to Pleydenwurff's *Descent from the Cross* (figs. 18, 42, 43). Here Expressionist works exaggerate anatomical, spatial, and coloristic features that had not been so stressed in their sources. Finally there are cases of stylistic ambivalence, where the Expressionist reaction depends upon both vanguard and traditional models, French and German prototypes. Such an example is Feininger's *Cathedral of Socialism* (1919) in its response both to French Cubism and to Caspar David Friedrich's *Cathedral* of a century before (figs. 46, 47).

Expressionists were influenced by a wide variety of style sources, which can be divided roughly into the following six classes:

1. Late Impressionism, Symbolism, Jugendstil
2. Fauvism, Cubism, Orphism, Futurism
3. German Gothic art, German Romanticism
4. Tribal art: both African and Oceanic
5. Folk art, naive art, children's art
6. Non-Western art: Islamic and Oriental

There are, in the end, two ways to subdivide these classes. First, according to Worringer's principle of national style origin: German models tended to replace Latin sources only after the war's outbreak, and Islamic and Oriental prototypes tended to signify Eastern renewal following Western decline—but only at the war's end. And second, according to Kandinsky's principle of the "living" and the "dead": the last three classes of primitive, archaic, or low art sources contained a more or less powerful vitalist impulse, while the first three classes of vanguard or national high art styles were more or less highly structured.

The latter distinction seems central to Expressionist style. Primitive and vanguard sources were equally important for Expressionists, but

artistic reactions to each differed. The vitalizing tendencies could be accentuated, sometimes to the point of caricature, while the structured styles would often be undermined to the point of destabilization. Most interesting of all, vitalizing and structured elements could be contained, and played off against each other, in individual works. At its best, Expressionist style communicates its ambivalence between structure and vitality, order and disorder, directly to the viewer. It is this ambivalence, this "inner truth," that ultimately justifies the artist in his borrowings.

With German Expressionism, then, can we speak of an anxiety of influence? Can we say, to paraphrase Harold Bloom, that a painting is a painter's melancholy at his lack of priority?[5] I think not. On the contrary, Expressionists are usually creators—like Nietzsche and Goethe—who "absorbed precursors with a gusto evidently precluding anxiety." Moreover, it was the *absence* of great German painters in the century preceding theirs that forced Expressionists to look elsewhere for worthy models. Indeed, in Nietzsche's words, "When one hasn't a good father, it is necessary to invent one."[6] This is just what Worringer meant when he wrote that Germans must take their cue from abroad.

3.2. DRESDEN: THE BRÜCKE, 1905–11

The Künstlergruppe "Brücke" started in June 1905 as a group without a style. Bleyl and Kirchner earned their architecture diplomas that month while Heckel and Schmidt-Rottluff, just beginning architecture study, were interested in literature and philosophy. Only Kirchner had formal art training: two semesters in Munich in 1903–04 at the High School for Art and at Wilhelm Debschitz and Hermann Obrist's private Atelier for Fine and Applied Art. But by 1905 even Kirchner, like his Dresden colleagues, was still interested in the contradictory tendencies of Impressionist naturalism and Jugendstil patternization.[7]

Kirchner's *1001 Nights Illustration* (fig. 4), for example, places in a Jugendstil border a boldly patterned interior with a nude couple. Probably drawn from imagination, the spontaneously sketched lovers nevertheless profited from Brücke drawing sessions known as *Viertelstundenakte* or "fifteen-minute nudes."[8] Heckel's *Friedrich Nietzsche* woodcut (fig. 3), by contrast, derives from an 1899 etching which Hans Olde made from a life photograph he took that year.[9] Unlike his source, however, Heckel arbitrarily casts the temple, cheek, and chin in deep shadow. Schmidt-Rottluff's woodcut, *Am the Child of Poor People* (fig. 120), is the most sensitive of these 1905 works. Impressionist in its lighting, the print nevertheless evokes the Brücke's precedents of "Vallotton and the Japanese" remarked by a contemporary reviewer.[10]

Stylistic indeterminacy began to give way, however, in 1906, largely due to the impact of a show of fifty paintings by Vincent Van Gogh which came to Dresden in November 1905. In responding to Van Gogh, Dresden artists consolidated German Expressionism's earliest style—one also known as the Brücke's first "collective style."[11]

Their response was historically significant. Van Gogh had been a prophet without honor in his adopted land of France, and did not fare much better in turn-of-the-century Germany. In Julius Meier-Graefe's *Evolution of Modern Art* (1904), for example, the "four pillars" of modern painting had been listed as Manet, Cézanne, Renoir, and Degas; Van Gogh was discussed mainly in the "circle of Millet."[12] And yet by 1912, in the influential Cologne Sonderbund exhibition, Van Gogh was devoted pride of place with 125 works, including 108 paintings. What the Brücke discovered in Van Gogh, and what the Sonderbund belatedly confirmed, was the fact that he showed the way out of the Impressionist cul-de-sac of "scientific" color and "optical" naturalism. He embodied emotion in painting (this was clear from his letters, first available in magazine translations in 1905), but he also established through his patterned strokes a strong claim on the decorative or even the abstract in art.[13]

Van Gogh's so-called *Sunset* of 1889, now in the Kröller-Müller Museum under the title *Rising Moon: Haycocks,* was almost certainly the one shown in the 1905 Dresden show;[14] it is thus the most likely source for Erich Heckel's 1906 composition also titled *Sunset* (figs. 49, 50). Heckel's clumps of foreground foliage resemble Van Gogh's loosely piled haystacks, while a few horizontal accents in the German work even mimic the middleground gray wall in the French oil which was once, mistakenly, called a river.

What is astonishing, however, are the differences between the two works. Heckel heightens his sky with pure yellows and oranges while Van Gogh, reserving these hues solely for the sun, retains a more naturalistic blue, blue-green, and white for the sky. Similarly, for all their powerful patternization, Van Gogh's brown and yellow strokes define the recognizable tonalities of a newly mown field, whereas Heckel's bushes and trees relieve naturalistic greens with improbable reds and oranges. Related to this, it is precisely the patternization of the Dutchman's strokes that creates an effect of logical order, even of scientific Divisionism. Heckel's strokes, by contrast, burst asunder any tendency toward repetitive pattern. The streaks and squiggles are wild not just in hue, but also in directional relation to one another.

The net result of Heckel's borrowing is that the Van Gogh prototype begins to look rational and disciplined—if not, indeed, scientific—by comparison with the Expressionist's more tumultuous and erratic brushstrokes. The earlier work reveals its origin within the French Impressionist tradition. The later work, in borrowing from it, contravenes that tradition. Those who accused Heckel and his Brücke friends of excessive dependence on Van Gogh—and there were several[15]—missed the point of this dependency. In the eyes of German and Austrian Expressionists, Van Gogh was still largely a French artist who—like all French artists—sought to achieve a painted surface of structure and order. The point of early Expressionism was to destructure the structural aspects of that otherwise expressive style.[16]

During the Brücke's first or "Late Impressionist" phase from 1905 to 1908, French sources issuing out of Impressionism were more numerous and more influential than Northern or Central European

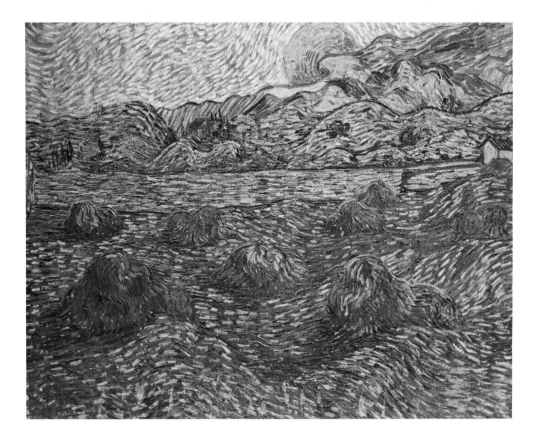

49. Vincent Van Gogh, *Rising Moon: Haycocks,* oil on canvas, 1889. State Museum Kröller-Müller, Otterlo, The Netherlands.

sources associated with Symbolism or Art Nouveau. This is evident simply from a list of modern art exhibitions held in Dresden during the Brücke's residence in that city:[17]

MODERN ART EXHIBITED IN DRESDEN, 1905–10

NOVEMBER 1905 (ARNOLD GALLERY): 50 paintings by Van Gogh

FEBRUARY 1906 (SAXON ART ASSOCIATION): 20 paintings by Munch

NOVEMBER 1906 (ARNOLD GALLERY): 132 works by Belgian and French Neo- and Post-Impressionists, including Seurat, Cross, Rysselberghe, Signac, Bernard, Denis, Vuillard, Bonnard, Vallotton, Gauguin, and Van Gogh

OCTOBER 1907 (ARNOLD GALLERY): 317 paintings and sculptures, additional drawings and prints, by Viennese artists including Klimt, the Vienna Secession, and the Künstlerhaus

MAY 1908 (RICHTER ART SALON): 100 paintings by Van Gogh

SEPTEMBER 1908 (RICHTER ART SALON): 16 or more French Fauve paintings by Vlaminck, Van Dongen, Marquet, Friesz, Puy, and Guerin

SEPTEMBER 1910 (ARNOLD GALLERY): 26 paintings by Gauguin

Edvard Munch influenced Ernst Ludwig Kirchner and Max Pechstein to an important extent in 1906–07, while Klimt was influential for Kirchner briefly in 1907–08,[18] but the Neo-Impressionists and Van Gogh were more broadly influential within the group through the summer of 1908.

Kirchner called Schmidt-Rottluff's 1907–08 style "a monumental Impressionism"[19]—really a late Impressionism—and the phrase is apt for such other Expressionists as Christian Rohlfs in 1907 and Emil Nolde as late as 1909 (plates 15, 5). But in each case the German artist transformed his French source, as Heckel had Van Gogh, by stressing the rawer aspects of late Impressionist color and facture. In a letter of January 1908, in fact, Heckel stated his need to replace "calm" with "passion": "That is my goal too—a calm, decorative effect; yet on the other hand everything pushes toward spontaneity and passion. . . . [Seurat] I found unsympathetic; for me, personal passion was missing. It was too academically calm, . . . [but] I admire Gauguin very much."[20]

50. Erich Heckel, *Sunset,* oil on canvas, 1907.

The Brücke's orientation toward advanced French painting reached a climax during its second or "German Fauve" phase, which lasted from 1908–09 until the group's move to Berlin in 1911. Here the sources—and mode of access to these sources—differed among the group's leading members, Pechstein and Kirchner. Pechstein visited Paris from December 1907 to the middle of 1908, and he managed to show three paintings at the Salon des Artistes Indépendants, which opened on 20 March 1908, though his entries were too late to be recorded in the catalogue.[21] At this show he would have seen paintings by all the French Fauves except Henri Matisse,[22] and there is stylistic evidence of his interest in the work of André Derain, Albert Marquet, Henri Manguin, and Kees Van Dongen. Not only might Pechstein have visited Manguin's studio, but he certainly met and befriended the Dutch-born Kees Van Dongen—who had exhibited with the Fauves in their pioneer Paris shows of 1905 and 1906. Thanks to this meeting, Van Dongen became a member of the Brücke in the winter of 1908–09, although without visiting Dresden, and Van Dongen's dancers and circus performers exercised an important influence on Pechstein as late as 1910.[23] As Georg Reinhardt has convincingly argued, Pechstein's sexually provocative *Dance II* (1910; not illustrated) derives thematically and coloristically from Van Dongen oils seen in 1908.[24]

Kirchner, too, saw some works by these lesser Fauve painters when they were exhibited at the Richter Art Salon in Dresden in Sep-

tember 1908, and there are certain thematic links between Van Dongen and Kirchner as late as 1911.[25] But unlike Pechstein, Kirchner was strongly drawn to the work of the oldest and most formally innovative of the French Fauve painters—Matisse himself. We know that Kirchner was visiting Berlin in early January 1909, during a one-man exhibition of Matisse's paintings, drawings, and sculptures, and that there are numerous Kirchner prints and paintings from 1909 and 1910 that give evidence of his encounter with Matisse's recent work.[26]

The similarities, and also the differences, may be seen by comparing Matisse's 1907 *Blue Nude* with Kirchner's *Girl under a Japanese Umbrella*, which he intentionally misdated "06" but actually painted in 1909 (figs. 51, 52).[27] The most startling similarity, of course, is the unnatural color. In the Matisse the intense blue modeling strokes are laid over scumbled pinks and greens, while in the Kirchner the modeling is in pink and turquoise but the basic flesh tone is a bright yellow. A more important similarity is to be found, however, in picture-spatial organization. For although Matisse has organized the upper torso and the thighs on two different axes—the torso diagonally and the thighs vertically—they are both considerably flattened and lie parallel to the picture-plane (the upward thrust of the buttock is contained by the palm frond above). Kirchner has done much the same thing, but he has managed to make his nude appear flatter still by providing a quasi-"Egyptian" arrangement of frontal torso and profile hips and legs (the sideward thrust of the buttock is contained by the left picture-edge). And in both cases the light nude is set off against blue-black shadows, with the shadow shapes both bluer and flatter in

73

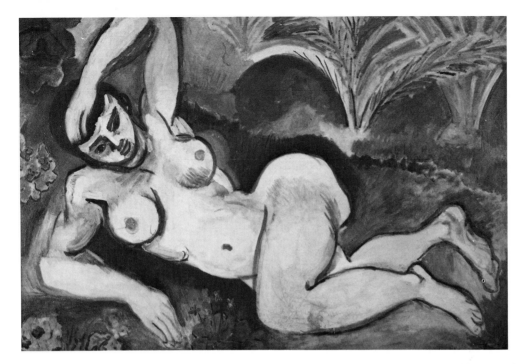

51. Henri Matisse, *The Blue Nude*, 1907. The Baltimore Museum of Art: The Cone Collection, formed by Dr. Claribel Cone and Miss Etta Cone, Baltimore, Maryland.

the German work than in the French one. Finally, when compared with the Fauve palm fronds, the Expressionist umbrella is painted more exuberantly. If the Fauve style is wild (*fauve* means "wild beast"), then the Expressionist style is still more arbitrary, more spontaneous, and more rudely constructed.

In terms of draftsmanship the Brücke's German Fauve phase has been divided into a "soft" style (1908–09) and a "hard" or angular style (1910–11).[28] The 1909 *Girl under a Japanese Umbrella,* like the late 1908 *Street* (fig. 13), are typical of the softer mode in presenting rounded shapes and generally flowing contours. Pechstein's *Brücke Exhibition Poster* (fig. 127) translates the style into the woodcut medium. The four faces are raised in light silhouette against a flat black ground, but the edges of cheeks, brows, eyes, and mouths are complexly curved in truth to life. The style is highly cursory but still based in nuance.

The angular mode makes its appearance rather abruptly in the middle months of 1910, and is associated with the group's increasing fascination with the tribal art of the Micronesian island of Palau, at that time a German colony. The change can be seen in Kirchner's *Exotic Scene,* a colored drawing sent as a postcard on 20 June 1910, and based directly on a Palau house beam in the Dresden Ethnographical Museum (figs. 53, 54). Kirchner's woman seated in a boat and his

nude male with erect phallus are drawn in a more brusquely angular style than the Palau carving itself. But in other respects the Oceanic beam carvings in the Ethnographical Museum offered "a parallel to his own creation," as Kirchner put it in his *Brücke Chronicle* (1913).[29] Both the Palau frieze and the Kirchner drawing are rigorously flat and two-dimensional. If we think of the red-and-black figures as "islands" and the yellow wood background as "mainland," then figures and ground are uniformly separated by light-colored "bodies of water": these light surrounds comprise thick grooves incised in the wood beam and firmly contoured white borders in the drawing. Since the islands lie flat and do not overlap the adjacent surrounds, they cannot suggest depth—either in the primitive carving or in the Expressionist postcard. In other works from 1910, such as Kirchner's color woodcut *Bathers Throwing Reeds* or Heckel's painting *Girl with Doll* (figs. 14, 15), the thick surrounds are black, but the figures and ground are similarly composed of colored shapes which do not overlap.

Of course there is also a thematic similarity between the *Exotic Scene* (1910) and the painted screen to the rear of the *Girl under a Japanese Umbrella* (1909). The female nude seems rotated ninety degrees to the left, while the adjacent males each sport an arrow-like erection, suggesting that Kirchner knew the Palau beams in 1909 and that his interest in them was as much erotic as stylistic from the start.

52. Ernst Ludwig Kirchner, *Girl under a Japanese Umbrella,* 1909. Kunstsammlung Nordrhein-Westfalen, Düsseldorf.

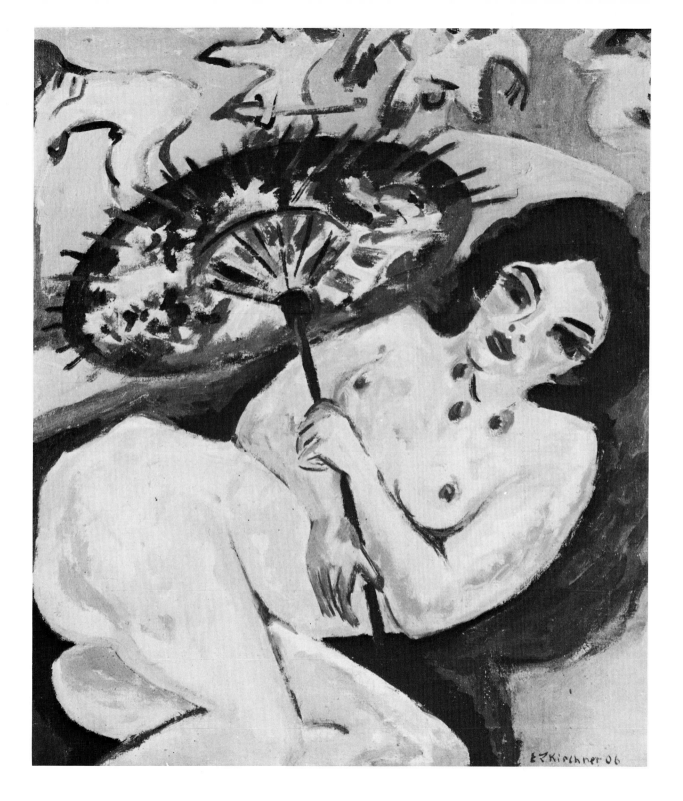

53. House beam, Palau Islands, nineteenth-century, painted and carved wood. Ethnographical Museum, Dresden.

54. Ernst Ludwig Kirchner, *Exotic Scene*, postcard (postmarked June 20, 1910). Altonaer Museum, Hamburg.

In other words, Brücke primitivism encompassed life style as well as art style.[30] But this does not change the fact that the Brücke's second or hard Fauve style approached the crude angularity of Palau beam carving only in 1910.

It might be objected that in the hard style of 1910–11 the Brücke finally found an expressive mode that was not derivative, that dependency in this case was *not* followed by self-assertion. But this is not true. Expressionists were not "savages," except in Franz Marc's intellectual sense that they possessed deadly "new ideas." As Gustav Hartlaub has suggested, tribal art was a "primary" mode of expression—unconscious, locally determined, and truly primitive—whereas Expressionist art employed a "secondary" approach which was "consciously" primitive or primitivizing "by choice."[31] In their handling of color, for example, Brücke paintings of 1910 owed more to Fauve than to Oceanic sources.[32] And in building on so sophisticated a precedent as Cranach's Renaissance *Venus,* Kirchner's *Standing Nude with Hat* directly opposed a tribal eroticism in the background with a fashionable European nude (figs. 165, 166).

Equally important, the Brücke *did* finally assert its mastery over—and independence from—Palau primitivism. This is apparent in comparing Schmidt-Rottluff's painted wood relief of *Two Female Nudes* from late in 1911 (fig. 55) with the Palau style. To be sure, Schmidt-Rottluff's figures are outlined by grooves deeply incised in the wood surface, thus capturing the planar flatness and the silhouette shape quality of the Palau relief mode. But the figures themselves are of unusual three-dimensional complexity. The woman on the left bends forward so that the black trapezoid of her hair approaches the black triangle of her pubic area. And the woman on the right, four times

55. Karl Schmidt-Rottluff, *Two Female Nudes,* painted wood relief, 1911. Brücke-Museum, Berlin.

overlapped by the limbs of her neighbor, is presented in a seated and awkwardly foreshortened pose. Nevertheless, Schmidt-Rottluff fuses these two torsos and eight limbs into a single orange shape, surrounded by a blue border and framed by an outer brown plane. Sophisticated three-dimensionality is nicely compressed within primitive flatness.

Despite his earlier enthusiasm for the Palau style Kirchner, too, moved beyond it by 1911. His new interest was the Buddhist cave paintings from Ajanta, India, which he discovered in an illustrated publication.[33] His excitement about the Ajanta imagery was prompted by just the kind of ambiguity between two and three dimensions that Schmidt-Rottluff was to display shortly thereafter. As Kirchner later wrote about the Ajanta frescos: "They are all plane and yet absolute mass and, accordingly, they have absolutely solved the mystery of painting."[34] A color illustration of a lady and servants from Ajanta cave XVII served as source for a drawing in the winter of 1910–11 and for a color woodcut from the fall of 1911 known as the poster for the "*MUIM-Institute*" (figs. 56, 57). In the drawing (not illustrated),[35] pencil smudges are used to model the woman's ovoid head, tubular arms, and spherical breasts. But in the course of 1911 he devised a zigzag hatching technique to model such rounded forms, both in his drawings and his paintings. By the time he made the woodcut Kirchner could translate this hatching into a spiky sawtooth pattern which combined the functions of flat decorative shape and tonal three-dimensional modeling—in this case of the breasts.

As the most form-oriented of the Expressionists, Kirchner understood the challenge the Ajanta frescos posed for advanced artists: "Their influence brings Europeans readily to sculpture, and one avoids this only by carving sculptures in wood. Also, by working in three dimensions one automatically arrives in the filling out of planes at the alignment of two dimensional curves. When one traces these curves back into the human figure, one is led back into the source— the inner life—that creates these forms and folds. Then begins the great struggle within oneself to express this in [appropriate] forms. With this one comes to one's real task."[36] Such statements make clear the fundamental ambivalence between sculptural and pictorial values, between representation and decoration, that lay at the heart of Expressionist style. They also suggest the motivation for the carving of near lifesize wood sculptures—by Heckel and Kirchner beginning around 1910–11 and by their Brücke colleagues a few years later. Finally, they suggest why the Brücke artists would soon be drawn away from the Palau relief style to the more volumetric shapes of figure sculpture from West Africa (figs. 102, 112).[37]

Kirchner's *MUIM-Institute* poster is a complex work of art. In its combination of exotic motif and drastically simplified form, it is unthinkable without the precedent of Gauguin's Tahitian work, which Kirchner saw at the Arnold Gallery in Dresden in September 1910.

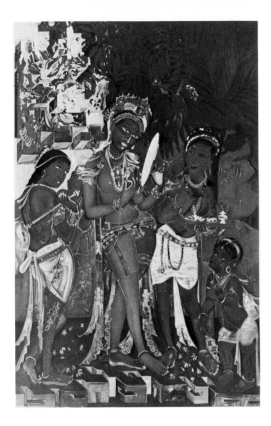

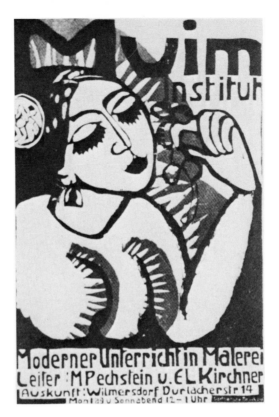

56. (left) Ajanta caves, India. A lady and servants, Cave xvii.

57. (right) Ernst Ludwig Kirchner, poster for the "MUIM-Institute," color woodcut, 1911.

But the woodcut still typifies the Brücke's German Fauve style; its planes of pink and black on off-white paper create a crude but highly graphic color pattern. Still, it was created within weeks of Kirchner's move from Dresden to Berlin, and so marks a transition from the Dresden hard style of 1910–11, angular and planar, to the more complex and volumetric configurations of the Brücke's Berlin period (see sec. 3.5).

3.3. MUNICH: NKVM AND BLAUE REITER, 1909–12

Unlike the Saxon capital of Dresden, a provincial if elegant court town, the Bavarian capital of Munich provided enlightened support for advanced art during the decades around 1900. Indeed the "secession" idea—following the example of the Society of Independent Artists in 1884 Paris—got its start in German-speaking lands in Munich in 1892. In that year a cabal of seventy-eight dissidents with-

drew from the Artists' Co-operative Society to form the Union of Fine Artists "Secession" (*Vereinigung der bildenden Künstler "Secession"*) with its own exhibition facilities. Well-known names among the founding members included the Impressionists Corinth, Israels, Liebermann; the Symbolists Carrière, Segantini, Stuck; the Jugendstil designers Behrens, Eckmann, Heine; and the Dachau colorists Dill, Hoelzel, Stadler. To be sure, the Secession was something of an establishment institution from the start, enjoying the patronage of the Bavarian Prince Regent and acting as a major showplace for fin-de-siècle art and design.[38] But the city itself was a renowned international art center—second only to Paris on the Continent—and accordingly attracted artists from all over Europe. Leading French painters exhibited in Munich or else, like Sérusier in 1905 or Matisse in 1910, actually came to work or to visit the city's splendid museums. And Munich was also a home away from home for emigré Russian painters and art students.

Chief among the latter was the Moscow-born Wassily Kandinsky, who at the age of thirty left a promising law career in Russia to take up painting in Munich in 1896. Despite his age (he was a contemporary of Munch and Klimt, three years older than Matisse), Kandinsky actively supported every radical development in German painting from the Jugendstil to the Bauhaus. Franz Marc before the war and Paul Klee afterward—men thirteen to fourteen years his junior—both con-

firmed that "during the crucial years of the rebirth of European art, Kandinsky was far in the vanguard and supplied them with the courage to go on."[39]

Yet two facts speak for Kandinsky's early remoteness from the kind of art that would soon be called Expressionist. First, he was a pioneer of abstract art; his importance for prewar European painting lies precisely in this achievement. And second, despite his leadership, there was no public display of specifically Expressionist painting in Munich until relatively late. The formation of Expressionist exhibiting groups in Dresden in 1905 (Brücke) or in Prague in 1907 (Osma) was not matched in Munich until 1909 (NKVM).

This was not necessarily for want of trying. From 1901 through 1904 Kandinsky led the Phalanx Society, an exhibition forum intended to bring to Munich the latest modern art. The exhibitions were still fin-de-siècle in tone, however. Indeed if the Munich Secession in the early 1890s had included four style directions—Impressionism, Symbolism, Jugendstil, and (through Hoelzel) incipient Abstraction—then the Phalanx continued to champion these same directions a decade later.[40] Moreover, these style directions were mixed in Kandinsky's personal development. In 1904, when he gave up the Phalanx organization, he was in the midst of an Impressionist phase. But there were already many signs of an increasing allegiance to Symbolism and Jugendstil.

Kandinsky's Symbolism was deep-rooted and still evolving. His concern with creation through destruction and his iconography of Deluge and Last Judgment are certainly Expressionist by 1909 or 1910 (see sec. 2.5). But his apocalypticism was always veiled in Symbolist ambiguity: like all true Symbolists Kandinsky would never describe the end of the world literally. "To name an object," said Mallarmé in 1891, "that is to suppress three-quarters of the enjoyment of the poem . . . : to suggest it, that's the dream." Or as the Munich Symbolist poet Stephan George put it in his Tapestry of Life (1901): "It will be revealed to many never and then never through speech / It may be revealed to a few but then through image only."[41]

Like George and his circle, Kandinsky also believed in the Gesamtkunstwerk—that "total work of art" which integrated poetry, stage, music, dance, painting, and architecture that was later to inform aspects of the Bauhaus curriculum. Kandinsky was close to Peter Behrens, co-founder of both the Munich Secession and the Darmstadt art colony, who was a leader of the theater reform movement after 1900. Such reform was to be anti-naturalistic, in Peg Weiss' summary: "Drama should be returned to its mystic-religious origins. It should be a celebration of life in which both audience and actors are creative participants. It should be a total aesthetic experience eliciting a total response."[42] The Russian regretfully declined Behrens' 1903 offer of a teaching post in the Düsseldorf Arts and Crafts School, but this did not prevent Kandinsky from designing stage costumes in 1905 and from writing "color-tone-dramas" from 1909 on. One of these, The Yellow Sound, was probably written for the vanguard Munich Artists' Theater, which had opened in 1908.[43] Finally, although not a musician, he also championed Schoenberg and Scriabin—causing articles by the one and about the other to be included in the 1912 Blaue Reiter almanac.

The Gesamtkunstwerk, following Richard Wagner's example, was essentially a Neo-Romantic concept. Yet the concept led inexorably, through Jugendstil theory, to the notion of an imageless (abstract, musical) art of pure feeling (expression, emotion). In the famous words of August Endell, the Munich Jugendstil designer: "We stand at the threshold of a totally new art, an art with forms that mean nothing, represent nothing, and recall nothing, yet which can move our souls as deeply, as strongly, as only music has previously been able to do with tones." Or again, in the words of a Munich art critic, "To borrow from the angry swan the rhythmic line and not the swan— that is the problem in ornamental usage." Or finally, in the words of Hermann Obrist, Endell's mentor, the new possibilities for modern art would lie in "deepened expression and emphasis on essence, instead of rapid impression."[44]

Despite his Symbolist and Jugendstil roots, however, Kandinsky was dissatisfied and restless; he still sought a style of his own. With the Berlin-born Gabriele Münter he began a series of trips that took him to Holland, Tunis (1904–05), Dresden, Rapallo (1905–06), Paris and Sèvres (1906–07), and Switzerland and Berlin (1907–08) before visiting the Bavarian alpine town of Murnau in August–September 1908. He settled in Munich permanently that fall, and, after Münter bought a house in Murnau early in 1909, the couple routinely summered in Murnau and wintered in Munich until 1914.[45] The first strongly Expressionist paintings come from the year 1908. Most subjects are from Murnau, though some must have been painted from sketches back in the Munich studio. The seventy-eight Kandinsky oils from 1908 are considerably more than the output of any other prewar year.[46]

Kandinsky's works contain vestiges of medievalism in 1906–07 and of Impressionism in the spring of 1908, but the Bavarian paintings of 1908 and 1909—like Brücke work of the same years—can be called German Fauve in style. The 1908 Riegsee Village Church, (fig. 58),[47] suggests the Fauve characteristics of these paintings. The color application is spontaneous. The brushstrokes used for foliage and sky are bold and sketchlike, yet never without pattern or rhythm. And the hues themselves are often quite bright. They are made to seem more intense, in fact, by their application over black or red underpainting. This characteristic—seen also in Kirchner's 1908 Street but not in French Fauve works—adds a rich chromatic resonance to Kandinsky's early Expressionist style.

A further Expressionist aspect to Kandinsky's 1908–09 style, however, has never received due emphasis—its startling, often even naive, simplification of shape. This development is due not to any French precedent but rather to a new interest in low art sources—children's drawings and Bavarian glass paintings—initiated by Gabriele Münter, who began making glass paintings in Murnau during the summer of 1908. As Münter later wrote: "It was [Alexei] Jawlensky who called our attention to Rambold and the Krötz Collection

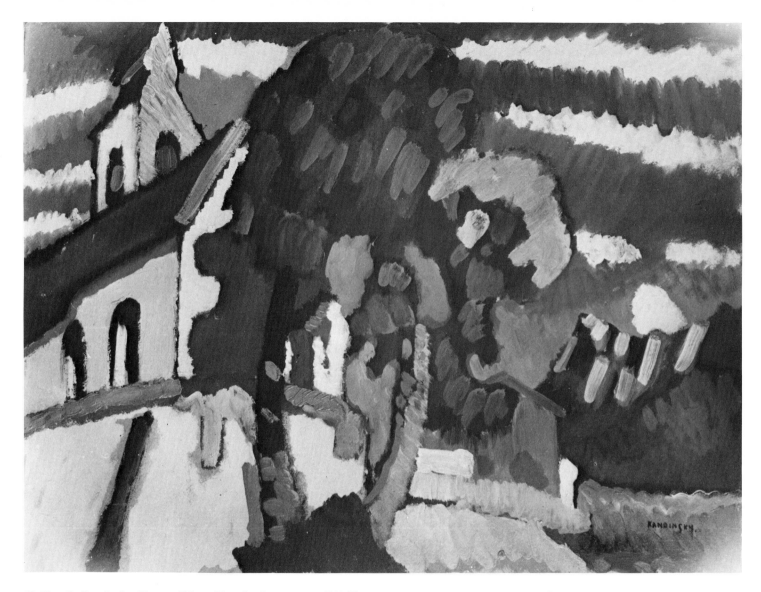

58. Wassily Kandinsky, *Riegsee Village Church,* oil on canvas, 1908. Von der Heydt-Museum, Wuppertal.

[of glass paintings]. We were all enthusiastic. From Rambold I learned how to make them. I was the first one—as far as I know—to take plates of glass and make them myself."[48]

That Münter was the first to discover children's drawings, though undocumented, is suggested by circumstantial evidence. First, she created a series of six linoleum-cuts entitled *Playthings* early in 1908 in Berlin and exhibited them in that year's Salon des Indépendants in Paris.[49] She may have intended to follow up the prints with illustra-

tions for a children's book.[50] Second, several examples of children's drawing dated in May 1908 were illustrated in the *Blaue Reiter* almanac of 1912 (see fig. 60). Someone in the Blaue Reiter circle must have been collecting children's art since 1908; in view of her *Playthings* prints, Münter was most likely that person. And third, by 1912 the affinities of Münter's art to children's drawings were publicly recognized by Paul Klee, who was himself fascinated by the genre. "Now and then Gabriele Münter," Klee wrote, "reminds one directly of children's art. By this means she has found the correct expression for her personality. A sensible person with a mischievous streak may rightly adopt this idiom." It seems likely that Kandinsky recognized Münter's gift for naive expression, and his own admiration for that gift,

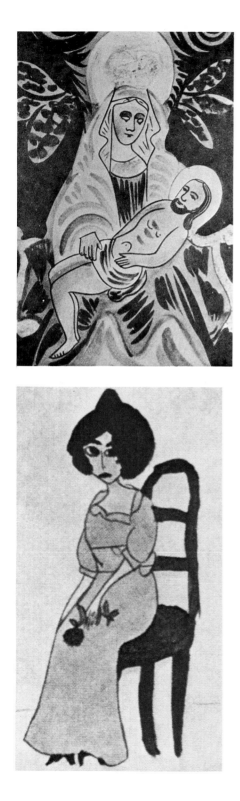

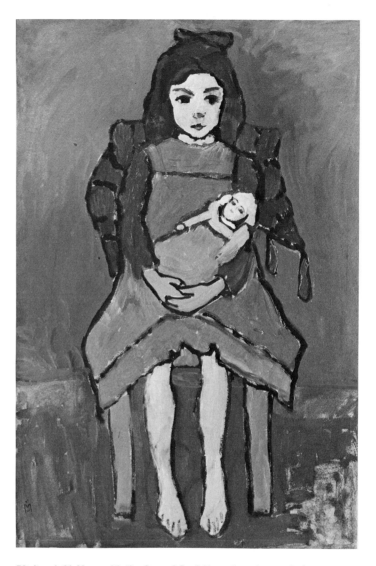

59. (top left) *Mary with the Son of God,* Bavarian glass painting.

60. (left) Children's drawing illustrated in *Der Blaue Reiter, 1912.*

61. (above) Gabriele Münter, *Girl with Doll,* oil on cardboard, 1908–09. Milwaukee Art Museum, Collection of Mrs. Harry Lynde Bradley.

when he wrote in the 1912 almanac: "The artist, whose whole inner life is similar in many ways to that of a child, can often realize the inner sound of things more easily than anyone else."[51]

In any event a Münter painting from 1908–09, *Girl with Doll,* bears direct comparison with a Bavarian glass painting and with drawings by children illustrated in the *Blaue Reiter* (figs. 59, 60, 61). Even a cursory comparison between the work of vanguard painter, folk artist, **81**

and child draftsman demonstrates the similarities in shape simplification and linear economy with which facial features, hands, and legs are drawn.

The similarity between the Münter and the folk art example rests primarily in the bold outlines. Indeed Münter's own glass paintings of 1908–09, closely based on Bavarian models, attain from the start a linear simplicity and expressiveness that are not seen in Kandinsky's glass paintings until 1911.[52] Yet the comparison between Münter's *Girl* and the Bavarian craftsman's *Mary with the Son of God* also shows the absence of those painterly flourishes which the folk artist employs, from long experience, in repetitive rhythms—for example, the six strokes for the Christ's loincloth, and the two arrays of five strokes each for the Virgin's dress.

In relation to the children's drawings Münter's work displays a similar awkwardness or naiveté. Still, her formal means of firm line and flat tone are even more severe and her image more rigorously frontal and more abstractly patterned than were her models; her precedent in this regard was the work of Vincent Van Gogh as recommended to her by Jawlensky during the summer of 1908.[53] Moreover, her girl's portrait is prettier and more age-specific than the schematic mode of children's drawing would permit. What Klee called Münter's "mischievous streak" lets her make out of the four parallel legs of girl and chair a witty identity (girls' legs are skinny, like chair legs) absent in the children's work. Münter's own style is thus more naive and more knowing, paradoxically more abstract and yet also more sentimental. Such ambivalence transforms her work from mere mimicry of low art sources into a complex, multi-leveled Expressionism.

In the genesis of Munich Expressionism, then, Münter was no longer the "student" of Kandinsky she had been in 1902–04: "By 1908 the teacher-student roles had changed; Kandinsky offered advice and encouragement rather than direction."[54] The changes in Kandinsky's style toward more "primitive" and childlike forms 1908–09 seem prompted, in the first instance, by Münter's initiatives in these directions. By 1910 these tendencies were reinforced by Kandinsky's interest in the Russian "Neo-Primitivism" of the Burliuk brothers, Mikhail Larionov, and Natalia Goncharova.[55]

A third aspect to Kandinsky's emerging Expressionist style, after the development of Fauve color and severely simplified form, was the introduction of what may be called "vibrating forms," which emerged from his fascination with certain Theosophic imagery beginning in 1909. This new stage can be illustrated by comparing "Music of Wagner," from Annie Besant and C. W. Leadbetter's *Thought-Forms,* which appeared in German translation in 1908, and Kandinsky's own painting called *Mountain* from 1909 (plates 13, 14, fig. 62).

Kandinsky not only owned the Besant-Leadbetter book, but he continued to praise it for years.[56] Sixten Ringbom has studied the book's influence and concluded that it fundamentally affected Kandinsky's approach to abstract art from about 1910 on: "Kandinsky defined the work of art in terms reflecting the Theosophical concept of the thought-form: the work is, as it were, a thought-form of the artist's materialized and immobilized in paint on a canvas. Hence the colors and forms not only reflect the inner life of such protagonists as may appear in the picture, but are in the last resort manifestations of the inner life of the artist himself.[57] Where Ringbom sees a specific thematic influence of "*Music of Wagner*" on certain 1913 works by Kandinsky,[58] however, I would argue for a more general stylistic influence as early as the 1909 *Mountain.*

The colors of the former, with the exception of lavender, all reappear in the latter. The textured blue, red, and green bands forming the base of "*Music*" anticipate the concentric green, blue and red bands forming the sides of the *Mountain.* In both, there is a triangular mountainous mass—the Theosophists call their illustration a "marvelous mountain-range"[59]—rising against a bright yellow field which grows paler above. The black sky in the Theosophic piece is echoed by black contours below in the Kandinsky. And the bright red vertical shape in the exact center of the one anticipates the red vertical figure, just left of center, in the other. Both images, in fact, resemble Kandinsky's recollection of hearing Wagner's music in Moscow some twenty years earlier:

> *Lohengrin,* however, seemed to me a full realization of this [fairy-tale] Moscow. The violins, the deep bass tones, and, most especially, the wind instruments embodied for me then the whole impact of the hour of dusk [which had so moved me]. I saw all my colors in my mind's eye. Wild, almost insane lines drew themselves before me. I did not dare use the expression that Wagner had painted "my hour" musically. But it became entirely clear to me that art in general is much more powerful than I had realized and that, on the other hand, painting can develop just as much power as music possesses.[60]

It is likely that when Kandinsky happened upon the Theosophic illustration of a synaesthetic experience so like his own—and one deriving as well from Wagner's music—he would have responded positively. Moreover, when Besant and Leadbetter went beyond the notion of musical color to speak of musical *form,* Kandinsky must have been extremely interested: "Many people are aware that sound is always associated with color—that when, for example, a musical note is sounded, a flash of color corresponding to it may be seen by those whose finer senses are already to some extent developed. It seems not to be so generally known that sound produces form as well as color, and that every piece of music leaves behind it a [shape] impression of this nature, which persists for some considerable time, and is clearly visible and intelligible to those who have eyes to see." For the entire thesis of *Thought-Forms,* stated at the outset and illustrated throughout, was that "Each definite thought produces a double effect—a *radiating vibration* and a *floating form.*"[61]

There is, of course, a literalism to Theosophic illustrations that Kandinsky would have found repugnant: "No attempt has been made in this drawing [Besant and Leadbetter write] to show the effect of single notes or single chords. . . . A striking feature in this form is the radical difference between the two types of music which occur in

62. Wassily Kandinsky, *Mountain,* oil on canvas, 1909. Städtische Galerie im Lenbachhaus, Munich. (See also plate 14)

it, one producing the angular rocky masses, and the other the rounded billowy clouds which lie between them. Having just started to avoid copying the forms of nature, Kandinsky would hardly have settled for copying the forms of music: "he did not believe," as Ringbom has written, "in the graphic representation of music as such." Indeed, when he wrote *Concerning the Spiritual in Art* at just this time (unpublished until 1912), Kandinsky warned his readers against "the tendency of the Theosophists toward theorizing and their excessive anticipation of definite answers in lieu of immense question marks."[62]

Nevertheless, Kandinsky's 1909 *Mountain* is one of the earliest of his paintings to utilize vibrating forms, in the Theosophic sense—pure thought-forms which both "float" and "radiate." Others from 1909 include *Improvisation 3* and *Improvisation 4,* which also depict

a hard-to-identify horse and rider.[63] But these others place the rider within a cityscape or landscape, whereas *Mountain* places the rider and waiting woman below, while setting a church with golden cupola at the very top of the mountain above.[64] Eberhard Roters, who first deciphered the images in *Mountain,* has seen it as inaugurating a series culminating in the rider depicted on the *Blaue Reiter* almanac cover (fig. 67). Kandinsky constructs a world, according to Roters, "in which he himself is at last the Blue Rider, and in which the setting serves as outer-directed sign of his [inner] spiritual world."[65] Besant and Leadbetter would say it is Kandinsky's *thought* of inner spirituality that creates the "radiating," "vibrating" forms of the mountain, and the shimmering "floating forms" of rider, woman, and church.

After the 1908 *Landscape* the 1909 *Mountain* marks a considerable advance toward more abstract formal "vibration."[66] As a practical matter, however, Kandinsky could hardly expect to foist Theosophical beliefs—or even a faith in abstraction[67]—on his Munich friends. The most he could accurately say in 1909 was that some **83**

artists were seeking a synthesis between the needs of both "inner" and "outer" worlds: "We start with the thought that the artist, besides the impressions he receives from the outer world, from nature, also ceaselessly gathers together experiences of an inner world, and searches for artistic forms which will express the mutual interaction of all these experiences, forms which must be cleansed of the incidental in order to give forceful expression only to the necessary—he searches, in short, for artistic synthesis. This appears to us to be a solution which is spiritually uniting more and more artists at this time.[68] This was the foundation manifesto for the Neue Künstlervereinigung München or NKVM ("Munich New Artists' Association"), which was formed in January 1909 with Kandinsky as elected president.

By late 1911, when Kandinsky and Franz Marc and a few friends walked out of the NKVM to form the Blaue Reiter ("Blue Rider"), the importance of the "inner" world alone was confidently stated in a new manifesto:

> The great revolution;
> The displacement of the center of gravity in art, literature, music;
> The multiplicity of forms: the constructive, the compositional, in these forms;
> The intensive turn to inner nature and the related renunciation of [the aim of] beautifying outer nature—
> —These are in general the signs of the new inner renaissance.
> To show the characteristics and manifestations of this change,
> To emphasize their inner relation to past epochs,
> To make known the externalization of inner strivings in *every* form with inner sound [innerlich klingenden Form]—
> —This is the goal which "The Blue Rider" will strive to achieve.[69]

Despite this difference in emphasis, however, there is a continuity in the two statements—just as there is continuity in the two art groups.

These Expressionist associations in Munich, following Kandinsky's pre-Expressionist pattern with the Phalanx Society, exhibited foreign artists as well as German ones. Expressionist works were commonly shown alongside Neo-Primitivist works from Russia and Fauve or Cubist works from France. As a result it is difficult to consider all the participants in vanguard Munich exhibitions from 1909 through 1912 as being equally Expressionist; on the contrary, writers usually focus on four or five. Nevertheless, it is important to realize how international and stylistically advanced Expressionist exhibitions in Munich actually were.[70]

LOCAL AND FOREIGN ARTISTS IN MUNICH EXHIBITIONS, 1909–12.

DECEMBER 1909 *NKVM:* Baum, Bechtejeff, Bossi, Dresler, Eckert, Erbslöh, Girieud, Hofer, Jawlensky, Kandinsky, Kanoldt, Kogan, Kubin, Münter, Pohle, Werefkin

SEPTEMBER 1910 *NKVM:* Bechtejeff, Bossi, Erbslöh, Jawlensky, Kahler, Kandinsky, Kanoldt, Kogan, Kubin, Mogilewski, Münter, Nieder, Scharff, Werefkin. *Foreign:* Braque, D. Burliuk, V. Burliuk, Denisoff, Derain, Durio, Girieud, Haller, Hoetger, Le Fauconnier, Picasso, Rouault, Soudbinine, Van Dongen, Vlaminck

DECEMBER 1911. *NKVM:* Barrera-Bossi, Bechtejeff, Erbslöh, Girieud, Jawlensky, Kanoldt, Kogan, Werefkin

DECEMBER–JANUARY 1911–12. *Blaue Reiter:* Bloch, Campendonk, Kahler, Kandinsky, Macke, Marc, Münter, Niestlé, Schönberg. *Foreign:* D. Burliuk, V. Burliuk, Delaunay, Epstein, Rousseau

FEBRUARY 1912. *Blaue Reiter:* Bloch, Franck-Marc, Kandinsky, Klee, Kubin, Macke, Marc, Münter. *German/ Swiss:* Arp, Gimmi, Heckel, Helbig, Kirchner, Lüthy, Melzer, Morgner, Mueller, Nolde, Pechstein, Tappert. *Foreign:* Braque, Delaunay, Derain, Goncharova, La Fresnaye, Larionov, Lotiron, Malevich, Picasso, Russian popular prints, Vera, Vlaminck

By 1910 Jawlensky, Münter, and Erma Bossi formed an Expressionist subgroup within the NKVM that was essentially German Fauve in orientation. Jawlensky, who had bought a Van Gogh landscape in 1904, exhibited six still lives at the 1905 Salon d'Automne and visited Matisse several times between 1905 and 1907.[71] His *Portrait of a Boy* at the 1910 NKVM show (not illustrated) is close in spirit to 1907 Matisse. But in its primitivizing contours it also resembles Münter's 1908–09 *Girl with a Doll* (fig. 61), partly because he too collected Bavarian glass paintings and had "a whole wall" of them in his Munich studio by 1911.[72] Bossi's *Still-Life with Easy Chair* (1910) resembles Münter's still lives, just as her *Portrait of Marianne von Werefkin* has elements in common with Jawlensky (neither illustrated).[73]

The younger German male artists like Adolf Erbslöh and Alexander Kanoldt were mostly mild-mannered Fauves, still largely naturalistic, while Karl Hofer had studied works by von Marées before 1908 and by Delacroix afterward, before he left the NKVM altogether. The American-born Albert Bloch, despite a quasi-Cubist style, claimed to be a misfit in the Blaue Reiter: "Marc and Kandinsky simply both made the mistake," he wrote later, "of considering me as 'modern.'"[74] On the other hand, the two Austrian participants in Blaue Reiter shows, Alfred Kubin and Arnold Schoenberg, were as strongly Expressionist as two so divergent artists could be (fig. 16, plate 3).

Franz Marc's enthusiastic encounter with the NKVM in September 1910 marks the beginning of a second style phase in Munich Expressionism. Following a viewing in August of the same Gauguin show that the Brücke saw in Dresden, Marc found the NKVM "wholly splendid" in September, and then was so "astonished and shocked" by Cameroon sculpture in Berlin in January 1911 that he considered himself "a completely different person."[75] Through a growing friendship with Kandinsky during the 1910–11 season, Marc's increasingly

powerful primitivism finally replaced Jawlensky's sophisticated Fauvism as the dominant force within the group—in a manner not unlike the Brücke's shift from soft to hard styles in mid-1910. Indeed when the rupture within the NKVM finally came in the autumn of 1911, it was Marc and his friends Campendonk, Macke, and Niestlé who provided the support necessary for the first Blaue Reiter exhibition. While Jawlensky himself underwent a major style change in the 1911 summer—when he began painting those colorful doll-like figures for which he is best known[76]—it is the collaboration between Kandinsky and Marc that made possible the Blaue Reiter and, with it, the further evolution of Expressionist art in Munich.

Marc's investigation of Gauguin and primitive art lasted through the winter of 1910–11. The relation between Gauguin's *Spirit of the Dead Watches* (1892) and Marc's own *Reclining Nude among Flowers* (1910) and *Reclining Dog in the Snow* (early 1911) has been shown elsewhere.[77] It is sufficient to say here that the dog is massively sculptural, and even angular, while the two nudes are still conceived in patterned, two-dimensional shapes.[78] Similarly sculptural is Marc's *Blue Horse II* (early 1911), especially when compared with its source seen the preceding August, Gauguin's *Tahitian Women Bathing* of 1891–92 (figs. 63, 64).[79] The hips of Gauguin's standing nude presage the haunches of Marc's horse, but the Symbolist's flattened forms are replaced by the Expressionist's volumetric masses. The same is true of Marc's *Yellow Cow* from later in 1911, where the animal's "instinctuality" requires a certain tangible solidity (fig. 17). But now it is an archaic, rather than a primitive, source that modifies the Gauguinesque flatness: a striding bull raised in relief on a Mycenaean gold cup from Vaphio, circa sixteenth century B.C. (not illustrated).[80] Nevertheless, in all these Marc works from 1911 it is not only sculptural modeling but also a drastic simplification of form that drives the Expressionist style beyond Post-Impressionist sophistication and toward primitive directness.

A similar simplification may be seen to proceed in Kandinsky's 1911–12 style. Now it is Bavarian glass painting that affects Kandinsky's style as it had Münter's a few years before. Thus the stylized heads and limbs seen in typical folk art paintings of *St. George* behind glass reappear in Kandinsky's own glass paintings of *St. George* in 1911 (figs. 65, 66). The Kandinsky glass painting is the chief precedent, in turn, for the color woodcut of *The Blue Rider* that appears on the almanach's cover (fig. 67). Though the dragon's head and body have disappeared in the 1911–12 woodcut (only its tail continues to rise behind the knight's back), Kandinsky's drive toward abstraction continues to take the primitivizing road of color and shape simplification. In the very cover of its almanach Kandinsky confirms the Blaue Reiter's credo, namely, to avoid "the harmful separation . . . of 'art' [fine art] from folk art, children's art, 'ethnography,'" and to show them to be "closely related, often identical phenomena."[81] The group was embracing all art forms with inner sound, all *innerlich klingende Form*.[82]

When the almanach reached its subscribers around June of 1912, it had 144 pages and exactly as many illustrations—a fact which tended to reduce the impact of the text's score of essays, poems, and quotations. About a third of the reproductions were devoted to works by the living artists exhibited in the several Munich exhibitions, particularly French avant-garde painters. But the other ninety-two illustrations were devoted to Bavarian and Russian folk art objects; to medieval European artifacts ranging from ivories to Gothic sculpture; to Chinese and Japanese paintings and woodcuts; to a miscellany of "primitive" art objects extending from Egyptian shadow-play silhouettes to African, Pre-Columbian, and Oceanic sculpture; and last but not least, to five drawings or drawing clusters by children or "amateurs" and seven paintings by the naive artist Henri Rousseau. Despite the Blaue Reiter's reputation as one of the vanguard movements of prewar Europe, it stressed less the high art of modernism than the primitive, archaic, and folk arts promising the potential for renewal. Still, the key to the Blaue Reiter was its contradictory embrace of *both* directions—progressive and primitive styles, high art and low—in one and the same almanach.

3.4. VIENNA AND PRAGUE, 1907–12

Viennese Expressionism begins not with the turn-of-the-century art of Klimt and Hoffmann, Olbricht and Moser, but a full decade later with the work of Gerstl and Schoenberg, Kokoschka and Schiele. There is a world of difference between Vienna in 1897–99 when the Secession made its impact, and Vienna in 1908–10 when Expressionism exploded on the scene. The difference has not always been recognized in the literature.[83]

The secession idea was realized in Vienna in 1897, as it had been in Paris in 1884 and Munich in 1892, when a group of dissidents walked out of the Artists' House Cooperative (*Künstlerhaus Genossenschaft*, founded in 1861). They called themselves The Association of Austrian Fine Artists "Secession" (*Vereinigung der bildenden Künstler Österreichs "Secession"*).[84] Observers often linked the Secession with Jugendstil or Art Nouveau—so much so that the group style was sometimes called *Secessionsstil*. From here it was easy to link the Jugendstil ("youth style") with literary figures from Hofmannsthal to Schnitzler known collectively as *Jung-Wien* ("young Vienna"). Moreover, since the writers were preoccupied with "the nature of modernity and the life of the psyche,"[85] such concerns could readily be attributed to Secession painters as well. But the facts are otherwise. The Secession was distinctive in neither program nor style. "From its inception, it brought together 'Impressionists' and 'Naturalists,' 'Modernists' and 'Stylists,' as well as artists working in quite different fields: painters and designers, graphic artists and typographers, even architects."[86] The Secession's importance in Vienna—as in Munich and Berlin—was that it institutionalized the break with traditional academies; Expressionists did not have to fight that battle again. Nevertheless, the Secession's art-for-art's-sake aesthetic, as promulgated chiefly by Hermann Bahr,[87] was replaced by an Expressionist attitude far closer to art-for-life's sake. Although Klimt was their earliest supporter, Viennese Ex-

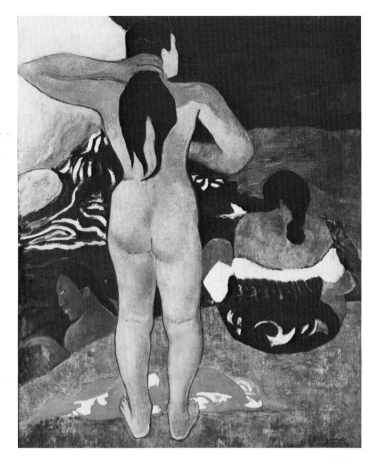

63. Paul Gauguin, *Tahitian Women Bathing*, oil on canvas, 1891–92. The Metropolitan Museum of Art, Robert Lehman Collection, 1975.

pressionists had to go well beyond Klimt to develop their own post-Secession styles.

The early development of Richard Gerstl and of Arnold Schoenberg is by no means clear, but Gerstl's pattern seems typical of many independent Expressionists. He started at the Vienna Academy under Christian Griepenkerl in 1898–1901, before beginning private studies—including some time in a class taught by "two painters from the Secession." Then followed two more terms with Griepenkerl in 1904–05, and two years with a more liberal academy instructor, Heinrich Lefler, to 1907.[88] But the change in Gerstl's outlook seems to have occurred with his discovery of paintings by Van Gogh, in an exhibition held in January 1906.[89] Before that time Gerstl talked of the Spanish Baroque painter Zuloaga;[90] afterward his style displays the Pointillism of Rysselberghe or Signac and the physiognomic expressiveness of Munch.[91] A kind of late Impressionism, part way between the French Renoir and the German Liebermann, is apparent

in the Schönberg family portraits of 1907–08. But by the last months of his life, in the *Self-Portrait* (fig. 137; 1908), these late Impressionist and Post-Impressionist properties serve as the springboard for a fully developed Expressionist style.

Arnold Schoenberg later claimed that it was his own amateur experiments in painting that prompted Gerstl, when they met in 1907, to "start to paint 'Modern.'"[92] But it is equally likely that Gerstl's paintings, and his discussions of aesthetic theory, confirmed Schoenberg in his commitment to an intentionally naive and subjective mode of expression.[93] In any event Schoenberg's fully Expressionist style did not emerge until 1910, as in *The Red Stare* from May of that year (plate 3). By this time the composer had had ample opportunity to see the work of local and foreign Post-Impressionists and Symbolists at the International Kunstschau held in Vienna in the summer of 1909.

In the case of Oskar Kokoschka and Egon Schiele, it was the styles of Gustav Klimt and other Secessionist and Symbolist masters that served as starting points for Expressionist careers. In his woodcut poster for the 1908 Kunstschau (not illustrated), for example, the twenty-two-year-old Kokoschka was still working in the Secessionist manner of highly patterned Jugendstil illustration. But in his *Poster for "Murderer, Hope of Women,"* which publicized his drama at the International Kunstschau the very next year (fig. 18), Kokoschka has shattered Secessionist conventions. Moreover, in his *Drawing* for the same play (fig. 8) the artist has transformed even his draftsmanship from descriptive modeling to a nervously vibrant calligraphy. These latter works are fully Expressionist.

The 1907–09 drawing features a set of tattoo-like markings across the skin and clothes of the figures. They almost certainly derive from the ornamental patterns of primitive masks which Kokoschka saw in the Vienna Ethnographic Museum. But, unlike German Expressionists in Dresden and Munich, the Viennese Expressionist was *not* especially moved by primitive art: "[I immediately understood] a Polynesian mask with its incised tattooing, . . . because I could feel my own facial nerves reacting to cold and hunger in the same way. For all my sympathy with primitive art, [however,] it would not have occurred to me to imitate it. I was not a savage. I would have had to live like them for my imitation to be genuine. And I had just as much feeling for fossils, stuffed animals, meteorites, or any documents of a time which is lost forever."[94] Tribal art was not perceived as Gauguin's art of rejuvenation but, instead, as an art that was extinct.

Response to primitive art marks a difference between Austrian and German Expressionism. Living in the long-established Hapsburg Empire, under its elderly Emperor Franz Josef, Austrians did not identify their culture with the art of "savages." Where Wilhelmian Germans believed in the possibility of social renewal, Hapsburg Austrians by and large did not; confidence in the future yielded here to the lethargy of the past. Primitivism was perceived in Vienna as exoticism, not as a corrective for the ills of modern society. As a result Austrian Expressionism was born, as it were, middle-aged. Vitalism in Austria was never far removed from cynicism, instinct from despair. But it was precisely the Austrian contribution that made Expressionist

64. Franz Marc, *Blue Horse II,* 1911. Kunstmuseum, Bern, Stiftung Othmar Huber.

art more sophisticated, more complex, more mature. When Kokoschka's *Drawing* and others like it were published in Berlin's *Sturm* magazine in July 1910, Berlin Expressionism received a nervous and visionary impetus not known in Dresden or Munich.

Austrian vitalism was associated, then, not with the "wild" arts of primitives or Fauves but rather with the expressive paintings of Van Gogh. Kokoschka's earliest paintings around 1907 show the impact of the Van Gogh exhibition held in Vienna the previous year.[95] And a masterful series of portraits from 1909–10 derive stylistically from Van Gogh portraits shown at the International Kunstschau from May to October 1909. We see this by comparing Van Gogh's *Madame Roulin and Her Baby* (1888), seen in that exhibition and illustrated in its catalogue, with Kokoschka's *Ludwig von Janikowsky* dated 14 October 1909 (figs. 68, 69). The entire facture of the Viennese portrait comes from the Arles one, as does the way the powerfully limned

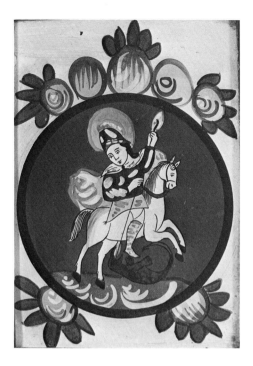

65. *St. George,* Bavarian glass painting. Bayerisches Nationalmuseum, Munich.

head stands forth from its background. Even Janikowsky's square jaw and prominent ear resemble Mme. Roulin's. There is also a vibrant intensity, almost a supernatural quality to the expression, that stems as much from Munch as from Van Gogh; Munch's sketches to Ibsen's *Ghosts* were also exhibited at the International Kunstschau.[96] And finally the staring eyes, the "speaking" likeness, and the projecting right ear are distortions which arise in Kokoschka's empathetic response to his sitter. For Janikowsky, who had "an extraordinarily fine feeling for languages," was incurably insane.[97] On the whole, then, Kokoschka's portrait "out-Van Goghs" Van Gogh: both in subject and in style *Janikowsky* reminds us of "the mad painter of Arles" yet goes beyond him in hallucinatory intensity.

As Kokoschka exceeded Van Gogh, so Schiele transformed Klimt. We have already contrasted Schiele's *Cardinal and Nun* of 1912 with Klimt's 1908 *Kiss* (figs. 19, 20). But even earlier the Symbolist's *Family* of 1909–10 was the source for the Expressionist's *Dead Mother I* of December 1910 (figs. 70, 71). Schiele's smaller oil is like a quotation from the upper right corner of Klimt's. Both depict a mother with head bowed over the face of her child, the faces the only accents in otherwise brown or blue-black surfaces. Also, a third light spot is present: a second child in the one, the mother's bony hand in the other. Nevertheless, the textural variations in the dark paint create a startling difference. The Symbolist's figures lie flat on the plane, befitting the

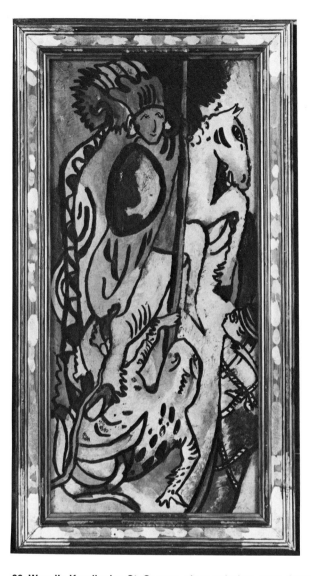

66. Wassily Kandinsky, *St. George,* glass painting, 1911. Städtische Galerie im Lenbachhaus, Munich.

decorative impulse of his Secession years: the family sits vertically, apparently against an equally vertical wall with drapery. But the Expressionist's planes are strongly foreshortened. The mother's swollen belly overlaps her cheek and neck, while the gold and pink infant seems to press even further forward from its womb.[98]

Klimt's painting has been known as *Widow* or *Emigrant,* providing a social explanation for the pathetically huddled figures. But Schiele's title provides a novel twist to another earlier theme. For in numerous Symbolist works it had been a *Mother Mourning her Dead*

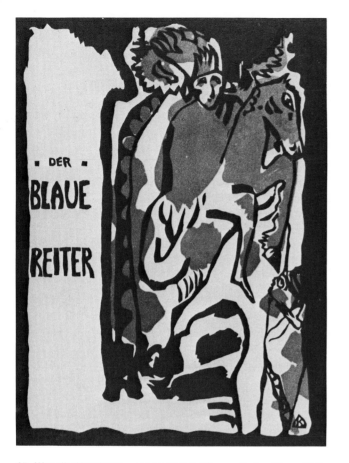

67. Wassily Kandinsky, cover of the *Almanach der Blaue Reiter,* color woodcut, 1911–12. Städtische Galerie im Lenbachhaus, Munich.

Child—as in Käthe Kollwitz's etching of 1903, or Georges Minne's sculpture of 1884—rather than the other way around. The explanation for Schiele's image is autobiographical. It is the male artist's birth that justifies his mother's suffering and death, a point clarified by the titling of a later version of the theme "birth of genius." For as Schiele wrote to his own mother in 1913, "Without doubt I shall be the greatest, the most beautiful, the most precious fruit. Through my independent will all beautiful and noble effects are united in me—this also, no doubt, because of the male [principle]. I shall be the fruit which after its decay will still leave behind eternal life; therefore how great must be your joy—to have borne me?"[99]

Taking this contrast one step further, however, we can see the Klimt painting as a soft surface steeped in sentiment: flat, ornamental, and sweet. But the Schiele surface has become harder, yet paradoxically more glowing and visionary. Line says it all. Klimt's draughtsmanship is sensuous, ductile, caressing—the epitome of fin-

de-siècle eroticism. Schiele's line is alternately brittle and keenly observed, wiry stiff or pulsing with life. Klimt's and Schiele's babes with rosebud lips may at first glance seem similar. But the contour of the latter face is full of angles and curves, hard edges and lumpy swellings, that tend to deny all sentiment. As Fritz Novotny has remarked, Schiele provides an "Expressionist intensification" of his Secessionist source.[100]

Minne, Van Gogh, and especially the Swiss Symbolist Ferdinand Hodler—all represented at the Internationale Kunstschau of 1909—also helped Schiele develop his Expressionist style in 1910. Surely comparable are the hand gestures—held horizontally across the chest with fingers not quite touching—in Hodler's *Sentiment* [*Empfindung,* ca. 1903] and a 1910 Schiele drawing of *Mime van Osen* (neither illustrated).[101] Moreover, Hodler's forced repetition of the shapes of tree trunks, bodies, or, as here, fingers—a repetitiveness Hodler himself called "Parallelism"[102]—goes a long way to explain the stiff and brittle qualities of Schiele's Expressionist draftsmanship. Yet if Klimt and Hodler together provide the basic ingredients of Schiele's drawing style, that style is considerably greater than the sum of its parts. Harder and bonier than Klimt's, less rigorously repetitive than Hodler's, Schiele's forms have their origin in acutely observed reality (cf. fig. 139).

Expressionism in Prague, the capital of the Austrian province of Bohemia, took rather a different form than it did in Vienna. Bohemian Expressionism began with a group of young men who had met as students at the Prague Academy and who exhibited in 1907 and 1908 under the name of Osma ("The Eight"). Their leaders were Antonín Procházka, Emil Filla, and Bohumil Kubišta, and their first inspiration had been Edvard Munch's "Frieze of Life" cycle as exhibited in Prague in 1905. But their early work was eclectic, borrowing not only from Munch and from French Post-Impressionists, but also from Baroque painting. Thus Procházka's *Card Players* and Filla's *Ace of Hearts* of 1908 take their styles from Daumier and Gauguin but their subjects from Cézanne and Caravaggio. By 1909 Kubišta's *Card Players* is based loosely on Van Gogh, but Procházka's *Eviction of the Money-Changers from the Temple* stems directly from El Greco. Literature was important in Filla's Munch-like *Reader of Dostoevsky* (1907) and in a fiery 1909 painting of *Anti-Christ*—based on Nietzsche's book of 1895—by Jan Zrzavý, who at nineteen was too young to have shown with Osma (none illustrated).[103]

A second stage to the movement in Prague looked not to Post-Impressionists or Fauves but, suddenly, to French Cubists. Lasting from 1910 to 1912, this stage was known as "Cubo-Expressionism"[104] The "Expressionist" part of the label originated in a catalogue by Antonín Matějček to a show of French Indépendants held in February–March of 1910—a catalogue which introduced the term "Expressionists" in one sense used today (see sec. 5.1). And the "Cubist" part of the label originated in a series of events begun by the same show when its sponsoring organization, the Manes Society, selected for purchase a painting by André Derain.[105] Also, in the course of Paris visits in 1909 and 1910 first Filla and the Kubišta had

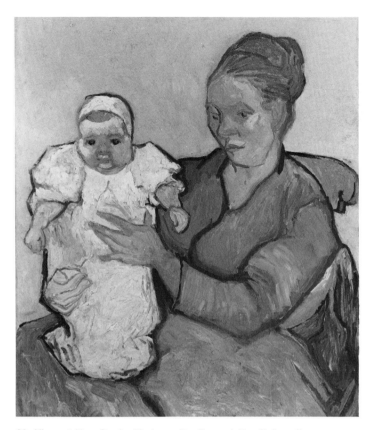

68. Vincent Van Gogh, *Madame Roulin and Her Baby,* oil on canvas, 1888–89. Philadelphia Museum of Art, Bequest of Lisa Norris Elkins.

69. Oskar Kokoschka, *Ludwig von Janikowsky,* oil on canvas, 1909. Knize Collection, USA.

become interested in the nascent Cubist innovations of Pablo Picasso and Georges Braque. And finally, by late 1910 or early 1911 the Czech art collector Vincenc Kramář brought from Paris to Prague a cast of Picasso's first Cubist sculpture of 1909, *Woman's Head.*[106]

Prague Cubo-Expressionism embodies particularly well the ambivalence toward style that typifies Expressionist art as a whole. Opposed to the Germanic culture enforced by the Austrian state, the Czech-speaking Bohemians understandably looked to the Paris avant-garde for artistic leadership. Yet they were not French but Central European, after all, and they shared many of the Germanic cultural values of their milieu. A 1911 sculpture by Otto Gutfreund, for example, is based on Rodin, indebted to Cubism, and yet titled *Anxiety* in the manner of Munch! (See figs. 128, 129.) By 1912–13, when Austrian/French ambivalence was finally resolved in favor of France, Gutfreund created a *Cubist Bust* that Douglas Cooper calls "one of the most serious and inventive attempts to transpose the synthetic Cubist technique into sculptural terms."[107] Finally, Prague exhibition activity confirms this stylistic ambivalence and its resolution. The

Artist Group Skupina ("Avant-Garde") was formed by Filla, Gutfreund, and their friends to bring the most advanced art to Bohemia. The group's first show in January 1912 was a local affair, and its second in September was devoted largely to the German Brücke artists; but Skupina's third show in May 1913 was a major Cubist retrospective, featuring French painting from Cézanne to Derain and from Picasso to Gris.[108]

His name notwithstanding, Bohumil Kubišta was the least Cubist of the Prague artists. We may see this in comparing Picasso's *Head of a Woman,* which Kramář had brought from Paris in 1910–11, with Kubišta's 1912 painting of *Saint Sebastian* (figs. 72, 73). Sweeping neck lines, protruding cheekbones, and angular features are similar in both works—so much so that the saint's body is decidedly less fragmented than the head. Kubišta has understood the structural implications of Picasso's style, and has even fused the planes of the martyr's arms and torso with the background forms in a Cubist manner. Yet despite his earnest study of the Cubist source, he is far more interested in its expressive than in its structural implications; his ear-

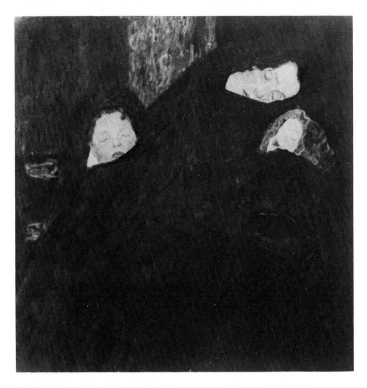

70. Gustav Klimt, *Family (Mother with Children),* oil on canvas, 1909–10. Österreichische Nationalbibliothek, Vienna.

lier apprenticeship to Munch has not been forgotten. Among Bohemian artists Kubišta "was the most outspoken and individual painter," according to Miroslav Lamač, "a passionate romantic who transformed the rationally determined designs of his pictures into metaphysical, often poignantly expressive, symbols of the existential conflicts of human life."[109]

Kubišta apparently did not join the Skupina group. Instead, he formed a friendship with Ernst Kirchner and Otto Mueller, when the Brücke artists visited Bohemia in September 1911; Dresden and Prague are only seventy-five miles apart. As a result, he was invited to exhibit with them at Neue Secession shows starting in the winter of 1911–12 in Berlin and was soon accompanied by Gutfreund. Thanks to Kubišta, then, Bohemian Cubo-Expressionism played a key role in bringing the latest French styles to the attention of Berlin Expressionists. As with the dissemination of the term "Expressionist" itself, the most direct road from Paris to Berlin wended its way through Prague.

3.5. BERLIN: NEUE SECESSION, BRÜCKE, PATHETIKER, 1910–12

Despite the presence of Expressionist groups in Dresden, Munich, Vienna, and Prague, it was in Berlin in 1910–11 that a unified Ex-

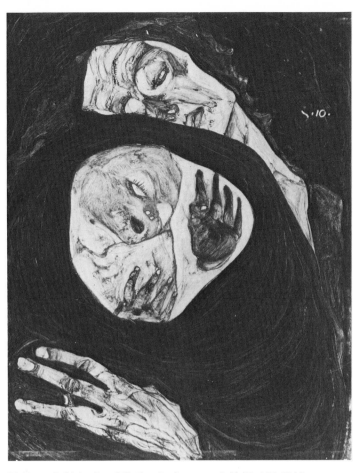

71. Egon Schiele, *Dead Mother I,* oil on wood, Kallir 115, 1910.

pressionist movement was born. The three contributing factors unique to Berlin were: (1) a generational confrontation between an "old" Secession and a "new" one; (2) the presence in the Neo-Pathetic Cabaret of fledgling literary Expressionists; and (3) the success of *Der Sturm* magazine and gallery in unifying the new generation of artists and writers. While none immediately associated himself with the label "Expressionism," and while it was the writer Kurt Hiller who actually took the lead in 1911, by 1914 Expressionism in art was identified with the Brücke, the Blaue Reiter, and "independent" creators (see sec. 5.1).

The Berliner Secession was established in 1898, somewhat after the Secessions of Munich (1892) and Vienna (1897). But as its prehistory demonstrates, the Berlin organization was guided more by ideological than by style considerations. For example, when Kaiser Wilhelm II forbade German participation in the Paris World's Fair of 1889 because the centennial of the French Revolution would show an "anti-monarchist tendency," the forty-two-year-old Impressionist

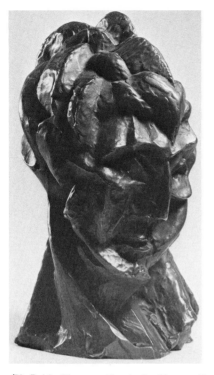

72. Pablo Picasso, *Head of a Woman (Fernande)*, bronze, 1909. Collection, The Museum of Modern Art, New York, Purchase.

painter Max Liebermann helped arrange a "private" participation. Again in 1892, prompted quietly by the same Liebermann, the Association of Eleven was formed to hold exhibitions separately from the Berlin Academy. Unfortunately its opening exhibition, devoted to early works by Edvard Munch, was closed the first week by a slim majority of the association's voting members. Finally, when the Berliner Secession was founded in 1898, with Professor Liebermann as president and the art dealer Paul Cassirer as business manager, stylistic variation was welcomed. As the 1899 catalogue stated, "We do not believe in a single, sacred direction in art." But this was precisely the Secession's ideological problem. For its laissez-faire attitude in matters artistic ran directly counter to the conservative views of academicians, the museum establishment, and the Kaiser himself. "William II expressed a common attitude in demanding that art should elevate, either by depicting ideal beauty or by arousing patriotic or other noble sentiments."[110] The Naturalism, Impressionism, and occasional working-class subjects favored by the Berliner Secession were considered immoral, and the display of works by such foreign artists as Van Gogh (1901), Munch (1902), Cézanne and Gauguin (1903)—at the expense of traditional German painting—was considered subversive.

Precisely because of the Kaiser's enmity, the Secession could seem liberal and radical when it was not. This became obvious in

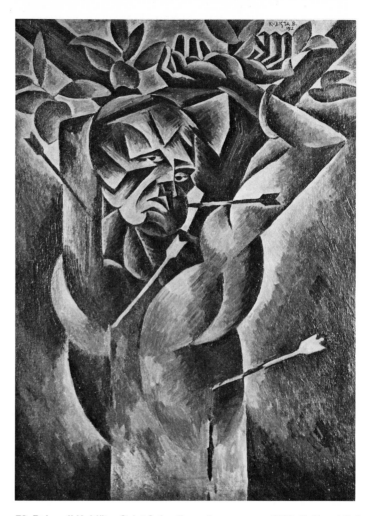

73. Bohumil Kubišta, *Saint Sebastian,* oil on canvas, 1912. National Gallery, Prague.

March 1910 when the Secession jury rejected eighty-nine paintings by twenty-seven artists—including Max Pechstein and Emil Nolde, who had already exhibited paintings before, and the other Brücke members Kirchner, Heckel and Schmidt-Rottluff, who had earlier shown only prints and drawings. It was Nolde who made the event into a generational confrontation. After attempts at healing the breach within the Secession had failed, he published a letter in December 1910 attacking "clever old Liebermann"—who was in fact sixty-three—on behalf of Secessionist "young ones" like himself, who was forty-three. "The entire younger generation is more than satiated with his works, can't even look at them any more," Nolde wrote. Liebermann can't change: "He himself hastens the inevitable; we young ones can regard it cooly."[111]

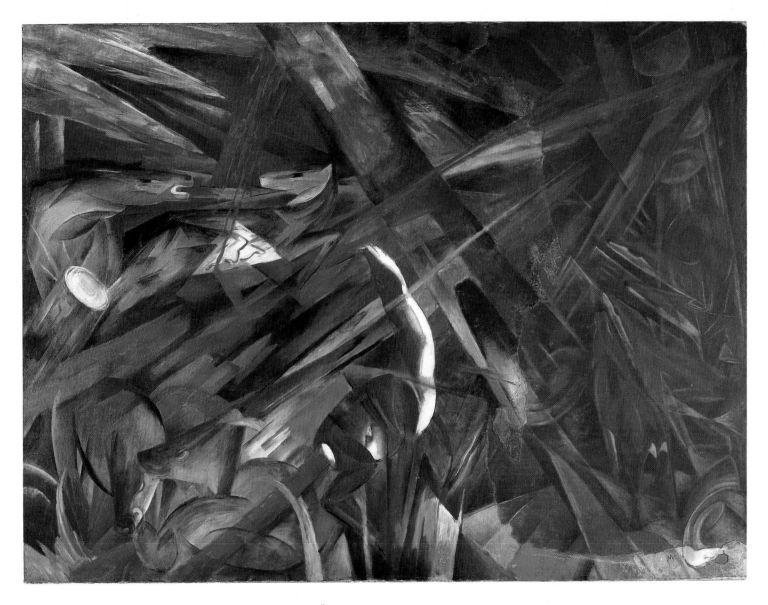

Plate 1. Franz Marc, *Animal Destinies,* oil on canvas, 1913. Öffentliche
Kunstsammlung, Kunstmuseum Basel.

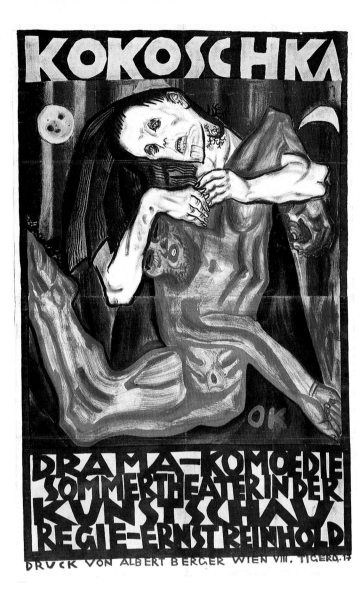

Plate 2. Oskar Kokoschka, poster for *Murderer, Hope of Women,* color lithograph, 1909. Museum of Modern Art, New York; Purchase.

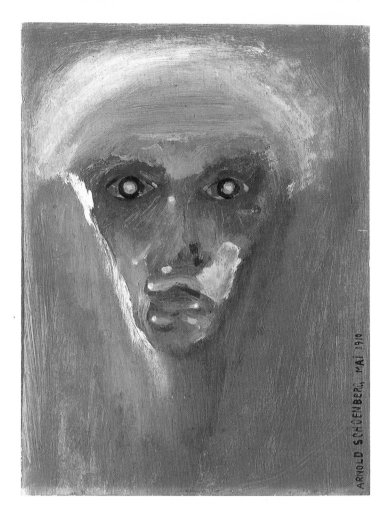

Plate 3. Arnold Schoenberg, *The Red Stare,* oil on canvas, 1910. Städtische Galerie im Lenbachhaus, Munich.

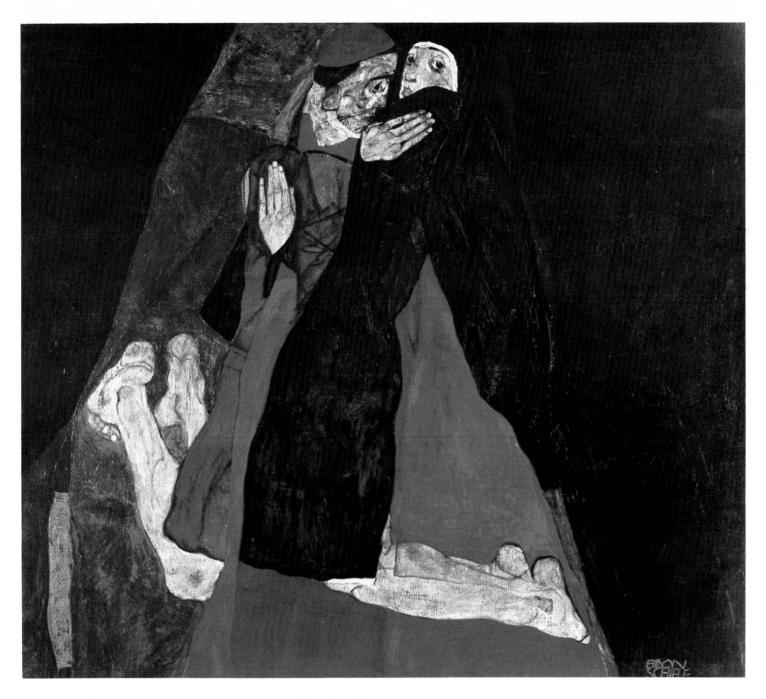

Plate 4. Egon Schiele, *Cardinal and Nun,* oil on canvas, Kallir 156, 1912.

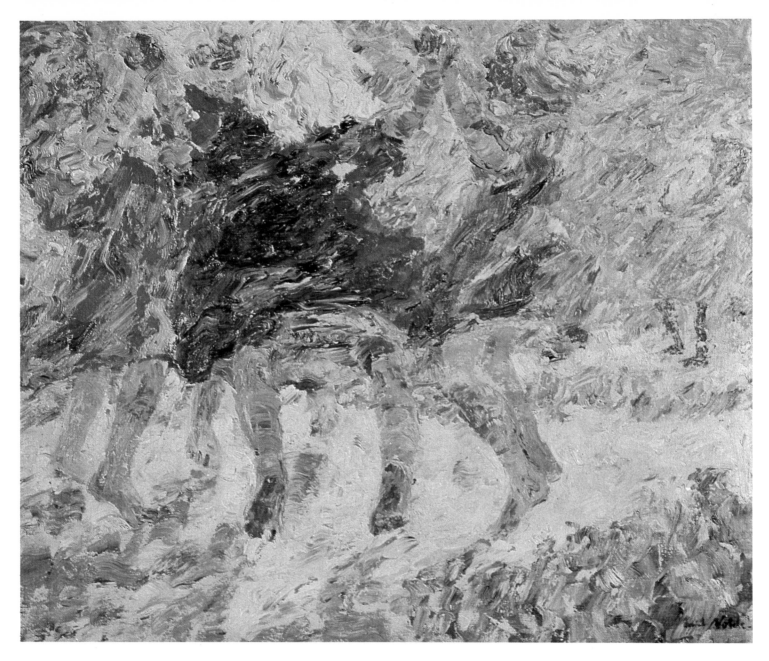

**Plate 5. Emil Nolde, *Wildly Dancing Children*, oil on canvas, 1909.
Kunsthalle zu Kiel.**

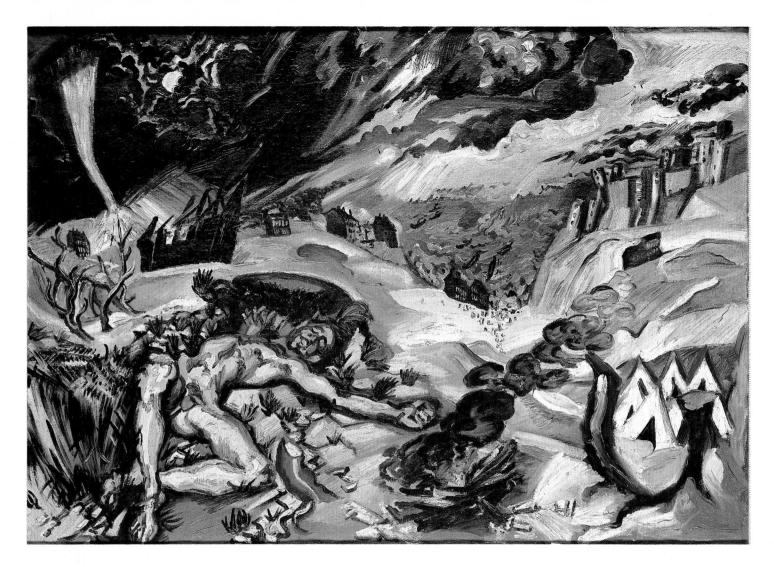

Plate 6. Ludwig Meidner, *Apocalyptic Landscape,* oil on canvas, 1912–13.
Nationalgalerie, Staatliche Museen Preussischer Kulturbesitz, Berlin.

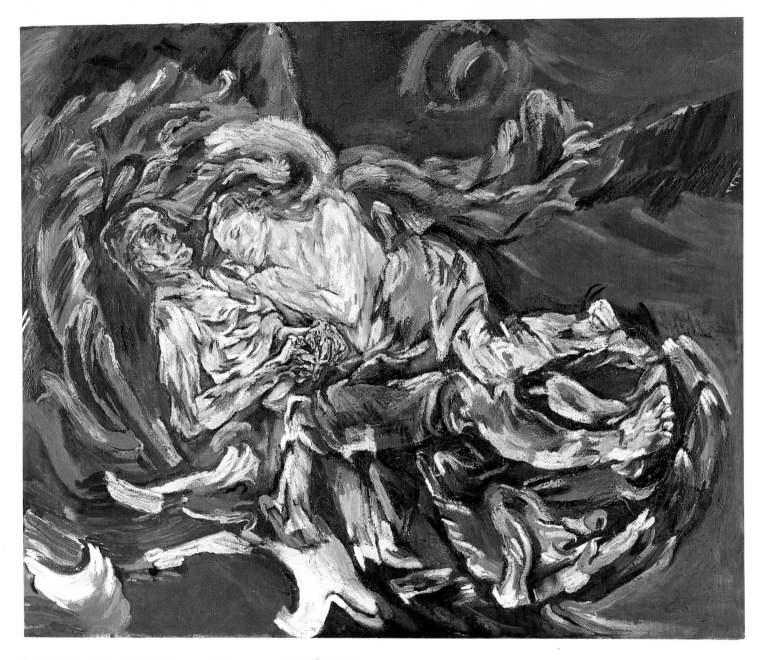

Plate 7. Oskar Kokoschka, *The Tempest,* oil on canvas, 1914. Öffentliche
Kunstsammlung, Kunstmuseum Basel.

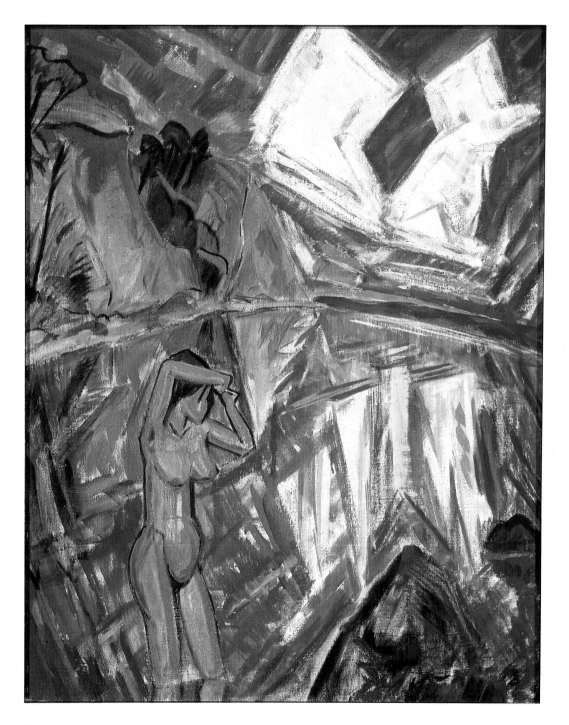

Plate 8. Erich Heckel, *Glassy Day,* oil on canvas, 1913. Bayerische
Staatsgemäldesammlungen, Staatsgalerie Moderner Kunst, Munich.

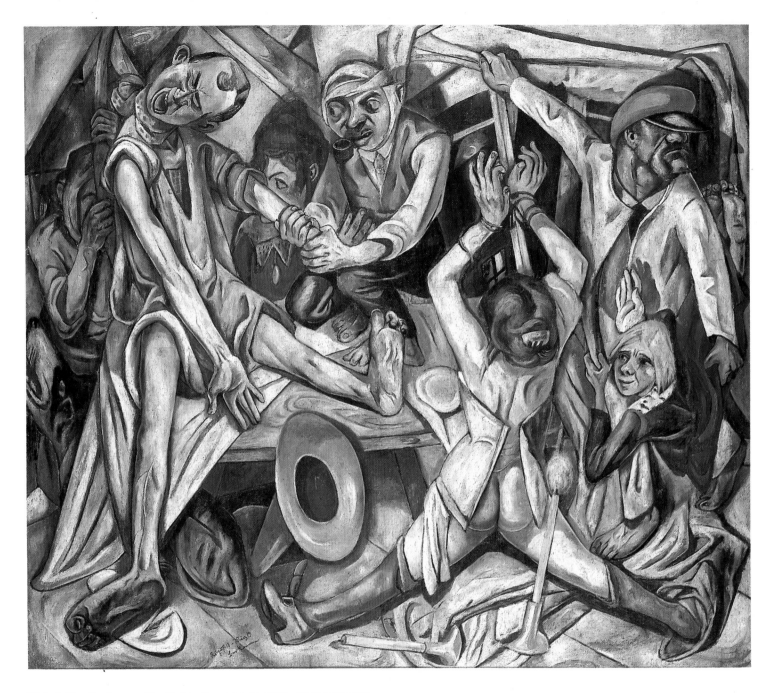

Plate 9. Max Beckmann, *The Night,* oil on canvas, 1918–19. Kunstsamm-
lung Nordrhein-Westfalen, Düsseldorf.

But the other rejected artists, led by Pechstein and his Brücke colleagues, seized the occasion with an act more radical still. In a matter of weeks they issued a call for a *salon des refusés* and opened the first of what turned out to be six Neue Secession exhibitions.[112]

ARTISTS SHOWING WITH THE NEUE SECESSION, BERLIN 1910–12.

MAY–AUGUST 1910. *First Show:* Ahlers-Hestermann, Assendorpf, Bengen, Besteher, Bonnevie, Einbeck, Hairoth, Heckel, Helbig, P. Klein, C. Klein, Kirchner, Lederer, Leschnitzer, Melzer, Mueller, Pechstein, Richter, Schlittgen, Schmidt-Rottluff, Schütz, Segal, Sigmund, Steinhardt, Tappert, Torsteinson, Waske

OCTOBER–NOVEMBER 1910. *Graphic Show:* Asendorf [*sic*], Beckerath, Bengen, Bülow, Chabaud, Einbeck, Freundlich, Heckel, Helbig, Kerkovius, Kirchner, C. Klein, Kogan, Melzer, Möller, Mueller, Nolde, Pechstein, Pick, Richter-Berlin, Schäfer, Schmidt-Rottluff, Schütz, Segal, Siegmund, Steinhardt, Suk, Tappert, Thiemann, Vollmer

FEBRUARY–APRIL 1911. *Third Show:* Asendorpf [*sic*], Bengen, Heckel, Helbig, Kirchner, Klein, Melzer, Mueller, Nolde, Pechstein, Richter-Berlin, Rohlfs, Rosenkranz, Schmidt-Rottluff, Segal, Tappert

NOVEMBER–JANUARY 1911–12. *Fourth Show:* Bengen, Dornbach, Freundlich, Feigl, Heckel, Helbig, Kirchner, Klein, Kubišta, Lehmbruck, Melzer, Morgner, Mueller, Nolde, Pechstein, Richter-Berlin, Rosenkranz, Schmidt-Rottluff, Segal, Stückgold, Tappert. *NKVM:* Bechtejeff, Barrera-Bossi, Erbslöh, Le Fauconnier, Girieud, Jawlensky, Kandinsky, Kanoldt, Marc, Münter, Werefkin

MARCH 1912. *Graphic Art, Sculpture:* Adler, Bengen, Bötticher, Dornbach, Gutfreund, Kandinsky, Keller, P. Klein, C. Klein, Kubišta, Klein, Lau, Macke, Melzer, Möller, Morgner, Richter-Berlin, Rosenkranz, Scheel, Segal (works withdrawn), Tappert

DECEMBER 1912. *Sixth Show:* Bengen, Dornbach, Kandinsky, Klein, Kubišta, Marc, Melzer, Morgner, Richter, Tappert

The importance of the Neue Secession should not be underestimated. Not only did it bring the provincial Brücke group to sudden national attention, with its woodcuts reproduced regularly in *Der Sturm* in the course of 1911, but it also brought Dresden, Berlin, Munich, and Prague Expressionists together as early as November of that year. Of course the Brücke, which had helped found the Neue Secession in 1910, effectively destroyed it early in 1912 when it withdrew to hold its own exhibitions in Berlin and Hamburg.

As Max Raphael wrote in the catalogue to its third exhibition, Neue Secession art was an expressive art of "decoration": "[T]he young artists of all countries . . . no longer take their rules from the object, whose impression Impressionists tried to reach with the means of pure painting. Instead they think of the wall and for the wall, purely in colors. They no longer want to reproduce nature in each of its tran-

sient manifestations. Rather they condense their personal sensations of an object, they compress them into a characteristic expression, in such a way that the expression of personal sensations is strong enough to produce a wall painting. A colored decoration."[113] It was at the third show early in 1911 that Christian Rohlfs first exhibited as a member of the Neue Secession. Though at sixty-two hardly a "young one," his art nicely exemplified Raphael's description of painting that went beyond Impressionism toward expressive decoration.

Rohlfs was a North German, like Nolde, and had been trained in the Weimar academy. His discovery of paintings by Claude Monet in 1890, his connection with Karl-Ernst Osthaus' museum in Hagen from 1901 on, and an acquaintance with Nolde in 1905 all facilitated his Post-Impressionist development. Indeed Rohlfs' *Birch Forest* of 1907 bears comparison with Monet's 1888 *Bend in the Epte River, near Giverny* (figs. 74, 75, plate 15). Just as Monet on the left displays spots of bright foliage against shadowed tree trunks and toward the right a play of warm lights against the cool blues of the sky, so Rohlfs employs these features in a similar way. And in another late Impressionist oil Monet paints grasses with thick, scumbled strokes of red, yellow and green[114] that remind us of Rohlfs' leafy ground cover. But in *Birch Forest* Rohlfs' brushstroke is Expressionist, no longer Impressionist. As Paul Vogt has noted, "Here every individual brushstroke is full of life and strength, and does not serve only to reflect atmospheric light as in French late Impressionist work."[115] It is the roughness, almost violence, of the Expressionist stroke that is "strong enough," in Raphael's phrase, "to produce a wall painting."

But Raphael's remarks actually describe as much a Fauve as a Post-Impressionist point of view. And the art of such prominent Neue Secession exhibitors as Cesar Klein, Georg Tappert, and Lasar Segal would readily fit this generic prescription. Still, it is the Neue Secession's leader Max Pechstein, who had extensive experience with decorative wall painting and even stained glass windows, to whom Raphael's words most directly apply.

Pechstein's 1911 work continued the Fauve orientation of previous years but was now also influenced by the art of Gauguin. In view of Pechstein's eventful trip to the South Pacific in 1914, following Gauguin's example a quarter-century before, it is surprising to realize that he had probably not known much of the Frenchman's Tahitian work prior to the Dresden Gauguin retrospective of September 1910.[116] Once the contact was made, however, the response was direct. Gauguin's *Tahitian Women Bathing* of 1891–92 (fig. 63) became a model for Pechstein's *Evening in the Dunes*, painted in the summer of 1911 (fig. 76, plate 16). The magnificent Polynesian native holding her hair was reincarnated as a German bather on an East Baltic beach. It was important, in Pechstein's recollection, that the work was done from nature and that the model was his wife: "I had the good fortune to always have with me now, in total naturalness, a human being whose movements I could absorb. Thus I continued my attempt to understand man and nature as one, but more vigorously and more inwardly than I had in Moritzburg in 1910. And also quite differently, because the creative process of art

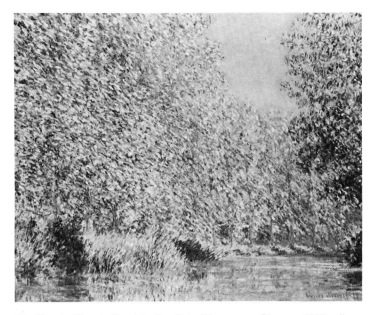

74. Claude Monet, *Bend in the Epte River, near Giverny,* 1888, oil on canvas. Philadelphia Museum of Art, The William L. Elkins Collection.

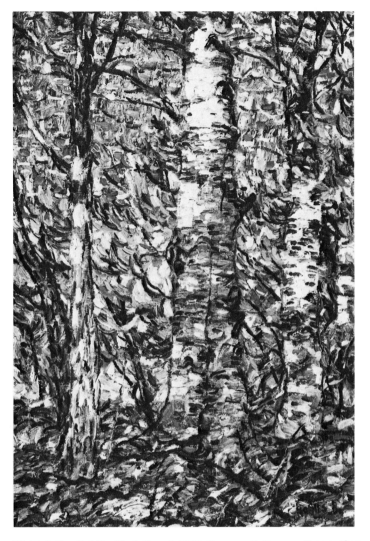

75. Christian Rohlfs, *Birch Forest,* 1907. Museum Folkwang, Essen. (See also plate 15)

made me and the person I now painted in flesh and blood . . . actually flow together into one."[117] This romantic effort to unify art and life is quite evident in the Expressionist painting. The women's gestures seem spontaneous and unposed: few Western artists before this time had hazarded a frontal nude with parted thighs. Also the setting sun casts pure red light on the left side of one figure's legs and, as well, pure blue shadows on the right side of another's. It was precisely this naturalness—this appeal to sensuous color and real "flesh and blood"—that departed so radically from Gauguin's Symbolist precedent. The entire goal of Gauguin's style had been musical "abstraction," after all; its function had been to evoke the insubstantiality of "dreaming."[118]

Why, then, did Pechstein take the trouble to interpose a remembered Gauguin image between the "total naturalness" of his model and the comparable naturalness of his art? The answer is twofold. First, he probably brought a photograph of the Symbolist source along with him on his summer vacation; his friend Kirchner, with whom he would soon open the MUIM art school (fig. 57), had made the photograph from the Gauguin original the previous September.[119] And second, he apparently wanted *Evening in the Dunes* to assert an unequivocal allegiance to modernist French art. He had, after all, just helped rebut Carl Vinnen's chauvinist protest against imported French art and against "Frenchified" German artists.[120] To make doubly sure that his viewers got the intended message, in fact, Pechstein not only patterned his second figure on Gauguin's but he also modeled his *first* figure—a seated profile nude with face resting on hand and gazing out at the observer—on the identically posed

nude in Edouard Manet's *Déjeuner sur l'herbe* (fig. 77). An identification with Manet, the hero of the 1863 *salon des refusés,* would not be surprising if Pechstein as Neue Secession leader considered himself a comparable hero of "artists refused by the Berliner Secession."[121]

Like Manet and like Gauguin himself, Pechstein was following a modernist precedent in borrowing motifs but not styles. Just as Manet had used Realism in 1863 to undermine the classical implications of a motif from a Marcantonio etching, and just as Gauguin had used Symbolism in 1891–92 to undermine the exotic tendencies of a Javanese Temple at Barabadur,[122] so Pechstein used Expressionism in 1911 to undermine the largely formalist initiatives of both his French

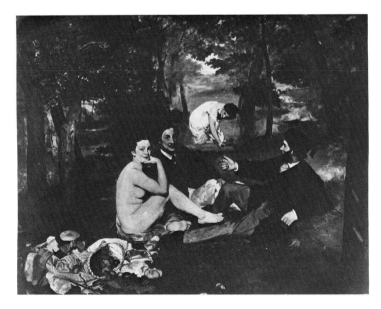

sources. As with other Expressionist responses to Symbolism we might mention, the citation of a source was but a prelude to its transformation.[123]

Neue Secession styles were broadly similar to Pechstein's—some more Post-Impressionist, some more Fauve—with the exception of Wilhelm Morgner's. Only twenty when he began showing with the group in November 1911, Morgner was already pursuing an independent path toward abstraction. *Woodworker,* exhibited on that occasion, employed large brick-like strokes in insistent curvilinear patterns; a similarly stylized drawing was shown in the Blaue Reiter's second exhibition and illustrated in its almanach. A student of Tappert in Berlin and an admirer of Kandinsky in Munich, Morgner by 1912 was developing his own brand of Abstract Expressionism in

76. Max Pechstein, *Evening in the Dunes,* oil on canvas, 1911. Leonard Hutton Galleries, New York. (See also plate 16)

77. (left) Edouard Manet, *Déjeuner sur l'herbe,* 1863. Musée d'Orsay, Paris.

95

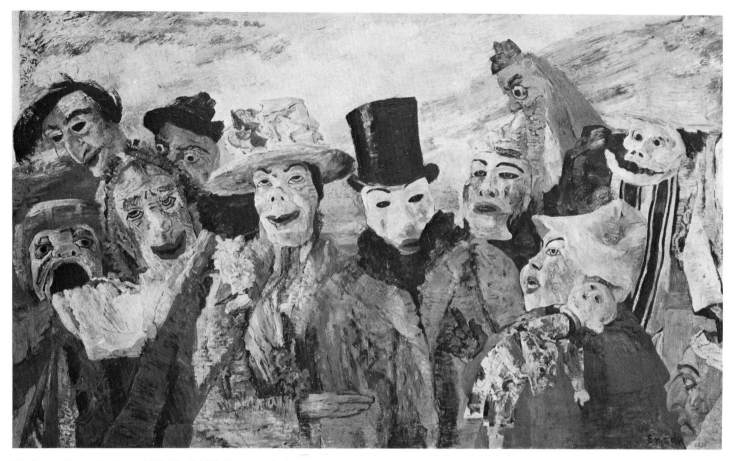

78. James Ensor, *Intrigue*, 1890. Koninklijk Museum, Antwerp.

Worship and *The Crucified One* (not illustrated).[124] Unfortunately he gave up this initiative when conscripted for army service in 1913. He did not survive the war.

Nolde belatedly joined the Neue Secession for its second exhibition in the fall of 1910, not for its first. His style had already proceeded from the late Impressionism of 1909 to the German Fauve colorism of 1910 (figs. 22, 23). But in 1911, after visiting James Ensor in Ostend, Belgium, Nolde started to study primitive masks from both folk art and tribal art sources. In his *Masks* (fig. 81), for example, the second and third faces resemble papier-mâché carnival masks of the type Nolde saw in Ensor's home and in his art. Indeed in Nolde's third mask the pig-snout nose and the garish laughing lips seem based on the similar features of two foreground masks, just left of center, in Ensor's

79. Yoruna tribe (Munduruku, Brazil), shrunken trophy head. Museum für Völkerkunde, Berlin.

Intrigue (fig. 78). Such selectivity, as we shall see, is typical of Nolde's primitivism.

The other masks in this *Still Life* come from Oceanic, South American, and African sources. The first head with diabolical grin and jack-o'-lantern eyes derives from an *Ornamental Canoe-Prow* from Vella Lavella in the Solomon Islands.[125] The fourth head, in the lower right of Nolde's painting, is based in part on a shrunken head from the Yoruna Indians of Munduruku, Brazil (fig. 79). And the fifth head seems partly taken from a type of Nigerian mask of the Ijo tribe (fig. 80). The Solomon Island and Peruvian pieces were copied in the Berlin Ethnographic Museum,[126] and pieces of the Ijo type were represented in the Ethnographic Museums of Leiden and Hamburg, either of which Nolde could have visited on the Ostend trip.

But what is fascinating is the Expressionist's selectivity in utilizing his sources. Like eclecticism in the whole, selectivity of the part suggests Nolde's focus on emotionally significant features. Thus from the Peruvian piece he copied the top of the face with its horrific sightless eyes, ignoring its recessed jaw; but from the Nigerian piece he took the authoritative expression of stern eyes and vertical nose, and not the lower facial region. Moreover, the latter features reappear in the *Crucifixion* (1912), the largest panel in Nolde's nine-part *Life of Christ* altarpiece (fig. 24).

It is revealing that these and other features of Nolde's saints and apostles come from tribal, rather than medieval, sources. The choice is apparently due to his wish to paint them not as Christians or Germans, but rather as "strong Jewish types," in other words as primitives. If Nolde also possessed what Ensor did, namely what Paul Haesaerts calls an "affinity for Christ,"[127] then such identification with Christ also involved a measure of self-identification with primitives and Jews.

80. Kalabari Ijo, Hippopotamus mask, wood, pigment. Raymond and Laura Wieglus Collection.

81. Emil Nolde, *Masks,* oil on canvas, 1911. Collection, The Nelson-Atkins Museum of Art. Gift of the Friends of Art.

82. Cameroon tribe, headdress Ekoi, wood, leather, and mixed media. Staatliches Museum für Völkerkunde, Munich.

Other members of the Neue Secession were also involved in 1911–12, like Nolde, in the utilization of tribal art sources. In the case of Otto Mueller, such primitivism involved little more than the depiction of a mask on a wall, and a consequent parallel of human face with mask.[128] Although Mueller was so valued by Kirchner and Heckel that he became a member of the Brücke itself (and not just of the Neue Secession), Mueller's Expressionism was mild, sensuous, and naive. Since his mother had been a gypsy child,[129] his occasional use of motifs from gypsy life is understandable.

Tribal sculpture was important for all the Brücke artists in Berlin from the winter of 1911–12 until May 1913, when the group broke up. It was employed as motifs for still-life painting, as models for near life-size sculpture, and as a general stylistic stimulus.[130] Perhaps the most novel use of tribal art was Schmidt-Rottluff's appropriation of a Cameroon headdress from the Berlin Ethnographic Museum, made from skin, hair, and teeth mounted on wood,[131] as prototype for a painted brass relief of *The Four Evangelists* (figs. 82, 83). Schmidt-Rottluff must have been particularly interested in the eye and mouth expressions in the Cameroon piece: the eye-holes were sightless

and misshapen and the lips excessively flattened because the skin was merely stretched on a wooden maquette. In any event Schmidt-Rottluff, like Nolde the year before, made use of these features selectively. *Matthew*'s almond-shell eyes, upper left, derive directly from the type of closed eye seen in the *Cameroon Head,* while *John*'s half-open but triangular eyes, lower right, resemble the misshapen eye-hole on the other side of this same head. Meanwhile *Mark*'s flat nose and prominent lips, upper right, and *Luke*'s tuft of forehead hair and even larger lips, lower left, are also faithful to the Cameroon source. The overall effect of the Expressionist relief is not obviously primitive.[132] Nevertheless, close examination reveals the sophisticated admixture of simple, geometric features—features that are individually tribal in origin.

Further examination of the relief, especially the *John* panel, suggests a nascent interest in Cubism. Indeed, ever since Kirchner playfully signed himself "Cézanne" on a postcard from late 1909,[133] and especially since the Cologne Sonderbund exhibition made recent Picasso paintings available in May 1912, Brücke painters sometimes experimented with early Cubist effects.[134] As in Heckel's *Glassy Day,* or in Kirchner's *Street, Berlin* (plates 8, 20), the Brücke's Berlin style is characterized by both strongly geometric volumes and quasi-Cubist formal flattening. The ties of this style to both tribal sculpture and Cubist painting exemplify, yet again, a typical Expressionist manipulation of divergent vitalist and structured impulses at once.

As early as 1911 the Brücke painters in Berlin befriended some of the poet members of the Neo-Pathetic Cabaret. Schmidt-Rottluff carved the group's woodcut letterhead,[135] and both he and Kirchner portrayed one of the Cabaret poets, Simon Guthmann, beginning in that year,[136] while Kirchner later illustrated the poems of Georg Heym, the group's most gifted writer, who died tragically in January 1912.[137] But the closest tie between an Expressionist painter and poet was that between Ludwig Meidner and Hans Davidsohn, who used the pen name Jakob van Hoddis.

Van Hoddis is generally credited with creating the first German Expressionist poem, which he read at one of the sessions of the Neo-Pathetic Cabaret late in 1910 and published in January 1911. It was called *End of the World:*

> The bourgeois' hat flies off his pointed head,
> the air re-echoes with a screaming sound.
> Tilers plunge from roofs and hit the ground,
> and seas are rising from the coasts (you read).
>
> The storm is here, crushed dams no longer hold,
> the savage seas come inland with a hop.
> The greater part of people have a cold.
> Off bridges everywhere the railroads drop.[138]

Johannes Becher, who considered this poem "The Marseillaise of the Expressionist rebellion," went on to define its style as "simultaneity":

> At the same time as the slaters are plunging from the rooftops, the flood-tide is mounting, or, nothing exists on its own in this world, every unique entity merely appears to be

Figures 83(a–d). Karl Schmidt-Rottluff, *The Four Evangelists,* **painted over brass relief, 1912. Brücke-Museum, Berlin.**

so, in fact it is part of an infinite whole. Most people have a cold and at the same time trains fall off railway bridges. The catastrophic event is unthinkable without a simultaneous triviality. . . . [Later] the experiences of simultaneity became a blueprint, and bureaucratic poetry was churned out, . . . with every statement followed by its opposite until the arbitrariness and lack of order destroyed any kind of connection or sense.[139]

The contradictory nature of Expressionist literary style, as defined by Becher, may directly be linked to the Expressionist art style of Meidner.

Meidner the painter became the poet van Hoddis' closest friend. They would take drunken walks through Berlin, Meidner later recalled, and end up at dawn before rows of "joyful-tragic tenements" with their "tragic-joyful balconies." Moreover, in explaining how to draw the city, Meidner's contrast of "straight line" and "feeling," "order" and "confusion," recapitulates van Hoddis' contrast between the catastrophic and the trivial: "Don't be fooled [Meidner wrote in 1913–14]. A straight line is not cold and static! You need only draw it with real feeling and observe closely its course. It can be first thin and then thicker and filled with a gentle, nervous quivering. Are not our big-city landscapes all battlefields filled with mathematical shapes? . . . Take a big pencil and cover a sheet with vigorously drawn straight lines. This confusion, given a little artistic order, will be much more vital than the pretentious little brushings of our professors." Since Meidner deplored "the stammerings of primitive races" and their influence on his contemporaries, it was Robert Delaunay's paintings of the Eiffel Tower and the manifestos of Italian Futurist painters that provided the "vital" quality he sought in depictions of urban life.[140]

These facts have other implications. It is sometimes thought that Meidner's *Apocalyptic Landscapes* of 1912–13 (plate 5) were devoted solely to disorder, not order, or to manic "quivering" and not mathematics. But as we see in comparing Raymond Duchamp-Villon's Cubist house of 1912 with Meidner's *Corner House* (*Villa Kochmann, Dresden*) of 1913 (figs 84, 85), the Expressionist had to do just as much mathematical construction as the Cubist except that he then, in addition, had to visualize *de*construction.[141] The Duchamp-Villon model is not Cubist, strictly speaking; classical, geometric, and understated, the structure becomes abstract only in its multiplication of cornice and pedimental forms. But in the Expressionist house Meidner had not only to multiply pediments and cornices; he had also to implode and explode the several sections of the elevation. Only in the end does the *Corner House* emerge as an "ecstatic portrait of a patron's home,"[142] like Delaunay's similarly glorifying portraits of the Eiffel Tower.

84. Raymond Duchamp-Villon, Cubist house, 1912. Building destroyed.

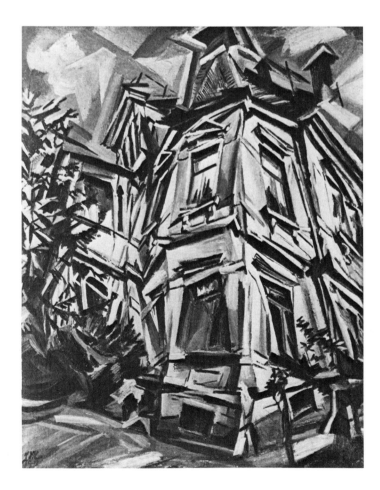

85. Ludwig Meidner, *Corner House (Villa Kochmann, Dresden),* oil on canvas, 1913. Sammlung Kirste, Recklinghausen.

Together with Jacob Steinhardt, a Neue Secession exhibitor in 1910, and Richard Janthur, with whom he had studied at the Breslau art academy, Meidner formed a group called the Pathetiker and exhibited at Herwarth Walden's Sturm Gallery in November 1912. In taking its name from the Neo-Pathetic Cabaret, Meidner's group expressed its solidarity with van Hoddis and other Expressionist writers. But what their name actually meant is more difficult to signify. For the Cabaret took its name from the notion of a "new pathos" advanced by Stefan Zweig in 1910: "It seems that our age is again preparing to return to this primordial, intimate contact between poet and listener, our age which is again originating a *new pathos*. . . . Today, as before, it seems that the lyric poet will have the right to become, if not the spiritual leader of his age, then at least the tamer and arouser of its passions, the rhapsodist, the challenger, the inspirer, the igniter of the sacred flame—in short, to become energy."[143] Thus the *neue Pathos* can be translated either "new passion"—stressing the Expressionist's emotionalism—or else "new compassion," indicating his pity and fellow-feeling for both his subject and his audience. Meidner's Pathetiker can in this sense be called the "pathetic" or the "compassionate" ones.[144]

3.6. PREWAR EXPRESSIONISM (CONTINUED): 1912–14

During the early months of 1912 the Expressionist movement entered a second stage in its consolidation, one comparable to the NKVM's and the Neue Secession's challenges of 1909–10 to the Munich and Berlin Secessions. First the Düsseldorf-based Sonderbund—a "Special League of West German Artists and Friends of Art"—assembled a survey of the entire modern movement in the arts, particularly the German avant-garde, and called this movement "Expressionism." It opened in Cologne in May 1912. Meanwhile certain independent art dealers were establishing a market for advanced art. Hans Goltz in Munich, who had mounted the second Blaue Reiter exhibition in February 1912, began to seek additional shows. And Herwarth Walden in Berlin, editor of *Der Sturm* magazine, opened his Sturm Gallery in March with a modified Blaue Reiter exhibition and then proceeded to mount *monthly* displays of the most advanced work he could find. These events had vast implications, for they meant that artists' groups—Brücke, Blaue Reiter, or Neue Secession—had lost the exhibition initiative. By June 1912 Franz Marc was compelled to announce, somewhat plaintively, that "Artists are not dependent upon exhibitions, but rather exhibitions depend completely on the artists."[145]

Thanks to Berlin's Sturm Gallery and Munich's Goltz organization, however, the situation had changed. The avant-garde art dealer, not the avant-garde art group, became the agent for the publicity and sale of Expressionist art. Inevitably, other shows were also mounted by other dealers in other cities.[146]

SOME PREWAR EXPRESSIONIST EXHIBITIONS, 1912–14
(* = retrospective or one-man show)

1912

MARCH: Berlin (Sturm). Blaue Reiter, French Expressionists; Kirchner, Kokoschka,* Pechstein

APRIL: Berlin (Sturm). Futurists. To Munich (Goltz) in November

MAY–SEPTEMBER: Cologne (Sonderbund). International Exhibition

JUNE–JULY: Berlin (Sturm). Works rejected by the Sonderbund

SEPTEMBER: Munich (Goltz). Kandinsky.* Then to Berlin (Sturm)

OCTOBER: Munich (Goltz). Group Exhibition I: 40 painters, including Berlin, Munich, Paris artists

NOVEMBER: Berlin (Sturm). Pathetiker

NOVEMBER: Munich (Neue Kunstsalon). Nolde*

1913

FEBRUARY: Berlin (Sturm). Delaunay*

FEBRUARY: Munich (Thannhauser). Picasso*

MARCH–APRIL: Berlin (Sturm). Marc*

MARCH–APRIL: Munich (Goltz). Moderne Bund. Then to Berlin (Sturm).

JUNE: Munich (Goltz). Schiele*

JULY–AUGUST: Bonn (Cohen). Rhineland Expressionists: 16 artists, including Campendonk, Ernst, Macke, Mense, Nauen

AUGUST–SEPTEMBER: Munich (Goltz). Group Exhibition II: 60 painters

SEPTEMBER–DECEMBER: Berlin (Sturm). First German Autumn Salon: 85 painters, including Berlin, Munich, Paris, Futurist, Moderne Bund, Rhineland, Skupina artists, R. Delaunay,* S. Delaunay-Terk,* Ernst, Feininger, Hartley, Klee,* Kokoschka, Mondrian, Rousseau,* Van Heemskerck

OCTOBER: Berlin (Gurlitt). Pechstein*

NOVEMBER: Berlin (Gurlitt). Kirchner,* Matisse*

1914

JANUARY: Dresden (Arnold). Expressionist Exhibition: 46 artists

FEBRUARY: Berlin (Sturm). Jawlensky*

MARCH: Berlin (Gurlitt). Erbslöh,* Heckel*

APRIL: Berlin (Gurlitt). Kanoldt,* Schmidt-Rottluff*

APRIL: Berlin (Sturm). Klee*

MAY: Düsseldorf (Flechtheim). Rhineland Expressionists. Then to Berlin (Neue Galerie)

JUNE: Berlin (Sturm). Chagall*

SUMMER: Munich (Goltz). Group exhibition: 45 painters, 12 sculptors

The variety of art from these Expressionist exhibitions was great. Yet the general style directions are readily characterized: on the one hand, the continuing progress toward the Post-Impressionist, the Fauve, and the Cubist/Futurist and, on the other hand, the continuing concern for the primitive, the childlike and, now, the medieval.

The medieval impulse in Expressionist art was relatively late in developing, but it long lay just beneath the surface.[147] By May 1912, when a chapel was installed at the Sonderbund exhibition in Cologne with stained glass windows by Johan Thorn-Prikker and a monumental *Madonna* painted by Kirchner and Heckel,[148] medievalism became fashionable. For example Pechstein, who had had only one stained glass commission in 1909, executed five more such commissions between August 1912 and February 1913.[149] And Lyonel Feininger in July 1912 did a humorous drawing *In the City at the End of the World* in which top-hatted burghers face a comical church, also top-hatted, which has scary window-eyes and a devouring doormouth. This apocalyptic spoof was published on the title page of Berlin's *Aktion* magazine in a late 1913 issue.[150] Meanwhile Feininger also did his first paintings of *Gelmeroda* in 1913, exhibiting one of them at the First German Autumn Salon in September of that year.

But it was the two great sculptors of German Expressionism, Ernst Barlach and Wilhelm Lehmbruck, who introduced the strongest medievalizing tendency. Barlach was playwright as well as artist—like Kokoschka and Kandinsky—and his mystical outlook was expressed in the 1912 drama *The Dead Day* and accompanying lithographs. The piece involves a son's dialogue with his mother in a deluded search for his father. After both have committed suicide, the play ends with the remark: "But what is strange is that mankind refuses to learn that its father is God."[151] In its folk tale atmosphere and heavy figural forms the drama and illustrations are rooted in North German peasant life. In 1912 several of these massive figures were carved in wood, presumably after rural medieval church sculptures; titled *The Vision* and *The Desert Preacher,* they were exhibited at the old Berliner Secession beginning the spring of 1912.[152] Earlier wood pieces, somewhat more anecdotal, were shown at the Cologne Sonderbund—so that Barlach was not immediately perceived in vanguard circles as an Expressionist pioneer.

Lehmbruck's contribution to the Cologne Sonderbund, however, included one of the masterpieces of German Expressionist sculpture, the 1911 *Kneeling Woman* (fig 87). Theodore Däubler saw it as spiritual and architectural: "no longer prayer but devotion, a faith in a verticality yet to come."[153] But it is also one of those works which cites a Symbolist source in order to transform it, namely Georges Minne's *Bather I* of 1899 (fig. 86). The Minne is self-contained, while the Lehmbruck not only unfolds into space but commands it three-dimensionally. The head-masses are similarly spiritual—elongated and slightly bowed—except that the boy's glance is inward while the woman's, introverted to a degree, also encompasses the forward-pointing limbs. These limbs are, of course, architectural, spanning space and supporting the body mass, whereas the youth's limbs are thin and ethereal, unused to material weight. In addition, the bony right arm and hand, closed in on itself in the Minne, opens gently into space in the Lehmbruck and subtly masters it. If there is a third term to the equation, it exists in Lehmbruck's *Rising Youth* of 1913 (not illustrated), where *both* arms begin to unfold, *both* elbows begin to separate, on the way from Minne's 1900 pose to Lehmbruck's 1911 gesture. *Kneeling Woman* has the capacity for action that its source lacks.

Lehmbruck's spirituality stems from Minne's, and not directly from spiritual "architecture." And yet both works were perceived in their time, by no less a witness than Julius Meier-Graefe, as medievalizing. In 1912 he called the Lehmbruck "Gothic," "a slitlike phantom," and "an awkward giant marionette."[154] But the Minne he also called a modern embodiment of "the Gothic." "Minne dreams of beauty," Meier-Graefe wrote in *Evolution of Modern Art,* "of those amazingly masterful figures which adorn the portals and cathedrals of the

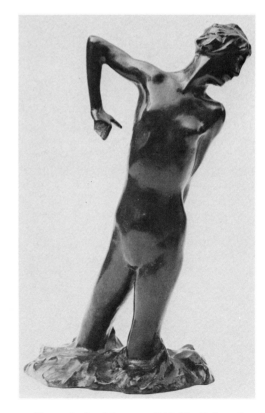

86. Georges Minne, *Bather I,* bronze, 1899. The Robert Gore Rifkind Collection, Beverly Hills, California.

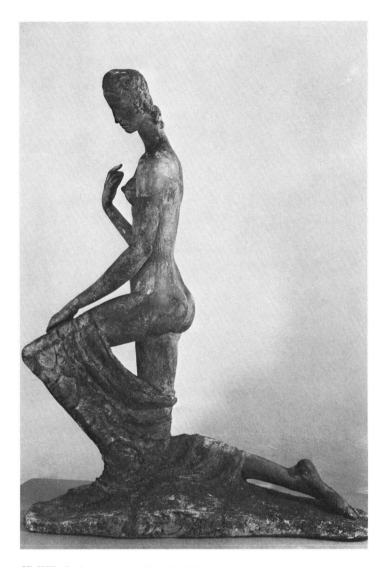

87. Wilhelm Lehmbruck, *Kneeling Woman,* cast stone, 1911. Collection, The Museum of Modern Art, New York. Abby Aldrich Rockefeller Fund.

Lehmbruck's *Kneeling Woman* makes explicit what had only been implicit in its source: a spirituality of palpable mass rather than ethereal surface, of architectural authority rather than mere sculptural idea. Symbolist "dreaming" becomes, once again, Expressionist "flesh and blood."[156]

The medievalizing tendency could become even more explicit in prewar Expressionism, as it did in 1913 in a group calling itself the Rhineland Expressionists.[157] Among the Rhenish artists first exhibiting in July of that year, both Heinrich Nauen and Max Ernst admired Mathias Grünewald's Isenheim Altarpiece housed in Colmar, up the Rhine River in Alsace. As Peter Selz has shown, Nauen's *Pietà* (1913) was based in part on Grünewald's "Crucifixion" (fig. 88).[158] Meanwhile Ernst's own *Crucifixion* (fig. 89) is even more generally related to the same source. In both the Christ's waist is pinched and his head falls to the horizontal.[159] Nevertheless, Ernst, the future Surrealist, responded to Grünewald in a poetic and dreamlike fashion. Despite the fingers clenched in agony, Ernst's work unaccountably reverses the positions of human and crucifix arms. As a result, the figure seems less to hang painfully from its pinned hands than to float serenely before the cross—an effect heightened by the moody landscape which confronts Gothic ruins with an overarching rainbow. This hopeful and redeeming touch reverses Grünewald's stark and moralizing message of death and decay. The Expressionist here romanticizes the Gothic.[160]

Though he organized the Rhineland group in 1913, August Macke retained his ties to the Munich artists of the erstwhile Blaue Reiter. He remained particularly close to Franz Marc, and traveled to Tunisia with Paul Klee in April 1914. Macke thus took part in Expressionism's last, heroic effort to resolve the contradiction if not between the medieval and the modern, then at least between the vital and the structural.

The contradiction can be seen in comparing a drawing of a *Snowball Fight* by an anonymous six-year-old girl with Klee's 1913 drawing of *Children as Actors* (figs. 90, 91). The child's drawing was published in Munich in 1905 by Dr. Georg Kerschensteiner in a massive study of school children's drawing ability,[161] and anyone interested in the subject would undoubtedly have known the source. Klee was interested. Indeed his initial response to the first Blaue Reiter exhibition in January 1912 had been to compare the most advanced art to that of children:

> For these are primitive beginnings in art, such as one usually finds in ethnographic collections or at home in one's nursery. Do not laugh, reader! Children also have artistic ability, and there is wisdom in their having it! The more helpless they are, the more instructive are the examples they furnish us; and they must be preserved free of corruption from an early age. Parallel phenomena are provided by the works of the mentally diseased; neither childish behavior nor madness are insulting words here, as they commonly are. . . . If, as I believe, the currents of yesterday's tradition are really be-

North. . . . He dreams of architecture in sculpture, new and age-old dreams, forgotten ideals." Furthermore, Meier-Graefe's remarks of 1904 were echoed in Kokoschka's experience of Minne's sculptures in 1908–09: "In their chaste forms and their inwardness, I seemed to find a rejection of the two-dimensionality of Jugendstil. Something was stirring beneath the surface . . . , something akin to the tension which, in Gothic art, dominates space and indeed creates it."[155]

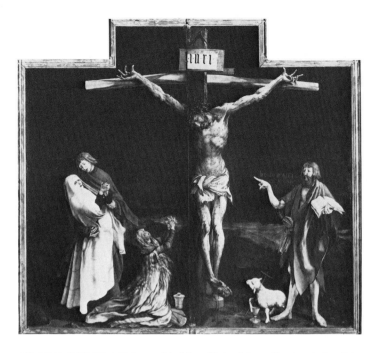

88. (above) Mathias Grünewald, "Crucifixion" from the Isenheim Altarpiece. Musée Unterlinden, Colmar.

89. (right) Max Ernst, *Crucifixion,* 1913. Museum Ludwig, Cologne.

coming lost in the sand and the so-called unflinching pioneers (liberal gentlemen) . . . are the very incarnation of exhaustion, then a great moment has arrived, and I hail those who are working toward the impending reformation. The boldest of them is Kandinsky.

And by 1913 he was seeking "A naive style. The will under anaesthesia"—statements which may well have referred to the type of drawing illustrated here.[162] In any event the six-year-old's figures are constructed out of a "schematic" hour-glass shape of crossed lines joined top and bottom; they are topped by circular heads with economically drawn features. Klee's drawing is similarly constructed. Kerschensteiner's text calls the child's drawing an example of "linear arrangement of space," where representation occurs "along one or several straight or crooked lines."[163] Here Klee's drawing follows the schema described in the author's text, in addition to those evident in the child's drawing itself.

Still, despite Klee's successful attempt to capture the spontaneity of the six-year-old's style, his drawing is less "naive" than fully Ex-

pressionist. The line quality is nervous, repetitive, and subtly varied. And the multiplication of hour-glass shapes produces smaller triangles and stars that resemble nothing so much as Cubist fragmentation.[164] Indeed this combination of childlike and Cubist elements, of vital and structural properties, is the hallmark of the Klee style.

For Macke and Marc the structural component was provided less by Picasso's and Braque's Cubism than by Delaunay's Orphism. To be sure, Marc's *Tiger* of 1912, shown in the Cologne Sonderbund that summer, can be linked directly to Picasso's *Head* drawing (1909), which had been exhibited at the NKVM's second show of September 1910 and reproduced in its catalogue (neither illustrated).[165] The diamond-shaped eyes and the fragmented face and body contours are similar in both works. And Marc's 1913 *Animal Destinies* (plate 1) owes something of its composition, although not its color, to Italian Futurist paintings widely shown in 1912. But after Macke and Marc visited Delaunay in Paris early in October 1912, and especially after Delaunay's one-man show in Berlin in February 1913, Cubism and Futurism receded in significance.[166]

Delaunay's Orphism profoundly affected Macke's 1913 *Bathing Girls,* both in its structure of colored planes and in its use of small circular forms (figs. 34, 35). And a similar derivation can be traced from Delaunay's 1912 *Windows on the City (First Part, Second Motif),* which both German artists knew,[167] to Marc's 1914 *Deer in the Forest II* (figs. 92, 93). Just as the Delaunay is at once a view of Paris with the Eiffel Tower top center and also a surface weave of fluctuating, prismatic color-planes, so the Marc weaves a sylvan setting with three animals into an abstract field of floating color-rectangles.

Nevertheless, the differences between the two works are, once again, revealing. Delaunay sought to achieve in his *Windows* what he called "the construction of reality in pure painting," where light itself was the "only reality." But light was also "simultaneous contrast," requiring "the dynamism of colors and their construction in the painting." "The first pictures [Delaunay continued, in this 1912 statement] were simply a line encircling the shadow of a man cast by the sun on the ground. But how far we have come, with our contemporary means, from this phantom image—we who possess light (light colors, dark colors, their complementaries, their intervals, and their simultaneity) and all the quantities of colors emanating from the intellect to create harmony."[168] The dynamic qualities of light were to be organized on the canvas (and here on the frame as well) in prismatic colors spanning the spectrum. No longer imitative, not yet fully abstract, the *Windows* seem to materialize light while dematerializing objects. They are, as it were, radiant energy in crystallized form—like panes of the purest stained glass.

90. (top) Anonymous, child's drawing, *Snowball Fight.* From Georg Kerschensteiner, *Die Entwickelung der zeichnerischen Begabung* (Munich, 1905), pl. 95.

91. (bottom) Paul Klee, *Children as Actors,* ink and pencil on paper, 1913. Paul Klee Stiftung, Kunstmuseum Bern.

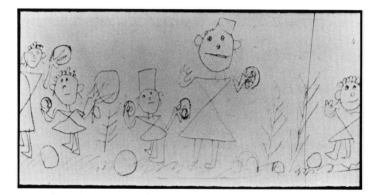

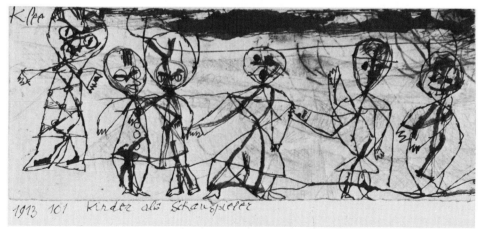

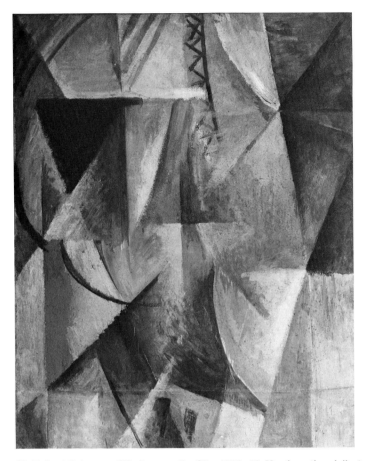

92. Robert Delaunay, *Windows on the City*, 1912–13. Musée national d'art moderne, Centre Georges Pompidou, Paris.

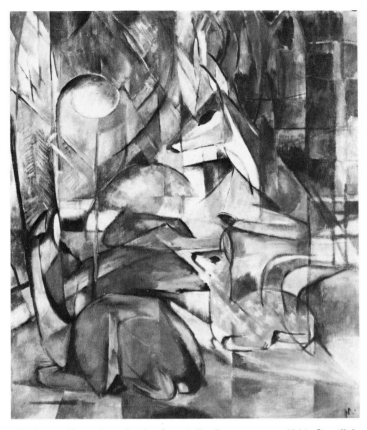

93. Franz Marc, *Deer in the Forest II*, oil on canvas, 1914. Staatliche Kunsthalle, Karlsruhe.

Marc, by contrast, showed his forest deer as if seen *through* such stained glass. The German artist possessed a specific color symbolism: "blue is the male principle, austere and spiritual; yellow the female principle, placid, cheerful, sensuous; while red [is] matter, brutal and heavy, and always the color to be fought and transcended by the two others."[169] In the triangular blue animal dominating *Deer in the Forest II* the spiritual principle is uppermost, though not without admixture of a placid, feminine quality in the central yellow rectangle. Meanwhile the fawn and doe below, naturalistic in hue except for touches of "material" red, are meant to yield to the superior spirituality of the dominant buck. Such color symbolism has little to do with Delaunay's light-based color simultaneity. In the end, despite Marc's acknowledged love for the French, he chose to stress his separateness. "I am German," he wrote to Macke on 12 June 1914, "and can only dig in my own field; what has the *peinture* of the Orphists to do with me?"[170]

With the outbreak of war seven weeks later, German painting would indeed become introspective. Never again would Expressionist art follow the lead of advanced French painting.

3.7. WARTIME EXPRESSIONISM, 1914–18

From the point of view of style, the effects of that war were debilitating. Having for so long followed Worringer's advice to "take our cue from abroad," having for a decade sought artistic renewal in the precedents of France and Russia, Expressionists had suddenly to reexamine their native sources. Not surprisingly, new importance was now given to the primitive arts, to the German Gothic, and to the German Romantics.

The change was partly due to the absence of international exhibitions—long the arena for the transmission of avant-garde styles. German artists before the war had immediately shown their response to contemporary French art and had rapidly absorbed the lessons of Fauvism and Cubism. After the war, on the other hand, half a decade passed (until 1922 and 1923) when the contributions of wartime Rus-

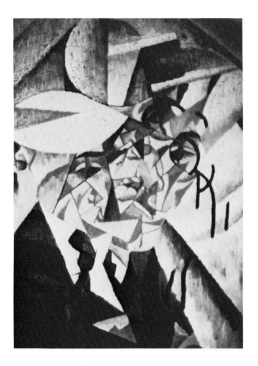

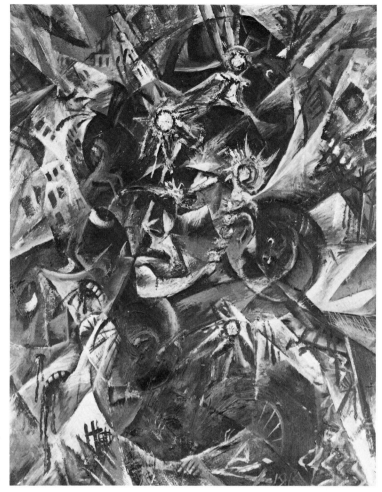

94. (above) Gino Severini, *Self-Portrait with Monocle,* 1912. Musée national d'art moderne, Centre Georges Pompidou, Paris.

95. (right) Otto Dix, *Self-Portrait as Mars,* oil on canvas, 1915. Deutsche Fotothek, Dresden.

sia and Holland became major forces in Germany's art. There was also another factor that helped transform Expressionist style. This was the absurdity of the war situation itself, its destruction of commonly shared ideals, and its invasion of the personal lives of artists.

Of course, as Hermann Bahr wrote in 1916, Expressionists hoped for a rebirth that might free the individual from his soulless environment: "That is the vital point—whether a miracle can still rescue this soulless, sunken, buried humanity. . . . Art too joins in, into the great darkness she too calls for help, she cries to the spirit: this is Expressionism."[171] But the hope for a miracle occurred precisely amid the "great darkness." It was the war experience itself against which any call for spiritual renewal had to be measured.

Indeed it was because of the war that Expressionists treated Futurist sources after 1914 in a way different from other sources before. To be sure, Italy remained neutral for some time. Though she declared war against Austria-Hungary in May 1915, she did not do so against Germany until 27 August, 1916. But Futurist painters were uniformly interventionist and anti-German; there was no longer the prospect of international cooperation. Instead, what Germans belatedly discovered about Futurism was that it could be more destructive than constructive. In the context of mechanized war, Futurist dynamism described a machinery of meaninglessness, no longer a machine-age excitement. This explains why Germans readily carried over into Dadaism the qualities they had absorbed from Futurism, without ceasing to be part of Expressionism's development.[172]

The absurdity of war is seen in Otto Dix's *Self-Portrait as Mars* (1915), but not in such typical Futurist works as Gino Severini's 1912 *Self-Portrait with Monocle* (figs. 94, 95). Both portraits have wit: the **107**

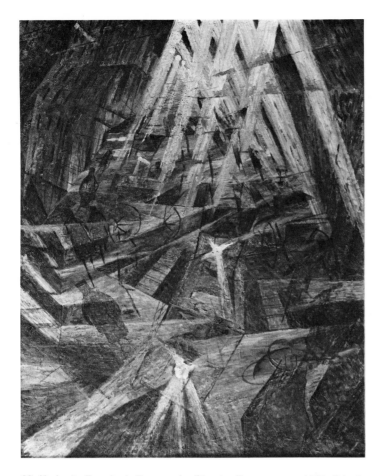

96. Umberto Boccioni, *Forces of a Street,* oil on canvas, 1911. Private collection, on loan to Kunstmuseum Basel.

one as a dandy somehow splintered in a speeding car or a juggled mirror, the other as a soldier somehow sliced by the very forces that destroy the background city. But there is irony, even masochism, in Dix's *Self-Portrait as Mars* that is missing in the Italian oil. That the god of war should be decimated by the very force he represents is a touch of black humor. We are reminded of Dix's *Self-Portrait as Shooting Target* from about this time (not illustrated),[173] even though that painting was perfectly realistic. Moreover, there is sadism as well as masochism in the martial self-image. Just beside and below the artist's cheek are painted a flaming horse, sightless eyes, and bleeding mouths. Dix's gory violence is absent in the prewar Severini.

Dix studied in Dresden before the war and came to Expressionism gradually, through Van Gogh and Nietzsche (fig. 9). Another young artist, George Grosz, studied in Berlin from 1912 on; somewhat later he met Ludwig Meidner and his literary friends. With the war's outbreak Grosz's Expressionist style became more angular and his

study of Italian Futurism more systematic. The results of this study may be seen by comparing Umberto Boccioni's *Forces of a Street* (1911) and Grosz's painting of 1916–17 entitled *The Big City* (figs. 96, 97).

The Boccioni, like other Futurist works shown at the Sturm Gallery in April 1912, had been bought by a banker friend of Walden's and remained in Berlin during the war;[174] and this specific painting was illustrated in Paul Fechter's 1914 book, *Expressionism.*[175] Although Boccioni's image is not immediately clear, it depicts a swaying streetcar with rectangular sides "exploded" upward; the tram is then repeated in diminished perspective.[176] Grosz apparently recalled this image when he painted his streetcar, right center, at a similar angle and apparent velocity. In addition, the Futurist's horsedrawn carriage on the right and his tilted human figures below must also have served as models for the Expressionist's careening truck and frenetically active pedestrians. Of course, Boccioni's precedent does not explain Grosz's crazily lettered street signs and advertisements, for example, *rauch Aurol* ("smoke Aurol cigarettes") on the left side of the central building. But these elements do appear in other Futurist works Grosz would have known, namely Severini's 1912–13 *Autobus* and *North-South Metro,* which were exhibited in Berlin in the summer of 1913 and were illustrated in the show's catalogue.[177]

These comparisons suggest differences as well as similarities. The function of the Futurist city scene was to celebrate the dynamic movement of the metropolis, whereas the Expressionist's purpose was to satirize aspects of it. As Grosz himself described this kind of image in a 1917 letter, there is irony in praising "the song of the signs": "the roundelay of letters and the kidney-destroying nights red as port wine, when the moon is near infection and cursing cabdrivers, and where people are strangled in dusty coal-cellars. Oh, emotion of the big cities!"[178]

Among Expressionist sources German Romanticism stood opposite Italian Futurism. In the wartime context it avoided big city emotion; its imagery was naive and pre-industrial. Moreover, it was native; its imagery was "safe" in a war against the West. As early as 1911 Franz Marc had compared such German Romantics as Friedrich and Runge with the best French Post-Impressionists. He wrote that "the inwardness of these [German] masters would stand up to the most modern of the French with astonishing power. True art is always good."[179] Finally, Expressionist idealism can be linked to Romantic idealism: Kandinsky and Marc's "blue rider" resembles in this regard Novalis' "blue flower."[180] Still, overt use of German Romantic visual imagery was rare before the war.[181]

One of the major Romantic-Expressionist relationships, heretofore overlooked in the specialized literature, is that between Philipp Otto Runge's *Morning* (1808) and Erich Heckel's *Ostend Madonna,* painted on an army tent for Christmas 1915 (figs. 98, 99). The Runge

97. George Grosz, *The Big City,* oil on canvas, 1916–17. Thyssen-Bornemisza Collection, Lugano, Switzerland.

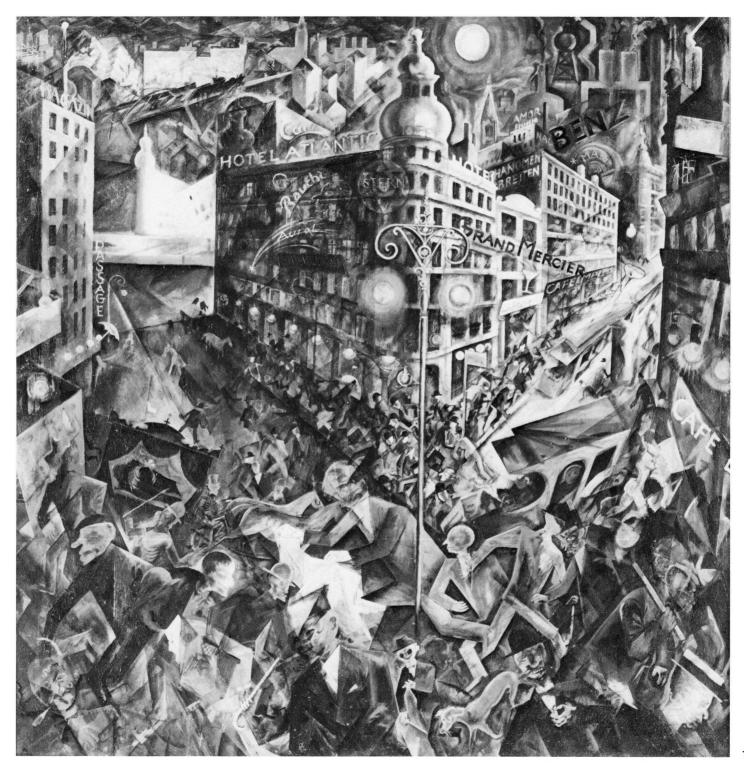

98. Philipp Otto Runge, *Morning* (small version), oil on canvas, 1808. Hamburger Kunsthalle.

99. Erich Heckel, *Ostend Madonna* [lost], oil on canvas, 1915.

was a masterpiece of the Hamburger Kunsthalle, and was also illustrated in a well-known modern art text of the period;[182] Heckel would have known the painting from both sources. The derivation is shown mainly by the framing device Heckel uses, filled with alternating angels and flowers, that mimics portions of the actual frame of Runge's painting. Then, too, the central figures are iconographically related, to the extent that Heckel has transposed the terms of Runge's allegory. The classical nude Aurora above and the innocent babe Morning below in the Romantic work turn into the Expressionist's traditionally Christian image of Virgin and Child—appropriate for Christmas devotion. It is even likely that the Virgin's appearance as a goddess arising from a rocky and wave-filled sea is derived from one of *Morning*'s preparatory drawings, where Runge makes the Aurora-motif recall the Birth of Venus.[183]

Despite these borrowings, however, no Romantic source can explain the scale relationships within the Expressionist composition. The tiny boat entering the scene lower left makes the Madonna appear some fifty feet tall. And her head, like that of the child, appears disproportionately large—in accordance with a figural canon which Heckel derived from both Gothic and tribal art sources. Finally, by rendering the Christ child as miniature adult, in the manner of late medieval prototypes, Heckel stresses his rejection of both the classicism and the illusionism of the Runge source with which he had started. If Ernst before 1914 had romanticized the Gothic (fig. 89), then Heckel now medievalizes Romanticism.

Similarity of landscape mood and color unites Caspar David Friedrich's 1832 *Large Enclosure* (*Evening on the Elbe*) and Emil Nolde's 1916 *Marsh Landscape* (*Evening*) (figs. 100, 101, plate 17).

100. (left) Caspar David Friedrich, *Large Enclosure (Evening on the Elbe),* 1832. Staatliche Kunstsammlungen, Dresden.

101. (below) Emil Nolde, *Marsh Landscape (Evening),* oil on canvas, 1916. Öffentliche Kunstsammlung, Kunstmuseum Basel. (See also plate 17)

Although Nolde's sky on the North German coast is overcast and Friedrich's near Dresden is not, the colors are almost identical. In each case, starting from the top, we see a neutral band of sky, a bright yellow sunset crossed with lavender clouds, an expanse of green field, and, below, a convex shape of foreground marsh or river reflecting the neutrals and yellows above. Nolde must certainly have seen the Friedrich painting.[184]

Yet despite his debt, the Expressionist departs from his source rather fundamentally. Where Friedrich phrased his dirge in plaintive woodwind tones, Nolde's picture resounds with more dramatic horns and drums. In the one case evening signifies eternal rest;[185] in the other the weather is turbulent, perhaps with the prospect of a cleans-

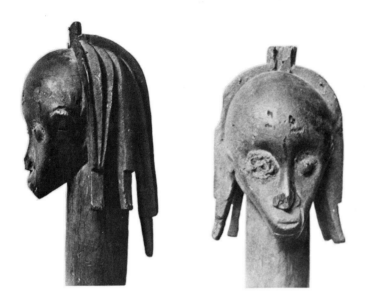

102. Fang tribe, Gabon, wooden head in two views.

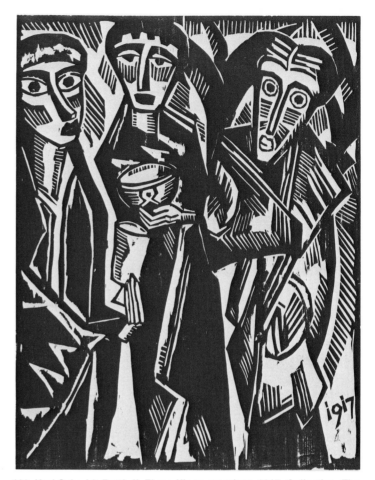

103. Karl Schmidt-Rottluff, *Three Kings,* woodcut, 1917. Collection, The Museum of Modern Art, New York; Purchase.

ing storm. Although a human presence is lacking in the Nolde, the very bravura of the painter's brush bespeaks a vitality absent in Friedrich. It can be argued, of course, that of all the Expressionists Nolde alone could infuse the natural with the supernatural, that his was the most genuinely Romantic sensibility of his time.[186] But to the degree that he was Expressionist, his vitalism made Romanticism look pale and cerebral.

Another link between Romanticism and wartime Expressionism can be mentioned: the dependence of some of Meidner's religious imagery after 1915 on that of the early Romantics.[187] But there were probably more thematic than stylistic links between the two movements now, as before.[188]

Expressionist fascination with tribal and folk art continued during the 1914–18 years, sometimes despite great difficulty. Nolde's return from his 1913–14 trip to Russia, China, the Philippines, and New Guinea was uneventful; the art objects he brought back were depicted in later paintings (e.g., figs. 116, 117). But Pechstein's 1914 journey to the Palau islands was less fortunate; after war was declared he was interned by the Japanese, then obliged to return home via the United States and Holland with the loss of all but a few sketches.[189] Meanwhile Expressionists at war lacked access even to illustrations of primitive art; before 1915 there was not a single book on the subject. After Carl Einstein's *Negro Sculpture* was published in that year, Schmidt-Rottluff used the reproductions in making sculptures and prints while still in a construction battalion on the eastern front. In this way Schmidt-Rottluff's *Three Kings* woodcut

112

from 1917 was based on a Fang head in two views illustrated in Einstein (figs. 102, 103). In both we see triangular chins and cylindrical necks, while in the Schmidt-Rottluff the pleated hair on the right and the "ski-jump nose" on the left derive directly from the Einstein reproduction. Moreover, the Fang head, like other pieces illustrated in Einstein, employs the kind of "concave face" that Schmidt-Rottluff introduced in several of his 1917 sculptures.[190]

Heinrich Campendonk emerged in 1916, after two years in the army, as the major Expressionist survivor in Germany of the Blaue Reiter and of the Rhineland Expressionists. By that time Kandinsky had returned to Russia, while both Macke and Marc had been killed in action. Campendonk's primitivism had many sources, judging from *The Tiger,* a 1916 woodcut (fig. 105). First, the overall naiveté of Campendonk's style and its concatenation of unrelated flora and fauna came from paintings by Marc Chagall exhibited in Berlin in

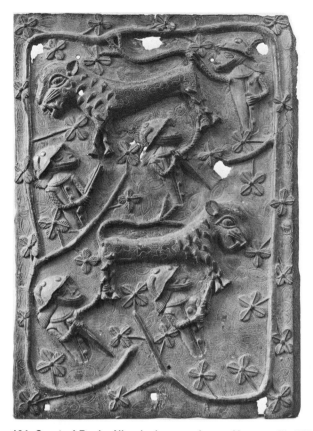

105. Heinrich Campendonk, *The Tiger,* woodcut, 1916. Bayerische Staatsgemäldesammlungen, Munich.

104. Court of Benin, Nigeria, bronze plaque. Museum für Völkerkunde, Staatliche Museen Preussischer Kulturbesitz, Berlin.

June 1914 and again, occasionally, during the war.[191] Second, some parts of the mythical beast in the Expressionist *Woodcut* suggest folk art inspiration. Its claws derive from Russian popular prints, while its dotted eyelids—and perforated patterns just to the right—come from Egyptian shadow-play figures; all were illustrated in the *Blaue Reiter* almanach.[192] Third, a Benin bronze plaque in the Berlin Ethnographic Museum (fig. 104) was the source for Campendonk's heraldic animal itself, from irregular clover-leaf spots to rhythmically striding silhouette. Like Nolde and Schmidt-Rottluff earlier (figs. 81, 83), Campendonk combines elements from divergent styles—a syncretist tendency typical of Expressionist primitivism.

The German Gothic was also of influence on wartime Expressionism, particularly on the work of Max Beckmann. We must assume that Beckmann, a prewar member of the old Berliner Secession, read an important wartime book on the subject by a leading Secessionist critic and editor, Karl Scheffler. For Scheffler's 1917 study *The Spirit of Gothic,* though supposedly remote from current events, actually gave Expressionists "much ammunition."[193] In Scheffler's view

"Gothic" meant not only "Germanic," "masculine," "vertical," and "proletarian," but it also signified agitation rather than contentment: "the Gothic spirit at all levels creates forms of unrest and of suffering; the Greek spirit creates forms of calm and happiness."[194] Not only did Beckmann praise four "masculine" Northern painters at this time—"My heart goes out to the four great painters of masculine mysticism: Mälesskircher, Grünewald, Bruegel, and van Gogh"[195]—but in yet another statement he also stressed the suffering in the world around him: "We must take part in the great misery to come. We must expose our heart and our nerves to the ghastly cries of pain of poor deluded mankind."[196]

In 1917 Beckmann's Gothicizing impulse was still awkward and caricatural, as we see by comparing Dürer's 1504 engraving of *The Fall of Man* with Beckmann's own painting of *Adam and Eve* (figs. 106, 107). Where Dürer's Eden is lush and fruitful, Beckmann's is barren, with only a few flowers sprouting from sandy soil. Where Dürer's figures are measured in classical proportions and reach across in amiable sociability, Beckmann's are "Gothic" in the awkward arches of their bodies and in the disparity of their misshapen size. And where Dürer's serpent had been the sly instigator of the Fall, Beckmann's snake becomes Eve's agent—with his evil head abutting hers, and with two bends of his body pointing to her provocative

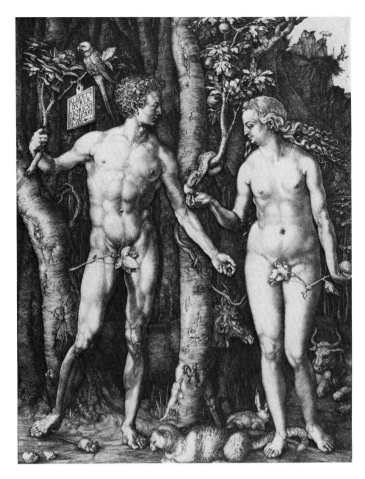

106. Albrecht Dürer, *The Fall of Man (Adam and Eve)*, engraving, 1504. Museum of Fine Arts, Boston.

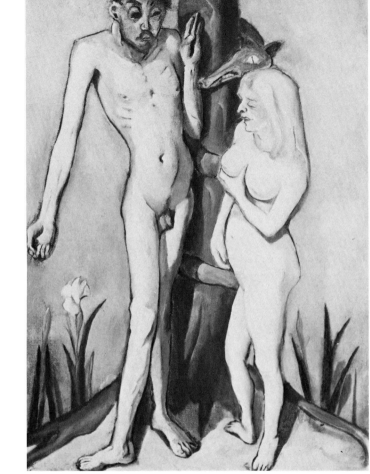

107. Max Beckmann, *Adam and Eve,* 1917. Private collection, USA.

sex. By the year 1918–19, in deriving his *Night* from Hans Pleydenwurff's fifteenth-century *Descent from the Cross* (figs. 42, 43), Beckmann was both more sophisticated in his method and more truly Gothic in his cramped and angular style.

3.8. WEIMAR AND EXPRESSIONIST RENEWAL, 1918–23

Although the Weimar Assembly did not meet until 9 February 1919, and did not adopt a German constitution until 31 July, the Weimar Republic effectively began on 9 November 1918, a few hours after Wilhelm II abdicated and fled to Holland. Not only was a republic declared by the Socialist leadership, but a new wave of Expressionist cultural activity was unleashed in response to the changed national prospects. At 8:00 P.M. of 9 November a "council of spiritual workers" met in the German Reichstag and drew up a list of utopian demands. Over the next few weeks the painters formed their own advisory group under the leadership of Max Pechstein and Georg Tappert. They called themselves "Novembrists" and held the first meeting of the Novembergruppe (November Group) on 3 December.[197]

By January 1919 the Novembergruppe agreed upon a set of radical "Guidelines." It demanded a voice in "all architectural projects," "the reorganization of art schools," "the transformation of museums," "the allotment of exhibition halls," and "legislation on artistic matters." More importantly, it provided for regular group exhibitions. For the second of these, held in Rome in November 1920, Enrico Prampolini wrote one of the last manifestos of the Expressionist movement: "Abstract art, free will, rebellion of all spiritual logic. Revolution, free will, rebellion of all social logic. The parallelism of these two terms—abstraction and revolution—explains

the cause of the beginning and of the free development of Expressionism in Germany and Russia."[198]

Moreover, following the prewar pattern, independent dealers such as Walden in Berlin and Goltz in Munich continued to sponsor Expressionist exhibitions. And finally, conservative museums and galleries now began to mount retrospectives of Brücke art, so that the prewar radicals were now treated in postwar exhibitions as established masters. All in all, Expressionist art was widely shown in the early Weimar years:[199]

SOME LATER EXPRESSIONIST EXHIBITIONS

1918

SUMMER: Berlin. Freie Secession IV
SUMMER: Munich (Goltz). The Expressionist Woodcut
NOVEMBER: Berlin (Sturm). Russian Expressionists

1919

MARCH: Dresden (Richter). Secession Gruppe 1919
JUNE–JULY: Düsseldorf (Kunsthalle). The Young Rhineland
SEPTEMBER–OCTOBER: Munich (Goltz). Group Exhibition V
NOVEMBER: Berlin (Altmann). Novembergruppe

1920

SPRING: Bremen (Kunsthalle). Munch and the Brücke Artists
JUNE–AUGUST: Berlin (Burchard). First International Dada Fair
JULY–SEPTEMBER: Darmstadt (Mathildenhöhe). German Expressionism
NOVEMBER: Rome. Expressionist Exhibition Novembergruppe

1921

SEPTEMBER: Berlin (Sturm). Hundredth Exhibition
NOVEMBER: Berlin (Altmann). Novembergruppe

1922

MAY–JULY: Düsseldorf. International Art Exhibition
DECEMBER: Berlin (Möller). Brücke Exhibition

Stylistic divergence continued and even increased in the early Weimar period with several shifts in orientation which reflected Germany's defeat. Paris, first of all, no longer held the attraction for artists that it held before the war. Visits were far fewer and there were even some, like George Grosz in 1925, who criticized the aestheticism of French painting. Picasso's neo-classicism was not relevant, in Grosz's view, at a time when art should be serving the revolution.[200] Expressionists therefore went on exploring the non-Latin sources they had favored during the war: Gothicism, primitivism, Romanticism. But, second, this disillusionment with the West was now accompanied, rather suddenly, by an interest in the East. Islamic and Oriental elements occasionally appeared in late Expressionism in ways not explored before.

The first volume of Oswald Spengler's *Decline of the West* appeared in 1918 and set the tone for an era. Yet it was Hermann Hesse, generally respected by Expressionists, who drew a key implication for the movement. For in his 1919 essay on "The Brothers Karamazov," subtitled "The Downfall of Europe," Hesse broached the idea of a rebirth in the East following the death of the West: "It seems to me that European and especially German youths are destined to find their greatest writer in Dostoevsky—not in Goethe, not even in Nietzsche. . . . The ideal of the Karamazovs, primeval, Asiatic, and occult, is already beginning to consume the European soul. That is what I meant by the downfall of Europe. This downfall is a return home to the mother, a turning back to Asia, to the source, to the 'Faustian Mothers' and will necessarily lead, like every death on earth, to a new birth." Hesse's sentiments were echoed by the architectural critic Adolf Behne—"Light perpetually comes from the East"—and by numerous Expressionist architects. Bruno Taut described the "ecstasy" of Indian architecture while Otto Bartning, when he saw the Javanese stepped temple at Borobudur, characterized it as "hardly by the hand of man, but rather as if the earth, sunk in dream, had depicted itself with its waking gesture."[201]

Where prewar interests in Ajanta painting (Kirchner) and Theosophical thought-forms (Kandinsky) had been circumscribed and specific, the new Orientalism was mystic and universal. Walter Gropius, in a draft for a Bauhaus speech, set down the words: "To build! To give form! Gothic—India."[202] And Johannes Itten, who taught the Bauhaus basic course from 1919 to 1922, had spent much time studying Oriental religions; Bauhaus students under Itten's tutelage sometimes shaved their heads in ritual self-purification. Meanwhile Annie Besant, the Indian-born president of the Theosophical Society, traveled throughout the world during the postwar years with the Indian youth Krishnamurti, whom she advertised as the new "World Teacher."[203]

At the war's end Hans Poelzig designed a structure that expressed the new enthusiasm for things Eastern—if not Indian then at least Islamic. This was the *Grosses Schauspielhaus,* or large theater, a 1918–19 remodeling of an old vaulted building on commission for Berlin's drama impresario Max Reinhardt (fig. 109). Poelzig's favorite motifs were the tower and the cave, themselves embodying the minaret and columned hall of Moslem religious architecture. But for the interior dome of the *Grosses Schauspielhaus* Poelzig devised a structure of 1200 wired-plaster stalactites that is probably drawn from the stalactite vaulting of the fourteenth-century Alhambra Palace in Granada, Spain (fig. 108). Typically Expressionist was Poelzig's combination of an Islamic architectural tradition with what Wolfgang Pehnt has called "popular gimmicks" in electric illumination: "In the *Schauspielhaus* the bulbs attached to the . . . stalactites were connected in such a way that, when lit, they reproduced different stellar constellations; they were also variously colored—in shades of yellow, green, and red—to resemble the actual stars in the night sky."[204]

Gropius' association of the "Gothic" with "India" suggests how universal the Expressionist idea of spiritual rebirth had by this time become. Such universalism, in turn, goes far to explain the syncretic aspects of late Expressionist style. In the Dresden Secession Gruppe

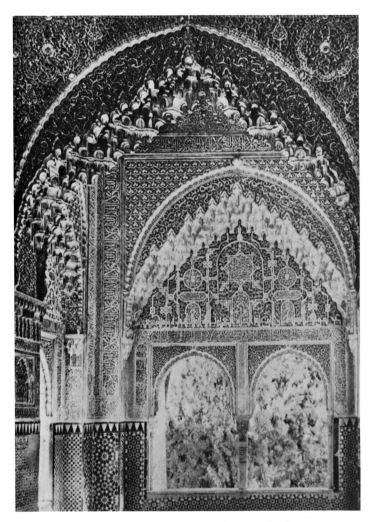

108. Stalactite vaulting, Alhambra Palace, Granada, Spain.

1919 ("1919 Group"), for example, styles varied from the quasi-Cubist primitivism of Dix (plate 10) and Felixmüller (fig. 161) to the more rigorously angular Gothic quality of Constantin von Mitschke-Collande. Indeed Mitschke-Collande's Gothicism, as seen in the 1919 woodcut *The Time is Ripe* (fig. 110), is marked by angular shapes and rays of streaming light. Still, this supernatural treatment of space and light is accompanied by elements of Cubist transparency (the clouds) and of Futurist dynamism (the upward ascent of the figure). Gruppe 1919 medievalism—like that of Feininger that same year (fig. 47)—is thus made to appear modishly modern.

Much the same is true of the film sets for the first Expressionist motion picture, *The Cabinet of Dr. Caligari* of 1919 (fig. 111). The sets were designed by Hermann Warm, Walter Röhrig, and Walter Reimann and approved by the director Robert Wiene. They establish the

film's locale in a medieval-looking German small town, but forms are intentionally askew and spatial illusions are intentionally ambivalent as in Cubist painting. As Lotte Eisner has written: "The depth comes from deliberately distorted perspectives and from narrow, slanting streets which cut across each other at unexpected angles. Sometimes it is also enhanced by a back-cloth which extends the streets into sinuous lines. The three-dimensional effect is reinforced by the inclined cubes of dilapidated houses. Oblique, curving, or rectilinear lines converge across an undefined expanse towards the background: a wall skirted by the silhouette of Cesare the Somnambulist, the slim ridge of the roof he darts along bearing his prey, and the steep path he scales in his flight."[205] Both the Gothic environment and the Cubist distortions combine to create a visual analogue for the states of anxiety and fear demanded by the script narrative. The sets establish a kind of dynamic Gothic style.

Other early Expressionist films also helped popularize the various style tendencies at work in postwar visual art. The architect Hans Poelzig served as artistic director for Paul Wegener's *The Golem* of 1920, and his wife Marlene Poelzig helped execute the bizarre interior sets he designed. And Cesar Klein, a co-founder in 1910 of the Neue Secession and a leader in 1918–19 of the Working Council for Art, was hired in 1920 to create the sets for Wiene's *Genuine*.[206] Even as late as 1926, in Fritz Lang's *Metropolis*, a number of late Expressionist style elements can still be discerned (see sec. 4.7).

If Expressionism managed to link Orientalism and medievalism with spiritual renewal, it did so even more readily with primitivism. Few artists went so far as Kirchner, who actually adopted a primitive life style in the Swiss Alps. In carving his own wood furniture in 1919–20 Kirchner compared his work to that of tribal sculptors: "Indeed how much further the Negros were," he wrote, "in this kind of carving."[207] But Max Pechstein in Berlin based his sculpture directly on carvings available in the local Ethnographic Museum. Thus his 1919 piece called *Moon* derives from a Congo fetish figure from the Ngombe tribe that had been in the Berlin ethnographic collection since 1885 (figs. 112, 113). Pechstein's piece seems initially more volumetric than its source. Angular incisions edge the face in a few straight lines on the Ngombe work but create a wholly circular facial frame in the Pechstein. Similarly breasts and lower torso are larger and more spherical in the German than in the Congo example. Nevertheless, Pechstein retains the interest in two-dimensional surface decoration that he had developed during his 1914 visit to Palau. Whether or not derived from the scarification patterns which he attributed to the Palau islanders' "sense of beauty" and "passion for structure,"[208] surface pattern is still stressed by the Expressionist carver in his 1919 *Moon*. There are diamond motifs in the hair, chevrons on the torso, and zigzag side stripes on the limbs and hands. Thanks especially to the stripes, Pechstein's fashionably ornamental style might here be called "Tribal Art Deco."

In the guise of a Polynesian cult figure, Paul Klee's *Portrait of the Artist* (1919) displays a more ambivalent primitivism (figs. 114, 115). The artist has borrowed from his source the multiple lines around

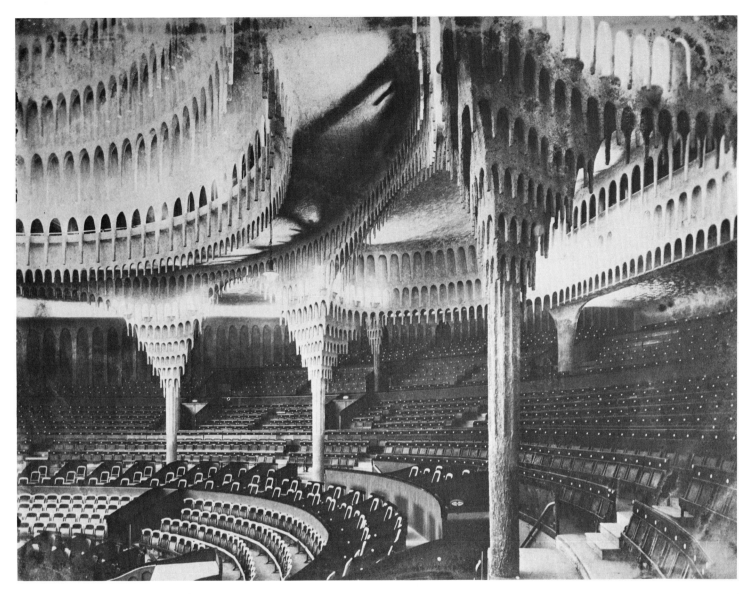

109. Hans Poelzig, *Grosses Schauspielhaus*, Berlin, 1919.

eyes and mouth, as well as such details as fingers, shoulders, and squared-off skull. It must have amused Klee to identify himself with an exotic masterpiece of the Ethnographic Museum in Munich, where he lived, especially one with such prominently displayed sex. But the amusement was clearly at Klee's own expense—the intellectual masquerading as instinctual—and perhaps as well at the Expressionist's very process of style dependency, reactivity, and syncretism.

In fact this late in Expressionism's development the movement's source repertoire seemed to encompass almost the entire history of culture. As Franz Werfel put it, in his ironic and disenchanted verse of 1920, Expressionist style had become eclectic indeed:

Eucharistic and Thomistic
Yet a little bit Marxistic
Theosophic, Communistic
Gothic-small-town-Cathedral-mystic
Super-Eastern, Taoistic,
Seeking in all Negro plastic
Refuge from an age so drastic,
Rolling words and barricades,
Making God and foxtrot mates.[209]

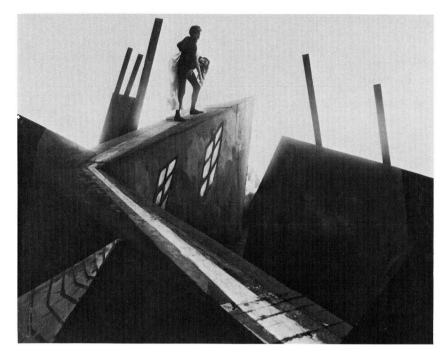

In drawing from India and Islam, from the Gothic and the Negro, and moreover in fusing these traditionally "spiritual" arts with up-to-date secular principles of abstraction and dynamism, Expressionist style was becoming the non-style that Franz Marc had anticipated a decade earlier (see sec. 3.1). Borrowing from everything, Expressionism ended by focusing upon nothing.

Thus "renewal" yielded finally to fatalism. We can see the process at work in the later Nolde, the oldest of the major Expressionists, who was now middle-aged. Nolde's *Still Life* (*Rider and China Figures*) (fig. 117), first of all, continues an earlier pattern by confronting disparate folk and primitive art objects for narrative effect.[210] Here he depicts a tiny earthenware horse and rider, possibly Russian, with two Taoist porcelain figures from China only eight inches high. The result is a monumental painting in which the active rider seems oblivious to the ghostly, conjuring figures hovering in the background. Life here seems finite: bounded by, and in the hands of, the gods. Indeed the left-hand porcelain probably represents Tung-fang-so, a longevity figure, who carries the peach of long life (fig. 116).[211] Yet a few years later, in 1927, Nolde was concerned more with death than with longevity. At his sixtieth birthday celebration that year he astonished

110. (right) Constantin von Mitschke-Collande, *The Time Is Ripe,* woodcut, 1919. Los Angeles County Museum of Art: The Robert Gore Rifkind Center for German Expressionist Studies.

111. (above) Hermann Warm, Walter Rohrig, and Walter Reimann, designers, still from Robert Wiene's film, *The Cabinet of Dr. Caligari,* 1919.

The Museum of Modern Art/Film Stills Archive.

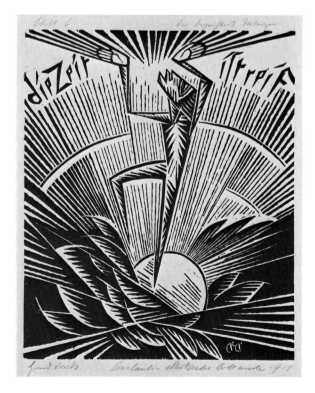

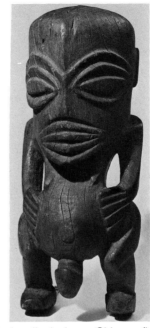

his guests by displaying a Chinese figurine symbolic, this time, of mortality. "This figurine embodies death," Nolde said, "or better, the transitoriness of life. When the waves of happiness are at their flood the Chinese hand this object around to their dinner guests and remind them that everything which lives must one day die. Let us do the same."[212]

A similarly gloomy outlook informs Otto Dix's *Portrait of the Artist's Parents* (1921), especially when compared with its Romantic source, Philipp Otto Runge's 1806 *Parents of the Artist* (figs. 118; 119, plate 18). The likenesses are striking: the long noses and grim mouths of the mothers are similar, while the squinty eyes of Runge's right-hand child resemble those of Dix's father. Runge's work, like much of German Romanticism, has left a twofold heritage—inward and sublime, but also impersonal and still—and Dix has chosen to emphasize the soberer characteristics. Light is active in both paintings, to be sure, but it radiates from within in the Romantic work while it plays restlessly over busy surfaces in the Expressionist portrait. And Runge's parents, for all their rightward motion, finally constitute a depersonalized

112. (top left) Ngombe tribe, Congo, female fetish figure, painted wood. Museum für Völkerkunde, Staatliche Museen Preussischer Kulturbesitz, Berlin.

113. (top center) Max Pechstein, *Moon*, painted wood, 1919. Location unknown.

114. (top right) Polynesian cult figure, "God of Fishermen." Staatliches Museum für Völkerkunde, Munich.

115. (left) Paul Klee, *Portrait of the Artist*, drawing, 1919. [Location unknown]

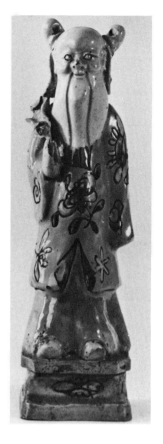

116. (right) Tung-fang-so, Chinese porcelain longevity figure. Nolde-Stiftung Seebüll.

117. (above) Emil Nolde, *Still Life (Rider and China Figures),* oil on canvas, 1920.

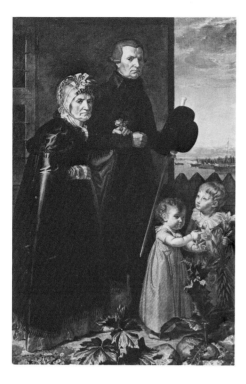

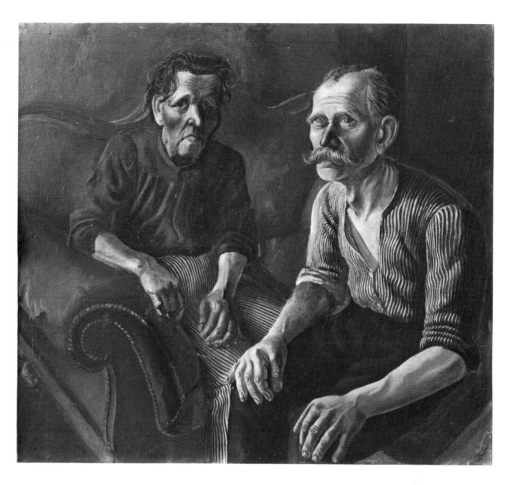

image of exactitude and stasis which Dix can enliven to only a limited degree.

In 1924 Dix painted a second version of the Portrait of his Parents in which the figures are stiffer and the composition more frontal; he also created a picture of his daughter *Nelly amidst the Flowers,* based in part on Runge's 1805–06 *Huelsenbeck Children* (none illustrated).[213] But the 1924 works exemplify a style of Neue Sachlichkeit—"New Sobriety" or "New Objectivity"—that is no longer Expressionist. By 1925, when Franz Roh published his book *Post-Expressionism,* the two styles could be schematically contrasted: "dynamic," "loud," and "monumental" Expressionism with its need for "thick pigment" and "summary execution" was followed by a "static," "quiet," and "miniature" Post-Expressionism characterized by "thin pigment" and "careful execution."[214]

There are problems with this schema. The distinctions between thick and thin pigment or summary and careful execution had been present in Expressionism from the start, as in the cases of Kandinsky and Klee, or Kokoschka and Schiele. A Mueller or a Macke was "quiet" rather than "loud," and a Dix as late as 1923 could be more

118. (left) Philipp Otto Runge, *Parents of the Artist,* oil on canvas, 1806. Hamburger Kunsthalle.

119. (above) Otto Dix, *Portrait of the Artist's Parents,* 1921. Öffentliche Kunstsammlung, Kunstmuseum, Basel. (See also plate 18)

"dynamic" than "static" (see fig. 167). And Expressionism could continue into the 1930s in individual cases (fig. 169), long after the movement had supposedly ended. An Expressionist/Post-Expressionist dichotomy simply makes less sense than the 1880s distinction between Impressionism and Post-Impressionism.

A more meaningful distinction between Expressionism and Neue Sachlichkeit would define the styles by content or attitude rather than by form. For the former still possessed a tension between gloom and hope, and this tension in turn justified the presence of vitalist or assertive formal properties in the style. But the tension finally yielded, in the latter, to an unrelieved pessimism or unillusionment, and so the vitalist formal properties disappeared. Hope for renewal was a message inconsistent with "sobriety." As with Expressionism's birth, so with its decline: a change in attitude dictated a change in style.

4.
Social Psychology

We have met the enemy and he is us.

POGO

4.1. QUESTIONS OF IDEOLOGY AND IDENTITY

At the climax of Georg Kaiser's 1916 play *From Morn till Midnight* the protagonist, a bank teller, announces the vanity of all materialism: "One can buy nothing of value, even with money from all the banks of the world. One always buys less than one pays. And the more one spends, the less the goods are worth. Money degrades value. Money disguises what is genuine. Money is the most miserable swindle of all frauds!" And in a memorable scene in Ernst Toller's 1919 drama *Man and the Masses* the chorus announces the masses' despair at urban working conditions:

> We who are huddled forever
> In canyons of steel, cramped under cliffs of houses,
> We who are delivered up
> To the mockery of the machine,
> We whose features are lost in a night of tears,
> We, torn forever from our mothers,
> Out of the depths of factories, we cry to you:
> When shall we, living, know the joy of life?
> When shall we, working, feel the joy of labor?
> When shall deliverance come?[1]

Just as the bank teller seeks deliverance from a money economy so the masses hope to escape the mockery of the machine. For both Expressionist playwrights, the capitalist era was associated with evil. Yet the Expressionist goal was neither communism nor fascism; it was rather "universal revolution," intended to "topple all values."[2] Expressionist revolution was directed less at bankers or factory owners than at bourgeois, urban society itself.[3] Man's hope was assumed to lie in some non-capitalist, non-industrial utopia.

There is irony in the fact that Kaiser and Toller, like most Expressionist artists, were born to middle-class homes and were members of the elite of Germany's first fully urban generation. The indicters of evil were themselves tainted by the very evil they would expunge. Their example suggests Expressionism's ambivalence toward modern life as a whole. Indeed, if Expressionism can be called post-Nietzschean in philosophy, post-Victorian in imagery, and Post-Impressionist in style, then it can also be called post-industrial in social aspiration.

Politics were relevant only indirectly, chiefly because political allegiances in turn-of-the-century Germany changed very rapidly. Nevertheless, the older the artist, generally speaking, the greater the

122

conservative bias he had to overcome. For example, Heinrich Mann, born in 1871, took years to complete an ideological shift toward liberal values that few artists born only a decade later had to undergo. An Impressionist aesthete in the early 1890s, a folkish anti-capitalist and anti-Semite in the mid-1890s, he was by 1904 an admirer of French culture and, by 1910, an advocate of German liberalism. Departing from Nietzsche's "aristocratic radicalism," he ultimately advocated a "democratic radicalism."[4] In the end he hoped for a German ethical Revolution that would unify *Geist* and *Tat,* spirit and deed. "For the spiritual type of man must become the dominant one in a folk now wishing to arise," he wrote. "The man of power, the man in authority, must be the enemy. The intellectual who aspires to the ruling caste commits treason against spirit."[5] This call for spiritual revolt, first published in 1910, was reprinted in 1916 by Expressionist activists of socialist persuasion.[6] Citing Jean-Jacques Rousseau, who anticipated the French revolution of 1789, Heinrich Mann seems to predict the German revolution which came, and failed, in 1918–19.

Still, Mann's would have been a *perpetual* revolution—in that someone has to have authority in the state, no matter what the politics of the party in power. It was Thomas Mann, Heinrich's junior by four years, who first called his brother's activism, like all Expressionist activism, "political."[7] But this was because Thomas, writing during World War I, found Expressionism's liberal ideals incompatible with German national culture. Only in 1922, after the assassination of the foreign minister of the Weimar Republic, Walter Rathenau, did Thomas Mann belatedly endorse liberal democracy.[8]

Heinrich and Thomas Mann, pre-Expressionist and anti-Expressionist, respectively, responded to political issues with some uncertainty. What both brothers shared was an ambivalence toward the North German *Bürgertum* or "old middle class" into which they had been born. Like their father, Thomas Johann Mann, the two sons despised the new *Wirtschaftsmensch* or "business man," who had been responsible for speculative excess in the early Empire and sought only rapid turnover of goods and profits. But where the father had clung to merchant capitalism in the face of emerging industrial capitalism and had in fact retreated into the *bürgerlich* life style to an exaggerated degree,[9] the sons vacillated. Although they valued the old-fashioned virtues of order, duty, and discipline, they both finally accepted the laissez-faire ethic of the modern industrial state.[10]

A similar process occurred in the case of Expressionists, except that they were born into the new industrial age; they came from families for whom the speculative business ethic was already established fact. For Kaiser and Toller, born in 1878 and 1893, respectively, the issue was not whether to accept laissez-faire capitalism, but how to counter the emerging ills of industrial civilization. While Expressionists shared these concerns with socialists, and with conservative thinkers as well, they saw them less as political issues than as questions of social psychology. These ills would have to be cured in the hearts of men, not by parliamentary majorities; how could the "new man" be formed who would create the "new society"?

If Expressionism is not narrowly political, then, neither is it ideological in the usual sense, which is why the sociologist Karl Mannheim designated Expressionist ideology as "chiliastic"—that is, as apocalyptic in mood and divorced from both history and politics: "This ahistorical ecstasy which had inspired both the mystic and the chiliast . . . is now placed in all its nakedness in the very center of experience. We find one symptom of this, for example, in modern Expressionist art, in which objects have lost their traditional meaning and seem simply to serve as a medium for the communication of the ecstatic."[11]

To be sure, what Mannheim calls the "spiritualization of politics" is as much at work in the modern as in the medieval period.[12] We see such spiritualization in Emil Nolde's idealistic Nazism, in Conrad Felixmüller's lyrical Communism, or in Max Pechstein's enthusiasm for the Socialism of the emerging Weimar state. The true context for Expressionist "revolution" is what Mannheim describes as the "total conception of ideology" underlying post-Romantic thought: "Only in a world in upheaval, in which fundamental new values are being created and old ones destroyed, can intellectual conflict go so far that antagonists will seek to annihilate not merely the specific beliefs and attitudes of one another, but also the intellectual foundations upon which those beliefs and attitudes rest."[13] In this sense Expressionism is an art of ideological conflict, even when the conflict is not explicitly political.

Thus if Expressionism reflects an ideological struggle within society, it embodies all the more an identity struggle within the individual. According to the psychologist Erik Erikson, in fact, identity crisis originates in social crisis: "Industrial revolution, world-wide communication, standardization, centralization, and mechanization threaten the very identities man has inherited from primitive, agrarian, feudal, and patrician cultures. What inner equilibrium these cultures had to offer is now endangered on a gigantic scale. As the fear of the loss of identity dominates much of our irrational motivation, it calls upon the whole arsenal of anxiety which is left in each individual from the mere fact of his childhood."[14]

Identity loss is indeed common in modern culture. Paul Gauguin spoke for an entire era when he asked, in the title of an 1897 painting, *Where Do We Come From? What Are We? Where Are We Going?*[15] And Max Beckmann touched on the same confusion with remarks he made in 1938: "What are you? What am I? Those are the questions that constantly persecute me and torment me and perhaps also play some part in my art." In answering these questions Gauguin, at forty-nine, looked to primitive myth, while Beckmann, at fifty-four, was looking for spiritual redemption. "One of my problems is to find the Self," Beckmann explained, "which has only one form and is immortal. . . . It is the quest of our Self that drives us along the eternal and never-ending journey we all must make."[16] Despite the mature form of their quests, both men were reactivating a major concern of youth: through mythic or religious ideals, they were seeking positive roles for themselves. For it is through integrated identity that one finally re-

solves the dilemma of being modern. Mannheim's "total conception of ideology" reflects Erikson's total questioning of self. The need for identity can in turn become a quest for utopia or redemption, a search for the archaic or for the divine.

As Erikson demonstrates, in fact, all such self-questioning originates in adolescence. It is during youth's transition years that ideological questions reinforce identity questions most acutely:

> The growing and developing youths . . . are now primarily concerned with what they appear to be in the eyes of others as compared with what they feel they are, and with the question of how to connect the roles and skills cultivated earlier with the occupational prototypes of the day. . . .
>
> To keep themselves together they temporarily overidentify, to the point of apparent complete loss of identity, with the heroes of cliques and crowds. This initiates the stage of "falling in love," which is by no means entirely, or even primarily, a sexual matter—except where the *mores* demand it. To a considerable extent adolescent love is an attempt to arrive at a definition of one's identity by projecting one's diffused ego-image on another and by seeing it thus reflected and gradually clarified. . . .
>
> The adolescent mind . . . is an ideological mind—and, indeed, it is the ideological outlook of a society that speaks most clearly to the adolescent who is eager to be affirmed by his peers, and is ready to be confirmed by rituals, creeds, and programs which at the same time define what is evil, uncanny, and inimical.[17]

Adolescence, defined as the years between puberty and the late twenties, is a time of heightened role confusion.[18] It need not be added that Expressionism in Dresden, Vienna, Prague, and Berlin (less so in Munich) was developed primarily by men under thirty.

Not only youth is subject to role confusion, however. Adolescence parallels urbanization and emigration in that uprootedness evokes rootlessness. As Mannheim writes, "a quite visible and striking transformation of the consciousness of the individual [takes place] when he is forced by events to leave his own social group and enter a new one—when, for example, an adolescent leaves home, or a peasant the countryside for the town, or when the emigrant changes his home, or a social climber his status or class."[19] It is no accident that Expressionist art is not only a youthful art but also an urban art and an art of confused ideologies.

But art goes beyond the artist when it expresses aspirations of society, when large segments of a people can recognize themselves in the art of their time. And Expressionists were good at discovering those ambivalent images to which many Germans could intuitively respond. As the individual tried out personal roles, in short, he simultaneously offered society certain collective responses to identity questions.

120. Karl Schmidt-Rottluff, *Am the Child of Poor People*, woodcut, 1905. Brücke-Museum, Berlin.

One such response was self-identification by class. Not yet twenty-one in 1905, Karl Schmidt-Rottluff expressed sympathy both for society's victims in general and for poverty-stricken youth in particular in a woodcut titled *Am the Child of Poor People* (fig. 120). The awkwardness of the title (*Bin armer Leute Kind,* literally "am poor peoples' child") adds to the pathos of the image: with shadowed eyes and set mouth, the youngster is not only bitter but fated to near-illiteracy as well. Though as a provincial miller's son Schmidt-Rottluff was not himself poor, he nevertheless displayed the Brücke's emerging identification with the lower classes. The group would soon rent studios in a Dresden working-class district and befriend actors, circus performers, and other marginal members of society. But this was, precisely, "identification"—because most of the artists were accustomed to middle-class comforts and even held their first Dresden exhibition in a lamp factory display room where the burghers, not the workers, came to shop.[20]

Another artist who identified with the working class, Käthe Kollwitz, actually maintained that identification throughout her life. But she started in the 1890s, well before there was an Expressionist movement, in the graphic cycle *A Weavers' Rebellion*. Based on Gerhart Hauptmann's 1893 drama *The Weavers*, Kollwitz's prints depict the desperation of Silesian handworkers in their 1844 revolt against the new textile industrialists. This was a Naturalistic cycle. Especially effective was the 1897 etching *March of the Weavers* (fig. 121), where the foreground mother and child recapitulate in themselves the determined yet resigned mood of the workers. As Renate Hinz has written, Kollwitz uses women and children to affirm not only a proletarian but also a sexual identity: "With [this theme], she calls attention to the important role women play in social conflict and at the same time reflects views expressed by [August] Bebel in his book *Woman in the Past, Present, and Future* (Zurich, 1883). It is also characteristic of Kollwitz that the women she portrays are almost always mothers.

Indeed, motherhood is a central motif in her work. The child is drawn into the mother's immediate sphere of influence and shares in her fate."[21] When *A Weaver's Rebellion* was chosen for a gold medal at the Great Berlin Art Exhibition of 1898, Kaiser Wilhelm II vetoed the prize because he disapproved of the subject matter. "Art should elevate and instruct," he once wrote. "It should not make the misery that exists appear even more miserable than it is."[22] Nevertheless, Kollwitz, wife of a working-class doctor, identified deeply with the Berlin laborers and their families among whom she spent her life. After 1918, when the Kaiser himself had abdicated, Kollwitz came to depict the misery not just of a class but rather of postwar Germans in general, and at this point her Naturalism gave way to an impassioned Expressionism.

Self-identification by gender was important for Kollwitz, but even more so for Paula Modersohn-Becker. The Worpswede painter made her home in a rural community among untutored farmers and

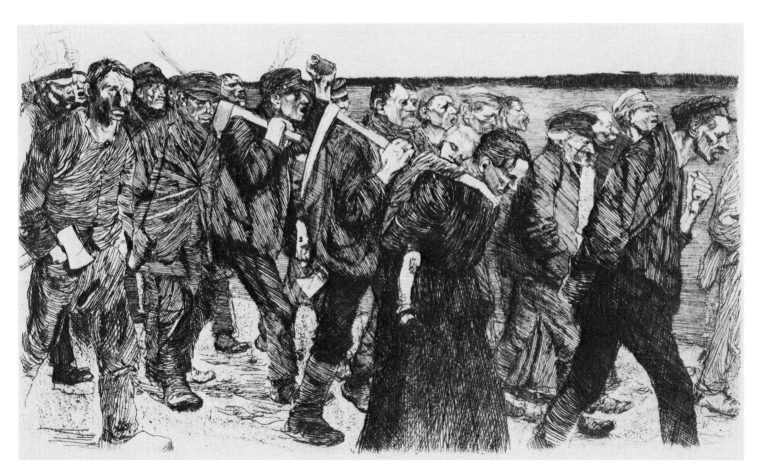

121. **Käthe Kollwitz,** *March of the Weavers,* **etching, 1897. The Robert Gore Rifkind Collection, Beverly Hills, California.**

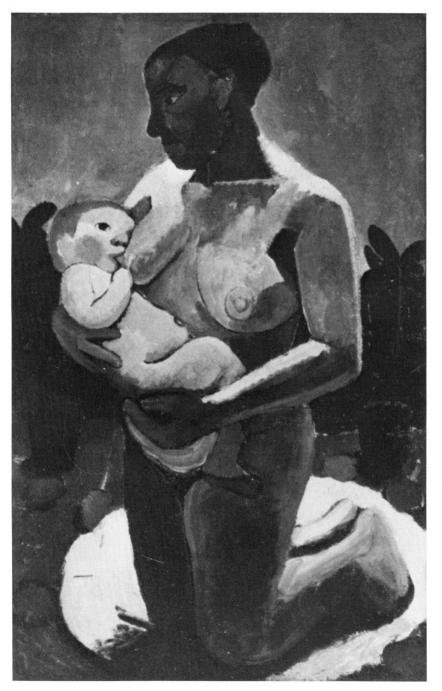

122. Paula Modersohn-Becker, *Kneeling Mother and Child,* oil on canvas, 1907. Private collection, West Germany. (See also plate 19)

peasants, and her favored themes included peasant mothers and children. Rather than August Bebel, however, Modersohn-Becker followed the views of Julius Langbehn and Ellen Key: Langbehn's *Rembrandt as Educator* (1890) had advocated a kind of anti-bourgeois *Kindlichkeit*—"childlikeness" or "naïveté"—in art, while Key's *Century of the Child* (1900; translated from Swedish into German in 1902) argued for more creative freedom in children's upbringing.[23] Under the circumstances, then, such a painting as *Kneeling Mother and Child* (fig. 122, plate 19) must have been intended to signify the creative force shared by both individuals. Such reduction of woman to her child-bearing function was common in the period. This was how Rainer Maria Rilke recalled Modersohn-Becker in his *Requiem* (1908) following her tragic death, soon after childbirth, at age thirty-one:

> And so you also saw women as fruit
> and you saw children so, driven from within into the forms
> of their existence.
> And, finally, you saw even yourself as fruit, disrobed, took
> yourself before the mirror and let yourself lose yourself
> down to your very gaze. But this remained vast
> and did not say "that is me" but, instead, "this is."[24]

As Alessandra Comini has written, Modersohn-Becker shows us not what motherhood looks like but what it feels like: "Not the coiffeured, saccharine, decolleté pyramid of a nursing coquette, but the spent interdependence of two undecorously reclining forms whose heads —whose intellects—are in shadow and whose bloated bodies press together in unrelieved, unselfconscious nakedness."[25] Only an early Expressionist style, based in the simplified form of Cézanne, Van Gogh, and Gauguin, could properly evoke the remarkable vitalism of this "earth mother" theme.[26]

The obverse to such female glorification of motherhood, however, was a male caricature of abortion. Emil Nolde in New Guinea, for example, praised the fecund Oceanic tribe over the "corrupt city people" of his native Europe: "Of course the natives here eat human flesh. . . . But are we so-called cultivated people really much better than the people here? A few people are killed here in feuds while thousands die in Europe in wars. And are not corrupt city people much lower and dirtier in their daily and nightly contraceptions and abortions of fetuses than nature's people here who bear many children to be strong, to be sure that the neighboring tribe does not have more men than they?"[27] And Lyonel Feininger delivered a similar message in a 1908 painting known as *The Manhole, I* (fig. 123), which was originally entitled *The Infanticide*. Where Frank Wedekind's drama *Spring's Awakening* had sided with a pregnant girl as an ignorant victim of circumstance (see sec. 2.1), Feininger embodies the dominant view of his time by presenting the aborted fetus as victim. In the painting the once-pregnant woman—with green face and arms and a bright red purse before her thighs—is seen as a murderer. By their satirical expressions and gestures the street-worker on the left and a yellow-coated pedestrian on the right both

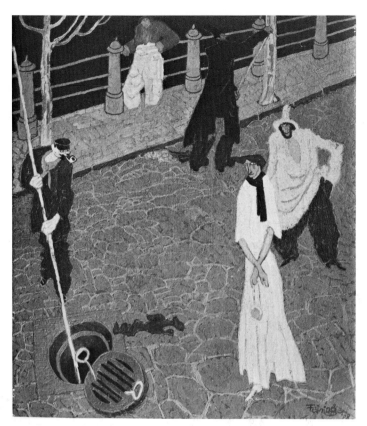

123. Lyonel Feininger, *The Manhole, I (Infanticide),* 1908. Location unknown.

express their disapproval. Male observers of Feininger's work will have no trouble identifying themselves with the offended onlookers, but it is the female protagonist—and the Feininger painting itself—which marks the real protest against the Victorian values of Wilhelmian German society.

If self-identification was possible by class or gender, it was also possible by nationality or race. This was the approach taken by the landscape painter Carl Vinnen, in his *German Artists' Protest* (1911). Objecting to the purchase and exhibition of modern French paintings by German museums and exhibiting societies (including the Berlin Secession and its Jewish leadership), Vinnen described the dangers for German art: "And when alien influences seek not only to improve us but to bring about fundamental changes, our national characteristics are gravely threatened. . . . Let us repeat it again and again: a people can be raised to the very heights only through artists of its own flesh and blood. . . . And since this domination is being imposed on us by a large, well-financed international organization, a serious warning is in order: let us not continue on this path; let us recognize that we are in danger of losing nothing less than our own individuality and our tradition of solid achievement."[28] While many Expressionists **127**

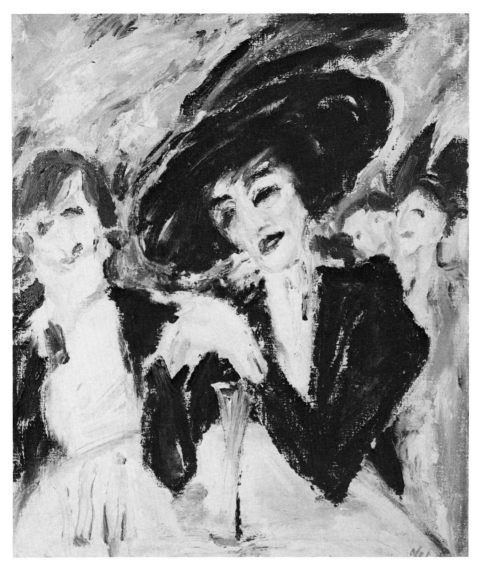

124. Emil Nolde, *At the Wine Table*, oil on canvas, 1911. Bayerische Staatsgemäldesammlungen.

were opposed to Vinnen's views, including Pechstein and Marc, and while Wilhelm Worringer was even prompted by the *Protest* to argue for the necessary *dependence* of German upon foreign art (see sec. 3.1), Vinnen's admirers briefly included Käthe Kollwitz.[29] But Emil Nolde, despite his recent attack on Max Liebermann and the Berlin Secession leadership (see sec. 3.5), took this occasion to paint subjects that were not obviously German but Jewish. Furthermore, in such 1911 oils as *At the Wine Table* (fig. 124), Nolde is by no means merely caricaturing the Jewish denizens of Berlin night cafés: he suggests their vitality and sophistication as well. As Martin Urban has noted, Nolde was ambivalent about metropolitan Berlin: "he scorned [it] as a place of decay and degeneracy . . . [yet] he was fascinated by the splendor and sensory stimuli, by the light and shadow of nightly bustle; with open senses, he took in the beauty and bliss, the hubbub and vice, the corruption and humanity of this world. . . . How he cursed the whore of Babylon—Berlin—where he spent all his winters!"[30]

But if class, gender, and race offered uncertain support either for a national or for an Expressionist identity, there remained a final category—that of generation. Certainly Expressionists identified themselves as "youth," ready to do battle with entrenched "older forces."

This is evident in the 1906 *Manifesto of Künstlergruppe Brücke:* "With faith in evolution, in a new generation of creators and connoisseurs, we call together all youth. And as youth, who carry the future, we want to create for ourselves freedom to move and to live opposite the well-established older forces. He belongs with us, who renders with immediacy and authenticity that which drives him to creation" (fig. 125). Moreover, self-identification by generation *permitted* the very ideological diversity that Expressionists displayed, since "youth" itself is neither progressive nor conservative.[31]

Most revealingly, however, there was a long tradition in nineteenth-century Germany for major art to be produced by—or from the viewpoint of—the young. Novalis and Philipp Otto Runge made their breakthroughs in their twenties and both died young (one at twenty-nine, the other at thirty-three), while the painters who founded the Brotherhood of St. Luke in Vienna in 1809 were all around twenty. And in 1834–35 another group of youths, writers in Frankfurt am Main, identified their group as "Young Germany." Both aesthetic and social issues were addressed. Not only did a novel by Karl Gutzkow attack conventional marriage mores, but Charlotte Stieglitz—before her suicide in 1834—exhorted her poet husband to be young and modern. "Join the young generation," she wrote; "then you will find in their world-wide and world-open interests the right subject matter for your work. . . . You don't need to talk much about the new age and about liberty, your whole work will breathe the spirit of liberty."[32] Young Germany's international aspirations were soon mirrored, in turn, by writers calling themselves Young Italy and Young Poland. By the 1860s even Russians were called "young" by Fyodor Dostoevsky. "We Russians are a young people," he wrote. "We are just beginning to live, although we are already a thousand years old; still, a great ship also needs a deep channel." These words appeared as the epigraph for Dostoevsky's *Political Writings,* published in translation in Munich in 1907.[33] But before this, the 1890s had seen *Jugend* magazine and the Jugendstil ("youth style") in Munich and the Jung-Wien ("young Vienna") movement in Austria (see sec. 3.4).

Youth's social function, of course, is to question traditional authority; the German advocacy of youth was simultaneously an advocacy of rebellion. It was in fact Dostoevsky, as supported by Thomas Mann, who first stressed this side of the German national identity. For Dostoevsky called Germans, historically, a people of protest: "As long as there has ever been a Germany, [Dostoevsky] says, her task has been protestantism, 'not merely that form of protestantism that developed at the time of Luther, but her *eternal* protestantism, her *eternal* protest . . . against the heirs of Rome and against everything that constitutes this heritage.' "[34] Moreover, "protest" can be seen as the Faustian element in the German character.[35] Goethe's Faust is precisely the man who retained his youth by perpetual rebellion against divine authority. Simultaneously, however, the psychology of Faust is that of a man vacillating and submissive, who achieves his power only by means of magic.

As early as the seventeenth-century tragic drama, according to Walter Benjamin, we find the fatal flaw in the Teuton prince, namely,

125. Ernst Ludwig Kirchner, *Manifesto of Künstlergruppe Brücke,* wood or linoleum cut, 1906. Collection, The Museum of Modern Art, New York. Gift of J. B. Neumann.

"the indecisiveness of the tyrant." And later German youth rebelled, it can be argued, because those in power lacked legitimate authority. As Erikson puts it:

> What differentiates . . . the German father's aloofness and harshness from similar traits in other Western fathers? I think the difference lies in the German father's essential lack of true inner authority—that authority which results from an integration of cultural ideal and educational method. . . .
>
> [T]he German identity never quite incorporated . . . the concept of "free man"—a concept which assumes inalienable rights, indispensable self-denial, and unceasing revolutionary watchfulness. . . . The average German father's

dominance and harshness was not blended with the tenderness and dignity which comes from participation in an integrating cause. . . .

The common feature of all these activities [pursued by German adolescents] was the exclusion of the individual fathers as an influence and the adherence to some mystic-romantic entity: Nature, Fatherland, Art, Existence, etc., which were super-images of a pure mother, one who would not betray the rebellious boy to that ogre, the father.[36]

Insofar as the problem of identity is concerned, the father's task is to mediate between the outer society of which he is only a part and the inner family in which he is, for sons at least, the leading role model.

In early modern Germany this task was especially difficult because the class structure of society was changing so rapidly. The father of the Mann brothers, for example, first lost his own economic bearings; loss of effectiveness in fostering his sons's identities inevitably followed:

According to Talcott Parsons, the function of the father is to embody an adequate conception of social reality and objectify or represent it to the children within the context of the family group. Thomas Johann Mann could not do this because he had turned his back on the ascendant social reality. . . . Between the cultural-ethical world the father clung to, and the objective world coming into being, there was a gap too great to be bridged. As a result, he lost his ascriptive function in relation to the children, since he would not socialize them into conditions which he opposed with his whole being.[37]

One must assume that the fathers of Expressionist artists, subject to similar social upheaval, fell victim to the same familial inadequacy.

It has been noted that German Expressionist literature commonly sets the sons against the fathers. As Egbert Krispyn has written, "Expressionists [had] the urge to destroy symbolically the world and authority of the 'fathers,' not as a nihilistic end in itself, but in order to pave the way for a better, higher form of life."[38] Moreover, by a bizarre twist which turned the "Fatherland" into a "young people," the idea of rebellion could be linked to the ideology of nationalism in the Weimar era (see sec. 5.3). For both German youth in general and Expressionist youth in particular, rebellion was often felt to be creative.

Erikson names the Wandervögel (or "wandering birds") as a typical example of rebellious German youth,[39] and Walter Laqueur has traced the continuities between this turn-of-the-century Jugendbewegung ("Youth Movement") and the Hitler Youth of the 1930s.[40] But the Youth Movement must also be seen as a possible precedent for post-1905 Expressionism.

Born almost accidently in a Berlin suburb in 1897, the movement was originally a cabal of middle-class high school boys who took weekly hikes in the country. In communing with nature its secret code words were Bunderlebnis (the "experience of union") and Fahrt ins

Blaue (the "trip to the wild blue yonder"). Within a few years, however, the suburban hikes took on all the trappings of a mass movement throughout Germany and Austria: "In 1901, this innocent escape from city life, from the dull drill of the school and the uncomprehending authoritarianism of the home, turned into the Wandervögel, and the organization spread at once to all parts of Germany." Individually the boys might prefer scouting or nudism, guitar-playing or mountain-climbing. But they were collectively responsive to leaders who upheld the views of Julius Langbehn's Rembrandt as Educator. In Fritz Stern's paraphrase of Langbehn's teachings, "Only by being themselves, by belonging to their people and accepting their past, could present-day Germans become free individuals again."[41] Langbehn's backward look to a pre-scientific, pre-industrial past touched many Germany adolescents—future Expressionists and future Nazis alike.

But the Youth Movement was only a "possible" precedent, for no Expressionist painter was a Wandervogel, so far as is known, and the movements were contemporary: the schoolboy wanderers of 1900 and most of the Expressionists of 1910 were all born in the 1880s. With the exception of Modersohn-Becker, in fact, German Expressionist artists apparently discounted Langbehn. And the Youth Movement, despite an initial interest in Expressionism, ultimately rejected it.[42] The most that can be said is that there were surprising parallels and similarities. As Laqueur has suggested, the Youth Movement was strictly middle-class, largely urban, and primarily Protestant. Although embodying "a somewhat inchoate revolt against authority," it was still "not intended to be a political organization."[43] Expressionists, too, came chiefly from bourgeois, urban, Protestant backgrounds. And Expressionism itself represented a revolt against authority without involvement in political parties, despite occasional art-political activity. But where in a Youth Group the leader's authority was "unquestioned," and where "the capacity for artistic expression was notably absent,"[44] Expressionist artists tried to win their public through rhetorical persuasion and artistic excellence. Expressionism was the more volatile movement, and also the more creative one.

Of course Wandervögel and Expressionists alike wished to throw off the yoke of bourgeois, materialist values. Both were vehicles of adolescent revolt, typical of a society deeply ambivalent about authority. Both, in short, were vehicles of protest—parts of a long German tradition of conflict between the generations, of youth against the establishment. Nevertheless, what they shared was a yearning, not an actuality, a negative hope rather than a positive public role. For, in the end, youth is not an identity; it is a search for one.

4.2. REGIONAL GROUPINGS, LACK OF REGIONAL LOYALTIES

There is a tautology here that requires elaboration. If Germans are a people of protest or rebellion, if ineffectual protest and rebellion are properties of youth, and finally, if youth represents the potential for

but not the achievement of full psychological identity, then it follows that Germans lacked an integrated sense of their own "Germanness." This fact should not be surprising. Friedrich Schiller had already despaired: "Germany, but where does it exist? I don't know where to find this country."[45] Before 1871 "Germany" was an abstraction, a language- and culture-area of uncertain borders, a country fragmented into petty dukedoms since the time of the Hohenstaufen emperors in the thirteenth century. Altogether missing was a German self-image based on territorial integrity, dynastic legitimacy, or constitutional continuity. The German family's lack of "true inner authority" (Erikson) mirrored a similar lack in the German state. Wilhelmian Germany came into being through Prussian military unification, not through shared values or integrated beliefs.

It was also a sign of weakness that Bismarck attempted a national consensus on Protestant cultural grounds. His *Kulturkampf* against the Catholics began in 1871 and, though moderated in 1874, opened the way for less responsible leaders to urge sanctions against the Jews as well. But while German Catholics sought political redress by starting their own Center Party, German Jews in 1879 determined to maintain "contemptuous silence" against anti-Semitic attack. The pattern of appeasement, with Jews exercising religious rights but not their civil rights to social and political equality, was to last for generations. By 1913, in fact, a German Jewish leader claimed that "we are completely assimilated. . . . By assimilation we mean total integration into *Deutschtum* [Germanness], into its nationality, language, and culture; without, however, giving up our religious beliefs."[46] The problem for German Jews, however, was that Germany's image of her own *Deutschtum* was still far from clear.

Julius Langbehn in 1890 took a different tack from Bismarck. Rather than cultural uniformity he advocated the regionalist "claim of the Heimat" ("homeland") in the arts. If there could not be a national culture, Langbehn argued, there should at least be a Holsteinian or a Bavarian one (see sec. 1.4). By the turn of the century the Heimatkunst movement was flourishing; local art colonies were started in such places as Worpswede near Bremen, Neu-Dachau near Munich, and Goppeln near Dresden. What was sought was the "folk character" of each region.[47] The other side of this rural romanticism, of course, was hostility toward the city; new evidence of urban growth was countered by renewed nostalgia for the vanishing countryside. Support organizations were founded, such as the *Deutscher Verein für ländliche Wohlfahrts- und Heimatpflege* (German Society for the Support of Rural Welfare and Homelands, 1904) and the *Bund für Heimatschutz* (League for the Protection of the Homeland). Such groups presumed, in principle, a folkish, peasant-centered culture.[48] They could foster neither a modern German identity nor an Expressionist art of the urban, sophisticated type.

Brücke artists, for example, were not regional in outlook. Not only did they move from Dresden to Berlin for wholly pragmatic reasons, but they spent long periods outside Saxony in places like Dangast on the North Sea or Nidden on the Baltic. To be sure, Erich Heckel's *Village Dance* (fig. 126) is one of numerous Brücke works to evoke the local customs of a peasant community—in this case, Dangast's. Max Pechstein not only painted the Nidden seashore (fig. 76) but also identified with the native fisher folk, upon occasion even joining the men for week-long fishing trips at sea.[49] But the Brücke's rural subjects involved as much tourist curiosity as genuine nature worship—motivations which prompted Pechstein's and Nolde's travels to the South Seas. Rather than cultivating a folkish identity, Brücke artists actually used international styles and urban subject matter in ways Langbehn would not have approved. It is precisely in the *absence* of nationalist or regionalist loyalties, in fact, that the artists gave their first loyalty to the Brücke itself. As is seen in Pechstein's poster for the Brücke exhibition at Emil Richter's, Dresden (fig. 127), the four visages are equally forthright and subtly complementary; differences of feature are merged in a similarity of vital expression. It is easy to understand why Brücke signatures were rare in the early years: theirs was not an individual but a group identity.

Munich Expressionism owes a bit more to the Bavarian region in which it was formed, particularly to the rural settings of Murnau and Sindelsdorf, where many NKVM and Blaue Reiter paintings were created; both in his preference for animal themes and in his friendly, outgoing personality, it is hard to imagine a more Bavarian painter than Franz Marc. Yet the fact remains that Bavaria was a Catholic region, and Marc was in the Protestant minority; did his devotional outsidership contribute to his need to see "a new religion arising in the country, still without a prophet, recognized by no one"? Outsidership, indeed, was Wassily Kandinsky's fate in Munich—as an Orthodox among Catholics, a Russian among Germans. He was quite conscious of identity confusion. "I grew up half-German; my first language, my first books were German," he recalled in 1904; he also called himself "Russian and yet un-Russian." In his 1913 parable of the piebald horse, in fact, Kandinsky explained how a Munich draft animal evoked a forgotten Moscow toy: "It aroused the little horse of lead within me and joined Munich to the years of my childhood." Similarly, in a Munich sunset painting, *The Old City,* "I was really chasing after a particular hour which was and always will be the nicest hour of the Moscow day."[50]

In Bohemia, where the Expressionist label first appeared, identity confusion was even more prevalent. The language of the majority in Prague was Czech—a Slavic tongue—yet the city owed its allegiance to the Hapsburg Emperor Franz Josef and to the Austro-Hungarian government in Vienna. Despite cultural ties to the Russian east (and the Parisian west), then, Prague was still part of the German-speaking world: "The Prague German writers had simultaneous access to at least four ethnic sources: German, naturally, to which culturally and linguistically they belonged; Czech, which was the milieu in which they lived; Jewish, even if they themselves were not Jewish, as it formed a vital historical factor in the city, making itself felt everywhere; and Austrian, in that Austria had nurtured and reared them and determined their fate whether they accepted it or rejected **131**

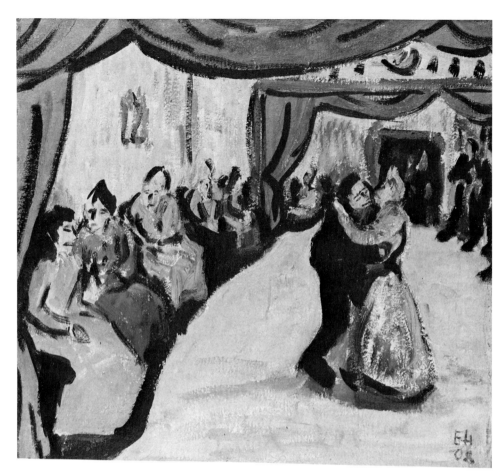

126. Erich Heckel, *Village Dance*, 1908. Nationalgalerie, Staatliche Museen Preussischer Kulturbesitz, Berlin.

it." This mélange of allegiances suggests a certain identity anxiety, such as that expressed by the Prague Jewish writer Franz Kafka—who was not himself an Expressionist—in his 1912 story *The Metamorphosis.* The tale begins with the famous words: "As Gregor Samsa awoke one morning from uneasy dreams he found himself transformed in his bed into a gigantic insect."[51]

It is thus a fact that Prague Expressionist artists, though for the most part not Jewish, were Czech, Germanic, and Austrian simultaneously. Identity confusion may well have contributed to the imagery of the monumental sculpture *Anxiety,* from 1911 (fig. 129), by the twenty-two-year-old Otto Gutfreund. Basing his bronze on August Rodin's *Monument to Balzac* (fig. 128), Gutfreund omitted the haughty grandeur of his source but nevertheless started with the image of a heavily cloaked figure, strongly faceted and undercut to catch the changing outdoor light. Then he bunched the cloak-folds around the elbows and huddled the head into the collar, so that the bronze's

mountainous mass swallowed up the tiny head—normally the place where individuality is specified. While the existential Angst of Søren Kierkegaard and the 1896 lithograph of *Anxiety* by Edvard Munch undoubtedly contributed to Gutfreund's imagery, the sculptor's own fear of identity loss may explain the near engulfment of the bronze's head. If Prague Expressionists were an ethnic group and their distinguishing mark an ethnic loyalty, that loyalty was based on a *lack* of integrated individuality.

Among Austrian Expressionists, meanwhile, regional loyalty was almost impossible to find; identification with a police state proved difficult. Vienna was the most repressive of all European capitals: "An isolation cell in which one is allowed to scream!" as Karl Kraus put it in 1905.[52] Cases of overt and covert censorship were legion. As early as 1900 Gustav Klimt's paintings for Vienna University were opposed by professors concerned about propriety and by newspaper critics worried about pornography.[53] In the summer of 1909, according to Oskar Kokoschka's recollection, the police stopped a performance of his first Expressionist play.[54] And in the spring of 1912 Egon Schiele was arrested and jailed without bond for twenty-four days because of neighbors' complaints about his alleged seduction of

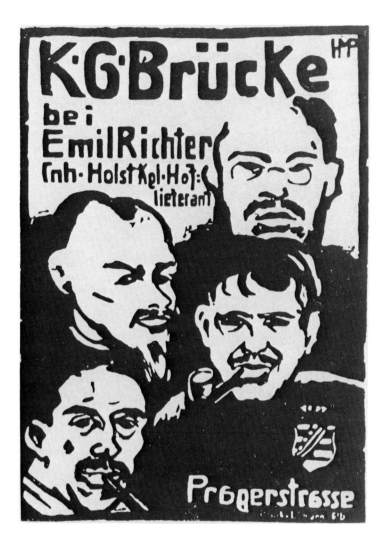

127. Max Pechstein, poster for the Brücke exhibition at Emil Richter's, Dresden, 1909.

child models.[55] Moreover, this center of Pan-Germanism and anti-Semitism was instructive to a young artist of a different kind; repressive Vienna served Adolf Hitler, from 1909 to 1913, as "the hardest, most thorough school of my life."[56]

Ideological strife flourished in Vienna, the home of an anti-Semitic yet popularly elected mayor, Karl Lueger, and also of an outspoken advocate of political Zionism, Theodor Herzl. As Jewish identity was increasingly debated, Jewish patronage became more receptive to Expressionist art. As Kokoschka put it: "Most of my sitters were Jews. They felt less secure than the rest of the Viennese establishment, and were consequently more open to the new, and more sensitive to the

tensions and pressures that accompanied the decay of the old order in Austria. Their own historical experience had taught them to be more perceptive in their political and artistic judgments." Nevertheless, Jewish artists felt themselves alienated from Viennese culture—even those who, like Gustav Mahler, had converted to Christianity. "I am thrice homeless," Mahler would say. "As a native of Bohemia in Austria, as an Austrian among Germans, and as a Jew throughout all the world."[57]

Others also experienced such alienation. Thus Hitler claimed that, by 1904, "I, too, . . . had an opportunity to take part in the struggle of nationalities in old Austria. . . . [W]e emphasized our convictions by wearing corn-flowers and red, black and gold colors; 'Heil' was our greeting, and instead of the imperial anthem we sang *Deutschland über Alles,* despite warnings and punishments." Like Mahler, such future Expressionists as Gerstl, Schoenberg, and Oppenheimer were lapsed Jews in Vienna. And like Hitler, the Expressionists Kubin, Kokoschka, and Schiele must have felt themselves if not Germans, then at least Bohemians, among the Austrians. Kubin was Bohemian by birth and, although he settled in provincial Austria in 1906, he had received more of his training in Munich than in Vienna. Kokoschka's father had been born in Prague, and the son was glad to leave Vienna for Berlin in 1910 and, again, for Prague itself in 1934. And Schiele's mother was from Bohemia: in 1910 he wanted to leave Vienna where "the city is black and all is formula" to travel instead "to the Bohemian forest."[58] In all Expressionist art, indeed, there are few pictures of urban Vienna. Since imperial Austria made most peoples aware of themselves as minorities, the capital was not a place for Expressionists to put down roots.

Schiele painted a number of city views, it is true, but these were of his mother's native town, Krumau in Bohemia, and were mostly made from picture postcards. Several of these from 1911–12 he designated "Dead City";[59] it has been argued that these represent a typically Expressionist "anti-urbanism," and that their designation may stem from the 1892 novella *Bruges-la-morte* by the Belgian Symbolist Georges Rodenbach.[60] But this argument overlooks the facts that Schiele had already linked motherhood with death in *The Dead Mother I* of December 1910 (fig. 71) and that Krumau was, after all, his mother's hometown. Moreover, it was the Symbolist Rodenbach rather than the Expressionist Schiele who originated the cult of urban mortality. In fact Fernand Khnopff, who had done the frontispiece to Rodenbach's book, created a 1904 view of Bruges called *Abandoned City* which Schiele probably used as model for his 1914 *Row of Houses,* once titled *Houses at the Ocean* (figs. 130, 131).[61] Since no town depicted by Schiele was actually situated on lake or sea, it was most likely Khnopff's hazy vision of half-submerged Bruges which prompted both the image and the title of the Expressionist work; the frontal, gabled houses are similar in both paintings. But despite these similarities, Schiele added yellow roofs and a few touches of red and green below which totally undermine Khnopff's Symbolist mood of loss and revery. In its place is a more caricatural distortion of house-windows into blankly staring eyes—a feature demonstrably Ex-

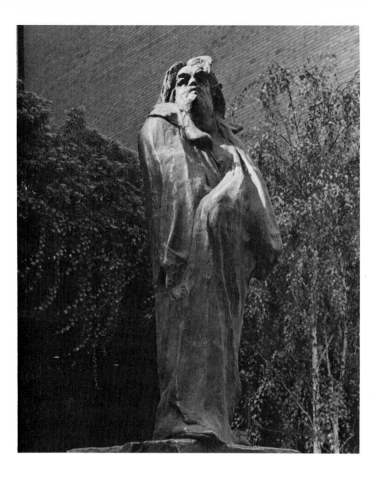

128. Auguste Rodin, *Monument to Balzac*, bronze, 1897–88. Collection, The Museum of Modern Art, New York. Presented in memory of Curt Valentin by his friends.

pressionist rather than Symbolist in effect. Such "humanization" of the city is not anti-urban but, clearly, more ambivalent instead.

4.3. THE VITAL AND THE DECADENT CITY

It is important to stress the difference between turn-of-the-century enmity for the city and Expressionist post-industrial ambivalence. As early as 1887, in a famous study called *Community and Society*, Ferdinand Tönnies distinguished between traditional rural and modern capitalist life styles. Community or *Gemeinschaft* was the "folk's" mode of social organization, based on familial feelings of love, kinship, and neighborhood, whereas the "educated classes" preferred a society or *Gesellschaft* based on individualism, contracts, and commodity values. "Organic" community grew from a consensus of "natural wills"; "mechanical" society yielded objective ties

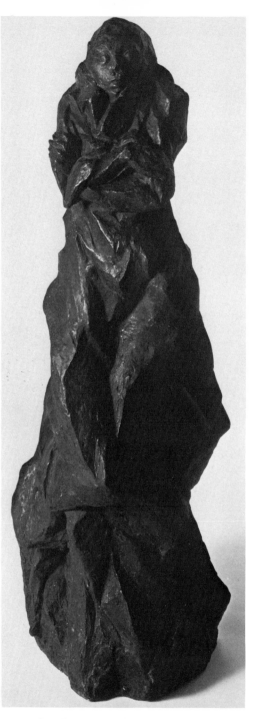

129. Otto Gutfreund, *Anxiety*, bronze sculpture, 1911. Private collection.

between "rational wills." *Gesellschaft* was implicitly urban and decadent, and other sociologists soon supported Tönnies in this assess-

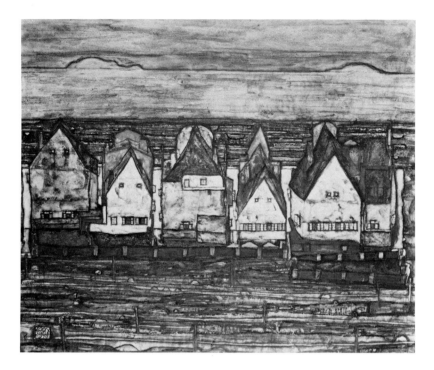

130. (left) Fernand Khnopff, *Abandoned City,* pastel and pencil on paper, 1904. Musées royaux des Beaux-Arts de Belgique.

131. (above) Egon Schiele, *Row of Houses,* oil on canvas, Kallir 198, 1914.

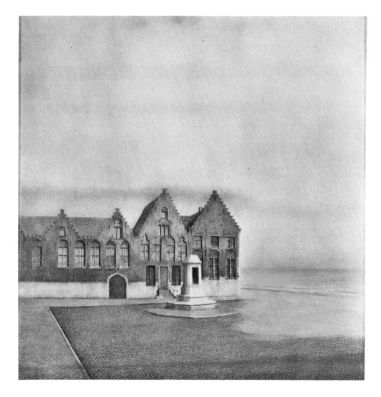

ment. Thus Emile Durkheim stated in 1897 that "suicide, like insanity, is commoner in cities than in the country." And Georg Simmel, in a 1903 essay on "The Metropolis and Mental Life," argued that urban life was alienating: "What appears in the metropolitan style of life . . . as dissociation is in reality only one of its elementary forms of socialization"; "under certain circumstances, one nowhere feels as lonely and lost as in the metropolitan crowd." Even poets joined in, such as Rainer Maria Rilke in his *Book of Hours* (1901): "Big cities are not true; they deceive / day and night, the animals and the child; / their silences lie, they lie with noises / and also with the things that are willing."[62]

Grim though the city was, however, it offered compensating values. In his 1903 study, for example, Simmel discovered a dialectic between the individual's "subjective spirit" and the "objective spirit" of the city:

> The individual has become a mere cog in an enormous organization of things and powers which tear from his hands all progress, spirituality and value in order to transform them

from their subjective form into the form of a purely objective life. It needs merely to be pointed out that the metropolis is the genuine arena of this culture which outgrows all personal life. Here in buildings and educational institutions, in the wonders and comforts of space-conquering technology, in the formations of community life, and in the visible institutions of the state, is offered such an overwhelming fullness of crystallized and impersonalized spirit that the personality, so to speak, cannot maintain itself under its impact.[63]

The same dialectic, discovered in the city in general, could also be attributed to Berlin in particular. To be sure, Tönnies' capitalist "society" was already exemplified by the imperial capital. By 1890 Julius Langbehn "considered Berlin's development ruinous for the entire folk"; its population, only 825,000 in 1871 when the Empire was founded, grew to two million in 1890 and reached three million around 1902.[65]

Yet by the Expressionist generation, Berlin was seen as a place of *both* decadence and vitality; not only as the arena for Darwinist struggle but also as the center for nervous and intellectual energy:

> Berlin: that means struggle, tragedy, naked life, will, energy, brutality, strength, nerves, and mind. All culture signifies repose, security, and tradition; Berlin possesses none of this. In Berlin the old and the mature die for the most part before their time. Those who remain must fight for the barest necessities for a long period until, with difficulty, a higher standard of living is attained. Thousands of people move daily to Berlin. They have their shoes, their clothes, their hands, and their head, only what is most necessary for life, and often not even that. They come as conquerors and adventurers to a wild country, from which there is hardly any turning back. And so every day the inhabitants, the immigrants, and the new residents struggle for their existence, sometimes, in doing so, very violently. Within a few years some rise to the top and become masters; but soon their power crumbles. A few remain victors until the end, and their children destroy the heritage. Almost by name one can identify, out of millions, the few who attain a living tradition through the generations. Their number is vanishing. The majority live in back rooms. The man dies—to the horror of his wife who mourns the corpse in her arms and is left behind, alone.
>
> Nevertheless, we love this romantic Berlin, the horrible, brutal, exciting, surprising, quarrelsome city, savage in its totality, just as we love the life of an individual human being if he is strong, great, and of heroic character.

These views of the Berlin critic Hans Kaiser resemble those of Expressionist artists themselves. Emil Nolde "scorned the metropolis of Berlin as a place of decay and degeneracy . . . [yet] he was fascinated by the splendor and sensory stimuli, by the light and shadow of nightly bustle." George Grosz introduced into his wartime Berlin

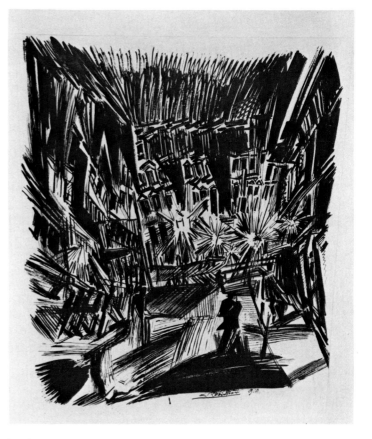

132. Ludwig Meidner, *Street at Night in Berlin*, brush ink and pen over pencil outline, 1913. Mr. and Mrs. Marvin L. Fishman, Milwaukee, Wisconsin.

paintings a "simultaneity of love and hate, crime and survival—the simultaneity of the anonymous events of the city." And in Ludwig Meidner's own words: "The time has come at last to start painting our real homeland, the big city we all love so much. Our feverish hands should race across countless canvases, let them be as large as frescoes, sketching the glorious and the fantastic, the monstrous and the dramatic—streets, railroad stations, factories and towers. . . . [A street] is a bombardment of whizzing rows of windows, of screeching lights between vehicles of all kinds, and a thousand jumping spheres, scraps of human beings, advertising signs, and shapeless colors."[66] Such a drawing as the *Street at Night in Berlin* (fig. 132) makes visible the "glorious" and the "monstrous," the "screeching lights" and "scraps of human beings" that Meidner experienced in the city.

Meidner's ambivalence toward Berlin was also based on his belief in its immediate overthrow: the capitalist city, however exciting, was

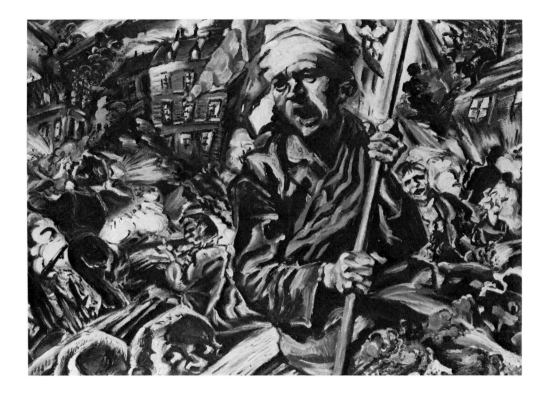

133. Ludwig Meidner, *Revolution,* oil on canvas, 1913. Nationalgalerie, Staatliche Museen Preussischer Kulturbesitz, Berlin.

doomed to destruction. But apocalypse and revolution were not fully distinguished from one another. Perhaps he was drawn to revolution the way the Berlin poet Georg Heym had been, as an antidote to boredom in a bourgeois environment: "For I require powerful external emotions in order to be happy. I always see myself in my waking dreams as a Danton or as a man on the barricades. Without my Jacobin bonnet I can't really even think."[67] Meidner himself actually painted a 1913 picture of *Revolution,* also called *Battle of the Barricades* (fig. 133), in just such a rebellious mood. Based on Eugène Delacroix's *Liberty Leading the People* (1830) and featuring, in the center, a Berlin factory worker in lieu of the patriotic Parisienne of the earlier allegory, Meidner nevertheless undercuts the very victory his predecessor had celebrated. Not only does the central hero scream ambiguously, but the fearful face at the barricade, bottom left, is a self-portrait of the artist.[68] Fear of death colors this scene of proletarian protest, just as the excitement of battle justifies the inevitable destruction that follows in its wake.

Ernst Ludwig Kirchner's Berlin street scenes embody yet another kind of ambivalence toward the Expressionist city in their focus on the prostitute as both bourgeois and anti-bourgeois symbol, integral to the nightlife of the urban middle class yet perceived by conventional

morality as evil. In *Street, Berlin* (fig. 134, plate 20), for example, the women with fashionable gowns and furs are invested with high style but no individuality: angular boots and stiffened hands extend, without distinction, from both figures. This implicit social criticism becomes explicit in the male figure to the right. In examining the store-window display, he is engaged in shopping; in measuring his wants against money values, he is deciding his actions in a capitalist economy. The interaction of bourgeois male shopper and depersonalized female cocotte is thus inevitable: "By choosing as his subject prostitutes and their clients, Kirchner focuses on the objectification of human relationships inherent in economic exchange; the angular hardening of organic form . . . is a perfect visual analogue for this process of thingification."[69] In addition, however, Kirchner represents these women as larger-than-life, subsuming, as it were, their role as commodities; they mean more than the automobile, for example, with which they are paired. In their angular rhythms and acrid colors, in fact, they suggest the sensuous excitement of forbidden sin—desirable and guilt-laden at once. As icons of evil they symbolize the entire Berlin environment: vital, electric, yet decadent as well.

In his later street scenes, such as the *Red Tower in Halle* (fig. 135) Kirchner uses distorted perspective systems to express his ambivalent feelings toward the city.[70] He depicts traditional monuments in an agitated style, suggesting both the city's excitement and its alienating effect. Probably made from a postcard view of the town

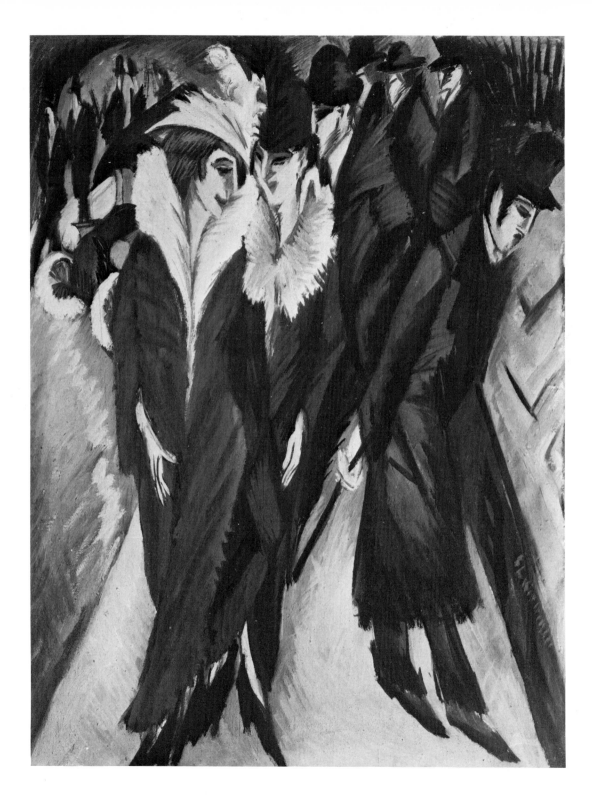

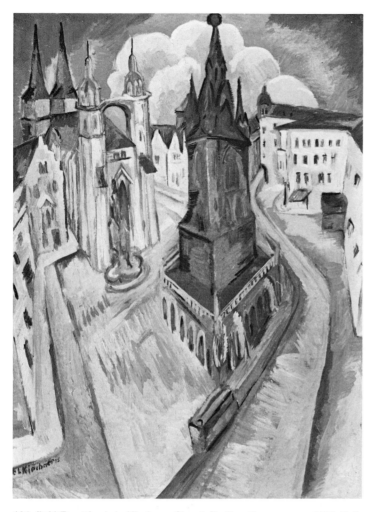

134. (left) Ernst Ludwig Kirchner, _Street, Berlin,_ oil on canvas, 1913. Collection, The Museum of Modern Art, New York; Purchase. (See also plate 20)

135. (above) Ernst Ludwig Kirchner, _Red Tower in Halle,_ 1915. Museum Folkwang, Essen.

where he received his army training, the painting represents a city square as experienced at night, devoid of human habitation. The sense of isolation infusing the scene is countered, however, by the forceful reds and blues and, especially, by the architectural planes which fall away precipitously on either side. _Red Tower's_ cataclysmic perspective, deriving from Robert Delaunay's _Eiffel Tower_ paintings, animates Kirchner's city view: it appears vital and alive.[71] Yet the city itself remains a lonely wasteland, responding to society's spiritual needs with outmoded symbols. Despite differences in emphasis, the same wasteland appears in Grosz's _Big City_ (fig. 97) and such other late Expressionist works as Max Beckmann's _Synagogue in Frankfurt_ (1919).[72] For all its animation, the traditional city of the industrial age no longer seems to meet human aspirations.

Bruno Taut, as a practicing architect, had thought a good deal about the industrial city and found, in the end, a typically Expressionist "countermovement." As early as 1913 he designed a low- and middle-income housing for the Berlin suburb of Falkenberg under the auspices of the German Garden City Association, and his purpose was clearly to make such housing as appealing as possible: "Despite the severe economic limitations faced by Taut in projects of this sort, he enlivened this otherwise rather plain architecture through the use of stucco painted in bright colors, in place of the more traditional grays: the pigments were olive green, pale red, white, blue, and yellow-brown. The critic Adolph Behne . . . saw in the use of these colors a clear relationship to Expressionist painting."[73] Taut also designed a master plan for Falkenberg which was praised in _Gartenstadt,_ the journal of the Garden City Association, and was included in a traveling exhibit in 1916.[74]

Taut's work illustrates, once again, a difference between turn-of-the-century "anti-urbanism" and Expressionist ambivalence toward urban values. The German Garden City Association, founded in 1902, had built on the paternalist tradition of Krupp company towns, the potentially "totalitarian" plans of Theodor Fritsch (_The City of the Future,_ 1896), as well as the more romantic-utopian ideas of the British writer Ebenezer Howard (_Tomorrow: A Peaceful Path to Real Reform,_ 1898).[75] But Taut was more directly influenced, through his teacher Theodor Fischer, by the far less folkish ideas of Camillo Sitte (_City Planning According to Artistic Principles,_ 1889).[76] As a result, Taut's vision from the start was both creative and post-industrial. His book _The Dissolution of Cities,_ published in 1920, proposed a "new start" far removed from the urban-industrial centers that, in Taut's view, had made World War I possible.[77] But already in the _City Crown,_ begun in 1916 and published in 1919, Taut envisioned the "new" city: "we want to have cities again in which, as Aristotle put it, we can live not only safely and soundly but also happily."[78]

The focus of the new city would be its center, its "crown" (fig. 136). Here a rectangular plot of 800 by 500 meters (2600 by 1600 feet), containing aquarium, arboretum, gardens, lawns, and other public spaces, would frame four cultural buildings—opera, theater, auditorium or concert-hall, and civic center or assembly-room—oriented along the cardinal dirctions.[79] These in turn would serve as bases for reinforced concrete bridges to the central, taller structure, a "crystal house" vaguely Oriental or Asian in silhouette but Gothic in structure. Light would enter the single monumental space through panes of clear and colored glass and, according to the daily progress of the sun, fall on pictorial and sculptural art within: "all intimate and exalted sentiments" would be aroused in the viewer.[80]

But the rest of the new city would resemble the old. An area four miles (seven kilometers) in diameter would contain extensive busi- **139**

ness and commercial districts, factories and parks, as well as homes for some 300,000 to 500,000 inhabitants. The latter project would involve the architect in low- and middle-income housing which, according to garden city principle, would be "as few stories as possible";[81] the Falkenberg garden city project was in fact illustrated in *The City Crown*.

As presented, Taut's new city was utopian—carving a metropolis out of nowhere whose spiritual center resembled what Hermann Hesse later described in *The Glass Bead Game*. But in other ways the new city actually predicted the future. For one thing, the Expressionist "city crown" served as model for the urban renewal, through erection of cultural centers, in the downtown cores of many Western cities after World War II. And for another, the new city's public housing served Taut as prototype for his expansion and master plans for the city of Magdeburg between 1921 and 1924, and for some 10,000 housing units erected by the Gehag, or Co-operative Homes Association, in Berlin between 1924 and 1932. Even during the years of the New Objectivity or New Sobriety, Taut continued his Expressionist efforts to humanize the city by using color for urban exteriors and by siting even row houses in a garden city environment. As Rosemarie Haag Bletter has described one of his housing estates of 1924–25: "Spacious green courtyards never degenerate into backyards; instead, they function as village greens, as social gathering points."[82]

136. Bruno Taut, *City Crown*, 1919.

4.4. THE ARTIST AS HERO AND VICTIM

As with the Expressionist cityscape, so with the Expressionist self-portrait, there is a fundamental ambivalence that is provocative. While the Expressionist self-image sometimes attains "the ultimate state of Romanticism," namely, "the soul contemplating itself,"[83] more often the state of contemplation turns into anxious questioning or nervous braggadocio. The Expressionist artist tends to see himself as hero or victim, sometimes simultaneously. For the non-German viewer, furthermore, there is an additional ambiguity in the Expressionist self-portrait. For it can be seen in two ways: as Everyman, and as specifically German man; as a view of the modern condition in general and as an image of the Germanic mental state in particular.

In the first sense, Expressionist man is that tragic, questing being described by Nietzsche: bereft of his god, his roots, and his ethical tradition—and yet, for all that, alive with the promise of Dionysian self-affirmation. In the second sense he is German man who, in addition to this, has the specific challenge of identity confusion—that void at the center of the German character which led, historically, to excessive self-assertion or equally excessive self-surrender (see sec. 4.1 and 3.1).

It was German psychology that discovered the principle of empathy or *Einfühlung,* which means a "feeling into" another. Empathy describes both kinds of ambivalence in the Expressionist self-portrait: the artist's in creating it, and the observer's in viewing it. It means self-identification by the artist with the fiction of his art; it also means self-identification by the observer with the view of the artist communicated by that fiction. Crucial in Theodor Lipps' definition of 1903 is the fact of identity loss: "In empathy I am not the real I, but am inwardly liberated from the latter, i.e., I am liberated from everything that I am apart from the contemplation of [artistic] form." Although Wilhelm Worringer in 1908 was more interested in "abstraction" than in "empathy," he, too, confirmed that empathy is dualist: it involves not only "self-affirmation" but also "self-alienation." Because "we are absorbed into an external object, an external form," in his words, there is the risk of "losing oneself" in the art work.[84]

Expressionist empathy is good, in other words, when it awakens a "fellow human being," as in a love relationship.[85] But it is more problematic when it requires the observer to follow the artist into such fixations as identification with Christ (fig. 48) or acceptance of split identities (fig. 147). Either way, in the words of the dramatist Paul Kornfeld, empathy distinguishes the "souled man" of Expressionism from the merely "psychological man" of the nineteenth century: "Psychological man is man *felt* from outside, as an object of portrayal and scientific analysis. 'Souled man' is man *felt* from inside, in his ineffable uniqueness."[86]

Viennese Expressionists were especially skilled at distinguishing this inner portrait from merely external likeness, at proceeding—as a recent writer puts it—"from façade to psyche."[87] There is a good deal of masculine swagger, for example, in Richard Gerstl's nude *Self-Portrait* (fig. 137)—done at the height of his affair with Mathilde

137. Richard Gerstl, *Self-Portrait,* oil on canvas, Kallir 42, ca. 1908.

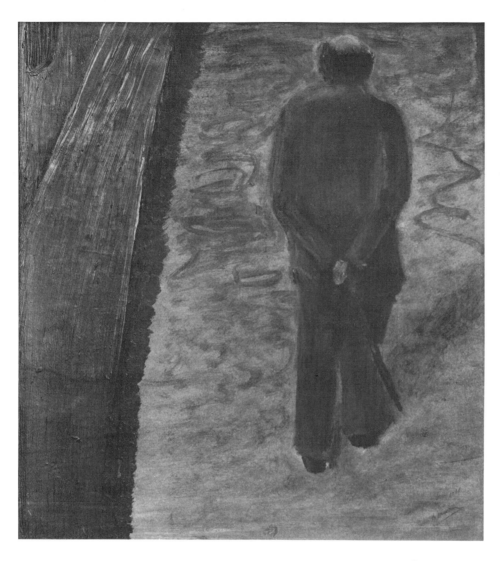

138. Arnold Schoenberg, *Self-Portrait,* oil on paper (#7), 1911.

Schoenberg (see sec. 2.2). To be sure, the couch and circular cushion to the left are merely "psychological," in Kornfeld's sense; they are the target-like place where a woman's love can be enjoyed. But the twenty-five-year-old's tense and wide-legged pose suggests continued arousal, as if he had turned to depict himself immediately upon his lover's departure. The bent arms focus attention on the body's midsection while the head is truncated; the dark genitals surrounded by light seem more prominent, in fact, than the dark-fringed, light-colored face above. The intellectual content is less important, in sum, than the erotic tension with which Gerstl manages to invest his glistening body.

Quite different is Arnold Schoenberg's *Self-Portrait* (fig. 138). Here we would seem to be presented only with an external view from above of a man strolling beside a house. But the fact that it is a self-portrait gives the image its hallucinatory power; in the real world, without mirrors, one cannot see oneself from the back! Thus the self-image takes its place among Schoenberg's other visionary portraits (cf. fig. 19), and was enough of an example of "inner necessity" to warrant its illustration in the *Blaue Reiter* almanach.

Schiele painted self-portraits like those of Gerstl and Schoenberg, but with an even greater sense of conflicted feelings. Thus the tense and defiant *Self-Portrait Nude Facing Front* stiffens the arms behind the torso and away from the genitals, while the *Self-Portrait Masturbating* displays a wan and sheepish expression (figs. 139, 140). The one suggests a guilt extreme enough to prevent erotic pleasure, the

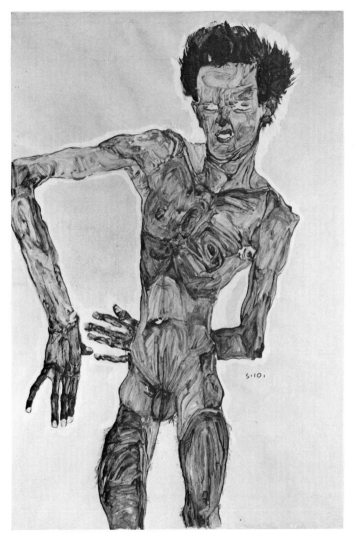

139. Egon Schiele, *Self-Portrait Nude Facing Front*, watercolor, 1910. Graphische Sammlung, Albertina, Vienna.

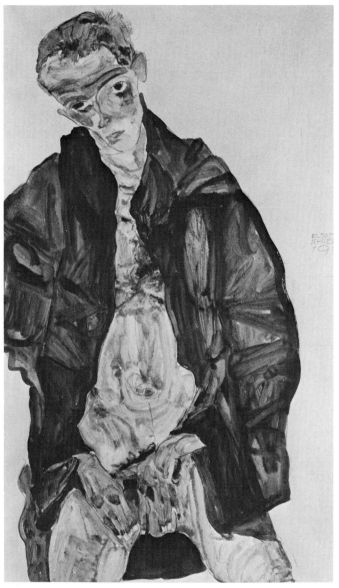

140. Egon Schiele, *Self-Portrait Masturbating*, watercolor, 1911. Graphische Sammlung, Albertina, Vienna.

other a post-orgasmic sadness or even displeasure; rather than being the hero of his own erotic impulse, Schiele presents himself as its victim.[88] Meanwhile, in such self-portraits as *Self-Seers II* (fig. 29), Schiele confronts himself with his own double: death. In this visionary image he has made use of the *doppelgänger* theme, traditional in German Romanticism, but now so as to suggest the potential of a split personality.[89]

The self as sufferer, implicit in these works of 1910 and 1911, becomes explicit in *Self-Portrait as St. Sebastian* (fig. 141). Whether Schiele considers himself hounded by art critics or by the risk of being drafted, he apparently made use of the St. Sebastian image recently popularized by Bohumil Kubišta in Prague (fig. 73).[90] Moreover, by adopting the role of suffering hero for himself and by advertising this persona in a poster for a one-man exhibition, Schiele demonstrates his belief that the Expressionist public in Vienna in 1915 will respond sympathetically to his self-image as victim.

Oskar Kokoschka followed a similar psychological path in showing himself as a fallen warrior in a *Fan for Alma Mahler* (1914) and in a

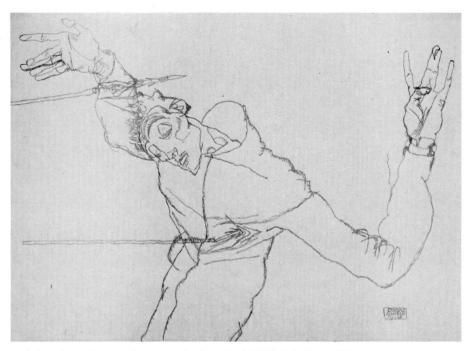

painting drawn from an image on the fan, the 1915 *Knight Errant* (fig. 142, plate 21; fig. 143). The left-central section of the *Fan* can be described as predicting Kokoschka's sufferings as a soldier on the Russian front late in 1915: "a gunner loads a cannon, while sailors are seen storming ahead; further, the painter is prostrate on the ground, a lance piercing his body; his forehead is bandaged; in the middle he appears again, wrestling with a bearded warrior—obviously a Russian—whom he looks straight in the eye."[91] And the *Knight Errant* has been interpreted in a similar manner, as "the desolation of the battlefield, the hopeless situation of the wounded soldier delivered up to a merciless enemy."[92] Nevertheless, the 1915 painting also depicts a sphinx-like Alma on the right and thus can be interpreted, like *The Tempest* of 1914 (fig. 30), as Oskar's "song of farewell" to Alma.[93] Just as that painting had presented the lovers in the *Liebestod* scene of Richard Wagner's opera *Tristan and Isolde* (see sec. 2.5), so the 1915 painting depicts them in the roles of the "holy fool" Parsifal and the temptress Kundry in the second act of Wagner's *Parsifal* (1882). Following Kundry's embrace, we recall, Parsifal confused the agitation of his heart with an actual bleeding wound:

> Here! Here! The brand in my heart!
> The longing, the terrible longing,
> that grips my senses in error's thrall!
> How all within me thrills, and quakes
> and throbs in sinful longing![94]

The tiny figure in the sky, another portrait of the artist, seems to scrawl the letters "E S," evoking Christ's complaint: "Elio, Eloi, lama sabachthani" ("My God, my God, why hast thou forsaken me?") (Mark 15:34,

141. Egon Schiele, *Self-Portrait as Saint Sebastian,* pencil and gouache, 1914. Private collection.

Matthew 27:46). Thus *Knight Errant* relates the artist's self-image not only to the suffering Parsifal and the suffering Christ, but also to the artist himself in the loss of his lover.

Despite its complex iconography, then, *Knight Errant* is another Expressionist example of a self-image as saintly sufferer, as heroic victim. Here, in the words of Angelica Zander Rudenstine, "the artist expresses . . . a combination of his own direct experience with Alma and of the more general and eternal dilemma of man's tortuous relations with woman."[95]

In Berlin, meanwhile, the relation of self to even more universal suffering is seen in Ludwig Meidner's *I and the City* (fig. 144). The artist's fearful face relates to the cowering self-image in the contemporary picture of *Revolution,* while the tumultuous city view is similar to those of the *Apocalyptic Landscapes* (figs. 133, 26). As Herschel B. Chipp has written, "Meidner's pathos . . . not only intensifies his inner emotions but at times impresses them on the physical world, forging cityscapes and landscapes into an organic entity that is but an extension of his own face."[96] It is difficult to determine whether Meidner is projecting his own subjective agitation on the city, or whether he is expressing a perfectly objective—and legitimate—fear about an imminent world conflagration. Either way, *I and the City* demonstrates the intimate link that exists between thoughts of self-destruction and the notion of world-destruction.[97]

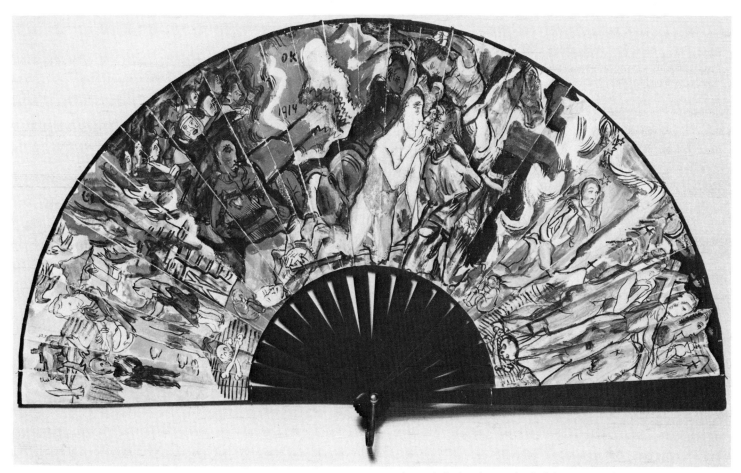

142. Oskar Kokoschka, *Fan for Alma Mahler,* 1914. Museum für Kunst und Gewerbe, Hamburg. (See also plate 21)

The link between the state of the self and the state of the world can also be one, however, of unresolvable contradiction. This is seen in Kirchner's extraordinary *Self-Portrait as Soldier* (fig. 145). Standing in his studio with a canvas behind him on one side and a nude model on the other, the artist wears the full uniform of the 75th Artillery Regiment in which he had enlisted. The right arm is raised but the right hand—the painting hand[98]—has been severed at the wrist. The artist cannot paint and the soldier cannot fight. His volition is as frustrated as his body is mutilated. The painting's personal symbolism is one of paralysis and castration, of functional loss both professional and sexual. Its social symbolism, however, is one of defiance against military authority, of an imagined sacrifice of a body part to avoid a battlefield sacrifice of the whole person. If a man must be unmanned to avoid military action, then Kirchner shows by a wished-for amputation a deeply felt pacifism.

In his letters from this time Kirchner identified himself as woman and as criminal—the one ineligible to serve, the other disobedient to authority—by comparing himself to the prostitutes he had painted.[99] Such comparisons suggest identity crisis: both the confusion in sexual identity noted earlier (cf. fig. 36) and a potentially schizophrenic split personality. We see the latter in Kirchner's 1915 woodcuts to *The Amazing Story of Peter Schlemihl* (1813) by the Romantic author Adalbert von Chamisso, particularly *Schlemihl's Encounter with the Shadow* (fig. 146, plate 22). The story of the man who sold his shadow in a Faust-like pact was, itself, a parable for loss of identity; Schlemihl was known in Berlin folklore as an incompetent Jew, while the shadow was the soul or self in traditional *doppelgänger* iconography. But as Annemarie Dube-Heynig has noted, Kirchner's color woodcuts "are more than illustrations, they have become self-representation." Indeed, in calling Schlemihl a "victim of persecution complex," Kirchner has in mind his own situation in the army reserves—subject to recall at any time. And in describing the *Encounter* print, he describes his own self-identification with the Faustian sufferer: "Schlemihl sits sadly in the fields when, suddenly, his shadow approaches across the sunlit land. He tries to place his feet in the footprints of the shadow, under the delusion that he can thereby **145**

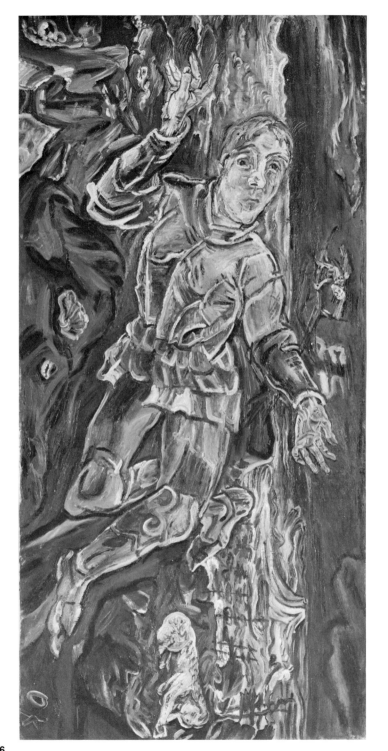

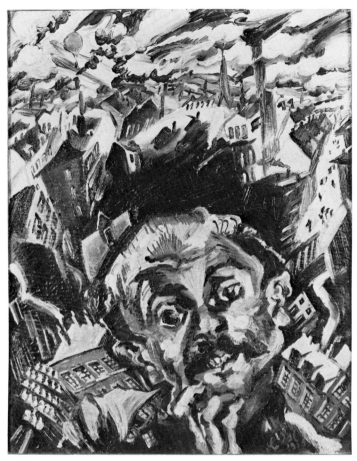

143. (left) Oskar Kokoschka, *Knight Errant,* oil on canvas, 1915. Solomon R. Guggenheim Museum, New York.

144. (above) Ludwig Meidner, *I and the City,* 1913. Collection Ruth Müller-Stein, Cologne.

145. (right) Ernst Ludwig Kirchner, *Self-Portrait as Soldier,* oil on canvas, 1915. Allen Memorial Art Museum, Oberlin College, Oberlin, Ohio. Charles F. Olney Fund, 50.29.

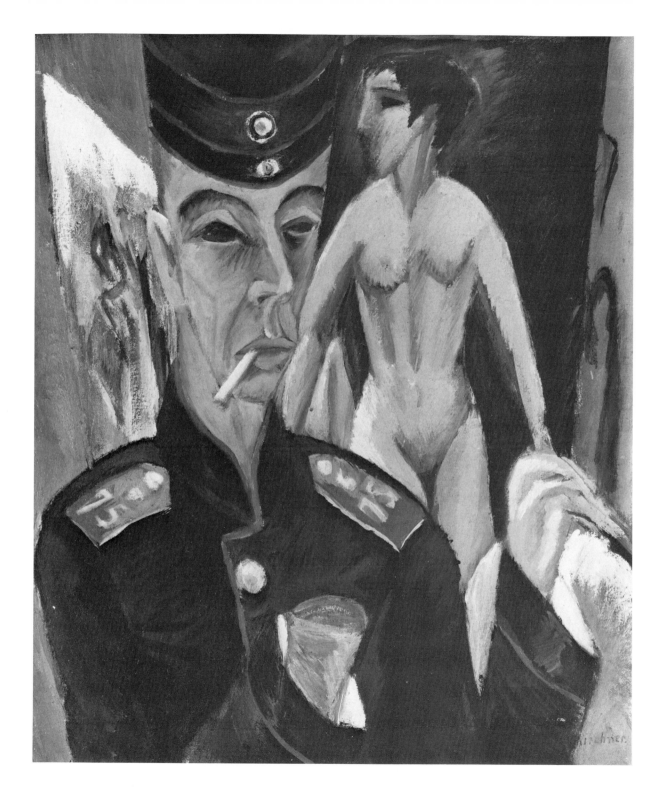

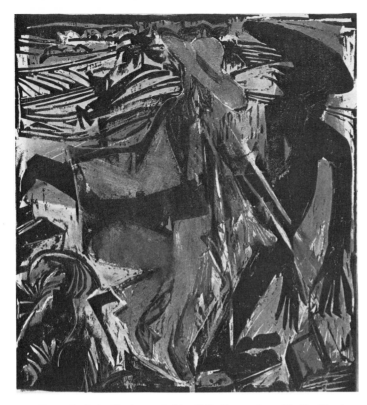

146. Ernst Ludwig Kirchner, *Schlemihl's Encounter with the Shadow,* reproduction after color woodcut, 1915. Los Angeles County Museum of Art. Purchased with Funds Provided by Anna Bing Arnold, Museum Acquisitions Fund, and Deaccession Funds. (See also plate 22)

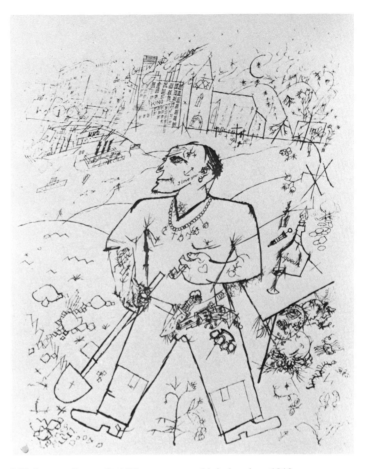

147. George Grosz, *Golddigger,* pen and ink drawing, 1916.

become himself again. An analogue is the mental process of one discharged from the military."[100]

Also in 1915, George Grosz recognized not two but *three* different identities within himself:

> I am infinitely lonely, i.e., I am alone with my *doppelgänger,* phantom figures in which I permit quite definite dreams, ideas, tendencies etc. to become real. I strain out three different people from my inner imagination; I believe in these impersonating pseudonyms. Gradually, three firmly delineated types have arisen: (1) Grosz; (2) Count Ehrenfried ["honorable peace"], the nonchalant aristocrat with manicured fingernails out to cultivate only himself—in a word, the elegant aristocratic individualist; (3) the physician, Dr. William King Thomas, the more practical, American, materialist, compensatory character in the mother-figure Grosz.[101]

From this passage one recognizes Grosz's alter ego in the 1914 painting *Lovesick*—a cane-carrying aristocrat with anchor-tattoo

and earring—and Grosz's other alter ego in *The Adventurer* of 1916: a knife-wielding cowboy, also with anchor-tattoo and earring (neither illustrated).[102] Yet a further variant of the American materialist type is seen in a 1916 drawing, *Golddigger* (fig. 147). For this imagined self-portrait Grosz also composed a poem, "The Song of the Golddiggers," in which express trains cross America and "Klondike calls again!!!"[103]

These identities, it appears, were subversive. No true German in 1915 would have identified himself with "honorable peace" or with non-German "materialist" values. Nor would a patriotic German have anglicized his name from Georg to "George" Grosz as the artist did in September 1916, at just the moment the British naval blockade—under the nominal command of King George V—was interdicting German food and war supplies.[104] Grosz's new identity apparently involved a childlike "identification with the aggressor"; his tough-guy, golddigger persona compensated for what he considered excessively passive, sentimental, and Germanic traits.[105]

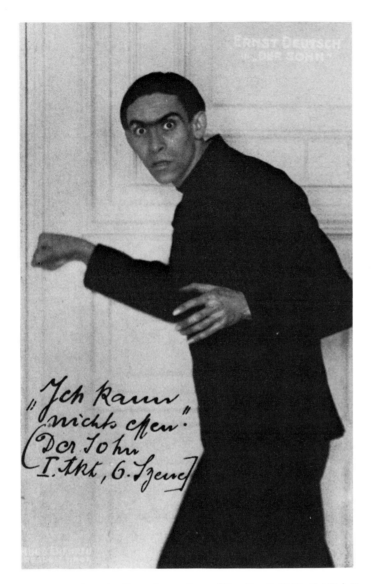

148. Hugo Erfurth, *Ernst Deutsch as "The Son,"* 1916. Schiller-Nationalmuseum, Marbach, 1960.

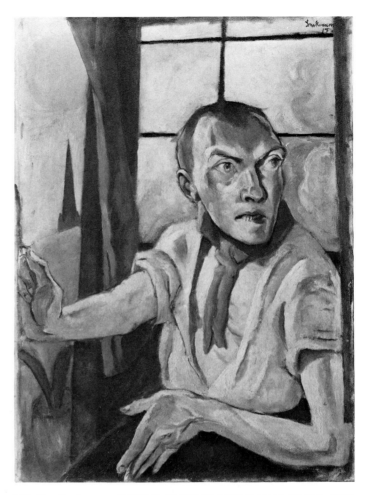

149. Max Beckmann, *Self-Portrait with Red Scarf,* oil on canvas, 1917. Graphische Sammlung, Staatsgalerie, Stuttgart.

Max Beckmann, too, put on a "tough guy" mask to hide a disillusioned spiritual quest. In his *Self-Portrait with Red Scarf* (1917), for example, he adopted the exaggerated gestures and intense stares so typical of the Expressionist stage—particularly of Ernst Deutsch, who had just starred in *The Son* in October 1916 (figs. 149, 148).[106] Moreover, Beckmann's self-identification with the actor was augmented, in this painting, by the placement of the head, Christlike, against a window-frame cross. As in the contemporary *Christ and the*

Woman Taken in Adultery,[107] Beckmann uses his own hardened features to mask a genuine and generous concern for his fellow human beings.

The placement of the head against the crossbars, the facial direction, and even the grimace in Beckmann's self-image were apparently drawn from Lovis Corinth's *Self-Portrait with Skeleton* (fig. 150), which had been exhibited in Berlin in 1913 and again in 1915.[108] Exhibited once more at the artist's sixtieth-birthday retrospective in Berlin in 1918, the Corinth painting most likely served as the model for Max Pechstein's *Self-Portrait with Death* (fig. 151). The Corinth is merely one of numerous nineteenth-century versions of this theme; it is a traditional memento mori, popular in Germany, where the skeleton as "double" reinforced the Romantic *doppelgänger* idea. But where the 1896 work was still a positivist allegory, wresting spiritual

meaning from material reality, the Expressionist painting is more pointedly ambivalent. It places the artist amid images symbolizing the pleasure of sex and the displeasure of mortality: where Pechstein's woman holds a cigarette, his skeleton holds a cartridge. By implication, the bullet-hole in the laughing skull is all that separates a fallen soldier from a living veteran.

Another postwar portrait of the artist as ambivalent survivor is Kokoschka's *Painter with Doll* (fig. 152). The life-size, sawdust-filled mannikin had been made by the Stuttgart artisan Hermine Moos between the summer of 1918 and the spring of 1919, according to exact instructions and pictures by the artist.[109] The doll was to be of his "beloved" (who was by now remarried, briefly, to Walter Gropius),

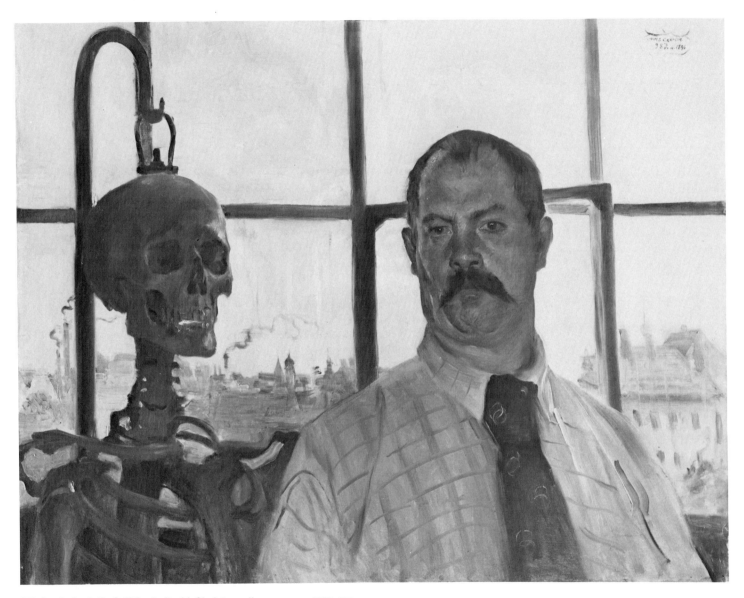

150. Lovis Corinth, *Self-Portrait with Skeleton,* oil on canvas, 1896. Städtische Galerie im Lenbachhaus, Munich.

although Edith Hoffman considers it as "tangible proof" of the brain concussion he had suffered at the front.[110] In painting himself with the doll some three years later, Kokoschka demonstrates both the reification of his love and the duration of his memories. Only afterward did he regretfully discard the erotic object: "The doll was an image of spent love that no Pygmalion could bring to life."[111]

During the Expressionist period there was an unfortunate confusion between the work of the suffering vanguard artist and the art of the mentally ill. The notion was popularized in France by the 1889 translation of Cesare Lombroso's *Genius and Insanity* and in Germany, more negatively, by the appearance in 1893 of Max Nordau's *Degeneration* (see sec. 1.4). Vincent Van Gogh, institutionalized in a Saint-Rémy asylum in 1889, was the paradigm case. Even since the winter of 1909–10, when Emil Nolde bought three drawings by the Swedish schizophrenic artist Ernst Josephson,[112] and ever since January 1912, when Paul Klee praised "the [art] works of the mentally diseased,"[113] the notion was current among German painters; in Berlin the most popular vanguard meeting place, the Cafe des Westens, was nicknamed Cafe Grössenwahn ("Megalomania"). By 1918 in Stockholm, Josephson was called "the first Ex-pressionist,"[114] and by 1921 in Zurich Oskar Pfister extensively analyzed the art of a mental patient under the heading *Expressionism in Art*.[115] In 1922, in an influential study on *Strindberg and Van Gogh*, Karl Jaspers found the schizophrenic the only "authentic" artist. "We live in a time of artifice and imitation," Jaspers wrote, and then asked: "In an age such as this does not the schizophrenic state become a condition of absolute sincerity?" Also in 1922, in his pioneering *Artistry of the Mentally Ill*, Hans Prinzhorn concluded simply: "The particularly close relationship of a large number of our [schizophrenics'] pictures to contemporary art is obvious."[116] This relationship enabled pictures by the insane to be discovered as art, and the medical establishment to be educated by the art-historically trained psychiatrist.[117]

The reverse relationship, however, is simply not true. The Expressionist artist playing the role of victim is not at all the same as the mental patient actually victimized by his illness.[118] As Prinzhorn himself put it: "The conclusion that a painter is mentally ill because he paints like a given mental patient is no more intelligent or convincing than [the thesis] that Pechstein and Heckel are Africans from the Cameroons because they produce wooden figurines like those by

151. (left) Max Pechstein, *Self-Portrait with Death,* 1920. Ostdeutsche Galerie Regensburg, on loan from private collection, Hamburg.

152. (below) Oskar Kokoschka, *Painter with Doll,* oil on canvas, 1922. Oskar Kokoschka-Dokumentation Pochlarn, Austria.

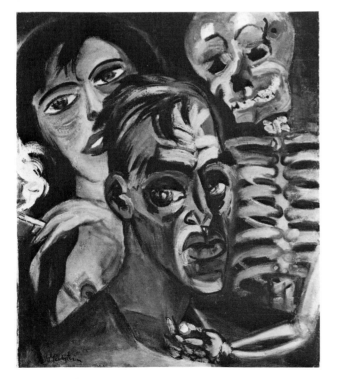

Africans from the Cameroons."[119] To be sure, in December 1918 Kokoschka was publicly labelled "the mad Kokoschka";[120] a year earlier, Austrian Army medical authorities had sent him to Stockholm for a head examination.[121] Beckmann had experienced mental exhaustion in 1915,[122] and Kirchner was institutionalized both in Germany and Switzerland during much of the 1916–18 period—though he continued to work avidly.[123] Even Grosz was treated briefly early in 1917 at a military hospital for the insane.[124] But these are all examples of wartime stress. It would be as absurd to call all Expressionists mentally ill—as the Nazis did in the 1930s—as it would be so to designate all German armies as a geared irrevocably to war.

4.5. PATRIOTS AND PACIFISTS

It was the war itself, both in theory before 1914 and in practice afterward, that had the most profound effect on Expressionist social thought. In Social Darwinist theory, war between nations was the testing ground by which the "fittest" survived; as seekers of self-knowledge were advised in *Zarathustra*, "You should love peace as a means to new wars—and the short peace more than the long."[125] Embodying the Nietzschean imperative, Filippo Marinetti advocated war in the first *Manifesto of Futurism*—published in Paris in 1909 and reappearing in *Der Sturm* in Berlin in March 1912: "We will glorify war—the only true hygiene of the world—militarism, patriotism, the destructive gesture of the anarchist, the beautiful Ideas which kill, and the scorn of woman."[126] And in the second Futurist manifesto, titled *Kill the Moonlight!*, Marinetti advocated a grisly state of war between past and future:

> War? Certainly! Our only hope, our justification for existence, our will. Yes, war! Against you, those of you who die too slowly, and against all the dead who bar the way!
>
> There in the distance notice the ears of corn, drawn up in battle order by the millions! These ears, pliant soldiers with delicate bayonets, glorify bread's ability to be turned into blood in order to rush, bubbling, toward the horizon. Blood—note well—has value and splendor only after it has been freed from its arterial prison by fire and sword! We shall show all armed soldiers on earth how to spill blood; but first, you insects, the great barracks in which it is housed must be cleaned out. Soon it will be done![127]

In answer to Marinetti's sadistic words, appearing in *Der Sturm* the last week of May 1912, Meidner's masochistic images of self-destruction and world-destruction—begun in June and July of that year—seem an immediate, if appropriately ambivalent, response.[128]

There was considerable post-Nietzschean ambivalence about war as early as the summer of 1911, when the "Moroccan crisis" erupted. Beginning in May, when France occupied Fez, and especially after 1 July 1911, when Germany sent the warship *Panther* into Agadir and the British fleet was put on alert, hostilities seemed inevitable: "War between England and Germany was seen to be a real possibility by the people of both countries for the first time."[129] The Expressionist poet Georg Heym responded with a poem on "War" ("Der Krieg"), which opens with a grim stanza:

> He has arisen who was long asleep
> Arisen below from the cellars deep.
> Vast and unknown, in twilight he stands
> And crushes the moon with a black hand.[130]

And Wassily Kandinsky evoked a similarly ominous image:

> The summer of 1911, which was unusually hot for Germany, lasted desperately long. Each morning upon awakening I looked out the window at the glowing blue sky. The storms came, allowed a few drops to fall, and then went away. I had the feeling that a very sick person had to be made to sweat, and that all remedies were failing; barely a few drops of sweat appear, and the tormented body burns anew. The skin splits. The breath ceases. Suddenly nature seemed white to me. White (the great silence—full of possibilities) appeared everywhere and spread itself visibly.[131]

Was not Europe that "very sick person" that summer, risking a death and the possibility of rebirth? The Moroccan crisis dominated German headlines from 2 July, when a nationalist daily announced Germany's awakening "after sleeping for twenty years," to 4 November when the threat was ended by diplomatic agreement.[132] Meanwhile Kandinsky devoted his largest painting until now—*Composition V*, begun in the "fall" and completed on 17 November 1911[133]—to what he called "the Resurrection."[134] Although any link of the artist's apocalyptic imagery to the threat of war in 1911 is entirely conjectural, it cannot at all be ruled out.[135]

By 1912–13, in fact, war was a common topic both in the newspapers and in Expressionist art. At the end of the first Balkan War in November 1912, German officials already threatened to "fight" Russia should Austria be forced into war with the Slavs. Between that moment and the second Balkan War of June–July 1913, the jingoist press advocated a war:

> If the twilight of the gods which has for so long overshadowed the European race and culture is at last to be lifted . . . we Teutons in particular must no longer look upon war as our destroyer . . . at last we must see it once more as the savior, the physician (*Politische-Anthropologische Revue*, November 1912).
>
> If, as a hundred years ago, a war is required, if the year of fire and flood is really to be followed by a year of blood—then the German people will demonstrate that today as in the past it can defy a world of enemies (*Jungdeutschland-Post*, 1 January 1913).
>
> A vigorous transition to an imperialist policy will give Germany the space it needs. . . . An unsuccessful war can do no more than set Germany back, although for a long time;

England it can destroy. As victor, England would for a while be rid of an awkward competitor; but Germany [as victor] would become what England is now, the world power (*Das Neue Deutschland,* 17 May 1913).[136]

Franz Marc's painting *The Wolves (Balkan War)* was in progress in May 1913, when Germany's planning for hostilities was at its height. Kandinsky's *Improvisation 30 (Cannons)* of 1913 has a similar reference,[137] as does another Kandinsky oil known as *War in the Air.*[138]

As a Russian citizen, Kandinsky was especially sensitive to the war threat. If battle began, he would have to risk internment or else leave Germany precipitously—as he in fact did in August 1914. But the risk of Europe-wide war was well known during 1912–13, and Expressionists were far from alone in "foretelling of disasters which the present [political] system made inevitable."[139] It is wrong, then, to speak of Expressionist "intuition" or "doomsaying,"[140] or of Expressionist "catastrophes which are of no specific time and place."[141] The catastrophes were all too predictable. Indeed, as Klee wrote in his diary at the outset of 1915: "I have long had this war inside me. This is why, inwardly, it means nothing to me."[142]

Yet when it finally came, World War I profoundly affected the directions of Expressionist art and the lives of Expressionist artists. Barlach, Feininger, and Nolde, in their forties, were too old to serve, while Kubin at thirty-seven underwent three annual military examinations until, at forty, he too was released from further consideration. But most of the major Expressionists were conscripted into the German or Austrian Army, or volunteered for preferred alternative duty. It is an extraordinary fact that of prewar and wartime Expressionist artists of military age, almost half died or were invalided out of the service:[143]

THE WAR EXPERIENCE

BECKMANN: Medical Corps, September 1914–summer 1915. *Medical discharge
CAMPENDONK: Army, 1914–16
DIX: Artillery, 1914–18
ERNST: Artillery, 1914–18
GROSZ: Guards Regiment, November 1914–May 1915. Recalled January–April 1917. *Medical discharge
HECKEL: Red Cross orderly, 1914–18
KIRCHNER: Artillery, April–October 1915. *Medical discharge. To avoid recall, to Switzerland permanently in May 1917
KLEE: Non-combat service, 1916–18
KOKOSCHKA: Dragoons, late 1914–September 1915. *Critically wounded
KUBIŠTA: Army, 1913–18. *Died of influenza, November 1918
LEHMBRUCK: Medical orderly, 1915–16. To avoid conscription, to Switzerland late in 1916. *Suicide March 1919
MACKE: Infantry, August–September 1914. *Killed in action
MARC: Cavalry, September 1914–March 1916. *Killed in action
MEIDNER: Infantry, later non-combat service, 1916–18
MORGNER: Infantry, late 1913–August 1917. *Killed in action

MUELLER: Armored corps, 1916–18
PECHSTEIN: Interned in New Guinea, 1914. Returns to Germany via the U.S. Oct. 1915. Infantry, spring 1916–spring 1917
SCHIELE: Non-combat service, June 1915–late 1918. *Died of influenza, October 1918
SCHMIDT-ROTTLUFF: Construction battalion, May 1915–late 1918
STEINHARDT: Infantry, 1914–16 (?). *Required year's recuperation
VOGELER: Dragoons, combat artist, 1914–18

Wartime stress was an important factor in most Expressionist art after 1914. Some artists who signed up early were out of uniform by 1915 for medical reasons (Kokoschka, Kirchner, Beckmann). Others, deferred early on, faced belated conscription when standards were lowered in 1916 (Meidner, Mueller). Lehmbruck could avoid the call only by moving to Switzerland, while Grosz was actually inducted twice. Civilians could at any time be drafted, soldiers at any time be hit (Dix was wounded on three separate occasions). Artists were forced to choose between patriotism and pacifism; as we have seen in their self-portraits, the result was often ambivalence.

Moreover, the entire context of Expressionist art was subtly changed by the new political and art-political environment. Compared to the prewar years, first of all, there was a new spirit of embattled unity among artists of previously diverse schools. Second, there was a more unillusioned attitude of "sobriety" or *Sachlichkeit* among painters in a nation at war. And third, there was a gradual but palpable shift from patriotism to pacifism as Germany's initial victories gave way to stalemate.

Paul Cassirer, the dealer and publisher who had long been a leader of the Berliner Secession, was the first in the art world to sense the initial change of mood. In the very month of the war's onset he started an illustrated weekly paper called *Kriegszeit* ("Wartime"), in which appeared patriotic prints by older and younger artists, Impressionist and Expressionist alike. Later, when the journal ran afoul of the censors, Cassirer published a similar but more subversive journal under the neutral title *Bildermann* ("Picture-Man").[144]

The new tone was set by Julius Meier-Graefe in *Kriegszeit*'s initial editorial of 31 August 1914: "The war bestows on us a gift. Since yesterday we are different. The fight over words and programs is over. We were tilting at windmills. Art was for many but an amusement. We had colors, lines, pictures, luxuries. We had theories. What we were missing was meaning—and that, brothers, the times now give us. May we be worthy of it. . . . May the spirit which kindles our respect speed the artist's eye. The war has given us unity. All parties are agreed on the goal. May art follow!"[145] Meier-Graefe's words, however eloquent, were but a paraphrase of Kaiser Wilhelm's remarks to the Reichstag on the occasion of Germany's declaration of war that fateful August. The Kaiser, too, had said that he recognized no further need for parties.

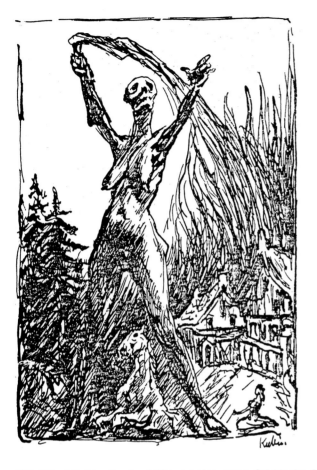

153. Alfred Kubin, *Torch of War*, drawing, 1914. Städtische Galerie im Lenbachhaus, Munich.

This message was given a more romantic, nationalist twist by Michael Georg Conrad in the Munich journal *Kriegs-Bilderbogen* ("War Picture-Sheet")—a monthly started by the dealer Hans Goltz to emulate Cassirer's *Kriegszeit*. Conrad's editorial was titled "Folk and Art": "Hail to the folk which understands and honors its artists; woe to it if it neglects them or betrays them to strangers. The artist is God's truest collaborator, the interpreter and glorifier of His world; without him the homeland lacks the best piece in its treasure-chest, in that armory inherited from its fathers. . . . See, art never tires of being blessing and salvation for itself and its folk. It is a fire in the mountain that is never extinguished. God bless folk and art! Let heart and eyes rise to eternal heights!" Such folkish subordination of the individual to the collective was picked up, once, in one of Marc's last published articles. By 1914, Marc wrote, "the folk as a whole . . . had a foreboding of the war, more so than any individual." But after the hostilities, "we will have to begin working from the very beginning again; first on

ourselves in the school of this great war, then upon the German folk."[146]

As news from the front became more sober, and as the artists themselves took on their war duties, Expressionists generally became more factual, more involved in the world around them. Rhetoric yielded increasingly to reality. Here, too, *Kriegszeit* noted the need to shift from a "learned" art to a "timely" art. Daumier was to be honored for his maxim, "il faut être de son temps" ("one must be of one's time"). Even so non-political a painter as Egon Schiele was chastened by 1915; his style became more matter-of-fact, more *sachlich*. In the wartime work of Schiele and other Expressionists, Alessandra Comini finds "a distinct lessening of subjective orientation as, in the reality of war, art made peace with society."[147]

The initial response to the outbreak of hostilities was mixed. On the one hand, Alfred Kubin's drawing published in Munich in December 1914 represented *War* as a rampaging harridan, half human, half beast (fig. 153). Similarly, Meidner, as might be expected, depicted *Cannons* manned by grisly skeletons.[148] On the other hand, Max Beckmann seemed a little surprised by his own patriotism upon seeing General von Hindenberg in September 1914. "I myself roared 'Hurrah,'" Beckmann wrote, "at the sight of this remarkably powerful, fierce face with the biting eyes."[149] And in several *Kriegszeit* issues from December 1914 others expressed this "hurrah spirit": the Impressionist Max Liebermann with a lithograph entitled *March, March. Hurrah!,* and the Expressionist Ernst Barlach with another advocating *The Holy War.*

The mood of 1915, by contrast, was more somber. No longer split between pacifist caricature and patriotic enthusiasm, Expressionist war imagery matured. Dix's *Self-Portrait as Shooting Target* and *Self-Portrait as Mars* (fig. 95) suggest with grim irony the unhappy situation of the warrior-artist. And Kirchner's *Artillerymen* (fig. 154) makes an even more bitter statement about the individual's predicament in the militarist state. For Kirchner depicts regimentation in even the most private act, authoritarian drill even when people, stripped naked, are at their most vulnerable. The mind which puts a uniformed officer in the shower room with his men is already, in principle, the "totalist" mind intent on what Robert Jay Lifton calls "milieu control": "Through this milieu control the totalist environment seeks to establish domain over not only the individual's communication with the outside. . . , but also—in its penetration of his inner life—over what we may speak of as his communication with himself. . . . Many things happen psychologically to one exposed to milieu control: the most basic is the disruption of balance between self and outside world."[150] Escape from the army was Kirchner's only available way to avoid that totalist environment in which self-expression becomes impossible.

Another unforgettable document of that year was Wilhelm Lehmbruck's *Fallen Man,* begun in 1915 but completed and exhibited in February 1916 (fig. 155). Here Lehmbruck expresses the essential futility of war. Gone are the uniforms, the insigniae, the valorous decorations by which the military dead are glorified. Missing is any gesture of defiance, any suggestion of heroism on the thresh-

154. Ernst Ludwig Kirchner, *Artillerymen,* oil on canvas, 1915. Collection, The Museum of Modern Art, New York. Gift of Mr. and Mrs. Morton D. May.

old of immortality. Instead we are given merely a dying body, still alive and crawling in its lower limbs and yet drooping, expiring, from the waist upward. Pathos is in the two hands, one still grasping a weapon and the other loosening its hold on life. As Paul Westheim observed on the occasion of the work's exhibition: "Something burdensome, something of the world's anxiety as it learned that the great Pan was dead, is the mood emitted by this figure. For once again a world has collapsed, a world filled with love, filled with activity, filled with happiness, a world whose focal point had been this hero. There are no soft lines, no melting surfaces in this body. Even in the form there is groaning and grating and oppression."[151] Lehmbruck's *Fallen Man* argues, eloquently, against the carnage of battle.

By the year 1916 Germany's early victories over the Allies were behind her; the two roughly equal contenders were stalemated. As a result of trench warfare in Galicia and around Verdun, the combatants on both fronts suffered 3,500,000 casualties (about 1,000,000 killed) before September of that year alone. By July the wish for peace was obvious among the rank-and-file workers of the Socialist party. Artists, too, expressed such sentiments in Cassirer's *Bildermann* journal. Thus, in October, Barlach expressed anti-war feeling in a lithograph titled *The Year of the Lord 1916 A.D.:* Christ, returned to earth, is shown a land entirely covered with army graves. And in December the Impressionist artist Max Slevogt published a *War Satire* in which a pot-bellied soldier uses his own severed leg to "fire" at the enemy. Meanwhile, in *Bildermann*'s Christmas issue, Barlach's pacifist message is stated openly in the title—*Give Us Peace!* (fig. 156).

For men at the front and at home, the war's last years were gruesome. Dix's experiences were so grisly that it took him until 1924

155. Wilhelm Lehmbruck, *Fallen Man*, bronze (cast posthumously), 1915–16. Bayerische Staatsgemäldesammlungen, Staatsgalerie Moderner Kunst, Munich.

to complete a fifty-etching portfolio, *The War;* included are battle views on the Somme in the fall of 1916 and scenes of a poison gas attack in Belgium the following year. Expressionist poetry could be equally grim, as in a bit of doggerel penned by the youthful Carl Zuckmayer in 1917:

> For seven days and nights I haven't eaten.
> Shot one man through the forehead with my gun.
> My shin's all ravaged where the lice have bitten.
> In next to no time I'll be twenty-one.

Perhaps the most poignant poem was the one which Lehmbruck wrote early in 1918, as a civilian, just a year before his suicide. It is titled *Who is Still Here?:*

> Who stayed behind after these murders,
> Who survived this bloody sea?
> I step across this stubbled field
> And look around at the crop
> Which murder butchered horribly.
> My friends lie all around me,
> My brothers are no longer here,
> Our faith, love, all is gone,
> And Death appears on every path, on every flower.
> Damn!
> You, who have prepared so much death,
> Have you no death
> for me?[152]

4.6. THE "NEW MAN": THEATER AND REVOLUTION

It is the peculiar virtue of German Expressionism to have associated war, unequivocally, with death. Where *Kriegszeit* dispensed with the "hurrah spirit" by 1915, the French art journal *l'Elan* was founded that year to propagate precisely such chauvinist sentiment. In Amédée Ozenfant's words: "This French journal . . . will fight against the enemy wherever it finds it, even in France . . . our only goal being the propaganda of French art, of French independence, in sum, of the true French spirit." Where Cassirer's journals reproduced image after image of wartime suffering, Ozenfant's *l'Elan* was what Kenneth E. Silver calls "the *civilized* magazine of war." For, as Ozenfant put it in an editorial of December 1915: "Faced with agony, the civilized pull the curtain . . . one must love life; oh yes, let us admire our poor, brother soldiers who sacrifice their lives, but let us cover their cadavers and even those of our enemy."[153]

Expressionists refused to cover the cadavers. Warfare, for them, was less a matter of patriotism or political advantage than of depersonalized, mechanized slaughter. This view of war helped determine, in turn, the Expressionist view of a future, postwar world. If it took capitalist and imperialist rivalries to produce war, and industrialized factories to mechanize the battlefield killing, then opposition to war meant inexorable opposition to capitalist, industrial society.

Barlach's first pacifist lithograph was published in *Kriegszeit* on 20 October 1916, in the aftermath of Verdun. On 7 November 1917, in the aftermath of sedition and rebellion, Vladimir Ilyich Lenin assumed the chairmanship of the world's first Soviet government, in Russia. And on 9 November 1918, in the aftermath of a naval mutiny and workers' strikes, a socialist republic was proclaimed in Germany. The volatile mix of pacifism, communism, and socialism typified the utopian hopes, political anarchy. and local military actions which lasted from November 1918 into January and, in Munich, into April of 1919. This was the moment of German revolution or, more accurately, of

156. Ernst Barlach, *Give Us Peace*, from *Der Bildermann*, December 1916.

"frozen" revolution.[154] It was also the climactic moment of Expressionist social consciousness.

During this entire thirty-month period the prewar founder of the Neo-Pathetisches Cabaret, Kurt Hiller, was articulating his philosophy of "activism." The activist goal was the transformation of society, but transformation achieved by spirit (*Geist*) rather than by political party. In the first of his *Ziel* yearbooks, published in 1916, Hiller reprinted Heinrich Mann's essay "Geist und Tat" and then offered this succinct catechism: "What do we want? Paradise. Who will achieve it? Spirit. What does spirit need to accomplish this? Power. How does spirit win power? Through alliance."[155] Like others, Hiller earlier had welcomed the Great War "as a fight for reforming society"; but by 1918 he labeled such activist reform "socialist" because it required collective action. Nevertheless, he rejected class war, trade unions, Bolshevism, even Marxism! Activist politics, for Hiller, was utopian politics. "Socialism," he said, "is not the doctrine of a party, but an ethical outlook. It is nothing but the realisation of brotherhood."[156]

To be sure, Hiller wanted to distinguish Expressionism from activism. To art's emotional and subjective "pathos" he preferred the "ethos" of universal, objective principle. Yet most Expressionists were activists at one time or another. Thus Käthe Kollwitz affirmed the spiritual nature of Expressionist politics in a 1917 letter to her son: "It seems to me that behind all the convulsions the world is undergoing, a new creation is already in the making. And the beloved millions who have died have shed their blood to raise humanity higher than humanity has been. That is my politics, my boy. It comes from faith." And

the editor of the major Expressionist journal *Die weissen Blätter,* René Schickele, agreed. In a passionate essay, *The Ninth of November,* completed early in 1919, Schickele found practical means incompatible with Expressionist ends: "No, a thousand times no! I am a socialist, but if one were to convince me that socialism is to be realized only by the Bolshevik method, then I—and not only I—would give up all claim to its realization." From any viewpoint, according to Wolfgang Rothe, Expressionist politics was non-Marxist and utopian: "The big 'no' to orthodox Marxism and, beyond that, to blinders of any color was the logical consequence of an axiomatic 'yes' to a limitlessly open horizon of thought and feeling. . . . [Activist magazines provided] a stage on which everyone could offer and act out his own good, concrete, real, utopia."[157]

Yet another stage on which utopian society was envisioned was that provided by the Expressionist theater. Here, again, the crucial moment was the thirty-month period between late 1916 and early 1919. For this was the time when the early Expressionist plays were first performed and when the "revolutionary" dramas were first written:[158]

PREMIERES OF SELECTED EXPRESSIONIST DRAMAS PUBLISHED BEFORE MID-1919.

HASENCLEVER, *The Son* (1914). Dresden, 8 October 1916 (Prague, 20 September 1916)

KAISER, *The Burghers of Calais* (1914). Frankfurt, 29 January 1917

KAISER, *From Morn to Midnight* (1916). Munich, 28 April 1917

KOKOSCHKA, *The Burning Bush* (1913), *Job* (1917). Dresden, 3 June 1917

KORNFELD, *The Seduction* (1916). Frankfurt, 8 December 1917

HASENCLEVER, *Antigone* (1917). Leipzig, 15 December 1917

SORGE, *The Beggar* (1912). Berlin, 23 December 1917

GOERING, *Naval Battle* (1917). Dresden, 10 February 1918 (then to Berlin)

VON UNRUH, *A Generation* (1917). Frankfurt, 16 June 1918

STRAMM, *Saint Susanna* (1914). Berlin, late October 1918

KAISER, *Gas I* (1918). Frankfurt, 28 November 1918 (then to Düsseldorf)

TOLLER, *Transformation* (written 1917–18). Berlin, 30 September 1919

BARLACH, *The Dead Day* (1912). Leipzig, 22 November 1919

KORNFELD, *Heaven and Hell* (1919). Berlin, 21 April 1920

TOLLER, *Man and the Masses* (written 1919). Berlin, 29 September 1921

The first social issue typifying the Expressionist theater was the generation conflict, the revolt of children against parents. In some of the earlier dramas the rebellion was unfocused: a mother kills herself in Ernst Barlach's *Dead Day,* and both parents are dispatched by the poet hero in Reinhard Sorge's *Beggar*. Written a few years later, Paul

Kornfeld's *Seduction* features a protagonist who acts out his disgust with society by gratuitously murdering a stranger.[159] In *The Son* by Walter Hasenclever, however, the ideological nature of the revolt is stressed. Now it is son against father, and the youth would have killed his sire had the latter not died, conveniently, of a stroke. "Remember," the hero cries, "that our fight against our fathers is equal to the vengeance wrought on the princes a hundred years ago. Today it is we who are in the right! . . . Today it is we who sing the Marseillaise!"[160]

Nevertheless, Expressionist rebellion had to be accompanied by sacrifice, and so parricide would be replaced by—suicide! Where murder might appear too warlike, self-sacrifice became the vehicle for a *peaceful* regeneration of society. The idea was Georg Kaiser's. From the start he called his pacifist goal *die Erneuerung des Menschen* (the renewal of man).[161] In 1914 he presented the idea in *The Burghers of Calais,* where an old man extols the son who killed himself in order to deliver his city from bondage. His eulogy closes the play: "Go you out into the light from this night. The great day has dawned—darkness is dispelled. I have seen the New Man; in this night he was brought to birth!"[162]

Suicide is also valued in Kaiser's next work, *From Morn to Midnight.* The 1916 play is constructed in "stations," rather than acts, to suggest the Stations of the Cross. The protagonist is a nameless bank teller who absconds with a fortune, leaves his family, wagers heavily, and then realizes that "Money is the most miserable swindle of all frauds!" In this anti-capitalist mood the hero shoots himself; the final stage direction reads: "His groaning rattles like an *Ecce*—his breathing hums like *Homo.*"[163] Here an important aspect of Expressionist social psychology becomes clear: Nietzsche's egoistic and amoral *Uebermensch* has become the post-Nietzschean New Man, universal and spiritual in outlook. The model is no longer Dionysos, in sum, but Christ—that is, the martyr as redeemer, the victim as suffering hero. In no other advanced culture is suicide given this social function; in the midst of World War I, death on the Expressionist stage had become a symbol for society's rebirth.[164]

Rebellion, pacifism, and a vague kind of socialism all appear in Hasenclever's *Antigone* (1917). Generation conflict occurs when Antigone defies King Creon, her prospective father-in-law, by leading the masses against him. Where he would make ruthless war— "Only the strong will conquer the world"—she utters the Jacobin call to revolt: "All men are brethren!" But self-sacrifice also appears. For after Antigone has been executed for her faith in freedom, the king's son—her fiancé—commits suicide at her side and is called "The first man of the new earth." Finally, after Creon resigns his throne, a "humble man of the people" leads the masses to liberty and peace: "The new world dawns."[165]

A pivotal play in the series was Fritz von Unruh's offering, *A Generation* (*Ein Geschlecht,* meaning "a lineage," almost "a racial inheritance"). For if authority is evil and if father-figures have to abdicate or die, then the remaining problems concern motherhood and brotherhood. Von Unruh names his central character, simply, The Mother.

Two of her sons are army prisoners, the one a deserter and the other a criminal whose suicide initiates the dramatic action. The heroine calls upon all mothers everywhere to end "this madness" of war which shatters the "edifice of mankind that we created." Writing in 1917, von Unruh sees the central issue no longer as enmity between generations but rather as the mystery of regeneration. Thus the Mother "snatches the staff of office" from a commander and praises the womb from which the renewed race will grow:

> O mother-womb, o womb so wildly cursed,
> and deepest source of all atrocities,
> thou shalt become the core of the universe
> and from thy ecstasy create a race
> that wields the staff more gloriously than they![166]

Though the Mother is killed, her Youngest Son takes up the staff and leads the soldiers to insurrection and peace.

In Ernst Toller's 1917–18 drama *Transfiguration* there are also visions of regenerated society in which the New Man is called "youth" and "brother"—but here regeneration is also called "revolution":

> Now born out of the world's womb I see
> The great cathedral of mankind arise;
> Through doors flung wide
> The youth of every nation marches singing
> Towards a crystal shrine.
>
> Brothers, stretch out your tortured hands,
> With cries of radiant, ringing joy!
> Stride freely through our liberated land
> With cries of Revolution, Revolution![167]

Constructed once again in "stations" instead of acts, *Transfiguration* makes clear that revolution is a spiritual, rather than a political, process: "Perhaps through crucifixion only / Liberation comes."[168]

Kaiser further explores the subject of Expressionist revolution in *Gas I,* the play which first describes post-industrial man. Kaiser's hero, The Billionaire's Son, is a transitional figure between the old capitalist era and the new utopian one. After his gas factory explodes, he urges the workers to forget modern industry and resettle the land: "Tomorrow you shall be free human beings—in all their fulness and unity! Pastures broad and green shall be your new domains. The settlement shall cover the ashes and the wreckage which now cover the land. You are dismissed from bondage and from profit-making. You are settlers—with only simple needs and with the highest rewards—you are men—Men!" But his opponent, the Engineer, wants the workers to return to industry: "You must go back to the works. . . . *You* give speed to the trains which go thundering your triumphs over bridges which *you* rivet. *You* launch leviathans upon the seas, and *you* divide the seas into tracks which your compasses decree! You build steep and trembling towers into the air, which goes singing about the antennae from which the sparks speak to all the world!" As Walter H. Sokel has observed, "In the brilliant dialectics of the debate

between Engineer and Billionaire's Son, two visions of human destiny clash—the technocrat's vision of limitless power through industrial specialization and the Expressionist's vision of happiness through simple spontaneous creativeness."[169]

But the two visions cannot be so neatly divided, for *both* advocates are Expressionist spokesmen. For one thing, the Engineer's views are presented positively. They mark what Herman Scheffauer has called "the expression, the efflorescence of the American spirit": "If we place our ears against the latticework of these metallic lines, we shall hear the hum, the vibrations of the engine that drives our epoch onward."[170] For another, the Billionaire's Son starts out by sharing factory profits with his workers—which is hardly an anti-industrial position. Moreover, although he is the hero of this play, the protagonist does not save mankind. He dies in the act of prophesying the New Man, who will appear in the postwar *Gas II,* and it is his daughter who ends *Gas I* by promising that "I will give him birth."[171]

Gas I is a great Expressionist drama because of this fundamental ambiguity. There is major ambivalence here—between capitalist and socialist prophecies, between visions of industrial and post-industrial utopias. It is also an extremely topical drama. Rushing his play to the stage in the very month of the armistice, Kaiser raised the chief issue to be faced by Germany's newly formed socialist republic.

The fact of the matter was that in November 1918, once Wilhelm II had abdicated, no one was in control. No group could predict events—neither the Majority (government) Socialists, the Independent (left-wing) Socialists, nor the Communist (Spartacist) party:

> In the end it was the masses themselves who decided when to come out and what form the revolution should take. The morning of 9 November saw processions of factory workers, some armed, streaming from the suburbs into central Berlin, where they were joined by soldiers on foot and in armored cars and took possession of the public buildings, on which they planted large red flags. The ease with which the capital of the Empire fell, practically without bloodshed, into the hands of workers and soldiers, who proceeded to set up their councils in factories and barracks, made a great impression on observers. . . . Power lay with the left. What would the left do with it?[172]

As it happened, the German republic was proclaimed by a Majority Socialist minister to forestall the proclamation of a Soviet republic by the Spartacist leader. But on 10 November the Socialist President Friedrich Ebert received a telephone call from General Wilhelm Groener, offering support for the republican regime on condition that the army officer's corps and power of command be preserved intact. Ebert accepted, effectively siding not with the soldiers' and workers' councils but with the army leaders and their soon-to-be-established "volunteer units" (*Freikorps*). The secret arrangement assured the salvation of the army from decimation by its own men, the establishment of a Weimar Republic that was "socialist" in name only, and, simultaneously, the premature end of that Expressionist dream link-ing *Geist* and *Tat.* Power was not allied with "spirit," but with authoritarian institutions of the state.

The next six months were precarious. The fragile coalition on the left would not last, the reactionary forces on the right would not wait:

> Rosa Luxemburg and Karl Liebknecht, the leaders of the Spartacist movement, were murdered on January 15, 1919; Kurt Eisner, Prime Minister of Bavaria, was murdered by an aristocratic student on February 21, and the Bavarian Soviet Republic which came out of the assassination was brutally put down by regular and *Freikorps* troops toward the end of April and the beginning of May. And these events could only exacerbate fratricidal hostilities: the Spartacists denounced the governing Socialists as pliant, socially ambitious butchers; the government Socialists accused the Spartacists of being Russian agents.[173]

Instead of the Expressionist fantasies of parricide and suicide, the real social danger in Germany during 1918–19 was fratricide.

Ernst Toller headed the Independent Socialists in Munich; for ten spring days in 1919, he was an officer of the Bavarian Soviet Republic: "Toller became military commander defending the northern suburbs, towards Dachau, but by his own account refused either to shell that town as ordered by the Communists or to shoot five White officers who were made prisoner when he nonetheless took it. After some ten days he resigned. This did not stop him from being arrested once [General von] Epp's troops had entered Munich, and sentenced to five years' imprisonment for high treason".[174] Toller's greatest Expressionist drama, *Man and the Masses,* was therefore not only written in prison; it was written from direct experience.

Toller goes beyond Kaiser in accepting the inevitability of the factory. Even The Woman, the Expressionist advocate, admits it: "For, see—this is the twentieth century. / We must realize / The factory cannot be wiped out. . . . The soul of man must master factories." *Man and the Masses* also goes beyond *Gas I* in topicality. Rather than contrasting capitalism with some vaguely socialist utopia, Toller opposes Expressionism and communism. In Sokel's summary, "The Woman and The Nameless One propose conflicting methods of revolution. The Woman wants the bloodless general strike which would force the capitalists to put an end to the war. The Nameless One wants a violent uprising to install the revolutionary clique in power."[175]

From another viewpoint, however, The Woman is really a transitional figure between the faceless communist leader and her husband, The Man, who has worked for the capitalist, war-making state. She is thus a champion of pacifism against two kinds of militarism— the capitalist *and* the communist kinds. She accuses the state: "Who built the torture of your golden mills / That grind out profit day by day?"; "Who sacrificed a million human lives / Upon the altars of some desperate game?" And she accuses the masses: "Madmen, drunk with battle! / I stay your arms"; "You shot half of your prisoners! / That was not self-defense. / Blind rage, not service to the cause."[176] **159**

Rather than letting a single man die, The Woman accepts her own death; she is once more a prophet of the New Man, not the champion of any revolutionary party.

Both Kaiser and Toller were apparently drawn more to prewar American thought than to post-1917 Russian doctrine. It is likely, in fact, that both had read a 1910 book published by the "individualist" H. L. Mencken and the "socialist" Robert Rives La Monte, titled *Men versus The Man.* In this published correspondence, Mencken argued that "the cosmic process" proves that "the millionaire . . . is inevitable—at least in our present stage of progress," but that "the idea of truth-seeking will one day take the place of money-making."[177] Kaiser may well have named his hero The Billionaire's Son to suggest Mencken's post-Nietzschean prophecy.[178] Meanwhile, Toller's *Masse-Mensch,* literally "*Masses-Man,*" picks up both La Monte's title and La Monte's post-Nietzschean view that human evolution favored spiritual rather than material progress. Future society would create "better manners, more worthy fiction, higher art and nobler drama"; the future *Uebermensch* would be Pasteur rather than Rockefeller.[179] Of course, thanks to events of the intervening decade, Toller's socialism has become considerably less starry-eyed than La Monte's.

As late as 1919, then, major Expressionist drama showed a link to prewar social thought; its post-industrial stance was rooted in a post-Nietzschean dynamic. Toller's *Man and the Masses,* for all its real involvement with proletarian issues, opposed a communist politics of power with a continuing Expressionist politics of spirit:

> Listen: no man has the right to kill another
> To forward any cause;
> And any cause demanding it is damned!
> Whoever, in its name, calls for the blood of man
> Is Moloch.
> So God was Moloch.
> State was Moloch.
> And the Masses,
> Moloch.[180]

By cutting himself off from the nationalist God, the capitalist state, and the proletarian masses, the Expressionist New Man was bound to exist without a class or country, without a fixed identity.[181]

Even in its social psychology, Expressionism was reactive; in an age of collective material values, it upheld the individual spirit—but never *initiated* an individualist position of its own. When the enemy was authority the hero was youth. When the enemy was Holy War the hero was the secular suicide, yet when the enemy was Mammon the hero was Christ. Still, when the enemy was capitalism the hero was socialism. And when the enemy was the masses the hero was man.

These are some of the events which helped create large audiences for Expressionist drama and which helped precipitate the new wave of Expressionist art itself. Before turning to that development, however, we must first mention an emerging schism within the German Expressionist movement. It too occurred during the 1916–19 period.

This was another kind of revolutionary "theater." To be sure, its political weapon was satire rather than spirit. Its arena was the cabaret or club rather than the traditional stage. And its actors chose to identify themselves by the absurdist term "Dada" rather than as Expressionists. Nevertheless, Dada must be seen as a protest by younger men and women against an Expressionist movement already a decade old. The rebellion of youth against established art, by now traditional in Germany (see sec. 4.1), was novel only in that the youths themselves were mostly former Expressionists. Indeed, Paul Raabe has demonstrated, for Germany at least, "how deeply anchored Dadaism is in so-called Expressionism."[182]

In an early Dadaist manifesto, read in Zurich, Switzerland, in July 1916, Hugo Ball took the Expressionist issue of pacifism and made it seem absurd: "Dada world war without end, Dada revolution without beginning, Dada, you friends and also poets, esteemed sirs, manufacturers and evangelists." And in the first Dadaist manifesto in Germany, read in Berlin in April 1918, Richard Huelsenbeck branded Expressionism as the enemy: "Have the Expressionists fulfilled our expectations of an art that burns the essence of life into our flesh? No! No! No! . . . The stages are filling up with kings, poets and Faustian characters of all sorts; the theory of a melioristic philosophy, the psychological naiveté of which is highly significant for a critical understanding of Expressionism, runs ghostlike through the minds of men who never act."[183] Nevertheless, such efforts at negation prove how central Expressionism was for Dadaists. The new direction originated largely within the old.

Zurich Dada had been formed in February 1916 by the founders of the Cabaret Voltaire: Ball, Huelsenbeck, Emmy Hennings, and Hans Arp from Germany, Tristan Tzara and Marcel Janco from Romania. Arp described a cabaret evening as follows: "The audience are shouting, laughing and clapping their hands above their heads. To which we reply with sighs of love, belches, poems, with the 'moo, moo' and 'miaow, miaow' of medieval Bruitists. Tzara is waggling his bottom like an Eastern dancer's belly, Janco is playing on an invisible violin and bowing to the crowd. Frau Hennings with the face of a Madonna is doing the splits. Huelsenbeck is banging the drum nonstop while Ball, as white as a ghost, accompanies him at the piano. We were given the honorable title of Nihilists." Huelsenbeck carried this manic pitch into his 1918 manifesto, read at the Club Dada in Berlin: "Yea-saying, nay-saying, the powerful hocus-pocus of existence blows the mind of the true Dadaist: and so he lies around, pursues the hunt and rides a bicycle—half Pantagruel, half St. Francis—and he laughs and laughs."[184] Such high jinks admittedly masked one serious purpose: the invention of "automatic" drawing. Arp made the pioneer experiments in 1916 and his close friend Max Ernst soon followed; Dada automatism eventually influenced Surrealist automatism in postwar France. Meanwhile Arp, a Zurich Expressionist since early in 1912, and Ernst, a Rhineland Expressionist since the summer of 1913, now left the German movement for good.

Ball's situation was similar. A prewar resident of Munich, he had shared the Blaue Reiter's interest in primitivism. He not only praised

the cabaret masks Janco had created (see fig. 158),[185] but he also insisted on the importance of childhood for artistic expression: "Childhood as a new world: all the directness of childhood, all its fantastic and symbolic aspects, against senilities and the adult world. . . . Childhood is nowhere near as self-evident as is generally believed. It is a world that is hardly noticed, a world with its own laws. No art can exist without the application of these laws, and no art can exist and be accepted without their religious and philosophical recognition."[186] These are the words of a believer, not of a nihilist; of a "St. Francis" rather than a "Pantagruel." Moreover, Ball lectured on Kandinsky and presented a Kokoschka play at the Dada Gallery in April 1917. And like another exponent of Expressionist theater, Reinhard Sorge, he converted to Catholicism a few years after his initial artistic breakthrough.

Huelsenbeck's Dadaist sensibility also has Expressionist aspects. The opening argument of his manifesto, for example, is quite familiar: "Art in its execution and direction is dependent upon the time in which it lives, and artists are creatures of their epoch. The highest art will be that which in its conscious content presents the thousandfold problems of the day."[187] This is precisely the call for timeliness that *Kriegszeit* had demanded of Expressionist artists in December 1914 (see sec. 4.5). But Huelsenbeck was premature in calling Expressionist playwrights "men who never act," men who find "their easy-chair more important than the noise of the street." This hardly applies to the Toller of 1918–19! Indeed, wartime Expressionist prints (cf. fig. 156) inaugurated the tradition of social concerns that Dadaists later continued.

Similarly seamless is Grosz's transition, around 1918–19, from Expressionism to Dada. The earlier Futurist interests in dynamism and violence continue in *Jack the Ripper* from 1918 (fig. 157). But here the thematic source is Frank Wedekind's 1913 *Lulu*—an amalgam of plays from 1895 and 1902—which was performed in Berlin in 1918. Wedekind's drama closes with Lulu's murder by the notorious British criminal, and we may be sure that there is here once again, as in Grosz's name-change and his *Golddigger* of 1916 (fig. 147), an identification with an enemy or aggressor. Accordingly, the protagonist of *Jack the Ripper* is both a sadistic English murderer and, at some level, Grosz himself.

Even as a child, Grosz recalls in his autobiography, he had been fascinated by violent panorama-pictures viewed at country fairs and sporting matches. One showed a fire in a Paris subway where "the figures looked like burnt matchsticks," and another the eruption of Mt. Pélé where one could see "people . . . spiraling in the whirlwind, houses flung into the air, the ocean boiling as the ships and the sails burned." But in answer to the query, "why should all this have taken such hold upon me in particular?," Grosz could only come up with the further question: "How many different kinds of people dwell within us? One on top, one in the middle and one on the bottom—perhaps also one confined somewhere in a closed closet."[188] This is as close as Grosz came to admitting the violent *doppelgänger* in his own personality.

Grosz's identity confusion explains the effectiveness of his Dadaist social criticism: he was uniquely able to project himself into, or empathize with, the butt of his satire. This process can be demonstrated by comparing Grosz's *Republican Automatons* (1920) with its source, a photograph of Hugo Ball in costume reading sound poems (figs. 159, 158). The automatons are, of course, bourgeois patriots cranking out their loyalty to the state—the very citizens whose middle-class conformity smothered Grosz's hopes for a communist revolution.[189] Yet the bowler-hatted figure with face stamped "12" is but a paraphrase for Grosz's fellow conspirator Ball, who wears a top hat and mask stamped "13." In this Dadaist context even the hated burgher is made to look a little comical, somewhat like a Charlie Chaplin film character. Thus Grosz secretly identifies, and makes the observer identify, with the object of his parody. The entire process remains, in principle, an Expressionist one.

4.7. THE "NEW MAN" IN ART: HIS RISE AND FALL

During the winter of 1917–18 Corporal Heinrich Vogeler, formerly a regionalist painter at Worpswede, became a convert to communism. At home on furlough, he read pamphlets distributed by striking Spartacist workers which described the decision by Soviet Russia to nationalize agriculture and industry. Recalling his own prewar efforts to establish craft studios, which were always unprofitable, Vogeler was struck by the notion of nationalizing *artistic* means of production. So taken was he by this idea that he wrote a letter to Kaiser Wilhelm II, protesting Germany's harsh demands on Russia in the Brest-Litovsk peace negotiations: "After three days the corporal . . . was arrested and committed to an asylum. There he was a calm and quiet guest and soon he began to work and express himself artistically. He made a sketch for an etching *Der Zusammenbruch* ["The Collapse"]. It was not without mysticism: rising flares light up the misery of war and then change themselves into the seven vials of God's wrath from Revelations. This work with its hard, sharp, abstract forms had all the characteristics of Expressionism. The director of the asylum refused to permit him to work any more, explaining: 'You are here in order to relax!' "[190] The words are Vogeler's own. The etching he describes was later called *Inferno,* and included in a series titled *Birth of the New Man.* The final etching in the series, executed in 1921–22, was titled *Becoming* (fig. 160). It graphically depicts the transformation of an apocalyptic horseman into a winged and haloed infant, of death into rebirth.

A similar transformation is effected in the art of Constantin von Mitschke-Collande, a founding member of the Dresden Secession "1919 Group" and another Expressionist convert to the German Communist party. Mitschke-Collande's best-known works are his woodcut illustrations to Walther Georg Hartmann's 1919 novel, *The Inspired Way.* Here a young soldier, radicalized by revolutionary slogans, dies on the barricades with red flag in hand. As a ghost he reappears to accuse *Freikorps* soldiers of murdering the red leader, and to enlist one of them in the Expressionist cause of awakened

161

157. George Grosz, *Jack the Ripper*, oil on canvas, 1918. Hamburger
Kunsthalle.

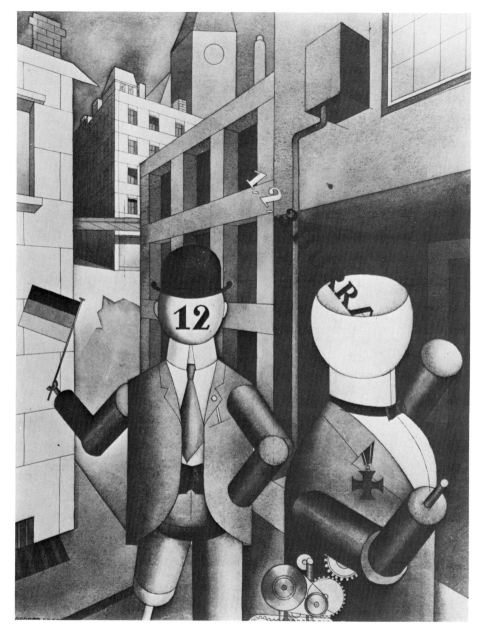

158. (right) Hugo Ball in costume reading sound poems, Cabaret Voltaire, Zurich, 1916.

159. (left) George Grosz, *Republican Automatons,* watercolor, 1920. Collection, The Museum of Modern Art, New York. Advisory Committee Fund.

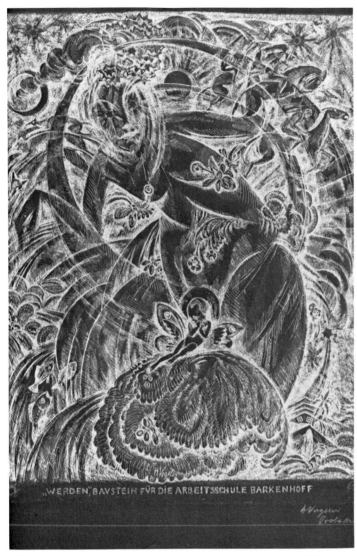

160. Heinrich Vogeler, *Becoming,* etching from the series *Birth of the New Man,* 1921–22.

161. Conrad Felixmüller, *People above the World,* lithograph, 1919. Los Angeles County Museum of Art.

consciousness and love. Finally, in the woodcut titled *The Time is Ripe* (fig. 110), the dead soldier is redeemed by the renewed dedication of his comrades. As Ida Katherine Rigby summarizes this climax to the woodcut cycle: "The ecstatic ghost rises up, freed, and ascends to heaven against a golden western sun."[191]

A similarly magical apotheosis is effected in another 1919 print by the twenty-two-year-old Conrad Felixmüller, also a founder of the 1919 Group and a Communist party member as well.[192] Felixmüller's lithograph of the martyred Karl Liebknecht and Rosa Luxemburg, published in Berlin's *Aktion* magazine, was captioned *People above*

the World (fig. 161). Where even Expressionist journals accused the Socialist government of the Liebknecht-Luxemburg "multiple murders,"[193] Felixmüller mythologizes the martyrs. Their cramped bodies float above city roofs and their tensed hands reach for a star. Rather than recalling the politics of their lives or the brutality of their deaths, the Expressionist idealizes their memory.

The Communist journal *Die rote Fahne* had reported the murders with the grim remark that "the Golgotha Way of the German working class is not ended."[194] In a similar spirit Käthe Kollwitz, in a woodcut *Commemorative Print for Karl Liebknecht* (1920),[195] depicted the bowed heads and rough hands of workers at the bier. A believer in neither Communism nor Expressionism at this time, Kollwitz still ap-

proached both in feeling: "My art is not, of course, pure art in the sense that Schmidt-Rottluff's is, but it is art nonetheless. . . . As an artist, I have the right to distill the emotional content out of everything and anything, to let that content take effect on me, and then to give outward expression to it. I also have the right to depict the workers' leave-taking from Liebknecht, indeed, the right to dedicate this work to the proletariat, without identifying myself with Liebknecht's political views. Or do I not?"[196] Kollwitz's wish to express the scene's "emotional content" is at least implicitly Expressionist.

More explicit in their Expressionism were Kollwitz's seven *War* woodcuts from 1924, especially the second one carved in 1922–23, *The Volunteers* (fig. 162). Recording the wartime death of her oldest son Peter, the woodcut nevertheless universalizes its anti-war message. For it depicts the volunteers as marching to the step of skull-faced death, the drummer, extreme left. Where Kollwitz's postwar prints differ from those of avowed Expressionists is in their unrelieved pessimism. Indeed, in transposing a revolutionary poem of 1848 into an inscription for the *Liebknecht* woodcut, Kollwitz's message was "From the living to the Dead."[197]

Not death but rebirth was the governing metaphor, however, for the first Expressionist images of the new Weimar Republic. We have seen this in the work of Vogeler and of Mitschke-Collande, and we see it as well in the Novembergruppe's autumn 1919 publication titled *To All Artists!* The well-known cover illustration by Max Pechstein depicts a man in flames who holds his pulsing heart, thus confirming both his sympathy for artists and his ability to survive. But an even more specific image is a drawing in the same pamphlet by Cesar Klein, entitled *The New Bird Phoenix* (fig. 163). Here the Expressionist New Man, arising from the flames of a burning city, is borne by the phoenix upward to sun, moon, and stars.

Yet another variation on the theme was provided by Pechstein's election poster from January 1919 entitled *The National Assembly: Foundation Stone for the German Socialist Republic*.[198] Here the republic is seen as a building-to-be, with democratic elections its cornerstone; the mason erecting this structure, silhouetted against a dawning sun, is the reborn hero—namely, the German worker.[199] In another government poster entitled *Don't Strangle the Young Freedom* (fig. 164), Pechstein goes one step further and depicts German

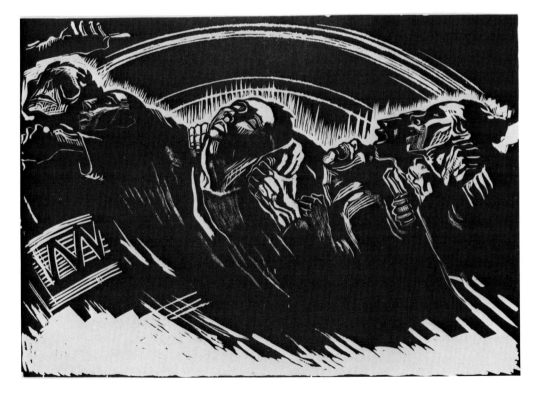

162. Käthe Kollwitz, *The Volunteers*, woodcut, 1922–23. The Los Angeles County Museum of Art: The Robert Gore Rifkind Center for German Expressionist Studies.

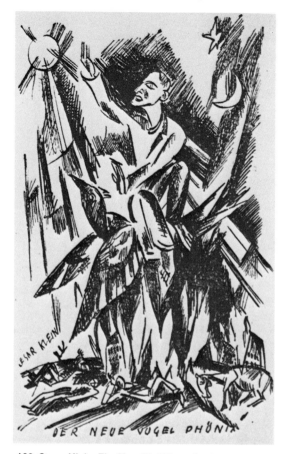

163. Cesar Klein, *The New Bird Phoenix*, drawing, 1919. Collection Rudolf Pfefferkorn, Düsseldorf.

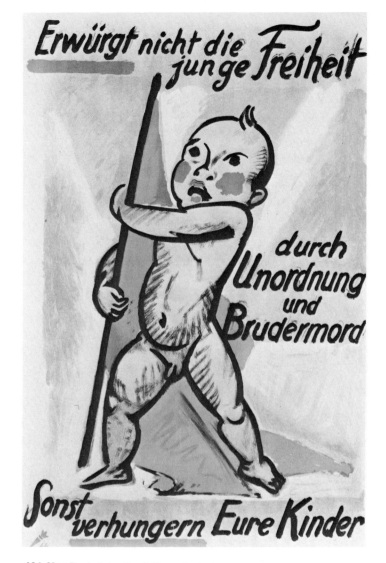

164. Max Pechstein, *Don't Strangle the Young Freedom*, color lithograph poster, ca. 1919. The Robert Gore Rifkind Collection, Beverly Hills, California.

freedom itself as a red-cheeked baby holding a flag. Now it is the German state that is born again. Pechstein's caption gives stern warning that freedom can be strangled "through disorder and fratricide" and that, should this happen, "your children shall starve." By a clever manipulation of the child image and the word "children," the Expressionist manages to concretize the danger to the abstraction of freedom as a real threat to the health of every German infant.

As sudden as was the flowering of rebirth imagery, just as sudden was its demise. It rarely appears after 1920, and the causes for this must be examined. First, there was the schism on the left which fractured Expressionist solidarity. Right from the start the German industrial worker, the Expressionist candidate for the role of "new man," turned his back on the vanguard art forms of Expressionist posters. As early as July 1919 a perceptive observer commented that the new art's "pointed, sharp representations" were perceived by workers as "caricature" and were "suspected of representing a lack

of respect and esteem." Within a few years, the Communist party line was vigorously opposed to all non-realist art. Thus the Soviet critic Fedorov-Davydov was hostile to a German Expressionist exhibition shown in Russia in 1924–25: "Is this truly the art of the revolutionary proletariat? Horrors, nightmares, fever dreams on all sides. It may be that contemporary German reality is like this, but must the revolutionary agitation of art be so? . . . What do these convulsive and oppressed souls, these sick, perverted psyches have to do with positive

subjects: the working class, the revolution?"[200] It would be only a few more years before a similar response to Expressionist art would dominate Nazi criticism as well.

By March 1920 Expressionists and Communists attacked one another; their world views had become irreconcilable. Thus, after the Kapp Putsch, when a painting in Dresden's Zwinger Museum was damaged as a result of streetfighting between workers and police, Oskar Kokoschka published a manifesto demanding that all parties, "whether of the left-, right-, or middle-radical," avoid shooting near museums so that art works, as Germany's "most sacred possessions," would not be needlessly sacrificed. To this George Grosz and John Heartfield responded with a countermanifesto called "The Artist as Scab." In Beth Irwin Lewis' summary: "They were particularly infuriated by his reference to works of art as the *heiligsten Güter* . . . of the German people. This, to them, was the essence of the whole bourgeois swindle which manipulated art and culture in order to stupefy the masses and to keep them tractable. . . . By appealing to the Dresdeners to place more importance upon the preservation of their art works than upon political battles, Kokoschka, they claimed, was trying to swindle the proletariat, dampen its revolutionary ardor, trick it into losing its class consciousness."[201] Just as Weimar was revealed as a bourgeois republic, so Expressionism stood accused of being a bourgeois art.[202]

A second factor dampening Expressionist enthusiasms was the presence of the movement's abstractionist wing, averse to social involvement. The key figure here was Herwarth Walden, impresario for Berlin's Sturm Gallery and journal, who had championed aesthetically advanced art styles since 1912. With the death or emigration of the early Blaue Reiter pioneers, however, Walden in 1916 began to feature such second generation abstractionists as Heinrich Campendonk and Paul Klee (figs. 105, 115), and such younger converts to Orphist/Cubist abstraction as Georg Muche and Maria Uhden.[203] None of these was politically active. Moreover, Walter Gropius favored this group in appointing Klee and Muche, along with Feininger and, later, Kandinsky to the Bauhaus staff.[204]

Furthermore, Expressionist aestheticism came to be associated, however wrongly, not with German but with Jewish artists. While Campendonk was known as the "German Rousseau," for example, it was actually Marc Chagall's *Animal Trader* (1912), available at the Sturm Gallery since the spring of 1914, that helped shape Campendonk's post-1915 style. Chagall's unique blend of primitive naiveté and vanguard abstraction was influential for many Sturm artists; Muche even dedicated a 1917 drawing to Chagall.[205] Given the prewar tendency to see Impressionism as a French style foisted on Germans by Jews (in that case, Liebermann and Cassirer), a postwar myth emerged which equated Expressionism with the internationally oriented Jews, Walden and Chagall (see secs. 3.5, 4.1).

It was an accident of history that dozens of Chagall's prewar works, shown by Walden in June 1914, remained in Berlin while the artist lived in Russia during the war—returning to Paris only in 1919. During the intervening years Walden had no qualms about displaying Chagall's art not only as French Cubism but also as Slavic Expressionism.[206] After Meidner, in fact, Chagall became the chief Jewish Expressionist in many German minds. As the poet Ludwig Rubiner wrote to Chagall, just after the war: "Do you realize you are famous here? Your pictures have introduced a new genre: Expressionism. They're selling for high prices. Just the same, don't count on the money Walden owes you. He won't pay you, for he maintains that glory is enough for you!" By 1929 Ernst Cohn-Wiener, in a book on *Jewish Art,* could praise Expressionism as the exemplary art for non-assimilated Jews. "As paradoxical, as apparently superficial as it sounds," Cohn-Wiener wrote, "it is still absolutely certain: Impressionism is the art of the assimilated; but a consciously Jewish art lives in Expressionism. . . . [I speak of Meidner, Steinhardt, Chagall,] of those who have given to Expressionism a characteristically Jewish form, which is perhaps really the seed-corn for a Jewish style." To be sure, Expressionism had long attracted Jewish interest. Kokoschka considered Jews enlightened patrons; they were "more open to the new, and more sensitive to . . . the decay of the old order in Austria." And the poet Gottfried Benn praised Berlin Jewry for "its international connections, its sensitive restlessness, and above all its dead-certain instinct for quality."[207]

But Expressionism's Jewish connection was vastly exaggerated; confirming a Jewish interest in Expressionism is hardly the same as saying, as did the Nazis in the 1930s, that Expressionism *was* Jewish. As Peter Gay has observed, "There were probably more Jews around Stefan George . . . than there were Jews among the Expressionist poets." And no major Expressionist painter was Jewish except Meidner. Karl Hofer was correct when he stated to a Nazi official in 1933: "Next to the army no field was as *judenrein*"—free of Jews—"as the visual arts."[208]

Yet a third factor in Expressionism's demise was, of course, its freewheeling utopianism in an age of conservative reaction. As early as 1919 Emil Nolde found it difficult to orient himself in a democratic republic. "I'm really helpless in political matters," he wrote. "Often I don't know myself whether I should vote German-National or left, that is, Socialist. Sometimes I believe firmly in the state, as a good burgher should. But sometimes I think that it would be good if it were dissolved. These doubts torment me frequently." And as late as 1922 Lovis Corinth still could not reconcile himself to the loss of the Hohenzollern Empire—which he had experienced as "the only greatness"; with the end of imperial rule he felt "the ground pulled out from under my feet." As with these older men, so with the younger artists who were potential Expressionist recruits: a loss of fixed public allegiance raised the risk of private identity confusion. As Erik Erikson later put it: "Germany's defeat and the Treaty of Versailles resulted in a widespread traumatic identity loss, especially in German youth, and thus in a historical identity confusion conducive to a state of national delinquency—under the leadership of a gang of overgrown adolescents of criminal make-up."[209]

Given its utopian aspirations, in fact, Expressionism was doomed as a movement at precisely the moment when the Weimar Republic

was stabilized as a bourgeois democracy. This began in 1920. In November of that year, Wilhelm Worringer suggested that Expressionist dreams were now history: "Agitated revelations, visionary flashes of light have been handsomely framed, declared permanent, and degraded to peaceful war decorations." Also in that year the poet Iwan Goll wrote his essay titled "Expressionism Is Dying." "Expressionism was a fine, good, grand thing," Goll wrote. "But the result is, alas, and through no fault of the Expressionists, the German republic of 1920." As John Willett has demonstrated, the number of German-language Expressionist periodicals declined from forty-four at the end of 1919 to twenty-two at the end of 1920; by 1921 and 1922 the end-of-year numbers were fifteen and eight, respectively.[210]

The year 1920 was one not of revolution but of counterrevolution. The Kapp Putsch in mid-March demonstrated the powerlessness of the Weimar regime against internal subversion by any bureaucrat able to muster rightist army support.[211] After a general strike by the trade unions ended the threat, moreover, the conspirators got off lightly. The putsch not only served as model for Benito Mussolini's more successful march on Rome in October 1922, but it also presaged other right-wing attacks in Germany. These included: (1) the murder on 29 August 1921 of Matthias Erzberger, leader of the Catholic Center party in the government coalition; (2) the assassination on 24 June 1922 of Walter Rathenau, Germany's Jewish foreign minister, who had just negotiated the Rapallo Treaty with Soviet Russia; and (3) the Beer Hall Putsch in Munich on 8–9 November 1923, in which Adolf Hitler tried and failed to seize power for his National Socialist party. The Rathenau murderers were killed or jailed, but the Erzberger assassins fled to Hungary and were not extradited, and Hitler served nine months of a five-year sentence.

Although the utopian New Man was extinct after 1920, Expressionist art was not. For as Germany's international situation worsened in the next few years, Expressionists responded with a new round of social criticism. It must be remembered that the Versailles Treaty contained "war guilt" and "war crime" paragraphs which were used to justify Allied occupation of the Saar valley and the Rhineland for fifteen years, and reparations in cash and in kind. In May 1921, after the reparations debt had been fixed at 132 billion gold marks, Germany was told to accept the figure unconditionally within six days, or else risk occupation of the Ruhr. Germany did accept, but in order to make the initial payment, the government had to sell marks on foreign exchanges, and the value of the mark fell 80 percent between May and September. A year later, unable to pay on time, Germany requested a moratorium; the Allies were divided, and the French occupied the Ruhr in January 1923. France now controlled more territory of peacetime Germany than Germany had won in wartime France.

In what was its finest hour, the German government responded not with guns but with a declaration of passive resistance. French orders were disobeyed; miners and railroad workers went on strike peacefully. When French troops fired on strikers in Essen, thirteen Germans were killed and fifty-two wounded. The mines and trains were manned by French workers, but the German government had to provide for the workless and the homeless, while replacing the missing Ruhr coal with foreign imports: by mid-1923 passive resistance was costing the government 40 million gold marks a day. The German mark plummeted on the exchange, from a rate of 10,000 marks to the dollar at the start of the occupation to 4.6 million in August. That month there was a general strike, and German Communists planned a workers' revolution for early November, which aborted, while Hitler's fascist putsch was crushed. Two weeks later, on 20 November 1923, the mark fell to the rate of 4.2 trillion to the dollar. It cost two hundred billion marks to buy a newspaper. A woman who accidentally left a basketful of banknotes outside a shop returned to find that the notes were still there. But the basket was stolen.[212]

Against this background, Expressionist art activity increased dramatically. In 1922 and 1923 Kollwitz completed her Seven Woodcuts on War (fig. 162) and Dix evolved his fifty-etching cycle, The War; both series were first published in 1924 after inflation had been brought under control.[213] Also in 1924 came such Kollwitz lithographs as German Children Are Starving and No More War!, evoking an earlier Expressionist tradition of pacifism and humanitarianism.[214] But there were more militant works from 1922–23 as well, including Grosz's White General and Hitler the Savior (fig. 171). Perhaps the most topical social comment was provided in Dix's Venus of the Capitalistic Age (fig. 167). Like Kirchner's Standing Nude with Hat (1910), Dix's painting, too, was modelled on Cranach's Venus (1532) in Frankfurt (figs. 166, 165). But where the Brücke work had been content to contrast European and primitive modes of eroticism (the rondels in the studio drapes depict coupling nudes), Dix's icon converts an aristocratic lady into a democratic whore. Extending Kirchner's 1913 metaphor of prostitute as capitalist commodity (fig. 134, plate 20), Dix's bourgeois Venus has now become, herself, the grasping, capitalist predator. The staring eyes, the bared teeth and twisted lips, the prehensile hands hanging to either side of frankly parted legs—all signify a caricature of materialist Weimar values. The image is particularly ironic, of course, in confirming the failure of Expressionism's earlier post-capitalist and post-industrial ideals.

4.8. TWO INTO ONE: THE SELF

Expressionism ended, as it began, as a movement of antithesis. Expressionists knew with certainty not what they wanted but what they opposed. Their post-industrial aspiration was a protest against the capitalist and mechanistic values of their own industrial era. Just what the post-industrial age would be, however, was never clear. Would it be individualist or collective? International or Germanic? Built on self-sacrifice or self-fulfillment? We can no more answer these questions than we can determine whether Expressionism's Post-Impressionist goal was vitalist or abstract, its post-Victorian impulse secular or spiritual, its post-Nietzschean paradigm destruction or renewal. With Nietzsche, Expressionists sought a countermovement to the nihilism and scientism of their age. But that countermovement was itself para-

dox. Like Zarathustra's bridge, it was both a crossing over and a going under.

The natural condition of Expressionist man, then, was ambivalence. Free to choose between alternatives, he found aspects of both desirable. Free to choose between opposites, he embedded the two in a dialectic. Here Nietzsche was, once again, precept and example. Where science and instinct were concerned, a fusion of the Apollonian and the Dionysian was the goal. Where health and sickness were opposed, ennoblement *through* degeneration was the prescription (see secs. 1.2, 1.5). In this way Expressionist empathy became both self-affirmation and self-alienation, the Expressionist city both stimulus and wasteland, the Expressionist New Man both suicide and prophecy. Dualism in Expressionism, like contradiction in Nietzsche, was fundamental.

This is why it is misleading to attribute to Expressionists, without qualification, a Romantic "quest for unity" or "feeling for the whole."[215] Such a confusion replaces realities of doubt with escape into certainty. One cannot make this substitution in the case of Nietzsche;[216] one ought not do it with Expressionism. When one does so, one falls into the Spenglerian trap of tying Expressionist culture to the abyss of a "Lost Center" or the ideal of a "Third Reich."[217] Critical precision is lost. Neo-Romantic *Wandervögel* are confused with Expressionist *Wilden*; Expressionist "wholeness" merges into fascist "totalism," and dualist ambivalence is converted into a monolithic cult of the irrational.

In terms of social psychology, Expressionist dualism is nowhere better seen than in four German films of 1913–16 discussed by Siegfried Kracauer. These films "anticipated important postwar subjects" of the German cinema—for example, topics of confused identity. That such topics should become an "obsession" of such a mass medium proves that the cinema had struck a major chord of the German psyche, namely, "a deep and fearful concern with the foundations of the self."[218]

In *The Student of Prague* (1913), Paul Wegener introduced the *doppelgänger* theme in the context of a Faustian pact. The student Baldwin is to become wealthy by giving his mirror reflection to a demonic figure; "the double is nothing more," Kracauer notes, "than a projection of one of the two souls inhabiting Baldwin."[219] Paul Lindau's *The Other* (1913) dramatized a case of split personality, a Berlin lawyer named Hallers who frequently awoke from a sleep in his "other" identity, in this case as a burglar's accomplice. In both Wegener's *The Golem* (1915) and Otto Rippert's six-part serial *Homunculus* (1916), artificial humans are created, who—frustrated in love—turn into raging monsters.[220] Whether in the Jekyll-and-Hyde or in the Frankenstein type of scenario, it is obvious that the German hero suffers the Faustian flaw: "Two souls, alas, are dwelling in my breast, / And one is striving to forsake its brother."[221]

Among Expressionist visual artists it was Max Beckmann who most consistently addressed the Expressionist issue of the dualist self. We see this in the two plays Beckmann wrote around 1920: *Ebbi*, published in 1924 and the recently published drama called *The Hotel*. Just as Lindau's Dr. Hallers in *The Other* is a lawyer who commits burglary, so Beckmann's Ebbi is a merchant who participates in a burglary (see sec. 2.6). And just as Baldwin in *The Student of Prague* has a mirror-image double with whom he struggles, so Beckmann's hotel manager Zwerch has a bitter dialogue with his double, called Zwerch II. In the latter dialogue, Zwerch rejects his alter ego: "I know you, you are the first who will betray me." Meanwhile, coming to grips with the problem of good and evil, Zwerch's self-hatred is transformed into a Job-like hatred for God: "Appear to me, Jehova, Moloch, or God, whatever you are called."[222]

Zwerch is both Everyman and monster, burgher and murderer. In this he reflects the contemporary demon-hero of the Expressionist stage and screen. In Robert Wiene's famous *Cabinet of Dr. Caligari* (1919), for example, there are two such characters: the somnambulist Cesare who wants to kill the sleeping heroine but instead, enamored of her beauty, carries her off and finally dies; and Caligari himself, who is both barker for Cesare's act at a local fair and also the unworthy director of a sanitarium who is revealed as killer and madman.[223] According to Kracauer, the film as a whole reveals "the German collective soul . . . wavering between tyranny and chaos": the chaos of the mesmerized individual, the tyranny of the evil authority figure.[224] Among the cinematic tyrants who succeeded Caligari, the protagonist of F. W. Murnau's *Nosferatu* (1922) stands out; like Cesare the somnambulist, Nosferatu the vampire is vanquished by a pure young girl.[225]

On the Expressionist stage there was a hero with similar traits of good and evil, innocence and madness. This was Count Umgeheuer in Paul Kornfeld's 1919 drama *Heaven and Hell;* his very name plays on the word *Ungeheuer* or "monster." Unable to love his wife, he comes to hate himself: "Oh, this ragout of embarrassment and shame! This knowledge: you have beaten others and are beaten yourself! You have made victims and are a victim yourself."[226] Here it is the wife who is a murderess, and the monster a Christ-like sufferer who finally learns to love.

Among Beckmann's prints and drawings of the early 1920s there are similar images of uncertain identity. The first print in the 1921 drypoint series *Annual Fair*, for example, depicts the artist as *The Barker* welcoming the public to "Circus Beckmann"—an assortment of the world's grotesque individuals.[227] In *Carnival* (1920), Beckmann depicts himself as a boy playing at the feet of his friends I. B. Neumann and Fridel Battenberg. The boy's head resembles the artist's, but he wears a vicious animal's mask.[228] And in *Self-Portrait as Clown* (fig. 168), the artist's horn attribute and his right hand extended as if to display stigmata also relate the self-image to Christ's Passion. But the mask in his left hand is that of a steely-eyed burgher with pig-snout nose. In this example, as in the others, Beckmann depicts himself as innocent or sensitive—in a word, as good—while the mask he wears or the role he plays is an aspect of evil.[229]

In *Departure* (fig. 169), good and evil are respectively evoked by the center panel and the two wings of the triptych. According to Beckmann, the painting also addresses "essential realities": "If peo-

ple cannot understand it of their own accord, of their own 'creative sympathy,' there is no sense in showing it. . . . The picture speaks to me of truths impossible for me to put in words and of which I did not ever know before. I can only speak to people who, consciously or unconsciously, already carry within them a similar metaphysical code. Departure, yes departure, from the illusions of life toward the essential realities that lie hidden beyond." "Life" and its illusions appear as evil in the side panels: "Life is torture, pain of every kind— physical and mental—men and women are subjected to it equally." But in the center, "The King and Queen, Man and Woman, . . . have freed themselves of the tortures of life" while the child Freedom, carried by the Woman, is central: "Freedom is the one thing that matters—it is the departure, the new start."[230]

While one can find complex philosophical meanings in *Departure*,[231] the painting can also be taken as a metaphor for what Beckmann called *das Ich* or, in English translation, "the Self." The latter word is properly capitalized to distinguish an immortal identity from a merely lifebound one. In Beckmann's own words from his London lecture of 1938: "One of my problems is to find the Self, which has only one form and is immortal—to find it in animals and men, in the heaven and hell which together form the world in which we live. . . . Self-realization is the urge of all objective spirits. It is this Self for which I am searching in my life and in my art. Art is creative for the sake of realization, not amusement; for transfiguration, not for the sake of play. It is the quest of our Self that drives us along the eternal and never-ending journey we must all take."[232] Beckmann's concept of a single, deathless Self corresponds to Carl Jung's concept of "the Self, as a symbol of wholeness" or, as he put it in 1928, as the "God within us."[233] In the Jungian canon elaborated by Richard Wilhelm in 1929, the Self can also be equated with central concepts of Confucian thought: the *T'ai-chi* as the "undivided One" and the *Tao* as the "right way."[234] Books by Jung and Wilhelm were among the artist's "favorite classics" in his later years.[235]

In this sense, Beckmann's Self is monist rather than dualist, an eternal essence evoking the German Romantic "feeling for the whole" which is post-Expressionist rather than Expressionist in emphasis. Beckmann's monist Self represents the ultimate post-Nietzschean position, namely, a rejection of Nietzsche altogether.[236] In the triptych *Departure,* the central figures of King, Queen, and child all embody the transcendent Self "which has only one form and is immortal."

Nevertheless, Beckmann's monist identity is located in a dualist world, "in the heaven and hell which together form the world in which we live." Elsewhere in his London lecture, Beckmann insists that "there are two worlds: the world of spiritual life and the world of political reality." Just as inner and outer scenes of *Departure* reconcile good and evil, so Beckmann sees God as a unity of opposites, as a fusing of two into one: "All these things come to me in black and white like virtue and crime. Yes, black and white are the two elements which concern me. . . . It is the dream of many to see only the white and truly beautiful, or the black, ugly and destructive. But I cannot

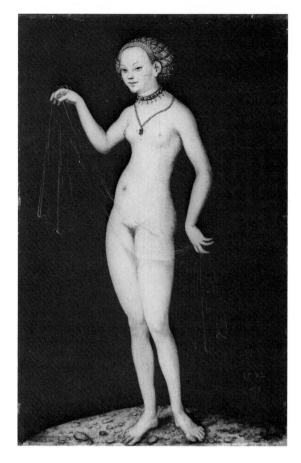

165. (above) Lucas Cranach (elder), *Venus,* 1832. Städelsches Kunstinstitut, Frankfurt.

166. (right) Ernst Ludwig Kirchner, *Standing Nude with Hat,* oil on canvas, 1910. Städelsches Kunstinstitut, Frankfurt.

167. (far right) Otto Dix, *Venus of the Capitalistic Age,* oil on canvas, 1923. Private collection.

help realizing both, for only in the two, only in black and in white, can I see God as a unity creating again and again a great and eternally changing terrestrial drama." Here too the artist follows Jung and Wilhelm; Jung characterizes the Self as "compensation of the conflict between inside and outside," while Wilhelm notes the *Tao*'s constituent aspects of *yang* and *yin,* light and dark.[237]

But Beckmann, like Jung, is also crucially indebted to Goethe. For it is Jung who relates the working of the *Tao,* the alternation of "light and darkness," to a passage from Goethe's *Faust:* "The radiance of Paradise alternates with deep, dreadful night." *Faust* often ad-

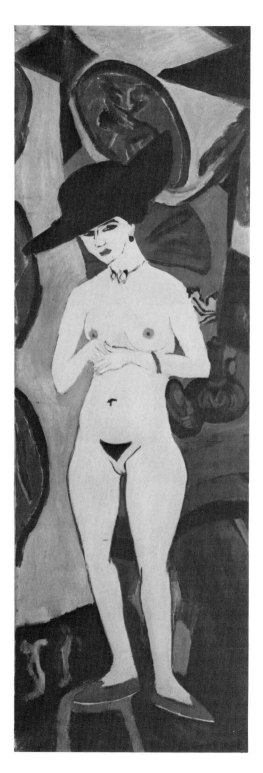

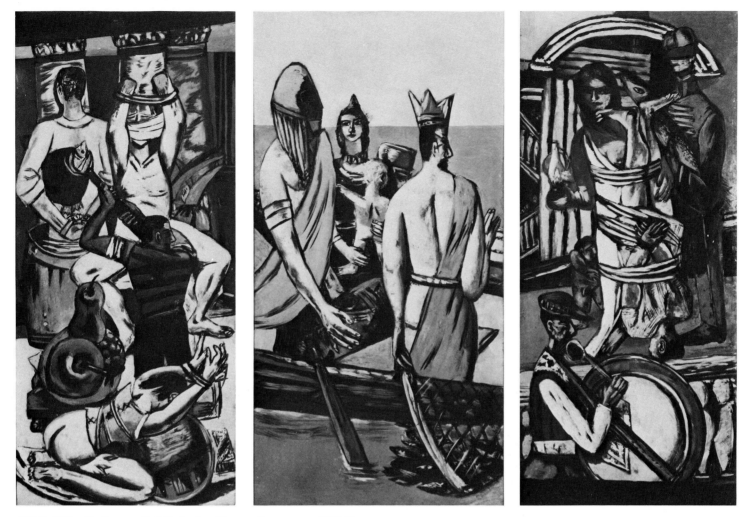

168. (left) Max Beckmann, *Self-Portrait as Clown,* oil on canvas, 1921. Von der Heydt-Museum, Wuppertal.

169. (above) Max Beckmann, *Departure,* triptych, oil on canvas, 1932–33. Collection, Museum of Modern Art, New York.

dresses the paradox of the two and the one; in its "Prologue in Heaven," the Lord welcomes Mephistopheles as a goad to man and, hence, as man's co-creator:

> Of all the spirits which negate,
> The knavish jester gives me least to do.
> For man's activity can easily abate,
> He soon prefers uninterrupted rest;
> To give him this companion hence seems best
> Who roils and must as Devil help create.

Beckmann's concern for the interaction of "black" and "white" evokes Goethe's great praise for the necessity of dualism: "It is contradiction that makes us productive."[238]

Although Beckmann has given up Nietzsche for Goethe, he has managed merely to project the sovereign unity of God onto the metaphysical construct of Self; worldly man can find only other-worldly redemption. In all other respects, Beckmann remains an Expressionist. Throughout the artist's later writings, there are echoes of Faustian "contradiction."[239] Concerning Beckmann's search for a true identity, then, we must admire the pathos of the quest but confirm the intensity of its ambivalence. In the perennial confrontation between good and evil, between the soul and the world, Beckmann continues to see man as a being caught in transit, as a restless wanderer between two quite different shores.

5.
Art Criticism

This is the great secret of pure emotion: that the eternal shines forth in the momentary, the limitless in the restricted, the lawful in the accidental. Only he who conceives art through sensuous feelings can grasp it whole; whoever would master it conceptually will possess it only in its parts.

KARL SCHEFFLER

5.1. ANTI-MIMESIS: ARTISTIC RENEWAL

The word "Expressionism" has meant rather different things at different times to different people. The first critics defined Expressionism in terms of French art; art historians until recently focused on the German prewar movement; literary historians saw a direction centered in the German war generation; later observers found Expressionist tendencies in Europe and America since World Wars I and II. There are, in short, a number of Expressionisms to be accounted for. All that is certain is that the label does *not apply* to the bodies of art for which it was first invented.

This is because it was originally used antithetically and retroactively. In the earliest sense, "Expressionism" connoted anti-Impressionism; the first Expressionists were the French Post-Impressionists from Cézanne to Matisse. Almost immediately, however, it came to mean anti-mimesis in general. Expressionists were those who were faithful to inner feeling, not outer appearance, and thus included the entire Symbolist generation from Gauguin to Munch and from Van Gogh to Hodler. In this international sense, outer representation had to serve inner expression, and German artists were, understandably enough, included. Nevertheless, this meaning of the Expressionist label must be rejected as overinclusive. Such words as "Post-Impressionist," "Symbolist," and "Fauve" designate the anti-mimetic impulse; any expressive component can readily be identified without labeling the entire impulse Expressionist.

There would have been no art called Expressionism, however, had Impressionism not already existed. Both labels originated, uncapitalized, in English common usage. An impressionist in the nineteenth century had been an impersonator, someone who gave "impressions" of famous personalities. And an Anglo-Saxon expressionist was simply a dissenter, someone who "expressed himself" instead of following current fashions. From the *Oxford English Dictionary* of 1897 we know that "the expressionist school of modern painters" was mentioned in an Edinburgh notice as early as 1850, while additional "expressionists" were noted in a Manchester review of 1880.[1] Meanwhile, the New York writer Charles De Kay published a novel in 1878 in which a group of Washington Square poets were named "The Expressionists."[2] But it was in France that the existence of a style called Impressionism prompted a painter to call his works "Expressionisms"; this was the little-known Julien-August Hervé, who exhibited paintings under this title at the Salon des Indépendants every spring from 1901 through 1908 and again from 1911 to 1914.[3]

There was an important sequel to this gesture. No less a master than Henri Matisse used the term "expression" to describe his protest against the superficial "impression" sought by his predecessors. He began the body of his famous "Notes of a Painter" with its best-known phrase, "What I am after, above all, is expression." Then he dissociated the work of his own generation from that of Monet and Sisley: "This term [Impressionism] cannot be used with reference to more recent painters who avoid the first impression and consider it deceptive. A rapid rendering of a landscape represents only one moment of its appearance. I prefer, by insisting upon its essentials, to discover its more enduring character and content, even at the risk of sacrificing some of its pleasing qualities."[4] Published in Paris in December 1908, Matisse's text was also widely studied in its German and Russian translations of 1909. But the painter himself did not quite go all the way. Whether he was too modest to claim to name a modern art movement, or whether he thought it superfluous to add that those who sought expression were Expressionists, Matisse left it to others to draw the obvious conclusion.

The actual inventor of the Expressionist label was Antonín Matějček, a twenty-year-old student of art history, who was born in Budapest, briefly resided in Paris, and published his seminal essay in Prague. His thesis was that there was a new antithesis to Impressionism in modern French art, which he explicitly labeled "Expressionism." Later a distinguished professor in postwar Czechoslovakia, Matějček developed a cogent and persuasive argument.[5] The Impressionist painter, in his view, had been caught on the horns of a dilemma. His "lyrical" response to nature was admirable; his paintings were as if "intoxicated" by natural color and light effects. But the Impressionist artist had also been locked into "blind obedience" to his motif, and so his pictures appear as if "reflected in a mirror." Even worse, the Impressionist's "longing for objectivity" subordinated art to science: "By equating the color scale with the spectrum, the painter's aesthetic with optics, he overlooked the insurmountable gap between science and art and . . . raised the rules of optics to laws of creation." The Expressionist artist differed, however:

> An Expressionist wishes, above all, to express himself. . . .
> [He rejects] immediate perception and builds on more
> complex psychic structures, expressing more fully his feel-
> ings about nature—composed from impressions previously
> gathered. Impressions and mental images pass through his
> soul as through a filter which rids them of all substantial
> accretions to produce their clear essence. Closely allied
> impressions are assimilated and condensed into more gen-
> eral forms, into types, which he transcribes through simple
> short-hand formulae and symbols.[6]

Where both Matisse and Matějček went astray was in contrasting the necessary impetuosity of Impressionism with the allegedly "enduring" and "assimilated" imagery of Expressionism; they were actually describing the decorative and abstract qualities of Post-Impressionist and/or Symbolist art. A vital spontaneity can exist in both directions, however, with Impressionist optical immediacy (Monet) matched by "Expressionist" emotional urgency (Van Gogh, say, or Vlaminck). Nevertheless, the Bohemian writer felt secure enough in his definition to apply it broadly. Where Matisse in 1908 had only vaguely mentioned "younger painters," Matějček in 1910 identified Cézanne as the "spiritual father" of the new direction, Gauguin and Van Gogh among its pioneers, and among living Expressionists the Nabi Bonnard, the Symbolists Redon and Girieud, and such Fauves as Matisse himself, Marquet and Manguin, Camoin and Puy. Even Braque as "the most primitive of all primitives" was mentioned, along with other painters shown by the "young dealer Kahnweiler."[7]

Matějček's essay was datelined "Paris, January 1910" and was published in the Czech language as the catalogue introduction to an exhibition held in Prague during February and March. Sponsored by the progressive Manes Society, it was devoted to paintings from the Paris Salon des Indépendants. The exhibition itself had been planned with Matisse's aid by the Prague painter (and later Neue Secession member) Bohumil Kubišta, and in June of 1910 Kubišta actually wrote of Matisse's Impressionist and Expressionist predecessors. "Expressionism" could be achieved, according to Kubišta, through "light" as in Rembrandt, through "line" as in Japanese prints and the Italian Primitives, and through "color" as in El Greco and the Venetian school.[8] Given the overinclusiveness of the Expressionist label, all non-mimetic art of the past could be so designated. But Matějček's application to a single French generation was less unwieldy, and so his definition was soon appropriated elsewhere.

In January 1911, for example, the British art critic A. Clutton-Brock wrote an appreciation of London's first exhibition of modern art, organized by Roger Fry under the title "Manet and the Post-Impressionists." Cézanne, Van Gogh, and Gauguin were featured, but also included were Matisse, Braque, and, now, Picasso. Clutton-Brock called these artists "Post-Impressionists" in the article's title and, in the text, "Expressionists." While he called the content of their art "the emotional experience of our time," which was admittedly "not rich or full or confident or joyous," the critic forgot himself when he turned to individual painters. For he compared Van Gogh to "a poet who makes music of his own experience" and he called Cézanne "a classical painter by nature" who tried to "express his own permanent relation to reality by insisting upon its permanent elements"—as if either musical poetry or classical permanence were necessary elements of emotional expression.[9] The situation was not improved when Clutton-Brock's highly respected compatriot, C. Lewis Hind, devoted a hastily written book to these same artists, again calling them *The Post-Impressionists* on the cover and "the Expressionists" inside.[10]

Back on the Continent, meanwhile, the word "Expressionist" continued to be too broadly applied and too vaguely defined. A Stockholm newspaper critic, Carl David Moselius, mentioned Clutton-Brock's usage but applied it to the local De Unga group—the Swedish "Young Ones"—in a review of 20 March 1911. The leaders

of this group were all students of Matisse, and so Moselius, too, saw Expressionism as "an uncompromising reaction against Impressionism." It meant, simply, "extreme Parisian art which some twenty of our young artists endeavor to transplant to Swedish soil."[11] A few weeks later, finally, the Berlin Secession opened its annual painting exhibition in April 1911, with emphasis on "a number of works by younger French painters, the Expressionists."[12] The label had previously been unknown in the German language.[13]

But why should the word be limited to the French? If there were Paris Expressionists, why not others? In May 1912 the sponsors of the Sonderbund International exhibition in Cologne took the final step of making the alleged art direction an international one. The catalogue identified a new Expressionist "movement," appearing "after the Naturalism of atmosphere and the Impressionism of transience." Borrowing from Max Raphael's reading of Neue Seccession painting as "colored decoration" intended "for the wall" (see sec. 3.5), the catalogue essay described the movement's goals as "a new rhythm and color" and as "decorative and monumental formulation."[14] That was all. The show featured the Paris school from Cézanne to Matisse and Van Gogh to Picasso, but it added Munch and Hodler among the pioneers and included, among the followers, some 150 artists from nine nations! Brücke, Blaue Reiter, and such unaffiliated artists as Kokoschka and Lehmbruck were lumped together with their counterparts in other lands. The Expressionist label now designated an entire Post-Impressionist, and allegedly anti-Impressionist, generation. Beginning with this 1912 exhibition, and not in 1914 as I once believed, German critics began to appropriate the Expressionist label more and more insistently for German art alone.[15]

5.2. ANTI-CLASSICISM: GERMANIC RENEWAL

The weakness of the Matisse/Matějček usage was that it failed to characterize Expressionist style: Cézanne, Redon, and Marquet had little in common, while Bonnard retained as much Impressionism as he rejected. Even the 1911 Secession, in presenting Expressionists as "younger French painters," signaled less a distinction of style than a difference of attitude and generation. Expressionism was clearly more recent than Impressionism and so, compared to their elders, Expressionists were presumably more passionate, more radical, more youthful. If "Expressionism" connoted a generational attitude, however, then that attitude had to have precedents in the past. If an objective, scientific Impressionism was to yield to a subjective, emotional Expressionism, in other words, then the latter required philosophical justification. This is where Nietzsche's teaching was crucial, demonstrating the necessity for positivist and logical values to give way to nonrational and Dionysian ones.

Art criticism needed more than Nietzsche, however; it required coherent art theory. Wilhelm Worringer provided the foundation for such theory by adopting Alois Riegl's notion of *Kunstwollen* or "artistic purpose,"[16] and applying it to primitive, Egyptian, and so-called "abstract" art in 1908 and to Romanesque, Oriental, and so-called

"Gothic" art in 1910.[17] In *Form Problems of the Gothic* from the latter year, for example, Worringer argued that, since their purposes differed, the concern of Classic art for sensuous beauty should not be attributed to Gothic art; instead, the latter's concern for "inner feeling" should be recognized. Greek architecture accepted the heavy weight of stone while the medieval cathedral seemed to deny it: "The antonym of matter is spirit. To dematerialize stone means to spiritualize it. And with that statement we have clearly contrasted the tendency of Gothic architecture to spiritualize with the tendency of Greek architecture to sensualize."[18] Moreover, Classic art is finite and monist whereas Gothic art, structural and spiritual at once, must be considered both infinite and dualist.[19] Their sequels, too, are opposed: "[Gothic] mysticism leads to Protestantism, the southern Renaissance to European Classicism." Further, compared to the "self-affirmation" in the Renaissance cult of personality, Gothic individualism leads "to self-negation, to self-contempt." And finally, the Gothic is a national and even racial precedent for German art: "For the Teutons, as we saw, are the *conditio sine qua non* of the Gothic."[20]

Worringer's arguments of 1910 were as yet unrelated to contemporary art criticism, but he expanded them in an influential article appearing in several places in mid-1911.[21] To be sure, he did not link modern art to the Gothic; instead he related it to an even more primitive *Ausdruckswollen* ("will-to-expression" or "expressive purpose") that allegedly appeared at the origin of every civilization. To a reappearance of this *Ausdruckswollen,* and thus *not* to French Post-Impressionism, Worringer attributed the peculiar properties of recent German painting. Moreover, although the "Expressionists" he mentioned were the Frenchmen just then being shown at the Berlin Secession, Worringer shrewdly allied them with an emerging renewal of German art.

The 1911 argument was complicated, but we have already encountered some of its elements. First, according to Worringer, German taste would have to adjust to "the grotesque unnaturalness and convincing simplicity" of the primitive will-to-expression. Second, the "young Parisian Synthetists and Expressionists" would help the Germans develop "a new sense organ for the perception of primitive art." This is because, third, the French are always initially ahead of the Germans: "we always have to take our cue from abroad" and "we must always first surrender and lose ourselves in order to find our own self" (see sec. 3.1). In the end, Worringer believed, there is an "imperturbable instinct of historical development" by which the primitive *Ausdruckswollen* is informing much modern art.[22]

As Matisse had done, then, Worringer defined a modern art of "expression" (*Ausdruck*) without actually naming names or identifying styles. But, again like Matisse, he prepared the way for one who would do so: in this case the art critic Paul Fechter, a friend of Max Pechstein's, who wrote the first book ever to be entitled *Expressionism*. In this study, published in 1914, Fechter named as Expressionists not the young Parisians clustered around Matisse and Picasso but, instead, the Brücke, the Blaue Reiter, and certain inde-

pendent German artists. Fechter managed this transformation by essentially combining Worringer's two arguments of 1910 and 1911.

From Worringer's 1911 essay, as supported by the Sonderbund's 1912 view of an international Expressionist movement, Fechter took the notion of an Expressionist *Zeitgeist* or spirit of the age. Now it was Expressionism—no longer Worringer's primitivizing will-to-expression—that was described as a "longing of the times," a "striving of the times." Expressionism was composed of two styles, the Blaue Reiter's "intensive Expressionism" and the Brücke's "extensive Expressionism," exemplified respectively by Kandinsky's "soul landscapes" and Pechstein's mediation between "self" and "world." But Fechter saw these impulses as determined by the period, not by the individual artist: "The individual perceives that he is more or less a link in the chain of communality. He discovers that he is somehow the medium for the expression of the world's soul, that there is a 'something,' a universality, carrying him to creation. He realizes that it is not his own small volition, bounded by individuality. . . . Expressionism actually is not a matter of volition; it is a destiny."[23] Fechter here reaches back to Riegl's concept of *Kunstwollen;* the artistic purpose of the entire Post-Impressionist era was Expressionism.

From Worringer's 1910 book, furthermore, Fechter took the notion of Gothic art as anti-Classic impulse and developed it into the even broader concept of a *gotischer Geist,* or "Gothic spirit." As an "age-old metaphysical necessity of the German people," it was the Gothic—again, no longer the primitive will-to-expression—that was transforming all modern art. Fechter even attributed the French Cubist "predilection for Negro sculpture and Polynesian art" to what he called "a new Gothic"; Italian Futurist work was said, similarly, to possess "late Gothic effects." No matter whether Expressionism had been French before it was German, "the tempo of the process was accelerated, the French lead was offset and, as things stand today, the leadership has shifted more and more to the German side again."[24]

In Fechter's view, Expressionism was an anti-intellectual, anti-scientific art opposed to Impressionism and, even more, to the entire Renaissance tradition. Its origins allegedly lay with "the true forefathers of German art—namely Gothic artists, the late-fifteenth-century masters and, above all, Grünewald." For Expressionism's underlying purpose "is not new at all. It is the same impulse that has been operative in the Germanic world from the beginning. It is the old Gothic spirit which still lives on despite the Renaissance and despite Naturalism; that spirit which erupted again everywhere during the German Baroque, which some believe can still be traced in the Rococo, and which arises again, indestructably, despite all rationalism and materialism. . . . Expressionism, in all its various forms, is basically but the emancipation of intrinsic psychological and spiritual forces from the bonds of a simple, one-sided intellectualism."[25] Instead of Post-Impressionist renewal, in sum, Expressionism now connoted—through equation with the Gothic—a kind of Germanic renewal in the arts. At the outbreak of the Great War, we readily recognize the nationalist parameters of the Worringer/Fechter defini-

tion: Expressionist art was anti-Classic, metaphysical, and essentially northern or Teutonic.[26]

The matter did not rest there, of course. Karl Scheffler published a book in 1917 called *The Gothic Spirit* in which he related Impressionism—rather than Expressionism—to the northern Gothic: "Impressionism is Gothic because it too is the product of an agitated feeling for the world, . . . because its form arises out of struggle, because it projects man's psychic unrest into appearances, and because it is the artistic transcription of a suffering condition."[27] But this is a misleading description: inaccurate about French Impressionism, relevant only to fringe aspects of German Impressionism. Scheffler's intent here was to present sympathetically such Berlin Secessionist friends of his as Slevogt, Corinth, and Beckmann (the latter enjoying pre-Expressionist reputations) at a moment when Gothic "unrest" was culturally fashionable in Germany.[28] Nevertheless, Scheffler's book confirmed and elaborated the Worringer/Fechter notion of Gothicism as anti-Classicism. The Gothic was not only "barbaric," "nordic," "ascetic," and "Protestant," but it was also the active agent within the fundamental dualism of German art and thought.[29]

Scheffler's book must also be seen as a sequel to Heinrich Wölfflin's *Principles of Art History* (1915), which had attempted to identify "the style of the school, the country, the race";[30] Wölfflin's polarity Renaissance/Baroque gave way to Scheffler's polarity Classic/Gothic, except that the art historian's method was visual and the art critic's metaphysical. Indeed, by 1918–19 German critics added a third polarity to the set, namely Impressionism/Expressionism.[31] At this point Van Gogh and Munch came to be considered Expressionist—not because, as with Matějček, they were Post-Impressionist, but because their "expressive requirements" allegedly paralleled German artists' rather than those of the French.[32] In yet another variation of 1919, *all* art was subsumed under a triple, rather than a double, style rubric, for example, Naturalism/Idealism/Expressionism.[33]

Yet this critical consensus, such as it was, began gradually to unravel. For the German Expressionist movement, seen heretofore as monolithic, came now to be split into several mutually incompatible directions. In 1920, for example, Eckart von Sydow defined four constituent currents, which he named "dynamic," "concrete," "arabesque-like," and "abstract" Expressionism. From here it was only a matter of time before German Abstraction was split off from German Expressionism. By 1941 Wilhelm Valentiner could distinguish in modern art "only three phases which are of fundamental importance: Impressionism, which is mainly a French style; Expressionism, which is mainly German; and Abstract art, which was produced at the same time in Europe (Russia, France, Italy, Germany, and Spain) and in America." And by 1977, in the latest edition of the *Propyläen* art history encyclopaedia, separate articles were devoted to "German Expressionism" and to "The Blaue Reiter," as if the two were separate.[34]

Just here was revealed the fundamental flaw in the Wor- **177**

ringer/Fechter art theory: German Expressionism was presented as a metaphysical, rather than as a historical, movement. Expressionist style was described less as existence than as essence. Expressionist reality was seen as the projection of ideal, changeless concepts—as if, somehow uniting a Kokoschka and a Kandinsky, there lay a Kantian *Ding-an-sich,* a conceptual thing-in-itself, called "Expressionism."[35] Things-in-themselves, being logically undemonstrable, could be multiplied or divided at will.

Yet, in one variation at least, Worringer's 1911 equation of Expressionism with a primitive *Ausdruckswollen* proved largely beneficial. For von Sydow, in his 1920 study on *German Expressionist Culture and Painting,* finally managed to transfer the discussion of Expressionism from a metaphysical to a historical level; for him, "culture" preceded "painting." At the outset of the century in von Sydow's view, Germany resembled "a pilgrim in a quiet garden" rudely disturbed by the "most fervent vitality" of Strindberg and Munch, Post-Impressionists and Fauves, Dostoevsky and Kandinsky, Cubists and Futurists—coming from the north, west, east, and south. Meanwhile Friedrich Nietzsche was named "the great prophet of individualism in Germany" so that, in turn, "the sudden shift from Impressionism to Expressionism" was called "a logical result of the radically individual life-principle." More fundamentally still, von Sydow saw German Expressionism as "an attempt to heal that spiritual negation-complex that we usually call 'decadence,' " a healing process which takes the form of "the will to the primitive, to a return to the earliest of human conditions."[36] This entire approach is the one elaborated in some detail in the early chapters of this book.

Nevertheless, von Sydow, writing before 1920, was too close to the subject to see it whole. One of the period's leading scholars of tribal art,[37] he oversimplified matters when he equated the "primitive" with the "Expressionist."[38] Moreover, in identifying "epochs of abstract Expressionism" in all earlier art,[39] he fell back into the very metaphysical and ahistorical approach he tried otherwise to deny. In paying but little attention to Expressionism's social dimension, he dealt only superficially with the optimistic and the pessimistic strains, the utopian and the despairing tendencies within the German movement's post-1914 decade. For Expressionism's vitalist aspect was not just primitivizing in von Sydow's sense, nor again merely post-industrial, as I have called it; it also held dangerously regressive and anti-modern implications.

5.3. NATIONALIST AND NAZI APPROACHES: CULTURAL RENEWAL AND DECLINE

Expressionism was the dominant cultural direction in Germany during the very years (1918–23) when political positions were first extremely polarized. Rejected by the left as a bourgeois art fit for a bourgeois republic (see sec. 4.7), it yet offered useful precedents for rightist thought. Ironically, however, just as National Socialist ideology could both absorb and repel the socialist aspirations of German workers, so the early Nazi acceptance of Expressionist ideas would turn, by the 1930s, into outright rejection.

It was Marxist critics who first noticed the Nazi affinity for Expressionism. In fact the first of these, Georg Lukács, condemned precisely the regressive and escapist dimensions of Expressionist art theory. In his 1934 essay on "The 'Greatness and Decline' of Expressionism," Lukács focused, first, on Worringer's notion of art as "abstraction" or "essence." Compared to Naturalism, a movement which "genuinely sought to portray the hopeless entanglement of the petty bourgeois in the capitalist mechanism," Expressionism's "subjective idealism" allegedly ignored such ties. For Expressionists, according to Lukács, reality appeared as "chaos": both capitalism and opposition to capitalism appeared to them as "meaningless" and "soulless." Expressionism accepted Symbolism's idealizing or abstracting purpose and now made such idealism the very basis of its style: "The reversal that Expressionism seeks to effect was that of transferring the process of creation—which existed in the mind of the modern writer—into the structure of the work itself; i.e., the Expressionist depicts the 'essence' . . . and—this is the decisive question of style—only this 'essence.' " In order to deny such essence, Lukács quoted Lenin: "There are no 'pure' phenomena, nor can there be, either in nature or in society—that is what Marxist dialectics teaches us, for dialectics shows that the very concept of purity indicates a certain . . . one-sidedness of human cognition which cannot embrace an object in all its totality and complexity."[40]

Lukács' second and more fundamental criticism was that practice followed theory, that Expressionism's "distortion" derived from its "essence" and that both were proto-Fascist: "The fact that the Fascists, with a certain justification, see Expressionism as a heritage they can use, only seals its tomb the more firmly. . . . [Josef] Goebbels accepts Expressionism, [Lukács continued]. He justifies it in the following interesting way: 'Expressionism had healthy beginnings, for the epoch did have something Expressionist about it.' If words do have any meaning, and with Goebbels this is not always the case, this means that he thinks of the Expressionist abstracting away from reality, the Expressionist 'essence,' in other words Expressionist distortion, as a method of portraying reality, as an adaptable means for Fascist propaganda." Lukács concluded that reactionary politics begot Expressionism as a reactionary art, a betrayal of the German working class and its abortive revolution of 1918–19: "It is not accidental that Fascism has accepted Expressionism as part of its inheritance."[41]

Lukács' arguments echoed in the so-called "Expressionism Debate," sponsored in Moscow by *The Word* magazine in 1937–38. Under a pseudonym, Alfred Kurella linked Expressionism directly to "formalism, chief enemy of a [Marxist] literature which truly strives for greatness." And the painter Heinrich Vogeler, among others, agreed: "[Expressionism] opened our eyes. We recognized the utter hopelessness of bourgeois art in its last stage; at its end is the pure formalistic discipline of Abstraction." To this kind of criticism Ernst Bloch made effective rebuttal. "Formalism was the least mistake of Ex-

pressionist art," Bloch wrote. "Rather it suffered from too little form-ing, from a raw or a wild or a pell-mell profusion of centrifugal ex-pression; its hallmark was de-formation. Thus too, I admit, its closeness to the folk, to folklore."[42]

Despite the controversy among German emigré writers and art-ists, it is Lukács' own indictment that was most damning. For Goeb-bels had indeed written an Expressionist novel in 1920–21, and had published it as late as 1929. In it, Goebbels expressed the view attributed to him by Lukács: "In composition our decade is thor-oughly Expressionist. We, the people of today, are all Expressionists. We want to structure the world from within. Expressionism wants to build a new world from within. Its secret and its source of strength is fervor."[43] These words were written not by a left-wing Marxist but by the future Propaganda Minister of the National Socialist state. They suggest that, ideologically at least, Nazism, too, wished to avoid the "chaos" of external reality and wanted instead to restructure the world "from within."

Arthur Moeller van den Bruck was a second German nationalist who began as an Expressionist sympathizer and yet ended as cham-pion of rightist ideology. An admirer around 1900 of Munch, Przybyszewski, and Dehmel and, later, of Barlach and Däubler, Moeller made his literary reputation as editor of the twenty-three-volume German edition of the collected works of Fyodor Dostoevsky (1906–14); by 1922, however, he was warmly praised by Adolf Hitler.[44] His shift from literary to political criticism was marked by a study on "The Right of Young Peoples," published in November 1918. In this polemic Moeller identified as "Young Peoples" certain vigorous and militarily adventurous nations: Japan, Bulgaria, Finland, Russia (in part), Germany, and the United States. In contrast to the decaying ancient states of Italy, France, and England, the young peoples had the future on their side. No matter whether America or Germany won the war, both countries would eventually win the ensu-ing peace: "The great dispute between old and young peoples, which will outlast the war and the peace, indeed any peace, may require many generations to be completed. But it would be against all of nature if the decision against the old and for the young peoples failed to take place."[45]

Moeller's political theory is Expressionist in two respects. First, the stress on youth was a traditionally Germanic one, as typical of the idealistic Youth Movement as of the more sophisticated Brücke revolt (see sec. 4.1). Thanks to Moeller, however, *all* of Germany was sud-denly made a "young folk"—not just its youth but its leaders, not just its radicals but its conservatives. Thus an Emil Nolde, who had once identified with youth as an Expressionist (see sec. 3.5), could now do so again as a nationalist; England and France necessarily appeared as older forces, doomed by evolutionary law to inevitable decay. But, second, the *idea* of a young people was more important than its historical reality: Russia was both old and young; Germany was a nation "reborn" under Bismarck, and so forth. The Expressionist art theory of abstract essences now became nationalist political theory.

Moeller's equation of Germanic lands with youth had the further advantage of permitting Germany to escape the inevitability of Euro-pean decline. This was Moeller's critique of Oswald Spengler's *De-cline of the West*. Where Spengler saw a victorious Germany leading the West through a final, late-capitalist phase of imperial civilization and, after that, a nation destroyed by barbarian cultures, Moeller saw Germany's loss of the war as, potentially, her salvation: "[Defeat could] restore to us other possibilities, those final possibilities which are always the first. It could permit us to rediscover in simplicity, in a more natural life, in the maternal soil of human concerns, the primor-dial requirements of a further development whose course can finally lead us out of a destroyed civilization, even out of renewed chaos, into a meaningful culture once again. Did not the outcome of the war . . . advance our destiny?"[46] Through ideological renewal, in other words, Germany might avoid the tawdry circumstances of de-feat and arise, reborn, as a young folk.

Much as he criticized Spengler, however, Moeller depended on that author for the title to his last and most famous book, *The Third Empire (Das dritte Reich)* of 1923. For in 1918 Spengler had praised the "Third *Reich*" as "the Germanic ideal, an eternal tomorrow, to which all great men from Joachim of Floris to Nietzsche and Ibsen tied their lives—arrows of longing for the other side of the river, as Zarathustra says."[47] In choosing the Nietzschean metaphor, Spengler had made the West's decline into a "bridge"—a rope of renewal running from the Hohenstaufens' medieval empire, beyond the Hohenzollerns' imperial empire, to some mystical empire still to come—just as the Brücke group had understood it half a generation before (see sec. 1.6).

But in *The Third Empire* Moeller drew even more directly on Ex-pressionist sources. Like Kandinsky, he may have first heard the phrase "third empire" from Dmitri Merezhkovsky, whom he had known in Paris around 1906.[48] Like Worringer, Moeller recognized "the fatal German weakness to fall under the spell of foreign modes of thought."[49] And like Expressionists in general, he utilized the philoso-phy of Nietzsche and the dialectics of antithesis. Indeed, Moeller's motto for the Third Empire, twice repeated, was as follows: "We must have the strength to live in antitheses."[50]

Moeller's mystical *Reich* transformed the Expressionist dream of a utopian "new man" into the Nazi fantasy of a utopian state. The con-cept of Third Empire as utopia was introduced early in the text: "The essence of utopia is that it is never realized. The essence of Christian hope is that it is never fulfilled. The essence of the millennium is that it lives in prophecy, but never in the present." Even though Moeller condemned Expressionism's "spiritual politics," he described the goal of his own empire as "a spiritual one, yet a political task is included." Just as Expressionist art theory sought a spiritual future through a primitive past, so the nationalist empire too avoided the historical present: "German nationalism is the champion of the final *Reich:* ever promised, never fulfilled. . . . We are not thinking of the Europe of today which is too contemptible to have any value. We are thinking of the Europe of yesterday, and whatever thereof may be salvaged for tomorrow. We are thinking of the Germany of all time, the **179**

Germany of a two-thousand-year past, the Germany of an eternal present which dwells in the spirit, but must be secured in reality and can only be politically secured."[51] The peculiar fantasy of progress through regress, so central to Expressionist theory (see sec. 1.8), saturated German social thought in the Weimar Republic. As Peter Gay has written: "Flight into the future through flight into the past, reformation through nostalgia—in the end such thinking amounted to nothing more than the decision to make adolescence itself into an ideology."[52] It was an ideology opposed, of course, to modernism.

In addition to Goebbels, Spengler, and Moeller van den Bruck, there were many others who sought a revolution in the future that was oriented toward the past—in other words, a conservative revolution. Some were postwar leaders of the Youth Movement; others spoke for a veterans' organization calling itself the Young German Order; still others were active in the various political factions of the right. For all of them the *Bund*—man's natural union into social groups—was the basis of the future "corporate" state. The community of primitive or medieval times was to be the model. "True socialism is the community of the folk," as Paul Krainhals wrote in 1928. The "organic state" was to be revived, Friedrich Hielscher remarked, because "everyone must be coordinated in the service of the folk." And according to Franz von Papen, Germany's chancellor shortly before Hitler, "all true revolutions are revolutions of the spirit against the mechanization [of man.]"[53] The conservative hope, like that of some Expressionists, was for an anti-modern utopia.

Further compounding the confusion between Expressionist and Nazi psychology was an obvious similarity in the use of caricature and expressive exaggeration for political propaganda. There can be little doubt, first of all, that National Socialist poster artists built on Expressionist precedent.[54] George Grosz's 1921 drawing *Toads of Capitalism,* for example, provided an image of the capitalist entrepreneur, fat-lipped, hook-nosed, well-dressed, and fat, an image was taken over by the anonymous creator of a Nazi poster for the Reichstag elections of 1932 (figs. 170, 171). Where Grosz's robber-barons play with jewels and with ten-thousand-mark packets of currency, however, the Nazi's entrepreneur simply carries a money-bag marked "one million." Of course, the difference between the caricatures is equally great, in that working-class socialists are presented sympathetically in the Grosz and satirically in the election poster. The steely-jawed, impoverished proletarians of 1921 are replaced in 1932 by the comical "protective angel of capitalism" with his hairy legs, drooping moustache, and engineer's cap with "SPD" and hammer-and-sickle insigniae.[55] Nevertheless, the fundamental opposition in each caricature is between a "good" environment above and an "evil" character below. In the Grosz the little men and women—the workers, veterans, and their families—actually outnumber the industrialists and their factory guards, while the capitalist lower right wears a hated Nazi swastika on his tie. And in the Nazi election poster it is the swastikas that surround the scene—like so many stars in the sky—while the capitalist below wears a Jewish Star of David on *his* tie.

The similarity is even more marked between such Expressionist caricatures as Otto Dix's *Venus of the Capitalistic Age* from 1923 (fig. 167) and such Nazi posters as that advertising a 1937 Munich exhibition called "The Eternal Jew" (fig. 172). Both figures are identified as capitalists or materialists—the Dix by its title and the Jew by the coins in his right hand. And both are marked as power-mad exploiters—the Venus by her greedy eyes and mouth and her predatory hands and legs and the Nazi nemesis by his whip and his association with the entire map of Eastern and Soviet Europe. In both cases the "evil" figure is given the attributes of age, overripeness, decay. By implication, the "good" German socialist of Weimar, like the "good" party member under Nazism, would be depicted as both innocent and young. This is indeed the case in Pechstein's Expressionist posters of 1919 (cf. fig. 164), and in Mjölnir's Nazi cartoons appearing in Goebbels' Berlin newspaper *Der Angriff.*[56] In both Expressionist psychology and Nazi ideology, goodness signified youth and renewal while evil rested with age and decline.

To be sure, when Adolf Hitler came to power in 1933, he converted Expressionist revolution into Nazi revolution by making two basic changes. First, he resorted continually to force—both internally, through his armed SS militia, and externally, through a revived German army. And second, he articulated a political myth that depended on the collective values of nation, folk, and race. These changes violated the most fundamental Expressionist beliefs articulated by Georg Kaiser and Ernst Toller in 1918–19: the faith in pacifism over militarism, and the valuation of the individual over the collective (see sec. 4.6). Nevertheless, there are enough beliefs common to both Expressionism and Nazism—the interiorization of reality, the desired Third *Reich* of the spirit, the saving power of youth—to warrant a closer examination of their exact relationship. Indeed, although the Expressionist "new man" was decidedly *not* the Nazi "folk," I would still argue that both were manifestations of the same German search for a viable identity.

One of the central reasons for the astonishing political success of the National Socialist German Workers' Party—to give it its full name—was that it gave to the average German citizen a new sense of self. Of course, as George Mosse points out, "[t]he phrase 'inner emigration' assumed some importance during the period of Nazi rule, for this seemed the only privacy left. There were no groups with an identity separate from party and state which one could join, *no kind of group identification which was not in some way related to the 'new Germany'* " (emphasis added). But this is precisely the point. Having for so long sought his roots in an increasingly rootless world, the German citizen discovered his identity not in the uniqueness of his individual personality but, instead, in the community of a totalitarian state: "[U]nder the Nazis the individual German had found a sense of belonging based on his membership in a community which through its world view reflected his own inner strivings. . . . In an age of industrialization and class conflict man was to be integrated into his folk; his true self would be activated and his feeling of alienation transformed into one of belonging."[57] Where Expressionists had dis-

played ambivalence—toward society, toward industry, toward the self—Nazi converts could escape from ambivalence into certainties, certainties given by party and state.

Moreover, there is a psychological difference between a romantic search for "wholeness," such as Expressionists sometimes pursued, and the Nazi kind of quest for "totality." In Erik Erikson's formulation: "Wholeness seems to connote an assembly of parts, even quite diversified parts, that enter into fruitful association and organization. . . . As a Gestalt, then, wholeness emphasizes a sound, organic, progressive mutuality between diversified functions and parts within an entirety, the boundaries of which are open and fluid. Totality, on the contrary, evokes a Gestalt in which an absolute boundary is emphasized: given a certain arbitrary delineation, nothing that belongs inside must be left outside, nothing that must be outside can be tolerated inside." The difference is not one of abnormality. Totalist thought, as Erikson points out, "is an alternate, if more primitive, way of dealing with experience"; for brief moments, it can even have adaptational advantages. "To say it in one sentence: When the human being, because of accidental or developmental shifts, loses an essential wholeness, he restructures himself and the world by taking recourse to what we may call *totalism*."[58]

The psychology of totalism is, nevertheless, regressive. It builds on the role uncertainty and identity confusion of adolescence. And it stems from the still earlier conflict within the small child trying to isolate the "totally good" from the "totally bad."[59] When reinforced by the "brainwashing" of the totalitarian state, such totalist psychology transforms the personality. Indeed, as Robert Jay Lifton has observed, "it was the combination of *external force or coercion* with an appeal to *inner enthusiasm through evangelistic exhortation* which gave thought reform its emotional scope and power." The subject of such thought reform must "die and be reborn," must perish in order to become a "new man." After assuming the "identity of the repentant sinner" and after rooting out the "negative identity" that he has always feared within himself, he must share, in Lifton's words, "the moral righteousness of a great crusade of mass redemption."[60]

A central assumption of the National Socialist regime was that the total integration of the German required the total elimination of the Jew. What this meant in practice was stated in the Nuremberg Laws of 1935: "Only the state citizen of German or of kindred blood who by his conduct proves that he is willing and able loyally to serve the German people and the Reich is a Reich citizen." Or, as it was put in a *Commentary on German Racial Legislation* (1936): "The Jews, who constitute an alien body among all European peoples, are especially characterized by racial foreignness. Jews cannot be regarded as possessing the capability for service to the German people and the Reich." Or, again, as it was stated in a 1938 article by a judge, Walther Buch: "The Jew is not a human being. He is an appearance of putrescence. Just as the fission-fungus cannot permeate wood until it is rotting, so the Jew was able to creep into the German people, to bring on disaster, only after the German nation, weakened by the loss of blood in the Thirty Years' War, had begun to rot from within."[61]

Under the Nazi regime, it now appears, the Jew became the German's "negative identity" (Lifton). In scapegoating the Jews, Germans projected their own intellectual, materialist, and internationalist values onto an available yet conveniently separate group. Jörg von Uthmann has even written of an "elective affinity between Germans and Jews," a "spiritual relationship" expressible only in the folk-image of the *doppelgänger*. What bound German and Jew together, in von Uthmann's view, was: "that feverish activity in business that has made both of them so unloved throughout the world; . . . that respect for the printed word that has made the Jews the 'people of the Book' and the Germans *das Volk der Dichter und Denker*; . . . the common faith in an absolute, the obsessiveness with which they push every good thing to the point where it becomes a bad one; . . . [and] that inimitable combination of tactlessness and sensitivity, of insolence and subservience, of arrogance in belonging to an Elect and yet of self-contempt." To this Gordon Craig has added further similarities between the two peoples: "their industry, their thrift and frugality, their perseverance, their strong religious sense, the importance they place on the family. . . . They are alike also in their intellectual pretensions, refusing to limit themselves to pragmatic and utilitarian goals, but sharing the Faustian ambition to find the secrets of the universe and to solve the riddle of man's relationship to God."[62] Moreover, as suggested earlier, both "Germanness" and "Jewishness" were abstract properties associated, for centuries and millennia, with no single nation or dynasty (see sec. 4.2). Like two brothers reared closely together in an alien land, German and Jew found in their love and hate for one another the most deadly sibling rivalry.[63] When the German ideology was finally buttressed by a totalist psychology, under the Nazi regime, the thought of fratricide could yield to the infinitely greater horror of genocide.

As with the Jews, so with the Expressionists. A totally German culture could not tolerate within its borders a partially non-German art. The very affinities we have observed between Expressionism and the German ideology—limited though they in fact turned out to be[64]—were enough to become that "negative identity" in the cultural sphere which the Nazis felt obliged to eliminate. Regarding Expressionism, however, there was initial uncertainty. Between 1933 and early 1934 there was a power struggle between the racist Alfred Rosenberg, follower of Houston Chamberlain and advocate of the folkish German ideology, and such supporters of Expressionist art as the National Socialist Student Alliance and Propaganda Minister Goebbels himself. Adolf Hitler decided the issue in the summer of 1934, by warning against *both* the modernizing "Cubists, Futurists, Dadaists, and others" and "those retrograde types who think they can make an 'old-fashioned German art.'" Ideologues like Rosenberg were replaced by bureaucrats, while Goebbels henceforth enforced Hitler's views. In late 1936 Goebbels forbade "the conduct of art criticism as it has been practiced to date"; the modern art section of the Berlin National Gallery was closed; and the Reich Chamber of Visual Arts under the academic and classicizing painter Adolf Ziegler was empowered "to select and secure for an exhibition works of **181**

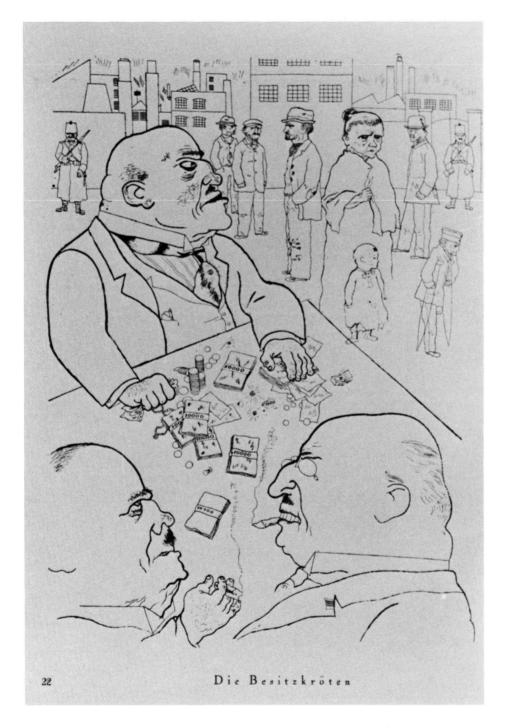

Die Besitzkröten

22

170. George Grosz, *Toads of Capitalism,* drawing, 1921.

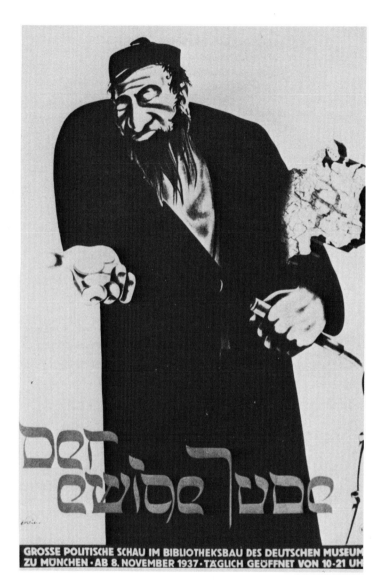

171. Poster for the Reichstag elections of 1932. Artist unknown.

172. Poster for "The Eternal Jew" exhibition, 1937, Germany. Artist unknown.

German degenerate art since 1910, both painting and sculpture, which are now in collections owned by the German Reich, by provinces, and by municipalities."[65]

Just as Max Nordau in 1893 had railed against *all* modern art and literature in France, Scandinavia, Russia, and Germany (see sec. 1.4), so Ziegler and his committee secured as "degenerate art" works by non-German Post-Impressionists, Symbolists, Fauves, and Cubists—as well as by German artists of the Expressionist, Dadaist, Bauhaus, and Neue Sachlichkeit movements. Some 16,000 paintings, sculptures, drawings, and prints were confiscated from German museums, and then eliminated from Germany either by auction or by burning. Of these the chief victims were the leading German Expressionists: [66]

WORKS OF "DEGENERATE ART" CONFISCATED FROM GERMAN MUSEUMS BY 1937

Barlach	381	Marc	130
Beckmann	509	Matisse	13
Campendonk	87	Meidner	84
Chagall	59	Melzer	17
Corinth	295	Mense	34
Dix	260	Modersohn-	
Feininger	378	Becker	70
Felixmüller	151	Molzahn	33
Grosz	285	Morgner	76
Heckel	729	Muche	13
Hofer	313	Mueller	357
Jawlensky	72	Munch	82
Kandinsky	57	Nauen	117
Kanoldt	20	Nolde	1,052
Kirchner	639	Pechstein	326
Klee	102	Picasso	19
Klein	13	Rohlfs	418
Kokoschka	417	Schmidt-	
Kollwitz	31	Rottluff	688
Kubin	63	Segall	53
Lehmbruck	116	Tappert	12

But this was not all. In Munich on 19 July 1937 Hitler opened an exhibition of degenerate art, which traveled in 1937–38 to other German cities and which featured chiefly, once again, the German Expressionists (fig. 173). In the exhibition and in its accompanying catalogue every effort was made to link Expressionist art with Marxist ideology, so-called Jewish racial characteristics, the "Nigger art" of Africa and the South Seas, and the work of madmen and "disturbed minds."[67] With the exception of borrowings from primitive art, of course, all these alleged connections were gross distortions.[68]

The show's catalogue concluded with the Führer's remarks calling for "An End to Artistic Bolshevism," remarks made the previous day at the Munich opening of the Great German Art Exhibition. Here Hitler castigated those artists "who see the present-day figures of our people only as degenerate cretins," artists "who are determined to perceive, or, as they would say, to experience, meadows as blue, skies as green, and clouds as sulphur yellow." Then, Hitler continued, there are only two possible explanations:

> Either these so-called artists really see things this way and believe they are representing things the way they are. If this were so we would only have to determine whether their faulty vision is due to a mechanical failing or a congenital defect. In the first case, we can do nothing but feel sorry for the afflicted; in the second, it would be the responsibility of the Reich Ministry of the Interior to consider preventive measures that would spare later generations from inheriting such dreadful visual defects. The other explanation is that these "artists" themselves don't believe in the reality of what they depict but have other reasons for imposing this hoax upon the nation. In this case, they are liable to persecution under criminal law.[69]

Here Hitler recommended, for artists, the sterilization and genocidal programs that he soon instituted for what he considered inferior individuals and races. The final solution, proposed for Expressionists in 1937, was carried out for six million Jews from 1940 to 1945. It is unlikely that anyone reading these words—and there were "over a million visitors" to the Degenerate Art Exhibition in Munich alone[70]—misunderstood the death blow that had been delivered to modern German art.

Certainly many former Expressionists could no longer do so. In the summer of 1937 Lyonel Feininger, who had been born in the United States, returned for good (George Grosz had left for America in 1933). Also that summer Max Beckmann emigrated from Germany to Amsterdam, where he was eventually caught by the war. And Oskar Kokoschka, in Prague, created his *Self-Portrait as a "Degenerate Artist"* in the fall of 1937 (fig. 174). Painting his self-image in precisely the free colors and distorted forms that Hitler had just proscribed, Kokoschka gave Expressionism's "last hurrah." In 1938 Ernst Barlach died of a stroke, a pariah in his hometown, with only Käthe Kollwitz among his former friends arriving for the funeral. The emigrations and deaths continued, with Ernst Kirchner committing suicide in Switzerland in June 1938, and Ludwig Meidner emigrating to England at the last moment, in August 1939. That year Otto Dix was imprisoned by the Gestapo; aged forty-nine, he was "allowed" to volunteer for the army, where he was soon captured.[71]

The final irony, however, is that the art theory of "Expressionism" bore little relation—in the end as in the beginning—to Expressionist art itself. The phenomenon that was called "Fascist" by the Marxists and "Bolshevist" by the Nazis was precisely that fiction which had earlier been named "Teutonic" and "Gothic." Once discussed

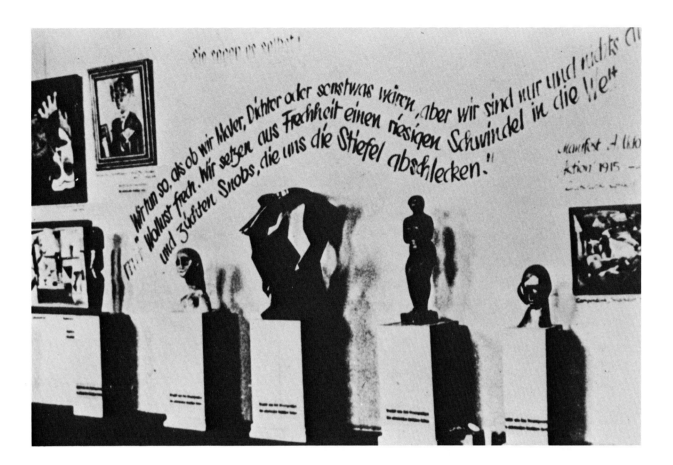

173. Anonymous, 1937 exhibition of degenerate art.

largely in terms of "abstraction" and "essence," German Expressionism never found in its time observers who grasped the ideational and social critique which lay behind its entire enterprise. Expressionism was not at all "degenerate" in the Nazi sense. Instead, it recorded the symptoms of decay and devolution in post-1914 Germany—and it did so for the most part honestly and fearlessly. Begun in the hope of renewing modern German culture, Expressionism ended by bearing witness to its decline.

5.4. EUROPEAN EXPRESSIONISM: INTERWAR DESPAIR

The irrelevance of Expressionist art theory to Expressionist art was further demonstrated by an important, and previously little understood, fact—namely, that when Expressionist art appeared in other European countries after 1914, it was not accompanied by German modes of art criticism. Expressionism in interwar Europe was simply the subjective or emotional alternative to international Constructivism and Abstraction. Art critics in such countries as Belgium, England, Sweden, and France occasionally recognized Expressionism's so-called "northern" or anti-Classical bias, but that was all. None of the excesses of German criticism were visited upon non-German artists.

There is no pattern to Expressionism's reception in other European lands. If the German variety had always been associated with renewal and with decline, a similar ambivalence may also be found elsewhere. Yet on balance, in the aftermath of World War I, more pessimistic tendencies were dominant. As J. A. Richardson has written:

> In terms of the history of ideas that war was unique, for it was conducted as a systematic, rationalized slaughter in which the thousands of dead who participated in desperate acts of horror were merely carrying out routine transactions subordinate to the tremendous effluences of the warring economies. The stalemated nature of the conflict, the ghastliness of trench fighting, and the total absence of a decisive strategy

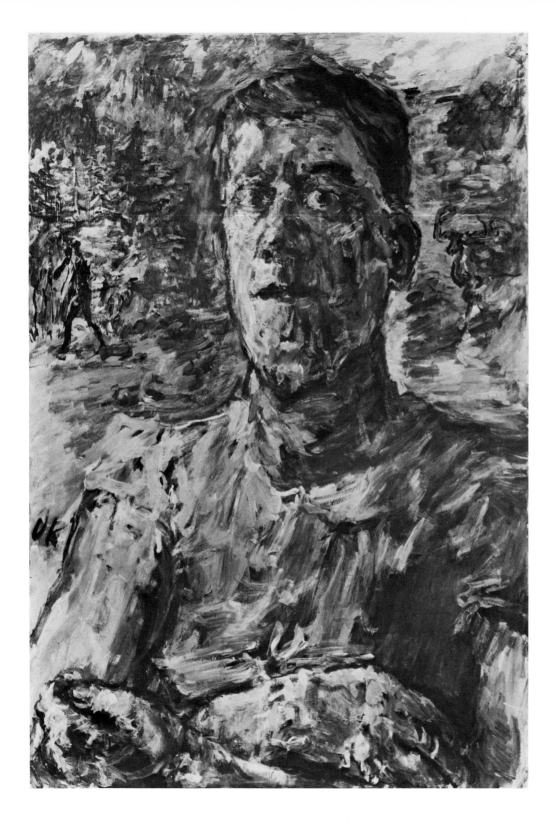

on either side emphasized the purely mechanical aspect of the hostilities. . . . The reduction of men to mere instrumentalities was supposed to have ended with the hostilities, but for many the experience revealed the governing forces of modernity and thereby rendered the experience interminable and modern life intolerable.[72]

Like Ezra Pound, who wrote in 1920 of "a botched civilization," many members of the so-called generation of 1914 found their great temptation in Fascism.[73] Moreover, the traumas of the Great War seemed to have rubbed off on its children; surely it was not just in Germany alone that inner despair in the 1930s can be traced back to childhood deprivations of the war and early postwar years.[74]

In the case of Belgium, for example, it was the Great War itself that transformed well-established Symbolist and Impressionist/Fauve directions into an independent Expressionist movement. To be sure, Germany's rape of neutral Belgium in August 1914 was as vicious as King Leopold's decision to defend it was heroic. Nevertheless, the anxiety among Belgian artists was not dissimilar to that among Germans: "The cry 'save himself who can!' spread from town to town; the exodus grew from hour to hour."[75] Just as there were some, like Frans Masereel, whose pacifist politics led them to neutral Switzerland, so there were others like Constant Permeke who served valorously before being invalided out of the army. Permeke's *Engaged Couple* from the early 1920s (fig. 175) embodies an indigenous Expressionist style: massive forms and somber colors, though not without primitivizing facial features.

A link to German Expressionism may be seen in *Birth* by Frits van den Berghe (fig. 176), since it recalls a question asked by Franz Marc early in 1914: "The world is giving birth to a new age. There is only one question: has the time now come in which the old world will be dissolved? Are we ready for the *vita nuova?*"[76] But where, in Marc's 1913–14 woodcuts *Birth of the Horses* or *History of Creation I* and *II,* man is conspicuous by his absence, van den Berghe depicts an enormous, balloon-like man hovering above newborn birds, deer, and fish. The difference between the two works evokes the difference between Europe early in 1914 and Europe early in 1927: while the German could still hope for an innocent creation, the Belgian knows that the postwar "new age" has been less than perfect. As in other van den Berghe paintings, somberness reigns. It is as if an unnamed horror—known also in the contemporary work of Max Ernst in France—were haunting a peaceful world.

As late as 1951 the Belgian playwright Michel de Ghelderode could still recall the crisis atmosphere of the Twenties and Thirties: "*Escape!* An expression that was fashionable twenty years ago and which has been much abused. However, it's the only one I find suitable at the moment—escape—but isn't this the worry of all men

today, isn't it our daily worry?" More recently, Francine Legrand has expressed similar sentiments about Belgian Expressionist painting as a whole: "[It] assumed a particular form, first of all, because it depends on a tradition or rather on a bridge which, from Jerome Bosch to [James] Ensor, embodies the racy and sensuous qualities of Flemish painting and, second, because it does not swim in the anguished current of nordic Expressionism. It speaks—at times with the accent of terror—those elementary truths which are valuable for all."[77]

There was no Expressionist movement in England, though individual artists sometimes passed through Expressionist phases. Compared to Otto Dix's war scenes, for example, Paul Nash's 1918 painting of *The Ypres Salient at Night* displays more objective reportage than subjective revulsion.[78] On the other hand, Jacob Epstein's sculptures of the 1920s and David Bomberg's paintings of the 1930s can be called Expressionist. Before 1914 a pioneer of British abstract painting, Bomberg created a *Self-Portrait* around 1937 with a highly-charged, gestural paint application.[79] Still, despite the unimportance of Expressionism in interwar England, it was Herbert Read in 1931 who first gave the word "Expressionism" a generic significance it had not previously possessed in Anglo-Saxon art criticism. It signified for Read not just inner feeling (as in Kandinsky, or in Symbolism) but actually unpleasant feelings: "Expressionist art is an art that gives outward release to some inner pressure, some internal necessity. That pressure is generated by emotion, feeling, or sensation, and the work of art becomes a vent or safety-valve through which the intolerable psychic distress is restored to equilibrium. Such a release of psychic energy is apt to lead to exaggerated gestures, to a distortion of natural appearances that borders on the grotesque. Caricature is a form of expressionism, and one which most people find no difficulty in appreciating." Moreover, Read found expressionism—with a small "e"—throughout world art: in "tropical" Africa, in the "Mediterranean" El Greco, and in the "Northern" Grünewald, Breughel, and Bosch: "It is a fundamentally necessary word, [Read believed,] like 'idealism' and 'realism,' and not a word of secondary implications, like 'impressionism' or 'super-realism.' It denotes one of the basic modes of perceiving and representing the world around us. I think that perhaps there are only these three basic modes—realism, idealism, and expressionism."[80]

In the Netherlands there was no recognized movement, but rather a prewar Fauve group in Paris (Kees van Dongen, Jan Sluyters, Leo Gestel), a post-1914 group influenced by Germans or Belgians (Jacba van Heemskerck by Marc, Jan Wiegers by Kirchner, Hendrik Chabot by Permeke), and a group of older men who first became Expressionists in the 1930s. Typical is Marius Richters, who saw in his landscapes "*more* than nature." For him, "the Spirit of God moved upon the face of the waters and over the fields, in rather fierce and vivid colors, perhaps echoing the spirit of Jehovah the Implacable. This had to come chiefly as an echo of these colors, for Richters permitted himself no liberties with actual forms. An Expressionist, he was trapped in the body of a fundamentalist."[81]

174. Oskar Kokoschka, *Self-Portrait as a "Degenerate Artist,"* oil on canvas, 1937. Oskar Kokoschka-Dokumentation Pochlarn, Austria. Modern Art, New York.

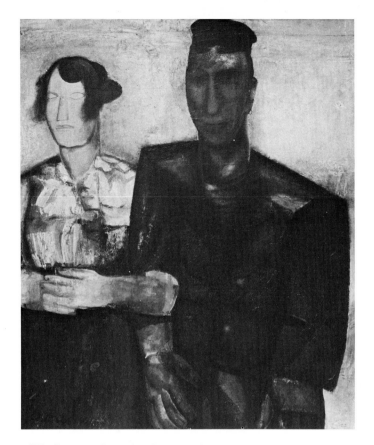

175. Constant Permeke, _Engaged Couple (Les fiancés),_ 1922. Musées royaux des Beaux-Arts de Belgique, Brussels.

Swedish Expressionism was an independent movement, like the Belgian direction, but one which evolved in phases like the Dutch. The Swedish movement began with the De Unga group in 1910, the "Young Ones" who had studied with Matisse in Paris 1908–09: Isaac Grünewald, Sigrid Hjertén-Grünewald, Edward Hald, and Einar Jolin (see sec. 5.1). These artists and their friends remained in neutral Sweden during the hostilities. Their art was fundamentally decorative, as in Grünewald's _War,_ in which exploding grenades were rendered in brightly colored, flower-like forms.[82] Next came the artists oriented toward Germany, beginning with Gösta Adrian-Nilsson ("GAN") who showed with the "Swedish Expressionists" at Berlin's Sturm Gallery in 1915 and who worked in a quasi-Cubist style. And finally came the postwar converts, including several women (Tora Vera Holmström, Siri Derkert, Vera Nilsson, and others). Among the male artists, some turned to social themes after the outbreak of the Spanish Civil War.

Albin Amelin was perhaps the most intense of the Swedish Expressionists. Chicago-born and Stockholm-raised, Amelin began his career with such war fantasies as the _Murdered Woman_ (fig. 177). Anticipating certain Picasso images of the 1930s and the Pollock drip-and-splatter drawings of the 1940s, Amelin saw creativity as an instinctual process: "I will, I shall, I _must_ paint. It is a life need for me. . . . To paint again—I can't describe how that feels. Battling to the limit. Even botching some of the drawings in my eagerness."[83] After traveling to Paris and adopting Chaim Soutine as his model, however, Amelin's Expressionism moderated in the later 1930s.

In Eastern Europe Expressionist tendencies flourished right after World War I, but were often suppressed later. Soviet Russia, for example, adopted Expressionism in 1919 as the state-approved art direction,[84] but dropped it a few years later. Despite visits to Russia in 1922–23 by George Grosz and Heinrich Vogeler, Soviet critics did not approve German depictions of workers (see sec. 4.7). And once Social Realism became the dominant Russian style, Pavel Filonov remained the only important dissident; his planned exhibition in 1930 was never opened "for political reasons." By 1933 Filonov was directly attacked by Leningrad critics for his "pathological . . . decadent Expressionism."[85]

The Czechoslovak Republic, vigorously Socialist from 1918 on, produced major works of Expressionist literature: Karel Cápek's 1921 drama _R.U.R.,_ which introduced the word "robot" into modern culture, and Jaroslav Hašek's 1920–23 satire on European militarism, _The Good Soldier Schweik._ But in the visual arts Czechs continued to look more to Paris than to Berlin. There was reportedly an Expressionist manifesto in Romania, while the Zdvoj group championed the style in Poland.[86]

In Hungary in 1919, during the five-month Soviet Republic led by Béla Kun, Expressionist tendencies were encouraged. Lajos Kassák put his Budapest magazine _Ma_ ("Today") at the service of Cubist and Expressionist artists. But when the revolution was suppressed, the leading painters fled to Berlin (Jozsef Nemes-Lamperth) or to Moscow (Béla Uitz). In 1931, after a lengthy effort to revitalize "greater Hungarian" culture, a reactionary Budapest regime established scholarships for artists to study neo-classical painting in Fascist Rome.[87] Nevertheless, by 1937–38 artists began to comment on approaching European war, Imre Ámos by means of a style he called "associative Expressionism."[88]

Italian modern art showed few Expressionist initiatives. To be sure, a minority view has held that prewar Futurism was Expressionist. As D. H. Kahnweiler put it, "Futurism was only one form of Expressionism, an Italian form." But it would be more accurate to say that Italian Expressionism began with an exhibition of the German Novembergruppe in November 1920. Mario Sironi was the leading figure at this time. Between his last exhibition as a Futurist in 1919 and his 1922 role as a founder of the classicizing Novecento ("Twentieth Century") group, Sironi adopted "a rather weighty and mordant Expressionism."[89] Under Fascism, however, Expressionist tendencies were scarce. An exception was Gino Bonichi (pseudonym "Scipione"), who painted a stirring _Apocalypse_ in 1930. More important was Renato Guttuso, who helped found the Expressionist group La Corrente

Plate 10. Otto Dix, *Pregnant Woman,* oil on canvas, 1919. Galerie Valentin, Stuttgart.

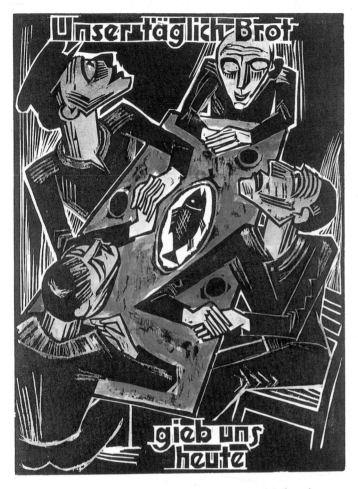

Plate 11. Max Pechstein, *Give Us This Day Our Daily Bread,* plate 5 from *The Lord's Prayer,* hand-colored woodcut, 1921. Los Angeles County Museum of Art.

Plate 12. (opposite) Lovis Corinth, *The Red Christ,* oil on canvas, 1922.

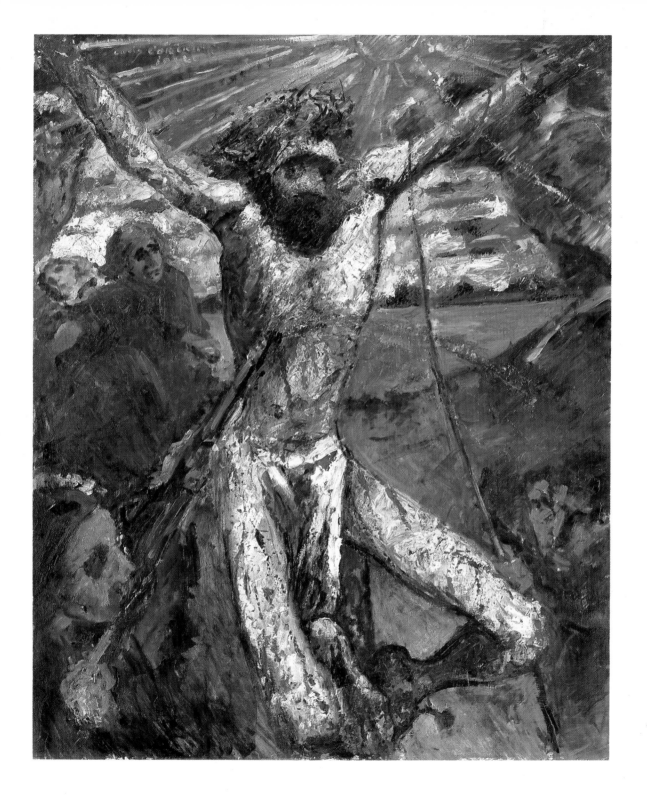

Plate 14. Wassily Kandinsky, *Mountain,* oil on canvas, 1909. Städtische Galerie im Lenbachhaus, Munich.

Plate 13. "Music of Wagner," from A. Besant and C. W. Leadbetter, *Thought-Forms,* 1908.

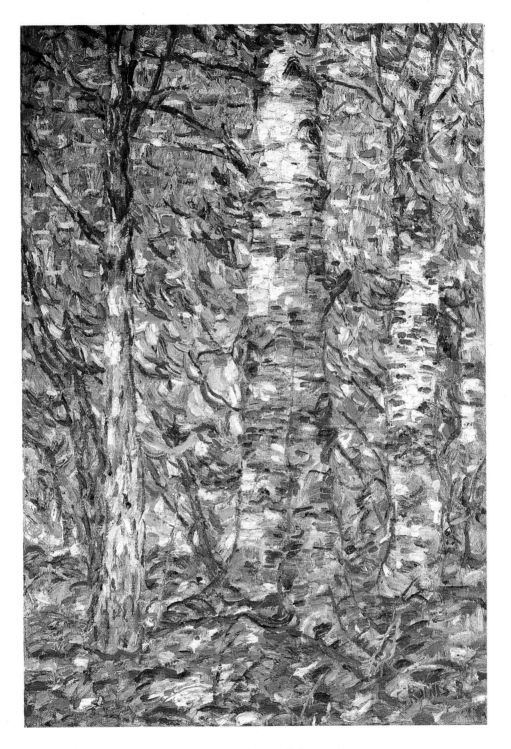

Plate 15. Christian Rohlfs, *Birch Forest,* **1907. Museum Folkwang, Essen.**

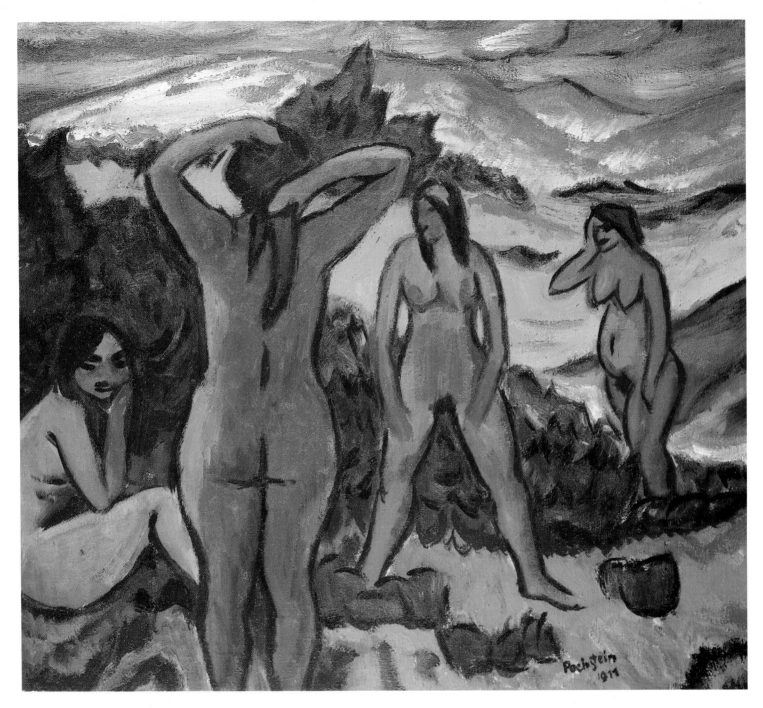

Plate 16. Max Pechstein, *Evening in the Dunes,* oil on canvas, 1911.
Leonard Hutton Galleries, New York.

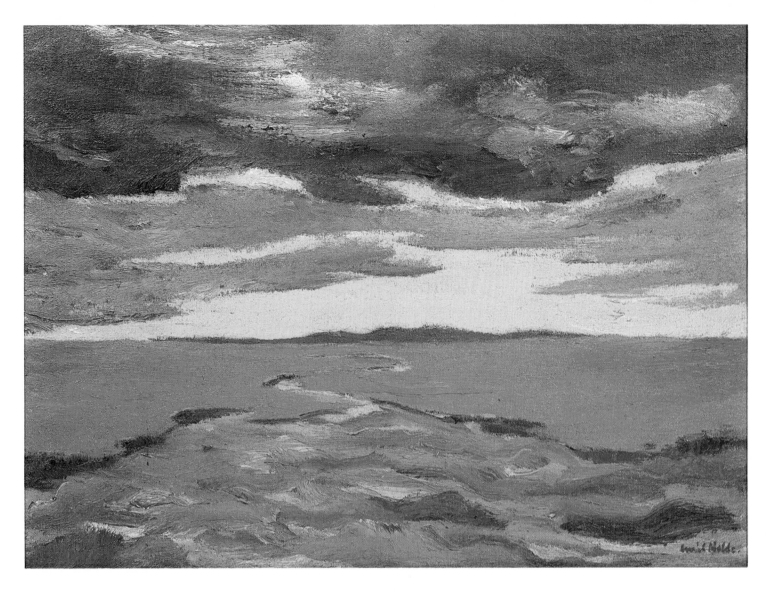

Plate 17. Emil Nolde, *Marsh Landscape (Evening),* oil on canvas, 1916.
Öffentliche Kunstsammlung, Kunstmuseum Basel.

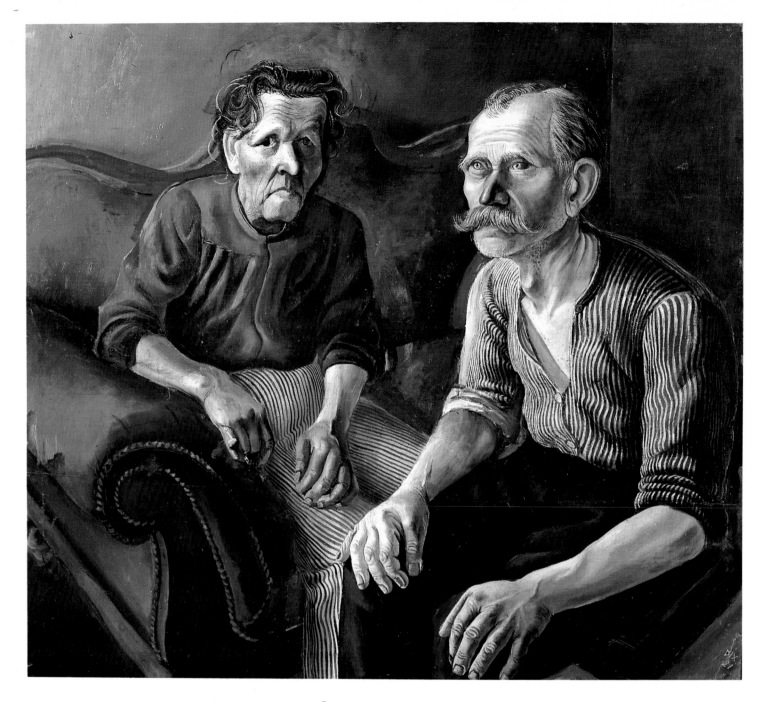

Plate 18. Otto Dix, *Portrait of the Artist's Parents,* 1921. Öffentliche Kunstsammlung, Kunstmuseum, Basel.

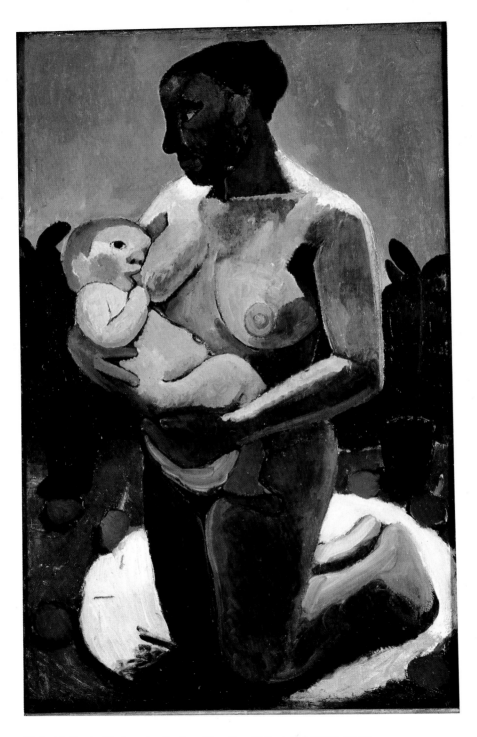

Plate 19. Paula Modersohn-Becker, *Kneeling Mother and Child,* oil on canvas, 1907. Private collection, West Germany.

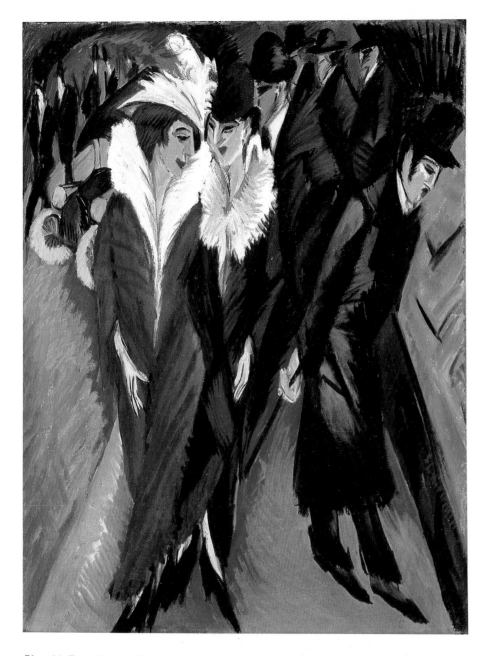

Plate 20. Ernst Ludwig Kirchner, *Street, Berlin,* oil on canvas, 1913. Collection The Museum of Modern Art, New York; Purchase.

Plate 21. (opposite, top) Oskar Kokoschka, *Fan for Alma Mahler,* 1914. Museum für Kunst und Gewerbe, Hamburg.

Plate 22. (opposite, bottom) Ernst Ludwig Kirchner, *Schlemihl's Encounter with the Shadow,* reproduction after color woodcut, 1915. Los Angeles County Museum of Art. Purchased with Funds Provided by Anna Bing Arnold, Museum Acquisitions Fund, and Deaccession Funds.

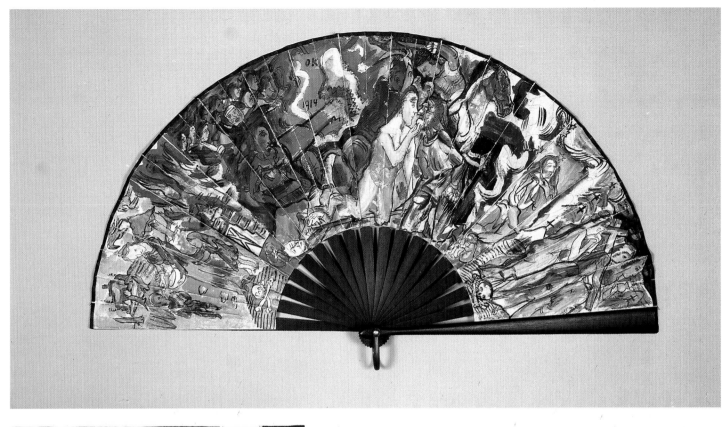

Plate 23. Jackson Pollock, *Bird,* oil and sand on canvas, 1941–42. Collection, The Museum of Modern Art, New York. Gift of Lee Krasner Pollock in memory of Jackson Pollock.

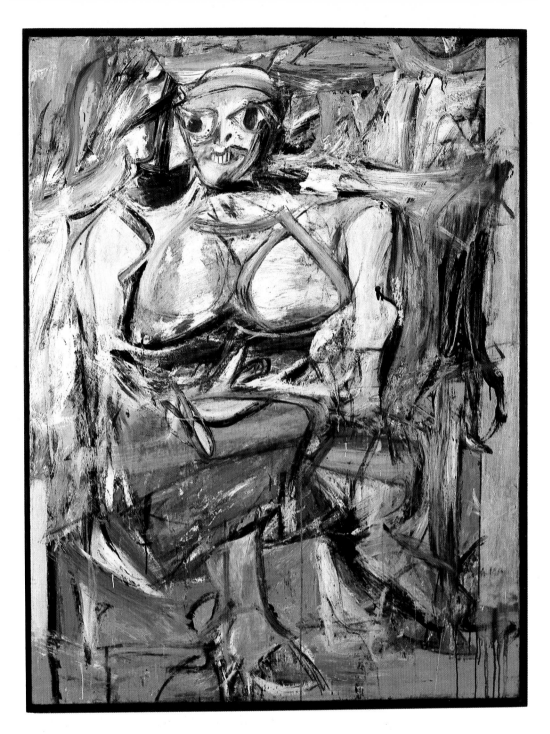

Plate 24. Willem de Kooning, *Woman, I,* oil on canvas, 1950–52. Collection, The Museum of Modern Art, New York.

Plate 25. Francis Bacon, *Painting,* oil and tempera on canvas, 1946. Collection, The Museum of Modern Art, New York.

Plate 26. Sandro Chia, *Dionysus' Kitchen*, oil on canvas, 1980. Marx Collection, Berlin.

Plate 27. Julian Schnabel, *Head (for Albert),* oil on canvas, 1980. Emmanuel Hoffmann Foundation, Museum für Gegenwartskunst, Basel.

176. Frits von den Berghe, *Birth (Naissance),* oil on canvas, 1927. Eman-
uel Hoffmann-Foundation, Kunstmuseum Basel.

177. Albin Amelin, *Murdered Woman*, 1928. Nationalmuseum, Stockholm.

("Current") in 1938. Guttuso's *Crucifixion* dates from 1941 (fig. 178), and is a topical commentary on the sufferings of war.[90]

Expressionism in France remains a topic of controversy. Anglo-American criticism has continued to see certain Post-Impressionists, much Fauve painting, and even Picasso's *Demoiselles d'Avignon* as Expressionist.[91] But Franco-German criticism has avoided this practice with two exceptions, and the exceptions are not convincing.[92] Thus, to the extent that pre-1914 French art was concerned with expression, it might merit the designation "expressionist" with a small "e"—but it should not be linked with the capitalized art movement of Expressionism.

French art criticism avoided the Expressionist label throughout the 1920s, in fact, precisely because it was associated with the enemy *boche*.[93] Beginning in the 1930s, however, Expressionist tendencies were finally discovered by French art critics at the heart of the school of Paris. Indeed, the notion of Expressionism as a characteristically Jewish style emerged not only in Berlin in 1929 (see sec. 4.7), but also in Paris the following decade. The *Gazette des Beaux Arts* sponsored an exhibition of "Instinctive Painters" late in 1935, for example, which employed the subtitle "Birth of Expressionism." Of the seven painters included, four were Jewish: Marc Chagall, Amedeo Modigliani, Jules Pascin, and Chaim Soutine. Chagall's 1914 exhibition in Berlin was credited, erroneously, with the origin of both French and German Expressionism.[94] By 1939 even the dean of French art critics, Louis Vauxcelles, could mention "a small number of artists of the Jewish race and religion, born in Russia and in Poland, in whom various historians believe they can discern the *revivers* of Fauvism."[95]

Chaim Soutine was the most painterly Expressionist of the French school; his impasto style was based on the example of Rembrandt and Van Gogh. But that style took on personal associations for the artist in a series of paintings done in the French Pyrenees village of Céret. In *Hill at Céret* from 1922 (fig. 179), for example, Maurice Tuchman has identified a space-denying "urge for immersion" and also a "dualism of despair-ecstasy."[96] And in his *Self-Portrait* of 1922–23, Soutine achieved a kinetic quality through blurred strokes that recalls some of Nolde's figure painting before the war. Soutine here captures movement on a still surface in a manner that anticipates Willem de Kooning and Francis Bacon in a later generation.

André Masson's automatic drawings of 1924 have an Expressionist quality; one of them, according to William Rubin, "convey[s] a sense of overwhelming urgency and conflicting impulses." A contributing source was an illustrated book on Paul Klee which Mas-

178. Aldo Renato Guttuso, *Crucifixion,* oil on canvas, 1941. Galleria del Milione, A. Della Ragione Collection, Milan.

son discovered and showed to Joan Miró late in 1922; according to Masson, "It was the single most important thing to take us out of Cubism." Just as Klee had believed in 1920 that "Motion is the basis of all becoming," so Masson expressed a similar sentiment: "If our eye were only more acute we would see everything in movement (the gaze of Heraclitus, of Nietzsche)."[97] As these words suggest, however, Masson's affinity for German art was matched by a concern for German philosophy in general and Nietzsche in particular.

Masson's Surrealism and Expressionism merge in his work from 1937–40. The style of a study for a stage design after Cervantes (fig. 180), for example, has been called by Carolyn Lanchner an "intensely expressionistic realism." Depicting a fist rising defiantly from the earth, and a bull's head holding a human skull between its horns, Masson's 1937 drawing combines the death imagery of German Expressionist war art (cf. fig. 153) with the political protest of Picasso's *Guernica* project. As André Breton commented in May 1939: "the

problem is no longer, as it once was, to know if a painting 'stands up' in a wheatfield for instance, but if it stands up alongside the daily newspaper. . . . No one has been willing and able to submit to the test as has André Masson; no one comes out of it more creditably." This is a typically Expressionist viewpoint, one shared by Masson himself. Looking back, in fact, Masson by 1966 was willing to believe that "Surrealism is only one of the aspects of Expressionism"; thus, he argued, "the Expressionist vision is a very important fact, an enormous groundswell from the north and the east. The Latin dam can do nothing to hold it."[98]

5.5. FIGURATIVE AND ABSTRACT EXPRESSIONISM: AMERICAN RENEWAL

When it crossed the Atlantic during the 1920s and 1930s, the label "Expressionism" had several widely different connotations. It designated a modernist style, anti-mimetic but otherwise undefinable; a modernist attitude, anti-materialist but also otherwise unspecific; and a romantic viewpoint, anti-intellectual but otherwise vague. The first American book on the subject, Sheldon Cheney's *Expressionism in Art* of 1934, gave all these connotations. In its anti-mimetic sense, **191**

179. Chaim Soutine, *Hill at Céret,* oil on canvas, 1922. The Israel Museum, Jerusalem.

Expressionism was opposed to "Victorian sentimental Realism [with its dictum] 'art is imitation.' " It sought "abstraction," in·the anti-materialist sense of "essence or summary," in order to "[get] to the soul of the object." And it conveyed meaning, in the anti-intellectual sense, through "the artist's feeling. . ., his image-compelling emotion [which was often] socially-valuable or humanly stirring." Cheney's source was Hans Hofmann, the German emigré teacher and painter.[99]

Like most American critics, Cheney had difficulty with the notion of "feeling" or "emotion" in art. But he resolved the issue by giving it a radical, specifically Marxist, interpretation:

Communism as we know it . . . may seem an imperfect vessel, and a faint promise upon which to pin hopes of a universally valid art of combined formal and human expressiveness. But in its world aspect and its essential idealism, beyond the immediate struggle and compromise and fear, it seems to me to exhibit the only unity to which millions of men are manifesting loyalty. . . . No other ideal of the world reconstructed, no other vision of human-social order, affords the slightest promise of developing a comparable conviction and passion, strong enough to stir determining numbers of men to world action and a widely compelling art.

This is a considerably more committed and idealist approach to the emotional issues of "loyalty" and "passion" in Expressionist art than

180. André Masson, study for stage design for Cervantes, *Numance,* ink on paper, 1937. Collection, The Museum of Modern Art, New York.

was common in European criticism of the period. It must be noted, however, that even in America Cheney's approach to Expressionist "emotion" was far more inspirational than will be found after World War II. By 1951, when the entire notion of Expressionism had been reduced to a romantic and anti-intellectual pseudo-style, John I. H. Baur defined the term so as "to indicate all art which depends on free and obvious distortions of natural forms to convey emotional feeling."[100]

What is significant about Cheney's approach, however, is its equation of Marxism and modernism in the characterization of Expressionist art. Cheney himself gave the art a social significance that it had possessed only once before, briefly, in Germany from 1917 to 1920. For in the American's view, "Expressionism represents a new stage in art's upward climb. . . . [I]t is the art born of the struggle between two worlds, of the death-confusion of an expiring civilization, and of the birth-pains of a different human society."[101] It is of course ironic that, with Cheney, the fundamentally German idea of cultural renewal was transformed into the American Marxist notion of political and social upheaval.

Be that as it may, Cheney's approach dominated thirties criticism in the United States. In the leftist *Art Front* magazine in November 1936, for example, the German emigrée Charmion von Wiegand

picked up the social emphasis in her discussion of "Expressionism and Social Change":

> Expressionism as a form in art . . . arises always in a period of great social change, when the individual is forced to repudiate the principles on which society is built. . . . Out of the surrounding disintegration of social forms arises the stark and lonely son of man definitely [sic] facing the universe, seeking in the whispers of his blood and in his dreams, in madness even, in the romantic past of primitive cultures, in the exotic surroundings of natural man a safe escape from the complexities of modern life, which has ceased to function satisfactorily for the vast majority. . . . Such a confused rebellion is animated by both reactionary and progressive elements. But the general movement of Expressionism . . . is *forward* moving. Its destructive activism is necessary in clearing the ground for future building.[102]

Von Wiegand's definition, since overlooked in the American literature, gave to Expressionist art a progressive aura—modernist, though no longer specifically Marxist—that it was never to lose in the United States.

The artistic milieu in New York in 1936–37 was one in which leftist thought seemed to generate a committed, emotional art. At the American Artists' Congress in 1936, for example, David Siqueiros argued—in accord with Moscow's "Popular Front" strategy—that "differences of aesthetic opinion do not prevent us from uniting solidly on the all-important question of the defense of culture against the menaces, Fascism and War."[103] One of the young New York artists who worked with Siqueiros in Union Square that year was Jackson Pollock. And another champion of the emerging American avant-garde was the Russian-born John D. Graham, already a friend of Willem de Kooning and David Smith, who published an important book on modernist art in 1937. Graham ended his *System and Dialectics of Art* with an essentially Expressionist prediction of a new art for a new society. Advocating "the primitive" over "the cultivated" and coarse but healthy "peasants" over ineffective "intellectuals," Graham looked forward to a post-industrial art: "The birth of the machine age has laid the foundations of a new society. This new society will develop a new culture and new art; an art rooted in sturdy, heroic wisdom of the soil and work, an art pregnant and relevant."[104]

Perhaps the most committed exponents of post-industrial culture during the 1930s were the Mexican mural painters Siqueiros, Diego Rivera, and José Clemente Orozco. Of these, Rivera and Siqueiros were the orthodox Marxists: Rivera was lionized in Russia during a 1927–28 visit, and Siqueiros spent most of the 1960s in a Mexican jail for his revolutionary activities. But Orozco's problem was that he distrusted all ideologies—whether of the left or the right—and so he failed to toe the shifting Communist line as well as his colleagues. In his 1937 fresco called *The Carnival of the Ideologies* (Government Palace, Guadalajara), for example, Orozco not only depicts the Axis militarists Hitler, Mussolini, and Tojo, but introduces caricatures of the

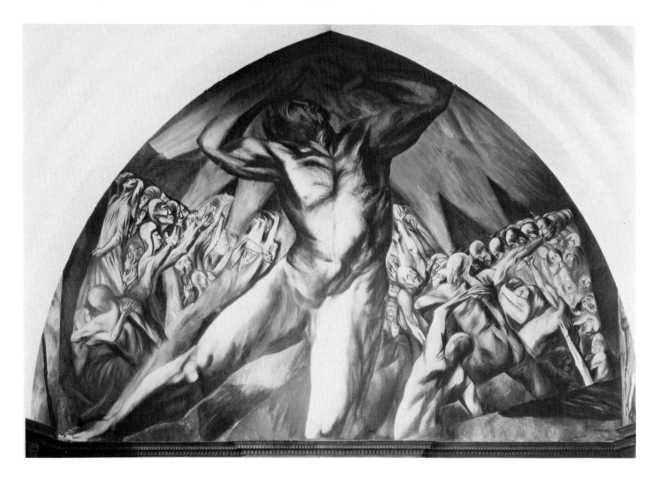

181. José Clemente Orozco, *Prometheus*, fresco, 1930. Pomona College, Claremont, California.

cleric and the Marxist as well. Moreover, Orozco's artistic attitude was clearly Expressionist. As he put it: "My one theme is HUMANITY; my one tendency is EMOTION TO A MAXIMUM; my means the REAL and INTEGRAL representation of bodies in themselves and in their interrelation."[105]

Orozco's 1930 fresco of *Prometheus,* painted at Pomona College near Los Angeles (fig. 181), may be seen as a kind of mythic representation of the Nietzschean *Uebermensch*. As Bernard Myers has described the work, men "recede" from the ascending hero with varying emotions, "depending on their respective reactions to the gift for which Prometheus defied the gods."[106] But these emotions of "terror, despair, smugness, and stiff-necked pride," it seems to me, are less appropriate responses to the gift of fire than to the strivings of a Higher Man who has transcended his uncomprehending brethren. In any event Orozco's Prometheus, twisted and pathetic, is less the Greek idealist adventurer than the Expressionist suffering hero.

In a similar manner, Orozco's Dartmouth College frescos of 1932–34 depict the evils of old world civilization that must somehow be overthrown by new world revolution. In the section of the narrative titled *The Machine* (Baker Library, Dartmouth College), for example, the white man's invention is seen as the engine of mankind's alienation and dehumanization—an engine that must somehow be reconciled with the needs of native American peoples. The message, as in Georg Kaiser's *Gas* dramas, is an Expressionist one (see sec. 4.6).

Orozco's most violently Expressionist mural was the 1934 fresco *Katharsis* in Mexico City's Palace of Fine Arts (fig. 182). Its title signifies modern civilization's purgation or cleansing destruction, just as Franz Marc's *Animal Destinies* (1913) evoked Nietzsche's "convulsion of earthquakes" and "moving of mountains and valleys" (fig. 7).[107] For above the lurid prostitutes with grotesque grimaces and the bare-chested native battling with his white-shirted oppressor, Orozco depicts the apocalyptic flames out of which a new order will arise. Even in his 1938–39 fresco of *The Four Elements,* Orozco makes of the foreshortened figure of Fire a self-consuming giant who yet affirms the essential optimism of the human spirit.[108]

Young Americans were interested in quite different aspects of

194

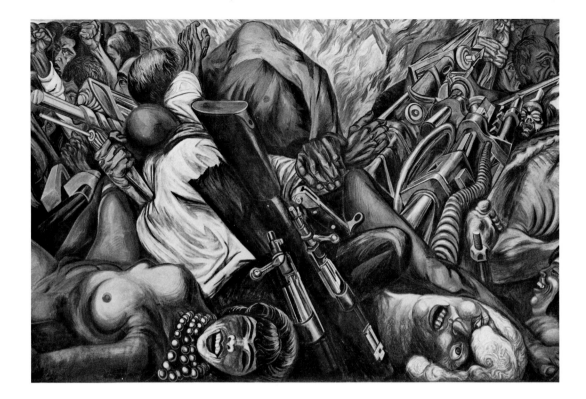

182. José Clemente Orozco, *Katharsis,* fresco, 1934. Museo del Palacio de Bellas Artes, INBA, Mexico.

Orozco's work. Pollock's *Porcelain Bowl* from about 1939 depicts elongated figures in a circular field, as did Orozco's *Four Elements;* moreover, Pollock reflected the Mexican's intense subjectivity by calling his bowl imagery "the story of my life."[109] But Marcus Rothkowitz—later Mark Rothko—appears to have studied Orozco's strongly structured *Subway* paintings of 1928–29 in developing his subway subjects of 1930–38.[110] Still, Rothkowitz's mild-mannered, well-crafted work was more typical of thirties Expressionism in New York than was Pollock's.

In fact the group called The Ten, in which Rothkowitz exhibited along with Adolph Gottlieb from 1935 to 1940, was the first Expressionist art group to be publicly recognized in America. In discussing The Ten's work in February 1937 in New York's *Art Front* journal, Jacob Kainen called its members "Our Expressionists." Drawing on von Wiegand's article on German Expressionism in *Art Front* a few months earlier, Kainen gave lip service to the group's political significance. In calling Expressionism "the vehicle for a socially revolutionary consciousness," Kainen advocated an urgent "shake-up of American art" in response to depression and Fascism.

"We are closer to chaos," he predicted, "than we think." Nevertheless, in actually defining the group's "Expressionist outlook," Kainen referred to raw emotion and expressive pigment:

> The Expressionist outlook is characterized by the following qualities, more or less;
> 1. The attempt to reduce the interpretation of nature or life in general to the rawest emotional elements.
> 2. A complete and utter dependence on pigment as an expressive agency rather than an imitative or descriptive one.
> 3. An intensity of vision which tries to catch the throb of life, necessarily doing violence to external facts to lay bare internal facts.[111]

Rothkowitz's *Self-Portrait* (fig. 183) epitomizes The Ten's Expressionism: it is painterly, subjective, somber, and yet poetic in mood. It does not, however, display a noticeably revolutionary consciousness.[112]

During World War II American Expressionism came more and more to appeal to the popular press, but in the work of individual artists rather than as a group phenomenon. Among the chief Expressionists of the time were older men like Max Weber (Rothkowitz's teacher) and Marsden Hartley; the New York painters Abraham Rattner, Paul Burlin, and Nahum Tschacbasov (a member of The Ten); and the Boston artists Jack Levine, Hyman Bloom, and Karl Zerbe.[113]

183. Mark Rothko, *Self-Portrait*, oil on canvas, 1936. Solomon R. Guggenheim Museum, New York.

184. Abraham Rattner, *Clowns and Kings*, oil on canvas, 1944. Collection of Esther Gentle Rattner, New York.

Rattner's 1944 painting of *Clowns and Kings* (fig. 184), like other examples of forties Expressionism, was freighted with anti-materialist meaning: "The 'kings,' in Rattner's symbolism, are those rich and powerful men whose success has become the measure of all human achievement. The 'clowns' are the grotesque, greedy, befogged fools who lust for the wealth they have neither the practical sense to achieve nor the sense of values to recognize as worthless. Among them . . . is that voice in the wilderness, the Artist."[114] And Levine's work managed to combine the earlier social protest viewpoint of Ben Shahn and William Gropper with the more painterly style—derived from Rouault, Soutine, and Kokoschka—preferred by American Expressionists. Levine's *Welcome Home* (1946) is a satire on militarism in peacetime, while his *Gangster Funeral* (fig. 185) embodies a typically Expressionist ambivalence in meaning. In Levine's words: "I

want the painting as a comedy. It must not be a tragedy. I will show the corpse but the emphasis could be on embalming."[115]

As these examples suggest, figurative Expressionism in the United States altogether lost the revolutionary edge that Cheney and von Wiegand had given it in the mid-1930s. Marxism was increasingly replaced by a kind of ambivalent emotionalism. Yet Cheney's formula of Marxism plus modernism was espoused once again, more effectively, by *Partisan Review* writers at the end of the decade. Led now by Clement Greenberg, art criticism this time used German Expressionist arguments to apply to a newly American abstract art.

The *Partisan Review* approach was the Nietzschean one of *The Will to Power*: decadence stood at the door, and only a countermovement in art could reverse the decline. Cultural pessimism was the danger that must be fought, beginning with Leon Trotsky's warning in

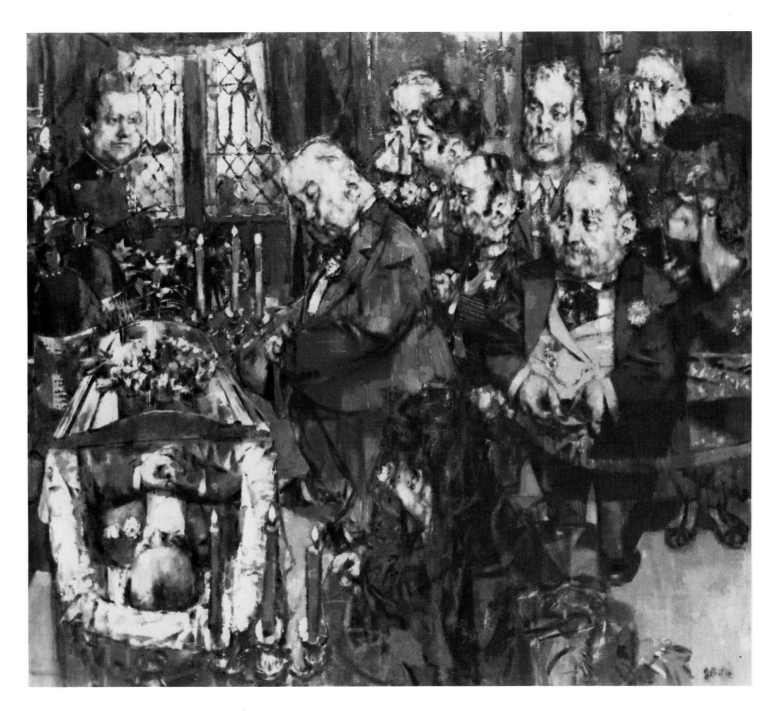

185. Jack Levine, *Gangster Funeral*, oil on canvas, 1952–53. Whitney
Museum of American Art, New York.

the summer of 1938 that "The decline of bourgeois society . . . [calls] forth an ever more burning need for a liberating art." The sickness was particularly prevalent in France, according to S. Niall's "Paris letter" early in 1939: "A spectre is haunting France—not, alas, the spectre of Communism, but that of internal fascism and external war." In America too there was little hope, according to Philip Rahv in a summer 1939 editorial entitled "Twilight of the Thirties." "This is the one period in many decades," Rahv wrote, "which is not being enlivened by the feats and excesses of . . . 'the younger generation.'" if on cue, W. H. Auden set the mood with his despairing poem "September 1, 1939," which begins as follows:

> I sit in one of the dives
> On Fifty-second Street
> Uncertain and afraid
> As the clever hopes expire
> Of a low dishonest decade

It is within this context that Greenberg spoke up *against* the decline of culture, which he, following Nietzsche, called "Alexandrianism":

> It is among the hopeful signs that in the midst of the decay of our present society that we—some of us—have been unwilling to accept this last phase for our own culture. In seeking to go beyond Alexandrianism, a part of Western bourgeois society has produced something unheard of heretofore: avant-garde culture. . . . Retiring from public altogether, the avant-garde poet or artist sought to maintain the high level of his art by both narrowing it and raising it to the expression of an absolute in which all relativities and contradictions would be either resolved or beside the point.

Greenberg's article from the fall of 1939 was titled "Avant-Garde and Kitsch," and he went on to castigate the role of "literature" in art in his piece called "Towards a Newer Laocoön" a year later. Greenberg's position led to an inevitable downgrading of the figurative type of French Surrealism. By 1943 Samuel Kootz could locate Surrealism "in the emptiness and decadence of France immediately before the present war." Meanwhile Rattner responded to a Surrealist show the previous year with these words: "Clever Barnum & Bailey stuff. . . . The keynote of the atmosphere is the word DIRGE. The song of death. Dilettante. Disease. Diarrhea. *Diable*. Decadent. Defeat."[116]

Moreover, after Greenberg became art critic for *The Nation* in 1941, his reviews became only slightly less hostile to figurative Expressionism than they were to figurative Surrealism. This was not because the art had "content" but because it lacked the quality of being avant-garde or, in other words, abstract. Yet Greenberg was *not* opposed to emotional content in advanced art per se; on the contrary, he grudgingly praised some aspects of the work of Beckmann and Hartley in 1944, and even of Hyman Bloom in 1946.[117] What he did believe, as he wrote in 1947, was that art "succeeds in

being good only when it incorporates the truth about feeling," and it "can now tell the truth about feeling only by turning to the abstract." As Piri Halasz has put it, "[W]ith Greenberg, the originality of the style meant that the painter was expressing more original and genuine feeling. This feeling became the content, and gained additional value in relation to its breadth, seriousness and forcefulness. He expressed his preference for Pollock, as opposed to Dubuffet, not only in terms of his greater stylistic originality but because Pollock had 'more to say in the end,' and 'a more reverberating meaning.'"[118] "Feeling become content through stylistic originality": this is as good a definition as we can give for the term "Abstract Expressionism." Indeed with this new label, and with the art to which the label was applied, Expressionism reached its last and culminating phase in early-twentieth-century art.

Greenberg's forties position is important for two reasons. First, it replaced political with aesthetic radicalism, the need for revolution with a romantic view of vanguard progress. Instead of Marxism plus modernism, Greenberg now advocated authentic emotional expression ("reverberating meaning") plus a formalist dialectic (Cubist and post-Cubist "abstraction")—or, in short, emotion plus modernism.[119] And second, Abstract Expressionism was a movement named and explained by critics, not artists. The label was truer to the aesthetic interests of American painters, I believe, than the word "Expressionism" had ever been for German artists. Greenberg provided the intellectual and aesthetic justification for a precariously unified movement. It was another influential critic—Robert M. Coates in *The New Yorker*—who first introduced the form to the American public in March 1946 in discussing the painter and art teacher Hans Hofmann.[120] Hofmann, born in Germany, immigrated to New York after having lived in Paris among the Cubists and then in Munich among Blue Rider artists and later Expressionists. In New York, he introduced his students in the 1930s and 1940s to varied aspects of European avant-garde art.

Insofar as the origins of Abstract Expressionism are concerned, Willem de Kooning was explicit: "Every so often a painter has to destroy painting. Cézanne did it and then Picasso did it again with Cubism. Then Pollock did it—he busted our idea of a picture all to hell. Then there could be new pictures again." I would date the Pollock initiative to the early 1940s. In 1941, in fact, according to correspondence between his brothers, Pollock was already interested in "men like Beckmann, Orozco and Picasso."[121] Expressionist sources (Beckmann, Orozco) were joined by Abstract ones (Picasso). Pollock's oil painting *Birth* (fig. 186) stems directly, in part, from Picasso's *Demoiselles d'Avignon*—both in its sexual symbolism and in its use of ritual masks.[122] The Pollock painting gains its significance from the fact that John D. Graham selected it for a major exhibition in January 1942—an exhibition which brought Pollock and de Kooning together for the first time—and then introduced Pollock to friends as "the greatest painter in America."[123] Moreover, Pollock's *Bird* (1941–42) (fig. 188, plate 23) is apparently a reversal, as I have argued

elsewhere, of Picasso's 1938 *Girl with Cock* (fig. 187). Symbolizing "the destruction of helpless humanity by the forces of evil," Picasso's painting depicts the *coq*'s (France's) castration by a bisexual *fille* whose head, according to Meyer Schapiro, "resembles no other female head by Picasso so much as it does his own head."[124] Reacting against both the triumph of Fascism and Picasso's recording of that triumph, Pollock's painting reviews the dead bird, now in the form of an American eagle surmounted by the eye of God (both from the back of the American dollar bill); the bird stands, in turn, astride a torso with severed neck, to either side of which lie two heads resembling the Picasso girl's split identity. Painted about the time of Pearl Harbor, Pollock's *Bird* "would predict a coming American *victory* over world Fascism, just as Picasso's *Girl with Cock* had once shown Europe victimized by the same evil. . . . Just as America will replace Europe as a political and military bulwark against world oppression, Pollock implies, so also will American *art* replace European art as the dominant force in world culture."[125] Thus the Pollock is both an example of Expressionist "reactivity," as I have defined it earlier, and a model of "American-type" painting which effectively consolidated American art's independence from Europe's.[126]

Of course, Abstract Expressionist criticism at the time recognized only Pollock's debt to Picasso's Cubism, not his debt to Picasso's Expressionism. In Cheney's *Expressionism in Art* (1934), Picasso is cited as saying: "Whilst I work, I take no stock of what I am painting on the canvas. Every time I begin a picture, I feel as though I were throwing myself into the void." And in 1947 Pollock made a similar statement: "When I am *in* my painting, I'm not aware of what I'm doing. It is only after a sort of 'get acquainted' period that I see what I have been about. I have no fears about making changes, destroying the image, etc., because the painting has a life of its own. I try to let it come through." But, also in 1947, Greenberg would not see Pollock's mode of creation as a vital and instinctual *process*. Instead, he saw only the surface evidence of the painting as completed *object*: "Pollock's strength lies in the emphatic surfaces of his pictures, which it is his concern to maintain and intensify in all that thick, fuliginous flatness which began—but only began—to be the strong point of late Cubism."[127]

Another difference between Abstract Expressionist criticism and the Continental art of Expressionism itself is that the Americans preferred the early Nietzsche, the Germans the later. In a 1937 article on "Primitive Art and Picasso," for example, John D. Graham wrote: "Primitive races and primitive genius have readier access to their unconscious mind than so-called civilized people." Nietzsche had said much the same thing in 1878: "I hold, that as man now still reasons in dreams, so man reasoned also *when awake* through thousands of years; the first cause which occurred to the mind . . . was sufficient and stood for truth. (Thus, according to travellers' tales,

186. Jackson Pollock, *Birth,* **oil on canvas, 1940–41. Estate of Lee Krasner Pollock.**

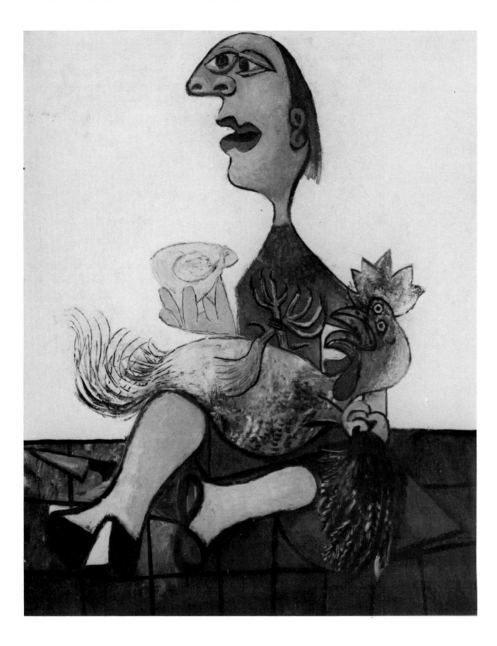

187. Pablo Picasso, *Girl with Cock,* **oil on canvas, 1938. Private collection on loan at the Kunsthaus, Zurich.**

savages still do to this very day)."[128] Whether through Nietzsche directly, or through Carl Jung, who prominently cited the Nietzsche passage,[129] the result was the same: Graham introduced New York painters to the notion of artistic renewal through primitive art. Certainly there are links between a Tlingit fringed blanket, owned by

Adolph Gottlieb, and his first Pictographs of 1941 such as *Eyes of Oedipus* (figs. 189, 190): both were constructed on similar grids. Indeed just as German Expressionists fused primitive and vanguard sources, so Gottlieb here combined references to American Indian, Egyptian, and Coptic art, as well as to Klee, Picasso, and Mondrian.[130]

On a more theoretical level, the early Nietzsche was quite influential for Gottlieb's closest colleague, who now was known as Mark

188. Jackson Pollock, *Bird,* oil and sand on canvas, 1941–42. Collection, The Museum of Modern Art, New York. Gift of Lee Krasner Pollock in memory of Jackson Pollock. (See also plate 23)

Rothko. Rothko had read *The Birth of Tragedy,* certainly by 1939,[131] and there is an important passage in a published letter of 1943 by Rothko and Gottlieb that paraphrases the Nietzsche source:

> We assert that the subject is crucial and only that subject-matter is valid which is tragic and timeless. (Rothko and Gottlieb, 1943)

> [T]ragedy . . . points to the eternal life of this core of existence [the thing-in-itself] which abides through the perpetual destruction of appearances. (Nietzsche, 1872)[132]

The early Nietzsche is the romantic Nietzsche, concerned both with the meaninglessness of godless nature (like Schopenhauer) and the opposite possibility of an eternal core or essence to life (like Kant). It is through this Nietzsche-induced access to German Romantic thought that Rothko's mature style and attitude would come to resemble those of Caspar David Friedrich.[133]

But there was also a brief moment around 1947 when Rothko, no longer figurative but not yet sublimely abstract, peopled his paintings with urgent and jostling luminous shapes, for example, *Number 26* (fig. 191). Here, too, he found a precedent in Nietzsche's *Birth of Tragedy:*

> I think of my pictures as dramas; the shapes in the pictures are the performers. They have been created from the need for a group of actors who are able to move dramatically

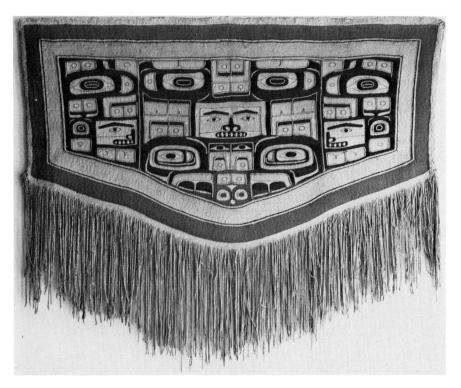

189. Tlingit fringed blanket, Chilkat. Collection Esther Gottlieb, New York.

without embarrassment and execute gestures without shame. (Rothko, 1947)

[A] poet is a poet only insofar as he sees himself surrounded by figures who live and act before him and into whose inmost nature he can see. (Nietzsche, 1872)[134]

Like the Rothko who needs his group of actors, the Nietzsche who visualizes acting figures around him is an existentialist—who is concerned, Hamlet-like, lest the "nausea" of knowledge inhibit necessary action.[135] It is no accident that, during the late forties, in the thinking of Philip Guston and others, French Existentialism affected the American movement.[136] Nor is it surprising that such existentialist thought affected Abstract Expressionist art criticism. Indeed, by 1952, the critic Harold Rosenberg sought to rename the New York artists "Action Painters": "A painting that is an act is inseparable from the biography of the artist. . . . The critic who goes on judging in terms of schools, styles, form, as if the painter were still concerned with producing a certain kind of object, . . . is bound to seem a stranger."[137]

By this time, ironically, Rothko the existentialist had reverted to Rothko the romantic, a color-field painter whose large, timeless shapes no longer evoked Expressionist associations. Nevertheless, the Nietzschean connection of the timeless and the tragic remained central for the later Rothko, though his original interest in Aeschylus gave way, with age, to a preference for "Shakespeare's tragic concept."[138]

Rosenberg's notion of "a painting that is an act" manages to combine two quite different concepts: the existential and the gestural, the emotional anguish "of confrontation, of impasse, of purging," and the physical movement of body, arm, and hand.[139] There are numerous Abstract Expressionist canvases that evoke one or both of these aspects of Action Painting—by Arshile Gorky in his response to the early Kandinsky,[140] by Franz Kline in his response to de Kooning,[141] and by de Kooning himself in the later 1940s and 1950s. De Kooning's *Light in August* (fig. 192), derives in part from the light/dark symbolism in William Faulkner's 1932 novel of the same title. De Kooning, a Dutch immigrant in New York, identified with what he called "that half-breed Joe Christmas," the novel's hero.[142] Though de Kooning's abstract forms are not intended to illustrate any particular incident in the Faulkner story, the painter's ambivalence about black and white seems to mimic the novelist's. Charles F. Stuckey has stressed the parallel in citing such Faulkner passages as these:

[Joe's] blood would not be quiet. . . . Because the black blood drove him first to the negro cabin. And then the white

190. Adolph Gottlieb, *Eyes of Oedipus*, oil on canvas, 1941. Courtesy of Adolph and Esther Gottlieb Foundation, NY © 1981.

blood drove him out of there, as it was the black blood which snatched up the pistol and the white blood which would not let him fire. And it was the white blood which sent him to the minister. . . .

After a time, a light began to grow beyond the hill, defining it. Then he could hear the car. . . . He watched his body grow white out of the darkness like a kodak print emerging from the liquid.[143]

And in de Kooning's painting the confrontation of white and black is, similarly, unresolved.

The gestural aspect of Action Painting comes through in de Kooning's fifties style, beginning with *Woman, I* (fig. 194, plate 24). Based on such Soutine paintings as *Woman in Red,* exhibited in New York in October 1950 (fig. 193), de Kooning's work builds up a much thicker and more complex paint surface—just as its iconography, ranging from the Hollywood sweater-girl to "Mesopotamian idols,"[144] possesses a richer range of cultural contradiction. The gestural quality of *Woman I,* if taken literally, records the countless hours, days, and months of rapid but wholly tiring arm and hand movements, movements which bespeak aesthetic tension, artistic frustration, and **203**

191. Mark Rothko, *Number 26,* oil on canvas, 1947. Formerly in the Betty Parsons Collection, New York.

motor conflict. Here, too, there is lack of resolution between physical exhaustion and instinctual renewal.

Harold Rosenberg saw Action Painting in many of the same terms that we have seen German Expressionism. He called it a "transformal" art and wrote that "it is precisely its contradictions . . . that make Action Painting appropriate to the epoch of crisis. . . . The artist's struggle for identity took hold of the crisis directly, without ideological mediation. In thus engaging art in the life of the times *as the life of the artist,* American Action Painting responded positively to a universal predicament." These words remind us that the concept of alienation, coined by Marx in the nineteenth century to describe labor's exploitation by the capitalist system, has become synonymous in our more psychological century with a loss of self. American Ex-

pressionism, in both its figurative and abstract directions, already reveals the "struggle for identity."[145]

In his 1956 study of Abstract Expressionist painting, William Seitz raised one more issue which related the American and the German movements. This was what he called the "problem of opposites" in the art enterprise. Starting with Nietzsche's opposed-but-related concepts of the Apollonian and the Dionysian, he found New York painting to involve such general questions as abstraction and representation, freedom and determinism.[146] But Seitz wrote, as it were, too soon. For a year later Gottlieb began his Burst series with such paintings as *Blast, I* (fig. 195), in which the dualist principle was pictorially—rather than just verbally—explored. As Lawrence Alloway has noted, the two forms "do not touch, but it feels as if they were bound together"; such readings as fire and earth, the solar and the tidal, order and chaos, atomic power and destruction, are all possible.[147] Gottlieb described the problem of these paintings as one of "juxtapos[ing] disparate images": "There has to be complete unity. But obviously unity and oneness doesn't mean anything unless you have some sort of polarities. In other words, there has to be a conflict. If there is no conflict and the resolution of some sort of opposites, there's no tension and everything is meaningless."[148] Like Max Beckmann in the thirties and forties, Gottlieb in the fifties and sixties was concerned with the resolution of the two into one.

5.6. AFTERMATH: END OF AN ERA

After the Nazi collapse in Europe there was no reason to link contemporary art with the Expressionist label—still associated with the Germans. Yet the ingredients for such a designation were briefly available. Art in the aftermath of Auschwitz and Buchenwald was often emotionally intense, becoming calmer only during the rebuilding years that ensued. In England Graham Sutherland's *Crucifixion* and Francis Bacon's *Painting* (fig. 196, plate 25), both from 1946, reflected the anguish of the early postwar period in raw and angry forms. In the Bacon oil not only the slaughtered ox but also the sense of suddenly arrested movement may well have derived from Soutine's work a quarter-century before. On the Continent Jean Dubuffet's *Corps de Dame* series of 1950–51 and Alberto Giacometti's *Man Pointing* of 1947 embodied that state of "alienation" which Dubuffet called "the condition proper to real creative activity."[149] Prompted by an interest in Hans Prinzhorn's 1922 study *The Artistry of the Mentally Ill,* Dubuffet's postwar collection of what he called *l'art brut*—"raw" or "uncultured" art, primarily of schizophrenics—would certainly have interested Paul Klee.

A particularly gestural kind of Expressionism came out of the 1948–51 group known as Cobra—an acronym for the cities of Copenhagen, Brussels, and Amsterdam, where most of the artists lived. In Asger Jorn's Danish oils, such as *Suicide's Counselor* (fig. 197) or the 1952–53 series on *The Mute Myths,* there is an especially compelling fusion of painterly power and childlike naiveté. The Cobra group was opposed equally to "Surrealist pessimism," "sterile ab-

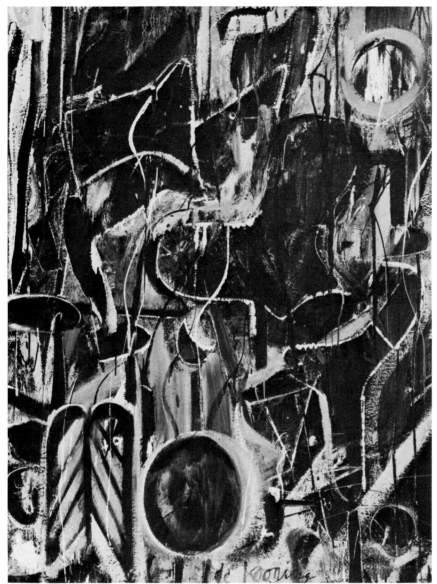

192. Willem de Kooning, _Light in August,_ ca. 1946. Teheran Museum.

straction," and "bourgeois naturalism," according to its manifestos, while its younger artists espoused a rather hackneyed equation between art and feeling. As Karel Appel put it in 1956: "Painting, like passion, is an emotion full of truth and rings a living sound, like the roar coming from the lion's breast."[150]

Nevertheless, during the 1950s, after Cobra, gestural abstraction became quite fashionable in Paris, as in New York. Around 1952 the European variety became known as _l'art informel_ ("intuitive art"), _un_ _art autre_ ("far-out art"), or _tachisme_ (an art of "spotting" or "spattering"). As these designations suggest, the Expressionist gesture was no longer linked to any purpose other than subjective utterance. In the New York school by the middle 1950s a Neo-Dadaist impulse denied meaning, rather nihilistically, even where meaning was marginally present.[151] In such paint-spattered pieces as the _Bed_ (1955) or the _Monogram_ (1959), for example, Robert Rauschenberg employed Expressionist means for totally anti-Expressionist ends. With the emergence of Pop Art, Minimalism, and Post-Painterly Abstraction after 1960, the entire direction of Abstract Expressionism in all its philosophical and aesthetic richness was made to seem either outmoded or absurd.

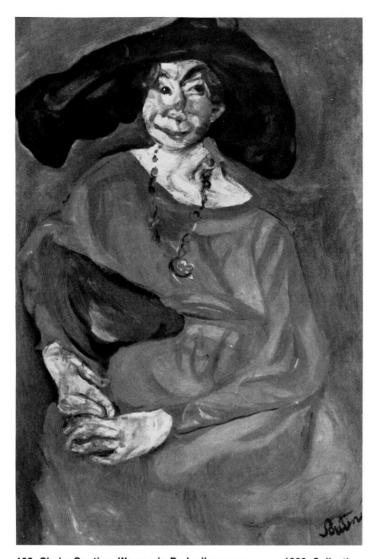

193. Chaim Soutine, *Woman in Red,* oil on canvas, ca. 1922. Collection E. M. Bakwin, Chicago.

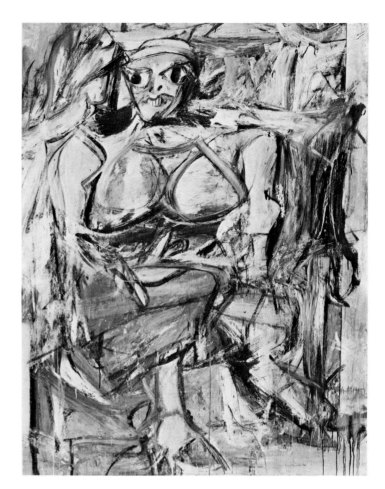

194. Willem de Kooning, *Woman, I,* oil on canvas, 1950–52. Collection, The Museum of Modern Art, New York. (See also plate 24)

Most of the German Expressionists had been born in the 1880s and had matured around 1910; most of the American and European Expressionists, like the Abstract Expressionists themselves, were born in the 1900s and matured around 1940. Just about a generation separated them, the generation between Sarajevo and Pearl Harbor.[152] No third generation immediately followed. Of artists born around 1930 a handful displayed Expressionist tendencies in Europe,[153] yet few such tendencies emerged in the United States. Few Americans after 1960 risked a "hot" art in a "cool" culture.[154] The Eisenhower years marked the end of an era.

The peculiar reticence of American youth just after mid-century may result from the fact that they were, in Kenneth Keniston's pointed phrase, "stranded in the present."[155] In his pioneer study of college students in the 1950s Keniston noticed "the emphasis on sensation, sentience, and experience; the reluctance to make future commitments, the sense of temporal confusion; the extreme emphasis on the present; the choice of 'realistic' and present-oriented values." Depression-born adolescents seemed to deny both the dreams and the drama of their own parents' lives. They could not cope with change; they did not know that "truly to assimilate it involves retaining some sense of connection with the past, understanding the relation of one's position to one's origins and one's destinations." Instead of expressive art, these Fifties students espoused the conformism of American suburbia. They distrusted rebellion.

195. Adolph Gottlieb, *Blast, I,* oil on canvas, 1957. Collection, The Museum of Modern Art, New York, Philip Johnson Fund.

The paucity of Expressionist recruits around 1960 has another, if related, explanation, namely a failure of the myth of vanguard progress. As late as 1962 Renato Poggioli complained that "avant-gardism has now become the typical chronic condition of contemporary art," but he still hoped that the modern spirit would triumph: "For it, not to renew itself means to die." Yet Poggioli's ambivalence was, just then, being pessimistically resolved. For Seitz in 1963, followed by Douglas Cooper in 1964, were already noting the "dissolution of the avant-garde" and the co-option of further artistic progress by "vested interests" in the cultural establishment. This perception of the avant-garde's demise—whether or not there had really been a vanguard, and whether or not it had truly ended—was disastrous for the prospect of further Expressionist experiment. For Expressionism had always both required and engendered change; Expressionist renewal required the vanguard tradition of the new. The game was over when Max Kozloff wrote, disparagingly, about the Expressionist artist's "charade of liberation." For in his 1964 study of "The Dilemma of Expressionism," Kozloff recognized that an art of feeling was so "alien" to current critical thought "that Expressionist art begins to look inflated and bombastic."[156]

The "Expressionist art" that Kozloff described was one shorn of philosophic meaning and social purpose. Its trait was "solipsism." Unrelated to hopes for renewal or fears of decline, the art ran uninterruptedly from Van Gogh and the Fauves through the Germans and Americans to end with Dubuffet and Jorn. In such art the painter's use of emotion "reeks of symbolism." The tragedy of Expressionism, Kozloff wrote, was that "[the artist] cannot maintain—nor can anyone, literally speaking—a prolonged state of mental anguish or anger, least of all over a whole career. If we are to take the presumption of Expressionist painting at face value, then we must suppose that we are witnessing a continuous, even discharge of the most intense and excruciating feeling that human beings can experience."[157] This was, of course, nonsense. Once set up, the straw man of Expressionist "feeling" was readily demolished. Like the allegedly "Gothic" Expressionism of the teens and the reportedly "degenerate" Expressionism of the thirties, the supposedly "emotionalist" Expressionism of the sixties was a creation of art criticism that bore little relation to the art itself.[158]

5.7. TOWARD NEO-EXPRESSIONISM

Expressionist art, in fact, survived its demolition by art critics. But it did so in a form and manner unexpected by observers in New York and Paris, namely as a broad, international movement stretching from Germany and Italy to England and the United States. The movement coalesced in the late 1970s and became known around 1980 as Neo-Expressionism.

The precursor of the movement in Germany was Josef Beuys, who was still part of the second Expressionist generation, if only barely. He was born in 1921, nine years after Pollock but four years before Karel Appel, and he had his first museum show in New York in 1979

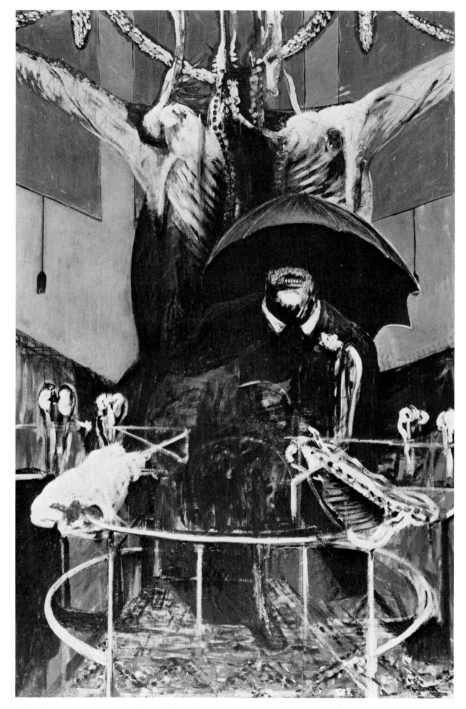

196. Francis Bacon, *Painting,* oil and tempera on canvas, 1946. Collection, The Museum of Modern Art, New York. (See also plate 25)

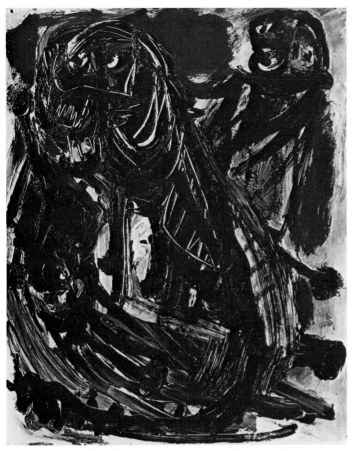

197. Asger Jorn, *Suicide's Counselor*, 1950. Collection of Erling Koeford, Copenhagen.

when he was almost sixty. Beuys' primary contribution was to re-introduce German Expressionist iconographic concerns into the international avant-garde, specifically the subjective and auto-biographical ideas of death and rebirth. This occurred in drawings as early as 1955–56: "*Self in Stone*," he wrote, "represents myself in part as a figure in a coffin. This is the stone coffin of initiation through death in druid cults. And here is the *Dead Man on Stag's Skeleton.* This concerns a special period in my own life when I wished to come to death. Like the stag and the stag leader before it has to do with resurrection and a full life after death."[159] In such mythic concerns Beuys was reviving traditionally Germanic ideas; he had in fact al-most died in a crash as a Luftwaffe pilot. But the period was not ripe for an Expressionist presentation of these ideas. Instead, as a re-sponse to "happenings" in New York, Beuys began to stage "ac-tions" in Europe, including *Twenty-Four Hours* in 1965 and *Eurasia* in and after 1966. In their absurd effect these performances were Neo-Dadaist.

Post-Nazi Germans were also forced, willy-nilly, into a committed social stance which echoed that of the Expressionists half a century earlier. A precursor here was Günter Grass, who published *The Tin Drum* in 1959. In it Grass, who was born in 1927, told the story of a dissident born the same year who had led a teenage gang in sabo-taging the Nazi war effort in Danzig in 1944. One of the gang mem-bers gave the group's rationale: "We have nothing to do with parties. . . . Our fight is against our parents and all other grownups, regardless of what they may be for or against."[160] Grass' view, de-spite an overtone of parody, not only echoed German Expressionist precedent but also anticipated the various protest movements of the later 1960s in Germany and elsewhere.

Youth's function was to protest. This was the lesson learned by a completely new generation—one born during the war and reconstruc-tion years of the 1940s and early 1950s. In 1963 a rock group in Liver-pool recorded the hit song *She Loves You* and, within months, The Beatles' sound had changed teenagers' tastes from Berlin to Los Ange-les. In 1964 the Free Speech movement was proclaimed at Berke-ley and, within a year or two, the passivity of American students yield-ed to a new activism. From Haight-Ashbury in the summer of 1967 to Central Park in the summer of 1968 middle-aged and middle-class America was disowned by its children. As Bob Dylan put it in 1965:

> How does it feel, how does it feel
> To be without a home
> Like a complete unknown
> Like a rolling stone?[161]

German students took over their universities, forcing a revision of at least some antiquated rules. Anarchy threatened, espoused by the Baader-Meinhof gang in Germany and Daniel Cohn-Bendit in Paris. In May of 1968 a double strike of students and of workers almost toppled the French regime of President Charles de Gaulle. Mean-while Lyndon Johnson, architect of American military policy in Viet-nam, announced he would not run for reelection.

The politics was passive resistance; the goal was a moratorium on militarism and violence, precisely the "spiritual" goal of earlier Ex-pressionist activists. Public opinion in Europe and America, weary of the Vietnamese slaughter, finally sided with the defiant young against their apparently ineffectual elders. "All political systems are on the way out," in Arlo Guthrie's words of 1969. "We're finally gonna get to the point where there's no more bigotry or greed or war. Peace is on the way. . . . People are simply gonna learn that they can get more by being groovy than by being greedy." Sixties adolescents achieved more than had thirties Marxists, as Lillian Hellman grudgingly admit-ted: "God knows many of them are fools, and most of them will be sellouts but they're a better generation than we were."[162]

Advocates of the counterculture were young: under thirty, under twenty-five, sometimes under twenty. In America they went directly from school into uniform or into hiding; for them there was no longer the chance of being stranded in the present. Counterculture art stressed intermedia experiment and instantaneous rapport between **209**

artist and audience. Mind-bending empathy replaced abstract thought. Jimi Hendrix and Stan Brakhage, Fillmore West and Woodstock, *Dog Star Man* and *Easy Rider*—all embodied highly expressive, if not also Expressionist, elements. But aside from psychedelic painting, counterculture visual art embodied Dadaist rather than Expressionist gesture. A good example is the Lidl activity in the late sixties by one of Beuys' students, Jörg Immendorff. Born in 1945, Immendorff chose the word "Lidl" as a nonsense word, derived from baby sounds, exactly as the term "Dada" had been selected half a century before.[163] And in 1968 the twenty-two-year-old art student staged a *Lidl-Action* before the German Bundestag in Bonn, which was directed at Germany's "unspiritual and uncreative" politics. The performance consisted of Immendorff walking by the government building trailing a wooden block inscribed "Lidl" and painted in the West German national colors of black, red, and gold.[164]

Expressionist visual art, as we have seen, was out of fashion in the 1960s; Action Painting and *tachisme* were despised as art forms that were selling, by then, for six figures per canvas on the art market. Indeed, the end of *all* vanguard painting was being regularly announced, and a retrospective mood dominated the museum world. Just when the avant-garde was allegedly expiring in New York, in fact, Expressionist painting was reemerging around the globe in historical exhibitions. Particularly in Italy, France, and England—where an interest in Expressionism had long been restricted to Germanophiles—there was an amazing turnaround. "In the single year 1964, for example, the *Mostra L'Expressionismo* was held at the Palazzo Strozzi in Florence, the Aix-en-Provence periodical *L'Arc* devoted a hundred-page issue to *Expressionnisme* (including the first French translations of most major German poets and writers), and London's Tate Gallery mounted the Arts Council show *Painters of the Brücke.*"[165] There followed other approaches to the subject in 1970: *L'Expressionnisme Européen* in Munich and Paris, which rested unconvincingly on visual similarities, but also *Germany in Ferment,* which focused on the radical aspects of German art and politics and which traveled late in the year from Durham to Sheffield to Leicester in England. Meanwhile, loan exhibitions of German Expressionist art were sent to such places as Salonika, Athens, and Beirut in 1962, and to Moscow and Tokyo in 1971,[166] and Abstract Expressionist canvases were being concurrently displayed. Even where exhibitions could not be mounted, as in East Germany and other Soviet-bloc countries, magazine articles and illustrations were avidly collected. Expressionist painting had become history.

Yet in the aftermath of Kent State, the Vietnam ceasefire, and especially the 1973–74 oil crisis, all this changed. On the one hand the free speech agitators, freedom marchers, and draft-card burners, having accomplished much of their mission, returned to a world of drab and materialist reality. Having briefly believed that "We shall overcome," few youngsters of the 1970s still hoped for the coming of a "New Man" in the future. Throughout the West, the seventies were an era of diminished expectations. But on the other hand the

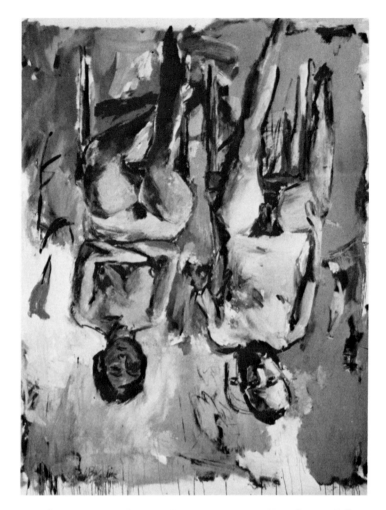

198. Georg Baselitz, *Family,* oil on canvas, 1975. Mary Boone Gallery, New York, and Galerie Michael Werner, Cologne.

arena of action gradually shifted from public to private protest, from social to artistic radicalism. Once again, after the sterile decade of Post-Minimal and Conceptual Art, there began to be what Wolfgang Max Faust has called a "hunger for pictures."[167] Among the German pioneers was Georg Baselitz with his *Eagle* (*Fingerpainting I*) of 1971–72 or his *Family* of 1975 (fig. 198). Born in 1938, Baselitz was the same age as The Beatles but required an additional decade to find his style. He had been born Georg Kern in Deutschbaselitz, near Dresden, but attempted to keep his East German identity when he moved to West Berlin in 1956; nevertheless, he was expelled from the East Berlin Kunst Hochschule the next year for "social and political immaturity."[168]

Baselitz's seventies style has both aesthetic and anti-aesthetic implications. The rich, painterly surfaces recall those of the fifties de Kooning. And the upside-down subject matter is perhaps a reference to fifties art pedagogy in the United States: inverting the images "with their heels to heaven" was a method of demonstrating, at that time, that "painting was really about painting."[169] On the other hand, Baselitz really paints his pictures the way they appear—at odds with both his own and his viewers' normal mode of vision—in order to create an "alienation effect," "a provocation of shocks and aggressions" for the viewer.[170]

A. R. Penck is an almost exact contemporary of Baselitz's, and like him, he also grew up in East Germany (Dresden) and took a pseudonym as substitute for his true identity (Ralf Winkler). Penck's early-seventies style, revived in the 1980s, fused the pictographs of late Klee with the stick-figures of anonymous graffiti artists. His imagery has political and absurdist implications, with titles like *Camp Blues, Atomicon,* or *Birth of Mike Hammer,* all from 1974, or again *The Siege and Taking of Beirut* from 1982.

Like Jörg Immendorff, Anselm Kiefer was born in 1945 and became a student of Josef Beuys. Immendorff was influenced by Renato Guttuso's *Caffé Greco* of 1976 and began his satirical series called *Café Deutschland* the following year.[171] But Kiefer throughout the seventies deepened his grasp of the Germanic ideology/mythology that Beuys had pioneered. Moreover, like Beuys, he worked in unorthodox media. His large 1983 painting *To The Unknown Painter* (fig. 199), for example, combines oil, emulsion, woodcut, shellac, latex, and straw on canvas. In dedicating the work to an artist instead of to an unknown soldier, as John Caldwell notes, Kiefer "mourn[s] the damage done by the Nazis to German art"; "[he] attempts, and by his success achieves, the rebirth of the culture that Hitler attempted to destroy."[172] Arguably the most gifted of the Neo-Expressionists, Kiefer seems to make the German past relevant to the present and, simultaneously, to keep it at a steady and sardonic distance.

By 1978 or so, the kind of painting pursued by these Germans began to appear more or less independently in Italy and America. As the New York painter Susan Rothenberg (born 1945) put it: "I think Expressionism just zipped in to fill the vacuum of Minimalism. Things rush into empty places and Minimal art had become an empty place." Of the Italian Neo-Expressionists, Sandro Chia is the most complex. Born in Florence in 1946, Chia grew up surrounded by Renaissance art, but after traveling to India in 1970 he gradually developed a primitivizing style related to those of Malevich and Chagall. In his words: "People say I'm in a European tradition, but I'm making graffiti from what I know."[173] Moreover, in rejuvenating his art Chia drew on earlier philosophy, mythology, and folk tales with such titles as *Heraclitus and His Other Half* or the 1980 *Dionysus' Kitchen* (fig. 200, plate 26). In the latter oil a sailor pulls a distant swing on which a girl rides with flying skirts; erotic content is visualized as an explosion of myriad colored paint strokes. The idea of artistic revitalization relates Chia's work to Nietzsche and to the German Brücke, but there is also

a conceptual dimension to his work that relates it to de Chirico. Indeed the artist denies an existential "bridge" from art to idea in favor of a metaphysical "jump."[174]

The American painter Julian Schnabel was born in New York in 1951 and exhibited in Milan and Düsseldorf in 1977–78. Like Kiefer, Schnabel uses unorthodox materials—including colored velvets and broken crockery. It was in July 1978 that Schnabel, studying Gaudi's work in Barcelona, first thought of making mosaics.[175] Instead he created paintings with fractured plates, including the *Head (For Albert)* (fig. 201, plate 27). In these works the imagery is drawn from a wide variety of sources, including art history (Goya, Caravaggio, Kokoschka), portrait photographs (of William Burroughs, Celine), children's books and artists' instruction manuals. In *Head (for Albert)*, for example, the face raised to expose the neck was drawn from an anatomical text, but the blue color of the plates and the dedication to Albert Camus confirm that the subject is, in Schnabel's words, "drowning, death." He does not "illustrate" *The Stranger,* but tries to find a "shared" equivalent in paint for the hallucinations and suffering described in words by the novelist. The result is "a kind of existential painting."[176] Schnabel's encrusted surfaces sometimes recall the detritus embedded in Pollock's thick paint: nails, buttons, keys, coins, cigarettes, and matches, for example, in the 1947 *Full Fathom Five.* But a truer analogy is to Rauschenberg's combine-paintings of the 1960s, which are syncretic, internally contradictory, and emotionally distancing. One senses that Schnabel does not himself feel the emotion that his agitated surfaces seem to evoke.[177] Instead, a cryptic construction that encodes feeling, a Schnabel painting is in his words "the application of a layer of information to the support."[178]

Schnabel, Chia, and the Germans discussed above are typical of dozens of Neo-Expressionists in Europe and North America.[179] Their art came to mass public attention through eighties exhibitions announcing the new movement, including London's *New Spirit in Painting* and Cologne's *Westkunst* in 1981; New York's *Italian Art Now* and *The Pressure to Paint* in early 1982; Kassel's *Documenta 7* and Berlin's *Zeitgeist* later in 1982; Los Angeles' *New Figuration* and St. Louis' *Expressions* in 1983. Since no two shows were limited to the same artists, however, there was no critical consensus as to just what Neo-Expressionism was.[180]

But there was some agreement as to what the movement was *against.* For the "new Expressionism," like the old, arose at a troubling historical moment. As Christos Joachimides stated, in the catalogue to the first of these shows, painting's New Spirit was a response to the increasing pessimism of the later 1970s: "The optimistic belief, so widespread in the 1960s, that the ills of society could be quickly rectified through sufficiently active personal commitment, did not last long into the 1970s; the oil crisis [of 1973–74] and the threat to material well-being it ushered in led to widespread feelings of resignation and mistrust. The more insecure one's material future seemed, the more inviting became the contents of the imagination." Even Clement Greenberg, no friend of figural Expressionism, recognized the chal-

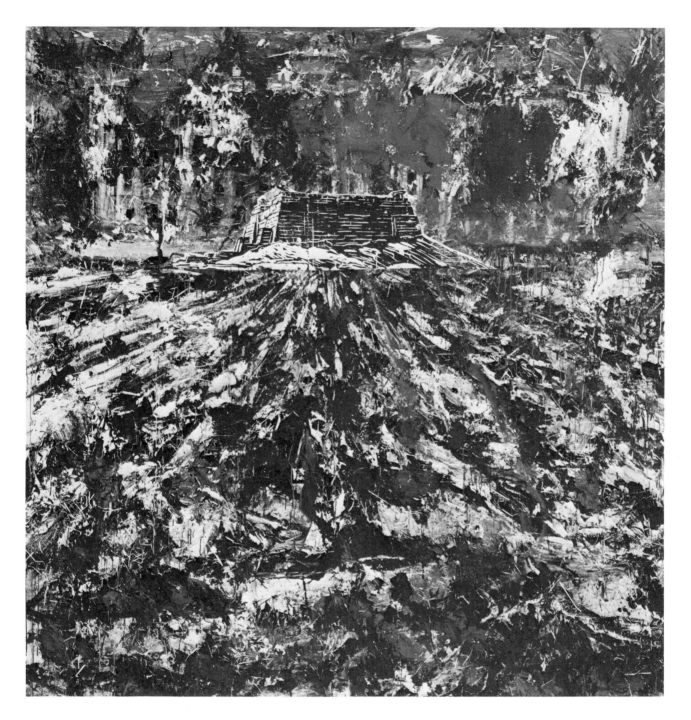

199. Anselm Kiefer, *To the Unknown Painter,* oil emulsion, woodcut, shellac, latex, straw on canvas. Carnegie Museum of Art, Pittsburgh. Gift of Richard M. Scaife and A. W. Mellon Acquisition Endowment Fund, 1983.

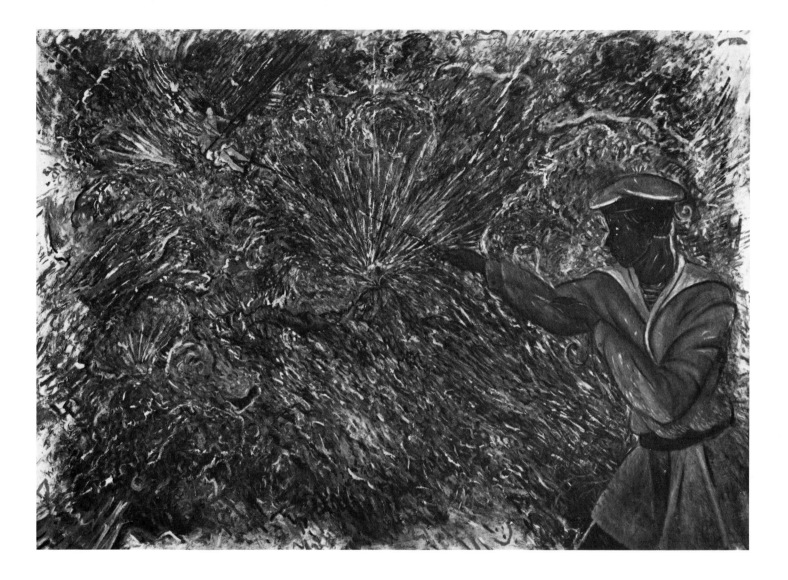

200. Sandro Chia, *Dionysus' Kitchen,* oil on canvas, 1980. Marx Collection, Berlin. (See also plate 26)

lenge implicit in the historical situation. For he equated the pessimism of the period with that "decadence" which had concerned him and other *Partisan Review* writers some forty years before: "Cultures and civilizations do run their 'biological courses.' The evidence says that, and the evidence forces me to accept Spengler's scheme in largest part. . . . If Western lateness, which means Western decline, is an actual fact, then our culture is headed—in Spengler's scheme—towards the same fate that overtook all previous, all other high cultures. It will become lifeless in the same way. But this will mean, as it now looks, far more than it did in those previous cases. Because then there'll be no more living high urban culture anywhere." Greenberg wrote in support, of course, of high "aesthetic standards" as an "answer" to decadence.[181] What Joachimides called "the sheer joy of painting" was hardly enough to "cope with" Spengler's gloomy prediction of inevitable societal decay. But however much the critics might disagree on the merits of Neo-Expressionism, both apparently saw it as an answer (or non-answer) to the same mood of emptiness and despair. Around 1980 as twice earlier, around 1905 and around 1940, Expressionism was a response to a broad cultural fear of decline.[182]

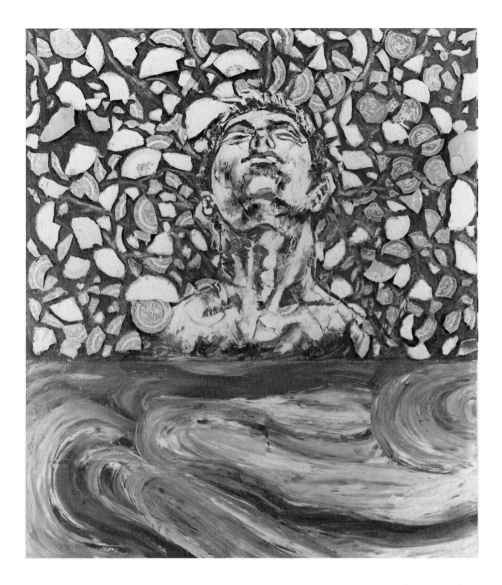

201. Julian Schnabel, *Head (for Albert),* oil on canvas, 1980. Emmanuel Hoffmann Foundation, Museum für Gegenwartskunst Basel. (See also plate 27)

5.8. AFTERWORD

The issues raised here reach far beyond art and the artist. For we have seen Expressionism as being dependent, in the final analysis, on cultural and psychological factors in the society at large. Mine is not a Marxist approach: this particular middle-class art is not, except in the broadest sense, socioeconomically determined.[183] But neither is it a Freudian approach: the childhoods and drives of artists have been mentioned almost exclusively in their social contexts. Marxists and Freudians appear as critics, of course, but not as key instigators of the art.

Instead I have tried, more or less consistently, to focus on the issues of social identity and cultural pessimism. Following Erik Erikson's *Identity: Youth and Crisis* (1968), I have argued for the importance of adolescence in the production of Expressionist art. And following Fritz Stern's *Politics of Cultural Despair* (1961), I have suggested the extent to which Expressionism was, and remains, a product of such despair. In the process I have tried to avoid the standard definition of Expressionism, so common for a generation, as being only an art of emotion subject merely to emotional response. To the contrary I believe that a vigorous and "youthful" art, such as Expres-

sionism, remains a primary bulwark against the "biological" destinies feared by Nietzsche and Spengler. Despite the potential weaknesses of such art—too little form or too much instinct[184]—Expressionism at its best can bridge the chasm between life and culture, between the social values of freedom and discipline.

What are Expressionism's prospects, then, for the near future? As early as 1973 I wrote that the new interest in Expressionist art came from a generation rediscovering German cultural and social hopes of 1918 as a model for their own aspirations. And I saw in the art schools of Germany and the United States an Expressionist orientation that has since come to fruition.[185] But, more than this, I then asked "whether there is anything *better* than Expressionism (in whatever form it takes) in a 'post-avant-garde' period":

> The contradiction between progress and tradition [I continued] is still as unresolved as it was when Expressionism and high art were (briefly) congruent. For high art will continue to be invented, valued and housed so long as history books determine reputations, and futures the free market. But, as we are recently learning, high art can also be de-accessioned and forgotten, once its moment passes from public taste. How dedicated to historicity should an artist be, to justify his art by a decade of "fame" and the promise of being briefly "rediscovered" twenty-five and fifty years hence? . . . [A]rtists seeking to avoid this dilemma today wish to transcend not only high art but the traditional nature of art itself.[186]

Short of a startling reintegration of high culture in the West, one capable of rivaling that of Cézanne, Matisse, and Picasso around 1900, I believe that Expressionist tendencies will endure, if not necessarily predominate, for some time to come.

But this means that certain social issues will also be with us as well. Two generations after German painting and German film came to grips with identity questions, for example, they have now become important American problems. As Andrew M. Greeley reported to an American congressional committee in 1970: "One of the most extraordinary events of our time has been the resurgence of tribalism in a supposedly secularized and technocratic world. Science and economic rationalization had been expected to reduce, if not eliminate, man's attachment to ancient ties of common ancestry, common land and common faith, but suddenly ties of race, nationality, and religion seem to have taken on new importance."[187] The ethnic revival of the 1970s, following upon the new enfranchisement of Blacks in the 1960s, was matched by significant struggles for women's rights and gay rights. Like the Jew who had "passed" as German earlier, the American assimilationist Jew, or Mexican, or Pole, or Italian, now found himself or herself "an orphan in history."[188] Instead of taking pride in their traditional "melting-pot," many adult Americans were questioning it. In the aftermath of sixties upheavals, they were all discovering themselves to be among ethnic, racial, religious, or sexual minorities.

More than this, recent findings on the frontier of science suggest that we *all* contain within ourselves the split personalities which German Expressionists discovered within themselves earlier. If German culture created the *doppelgänger,* American pioneers in artificial intelligence have created the Triple-, Quadruple-, or Multiple-*gänger,* which they call The Society of Minds: "[Marvin] Minsky and [Seymour] Papert argue that the mind is composed of many smaller minds, which are themselves composed of yet smaller minds. These minds, or agents, and the connections between them, form a society known as the self. This theory . . . they call The Society of Minds."[189] Moreover, as a research report indicates, the different minds are activated precisely in those oppositions or pairs which Nietzsche and some Expressionists stressed in their cultural productions.[190] Expressionist culture is, once again, predictive of a more general cultural state.

On the topic of decadence here, too, modern science recognizes the reality of an issue which first engrossed Expressionists. The psychologist of art Rudolf Arnheim has examined the problem from the viewpoint of entropy, that potential for cosmic heat-death or absolute equilibrium which was so feared at the turn of the century. And to close his study on *Entropy and Art* Arnheim issues not only a call for "articulate structure" in art, but also a plea for art to reflect "the human condition whose particular form of order it [art] makes visible or audible." Not only must art avoid excessive structure ("art is not meant to stop the stream of life"), but the very progress of culture depends on this avoidance. Furthermore, concerning the final balance between decline and renewal, decadence and rebirth, Arnheim is guardedly optimistic: "Within a narrow span of duration and space the work of art concentrates a view of the human condition; and sometimes it marks the steps of a progression, just as a man climbing the dark stairs of a medieval tower assures himself by the changing sights glimpsed through its narrow windows that he is getting somewhere after all."[191]

Notes

INTRODUCTION

1. Donald E. Gordon, "On the Origin of the Word 'Expressionism,'" *Journal of the Warburg and Courtauld Institutes* 29(1966); 368–85.

2. John M. Spalek, et al., *German Expressionism in the Fine Arts: A Bibliography* (Los Angeles: Hennessey & Ingalls, 1977).

3. Paul Raabe, ed., *Index Expressionismus: Bibliographie der Beiträge in den Zeitschriften and Jahrbüchern des literarischen Expressionismus 1910–1925* (Nendeln, Liechtenstein: Kraus-Thomson, 1972), 18 vols.

4. Peter Selz, *German Expressionist Painting* (Berkeley: University of California Press, 1957).

5. Victor H. Miesel, ed., *Voices of German Expressionism* (Englewood Cliffs: Prentice-Hall, 1970), 7.

6. German scholarship initially preferred the Selz chronology; cf. Wolf-Dieter Dube, *Expressionism,* tr. Mary Whittal (New York: Oxford University Press, 1972). But, in addition to Miesel, other Anglo-British sources have stressed the post-1914 years, e.g. John Willett, *Expressionism* (New York: McGraw-Hill, 1970); and Orrel P. Reed, Jr., *German Expressionist Art: The Robert Gore Rifkind Collection* (Los Angeles: Frederick S. Wight Gallery, 1977).

7. Donald E. Gordon, "Expressionism: Art by Antithesis," *Art in America* 69(March 1981):98–111, esp. 103–05.

8. Gelett Burgess, "The Wild Men of Paris," *The Architectural Record* 29(May 1910):400–14, esp. 414.

9. Frederick Copelston, *A History of Philosophy: Schopenhauer to Nietzsche* (Garden City: Doubleday, 1956), vol. 7, part 2, 191.

10. Donald E. Gordon, "Content by Contradition," *Art in America* 70(December 1982):76–89.

11. In *The Will to Power,* trans. Walter Kaufmann and R. J. Hollindale (New York: Vintage, 1968), sec. 847, Nietzsche asks: "Whether behind the antithesis classic and romantic there does not lie hidden the antithesis active and reactive?"

12. Ida Katherine Rigby, *An alle Künstler!: War—Revolution—Weimar* (San Diego: San Diego State University Press, 1983).

13. Miesel, *Voices of German Expressionism,* 7–8.

14. Alessandra Comini, *Egon Schiele's Portraits* (Berkeley: University of California Press, 1974), 1f.

15. Michel Foucault, *The Order of Things: An Archaeology of the Human Sciences* (New York: Pantheon, 1970), xxii–xxiv.

16. Ellen C. Oppler, *Fauvism Reexamined* [1969] (New York: Garland Publishing, 1976), 201–04; cf. Theda Shapiro, *Painters and Politics: The European Avant-Garde and Society, 1900–1925* (New York: Elsevier Scientific Publishing, 1976), 28–29.

CHAPTER I

Paul Gauguin, *Lettres de Gauguin à sa femme et à ses amis,* ed. Maurice Malingue (Paris: B. Grasset, 1946), 319, no. 181.

1. Friedrich Nietzsche, *The Will to Power,* tr. Walter Kaufmann and R. J. Hollingdale (New York: Vintage, 1968) 261, 243, secs. 466, 440.

2. Friedrich Nietzsche, *Beyond Good and Evil*, tr. Walter Kaufmann (New York: Vintage, 1966), 21, sec. 14; 21, sec. 13; 22, sec. 14; for Socrates as "moralizing" scientist, see *The Will to Power*, 245, sec. 443.

3. Nietzsche, *The Will to Power*, 44–46, secs. 68, 69. As the "nihilist trait" in art Nietzsche named "romanticism" and its sequels.

4. Franz Marc, "Two Pictures," in Wassily Kandinsky and Franz Marc, eds., *The Blue Rider Almanac* [1912], doc. ed. Klaus Lankheit (New York: Viking, 1974), 65–69, esp. 65.

5. Peter Selz, *German Expressionist Painting* (Berkeley: University of California Press, 1957), viii; Wassily Kandinsky, "Der Blaue Reiter (Rückblick)," *Das Kunstblatt* (February 1930):57–60, esp. 60, as tr. in Kenneth C. Lindsay and Peter Vergo, eds., *Kandinsky: Complete Writings on Art* (Boston: G. K. Hall, 1982), vol. 2, 748; Emil Nolde, *Jahre der Kämpfe* (Berlin: Rembrandt, 1934), 242.

6. Nietzsche, *The Will to Power*, 419, sec. 794. These words are used to open the chapter entitled "The Will to Power as Art."

7. Ernst Ludwig Kirchner, "Letter of 17 April 1937," *Ernst Ludwig Kirchner* (New York: Curt Valentin Gallery, 1952), n.p.

8. Wassily Kandinsky, "Letter from Munich, 3 October 1909," *Apollon* (St. Petersburg), as tr. in Lindsay and Vergo, *Kandinsky: Complete Writings on Art*, vol. 1, 56.

9. Walter H. Sokel, *The Writer in Extremis: Expressionism in Twentieth-Century German Literature* (Stanford: Stanford University Press, 1959), 103.

10. Kandinsky, *On the Spiritual in Art* (Munich: R. Piper, 1912), In *Complete Writings on Art*, vol. 2, 119–220, esp. 146.

11. Ferdinand Hodler, letter, as cited in Sharon L. Hirsh, *Ferdinand Hodler* (Munich: Prestel, 1981), 19.

12. Robert Goldwater, *Symbolism* (New York: Harper & Row, 1979), 221; Ernst Stohr, in *Ver Sacrum* 4(1901):158f, as tr. in Peter Vergo, *Art in Vienna, 1898–1918* (London: Phaidon, 1975), 58; Maurice Maeterlinck, preface, *Theatre*, 1901, as tr. in Jethro Bithell, *Life and Writings of Maurice Maeterlinck* [1913] (Port Washington, N.Y.: Kennikat Press, 1972), 40.

13. The distinction is overlooked by Sokel (*The Writer in Extremis*, chs. 1, 2), who stresses Schopenhauer and Kant as Expressionist sources; Nietzsche's nihilism, in fact, is not even mentioned.

14. But for the "Darwin impulse" as "godparent to Expressionism," see Eberhard Roters, "Wissenschaftlichkeit: Ein Wesenszug der bildenden Kunst im 19. und im 20. Jahrhundert," *Beiträge zum Problem des Stilpluralismus*, eds. Werner Hager and Norbert Knopp (Munich: Prestel, 1977), 68.

15. Arthur de Gobineau, *Essay on the Inequality of the Human Races* [1853–55], as tr. in Michael D. Biddiss, *Gobineau: Selected Political Writings* (New York: Harper & Row, 1970), 42–44, 58–59.

16. Ibid., 134, 155, 176.

17. Gustave le Bon, *The Crowd: A Study of the Popular Mind* [1895], tr. Robert K. Merton (New York: Viking, 1963), 13–14.

18. Henry Adams, *The Degradation of the Democratic Dogma* [1910] (New York: Capricorn, 1958), 182–83; also cited in Rudolf Arnheim, *Entropy and Art: An Essay on Order and Disorder* (Berkeley: University of California Press, 1971), 9.

19. Charles Darwin, *On the Origin of Species by Means of Natural Selection, or the Preservation of Favoured Races in the Struggle for Life* [1859], facsimile ed. (Cambridge: Harvard University Press, 1964), 63–67.

20. Herbert Spencer, *Social Statics* [1865] (New York: Appleton Davies, 1882), as cited in Jacques Barzun, *Darwin, Marx, Wagner: Critique of a Heritage* (Boston: Little, Brown, 1941), 107.

21. Barzun, *Darwin, Marx, Wagner*, 107–08.

22. Charles Darwin, *The Descent of Man and Selections in Relation to Sex* [1871] (London: Murray, 1909), 157f, 180; also cited in B. Tierney, D. Kagan, and L. P. Williams, eds., *Social Darwinism: Law of Nature or Justification of Repression?* (New York: Random House, 1977), 12. For Darwin on human racial "extinction," see the end of this section.

23. Robert C. Bannister, *Social Darwinism: Science and Myth in Anglo-American Social Thought* (Philadelphia: Temple University Press, 1979), 4.

24. Benjamin Kidd, *Social Evolution* (Chicago: Charles S. Sergel, 1895), 252–54.

25. Charles Morris, "War as a Factor in Civilization," *Popular Science Monthly* 47(1895):823f, as cited in Tierney, *Social Darwinism*, 33; Karl Pearson, *National Life from the Standpoint of Science* [1900], 2d ed. (Cambridge: Cambridge University Press, 1907), 46f, as cited in Tierney, *Social Darwinism*, 28.

26. Ernst Haeckel, *The History of Creation: or the Development of the Earth and its Inhabitants by the Action of Natural Cause*, tr. E. R. Lankester, 2 vols. (New York: Appleton Davies, 1876), vol. 1, 170–73; vol. 1, 174. Daniel Gasman cites Haeckel on "artificial selection" but not on "natural selection"; Haeckel did not believe that a healthy society "had to be governed according to absolutely unimpeded laws of nature," as Gasman maintains. See Gasman, *The Scientific Origins of National Socialism: Social Darwinism in Ernst Haeckel and the German Monist League* (New York: Elsevier, 1971), 36; Haeckel, *History of Creation*, vol. 1, 95.

27. Friedrich Nietzsche, *Human, All-too-Human* [1878], as excerpted in *The Portable Nietzsche*, ed. Walter Kaufmann (New York: Viking, 1975), 55. Nietzsche was not unaware of the role played by his own illness in generating his ideas. For more on "inoculation," see sec. 1.8.

28. Friedrich Nietzsche, *Thus Spoke Zarathustra: A Book for All and None* [1883–85], tr. Walter Kaufmann (Harmondsworth: Penguin, 1978), 47; On eugenics, see Friedrich Nietzsche, *The Will to Power* [1901], tr. Walter Kaufmann and R. J. Hollingdale (New York: Vintage, 1968), 388–89, secs. 733–34.

29. Walter A. Kaufmann, *Nietzsche: Philosopher, Psychologist, Antichrist* (Princeton: Princeton University Press, 1950), 338.

30. Houston Stewart Chamberlain, *Foundations of the Nineteenth Century* [1899], tr. John Lees, 2 vols. (New York: Fertig, 1977), vol. 1, 359f, 498f; vol. 1, 392, 522.

31. Friedrich Hertz, *Race and Civilization*, tr. A. S. Levetus and W. Entz (New York: Macmillan, 1928), 10.

32. Chamberlain, *Foundations of the Nineteenth Century*, vol. 2, 218–22.

33. Darwin, *Origin of Species*, 207, 209.

34. Ibid., 88; Darwin, *Descent of Man*, 281f; 282–87: "Extinction follows chiefly from the competition of tribe with tribe, and race with race. . . . When civilized nations come into contact with barbarians the struggle is short, except where a deadly climate gives its aid to the native race. The most potent of all the causes of extinction appears in many cases to be lessened fertility and ill-health, especially among the children"; 288–89: A population decrease in the Sandwich Islands "has been attributed by most writers to the profligacy of the women, to former bloody wars, and to the severe labor imposed on conquered tribes and to newly introduced diseases, . . . but the most potent of all causes seems to be lessened fertility. [High childhood mortality] has been attributed to the neglect of the children by the women, but it is probably in large part due to innate weakness of constitution in the children, in relation to the lessened fertility of their parents."

35. Darwin, *Origin of Species*, p. 88; Darwin, *Descent of Man*, p. 763. There are admittedly two passages in his final summary (pp. 939, 941) where Darwin tries to give the female some effective role in evolution, but the effort is

not too convincing. Thus evolution by female selection is described as a process by which the females "no longer remain passive, but select the more agreeable partners." The selection has little biological impact, however, just as man's selection of domestic animals "preserves . . . the most pleasing or useful individuals, *without any wish to modify the breed*" (emphasis added). Evolution by female selection should explain, again, "how the more attractive males succeed in leaving a larger number of offspring to inherit their superiority in ornaments or other charms than the less attractive males." Yet even in this aesthetic choice the females presumably prefer "not only the more attractive but at the same time *the more vigorous and more victorious males*" (emphasis added). Here the females, no matter how "active," are presumed to mate with the still more active and competitively dominant partners, so that the female choice in sexual selection is actually no choice at all.

36. Darwin, *Descent of Man*, 854; 858.

37. Nietzsche, *Thus Spoke Zarathustra*, 67; cf. 12; Richard von Krafft-Ebing, *Psychopathia Sexualis, with Especial Reference to Contrary Sexual Instinct; A Medico-Legal Study*, tr. Charles G. Chaddock (Philadelphia and London: F. A. Davis, 1893), 13; Paul Julius Möbius, *Ueber den physiologischen Schwachsinn des Weibes* (Halle: Marhold, 1906), 69; Otto Weininger, *Sex and Character* (London: W. Heinemann, and New York: Putnam, 1906), 69; Sigmund Freud, *Three Essays on the Theory of Sexuality* [1905], *Standard Edition* (London: Hogarth, 1953), vol. 7, 195; F. T. Marinetti, "Tod dem Mondschein! Zweites Manifest des Futurismus," *Der Sturm* 3(May 1912):150.

38. Gordon A. Craig, *The Germans* (New York: Putnam, 1982), 154–57.

39. August Bebel, *Woman under Socialism* [sic], tr. Daniel de Leon (New York: Labor News, 1904), 187, 201, 204–05, 208–15.

40. W. F. Magie, ed., *The Second Law of Thermodynamics: Memoirs by Carnot, Clausius and Thomson* (New York and London: Harper & Row, 1899), v–vi.

41. G. J. Whitrow, "Entropy," *Encyclopedia of Philosophy*, ed. Paul Edwards (New York: Macmillan, 1967), vol. 2, 526; 527. Whitrow goes on to rebut Clausius' position (p. 528): "not only is it difficult to formulate the concept of entropy for the whole universe but [there is also] no evidence that the law of entropy increase applies on this scale." Indeed the red shift of extragalactic spectra "is evidence to the contrary."

42. Herbert Spencer, *First Principles* [1875], 6th ed. (New York: Appleton Davies, 1901), 260–61.

43. Haeckel, *The History of Creation*, vol. 1, 19–20; *The Riddle of the Universe at the Close of the Nineteenth Century* (New York and London: Harper & Row, 1900), 243–44; 247.

44. André Lalande, *La dissolution opposée à l'évolution dans les sciences physiques et morales* (Paris: F. Alcan, 1899), 384, cf. 3–4; 70; cf. 63–64.

45. Ibid., 403–04.

46. Arthur Schopenhauer, *The World as Will and Representation* [1819], tr. E. F. Payne, 2 vols. (New York: Dover, 1966), vol. 2, 411–12.

47. Sokel, *The Writer in Extremis*, 25.

48. Charles Baudelaire, *Oeuvres complètes* (Paris: Gallimard, 1961), 111–13; Reinhold Heller, "Edvard Munch's 'Night,' the Aesthetics of Decadence, and the Content of Biography," *Arts Magazine* 53(October 1978):80–105, p. 89; Richard Gilman, *Decadence: The Strange Life of an Epithet* (New York: Farrar, Straus & Giroux, 1979), 89; Paul Bourget, *Essais de psychologie contemporaine* [1883], 2 vols. (Paris: Librairie Plon, 1937), vol. 1, 19–20.

49. Friedrich Nietzsche, *The Case of Wagner* [1888], in *The Birth of Tragedy and The Case of Wagner*, tr. Walter Kaufmann (New York: Vintage Book,

1967), 170; see also Kaufmann, *Nietzsche*, p. 53. But note that even before he turned against Wagner, in the 1872 *Birth of Tragedy* (110–11), Nietzsche had given a Schopenhaurean warning against the contemporary, science-based, and falsely optimistic "Alexandrian culture" which, without the healing balm of myth, was headed for destruction.

50. Franz Marc, "Two Pictures," *The Blue Rider Almanach:* 66; Andreas Aubert, "Höstudstillingen. Aarsarbeidet IV. Edvard Munch," *Dagbladet* (5 November 1890):2–3, as tr. in Heller, "Edvard Munch's 'Night,'" 81.

51. Paul de Lagarde, *Deutsche Schriften* [1886], 3d ed. (Munich: J. F. Lehmann, 1937), 201, 325, as tr. in Fritz Stern, *The Politics of Cultural Despair* [1961] (Berkeley: University of California Press, 1974), 31.

52. Julius Langbehn, *Rembrandt als Erzieher* [1890] (Leipzig: C. L. Hirschfeld, 1922), 45. Langbehn's title is drawn from Nietzsche's 1874 *Schopenhauer as Educator* and he even tried to "save" Nietzsche during the latter's illness. Nevertheless such nationalists as Langbehn and Lagarde "were not disciples of Nietzsche": Stern, *The Politics of Cultural Despair*, 107–08, 284f. Despite a similarity in pessimistic diagnosis, Nietzsche's prescribed cure was fundamentally different; Langbehn, *Rembrandt als Erzieher*, 89–90; 94–95.

53. Stern, *The Politics of Cultural Despair*, 83, 155; Hermann Bahr, "Neue Zeichen," *Studien zur Kritik der Moderne* (Frankfurt: Rüiten, 1894), 245, as tr. in Heller, "Edvard Munch's 'Night,'" 85.

54. Max Nordau, *Degeneration* [1892–93], tr. from the 2d German ed. (New York: Fertig, 1968), 536–37.

55. George L. Mosse, "Introduction," in Nordau, *Degeneration*, xviii–xxi.

56. I am grateful to my colleague Aaron Sheon for this information.

57. Nordau, *Degeneration*, 17–20; 34–44.

58. Mosse, in *Degeneration*, xxi–xxii; Nordau, *Degeneration*, passim.

59. Nordau, *Degeneration*, 168, 180–81, 499; yet note that Wagner is elsewhere accused, 451, not of sadism but of "masochism"; 27, 557–58.

60. August Forel, *The Sexual Question* [1905], tr. C. F. Marshall (Brooklyn: Educational Publishing Co., 1933), 491–92. Note that Nordau's book was translated into a dozen languages (Milton Gold, *Nordau on Degeneration*, unpub. diss. [Columbia University, 1957], 9), while Forel's appeared in sixteen languages: Jan Romein, *The Watershed of Two Eras: Europe in 1900*, tr. Arnold J. Pomerans (Middletown: Wesleyan University Press, 1977), 588.

61. Review cited in Trust [pseud. Herwarth Walden], "Halt," *Der Sturm* 2(May 1911):499–500.

62. Nordau, *Degeneration*, 454, 184; cf. Langbehn, *Rembrandt als Erzieher*, 95–98, and Nietzsche, *The Case of Wagner*, esp. 166.

63. Friedrich Nietzsche, *On the Genealogy of Morals* [1887], tr. Walter Kaufmann and R. J. Hollingdale, in *On the Genealogy of Morals and Ecce Homo* (New York: Vintage, 1969), 30–40, secs. 11, 5, 7, cf. Nordau, *Degeneration*, 421–23; Nordau, *Degeneration*, 427.

64. George Bernard Shaw, *The Sanity of Art: An Exposure of the Current Nonsense about Artists being Degenerate* [1895] (London: New Age Press, 1908), 72–73, 38–39; Alfred E. Hake, *Regeneration: A Reply to Max Nordau* (New York: Putnam, 1896), 41.

65. Nordau himself turned to Zionism as a cure for one aspect of European decline; see his *Der Zionismus und seine Gegner* (Berlin: Berliner Zionistische Vereinigung, 1905).

66. Friedrich Nietzsche, *The Will To Power* [1901], tr. Walter Kaufmann and R. J. Hollingdale (New York: Vintage, 1968), esp. Kaufmann, "On the Editions of 'The Will to Power,'" xxvii–xxxii; Friedrich Nietzsche, *Ecce Homo* [1908], in *On the Genealogy of Morals and Ecce Homo*, tr. Walter Kaufmann (New York: Vintage, 1969), 213–14.

67. Nietzsche, *The Will to Power*, 7, sec. 1; preface, 3–5.

68. Nietzsche, *Ecce Homo*, 223–24; 327.

69. Ronald Hingley, *Nihilists: Russian Radicals and Revolutionaries in the Reign of Alexander II (1875–1881)* (New York: Delacorte, 1969), v. 16; Nietzsche, *The Will to Power*, 51, sec. 82, note.

70. R. W. K. Paterson, *The Nihilistic Egoist Max Stirner* (London: Oxford University Press, 1971), 144.

71. Nietzsche recommended the Stirner book to a pupil as early as 1874, and he knew its content from secondary sources if not also from the original. Franz Overbeck, Nietzsche's close friend, concluded that "Nietzsche had read Stirner" but was reticent lest he "be confused with him": Max Stirner, *The Ego and His Own* [1845], ed. John Carroll (London: Cape, 1971), 25. Cf. Paterson, *Max Stirner*, 149.

72. Paterson, *Max Stirner*, 146–47.

73. Stirner, *The Ego and His Own*, 41, 261. Benjamin R. Tucker, *Instead of a Book* (New York: B. R. Tucker, 1893), 24, and Emma Goldman, *Living my Life*, 2 vols. (New York: Knopf, 1931), vol. 1, 194, as cited in Paterson, *Max Stirner*, 129, 143.

74. Sigmund Freud, "Negation" [1925], *Standard Edition* (London: Hogarth, 1961), Vol. 19, 235–39, esp. 235; Karl Mannheim, "The Problem of Generations," *Essays on the Sociology of Knowledge*, ed. Paul Keckskemeti (New York: Oxford University Press, 1952, 276–322, esp. 298; Siegfried Kracauer, *From Caligari to Hitler: A Psychological History of the German Film* [1947] (Princeton: Princeton University Press, 1974), 162.

75. Friedrich Nietzsche, *The Birth of Tragedy* [1872, 1886], in *The Birth of Tragedy and The Case of Wagner*, tr. Walter Kaufmann (New York: Vintage, 1967), 33f.

76. Ibid., 31–32, 19.

77. Wolf-Dieter Dube, "The Artists Group 'Die Brücke,'" *Expressionism: A German Intuition* (New York: Solomon R. Guggenheim Museum, 1980), 92; Lothar Grisebach, *E. L. Kirchners Davoser Tagebuch* (Cologne: M. DuMont Schauberg, 1968), 78, and Emil Nolde, *Jahre der Kämpfe* (Berlin: Rembrandt, 1934), 92, as tr. in Donald E. Gordon, *Ernst Ludwig Kirchner* (Cambridge: Harvard University Press, 1968), 18. For the authors Heckel and Schmidt-Rottluff read in Chemnitz—Ibsen, Strindberg, Dostoevsky and Nietzsche—see Paul Vogt, *Erich Heckel* (Recklinghausen: A. Bongers, 1965), 7; and for Schmidt-Rottluff around 1918 as "an expert on Nietzsche," see Wolfgang Pehnt, *Expressionist Architecture*, tr. J. A. Underwood and Edith Küstner (London: Thames & Hudson, 1973), 42.

78. Nietzsche, *Thus Spoke Zarathustra*, 14–15. Cf. Annemarie Dube-Heynig, *E. L. Kirchner Graphik* (Munich: Prestel, 1961), 21.

79. Leopold Reidemeister, *Künstlergruppe Brücke: Fragment eines Stammbuches* (Berlin: Mann, 1975), 25.

80. Ibid. 36; Nietzsche, "Attempt at a Self-Criticism," *Birth of Tragedy*, 19.

81. Nietzsche, *The Will to Power*, sec. 805, p. 424. Peter Selz was the first to link Expressionist origins "in Dresden and Munich as well as in Paris" with Nietzsche's "transvaluation of values": see Selz, "Fauvism and Expressionism," in Herschel B. Chipp, *Theories of Modern Art* (Berkeley: University of California Press, 1968), 124. The Brücke's beginnings are exhaustively discussed in Georg Reinhardt, "Die frühe 'Brücke': Beiträge zur Geschichte und zum Werk der Dresdner Künstlergruppe 'Brücke' der Jahre 1905 bis 1908," *Brücke-Archiv* no. 9/10(1977–78):1–215. However, Reinhardt's discussion of Nietzsche's influence (28–31) is flawed by his belief that *The Will to Power* was first published in 1906 rather than in 1901. The 1901 title page is reproduced in the edition of *The Will to Power* we have been citing, p. xxvii.

82. Sublimation was first named by Freud in the 1905 *Three Essays on the Theory of Sexuality*. However, the idea was current in Nietzsche's generation and was even advanced by Tieck and Novalis among the German Romantics: Jack J. Spector, *The Aesthetics of Freud: A Study in Psychoanalysis and Art* (New York: McGraw, 1974), 216, no. 30. Spector, who does not cite *The Will to Power*, nevertheless points to several parallels between Nietzsche and Freud: 30, 205.

83. Karlheinz Gabler, ed., *E. L. Kirchner: Dokumente* (Aschaffenburg: Museum der Stadt, 1980), 354, nos. 1382, 1384. Kirchner also owned two editions of Nietzsche's letters (no. 1331), two copies of *Zarathustra*, and one copy each of *Ecce Homo*, *Götzen-Dämmerung*, and *Dionysos-Dithyramben*; Lothar Grisebach, *E. L. Kirchners Davoser Tagebuch* (Cologne: M. DuMont Schauberg, 1968), 78; Emil Nolde, *Jahre der Kämpfe* (Berlin, Rembrandt, 1934), 182.

84. Selz, *German Expressionist Painting*, 337, n. 38, erroneously identifies this figure as a "nude *Diana*."

85. Nietzsche, *The Will to Power*, 446, sec. 846. The idea was anticipated in *Thus Spoke Zarathustra*, 116: "And whoever must be a creator in good and evil, verily, he must first be an annihilator and break values. Thus the highest evil belongs to the highest goodness, but this is creative." German Romantics like Novalis and F. Schlegel "occasionally" courted the "mystique of destruction": Wiedmann, *Romantic Roots in Modern Art*, 114–15.

86. Wassily Kandinsky, *Rückblicke*, in the album *Kandinsky 1901–1913* (Berlin: Der Sturm, 1913), xix, xxxviii.

87. Kandinsky, *Complete Writings on Art*, vol. 1, 139, 142 mod., 145; see also Kandinsky's "Whither the 'New' Art" (Odessa, 1911), 103: "Consciously or unconsciously, the genius of Nietzsche began the transvaluation of values. What had stood firm was displaced—as if a great earthquake had erupted in the soul."

88. Selz, *German Expressionist Painting*, pl. 168, and Levine, *The Apocalyptic Vision*, fig. 25, translate Marc's title as "Fate of the Animals," but Heller points out in his review of Levine (327, n. 17) that the "destinies" are plural. While "man is the major instigator of suffering" in the painting, as Heller suggests, I would add that man is also symbolically the victim as well. He is in both cases Nietzsche's "man of calamity."

89. August Macke and Franz Marc, *Briefwechsel* (Cologne: M. DuMont Schauberg, 1964), 40; cf. Nietzsche, *The Will to Power*, 487, sec. 921–22.

90. Franz Marc, "Das geheime Europa" [1914], *Schriften*, ed. Klaus Lankheit (Cologne: M. DuMont Schauberg, 1978), 163–67. Cf. Friedrich Nietzsche, *The Gay Science* [1882], tr. Walter Kaufmann (New York: Vintage, 1974), 307f, 340, secs. 357, 357, and Nietzsche, *Beyond Good and Evil: Prelude to a Philosophy of the Future* [1886], tr. Walter Kaufmann (New York: Vintage, 1966), preface, 4, 174, sec. 241.

91. Nietzsche, *The Will to Power*, 33, sec. 54. See also Nietzsche, *Thus Spoke Zarathustra*, 114: "Where I found the living, there I found will to power; and even in the will of those who serve I found the will to be master"; Oskar Kokoschka, *My Life*, tr. David Britt (New York: Macmillan, 1974), 82.

92. Nolde, *Jahre der Kämpfe*, 92, 175. Linda F. McGreevy, *The Life and Works of Otto Dix* (Ann Arbor: University of Michigan Press, 1981), 11–13.

93. Barbara C. Buenger, "Beckmann's Beginnings: 'Junge Männer am Meer,'" *Pantheon* 41(1983):134–44, esp. 137 and n. 45; cf. Ernst-Gerhard Güse, *Das Frühwerk Max Beckmanns: Zur Thematik seiner Bilder aus den Jahren 1904–1914* (Frankfurt: P. Lang; Bern: H. Lang, 1977), 14–18. In contrast to Güse, Buenger shows convincingly how Beckmann fused a Neo-Idealist world-weariness with Nietzschean "life affirmation."

94. See also the title of Grosz's 1946 autobiography, *A Little Yes and a Big No*, tr. Lola Sachs Dorin (New York: Dial, 1946).

95. Theda Shapiro, *Painters and Politics: The European Avant-Garde and Society, 1900–1925*, (New York, Oxford, Amsterdam: Elsevier Scientific Publishing, 1976), 28; 29.

96. Ellen C. Oppler, *Fauvism Reexamined* [1969] (New York: Garland Publishing, 1976), 201–04. See also Ron Johnson, "The 'Demoiselles d'Avignon' and Dionysian Destruction," *Arts Magazine* 55(October 1980):94–101, esp. 101 n. 39, and Mark Rosenthal, "The Nietzschean Character of Picasso's Early Development," *Arts Magazine* 55(October 1980):87–91, esp. 87.

97. Joseph Emile Muller, *Fauvism* (New York: Praeger, 1967), 57. Alfred H. Barr, Jr., *Picasso: Fifty Years of His Art* (New York: Museum of Modern Art, 1946), 272; cf. Johnson, "The 'Demoiselles d'Avignon,'" 99.

98. Gelett Burgess, "The Wild Men of Paris," *The Architectural Record* 29(May 1910):400–14, esp. 414. For mention of Nietzsche in later Cubist criticism, see J. M. Nash, "The Nature of Cubism: A Study of Conflicting Explanations," *Art History* 3(1980):435–47.

99. Donald E. Gordon, "On the Origin of the Word 'Expressionism,'" *Journal of the Warburg and Courtauld Institutes* 29(1966):368–85, esp. 385.

100. Marianne Martin, *Futurist Art and Theory, 1909–1915* (Oxford: Clarendon Press, 1968), 39–41.

101. Shapiro, *Painters and Politics*, 29.

102. Nietzsche, *The Will to Power*, 7–8, sec. 1.

103. Even though Max Nordau was a medical doctor who by 1893 diagnosed sickness in society and recovery in art, I do not include him among "post-Nietzschean" prophets of renewal. The sickness of urban society was evident in its overstuffed homes: its tapestried drawing-rooms, its ostentatiously displayed antiquities less than genuine, its lady's boudoir half chapel and half harem, and its dining-room silver deposited in old farmhouse furniture. But art was to revive not through some transformation of bourgeois society (the post-Nietzschean solution), but rather by magically responding to Nordau's diagnosis: "The aberrations of art have no future. They will disappear when civilized humanity shall have triumphed over its exhausted condition." (Nordau, *Degeneration*, 10, 550).

104. Thomas H. Huxley, "Evolution and Ethics," in *Evolution and Ethics and Other Essays* (New York: Appleton Davies, 1898), 46–86, esp. 51–52.

105. Ibid., 80–82; 83–85.

106. Henri Bergson, *Creative Evolution* [1907], tr. Arthur Mitchell (New York: Modern Library, 1944), 149–50; 164, 167, 182; 271; 269 note.

107. Sigmund Freud, "The Interpretation of Dreams" [1900] in *Standard Edition* (London: Hogarth, 1953), vol. 5, 588ff; C. G. Jung, *Symbols of Transformation*, tr. R. F. C. Hull (New York: Pantheon, 1956), 29. Note that this book and also Jung's *Psychology of the Unconscious: A Study of the Transformations and Symbolisms of the Libido*, tr. Beatrice M. Hinckle (New York: Moffat, Yard, 1917), are both translations of the 1911–12 *Wandlungen und Symbole der Libido*.

108. Freud, *Interpretation of Dreams*, 567; Jung, *Symbols of Transformation*, 32.

109. Freud, *Interpretation of Dreams*, 549; Jung, *Symbols of Transformation*, 23. The Nietzsche source cited is the 1878 *Human, All-too-Human*.

110. Freud's book sold "only 351 copies" through 1906 and was not reprinted until 1909; even then, Freud's and Jung's early works were so specialized that they were not discussed or even known by artists, to my knowledge, until well into the First World War.

111. Gosta Svenaeus, *Edvard Munch: Im männlichen Gehirn*, 2 vols. (Lund: Vetenskaps-Societeten, 1973), vol. 1, 96f, 118f.

112. Stanislaus Przybyszewski, *Zur Psychologie des Individuums: Chopin und Nietzsche* (Berlin: Fontane, 1892), 46. In translating "synthesierende

Geist" as "synthetist ideal," I follow a suggestion of Reinhold Heller (*Art Journal* 39(1980):319) that "after the initial influx of French Symbolist concerns into Germany around 1890, *ideal* was most frequently rendered as *Geist* or *Vergeistigung*."

113. T. A. Goudge, "Thomas Henry Huxley," *The Encyclopedia of Philosophy*, ed. Paul Edwards (New York: Macmillan, 1967), vol. 4, 101–03; Bebel, *Women under Socialism*, 204; Herbert Spencer, *First Principles* [1875], 6th ed. (New York: Appleton Davies, 1901), 509–10.

114. Ernst Haeckel, *Monism as Connecting Religion and Science: The Confession of Faith of a Man of Science* [1892] (London: Adam & Charles Black, 1903), 50–51; for substance as a "philosophic conception," 17.

115. Ibid., 23–25, 106. For sarcastic reference to Haeckel's "ether-god," see William James, *Pragmatism: A New Name for Some Old Ways of Thinking* [1907] (New York: Longmans, Green, 1909), 16.

116. Haeckel cites Hertz on ether and Vogt on substance (*Monism*, 102–03), but the Michelson-Morley experiment of 1887 had already failed to prove ether's existence.

117. Ernst Haeckel, *The Riddle of the Universe at the Close of the Nineteenth Century* (New York and London: Harper & Row, 1900), 211, 229; 163 (for the 1866 theory, see 152–53); 201.

118. H. P. Blavatsky, *Isis Unveiled: A Master-Key to the Mysteries of Ancient and Modern Science and Theology* [1877], facsimile ed., 2 vols. in one (Los Angeles: Theosophy, 1975), vol. 1, 128; vol. 1, 152–53.

119. H. P. Blavatsky, *The Secret Doctrine: The Synthesis of Science, Religion, and Philosophy* [1888], facsimile ed., 2 vols. in one (Los Angeles: Theosophy, 1974), v. 2, 789; 348.

120. See, for example, the table of contents for *The Secret Doctrine*.

121. Rudolf Steiner, *Haeckel, die Welträtsel, und die Theosophie* [c. 1902?] (Dornach: Anthroposophischer Verlag, 1926), 16; 28.

122. Rudolf Steiner, *Friedrich Nietzsche: Ein Kämpfer gegen seine Zeit* (Weimar: E. Felber, 1895), 31, 35.

123. Ibid., 89.

124. Rudolf Steiner, *Theosophy: An Introduction to the Supersensible Knowledge of the World and the Destination of Man* [1904] (New York: Anthroposophic Press, 1971), 70, 85, 86, 87, 89, 97–98.

125. Steiner's *Theosophy* is cited by Kandinsky in *Concerning the Spiritual in Art*, 32 n. 5; for further discussion, see sec. 1.4.

126. Catalogue, *Die zweite Ausstellung der Redaktion: Der blaue Reiter, Schwarz-weiss* (Munich: H. Goltz Kunsthandlung, 1912: n. p.

127. G. J. Whitrow, "Albert Einstein," *Encyclopedia of Philosophy*, vol. 2, 468–71, esp. 469; Einstein's relativity theory of 1905 differed from that of Poincaré's of 1904 precisely in Poincaré's assumption that "the ether concept" had to be retained.

128. Norwood Russell Hanson, "Quantum Mechanics, Philosophical Implications of," *Encyclopedia of Philosophy*, vol. 7, 41–49, esp. 42.

129. Albert Einstein, as cited in M. Capek, *The Philosophical Impact of Contemporary Physics* (Princeton: D. Van Nostrand, 1961), 319; Niels Bohr, *Atomic Physics and the Description of Nature* (Cambridge: Cambridge University Press, 1934), 57.

130. Kandinsky, *Concerning the Spiritual in Art*, 31–32.

131. Franz Marc, "Die 100 Aphorismen" [1915], *Schriften*, no. 14: 189; nos. 40–41: p. 197; nos., 64–65: p. 204.

132. Marc wanted somehow to honor both Nietzsche and the "mythic, great Kant," but he finally made Kantian "pure reason" subservient to the Nietzschean "passions": aphorisms no. 28, 77, *Schriften*, 194, 207. Cubist criticism, however, was often Kantian—as when Cubism was seen as part of

"the world of ideas where man reigned as a part of the absolute": Christopher Gray, *Cubist Aesthetic Theories* (Baltimore: Johns Hopkins Press, 1953), 8. But for a comparison of Nietzschean and neo-Kantian views, see now J. M. Nash, "The Nature of Cubism: A Study of Conflicting Explanations," *Art History* 3(1980):435–47, esp. 444f.

133. For an unconvincing discussion of "vitalism" in German Expressionist literature—by which is meant opposition to "cerebralism" or "abstractionism"—see Sokel, *The Writer in Extremis,* 87f.

134. Thomas Grochowiak, *Ludwig Meidner* (Recklinghausen: A. Bongers, 1966), 29; Hermann Bahr, *Expressionism* [1916], tr. R. T. Gribble (London: Frank Henderson, 1925), 83–84.

135. Oswald Spengler, *The Decline of the West* [1918, 1922], tr. Charles Francis Atkinson (London: Allen & Unwin, 1971), vol. 1:39, 423–424 mod.; Sigmund Freud, *Beyond the Pleasure Principle* [1920], in *Standard Edition* (London: Hogarth, 1961), vol. 18, 52–55. For a view of Freud's psychology as dependent on "the physics of entropy and the economics of scarcity," see David Riesman, *Individualism Reconsidered* (Glencoe: Free Press, 1954), 325; also cited in Arnheim, *Entropy and Art,* 45.

136. Oskar Pfister, *Expressionism in Art: Its Psychological and Biological Basis* [1920], tr. B. Low and M. A. Muegge (New York: Dutton, 1923), 166, 195.

CHAPTER II

Wilhelm Worringer, *Form Problems of the Gothic* [1910] (New York: G. E. Stechert, 1920), 28.

1. Gordon A. Craig, *The Germans* (New York: Putnam, 1982), 94; 95.

2. Michel Foucault, *The History of Sexuality, Volume I: An Introduction,* tr. Robert Hurley (New York: Vintage, 1980), 146; August Forel, *The Sexual Question* [1905], tr. C. F. Marshall (Brooklyn: Educational Publishing, 1933), 491. See also sec. 1.4.

3. *Webster's New World Dictionary of the American Language,* college ed. (Cleveland: World Publishing, 1960), 1625.

4. Egbert Krispyn, *Style and Society in German Literary Expressionism* (Gainesville: University of Florida, 1964), 15.

5. Frank Whitford, "Radical Art and Radical Politics," *Germany in Ferment* (Durham: Durham University, 1970): 5–9.

6. Anne Orde, "German Society and Politics, 1900–1933," *Germany in Ferment,* 25–29, esp. 26.

7. Charles S. Kessler, *Max Beckmann's Triptychs* (Cambridge: Harvard University Press, 1970), 79–80; Ludwig Meidner, *Eine autobiographische Plauderei,* 2d ed. (Leipzig: Klinkhardt & Biermann, 1923), ill. facing 16; George Grosz, *A Little Yes and a Big No,* tr. Lola Sachs Dorin (New York: Dial, 1946), 55–56; Oskar Kokoschka, *My Life,* tr. David Britt (New York: Macmillan, 1974), 16; Emil Nolde, *Das eigene Leben: Die Zeit der Jugend, 1867–1902,* 3d ed. (Cologne: M. DuMont Schauberg, 1967), 49–50; E. L. Kirchner, letter to Carl Hagemann, 25 December 1928, as cited in catalogue *Ernst Ludwig Kirchner, 1880–1938* (Berlin: Nationalgalerie, 1979–80), 96.

8. Reinhold Heller, *Edvard Munch: The Scream* (New York: Viking, 1973), ch. 1.

9. Miroslav Lamač, *Modern Czech Painting, 1907–17,* tr. Arnošt Jappel (Prague: Artia, 1967), 52.

10. Heller, *Edvard Munch,* 22. For a variant translation, see Arne Eggum, "The Theme of Death," tr. Gregory P. Nybo, *Edvard Munch: Symbols and Images* (Washington: National Gallery of Art, 1978), 154; ibid., 22; Eggum, "Theme of Death," 166. For the lithograph's date, see *Munch: Symbols and Images,* 220.

11. Heller, *Edvard Munch,* 22–23; Eggum ("Theme of Death," 159) finds a "great similarity" between the Madonna's features and those of the artist's mother, whose own early death he apparently associated with female death-images in his art.

12. For the likelihood that Maeterlinck's pessimism influenced Munch, see the Norwegian sources cited by Eggum, "Theme of Death," 183 n. 126.

13. Oslo, National Gallery.

14. Arthur Schnitzler, *Reigen: zehn Dialoge geschrieben Winter 1896–97,* 15th ed. (Vienna: Wiener, 1903).

15. Annemarie and Wolf-Dieter Dube, *E. L. Kirchner: Das graphische Werk,* 2 vols. (Munich: Prestel, 1967), woodcuts no. 40–48; cf. Richard Dehmel, "Zwei Menschen" [1903], *Gesammelte Werke* (Berlin: S. Fischer, 1913), vol. 2, 143–283.

16. The borrowing was first documented by Eberhard Roters, "Beiträge zur Geschichte der Künstlergruppe 'Brücke' in den Jahren 1905–1907," *Jahrbuch der Berliner Museen* 2(1960):204–06. Georg Reinhardt, "Die frühe 'Brücke,'" *Brücke-Archiv* no. 9/10(1977–78):114, finds the two works related "neither in expression nor in content." But Reinhardt fails to consider the Expressionist practice of countermovement or reaction against its source(s), as discussed here and in secs. 2.8 and 3.1.

17. For the 1908–09 style and its Fauve sources, see sec. 3.2.

18. The Brücke artists denied a debt to Munch. Kirchner in 1937 protested against Munch's "gloomy, misanthropic pictures": Donald E. Gordon, *Ernst Ludwig Kirchner* (Cambridge: Harvard University Press, 1968), 456 n. 43. Schmidt-Rottluff and Heckel in 1946 admitted only a common root in Jugendstil: Lothar-Günther Buchheim, *Die Künstlergemeinschaft Brücke* (Feldafing: Buchheim, 1956), 66, 67. Nevertheless, the Dresden artists sent Munch no less than nine letters and postcards between 1906 and 1909, inviting him to join with them: Merit Werenskiold, "Die Brücke und Edvard Munch," *Zeitschrift des deutschen Vereins für Kunstwissenschaft* 28(1974): 140–52.

19. Friedrich Nietzsche, *The Will to Power,* tr. Walter Kaufmann and R. J. Hollingdale (New York: Vintage Book, 1968), preface, 3–4; also cited sec. 1.5.

20. Peter Selz, *German Expressionist Painting* (Berkeley: University of California Press, 1957), 70. For Kirchner's 1937 recollection of Whitman's book as his "comfort and encouragement," see sec. 1.1.

21. Walt Whitman, *Leaves of Grass* [1855], facsimile ed. (Portland, Maine: T. B. Mosher and W. F. Gable, 1942), 17.

22. Ibid.

23. Ward B. Lewis, "Walt Whitman: Johannes Schlaf's 'neuer Mensch,'" *Revue de littérature comparée* 47(1973):596–611, esp. 605.

24. Walt Whitman, *Grashalme,* tr. Johannes Schlaf (Leipzig: P. Reclam jun., 1907); cf. Paul Raabe and H. L. Greve, eds., *Expressionismus: Literatur und Kunst, 1910–1923* (Marbach: Schiller Nationalmuseum, 1960), 46, 18, 63.

25. Whitman's bisexuality was publicly discussed in 1905–06; see Edward Bertz, *Walt Whitman: Ein Charakterbild* (Leipzig: M. Spohr, 1905) and Johannes Schlaf, *Walt Whitman Homosexueller? Kritische Revision einer Whitman-Abhandlung von Eduard Bertz* (Minden: J. C. Bruns, 1906).

26. Kirchner's *Girl under Japanese Umbrella* has been interpreted as being "sprawled powerlessly" before the artist, implying that Kirchner, "in asserting his own sexual will, has annihilated his opponent's": Carol Duncan, "Virility and Domination in Early 20th-Century Vanguard Painting," *Artforum* 12(December 1973):31. However, the girl's pose seems considerably more willful and active than such a reading permits.

27. Lothar Grisebach, ed., *E. L. Kirchners Davoser Tagebuch* (Cologne: M. DuMont Schauberg, 1968), 43.

28. Max Pechstein, *Erinnerungen,* ed. L. Reidemeister (Wiesbaden: Limes, 1960), 42; •for the girls' ages as "about" twelve and fourteen see Karlheinz Gabler, ed., *E. L. Kirchner Dokumente: Fotos, Schriften, Briefe* (Aschaffenburg: Museum der Stadt Aschaffenburg, 1980), 68.

29. For a reading of an object in the nude Fränzi's lap in a closely related Kirchner woodcut as "doll or fetus," see Alessandra Comini, "The Birth of German Expressionism," in catalogue, *German Expressionism: Die Brücke* (Charlottesville: University of Virginia Art Museum, 1978), 16.

30. Selz's dating of the Moritzburg visits in "1908, 1909 and 1910" (*German Expressionist Painting,* 99) was first corrected in Gordon, *Ernst Ludwig Kirchner,* 64, 68, 73–76.

31. Pechstein, *Erinnerungen,* 42.

32. Arthur Schopenhauer, *The World as Will and Representation* [1819], in *The Philosophy of Schopenhauer,* ed. Irwin Edman (New York: Modern Library, 1956), 274; cf. Alfred Kubin, "Autobiography," in *The Other Side: A Fantastic Novel,* tr. Denver Lindley (London: Victor Gallancz, 1969), xxi.

33. See sec. 1.6. Kubin's interest in Steiner's writings is suggested by a 1906 *Astral Portrait* drawing (New York: Serge Sabarsky Gallery) and by a 1911 letter to Karl Wolfskehl mentioning "my mystical endeavors." For the latter see Rose-Carol Washton Long, *Kandinsky: The Development of an Abstract Style* (Oxford: Clarendon Press, 1980), 23.

34. Kubin, *The Other Side,* 209–11; 227.

35. Nietzsche, *The Will to Power,* sec. 440, p. 243; Henri Bergson, *Creative Evolution* [1907], tr. Arthur Mitchell (New York: Modern Library, 1944), 185. Cf. 155, 158: "[I]nstinct perfected is a faculty of using and even of constructing organized instruments; intelligence perfected is the faculty of making and using unorganized instruments. . . . Instinct and intelligence therefore represent two divergent solutions, equally fitting, of one and the same problem."

36. August K. Wiedmann, *Romantic Roots in Modern Art; Romanticism and Expressionism: A Study in Comparative Aesthetics* (Old Woking: Gresham, 1979), 37f; cf. 22 for "unity" between nature and man.

37. Franz Marc, *Schriften,* ed. Klaus Lankheit (Cologne: M. DuMont Schauberg, 1978), 98.

38. Solomon R. Guggenheim Museum, New York.

39. Goethe, *Conversations with Eckermann,* as cited in Klaus Lankheit, *Franz Marc: Sein Leben und seine Kunst* (Cologne: M. DuMont Schauberg, 1976), 123.

40. August Strindberg, *The Father: A Tragedy in Three-Acts,* tr. Valborg Anderson (New York: Appleton-Century-Crofts, 1964), 38, 42.

41. Strindberg's Symbolism, not his Naturalism, is sometimes called Expressionist; see e.g., Carl E. W. L. Dahlström, *Strindberg's Dramatic Expressionism* (Ann Arbor: University of Michigan Press, 1930).

42. Strindberg, *The Father,* 40–41. For the Captain's first speech see Shakespeare's *Merchant of Venice,* act III, sc. 1. For Laura's second speech see Nietzsche, *Thus Spoke Zarathustra,* 66: "Go to it, women, discover the child in man!"

43. For Kokoschka's debt to the Kleist piece, see Carl E. Schorske, *Fin-de-siècle Vienna: Politics and Culture* (New York: Knopf, 1980), 335–36. See Heinrich von Kleist, *Sämtliche Werke und Briefe,* Wilhelm Herzog, ed. (Leipzig: Insel, 1909), vol. 2, 249–467.

44. Oskar Kokoschka, "Mörder Hoffnung der Frauen," *Dramen und Bilder* (Leipzig: K. Wolff, 1913), 11–21, as tr. in *Anthology of German Expressionist Drama: A Prelude to the Absurd,* ed. Walter H. Sokel (Garden City: Anchor, 1963), 17–21. The first performance was given "4 July 1909, in the Garden

Theater of the International Kunstschau in Vienna" (*Dramen und Bilder,* 21), while the earliest publication was in *Der Sturm* 1 (July 1910):155–56. Drawings were first illustrated in the 1910 source, including fig. 8.

45. For illustration of this comparison, see Donald E. Gordon, "Oskar Kokoschka and the Visionary tradition," *The Turn of the Century: German Literature and Art, 1890–1915,* ed. C. G. Chapple and Hans Schulte (Bonn: Bouvier, 1981), 23–52, esp. figs. 3 and 4.

46. Oskar Kokoschka, *My Life,* tr. David Britt (New York: Macmillan, 1974), 28.

47. Ibid., 26.

48. Nicholas Slonimsky, *Music since 1900,* 4th ed. (New York: Scribner, 1971), 1447.

49. René Leibowitz, *Schoenberg and his School: The Contemporary Stage of the Language of Music,* tr. Dike Newlin (New York: Philosophical Library, 1949), 91.

50. For Schoenberg's perspective on this affair, see Schorske, *Fin-de-siècle Vienna,* 351, 354; for Gerstl's, Jane Kallir, *Austria's Expressionism* (New York: Galerie St. Etienne & Rizzoli International, 1981), 26. For more on Gerstl, see secs. 3.4 and 4.4.

51. Jan Meyerowitz, *Arnold Schönberg* (Berlin: Colloquium, 1967), 16; also Werner Hofmann, "Beziehungen zwischen Malerei und Musik," *Schoenberg, Webern, Berg: Bilder, Partituren, Dokumente* (Vienna: Museum des 20. Jahrhunderts, 1969): 103–13, esp. 106.

52. Schorske, *Fin-de-siècle Vienna,* 351f; 355.

53. Heverlee, Belgium: coll. Prof. Vanderbroucke.

54. For the collaboration between the editors of Berlin's *Sturm* and Vienna's *Die Fackel,* see George C. Avery, "The Unpublished Correspondence of Herwarth Walden and Karl Kraus," *Expressionism Reconsidered: Relationships and Affinities,* eds. Gertrud Bauer Pickar and Karl Eugene Webb (Munich: W. Fink, 1979), 19–24.

55. Stanislaw Przybyszewski, "Das Geschlecht," *Der Sturm,* 1 (September 1910):243–44, and 1 (October 1910):251–52. "Im Anfang war das Geschlecht" was the opening sentence to Przybyszewski's *Totenmesse* (Berlin: Fontane, 1893), but the 1910 material was mostly new.

56. Alessandra Comini, *Egon Schiele's Portraits* (Berkeley: University of California Press, 1974), 61–62.

57. Alessandra Comini, *Schiele in Prison* (Greenwich: New York Graphic Society, 1973), 34. The German text is "wie eine gläubig scheinende Religion": Comini, *Egon Schiele's Portraits,* 219.

58. Arthur Roessler, "Erinnerungen an Egon Schiele," *Das Egon Schiele Buch,* ed. Fritz Karpfen (Vienna: Verlag der Wiener graphischen Werkstätte, 1921), 92–93.

59. Comini, *Egon Schiele's Portraits,* 106.

60. Emil Nolde, *Jahre der Kämpfe* (Berlin: Rembrandt, 1934), 107, 113f.

61. Ibid., 92; Friedrich Nietzsche, *The Anti-Christ* [1895], in *Twilight of the Idols and The Anti-Christ,* tr. R. J. Hollingdale (Harmondsworth: Penguin, 1978), sec. 6, 117; Nietzsche, *Thus Spoke Zarathustra,* 188. Nietzsche's word *Wollust* can be translated as "voluptuousness," "lust," or even as "sex."

62. For Nietzsche's opposition to anti-Semitism, see Hollingdale's comments in *The Anti-Christ,* 134, sec. 24, note; also Walter A. Kaufmann, *Nietzsche: Philosopher, Psychologist, Antichrist* (Princeton: Princeton University Press, 1950), esp. 37–40, 261–67.

63. Nolde, *Jahre der Kämpfe,* 134.

64. For the Liebermann work, see catalogue, *XIV. Ausstellung der Berliner Secession* (Berlin: Secession Ausstellungshaus, 1907), no. 125, as cited in Donald E. Gordon, *Modern Art Exhibitions, 1900–1916: Selected Catalogue*

Documentation, 2 vols. (Munich: Prestel, 1974), vol. 2, 199; for Nolde's response to the Liebermann, see Donald E. Gordon, "Expressionism: Art by Antithesis," Art in America 69(March 1981):106–08; for the Corinth and the Beckmann, see catalogue, XVIII. Ausstellung der Berliner Secession (Berlin: Secession Ausstellungshaus, 1909), nos. 7 and 45, as cited in Gordon, Modern Art Exhibitions, vol. 2, 319; for Nolde's 1911 response to Corinth, see Gordon, "Art by Antithesis."

65. Nolde, Jahre der Kämpfe, 189.

66. Emil Nolde, Das eigene Leben, 3d ed. (Cologne: M. DuMont Schauberg, 1967), 52–53.

67. Nolde, Jahre der Kämpfe, 170.

68. Nolde, Jahre der Kämpfe, 124, 102.

69. Ludwig Meidner, "Ein denkwürdiger Sommer," Der Monat 16(1964): 75, as cited in Thomas Grochowiak, Ludwig Meidner (Recklinghausen: A. Bongers, 1966), 29.

70. Illustrated in Ludwig Meidner, Eine autobiographische Plauderei, 2d ed. (Leipzig: Klinkhardt & Biermann, 1923), 16 bis. Cf. sec. 2.1.

71. Ludwig Meidner, Im Nacken das Sternemeer (Leipzig: K. Wolff, [1918]).

72. Ludwig Meidner, Septemberschrei: Hymnen, Gebete, Lästerungen (Berlin: P. Cassirer, 1920), 44, 19.

73. In Im Nacken das Sternemeer, 30, Meidner longs for both "thin, languid girls" and "unchaste, laughing ephebes"; on 41 he includes a pleading letter to his wartime soldier-lover, and on 62 recalls a prewar affair with a Munich actress. Meanwhile on 9–16 he delivers an invocation to death, "the sweet, insatiable punisher," and on 79–82 another one to the "muzzle of my rifle": "Why not lie still, rest forever. . . . Here, you sweet gun barrel. . . ; don't misfire, don't misfire!"

74. Daniel Paul Schreber, Denkwürdigkeiten eines Nervenkranken (Leipzig: O. Mutze, 1903), as translated by Ida Macalpine and Richard A. Hunter in Schreber, Memoirs of My Nervous Illness (London: Dawson, 1955). The English-language title presents a problem. Rather than that of Macalpine and Hunter, we follow the somewhat more literal title preferred in the psychoanalytic literature: see Sigmund Freud, "Psycho-Analytic Notes on an Autobiographical Account of a Case of Paranoia (Dementia Paranoides)" [1911], Standard Edition (London: Hogarth, 1958), vol. 12, 10. Actually, "ein Nervenkranker" would be a "neurotic" or "sufferer from neurasthenia"—meanings hardly consonant with the patient's violent actions and repeated hallucinations.

75. Schreber, Memoirs, 84; 73–74; 4.

76. Friedrich Nietzsche, Ecce Homo, in On the Genealogy of Morals and Ecce Homo, tr. Walter Kaufmann (New York: Vintage, 1969), 335; Nietzsche, The Will to Power, 543, sec. 1052.

77. Johannes Hemleben, Rudolf Steiner (Reinbek bei Hamburg: Rowohlt, 1963), 105; additional runs of The Drama of Eleusis in Munich under Steiner's production began on 13 August 1911 and 18 August 1912.

78. Edouard Schuré, The Sacred Drama of Eleusis [c.1900], in The Genesis of Tragedy and The Sacred Drama of Eleusis, tr. Fred Rothwell (New York: Anthroposophic, 1936), 300; 299.

79. Edouard Schuré, The Great Initiates: A Study of the Secret History of Religions, tr. Gloria Rasberry (Blauvelt, N.Y.: Steinerbooks, 1977), 397.

80. Schuré, The Sacred Drama of Eleusis, 283–84.

81. Schuré, The Genesis of Tragedy, 25.

82. E. G. Jan Verkade, Alexei Jawlensky, or Karl Wolfskehl. See Rose-Carol Washton Long, Kandinsky: The Development of an Abstract Style (Oxford: Clarendon Press, 1980), 31, 19–23.

83. Ibid., 28.

84. Rudolf Steiner, Die Theosophie an der Hand der Apokalypse (typescript of lecture cycle given at Nuremberg, June 1908; with the Anthroposophical Society, New York City: 52, as tr. in Long, Kandinsky, 28.

85. Ernst Haeckel, The History of Creation: or the Development of the Earth and its Inhabitants by the Action of Natural Causes, tr. E. R. Lankester, 2 vols. (New York: Appleton Davies, 1876), vol. 1, 19–20.

86. Jelena Hahl-Koch, Marianne Werefkin und der russische Symbolismus: Studien zur Aesthetik und Kunsttheorie (Munich: O. Sagner, 1967), 22–23.

87. Long, Kandinsky, 34.

88. The appearance of Halley's comet in May 1910 was F. S. Archenhold, Kometen: Weltuntergangsprophezeiungen und der Halleysche Komet (Berlin-Treptow, 1910), as cited in Reinhold Heller, "Kandinsky and Traditions Apocalyptic," Art Journal 43(1983):19–26.

89. Wassily Kandinsky, Concerning the Spiritual in Art [1912], tr. Francis Golffing, Michael Harrison, and Ferdinand Ostertag (New York: Wittenborn, 1970), 31; cf. 29–32.

90. Klaus Brisch, Wassily Kandinsky (1866–1944): Untersuchung zur Entstehung der gegendstandslosen Malerei an seinem Werk von 1900–1921, diss. (Bonn, 1955): 281; cf. Rose-Carol Washton Long, "Kandinsky and Abstraction: The Role of the Hidden Image," Artforum 10(June 1972):42–49.

91. Long, Kandinsky, 118; Brisch, Wassily Kandinsky, 252–53.

92. Hendrik Ibsen, Emperor and Galilean: A World-Historic Drama, tr. William Archer (New York: Scribner, 1911), 372–74. For other nineteenth-century usages known to Ibsen, see Julius Petersen, Die Sehnsucht nach dem dritten Reich in deutscher Sage und Dichtung (Stuttgart: J. B. Metzler, 1934), passim.

93. Henry Bett, Joachim of Flora (London: Methuen, 1931), 48.

94. Johannes Schlaf, Das dritte Reich: Ein Berliner Roman [1900] (Berlin: E. Fleischel, 1903), 12f; cf. 57 where Walt Whitman is cited as another forerunner; 10; 101.

95. Petersen, Die Sehnsucht nach dem dritten Reich, 49–50.

96. Felix Holländer, Der Weg des Thomas Truck [1902], 10th ed. (Berlin: S. Fischer, 1910), pt. 2, 406; pt. 1, 402–04; pt. 2, 383f.

97. Dmitry Merejkowsky, "La question religieuse; enquête internationale," Mercure de France 67(1907):68–71, esp. 69; also cited in Sixten Ringbom, The Sounding Cosmos: A Study in the Spiritualism of Kandinsky and the Genesis of Abstract Painting (Abo, Finland: Abo Akademi, 1970), 175.

98. Long, Kandinsky, 105.

99. Wassily Kandinsky, Rückblicke, in album, Kandinsky, 1901–1913 (Berlin: Der Sturm, 1913): xxiii–xiv, as tr. in Robert L. Herbert, ed., Modern Artists on Art: Ten Unabridged Essays (Englewood Cliffs: Prentice-Hall, 1964), 38–39 mod. It is presumably in this Kandinskian sense that Expressionism as a whole was once called "a new philosophy, a new religion, the onset of the Third Kingdom": Hermann Bahr, Expressionismus (Munich: Delphin, 1916), 42–43.

100. See esp. Improvisation 27 (Garden of Love) and a watercolor study for it, both 1911–12, as discussed in Long, Kandinsky, 102–04. Since his schooling around 1900, Kandinsky did not depict the nude female figure until these works of 1911–12: Rose-Carol Washton Long, "Kandinsky's Vision of Utopia as a Garden of Love," Art Journal 43(1983):50–60, esp. 53.

101. Long, Kandinsky, 102, 120–21.

102. We follow Reinhold Heller here in his criticism of Frederick S. Levine. See Levine, The Apocalyptic Vision: The Art of Franz Marc as German Expres-

sionism (New York: Harper & Row, 1979), ch. 3, and Heller, review of same in *Art Journal* 39(1980):321.

103. Franz Marc, letter of 22 May 1913, in August Macke and Franz Marc, *Briefwechsel* (Cologne: M. DuMont Schauberg, 1964), 163.

104. Marc, letter of 12 December 1910, in *Briefwechsel*, 28.

105. Levine, *The Apocalyptic Vision*, 133. Once again we support Heller, review of Levine, *Art Journal*, 323, who believes that Marc drew his Madonna not from Dürer's 1498 *Apocalypse* but rather from Marian altars of Bavarian Catholic churches, where she is simply "a comforter and healer."

106. Catalogue, *Schoenberg, Webern, Berg: Bilder, Partituren, Dokumente* (Vienna: Museum des 20. Jahrhunderts, 1969), 20.

107. Comini, *Egon Schiele's Portraits*, 94, 232 n. 40.

108. Ibid., 85; cf. 81–84.

109. Kokoschka, *My Life*, 79; Alma Mahler-Werfel, *Mein Leben* (Frankfurt: S. Fischer, 1960), 140; 62, 66.

110. Richard Wagner, *Tristan und Isolde: Opera in Three Acts*, tr. Stewart Robb (New York: Schirmer, 1965), act III, scene iii; Kokoschka, *My Life*, 72–73; Mahler-Werfel, *Mein Leben*, 367; for other literary and mythic associations, see Gordon, "Kokoschka and the Visionary Tradition," 47–51.

111. Lothar Lang, *Expressionist Book Illustration in Germany, 1907–1927*, tr. Janet Seligmann (Boston: New York Graphic Society, 1976), 100–103.

112. Nietzsche, *The Will to Power*, 134–35, sec. 233; 434–35, sec. 821; favorably comparing Dostoevsky to Schopenhauer and Zola.

113. Friedrich Nietzsche, letter to Peter Gast, 7 March 1887, *Friedrich Nietzsche's Gesammelte Briefe* (Berlin & Leipzig: Schuster & Loeffler, 1900ff), 5 vols., as cited by Walter Kaufmann in his tr. of *On The Genealogy of Morals* (New York: Vintage, 1969), 150 n. 8. Nietzsche first discovered Dostoevsky's work in French translation in February 1887.

114. Paul Vogt, *Erich Heckel* (Recklinghausen: A. Bongers, 1965), no. 1912/2, "Zwei Männer am Tisch (Dostojewski Der Idiot)"; no. 1912/13, "Die Tote (Dostojewski Der Idiot)"; no. 1912/15, "Gefangene am Dampfbad (Dostojewski aus einem Totenhaus)"; no. 1913/19, "Frauen am Meer"; no. 1913/21, "Gläserner Tag": no. 1914/18, "Parksee."

115. Fyodor Dostoevsky, *Notes from Underground* [1864], tr. Ralph E. Matlaw (New York: Dutton, 1960), pt. 1, secs. iii, iv, 9, 16 mod. For felicitous phrases—e.g., "acute" for "hyper"-consciousness—I have followed the tr. in Walter Kaufmann, *Existentialism: From Dostoevsky to Sartre*, rev. ed. (New York: New American Library, 1975), 59, 65; pt. 1, sec. ix, 30–31 mod.; cf. Kaufmann, *Existentialism*, 13, 18.

116. Fyodor Dostoevsky, *The Idiot* [1868], tr. Constance Garnett (New York: Modern Library, 1962), pt. 2, secs. 3–5.

117. Wilhelm Worringer, *Abstraction and Empathy: A Contribution to the Psychology of Style* [1908], tr. Michael Bullock (New York: International Universities Press, 1963), 133–34.

118. See sec. 2.6; the words are Adolf Behne's.

119. Edvard Munch's 1897 lithograph *In the Land of Crystal* can be discounted as a possible stylistic source (its forms are rounded, not angular), but the "land of crystal" as an eternal realm beyond death may well have interested Heckel.

120. Wenzel Hablik, "Schaffende Kräfte," catalogue, *Dritte Ausstellung: Graphik* (Berlin: Der Sturm), May 1912, nos. 33–52.

121. Hablik, introductory note, "Schaffende Kräfte," as tr. in Eugene A. Santomasso, *Origins and Aims of Expressionist Architecture: An Essay into the Expressionist Frame of Mind in Germany, Especially as Typified in the Work of Rudolf Steiner*, diss. (Columbia University, 1973), 143.

122. Paul Scheerbart, *Glass Architecture* [1914], tr. James Palmes, in *Glass Architecture by Paul Scheerbart and Alpine Architecture by Bruno Taut*, ed. Dennis Sharp (New York: Praeger, 1972), 71, 74.

123. Rosemarie Haag Bletter, *Bruno Taut and Paul Scheerbart's Vision: Utopian Aspects of German Expressionist Architecture*, diss. (Columbia University, 1973), 275–87.

124. Johann Wolfgang von Goethe, "Entoptische Farben," *Goethes Werke: Weimar*, Abt. I, vol. 3, 101, as tr. in Santomasso, *Origins*, 142.

125. August Macke, "Masks," in Wassily Kandinsky and Franz Marc, eds., *The Blue Rider Almanach* [1912], doc. ed. Klaus Lankheit (New York: Viking, 1974), 83–89, esp. 85 mod.

126. John Constable, *Memoirs of the Life of John Constable*, ed. Jonathan Mayne (London: Phaidon Press, 1951), 85; Novalis (Friedrich von Hardenberg), "Fragmente und Studien," *Schriften*, eds. Paul Kluckhohn and Richard Samuel (Stuttgart: Kohlhammer, 1960), vol. 3, 650; both as cited in Wiedmann, *Romantic Roots in Modern Art*, 49.

127. Wiedmann, *Romantic Roots in Modern Art*, chs. 3, 4.

128. Annemarie and Wolf-Dieter Dube, *E. L. Kirchner: Das graphische Werk*, 2 vols. (Munich: Prestel, 1967), woodcuts nos. 186–87.

129. Gustav Schiefler, *Das graphische Werk von Ernst Ludwig Kirchner, 1917–1927* (Berlin-Charlottenburg: Euphorion, 1931), 70.

130. Ernst Kirchner, letter to Gustav Schiefler 25 November 1919, as cited in Günther Gercken, *Ernst Ludwig Kirchner Holzschnittzyklen: Peter Schlemihl, Triumph der Liebe, Absalom* (Stuttgart: Belser, 1980), 35; Gercken, *Holzschnittzyklen*.

131. Ibid., 36.

132. Otto Weininger, *Sex and Character* [1903] (London: Heinemann, 1906), 7–10 mod. Note incidentally that Przybyszewski, who praised Weininger in his 1910 article "Das Geschlecht," also saw sex as "androgynous 'father' "; see sec. 2.2. For evidence that Weininger's thesis was indirectly prompted by Sigmund Freud's confidant, Wilhelm Fliess, see Peter Heller, "A Quarrel over Bisexuality," *The Turn of the Century*, 87–115.

133. Ibid., 29; for contrasexual types, 2; 37, 46.

134. In the "Second or Principle Part" of *Sex and Character*, woman was defined as unconscious of her sexuality (ch. 2), without consciousness at all (ch. 4), without a longing for immortality (ch. 5), without logic (ch. 6), lacking any "permanent relation to the idea of truth" (ch. 9), and so on. To complete the picture of woman as mindless sexual vessel, she was equated with the allegedly materialist Jew: "Woman has no share in ontological reality, no relation to the thing-in-itself, which, in the deepest interpretation, is the absolute, is God" (ch. 12).

135. Georg Reinhardt, "Im Angesicht des Spiegelbildes: Anmerkungen zu Selbstbildnis-Zeichnungen Ernst Ludwig Kirchners," *Brücke-Archiv* no. 11(1979–80):18–40, esp. 25; cf. figs. 3, 4.

136. Karlheinz Gabler, "E. L. Kirchners Doppelrelief: Tanz zwischen den Frauen—Alpaufzug," *Brücke Archiv* no. 11(1979–80):3–12, esp. 3; cf. figs. 1, 2.

137. Ernst Kirchner, letters to Botho Gräf' 21 September 1916, to Dr. Carl Hagemann, 3 December 1915, and to Gustav Schiefler 28 March 1916, as tr. in Donald E. Gordon, *Ernst Ludwig Kirchner* (Cambridge: Harvard University Press, 1968), 26–27. Cf. also 29 for Karl Scheffler's 1920 designation of Kirchner as "a 'Prince Nearly.' At times he is not far from masculine mastery, but he occasionally touches on the feminine."

138. Gercken, *Holzschnittzyklen*, 34.

139. Ibid., 48; cf. secs. 2.1, 2.2.

140. Jean Paul Friedrich Richter, *Titan: A Romance* [1800, 1803], tr.

Charles Timothy Brooks, 2 vols. (Boston: Ticknor Fields, 1863), vol. 1, 119, 276.

141. Hodler statement, as cited in Sharon L. Hirsh, *Ferdinand Hodler* (Munich: Prestel, 1981), 106.

142. Nietzsche, *The Anti-Christ*, 185, sec. 61, mod.

143. Oskar Panizza, *Das Liebeskonzil: Ein Himmels-Tragödie in fünf Aufzügen* (Zurich: F. Schabelitz, 1895), 13–14.

144. Friedrich Lippert, ed., *In memoriam Oskar Panizza* (Munich: H. Stobbe, 1926), 12–14.

145. George Grosz, letter to Otto Schmalhausen, 15 December 1917, in *Briefe, 1913–1959* (Reinbek bei Hamburg: Rowohlt, 1979), 57. For the Tucholsky statement, see Uwe M. Schneede, *George Grosz: His Life and Work,* tr. Susanne Flatauer (New York: University Books, 1979), 54. For the Kubin illustrations, see Lippert, *In memoriam,* 14.

146. For Strindberg's blasphemy trial concerning a story in the 1884 collection *Married,* see August Strindberg, *A Madman's Manifesto,* tr. Anthony Swerling (University, Ala.: University of Alabama Press, 1971), vii. For Ensor's trial in 1889 and Grosz's in 1928 and 1930, see Beth Irwin Lewis, *George Grosz: Art and Politics in the Weimar Republic* (Madison: University of Wisconsin Press, 1971), 220f.

147. Will Grohmann, *Karl Schmidt-Rottluff* (Stuttgart: W. Kohlhammer, 1956), 262.

148. Rudolf Otto, *The Idea of the Holy: An Inquiry into the Non-Rational Factor in the Idea of the Divine and its Relation to the Rational* [1917], tr. John W. Harvey (London: Oxford University Press, 1977), 31.

149. Württemburgische Staatsgalerie, Stuttgart.

150. Max Beckmann, letter of 24 May 1915, in *Briefe im Kriege* (Berlin: P. Cassirer, 1916), 66.

151. Max Beckmann, "Max Beckmann," in *Schöpferische Konfession,* ed. Kasimir Edschmid (Berlin: E. Reiss, 1920), 61–67, esp. 63–64.

152. Günter Busch, *Max Beckmann* (Munich: R. Piper, 1960), 53; Peter Selz, *Max Beckmann,* with contributions by Harold Joachim and Perry T. Rathbone (New York: Museum of Modern Art, 1964), 32; Friedhelm W. Fischer, *Max Beckmann: Symbol und Weltbild—Grundriss zu einer Deutung des Gesamtwerkes* (Munich: Wilhelm Fink, 1972), 17; Marcel Franciscono, "The Imagery of Max Beckmann's 'The Night,'" *Art Journal* 33(1973):18–22, esp. 20.

153. Fischer, *Max Beckmann,* 19 n. 21, 17–18 n. 18; Hans Jonas, *The Gnostic Religion* (Boston: Beacon Press, 1958), 254, 263; 264: "the mutual concern of the brotherhood, thrown together by the common cosmic solitude, is to deepen this very alienation and to further the other's redemption, which to each self becomes a vehicle of his own."

154. Franciscono, "Imagery of 'The Night,'" 20.

155. Franciscono ("Imagery of 'The Night,'" 19) points to Beckmann's wartime experience as a medical orderly; the right-hand man, for example, wears a "white uniform."

156. For a similarly Christian reference in an ostensibly secular work, see Selz's reading of Beckmann's 1921 *Dream* (*Max Beckmann,* 33–35). Here the placement of fish and ladder derive from the position of Christ's head and arms in Hans Hirtz's Karlsruhe altar, *The Nailing to the Cross.*

157. Max Beckmann, *Ebbi: Komödie* (Vienna: Johannes, 1924), act I, 8, 12; acts II, III, 13, 24.

158. Kurt Junghanns, *Bruno Taut 1880–1938* (Berlin: Henschel, 1970), 32.

159. Bruno Taut, *Alpine Architecture* [1919], in Denis Sharp, ed. *Glass Architecture and Alpine Architecture* (New York: Praeger, 1972), plate 12.

160. Bruno Taut, *Die Auflösung der Städte oder die Erde eine gute Wohnung, oder auch der Weg zur Alpinen Architektur* (Hagen: Folkwang, 1920), "Die grosse Blume," n.p.; also ill. in Wolfgang Pehnt, *Expressionist Architecture,* tr. J. A. Underwood and Edith Küstner (London: Thames & Hudson, 1973), fig. 178.

161. Pehnt, *Expressionist Architecture,* 79.

162. Ibid., 42.

163. Nietzsche, *Thus Spoke Zarathustra,* 42: "On the Tree on the Mountainside"; Pehnt, *Expressionist Architecture,* 80.

164. Ulrich Conrads and Hans G. Sperlich, *The Architecture of Fantasy: Utopian Building and Planning in Modern Times,* tr. C. C. Collins and G. R. Collins (New York: Praeger, 1962), 142.

165. Adolf Behne, *Die Wiederkehr der Kunst* (Leipzig: K. Wolff, 1919), 24; 64–67; also cited in Conrads and Sperlich, *Achitecture of Fantasy,* 134.

166. Pehnt, *Expressionist Architecture,* 89–91.

167. Herbert Bayer, Walter Gropius, and Ise Gropius, eds., *Bauhaus, 1919–1928* (New York: Museum of Modern Art, 1938), 18; Nikolaus Pevsner, "Gropius and van de Velde," *Architectural Review* 133(March 1963):167, as cited in Marcel Franciscono, *Walter Gropius and the Creation of the Bauhaus in Weimar: The Ideals and Artistic Theories of its Founding Years* (Urbana: University of Illinois Press, 1971), 14.

168. Robert Rosenblum, *Modern Painting and the Northern Romantic Tradition* (New York: Harper & Row, 1975), 161.

169. Though Feininger called himself an Expressionist in 1917 (Selz, *German Expressionist Painting,* 278), some would now exclude him. See e.g., Robert Gore Rifkind, "Wild Passion at Midnight: German Expressionist Art," *Art Journal* 39(1980):267.

170. Hans Hess, *Lyonel Feininger* (New York: Abrams, 1961), 29 mod.; Rosenblum, *Northern Romantic Tradition,* 218.

171. Johannes Molzahn, Karl Hermann, and Jacoba van Heemskerck, "Das Manifest des absoluten Expressionismus," *Der Sturm* 10(September 1919):90–91; cf. Helga Kliemann, *Die Novembergruppe* (Berlin: Mann, 1969), 120–21.

172. Joseph Campbell, *The Masks of God: Oriental Mythology* (New York: Penguin, 1977), 129. Less likely is an identity as the Egyptian goddess Hathor, who was *herself* "the great celestial cow who created the world and all it contains": *New Larousse Encyclopedia of Mythology* (London: Prometheus, 1972), 46.

173. Ibid., esp. 52–53.

174. Karl Scheffler, review of "Ja! Stimmen des Arbeitsrats für Kunst," *Kunst und Künstler* 18(1920):343, as tr. in Conrads and Sperlich, *The Architecture of Fantasy,* p. 140.

175. Otto Conzelmann, "Le Cas Otto Dix," *Dix* (Paris: Musée d'Art Moderne, 1972), n. p.

176. Lang, *Expressionist Book Illustration,* 45.

177. Formerly, Evangelical Church, Tapiau, East Prussia; present location unknown.

178. Paul Tillich in 1931 considered the 1910 altarpiece *"the* religious art work of our time": Charlotte Berend-Corinth, *Die Gemälde von Lovis Corinth: Werkkatalog* (Munich: F. Brückmann, 1958), 106. But today the Tapiau piece appears anecdotal, rigidly symmetrical, and too obviously dependent on Grünewald's Isenheim Altar *Crucifixion.*

179. Hans Konrad Röthel, "Einführung," *Lovis Corinth Werkkatalog,* 48.

180. Lovis Corinth, *Selbstbiographie* (Leipzig, 1926), 158, 161 (the latter entry from 20 December 1922), as cited in Röthel, "Einführung," *Lovis Corinth*

Werkkatalog, 45. Röthel also notes Corinth's early self-identification with Bismarck.

181. Berend-Corinth, *Lovis Corinth Werkkatalog,* nos. 865, 916. •

182. Kunstmuseum, Basel.

183. Charlotte Berend-Corinth, as cited in Gert von der Osten, *Lovis Corinth,* 2d ed. (Munich: F. Brückmann, 1959), 182.

184. Von der Osten, *Lovis Corinth,* 182.

185. Corinth, *Selbstbiographie,* 165 (entry from 15 April 1928), as cited in Röthel, "Einführung," *Lovis Corinth Werkkatalog,* 48.

186. Wilhelm Hausenstein, "Lovis Corinth," in *Das Pantheon,* ed. Hans Martin Elster (Berlin: Deutsche Buchgemeinschaft, 1925), 330, as cited in Röthel.

187. As did all modern culture: see Frank Kermode, *The Sense of an Ending* (New York: Oxford University Press, 1967), esp. ch. 4.

188. See e.g., Reinhold Heller, "Edvard Munch's 'Vision' and the Symbolist Swan," *The Art Quarterly* 36(1973):209–49.

189. It should be pointed out that many former Expressionists left the movement in the early 1920s by stressing an unrelieved disillusionment or nihilism; it is the "unrelieved" content that is Post-Expressionist, whether optimistic or pessimistic.

190. Ernst Kris and E. H. Gombrich, "The Principles of Caricature," in Ernst Kris, *Psychoanalytic Explorations in Art* (New York: Schocken, 1967), 189–203, esp. 199.

191. Ibid.

192. Donald E. Gordon, "Expressionism: Art by Antithesis," *Art in America* 69(March 1981):99–111, esp. 103.

CHAPTER III

George Kubler, *The Shape of Time* (New Haven: Yale University Press, 1962), 72.

1. Franz Marc, "Two Pictures," in Wassily Kandinsky and Franz Marc, eds., *The Blue Rider Almanach* [1912], doc. ed. Klaus Lankheit (New York: Viking, 1974), 65–69, esp. 66.

2. Catalogue, *Kandinsky, Franz Marc, August Macke: Drawings and Watercolors* (New York: Hutton-Hutschnecker Gallery, 1969), 72; Paul Klee, "Paul Klee," in: *Schöpferische Konfession,* ed. Kasimir Edschmid (Berlin: E. Reiss, 1920), 28–40, esp. 38–39, Werner Haftmann, *Painting in the Twentieth Century,* tr. Ralph Manheim, 2 vols. (New York: Praeger, 1967), vol. 1, 81; Daniel-Henry Kahnweiler, *Juan Gris: His Life and Work,* tr. Douglas Cooper (New York: Curt Valentin, 1947), 96–97.

3. Wilhelm Worringer, "Zur Entwicklungsgeschichte der modernen Malerei," *Der Sturm* 2(August 1911):597–98, as reprinted from *Die Antwort auf den Protest deutscher Künstler* (Munich: R. Piper, 1911).

4. Wassily Kandinsky, "On the Question of Form," in Kandinsky and Marc, *The Blue Rider Almanach,* 147–87, esp. 17s.

5. Harold Bloom, *The Anxiety of Influence: A Theory of Poetry* (New York: Oxford University Press, 1973), 96.

6. Ibid., 50; 56.

7. Georg Reinhardt, "Die frühe 'Brücke': Beiträge zur Geschichte und zum Werk der Dresdener Künstlergruppe 'Brücke' der Jahre 1905 bis 1908," *Brücke-Archiv* no. 9/10(1977–78) convincingly demonstrates the Impressionist properties (46–48) and Jugendstil sources (n. 162, fig. 28) of works from 1905.

8. Ibid., 19–22.

9. Ibid., 30, fig. 8.

10. Ibid., 52.

11. Beat Stutzer, "Das Stammbuch 'Odi Profanum' der Künstlergruppe 'Brücke,'" *Zeitschrift des deutschen Vereins für Kunstwissenschaft* 36(1982):87–105, esp. 100.

12. Julius Meier-Graefe, *Entwicklungsgeschichte der modernen Kunst,* 3 vols. (Stuttgart: J. Hoffmann, 1904), vol. 1, 114–30. By 1910, when Meier-Graefe devoted a separate book to it, Van Gogh's art was known to leading Expressionists in Dresden, Munich, and Vienna.

13. This was Meier-Graefe's view: *Entwicklungsgeschichte,* vol. 1, 130.

14. A painting entitled *Sonnenuntergang über den Rhone (Sunset over the Rhone)* was listed in a catalogue documenting this exhibition: see Donald E. Gordon, "Kirchner in Dresden," *The Art Bulletin* 48(1966):339, n. 26. However, of all the paintings of sunsets known to Van Gogh's cataloguer, this is the only one permitting a misreading of a river: J. B. de la Faille, *L'Oeuvre de Vincent van Gogh: Catalogue Raisonné,* 4 vols. (Paris and Brussels: G. van Oest, 1928), vol. 1, no. 735. Ironically, the painting's title has since been corrected once again, this time to *Moon Rise: Haycocks:* see de la Faille, *The Works of Vincent van Gogh: His Paintings and Drawings* (London: Weidenfeld & Nicholson, 1970), 281.

15. Specifically, in 1907, the art critic Paul Fechter and the painter Emil Nolde: see Gordon, "Kirchner in Dresden," 342–44.

16. Expressionist responses to Van Gogh were numerous but varied. For Van Gogh and Jawlensky in 1904 and (through Jawlensky) Münter in 1908, see sec. 2.2. For Van Gogh and Franz Marc from 1907 through the winter of 1909–10, see catalogue *Franz Marc 1880–1916* (Munich: Städtische Galerie im Lenbachhaus, 1980), nos. 19, 23, pp. 147, 150. For Van Gogh's impact on Richard Gerstl and Oskar Kokoschka from 1906 to 1908, see sec. 3.4. For Van Gogh and Kokoschka in 1909, see figs. 73, 74. And for Van Gogh and Egon Schiele in 1911, see Alessandra Comini, *Egon Schiele* (New York: Braziller, 1976), 26.

17. Donald E. Gordon, *Ernst Ludwig Kirchner* (Cambridge: Harvard University Press, 1968), 20. Exhibited artists' names are representative; the list is not intended to be complete. For other possible Dresden sources, see Gordon, "Kirchner in Dresden," and Reinhardt, "Die frühe 'Brücke,'" passim.

18. Munch's frontality and multiple contours influenced Pechstein's crayon *Street Scene* of 1907 in the Harvard University Collections. For Kirchner's dependence upon Munch and Klimt, see Gordon, *Ernst Ludwig Kirchner,* 48–60. But where Munch influenced Kirchner's *style,* motifs could originate elsewhere—e.g., in van Rysselberghe or Toulouse-Lautrec: Reinhardt, "Die frühe 'Brücke,'" figs. 74, 80.

19. Kirchner, "Chronik der Brücke" [1913], as tr. in Peter Selz, *German Expressionist Painting* (Berkeley: University of California Press, 1957), 320.

20. Heckel, letter to Cuno Amiet, 20 January 1908, as cited in Leopold Reidemeister, *Künstler der Brücke: Gemälde der Dresdener Jahre* (Berlin: Brücke-Museum, 1973), 15. Heckel first saw Gauguins in February 1907 at the Osthaus Museum in Hagen: Reidemeister, *Künstler der Brücke,* 13.

21. Günter Krüger, "Die Jahreszeiten, ein Glasfensterzyklus von Max Pechstein," *Zeitschrift des Deutschen Vereins für Kunstwissenschaft* 19(1965):77–94, esp. 93.

22. Donald E. Gordon, *Modern Art Exhibitions, 1900–1916: Selected Catalogue Documentation* (Munich: Prestel, 1974), vol. 2, 252–56.

23. Reinhardt, "Pechsteins Paris-Aufenthalt 1908," in "Die frühe 'Brücke,'" 142–48.

24. Ibid., 144–45. The Van Dongen works in question are *Nini—La Prostituée* (1907), *Anita—La Belle Fatima et sa Troupe* (1907–08), and *Les Lutteuses de Tabarin* (1907), the latter exhibited at the 1908 Indépendants: see **227**

Louis Chaumeil, *Van Dongen: L'Homme et l'artise; La Vie et l'oeuvre* (Geneva: P. Cailler, 1967), 59, 54, 64.

25. Van Dongen's *Le Chapeau Cloche* of 1911 (Chaumeil no. 75) has been linked to Pechstein's 1911 *Damenbildnis*: Reinhardt, "Die frühe 'Brücke,'" figs. 115 and 189, n. 728. But the facial features and eyes without pupils also relate to Kirchner's 1911 *Half-Length Nude with Hat* (Gordon, *Ernst Ludwig Kirchner*, no. 180).

26. Gordon, "Kirchner in Dresden," figs. 31–36 and 348–49.

27. Problems concerning Kirchner's predating are addressed in Gordon, "Kirchner in Dresden," 335–37 and appendix 1, 362–63.

28. Karlheinz Gabler, in catalogue *Ernst Ludwig Kirchner: Zeichnungen I, 1906–1925* (Kassel: Staatliche Kunstsammlungen, 1967), passim.

29. Selz, *German Expressionist Painting*, 320.

30. For a discussion of both the chronology and the life-and-art aspects of Brücke primitivism, see Donald E. Gordon, "German Expressionism and the Romance of Primitive Art," *Affinities: 'Primitivism' and Modern Art*, ed. William Rubin (New York: Museum of Modern Art, 1984): esp. secs. 2 and 3.

31. Franz Marc, "The 'Savages' of Germany," *The Blue Rider Almanach*, 6–164, esp. 61; Gustav F. Hartlaub, *Die Graphik des Expressionismus in Deutschland* (Stuttgart: G. Hatje, 1947), 9–10.

32. This may be seen by comparing Kirchner's *Fränzi in Carved Chair* of 1910 (Gordon, *Ernst Ludwig Kirchner*, no. 122) with Matisse's *Green Line* of 1905 (Copenhagen, Statens Museum). Despite the Palau source for the chair, Kirchner's colors are Fauve. Thus just as Matisse's background employs fields of intense green, red, and purple, with the red and purple reappearing in the dress, so Kirchner's background fields are of blue, orange, green, and red, with the latter two colors used in Fränzi's costume. Even the German girl's startling green face recalls the green stripe down Madame Matisse's face, which gives the French painting its popular name.

33. John Griffiths, *The Paintings of the Buddhist Cave-Temples of Ajanta, Kandesh, India,* 2 vols. (London: n.p. 1896–97).

34. E. L. Kirchner, *Briefe an Nele und Henry van de Velde* (Munich: R. Piper, 1961), 21.

35. Gordon, "Kirchner in Dresden," fig. 66.

36. Kirchner, *Briefe an Nele*, 21.

37. See Gordon, "Expressionism and Primitive Art" (esp. secs. 6 and 8).

38. Catalogue, *Secession: Europäische Kunst um die Jahrhundertwende* (Munich: Haus der Kunst, 1964), esp. 3–19.

39. Will Grohmann, *Wassily Kandinsky: Life and Work* (New York: Abrams, 1958), 9.

40. For the contents of the Phalanx exhibitions, see Peg Weiss, *Kandinsky in Munich: The Formative Jugendstil Years* (Princeton: Princeton University Press, 1979), 59–72.

41. Stephane Mallarmé, "Réponse à une enquête," *L'Art Moderne* (Paris), 9 August 1891, as cited in Peter Selz and Mildred Constantine, eds., *Art Nouveau: Art and Design at the Turn of the Century* (New York: Museum of Modern Art, 1960), 9; George, "Der Teppich des Lebens 1901," as tr. in Weiss, *Kandinsky in Munich*, 90.

42. Weiss, *Kandinsky in Munich*, 93.

43. Ibid., 120, 92–103.

44. August Endell, "Formenschönheit und dekorative Kunst," *Dekorative Kunst* (Munich) (November 1897):75–77; Weiss, *Kandinsky in Munich*, 26; Hermann Obrist, *Neue Möglichkeiten in der bildenden Kunst* (Leipzig: E. Diederichs, 1903), 165. Kirchner, it should be remembered, studied with Obrist in Munich in 1903–04.

45. For the most complete Kandinsky biographical outline, see now Hans K. Roethel and Jean K. Benjamin, *Kandinsky: Catalogue Raisonné of the Oil Paintings*, Vol. 1: 1900–1915 (Ithaca: Cornell University Press, 1982), 31–46.

46. Donald E. Gordon, review of Roethel and Benjamin, *Burlington Magazine* 125, no. 968(Nov. 1983):705.

47. Roethel and Benjamin, *Kandinsky*, no. 225, p. 220.

48. Gabriele Münter, statement of 10 February 1933, as cited in catalogue, *Gabriele Münter 1877–1962* (Munich: Städtische Galerie im Lenbachhaus, 1962), n.p., as tr. in Anne Mochon, *Gabriele Münter: Between Munich and Murnau* (Cambridge: Busch-Reisinger Museum, Harvard University, 1980), 32 n. 9.

49. Gordon, *Modern Art Exhibitions*, vol. 2, 254.

50. This is the view of Sabine Helms, Städtische Galerie im Lenbachhaus, as reported in Mochon, *Gabriele Münter*, 24 n. 22.

51. Paul Klee, "Die Ausstellung des Modernen Bundes im Kunsthaus Zürich," *Die Alpen* 6, no. 12(1912):701; Wassily Kandinsky, "On the Question of Form," *The Blaue Reiter Almanach:* 178; cf. 174ff.

52. Rosel Gollek, *Der Blaue Reiter im Lenbachhaus München* (Munich: Prestel, 1974), 120f (Kandinsky) and 243f (Münter).

53. "If I had a formal model . . . it was probably Van Gogh, through Jawlensky and his theories (his talk of synthesis)": Münter, undated note in catalogue, *Der Blaue Reiter* (Munich: Städtische Galerie, 1966), 122. For the 1908 chronology, see Grohmann, *Wassily Kandinsky*, 53–54, and Clemens Weiler, *Alexei Jawlensky: Der Maler und Mensch* (Wiesbaden: Limes, 1955), 15–17.

54. Mochon, *Gabriele Münter*, 28.

55. Kandinsky was in Moscow, St. Petersburg, and Odessa in October–December 1910. Both in the second Izdebsky Salon in Odessa and the first Jack of Diamonds exhibition in Moscow, the latter organized by Larionov, Kandinsky exhibited his work alongside such Neo-Primitive works as Larionov's *Soldiers:* Roethel and Benjamin, *Kandinsky*, 37; Gordon, *Modern Art Exhibitions*, vol. 1, 35 n. 16.

56. Grohmann, *Wassily Kandinsky*, 41.

57. Sixten Ringbom, *The Sounding Cosmos: A Study in the Spiritualism of Kandinsky and the Genesis of Abstract Painting* (Abo: Abo Akademi, 1970), 141.

58. Ibid., 148–49.

59. Annie Besant and C. W. Leadbetter, *Thought-Forms* (Wheaton, Ill.: Theosophical Publishing House, 1969), 74.

60. Wassily Kandinsky, "Rückblicke," in album, *Kandinsky 1901–1913* (Berlin: Der Sturm, 1913): p. ix, as tr. in *Modern Artists on Art,* ed. Robert L. Herbert (Englewood Cliffs: Prentice-Hall, 1964), 26.

61. Besant and Leadbetter, *Thought-Forms*, 67; 11. Emphasis added.

62. Ibid., 83; Sixten Ringbom, "Art in 'The Epoch of the Great Spiritual': Occult Elements in the Early Theory of Abstract Painting," *Journal of the Warburg and Courtauld Institutes* 29(1966):405; Wassily Kandinsky, *Concerning the Spiritual in Art* (New York: Wittenborn, 1947), 33. Also cited in Ringbom, "Great Spiritual," 394.

63. Roethel and Benjamin, *Kandinsky*, nos. 276, 282.

64. Eberhard Roters, "Wassily Kandinsky und die Gestalt des blauen Reiters," *Jahrbuch der Berliner Museen* 5(1963):201–26, esp. 218.

65. Ibid.

66. In addition to the Besant-Leadbetter source, Kandinsky's use of the word "vibration" had other precedents from Gauguin to Rudolf Steiner: Rose-Carol Washton Long, *Kandinsky: The Development of an Abstract Style* (Oxford: Clarendon Press, 1980), 32–33.

67. Kandinsky's interest in abstraction was whetted by Wilhelm Worringer's *Abstraction and Empathy,* published in Munich in 1908.

68. Catalogue, *Neue Künstlervereinigung München* (Munich: Moderne Galerie, 1909), n.p., also reprinted in Gollek, *Der Blaue Reiter,* 262.

69. Manifesto in pamphlet form, inserted in catalogue, *Die erste Ausstellung der Redaktion: Der blaue Reiter* (Munich: Moderne Galerie Thannhauser, 1911–12), n.p. Mentioned, but not reprinted, in Gollek, *Der Blaue Reiter,* 274.

70. Names were taken from exhibition catalogues in the Städtische Galerie im Lenbachhaus, Munich. It should be noted that Jawlensky and Werefkin did *not* exhibit with the Blaue Reiter in 1912, either in Munich or Berlin, but were included in a Scandinavian travel exhibition of Blaue Reiter works organized by Der Sturm Gallery in 1914: Gordon, *Modern Art Exhibitions,* vol. 2, 796. Gollek, *Der Blaue Reiter,* 29, 254, erroneously states their "participation in 'Blaue Reiter' exhibition organized by 'Sturm,' 1912."

71. Gollek, *Der Blaue Reiter,* 29, although the number of paintings shown at the Autumn Salon is wrongly listed as 10 (30).

72. Elisabeth Erdmann-Macke, 1962, as cited in Gollek, *Der Blaue Reiter,* 188.

73. Gollek, *Der Blaue Reiter,* 271, 15.

74. Albert Bloch, 1955, as cited in Gollek, *Der Blaue Reiter,* 22.

75. August Macke and Franz Marc, *Briefwechsel* (Cologne: M. DuMont Schauberg, 1964), 17 (Gauguin), 18 (NKVM), and 39–40 (primitive art).

76. See Jawlensky's statement, cited in Gollek, *Der Blaue Reiter,* 44.

77. Donald E. Gordon, "Content by Contradiction," *Art in America* 70(December 1982):78.

78. This point is further elaborated in Gordon, "Expressionism and Primitivism," sec. 4, which traces the influence of a Cameroon *Oxhead Mask* in the Berlin Ethnographic Museum on Marc's *Donkey Frieze* of 1911.

79. This comparison was first published in Donald E. Gordon, "Marc and Friedrich Again: Expressionism as Departure from Romanticism," *Source: Notes in the History of Art* 1(Fall 1981):29–32.

80. This link was first established in Klaus Lankheit, *Franz Marc: Sein Leben und seine Kunst* (Cologne: M. DuMont Schauberg, 1976), 78. Aside from the "extroverted" color symbolism cited by Lankheit we might point to the golden cup as a contributing factor in Marc's choice of the color yellow for his cow.

81. Wassily Kandinsky, "Der blaue Reiter (Rückblick)," *Das Kunstblatt* 1930, as tr. in *Kandinsky: Complete Writings on Art,* eds. Kenneth C. Lindsay and Peter Vergo (Boston: G. K. Hall, 1982), vol. 746. Roters, who first published the three-stage *St. George–Blue Rider* comparison, cites a similar Kandinsky statement from 1936; see Roters, "Gestalt des blauen Reiters," 211.

82. See the Blaue Reiter manifesto, cited earlier in this section.

83. See for example Peter Selz, *German Expressionist Painting* (Berkeley: University of California Press, 1957), where ch. 12 (147ff) is titled "The Vienna Secession, Klimt, and Schiele." See also the catalogue, *Viennese Expressionism, 1910–1924* (Berkeley: University Art Gallery, 1963), where Klimt and Kokoschka are included in a show devoted to Schiele.

84. Peter Vergo, *Art in Vienna, 1898–1918: Klimt, Kokoschka, Schiele and their Contemporaries* (London: Phaidon Press, 1975), 18–23.

85. Carl E. Schorske, "Generational Tension and Cultural Change: Reflections on the Case of Vienna," *The Turn of the Century: German Literature and Art, 1890–1915,* eds. Gerald Chapple and Hans H. Schulte (Bonn: Bouvier, 1981), 415–31, esp. 420.

86. Vergo, *Art in Vienna,* 24–25.

87. Donald G. Daviau, "Hermann Bahr and the Secessionist Art Movement in Vienna," *The Turn of the Century,* 433–62, esp. 447.

88. See the two eyewitness accounts by Alois Gerstl (1954) and by Victor Hammer (1963), in Otto Kallir, "Richard Gerstl (1883–1908): Beiträge zur Dokumentation seines Lebens und Werkes," *Mitteilungen der Österreichischen Galerie* (Vienna) 18:64(1974):137–44.

89. Jane Kallir, *Austria's Expressionism* (New York: Galerie St. Etienne, 1981), 27. This same Van Gogh exhibition had been shown in Dresden in November 1905: Gordon, "Kirchner in Dresden," 339.

90. Victor Hammer in Kallir, "Richard Gerstl," 142.

91. According to Hammer, Gerstl spoke of Van Gogh and not of Munch. But Vergo, *Art in Vienna,* 201, argues for the Munch connection.

92. Arnold Schönberg, "Painting Influences", *Journal of the Arnold Schönberg Institute* 11:3(June 1978):238, as cited in Jane Kallir, *Austria's Expressionism,* 27–28.

93. Jane Kallir, *Austria's Expressionism,* 27–28.

94. Oskar Kokoschka, *My Life,* tr. David Britt (New York: Macmillan, 1974), 20.

95. Hans Maria Wingler, *Oskar Kokoschka: The Work of the Painter* (Salzburg: Galerie Welz, 1958), 293, nos. 3, 4.

96. Kokoschka expressed admiration in 1953 for both Van Gogh and Munch. See his "Van Gogh's Influence on Modern Painting," *Mededelingen . . .* (The Hague), 1953, nos. 5–6, 79–81, as tr. in Victor H. Miesel, ed., *Voices of German Expressionism* (Englewood Cliffs: Prentice-Hall, 1970), 101–04; and his "Edvard Munch's Expressionism," *College Art Journal* 12(1953):312–20; 13(1953):15–18.

97. Wingler, *Oskar Kokoschka,* 296, no. 27.

98. According to one interpretation, "the infant's right hand has already emerged from its mother's body": James T. Demetrion, in catalogue, *Gustav Klimt and Egon Schiele* (New York: Solomon R. Guggenheim Museum, 1965), 66.

99. Arthur Roessler, ed., *Briefe und Prosa von Egon Schiele* (Vienna, 1921), 29, as tr. in Alessandra Comini, *Egon Schiele's Portraits* (Berkeley: University of California Press, 1974), 87.

100. Fritz Novotny and Johannes Dobai, *Gustav Klimt* (Salzburg: Galerie Welz, 1967), 45.

101. The Hodler is in Vienna's Kunsthistorisches Museum; the Schiele is in the collection of Dr. Rudolf Leopold, Vienna (see Erwin Mitsch, *The Art of Egon Schiele,* tr. W. Keith Haughan [London: Phaidon Press, 1975], figs. 17, 69).

102. Hodler, "Parallelism," as tr. in Herschel B. Chipp, *Theories of Modern Art* (Berkeley: University of California Press, 1968), 107–09.

103. Miroslav Lamač, *Modern Czech Painting, 1907–1917* (Prague: Artia, 1967), passim.

104. Ibid., 87.

105. Catalogue, *Le Cubisme à Prague et la Collection Kramář* (Rotterdam: Museum Boymans-van Beuningen, 1968), [23].

106. Douglas Cooper, *The Cubist Epoch* (London: Phaidon Press, 1970), 150–52.

107. Ibid., 248.

108. Gordon, *Modern Art Exhibitions,* vol. 2, 539f, 611f, 716f.

109. Lamač, *Czech Painting,* 45.

110. The best analysis of these events is by Peter Paret, *The Berlin Secession: Modernism and Its Enemies in Imperial Germany* (Cambridge: Harvard University Press, 1980), passim. The quotations are from 83 and 86.

111. Emil Nolde, *Jahre der Kämpfe* (Berlin: Rembrandt, 1934), 143–44.

112. Names were taken from catalogues in the Kunstarchiv Arntz, Haag, Oberbayern, and in the library of the National Gallery, Berlin. In the fourth show, the NKVM was credited with its own jury. The sixth show we know only

indirectly, from its Jan.–Feb. 1913 showing in Düsseldorf: see Gordon, *Modern Art Exhibitions,* 1, 92.

113. M. R. Schünlank [pseud. Max Raphael], introduction, *Katalog der Neuen Secession Berlin* (Berlin: Baron, 1911), n.p. The word "decoration," with its implications of color, abstraction, and flatness, did not then possess the pejorative overtones it took on later.

114. For example, in the Louvre's 1886 *Woman with Umbrella Turned toward the Right,* ill. in catalogue, *Hommage à Claude Monet* (Paris: Editions de la Réunion des musées nationaux, 1980), 269, cat. no. 92.

115. Paul Vogt, *Christian Rohlfs* (Cologne: M. DuMont Schauberg, 1967), 12.

116. Although Heckel had seen Gauguins in Hagen in 1907, there were no Gauguins at the 1908 Salon des Indépendants in which Pechstein participated in Paris: see notes 20 and 21 this chapter. Nor were Gauguin oils displayed at the Secession in Berlin after Pechstein settled there later in 1908: Gordon, *Modern Art Exhibitions,* passim.

117. Max Pechstein, *Erinnerungen* (Wiesbaden: Limes), 50.

118. Paul Gauguin, letters of 14 August 1888, and August 1892, *Lettres de Gauguin à sa femme et à ses amis,* ed. Maurice Malingue (Paris, 1949), 134, 232, as tr. in Herschel B. Chipp, ed., *Theories of Modern Art* (Berkeley: University of California Press, 1968), 60, 64.

119. For a discussion of this photograph and its effect on Kirchner works of 1910–11, see Gordon, "Kirchner in Dresden," 356–57 n. 126.

120. Paret, *The Berlin Secession,* 182ff, 190.

121. This is the inscription on Pechstein's 1910 poster for the first Neue Secession exhibition. The Manet-Pechstein connection was first suggested to me by George Rugg, Pittsburgh.

122. For Manet and Marcantonio, see John Rewald, *The History of Impressionism* (New York: Museum of Modern Art, 1961), 85; for Gauguin and photographs of the Javanese Temple, see Bernard Dorival, "Sources for the Art of Gauguin from Java, Egypt and Ancient Greece," *Burlington Magazine* 93(1951):118–23.

123. For Gauguin and Marc 1910–11, see fig. 69. For Hodler and Marc 1910, see Johannes Langner, "Iphigenie als Hund: Figurenbild im Tierbild bei Franz Marc," in Catalogue, *Franz Marc, 1880–1916* (Munich: Städtische Galerie, 1980), 59 and n. 12. For Hodler and Schiele 1910, see sec. 3.3.; for numerous Symbolists and Schiele, see Comini, *Egon Schiele,* 13–17, 22–25. For Hodler and Cuno Amiet 1904–10, see George Mauner, "Amiet und Hodler," *Berner Kunstmitteilungen* no. 188(April–May 1979):1–5. For Ensor and Nolde 1911, see fig. 85. For Munch's influence in Vienna and Prague, see sec. 3.4 above. For Munch and Kirchner 1908, see fig. 55. For Seurat and Kirchner 1912, see Gordon, *Ernst Ludwig Kirchner,* 84 and n. 30.

124. Harald Seiler, *Wilhelm Morgner* (Cologne: E. A. Seemann, 1956), 34, 35.

125. This mask is illustrated, and Nolde's other tribal art sources discussed in greater detail, in Gordon, "German Expressionism and Primitive Art," sec. 5.

126. Nolde's pencil drawings after these pieces were first illustrated in Leopold Reidemeister and Kurt Krieger, *Das Ursprüngliche und die Moderne* (Berlin: Akademie der Künste, 1964), nos. 142, 140.

127. Nolde, *Jahre der Kämpfe,* p. 170, as cited in sec. 23; Paul Haesaerts, *James Ensor* (New York: Abrams, 1959), 200f.

128. E.g., an undated watercolor *Couple,* from before 1914, in the Berlin Brücke-Museum: catalogue, *Künstler der Brücke in Berlin, 1908–1914* (Berlin: Brücke-Museum, 1972), no. 125, plate 61.

129. Selz, *German Expressionist Painting,* 115.

130. See Gordon, "German Expressionism and Primitive Art," sec. 6.

131. The Berlin museum guide describes these "most remarkable heads covered with skin, which are rank insigniae for secret societies": *Führer durch das Museum für Völkerkunde* (Berlin: G. Reimer, 1911), 70. But since none of the Berlin examples have survived, we illustrate one from Munich.

132. Leopold Reidemeister, "Die vier Evangelisten von Karl Schmidt-Rottluff," *Brücke-Archive* no. 8(1975–76):13–16, suggests German Gothic inspiration.

133. Catalogue, *Bemalte Postkarten und Briefe deutscher Künstler* (Hamburg: Altonaer Museum, 1962), no. 205, 47; see also no. 232, 52.

134. See 1912 paintings in Will Grohmann, *Karl Schmidt-Rottluff* (Stuttgart: W. Kohlhammer, 1956), 257, and Gordon, *Ernst Ludwig Kirchner,* nos. 281–82.

135. Paul Raabe and H. L. Greve, *Expressionismus: Literatur und Kunst, 1910–1923* (Marbach: Schiller-Nationalmuseum, 1960), 23.

136. Grohmann, 257; Gordon, *Ernst Ludwig Kirchner,* no. 215.

137. George Heym, *Umbra vitae: Nachgelassene Gedichte, mit 47 Original-Holzschnitten von Ernst Ludwig Kirchner* (Munich: K. Wolff, 1924).

138. Van Hoddis, "Weltende," *Der Demokrat* (Berlin), 11 January 1911, as tr. in Michael Hamburger and Christopher Middleton, eds., *Modern German Poetry* (New York: Grove, 1962), 48–49.

139. Johannes R. Becher, *Das poetische Prinzip* (Berlin, 1957), 102f, as tr. in Paul Raabe, ed., *The Era of German Expressionism,* tr. J. M. Ritchie (Woodstock: Overlook Press, 1974), 46.

140. Ludwig Meidner, in Jakob van Hoddis, *Weltende: Gesammelte Dichtungen,* ed. Paul Pörtner (Zurich, 1958), 88f, as tr. in Raabe and Greve, *Expressionismus,* 27–28; Meidner, "Anleitung zum Malen von Grossstadtbildern," *Kunst und Künstler* 12(1914):299f, as tr. in Miesel, *Voices of German Expressionism,* 113; 114.

141. *Corner House* "was based upon a carefully drawn series of views made from different vantage points": Victor H. Miesel, in catalogue, *Ludwig Meidner: An Expressionist Master* (Ann Arbor: University of Michigan Museum of Art, 1978), 20 n. 29.

142. Ibid., 8.

143. Stefan Zweig, *Emil Verhaeren* (Leipzig, 1910), as cited in Paul Raabe, *Die Zeitschriften und Sammlungen des literarischen Expressionismus* (Stuttgart: J. B. Metzler, 1964), 45. *Das neue Pathos* was a Berlin journal, 1913–20.

144. Miesel, in *Ludwig Meidner,* 4.

145. Franz Marc, "Ideen über Ausstellungswesen," *Der Sturm* 3(June, 1912):66.

146. Exhibitions are representative; artist listings in each exhibition are not intended to be complete. List compiled from various sources.

147. Medievalism may be identified in the Brücke's early woodcut technique, allegedly influenced by "the old prints in Nuremberg," and in the group's later study of "Cranach, Beham and other medieval German masters" (Kirchner, *Chronik der Brücke,* 1913). It can also be argued that Nolde's religious paintings from 1909 on, despite their Fauve coloration, owe something to North German altarpieces that the artist may have seen in local churches. Similarly Kokoschka's 1909 poster for "Murderer, Hope of Women" (fig. 18) can be linked to the *Rondanini Pietà,* itself a medievalizing late work by Michelangelo. Finally, following Wilhelm Worringer's argument that "the primitive" and "the Gothic" are closely related (*Form Problems of the Gothic,* 1910), the folk art orientation of Kandinsky and Marc in 1911–12 directly expresses their concern for "the spiritual."

148. Gordon, *Ernst Ludwig Kirchner,* no. 1025.

149. Krüger, "Die Jahreszeiten," 83, nn. 11–15.

150. *Die Aktion* 3(1913):1.

151. Ernst Barlach, *Der tote Tag: Drama in fünf Akten* (Berlin: P. Cassirer, 1919), as excerpted and tr. in Miesel, *Voices of German Expressionism*, 127–36.

152. Friedrich Schult, *Ernst Barlach: Das plastische Werk* (Hamburg: E. Hauswedell, 1960), nos. 123, 127.

153. Theodor Däubler, *Der neue Standpunkt* (Leipzig: Insel, 1919), 187; he also called *Kneeling Woman* "the preamble to Expressionism in sculpture."

154. Julius Meier-Graefe, reminiscence, as tr. in Reinhold Heller, *The Art of Wilhelm Lehmbruck* (Washington: National Gallery of Art, 1972), 24.

155. Meier-Graefe, *Entwicklungsgeschichte*, vol. 2, 541; Kokoschka, *My Life*, 21–22.

156. For a comparison of Gauguin's "dreaming" and Pechstein's "flesh and blood," see the discussion of fig. 82.

157. The Rhineland Expressionist group was organized by August Macke rather than a dealer, yet it is the exception which proves the rule of the dealer's significance. For Macke stated that he had formed the group "first to get the jump on [the dealer Paul] Cassirer . . . , and second as a rehearsal for the Autumn Salon" organized by another dealer, Herwarth Walden: Macke, letter to Walden, 9 July 1913, in *Die Rheinischen Expressionisten* (Recklinghausen: A. Bongers, 1980), 10.

158. Selz, *German Expressionist Painting*, 17.

159. These parallels cannot be duplicated in El Greco's ca. 1588 *Crucifixion*, which has also been proposed as Ernst's source: *Die Rheinischen Expressionisten*, 24.

160. I have profited from Robert Rosenblum's reading of the Grünewald-Ernst comparison in *Modern Painting and the Northern Romantic Tradition: Friedrich to Rothko* (New York: Harper & Row, 1975), 167.

161. Georg Kerschensteiner, *Die Entwickelung der zeichnerischen Begabung* (Munich, 1905), plate 95.

162. Felix Klee, ed., *The Diaries of Paul Klee, 1898–1918* (Berkeley: University of California Press, 1964), 266, no. 905; 278, no. 922. The association of statements and drawing was made by O. K. Werckmeister, who also proposed the comparison we illustrate here: Werckmeister, "Klees 'kindliche' Kunst," in *Versuche über Paul Klee* (Frankfurt: Syndikat, 1981), 124–78, esp. 144. *Arts Magazine* 52(September 1977):138–51.

163. Kerschensteiner, *Entwickelung*, 320, accompanying plate 95.

164. For further discussion of the 1913 debt to Cubism, see Jim Jordan, *Paul Klee and Cubism* (Princeton: Princeton University Press, 1983).

165. Klaus Lankheit, *Franz Marc: Katalog der Werke* (Cologne: M. DuMont Schauberg, 1970), no. 164. For the Picasso, see Gordon, *Modern Art Exhibitions*, vol. 1, 180, no. 628.

166. For Macke's views on Cubism and Futurism, see his letter to Ernst Grisebach, 20 March 1913, in Gustav Vriesen, *August Macke* (Stuttgart: W. Kohlhammer, 1953), 261.

167. Delaunay transported the *Windows* oils from La Madeleine to Paris just before meeting Macke and Marc on 2 October 1912: Gustav Vriesen and Max Imdahl, *Robert Delaunay: Light and Color* (New York: Abrams, 1969), 50. Vriesen believes (p. 46) that it was this very version with painted frame—"or another very similar version"—that most moved Macke. Since it apparently didn't leave Paris, though other versions were shown in Zurich and Berlin, it is all but certain that this specific painting was seen and admired by Macke and Marc during their Paris visit.

168. Robert Delaunay, "Erklärung über die Konstruktion der Realität in der reinen Malerei," in Guillaume Apollinaire, "Réalité, peinture pure," *Der Sturm* 3(December 1912):224–25. For the relation of this German text to two French versions, see LeRoy C. Breunig, ed., *Apollinaire on Art* (New York: Viking, 1972), 496 n. 54.

169. Franz Marc, letter of 12 December 1910, in Macke and Marc, *Briefwechsel*, 28. Max Imdahl also believes that Marc's colors were "used as symbols" and thus "do not stand for light": Vriesen and Imdahl, *Delaunay*, 52.

170. Marc, letter of 12 June 1914, in Macke and Marc, *Briefwechsel*, 184.

171. Hermann Bahr, *Expressionism*, tr. R. T. Gribble (London: Frank Henderson, 1925), 83–84; also cited in sec. 1.8.

172. Italian Futurists encountered the same wartime risk, as in the Dada quality of Carra's *Guerrapittura* or of the Balla-Depero 1915 manifesto noted in Marianne Martin, *Futurist Art and Theory, 1909–1915* (Oxford: Clarendon Press, 1968), 199–201. George Grosz and Otto Dix, the most Futurist of Expressionists, were later the most aggressively Dadaist as well.

173. Fritz Löffler, *Otto Dix: Oeuvre der Gemälde* (Recklinghausen: A. Bongers, 1981), no. 1915/2.

174. Martin, *Futurist Art*, 121, n. 3.

175. Paul Fechter, *Der Expressionismus* (Munich: R. Piper, 1914), 46 bis.

176. See two related 1911 works in Martin, *Futurist Art*, figs. 79, 80.

177. See Gordon, *Modern Art Exhibitions*, vol. 2, 724; vol. 1, 260.

178. Grosz, letter of 30 June 1917, in George Grosz, *Briefe, 1913–1959*, ed. Herbert Knust (Reinbek bei Hamburg: Rowohlt, 1979), 54.

179. Franz Marc, "Deutsche und französische Kunst," *Schriften*, ed. Klaus Lankheit (Cologne: M. DuMont Schauberg, 1978), 129–31.

180. Selz, *German Expressionist Painting*, 19–20.

181. For a discussion of alleged 1911 uses, see Gordon, "Marc and Friedrich Again," passim.

182. Fritz Burger, *Cézanne und Hodler: Einführung in die Probleme der Malerei der Gegenwart* (Munich: Delphin, 1913), no. 15.

183. See Jörg Traeger, *Philipp Otto Runge und sein Werk* (Munich: Prestel, 1977), no. 384, pp. 419–20, a drawing in the Hamburg Kunsthalle where not only is Aurora reflected in the water but the angels also carry conch shells and snails.

184. Friedrich's *Large Enclosure* was acquired by the Dresden Gemäldegalerie in 1909: Helmut Börsch-Supan and Karl Wilhelm Jähnig, *Caspar David Friedrich* (Munich: Prestel, 1973), no. 399, 431. Nolde's wife Ada spent time "year after year" at the Lahmann Sanatorium near Dresden, from 1909 or 1910 on, and Nolde visited there at least once: Nolde, *Jahre der Kämpfe*, 116, 118.

185. This is the interpretation of Friedrich's sunset imagery offered in Börsch-Supan and Jähnig, *Caspar David Friedrich*, passim.

186. This view is offered in Rosenblum, *Northern Romantic Painting*, p. 137: "Nolde, one feels, would have arrived at the same expression of divinity with or without the support of Romantic precedent, for his very attitudes toward nature closely perpetuated those of the early nineteenth century. For him, nature was saturated with the spirit of a supernatural deity."

187. Compare, for example, Meidner's 1916 *Self-Portrait* drawing (catalogue, *Ludwig Meidner*, no. 29) and Runge's 1793 drawing of *St. Paul* (Traeger, *Philipp Otto Runge*, no. 33, 247).

188. For Richard Wagner and Kokoschka's 1915 *Knight Errant*, see Gordon, "Oskar Kokoschka and the Visionary Tradition," 30–31, 44f. For Adelbert von Chamisso and Kirchner's 1915 *Peter Schlemihl*, see Annemarie Dube-Heynig, *E. L. Kirchner: Graphik* (Munich: Prestel, 1961), 58–60. For Jean Paul and Heckel's 1917 *Roquairol*, see Paul Vogt, *Erich Heckel* (Recklinghausen: A. Bongers; 1965), 56.

189. Pechstein, *Erinnerungen*, 91–101.

190. Schmidt-Rottluff apparently combined features from Einstein illustrations with those remembered from sculptures seen earlier in Berlin's Ethnographic Museum in the original: see Gordon, "German Expressionism and Primitive Art," sec. 8.

191. A resident of Paris, Chagall spent the war years in Russia, but dozens of his works remained in Herwarth Walden's wartime possession and were occasionally exhibited. Indeed Chagall's reputation in Germany as an Expressionist stemmed from Walden's activities during these years; see sec. 4.7.

192. For the Russian popular prints, see The Blaue Reiter Almanach, pp. 118, 216; for the shadow-play figures, 194, 201.

193. Wolfgang Pehnt, Expressionist Architecture, tr. J. A. Underwood and Edith Küstner (London: Thames & Hudson, 1979), 51.

194. Karl Scheffler, Der Geist der Gotik (Leipzig: Insel, 1917), 38; cf. 18, 30, 39, 43.

195. Max Beckmann, undated statement to J. B. Neumann, as tr. in Peter Selz, Max Beckmann (New York: Museum of Modern Art, 1964), 26.

196. Beckmann, "Max Beckmann," in Schöpferische Konfession, ed. Kasimir Edschmid (Berlin: E. Reiss, 1920), 63–64.

197. Helga Kliemann, Die Novembergruppe (Berlin: Mann, 1969), 9–11.

198. Kliemann, Novembergruppe, 57; 23.

199. This is once again a sampling of representative exhibitions and is not intended to be complete. Among the sources consulted were Kliemann, Novembergruppe, 22–52, and Gordon, Ernst Ludwig Kirchner, 449–50.

200. George Grosz, "Paris als Kunststadt," in Grosz and Wieland Herzfelde, Die Kunst ist in Gefahr (Berlin: Malik, 1925), 33–38.

201. Hermann Hesse, "Die Brüder Karamazoff oder Der Untergang Europas" [1919], Gesammelte Schriften (Frankfurt: Suhrkamp, 1970), vol. 12, 320–27, esp. 321; Adolf Behne, Die Wiederkehr der Kunst (Leipzig: K. Wolff, 1919), 56; Wolfgang Pehnt, Expressionist Architecture, tr. J. A. Underwood and Edith Küstner (London: Thames & Hudson, 1979), 53.

202. Walter Gropius, manuscript, Bauhaus Archive, Berlin, as tr. in Pehnt, Expressionist Architecture, 53.

203. Pehnt, Expressionist Architecture, 110, 53.

204. Ibid., 20.

205. Lotte H. Eisner, The Haunted Screen: Expressionism in the German Cinema and the Influence of Max Reinhardt (Berkeley: University of California Press, 1973), 21.

206. Eisner, The Haunted Screen, 59–60, 27.

207. Lothar Grisebach, E. L. Kirchners Davoser Tagebuch (Cologne: M. DuMont Schauberg, 1968), 70.

208. Pechstein, Erinnerungen, 78.

209. Franz Werfel, Spiegelmensch: Magische Trilogie (Munich: K. Wolff, 1920, 130), as tr. in Walter H. Sokel, The Writer in Extremis: Expressionism in Twentieth-Century German Literature (Stanford: Stanford University Press, 1959), 215.

210. See, for example, Nolde's 1912 Missionary and his 1915 Still Life with "Uli" Figure in catalogue, Emil Nolde: Masken und Figuren (Bielefeld: Kunsthalle, 1971), nos. 6 and 15.

211. Ibid., no. 20b.

212. Hans Fehr, Emil Nolde: Ein Buch der Freundschaft (Cologne: M. DuMont Schauberg, 1957), 108.

213. The Runge is in the Kunsthalle, Hamburg; the Dixes are respectively in the Landesmuseum, Hanover, and in the artist's estate.

214. Franz Roh, Nach-Expressionismus, magischer Realismus: Probleme der neuesten europäischen Malerei (Leipzig: Klinkhardt & Biermann, 1925), 119–20.

CHAPTER IV

1. Georg Kaiser, Von Morgens bis Mitternachts: Stück in zwei Teilen [1916] (Potsdam: G. Kiepenhauer, 1920), 116–17; Ernst Toller, Man and the Masses, tr. Louis Untermeyer (Garden City: Doubleday, Page, 1924), 35.

2. Paul Vogt, "Introduction," in catalogue, Expressionism: A German Intuition, 1905–1920 (New York: Solomon R. Guggenheim Museum, 1980), 16.

3. Thus Georg Lukács could speak of "the complete emptying of the concept 'revolution' among Expressionists"; see Lukács, " 'Grösse und Verfall' des Expressionismus," Internationale Literatur (Moscow) 1934:153–73, as excerpted in Paul Raabe, ed., Expressionismus: Der Kampf um eine literarische Bewegung (Munich: Deutscher Taschenbuchverlag, 1965), 254–73, esp. 267.

4. David Gross, The Writer and Society: Heinrich Mann and Literary Politics in Germany, 1890–1940 (Atlantic Highlands: Humanities, 1980), 39–96, esp. 87.

5. Heinrich Mann, "Geist und Tat" [1910], in Wolfgang Rothe, ed., Der Aktivismus, 1915–1920 (Munich: Deutscher Taschenbuchverlag 1969), 23–28, esp. 28.

6. Kurt Hiller, ed., Das Ziel: Aufrufe zu tätigem Geist (Munich and Berlin: G. Müller, 1916), 1–8. Hiller's own gloss on Mann is given in his "Philosophie des Ziels," 187–217: "Since all previous experience shows that the administrators of nations do not listen to the mere word of the spirit, the spiritual people themselves must take over the administration of the earth" (Rothe, Aktivismus, 50).

7. Thomas Mann, Reflections of a Nonpolitical Man [1918], tr. Walter D. Morris (New York: Ungar, 1983), 14–15: "[The twentieth century] adores 'the human being' in dix-huitième fashion. . . . Where is there still a trace of 'submission to reality'? Instead, one finds activism, voluntarism, reform, politics, Expressionism; in short: the domination of ideals. [I oppose the neue Pathos] because it confronted me . . . in a form that had to call forth from me . . . the basic national element of my nature and culture: because it confronted me in political form."

8. Ibid., xi–xii. Despite his early conservatism, Thomas Mann's "critical realism" was later endorsed over Franz Kafka's "decadent modernism" by the Marxist critic Georg Lukács. See Lukács, Realism in Our Time, tr. John and Necke Mander (New York: Harper & Row, 1964), 92.

9. Gross, The Writer and Society, 10–11.

10. Gross documents both sons' admiration for their father's virtues but sees their more fundamental qualities as writers as stemming from their mother, 13–15.

11. Karl Mannheim, Ideology and Utopia: An Introduction to the Sociology of Knowledge (London: Routledge & Kegan, 1954), 233–34.

12. Ibid., 190f.

13. Ibid., 57.

14. Erik H. Erikson, Childhood and Society [1905] (Harmondsworth: Penguin, 1965), 402.

15. Museum of Fine Arts, Boston.

16. Max Beckmann, "On My Painting" [1938], in Modern Artists on Art: Ten Unabridged Essays, ed. Robert L. Herbert (Englewood Cliffs: Prentice-Hall, 1964), 131–37, esp. 135; 132; see sec. 4.8.

17. Erikson, Childhood and Society, 253–54.

18. Adolescence can also involve "a quasi-deliberate giving in . . . to the pull of regression, a radical search for rock-bottom—i.e., both the ultimate limit of regression and the only firm foundation for renewed progression": Erik H. Erikson, "The Problem of Ego Identity," *Journal of the American Psychoanalytic Association* (New York) 4 (1956):56–121, esp. 89.

19. Karl Mannheim, "The Problem of Generations," *Essays on the Sociology of Knowledge,* ed. Paul Kecskemeti (New York: Oxford University Press, 1952), 276–322, esp. 293.

20. For photographs of the Seifert lamp factory and exhibition hall, see Georg Reinhardt, "Die frühe 'Brücke': Beiträge zur Geschichte und zum Werk der Dresdener Künstlergruppe 'Brücke' der Jahre 1905 bis 1908," *Brücke-Archiv* no. 9/10(1977–78):71, figs. 46, 47.

21. Renate Hinz, ed., *Käthe Kollwitz: Graphics, Posters, Drawings,* tr. Rita and Robert Kimber (New York: Pantheon, 1981), xix.

22. Ibid.

23. Gillian Perry, *Paula Modersohn-Becker: Her Life and Work* (New York: Harper & Row, 1979), 70, 72–73.

24. Rainer Maria Rilke, "Requiem für eine Freundin," in *Sämtliche Werke,* vol. 1 (Wiesbaden: Insel, 1955), 645–56, esp. p. 649.

25. Alessandra Comini, "Introduction," in *The Letters and Journals of Paula Modersohn-Becker,* tr. J. Diane Radycki (Metuchen: Scarecrow, 1980), xi–xii.

26. Perry, *Modersohn-Becker,* 32–33.

27. Emil Nolde, *Jahre der Kämpfe* (Berlin: Rembrandt, 1934), 240–41.

28. Carl Vinnen, *Ein Protest deutscher Künstler* (Jena: E. Diederich, 1911), 8–16, as tr. in Peter Paret, *The Berlin Secession: Modernism and Its Enemies in Imperial Germany* (Cambridge: Harvard University Press, 1980), 184–85.

29. Paret, *The Berlin Secession,* 188–89.

30. Martin Urban, "The North Germans," in *A German Intuition,* 36.

31. "Nothing is more false than the usual assumption uncritically shared by most students of generations, that the younger generation is 'progressive' and the older generation *eo ipso* conservative. . . . Whether youth will be conservative, reactionary, or progressive, depends (if not entirely, at least primarily) on whether or not the existing social structure and the position they occupy in it provide opportunities for the promotion of their own social and intellectual ends": Mannheim, "Problem of Generations," 297.

32. Hans Kohn, *The Mind of Germany: The Education of a Nation* (New York: Scribner, 1960), 109.

33. Fyodor Dostoyevsky, *Politische Schriften,* ed. Arthur Moeller van den Bruck (Munich: R. Piper, 1907), ii.

34. Mann, *Nonpolitical Man,* 25.

35. "There was an Oedipus chord in every Greek that longed to be directly touched and to vibrate after its own fashion. The same is true of *Faust* and the German nation": Jakob Burckhardt, *Letters,* ed. Alexander Dru (London: Pantheon, 1955), 116.

36. Walter Benjamin, *The Origin of German Tragic Drama* [1928] (London: New Left Books, 1977), 71; Erikson, *Childhood and Society,* 323–25.

37. Gross, *The Writer and Society,* 11–12.

38. Egbert Krispyn, *Style and Society in German Literary Expressionism* (Gainesville: University of Florida Press, 1964), 25.

39. Erikson, *Childhood and Society,* 325: "As 'Wander birds,' adolescent boys would indulge in a romantic unity with Nature, shared with many co-rebels and led by special types of youth leaders, professional and confessional adolescents."

40. Walter Laqueur, *Young Germany: A History of the German Youth Movement* (New York: Basic, 1962). See also George L. Mosse, *The Crisis of German Ideology: Intellectual Origins of the Third Reich* (New York: Schocken), 1981, ch. 9: "The Youth Movement."

41. Fritz Stern, *The Politics of Cultural Despair: A Study in the Rise of the Germanic Ideology* [1961] (Berkeley: University of California Press, 1974), 176–77; 120.

42. Mosse, *Crisis of German Ideology,* 186–87.

43. Laqueur, *Young Germany,* 11–16. 41.

44. Ibid., 18.

45. Jörg von Uthmann, *Doppelgänger, du bleicher Geselle: Zur Pathologie des deutsch-jüdischen Verhältnisses* (Stuttgart: Seewald, 1976), 55. For further discussion of the German identity question, see sec. 5.3.

46. Jehuda Reinharz, *Fatherland or Promised Land: The Dilemma of the German Jew, 1893–1914* (Ann Arbor: University of Michigan Press, 1975), 13–16; 225.

47. Julius Langbehn, *Rembrandt als Erzieher* (189), 16, as cited in Klaus Bergmann, *Agrarromantik und Grossstadtfeindschaft* (Meisenheim am Glan: A. Hain, 1970), 106; see also Gerhard Wietek, ed., *Deutsche Künstlerkolonien und Künstlerorten* (Munich: K. Thiemig, 1976), passim.

48. Bergmann, *Agrarromantik,* 89f, 121f. But see now Christian F. Otto, "Modern Environment and Historical Continuity: The Heimatschutz Discourse in Germany," *Art Journal* 43(1983):148–57, esp. 150–51, for aspects of the Heimatschutz movement sympathetic to modern, functional design. Similarly, the *Deutsche Gartenstadtgesellschaft* (German Garden City Association, 1902) fostered improvements in workers' housing ignored in Bergmann, 135–63; see sec. 4.3.

49. Max Pechstein, *Erinnerungen* (Wiesbaden: Limes, 1960), 36–37.

50. Franz Marc, "Two Pictures," in Wassily Kandinsky and Franz Marc, *The Blaue Reiter Almanach,* doc. ed. Klaus Lankheit (New York: Viking, 1974), 66; Will Grohmann, *Wassily Kandinsky: Life and Work* (New York: Abrams, 1958), 16; Wassily Kandinsky, "Reminiscences" [1913], as tr. in *Modern Artists on Art,* ed. Robert L. Herbert (Englewood Cliffs: Prentice-Hall, 1964), 21–22.

51. Johannes Urdizil, "In Expressionist Prague," in Paul Raabe, ed., *The Era of German Expressionism,* tr. J. M. Ritchie (Woodstock: Overlook Press, 1974), 61–66, esp. 62 mod.; Franz Kafka, *The Metamorphosis: Die Verwandlung,* tr. Willa and Edwin Muir (New York: Schocken, 1968), 7.

52. Alessandra Comini, *Egon Schiele's Portraits* (Berkeley: University of California Press, 1974), 3.

53. Peter Vergo, *Art in Vienna, 1898–1918* (London: Phaidon Press, 1975), 55f, 60f.

54. Oskar Kokoschka, *My Life,* tr. David Britt (New York: Macmillan, 1974), 29; Vergo, *Art in Vienna,* 249 n. 16, questions whether the police intervened.

55. Comini, *Egon Schiele's Portraits,* 101.

56. Adolf Hitler, *Mein Kampf* [1925], tr. Ralph Manheim (Boston: Houghton Mifflin, 1971), 125.

57. Kokoschka, *My Life,* 35; Alma Mahler, *Gustav Mahler: Memories and Letters,* tr. Basil Creighton (London: Murray, 1968), 109.

58. Hitler, *Mein Kampf,* 12–13; Anton Roessler, ed., *Briefe und Prosa von Egon Schiele* (Vienna: R. Lanyi, 1921), 97.

59. Otto Kallir, *Egon Schiele: Oeuvre-Katalog der Gemälde* (Vienna: P. Zsolnay, 1966), nos. 140, 169; cf. 167, 168. Note that no. 117 from 1910 was not so designated by Schiele, as implied in Reinhold Heller, " 'The City is Dark': Conceptions of Urban Landscape and Life in Expressionist Painting and Architecture," in G. B. Pickar and K. E. Webb, eds., *Expressionism Re-*

considered: *Relationships and Affinities* (Munich: W. Fink, 1979), 42–57, esp. 54 n. 17.

60. Heller, "The City is Dark," 44–45 and n. 17.

61. *Une ville abandonée* was available to Schiele in reproduction; see Louis Dumont-Wilden, *Fernand Khnopff* (Brussels, 1907), 73.

62. Ferdinand Tönnies, *Community and Society* (East Lansing: Michigan State University Press, 1957), parts 1, 2; Emile Durkheim, *Suicide: A Study in Sociology* (New York: Free Press, 1966), 70; Georg Simmel, "The Metropolis and Mental Life," in Kurt H. Wolff, ed., *The Sociology of Georg Simmel* (Glencoe: Free Press, 1950), 416, 418 mod.; Rainer Maria Rilke, *Das Stundenbuch* (Wiesbaden, 1959), 97, as cited in Bergmann, *Agrarronmantik*, 86–87 n. 306.

63. Simmel, "Metropolis and Mental Life," 421–22.

64. Langbehn, *Rembrandt als Erzieher,* passim, as summarized in Bergmann, *Agrarromantik,* 105.

65. Bergmann, *Agrarromantik,* 104; Bergmann's figures do not agree with other authoritative sources, but they are approximately correct.

66. Hans Kaiser, *Max Beckmann* (Berlin: P. Cassirer, 1913), 8–9; Urban, in *A German Intuition,* 36, as cited in sec. 4.1; Hans Hess, *George Grosz* (New York: Macmillan, 1974), 72; Ludwig Meidner, "Anleitung zum Malen von Grossstadtbildern," *Kunst und Künstler* 12(1914):299f, as tr. in Victor H. Miesel, ed., *Voices of German Expressionism* (Englewood Cliffs: Prentice-Hall, 1970), 111–15, esp. 111.

67. Georg Heym, diary entry for 15 September 1911, in Paul Raabe and H. L. Greve, *Expressionismus: Literatur und Kunst, 1910–1923* (Marbach: Schiller-Nationalmuseum, 1960), 31–32.

68. Thomas Grochowiak, *Ludwig Meidner* (Recklinghausen: A. Bongers, 1966), 72–73.

69. Rosalyn Deutsche, "Alienation in Berlin: Kirchner's Street Scenes," *Art in America* 71(January 1983):65–72, esp. 69. Deutsche points out that Kirchner's earliest scene, the *Five Women on the Street* (Gordon no. 362), relates prostitutes directly to the store-window, thus "turning the street into a marketplace."

70. Kirchner's trolley tracks alone express urban ambiguity, according to Charles S. Kessler, "Sun Worship and Anxiety: Nature, Nakedness and Nihilism in German Expressionist Painting," *Magazine of Art* 45(1952):304–12, esp. 310: "The railroad is [an] ambivalent symbol of escape, permitting one to flee either towards the city or away from it."

71. Heller, "City is Dark," 50, would exclude the spatial manipulations of Kirchner's 1915 cityscapes from the Expressionist canon because Expressionism, "originating near the end of the nineteenth century," makes use of Impressionist "surface emphasis" and so does not extend past 1914. While this is one definition of Expressionism (sec. 5.1), it is not the one generally accepted today.

72. Erhard and Barbara Göpel, *Max Beckmann: Katalog der Gemälde,* 2 vols. (Bern: Kornfeld & Cie, 1976), no. 204.

73. Rosemarie Haag Bletter, "Expressionism and the New Objectivity," *Art Journal* 43(1983):108–20, esp. 112.

74. Ibid., 112.

75. Bergmann, *Agrarromantik,* 140, 147, 137f.

76. Bletter, "Expressionism and New Objectivity," 111.

77. Ibid., 113.

78. Bruno Taut, *Die Stadtkrone* (Jena: E. Diderichs, 1919), 55.

79. Ibid., 64–66.

80. Ibid., 67–78.

81. Ibid., 64.

82. Bletter, "Expressionism and New Objectivity," 115; cf. figs. 16, 17; for polychrome stucco used for color accents in downtown Magdeburg under Taut's planning, see Oskar Fischer's *Barasch House,* ca. 1921–22, as illustrated in Bletter, fig. 15.

83. Herschel B. Chipp, "Self-Portraiture," in catalogue, *The Human Image in German Expressionist Graphic Art from the Robert Gore Rifkind Foundation* (Berkeley: University Art Museum, 1981), 16.

84. Theodor Lipps, *Aesthetik: Psychologie des Schönen in der Kunst* (Hamburg and Leipzig, 1903), vol. 1, 247; Wilhelm Worringer, *Abstraction and Empathy: A Contribution to the Psychology of Style,* tr. Michael Bullock (New York: International Universities Press, 1953), 24.

85. Oskar Kokoschka, "Edvard Munch's Expressionism," *College Art Journal* 12(1953):312–20, esp. 320.

86. Paul Kornfeld, "Der beseelte und der psychologische Mensch," *Das junge Deutschland* 1(1918):1f, as summarized in Walter H. Sokel, *The Writer in Extremis: Expressionism in Twentieth-Century German Literature* (Stanford: Stanford University Press, 1959), 52.

87. Comini, *Egon Schiele's Portraits,* 1.

88. For a discussion of masochism and guilt in Schiele's drawings of 1910–11, see Comini, *Egon Schiele's Portraits,* 61–62.

89. Ibid., 81–85. Note that Schiele here anticipates the first use of the *doppelgänger* in German Expressionist film, namely in Paul Wegener's 1913 *Student of Prague.* This theme was to become "an obsession of the German cinema": Siegfried Kracauer, *From Caligari to Hitler: A Psychological History of the German Film* [1947] (Princeton: Princeton University Press, 1974), p. 30; see sec. 4.8.

90. Kubišta's *St. Sebastian* of 1912 was included in the international exhibition of Cubo-Expressionist art held in Prague in February–March 1914; Donald E. Gordon, *Modern Art Exhibitions, 1900–1916: Selected Catalogue Documentation* (Munich: Prestel, 1974), vol. 2, 790. It is uncertain, but likely, that Schiele was aware of avant-garde developments in the capital of Bohemia—the province where his mother had been born.

91. Edith Hoffmann, *Kokoschka: Life and Work* (London: Faber & Faber, 1947), 132–33. Kokoschka indeed received a bullet in the head and a bayonet, not a lance, in the lungs: Kokoschka, *My Life,* 93–95.

92. Hans Maria Wingler, *Oskar Kokoschka: The Work of the Painter* (Salzburg: Galerie Welz, 1958), 305.

93. Ibid., 304.

94. Richard Wagner, *Parsifal: Music Drama in Three Acts,* tr. Stewart Robb (New York: Schirmer, 1962), act 2. For further links of *Knight Errant* to Parsifal, see Donald E. Gordon, "Oskar Kokoschka and the Visionary Tradition," in *The Turn of the Century: German Literature and Art, 1890–1915,* ed. Gerald Chapple and Hans H. Schulte (Bonn: Bouvier, 1981), 23–52.

95. Angelica Zander Rudenstine, *The Guggenheim Museum Collection: Paintings, 1880–1945* (New York: Solomon R. Guggenheim Museum, 1976), vol. 2, 428.

96. Chipp, *The Human Image,* 18.

97. In psychoanalytic theory, schizophrenics are like nursing infants in that they "identified themselves with the world, then destroyed it by swallowing it. . . . Falling asleep coincides with the baby's ingestion of the breast; the result is an identification with what was eaten. . . . Thus sleep, mania, suicide, and world destruction complete and partial, are all the very different results of the same simple, primary, oral wish": Bertram Lewin, "Sleep, the Mouth, and the Dream Screen," *Selected Writings* (New York: Psychoanalytic Quarterly,

1973), 94, 98–99. For Meidner's own thoughts of suicide, see Ludwig Meidner, *Im Nacken das Sternemeer* (Leipzig: K. Wolff, [1918]), 9–16, 79–82.

98. Kirchner verifies that this is the right hand by depicting the numbers "75" normally, rather than in mirror-image.

99. See letters to Carl Hagemann, 3 December 1915, and to Gustav Schiefler, 28 March 1916, as tr. in Donald E. Gordon, *Ernst Ludwig Kirchner* (Cambridge: Harvard University Press, 1968), 27.

100. Annemarie Dube-Heynig, *E. L. Kirchner: Graphik* (Munich: Prestel, 1961), 58; Kirchner, letter to Schiefler, as cited in ibid.

101. George Grosz, letter to Robert Bell, early September 1915, in Grosz, *Briefe, 1913–1959*, ed. Herbert Knust (Reinbek: Rowohlt, 1979), 30–31.

102. Hans Hess, *George Grosz* (New York: Macmillan, 1974), figs. 50, 46; 66, 60.

103. The poem, published in *Die neue Jugend,* 1917, is tr. in Hess, *George Grosz,* 62.

104. Grosz's close friend Helmut Herzfeld also changed his name to "John Heartfield" at this time for similar reasons: Hess, *George Grosz,* 64. For a Grosz letter of 1915–16 mentioning "my hatred of the Germans," see Hess, 51.

105. Anna Freud, *The Ego and the Mechanisms of Defense* [1936], rev. ed. (New York: International Universities Press, 1966), 110f: "By impersonating the aggressor, assuming his attributes or imitating his aggression, the child transforms himself from the person threatened into the person who makes the threat."

106. Peter Selz, *Max Beckmann* (New York: Museum of Modern Art, 1964), 25, sees "early German Expressionist films" as contributing source.

107. Göpel no. 197.

108. Charlotte Berend-Corinth, *Die Gemälde von Lovis Corinth* (Munich: F. Brückmann, 1958), 339.

109. Paul Westheim, "Der Fetisch," in *Künstlerbekenntnisse* (Berlin: Ullstein, [1925]), 243–52.

110. Hoffmann, *Kokoschka,* 144–45.

111. Kokoschka, *My Life,* 118.

112. Erik Blomberg, "Ernst Josephson," in catalogue, *Paintings and Drawings by Ernst Josephson* (Portland: Portland Art Museum, 1964), 19.

113. Felix Klee, ed., *The Diaries of Paul Klee, 1898–1918* (Berkeley: University of California Press, 1964), 266; see also sec. 3.6.

114. Isaac Grünewald, *Den nya renässansen inom konsten* (Stockholm, 1918) as cited in Blomberg, *Paintings and Drawings by Ernst Josephson.*

115. Oskar Pfister, *Expressionism in Art: Its Psychological and Biological Basis* [1912], tr. B. Low and M. A. Mügge (New York: Dutton, 1923). Another Swiss study was Walter Morgenthaler, *Ein Geisteskranker als Künstler* (Bern, 1921).

116. Karl Jaspers, *Strindberg und Van Gogh* (Munich: R. Piper, 1949), 182; Hans Prinzhorn, *Artistry of the Mentally Ill,* tr. James L. Foy (New York: Springer-Verlag, 1972), 270.

117. John M. MacGregor, *The Discovery of the Art of the Insane,* diss. (Princeton University, 1978), passim.

118. See the distinction between an "ego overwhelmed by regression" in pathology and a "regression in the service of the ego" in creativity: Ernst Kris, *Psychoanalytic Explorations in Art* (New York: Schocken, 1967), 177.

119. Prinzhorn, *Artistry of the Mentally Ill,* 271.

120. Michaelis, in *Das Kunstblatt,* December 1918, as cited in Hoffmann, *Kokoschka,* 143.

121. Kokoschka, *My Life,* 103f.

122. Selz, *Max Beckmann,* 23.

123. Gordon, *Kirchner,* 27–29.

124. Hess, *George Grosz,* 68.

125. Friedrich Nietzsche, *Thus Spoke Zarathustra: A Book for All and None,* tr. Walter Kaufmann (Harmondsworth: Penguin, 1978), 47 (see sec. 1.2).

126. F. T. Marinetti, "Manifest des Futurismus," *Der Sturm* (March 1912): 828, as tr. in Herschel B. Chipp, *Theories of Modern Art* (Berkeley: University of California Press, 1968), 286

127. F. T. Marinetti, "Tod dem Mondschein! Zweites Manifest des Futurismus," *Der Sturm* (May 1912): 50.

128. Meidner began the *Apocalyptic Landscapes* in the 1912 "summer," working from "the end of May . . . through June until the July moon set": Grochowiak, *Ludwig Meidner,* 29; while Daniel Schreber's *Memoirs of a Nerve-Patient* (1903) and Jakob van Hoddis' poem *End of the World* (January 1911) were general sources (secs. 2.3, 3.5), the Marinetti manifestos were the immediate sources, I believe, which triggered Meidner's *Apocalyptic Landscapes.*

129. A. J. Ryder, *Twentieth-Century Germany: From Bismarck to Brandt* (New York: Columbia University Press, 1973), 85.

130. *War* may be dated between the publications of Heym's two anthologies, *Eternal Day* (1911) and *Shadow of Life* (1912); it appeared in the latter.

131. Johannes Eichner, *Kandinsky und Gabriele Münter: Von Ursprüngen moderner Kunst* (Munich: F. Brückmann, 1957), 113.

132. Fritz Fischer, *War of Illusions: German Politics from 1911 to 1914,* tr. Marian Jackson (New York: Norton, 1975), 74–75.

133. Will Grohmann, *Wassily Kandinsky: Life and Work* (New York: Abrams, 1958), 119.

134. Eichner, *Kandinsky und Gabriele Münter,* 114.

135. While Kandinsky's apocalyptic paintings begin in 1909–10, most probably due to Rudolf Steiner's influence (sec. 3.4), the threat of war in 1911 may well explain the increase of such imagery that year; see Julia Rowland, *Kandinsky 1911: The Agitated Style,* M.A. thesis (University of Pittsburgh, 1979), 28.

136. Ryder, *Twentieth-Century Germany,* 96; Fischer, *War of Illusions,* 159, 194, 193, i.

137. Klaus Lankheit, *Franz Marc: Katalog der Werke* (Cologne: M. DuMont Schauberg, 1970), no. 206; Hans K. Roethel and Jean K. Benjamin, *Kandinsky: Catalogue Raisonné of the Oil Paintings* (London: Sotheby, 1982), vol. 1, no. 452. Kandinsky wrote that "The presence of the cannons in the picture could probably be explained by the constant war talk that had been going on throughout the year": Arthur J. Eddy, *Cubists and Post-Impressionists* (Chicago: A. C. McClurg, 1914), 125.

138. Michael Sadler, *Modern Art and Revolution* (London: L. & V. Woolf, 1932), 18–19.

139. Frank Whitford, "Radical Art and Radical Politics," *Germany in Ferment* (Durham: Durham University, 1970), 8.

140. Catalogue, *Expressionism: A German Intuition* (New York: Solomon R. Guggenheim Museum, 1980), esp. 239.

141. Whitford, "Radical Art," 8.

142. Klee, *Diaries,* nos. 952, 313.

143. The list, not complete, is drawn from artists' biographies and from Theda Shapiro, *Painters and Politics: The European Avant-Garde and Society, 1900–1925* (New York: Elsevier, 1976), 232–76.

144. The best study of these events is Victor H. Miesel, "Paul Cassirer's *Kriegszeit* and *Bildermann* and Some German Expressionist Reactions to World War I," *Michigan Germanic Studies* 2(Fall 1976):149–68.

145. Julius Meier-Graefe, editorial, *Kriegszeit* (31 August 1914):4.

146. Michael George Conrad, "Volk und Kunst," *Kriegs-Bilderbogen Münchner Künstler* (Munich: Goltzverlag) (September 1914):2; Franz Marc, "Im Fegefeuer des Krieges," *Kunstgewerbeblatt* (Leipzig), 1915, 128–30, as tr. in Miesel, *Voices of German Expressionism*, 160–62.

147. Alfred Gold, "Der Krieg und die Bildung," *Kriegszeit* (16 December 1914):4; Comini, *Egon Schiele's Portraits*, 143.

148. Grochowiak, *Ludwig Meidner*, figs. 48, 100; see also a related drawing called *Slaughter*, formerly in the collection of Hannah Bekker vom Rath, Frankfurt.

149. Max Beckmann, *Briefe im Kriege* (Berlin: P. Cassirer, 1916), 9.

150. Robert Jay Lifton, *Thought Reform and the Psychology of Totalism: A Study of "Brainwashing" in China* (New York: Norton, 1961), 420–21.

151. Paul Westheim, "Heimaturlaub zur Kunst: Zur Ausstellung der 'Freien Sezession' in Berlin," *Frankfurter Zeitung* (2 March 1916):1, as tr. in Reinhold Heller, *The Art of Wilhelm Lehmbruck* (Washington: National Gallery, 1972), 29–30.

152. Carl Zuckmayer, *Als wär's ein Stuck von mir* (Frankfurt: S. Fischer, 1966), as tr. in John Willett, *Art and Politics in the Weimar Period: The New Sobriety, 1917–1933* (New York: Pantheon, 1978), 23; Heller, *Wilhelm Lehmbruck*, 198.

153. Amédée Ozenfant, editorial *l'Elan* (Paris), (15 April 1915):2, as tr. in Kenneth E. Silver, "Purism: Straightening Up after the Great War," *Artforum* 15(March 1977):56–63, esp. 56, 57.

154. The phrase is Walter Rathenau's; see Ryder, *Twentieth-Century Germany*, 197.

155. Kurt Hiller, "Philosophie des Ziels," *Das Ziel: Aufrufe zu tätigem Geist* (Munich and Berlin: G. Müller, 1916), as cited in Rothe, *Aktivismus*, 42. For Hiller and Heinrich Mann, see sec. 4.1.

156. Richard Samuel and R. Hinton Thomas, *Expressionism in German Life, Literature and the Theatre (1910–1924)* (Cambridge: H. Heffer, 1939), 105.

157. Hans Kollwitz, ed., *The Diaries and Letters of Käthe Kollwitz*, tr. Richard and Clara Winston (Chicago: Regnery, 1955), 157; René Schickele, *Der neunte November* (Berlin: E. Reiss, 1919), 75; Rothe, *Aktivismus*, 12.

158. John Willett, *Expressionism* (New York: McGraw, 1970), 118; Annaliese Viviani, *Das Drama des Expressionismus* (Munich: Winkler, 1970), 64–73.

159. H. F. Garten, *Modern German Drama* (London: Methuen, 1964), 109, 117, 118.

160. Walter Hasenclever, *Der Sohn: Ein Drama in fünf Akten* (Leipzig: K. Wolff, 1914), as tr. in Garten, *Modern German Drama*, 120.

161. Garten, *Modern German Drama*, 148.

162. Ibid., 154.

163. Kaiser, *Von Morgens bis Mitternachts*, 117 (see sec. 4.1); 119.

164. In archaic societies, dying is seen as the initiation of life. "In no rite or myth do we find the initiatory death as something *final*, but always as the *sine qua non* of a transition to another mode of being, a trial indispensable to regeneration; that is, to the beginning of a new life": Mircea Eliade, *Myths, Dreams and Mysteries: The Encounter between Contemporary Faiths and Archaic Realities*, tr. Philip Mairet (New York: Harper & Row, 1960), 224.

165. Walter Hasenclever, *Antigone: Tragödie in fünf Akten* (Berlin: P. Cassirer, 1919), as tr. in Garten, *Modern German Drama*, 131–32.

166. Fritz von Unruh, *Ein Geschlecht: Tragödie* (Leipzig: K. Wolff, 1918), as tr. in Garten, *Modern German Drama*, 135–36.

167. Ernst Toller, *Die Wandlung: Das Ringen eines Menschen* (Potsdam: G. Kiepenhauer, 1919), also *Transfiguration*, tr. by Edward Crankshaw, in *Modern Continental Dramas*, ed. Harlan Hatcher (New York: Harcourt, Brace, 1941), 656–87, esp. 681, 687 mod. Note the similarity of Toller's imagery here to Feininger's 1919 *Cathedral of Socialism* (fig. 48).

168. Toller, *Transfiguration*, 678.

169. Georg Kaiser, *Gas I: A Play in Five Acts*, tr. Herman Scheffauer (New York: Ungar, 1975), 77–78; 79–80; Sokel, *The Writer in Extremis*, 193.

170. Herman George Scheffauer, *The New Vision in the German Arts* [1924] (Port Washington, N.Y.: Kennikat Press, 1971), 206, 188. Similarly, Fritz Lang first conceived his 1926 film *Metropolis* on seeing New York for the first time: Kracauer, *From Caligari to Hitler*, 149.

171. Kaiser, *Gas I*, 96. In Expressionist drama the New Man can be the son of a heroic mother, as in von Unruh's *A Generation*, or must be produced, as here, by the daughter of a heroic father. The Oedipal aspects of these magical births should be noted. Moreover, the magical dimension of *Gas I* requires that the New Man be *both* the prophet and the prophesied. He dies now but is to be regenerated, later, by his own daughter. Conceptually, then, he is the child of his own child, the ancestor of his own ancestor. He is the victim, in short, of what Ernest Jones has called the "grandfather complex." "With very many children there is a lively desire to become the parents of their own parents, and they may even entertain the fantastic belief that just in proportion as they grow bigger, so will their parents grow smaller, till in time the present state of affairs will be completely reversed. This curious construction of the imagination, which is probably one of the sources of belief in reincarnation, is evidently closely connected with incestuous wishes, since it is an exaggerated form of the commoner desire to be one's own father": Leland E. Hinsie and Robert Jean Campbell, *Psychiatric Dictionary*, 3d ed. (New York: Oxford University Press, 1960), 140.

172. Ryder, *Twentieth-Century Germany*, 189.

173. Peter Gay, *Weimar Culture: The Outsider as Insider* (New York: Harper & Row, 1968), 13.

174. Willett, *Expressionism*, 129.

175. Toller, *Man and the Masses*, 36–37; Sokel, *The Writer in Extremis*, 197.

176. Toller, *Man and the Masses*, 94, 69.

177. *Men versus The Man, a Correspondence between Robert Rives La Monte, Socialist, and H. L. Mencken, Individualist* (New York: Holt, Rinehart & Winston, 1910), 201, 205.

178. *Men versus The Man* was a debate initiated by La Monte in answer to Mencken's book, *The Philosophy of Friedrich Nietzsche* (Boston: Luce, 1908); Mencken's willingness to adopt a post-Nietzschean view is stressed in Robert C. Bannister, *Social Darwinism: Science and Myth in Anglo-American Social Thought* (Philadelphia: Temple University Press, 1979), 206.

179. *Men versus The Man*, 14–15; Bannister.

180. Toller, *Man and the Masses*, 102–03.

181. By choosing the Yiddish term "Moloch" (a Biblical god demanding child sacrifice), Toller could be suggesting his own Jewish background.

182. Raabe, *Era of German Expressionism*, 340.

183. Hugo Ball, *Flight out of Time: A Dada Diary*, ed. John Elderfield (New York: Viking, 1974), 220; Hans Richter, *Dada: Art and Anti-Art* (New York: Oxford University Press, 1978), 104.

184. Hans Arp, "Dadaland," in Raabe, *Era of German Expressionism*, 1976; Richter, *Dada: Art and Anti-Art*, 107 mod.

185. Ball, *Flight out of Time,* 65.

186. Ibid., 72.

187. Richter, *Dada: Art and Anti-Art,* 104 mod.

188. George Grosz, *A Little Yes and a Big No: The Autobiography of George Grosz,* tr. Lola Sachs Dorin (New York: Dial, 1946), 28–29.

189. Grosz joined the German Communist Party on 31 December 1918: Beth Irwin Lewis, *George Grosz: Art and Politics in the Weimar Republic* (Madison: University of Wisconsin Press, 1971), 67.

190. Heinrich Vogeler, "Erfahrungen eines Malers," *Das Wort* no. 6(1938): 84–94, as tr. in Miesel, *Voices of German Expressionism,* 158.

191. Ida Katherine Rigby, *An alle Künstler! War—Revolution—Weimar* (San Diego: San Diego State University Press, 1983), 41.

192. He left the party ca. 1926; see catalogue, *Conrad Felixmüller: Werke und Dokumente* (Nuremberg: Germanisches Nationalmuseum, 1981–82), 225.

193. Anonymous, "Menschen! Menschen!," *Menschen* (15 January 1919):1, as tr. in Rigby, *War—Revolution—Weimar,* 46.

194. Rigby, *War—Revolution—Weimar,* 48.

195. A lithograph was completed in 1919, but Kollwitz's woodcuts began only after she saw Barlach's woodcuts in June 1920: Hans Kollwitz, ed., *The Diary and Letters of Käthe Kollwitz,* tr. Richard and Clara Winston (Chicago: Regnery), 97.

196. Renate Hinz, ed. *Käthe Kollwitz: Graphics, Posters, Drawings,* tr. Rita and Robert Kimber (New York: Pantheon, 1981), xxiii.

197. Hinz, *Käthe Kollwitz,* 23; Rigby, *War—Revolution—Weimar,* 47–48.

198. Rigby, *War—Revolution—Weimar,* 34, points out that the red torch was the symbol of the government's Publicity Office; it appears lower right in this poster, confirming that the designation of the new republic as "Socialist" was a government action, not one by the Socialist party.

199. The poster is illustrated in ibid., 32, fig. 40.

200. Hans Freideberger, "Das Künstlerplakat der Revolutionszeit," *Das Plakat* (July 1919):275, as tr. in ibid., 35; catalogue, *Wem gehört die Welt: Kunst und Gesellschaft in der Weimarer Republik* (Berlin: Neue Gesellschaft für Bildende Kunst, 1977), 244, as tr. in Rigby, *War—Revolution—Weimar,* 65–66.

201. Lewis, *George Grosz,* 94; for the Kokoschka manifesto, see Hoffmann, *Kokoschka,* 143.

202. This accusation was already made in Huelsenbeck's first German Dada manifesto of April 1918 mentioned above: "Expressionism, discovered abroad, and in Germany, true to style, transformed into an opulent idyll and the expectation of a good pension"; see Richter, *Dada: Art and Anti-Art,* 106. This was also Georg Lukács' Marxist thesis in 1934; see Lukács, "'Grösse und Verfall' des Expressionismus," in Raabe, *Kampf um eine literarische Bewegung,* esp. 264–70.

203. Sturm Gallery exhibitions are listed for Campendonk in October 1916 and September 1918; for Klee in March 1916, February and December 1917, and January 1919; for Muche in January 1916, February 1917, January 1918 and September 1919; and for Uhden in February 1918 and August 1919: see Nell Walden and Lothar Schreyer, *Der Sturm: Ein Erinnerungsbuch und Herwarth Walden* (Baden-Baden: W. Klein, 1954), 257–66.

204. Feininger was appointed in May 1919, Muche in mid-1920, and Klee in January 1921: Herbert Bayer, Walter Gropius, and Ise Gropius, eds., *Bauhaus, 1919–1928* (New York: Museum of Modern Art, 1938), 20.

205. Illustrated in Walden and Schreyer, *Der Sturm,* 99.

206. Chagall was shown October 1917 and July–August 1918: Walden and Schreyer, *Der Sturm,* 263–64.

207. Marc Chagall, *My Life* [1932], tr. Elisabeth Abbott (New York: Orion, 1960), 173; Ernst Cohn-Wiener, *Die jüdische Kunst* (Berlin: M. Wasservogel, 1929), 260–61; Kokoschka, *My Life,* 35, as cited in sec. 4.2; Peter Gay, *Freud, Jews and Other Germans: Masters and Victims in Modernist Culture* (New York: Oxford University Press, 1978), 171.

208. Gay, *Freud, Jews and Other Germans,* 133; Walter Laqueur, *Weimar: A Cultural History, 1918–1933* (New York: Putnam, 1974), 182.

209. Hans Fehr, *Emil Nolde: Ein Buch der Freundschaft* (Cologne: M. DuMont Schauberg, 1957), 66; Charlotte Berend-Corinth, *Die Gemälde von Lovis Corinth: Werkkatalog* (Munich: F. Brückmann, 1958), 45 (also cited in sec. 2.7); Erik H. Erikson, *Identity: Youth and Crisis* [1968] (New York: Norton, 1978), 192.

210. Wilhelm Worringer, *Künstlerische Zeitfragen* (Munich: R. Piper, 1921), 18; this lecture was delivered to the Munich *Goethegesellschaft* the previous November; Iwan Goll, "Der Expressionismus stirbt," *Zenit* (Zagreb), 1921, no. 8, 8f, as cited in Raabe, *Kampf um eine literarische Bewegung,* 180; John Willett, *Expressionism* (New York: McGraw, 1970), 133.

211. The putsch began when General Walther von Lüttwitz, Captain Hermann Erhardt, and the East Prussian official Wolfgang Kapp presented demands to the government and then marched on Berlin. According to Ryder, *Twentieth-Century Germany,* 213: "The government was faced with a choice: to abandon the capital; to stay and negotiate with Kapp; or to resist by force. [President] Ebert and [Defense Minister] Noske held a council with senior officers . . . in the middle of the night. It became clear that the *Reichswehr* (which was split three ways in its attitude) would not fire on *Reichswehr* and in any case the government did not want bloodshed. Since it was not prepared to negotiate, the only course was flight. Ehrhardt occupied Berlin and declared that he and Kapp had formed a new government. The trade unions answered with a general strike . . . against which the new 'regime' was powerless. After five days Kapp and Lüttwitz acknowledged defeat, and the lawful government returned from Stuttgart, where it had taken refuge."

212. Ryder, *Twentieth-Century Germany,* 225.

213. The fullest discussion of these works is to be found in Rigby, *War—Revolution—Weimar,* 7–14.

214. Hinz, *Käthe Kollwitz,* nos. 98 and 102. It should be noted that Kollwitz's poster *The Survivors—Make War on War,* commissioned by the Soviet-supported International Workers' Aid in 1924, embodies a lithograph actually executed in 1923; see Hinz, no. 93.

215. See, e.g., August K. Wiedmann, *Romantic Roots in Modern Art: Romanticism and Expressionism, A Study in Comparative Aesthetics* (Old Woking: Gresham, 1979), 3, 5, 21, 24.

216. Wiedmann mentions Nietzsche only three times, in no case substantively.

217. See Hans Sedlmayr, *Art in Crisis: The Lost Center* (Chicago: Regnery, 1958), passim, and Oswald Spengler, *The Decline of the West,* tr. Charles Francis Atkinson (London: Allen & Unwin, 1971), vol. 1, 467.

218. Kracauer, *From Caligari to Hitler,* 28, 30.

219. Kracauer, *From Caligari to Hitler,* 29; Kracauer goes on to compare Baldwin to the "two Germanys"—imperial rulers and middle class—and to the latter's love-hate relationship with the former.

220. Ibid., 31–34.

221. *Goethe's Faust,* tr. Walter Kaufmann (Garden City: Anchor, 1963), 145; Max Beckmann, *Das Hotel.*

222. Beckmann, *Das Hotel* (unpublished typescript), act 4, scene ii; I am grateful to Dr. Peter Beckmann, Murnau, for permission to cite from this drama prior to its publication. Zwerch's Job-like protest is discussed in

Friedhelm W. Fischer, *Max Beckmann: Symbol und Weltbild—Grundriss zu einer Deutung des Gesamtwerkes* (Munich: W. Fink, 1972), 18–19. Zwerch's double identity is mentioned in Peter Beckmann, *Max Beckmann: Leben und Werk* (Stuttgart: Belser, 1982), 52.

223. Kracauer, *From Caligari to Hitler*, 64f.

224. Ibid., 74.

225. Ibid., 77–79; Nosferatu's appeal, like that of any tyrant hero, is to "the compulsion of hate-love."

226. Paul Kornfeld, "Himmel und Hölle: Eine Tragödie in fünf Akten und einem Epilog," *Die Erhebung* 1(1919):118, as tr. in Sokel, *The Writer in Extremis*, 153.

227. Klaus Gallwitz, *Max Beckmann: Die Druckgraphik—Radierungen, Holzschnitte, Lithographien* (Karlsruhe: Badischer Kunstverein, 1962), no. 168.

228. Göpel, *Max Beckmann*, no. 206.

229. Peter Beckmann, *Beckmann: Leben und Werk*, 49, also mentions *Before the Masked Ball* of 1922 (Göpel, *Max Berkmann*, no. 216) in which the artist wears a sinister black mask.

230. Max Beckmann, letter to Curt Valentin, 11 February 1938, as tr. in Peter Selz, *Max Beckmann* (New York: Museum of Modern Art, 1964), 61; Lily von Schnitzler, letter to Alfred H. Barr, Jr., 1 June 1955, paraphrasing Beckmann's remarks of February 1937, as tr. in Stephan Lackner, *Max Beckmann* (New York: Abrams, 1977), 116.

231. For the fullest discussion of these meanings, see Fischer, *Beckmann: Symbol und Weltbild*, 93–115.

232. Max Beckmann, "On My Painting," 132–33; see sec. 4.1.

233. C. G. Jung, *Symbols of Transformation: An Analysis of the Prelude to a Case of Schizophrenia* [1912], tr. R. F. C. Hull (Princeton: Princeton University Press, 1972), 368; C. G. Jung, *Die Beziehungen zwischen dem Ich und dem Unbewussten* (Zurich: Rascher, 1928), para. 399, as tr. by R. F. C. Hull in *Two Essays on Analytical Psychology*, 2d rev. ed. (Princeton: Princeton University Press, 1972), 238.

234. Richard Wilhelm and C. G. Jung, *The Secret of the Golden Flower: A Chinese Book of Life*, tr. Cary Baynes (New York: Harcourt, Brace, World, 1962), 11; cf. 103 where Jung calls the Tao the "central white light."

235. Mathilde Q. Beckmann, *Mein Leben mit Max Beckmann*, tr. Doris Schmidt (Munich: R. Piper, 1983), 132.

236. See Fischer, *Beckmann: Symbol und Weltbild*, 95 and no. 332.

237. Beckmann, "On My Painting," 132, 133; Jung, *Two Essays on Analytical Psychology*, 239; Wilhelm and Jung, *Secret of the Golden Flower*, 12. Cf. Wilhelm, in *Secret of the Golden Flower*, 17: "A man who reaches this stage transposes his ego; he is no longer limited to the monad, but penetrates the magic circle of the polar duality of all phenomena and returns to the undivided One, the Tao."

238. Jung, in *Secret of the Golden Flower*, 103–04; Goethe, *Faust*, tr. Kaufmann, 89; Johann Wolfgang von Goethe, to Eckermann, 28 March 1827, as tr. in Mircea Eliade, "Mephistopheles and the Androgyne or the Mystery of the Whole," in *The Two and the One*, tr. J. M. Cohen (Chicago: University of Chicago Press, 1979), 78.

239. Beckmann in fact illustrated *Faust, Part II*, in 1943–44; see Goethe, *Faust: Der Tragödie zweiter Teil* (Munich: Prestel, 1970), passim.

CHAPTER V

Karl Scheffler, *Der Geist der Gotik* (Leipzig: Insel, 1917), 10.

1. "Expressionism," in *A New English Dictionary on Historical Principles* (Oxford: Clarendon Press, 1897), vol. 3, part 2, 448.

2. Armin Arnold, *Die Literatur des Expressionismus: Sprachliche und thematische Quellen* (Stuttgart: W. Kohlhammer, 1966), 9–10.

3. Donald E. Gordon, *Modern Art Exhibitions, 1900–1916: Selected Catalogue Documentation*, 2 vols. (Munich: Prestel, 1974), passim.

4. Henri Matisse, "Notes d'un peintre," *La Grande Revue* (25 December 1908), as tr. in Alfred H. Barr, Jr., *Matisse: His Art and His Public* (New York: Museum of Modern Art, 1951):119–23.

5. For information on Matějček I am indebted to his former student Dr. Jiri Setlik, Prague.

6. Antonín Matějček, introduction, *XXXI. Výstava: Les Indépendents* (Prague: Manes Society, 1910), 1–11, esp. 2–3; tr. courtesy of Jana Hearn, Pittsburgh; 4–5.

7. Ibid., 3–4, 7–9.

8. Bohumil Kubišta, "Henri Matisse," *Novina* (Prague) (June 1910):464–67. For material concerning Kubišta I am grateful, once again, to Dr. Setlik in Prague.

9. A. Clutton-Brock, "The Post-Impressionists," *Burlington Magazine* 18(1911): 216–19.

10. C. Lewis Hind, *The Post-Impressionists* (London: Methuen, 1911).

11. Carl David Moselius, in *Dagens Nyheter* (20 March 1911), as cited in catalogue, *1909 ars män: Jubileumsutställning* (Stockholm: Liljevalchs Konsthall, 1959), 7–8. Tr. courtesy of Barbara Branon, Poughkeepsie.

12. Catalogue, *XXII, Ausstellung der Berliner Secession* (Berlin: Ausstellungshaus, 1911), 11.

13. In an earlier study I stressed the Secession show's importance in announcing "a French Expressionist school": Donald E. Gordon, "On the Origin of the Word 'Expressionism,'" *Journal of the Warburg and Courtauld Institutes* 29(1966):368–85, esp. 371. Geoffrey Perkins later questions my thesis "that there was a school . . . of Expressionism in France": Perkins, *Contemporary Theory of Expressionism* (Bern and Frankfurt: H. Lang, 1974), 13. New evidence suggests that such a school was recognized in Prague, London, Stockholm, and Berlin, but that—as Perkins maintained—no French critic joined publicly in the recognition. Nevertheless, we still do not know whether Berlin Secession officials borrowed the Expressionist label from Matějček, Clutton-Brock, Hind, or—as I continue to believe—from the circle of Matisse in Paris.

14. R. Reiche, "Vorwort," *Internationale Kunstausstellung des Sonderbundes westdeutscher Kunstfreunde und Künstler zu Köln*, 1912, 3–7.

15. See Perkins, *Theory of Expressionism*, 21, nos. 16, 17, for a list of articles and books published in Germany in 1912 and 1913 which contained sections on Expressionist art; cf. Gordon "Word 'Expressionism,'" 375–76.

16. For this translation, rather than "will-to-art," see Peter Selz, *German Expressionist Painting* (Berkeley: University of California Press, 1957), 8.

17. Wilhelm Worringer, *Abstraction and Empathy* [1908] (New York: International Universities Press, 1963), 9f; Worringer, *Form Problems of the Gothic* [1910] (New York: G. E. Stechert, 1920), 21f.

18. Worringer, *The Gothic*, pp. 24, 84.

19. Ibid., 87: "In its art every people provides itself with ideal possibilities for the liberation of its sense of vitality. The Gothic man's sense of vitality is depressed by dualistic distraction and dissatisfaction. To relieve this depression he needs the highest state of exaltation, the highest quality of pathos. He builds his minsters into infinity . . . [so] that the sight of this vertical movement, far exceeding all human measure, may set free in him that frenzy of feeling in which alone he can drown his inner discord, in which alone he can find happiness."

20. Ibid., 143, 145, 146.

21. Wilhelm Worringer, "Zur Entwicklungsgeschichte der modernen Malerei," *Der Sturm* 2(August 1911):597–98, as reprinted from *Die Antwort auf den Protest deutscher Künstler* (Munich: R. Piper, 1911).

22. Worringer, "Entwicklungsgeschichte."

23. Paul Fechter, *Der Expressionismus* (Munich: R. Piper, 1914), 39, 49, 25, 27, 49–50.

24. Ibid., 29, 39–40, 46, 13.

25. Ibid., 28–29.

26. Where I introduced the Worringer/Fechter material in 1966 as a "semantic confusion" (Gordon, "Word 'Expressionism,' " 376–80), Perkins correctly sees this material as a chauvinist yet "cohesive theory of Expressionism"; however, despite his critique of my study, Perkins "is at one with Donald Gordon in doubting whether this theory has anything to do with either art or literature between 1905 and 1920 in Germany" (Perkins, *Theory of Expressionism*, 18). For a survey of the Gordon-Perkins findings, see now Richard Brinkmann, *Expressionismus: Internationale Forschung zu einem internationalen Phänomen* (Stuttgart: J. B. Metzler, 1980), 1–3.

27. Scheffler, *Geist der Gotik*, 105.

28. Beckmann, in turn, apparently made use of Scheffler's text; see sec. 3.7.

29. Scheffler, *Geist der Gotik*, 48, 51, 30. "In art as in nature there is both a centrifugal and a centripetal force; in art as in nature the deciding powers are called drive and inhibition, freedom and law. Man's creative urge had to split dualistically to achieve the highest degree of creativity—more or less as nature divided human beings into male and female to preserve and propagate the species. In this sense, Gothic form is masculine, it is the stimulating and procreative form."

30. Heinrich Wölfflin, *Kunstgeschichtliche Grundbegriffe* (Munich: F. Brückmann, 1915), 6.

31. Max Picard, *Expressionistische Bauernmalerei* (Munich: Delphin, 1918), 7–17; Franz Landsberger, *Impressionismus und Expressionismus: Eine Einführung in das Wesen der neuen Kunst* (Leipzig: Klinkhardt & Biermann, 1919), passim.

32. Landsberger. *Impressionismus und Expressionismus*, 15.

33. Max Deri, *Naturalismus, Idealismus, Expressionismus* [1919] (Leipzig: E. A. Seemann, 1922), passim; Grünewald and Hodler are the major Expressionists.

34. Eckart von Sydow, *Die deutsche expressionistische Kultur und Malerei* (Berlin: Furche, 1920), 76, 87, 121, 105; Wilhelm R. Valentiner, "Expressionism and Abstract Painting," *Art Quarterly* 4(1941):210–39, esp. 210; Manfred Schneckenburger, "Der deutsche Expressionismus"; Eberhard Roters and Rosel Gollek, "Der blaue Reiter," in *Propyläen Kunstgeschichte XII: Die Kunst des 20. Jahrhunderts, 1880–1940*, ed. Giulio Carlo Argan (Berlin: Propyläen, 1977), 148f, 168f.

35. Cf. Perkins, *Theory of Expressionism*, 123: "[Expressionist apologists tried] to change a given phenomenon, art, literature, nation, age, from something fluid to something static, from something capable of and susceptible to change and development to something fixed and eternal."

36. Von Sydow, *Kultur und Malerei*, 7–11, 12.

37. Cf. his contribution in the original *Propyläen Kunstgeschichte* series, *Die Kunst der Naturvölker und die Vorzeit* (Berlin: Propyläen, 1923).

38. See von Sydow, *Kultur and Malerei*, 12f, a chapter titled "Dekadente und primitiv-expressionistische Lebensrichtung."

39. Ibid., a chapter titled "Epochen des abstrakten Expressionismus in der bildenden Kunst."

40. Georg Lukács, " 'Grösse und Verfall' des Expressionismus," *Internationale Literatur* (Moscow), 1934, 153–73, as tr. by David Fernbach in Lukács, *Essays on Realism*, ed. Rodney Livingstone (Cambridge: MIT Press, 1981), 76–113, esp. 102–04; 103: "They stood in a romantic opposition to capitalism, yet purely in an ideological sense, not even seeking any insight into its economic laws"; 105; 107.

41. Ibid., 110–11; cf. 113.

42. Hans-Jürgen Schmitt, *Die Expressionismusdebatte: Materialien zu einer marxistischen Realismuskonzeption* (Frankfurt: Suhrkamp, 1973), 60, 165, 190.

43. Josef Goebbels, *Michael: Ein deutsches Schicksal in Tagebuchblättern* (1929), as tr. in Frank Whitford, "Radical Art and Radical Politics," *Germany in Ferment* (Durham, Eng.: Durham University, 1970), 5.

44. Fritz Stern, *The Politics of Cultural Despair: A Study in the Rise of the Germanic Ideology* [1961] (Berkeley: University of California Press, 1974), 185–90, 209, 237.

45. Arthur Moeller van den Bruck, "Das Recht der jungen Völker," *Deutsche Rundschau*, November 1918, as reprinted in *Das Recht der jungen Völker: Sammlung politischer Aufsätze*, ed. Hans Schwarz (Berlin: Der nahe Osten, 1932), 170. Cf. Stern, *Cultural Despair*, 216–18.

46. Moeller van den Bruck, "Der Untergang des Abendlandes: Für und wider Spengler," *Deutsche Rundschau* (July 1920), in *Aufsätze*: 30. Cf. Stern, *Cultural Despair*, 239.

47. Oswald Spengler, *The Decline of the West*, tr. Charles Frances Atkinson (London: Allen & Unwin, 1971), vol. 1, p. 467.

48. Stern, *Cultural Despair*, 190. For Kandinsky, see sec. 2.4.

49. Moeller van den Bruck, *Das dritte Reich*, 3d ed.. ed. Hans Schwarz (Hamburg: Hanseatische Verlagsanstalt, 1931), 241, as tr. by E. O. Lorimer, *Germany's Third Empire*, condensed ed. (New York: Fertig, 1971), 257. For Worringer, see sec. 3.1.

50. Moeller, *Third Empire*, 142–43, 250f: "We were barbarians who took over the inheritance of Mediterranean civilization. We were heathen and became protectors of Christendom. We were tribes and created a nationality," etc.; 242, 250.

51. Ibid., 39, 261 (cf. 25), 263–64 (cf. Stern, *Cultural Despair*, 261).

52. Peter Gay, *Weimar Culture: The Outsider as Insider* (New York: Harper & Row, 1970), 79.

53. George L. Mosse, *Germans and Jews: The Right, the Left, and the Search for a "Third Force" in pre-Nazi Germany* (New York: Fertig, 1970), 118–36.

54. This observation was first made by Herschel B. Chipp, *The Human Image in German Expressionist Graphic Art from the Robert Gore Rifkind Foundation* (Berkeley: University Art Museum, 1981), 37. But it was already implied by the visual comparison of an 1899 Kollwitz etching with a drawing by the Nazi artist Hans Schweitzer (pseud. Mjölnir), in Berthold Hinz, *Art in the Third Reich*, tr. Robert and Rita Kimber (New York: Pantheon, 1979), 4.

55. *Toads of Capitalism* was first published in Grosz's *Das Gesicht der herrschenden Klasse: 55 politische Zeichnungen von George Grosz* (Berlin: Malik, 1921), 22 and, later, in Grosz's *Die Räuber: Neun Lithographien zu Sentenzen aus Schillers "Räuber"* (Berlin: Malik, 1922), plate 2. Schiller's text reads in part, "Haggard want and crouching fear are my insigniae; and in this livery will I clothe thee": Alexander Duckers, *George Grosz: Das druckgraphische Werk* (Frankfurt: Propyläen, 1979), 198.

56. For typical Mjölnir caricatures, see Josef Goebbels, *Kampf um Berlin* (Munich: F. Eher, 1934), passim, and Derrick Sington and Arthur Weidenfeld, *The Goebbels Experiment* (New Haven: Yale University Press, 1943), 16bis.

57. George L. Mosse, *Nazi Culture: Intellectual, Cultural and Social Life in*

the Third Reich, tr. Salvator Attanasio et al. (New York: Grosset & Dunlap, 1966), xxi.

58. Erik H. Erikson, Identity: Youth and Crisis (New York: Norton, 1968), 80–81.

59. Ibid., 89: "the study of this third major crisis of wholeness, at the very end of childhood and youth, reveals the strongest potentiality for totalism and, therefore, is of great signficance to the emergence of new collective identities in our time. Totalitarian propaganda everywhere conceptrates on the claim that youth is left high and dry by the ebbing wave of the past"; 86; for the still earlier conflict between basic trust ("whole") and basic mistrust ("total"), see 85.

60. Robert Jay Lifton, Thought Reform and the Psychology of Totalism: A Study of "Brainwashing" in China (New York: Norton, 1961), 13, 16, 74, 77–79.

61. Wilhelm Stuckart and Hans Globke, Kommentare zur deutschen Rassengesetzgebung (Munich and Berlin, 1936), vol. 1, 31, as tr. in Mosse, Nazi Culture, 336; Stuckart and Globke, Kommentare, 28, as tr. in Mosse, Nazi Culture, 333; Walter Buch, in Deutsche Justiz (21 October 1938), as tr. in Mosse, Nazi Culture, 336–37.

62. Lifton, Totalism, 77. Cf. Erik H. Erikson, Young Man Luther: A Study in Psychoanalysis and History (New York: Norton, 1962), 102: "negative identity—meaning an identity which [the individual] has been warned not to become, which he can become only with a divided heart, but which he nevertheless finds himself compelled to become, protesting his wholeheartedness"; Jörg von Uthmann, Doppelgänger, du bleicher Geselle: Zur Pathologie des deutsch-jüdischen Verhältnisses (Stuttgart: Seewald, 1976), 49–50, 53–54; Gordon A. Craig, The Germans (New York: Putnam, 1982), 126.

63. The phrase "deadly sibling rivalry" is Craig's (The Germans, 127). But the thesis is von Uthmann's (Doppelgänger, 10), who cites the nineteenth-century Zionist Moses Hess to this effect: "In the entire organism of mankind there are no other two peoples who attract and repel each other more than the Germans and the Jews."

64. Lukács' most compelling thesis of 1934 was that Nazi political theory followed Expressionist art theory. But we must continue to question, with Perkins (Theory of Expressionism, 18), "whether this theory has anything to do with either art or literature between 1905 and 1920 in Germany."

65. Hitler, as cited in H. Brenner, Die Kunstpolitik des Nationalsozialismus (Reinbek: Rowohlt, 1963), 82f, and tr. in Hinz, Art in the Third Reich, 35–36; cf. Robert Pois, ed., Race and Race History, and Other Essays by Alfred Rosenberg (New York: Harper & Row, 1970), 12; Goebbels, as cited in K. F. Schrieber, Das Recht der Reichskulturkammer (Berlin, 1937), vol. 5, 26f, and tr. in Hinz, Art in the Third Reich, 37; Goebbels, as cited in Paul Ortwin Rave, Kunstdiktatur im dritten Reich (Hamburg, 1949), 52f, and tr. in Hinz, Art in the Third Reich, 38.

66. Rave, Kunstdiktatur im dritten Reich, 85–91; the list is, of course, incomplete.

67. Führer durch die Ausstellung entarteter Kunst, ed. Fritz Kaiser (Berlin: Verlag für Kultur- und Wirtschaftswerbung, 1937), passim.

68. See the discussion of Expressionism's relation or, better, non-relation to the art of the insane, to Marxism, and to the Jew, in sections 4.4, 4.6, and 4.7.

69. Entartete Kunst, 28; Hinz, Art of the Third Reich, 42; Entartete Kunst, 30; Hinz, Art of the Third Reich, 42.

70. John Willett, Expressionism (New York: McGraw, 1970), 205.

71. Theda Shapiro, Painters and Politics: The European Avant-Garde and Society, 1900–1925 (New York: Elsevier, 1976), 239.

72. John Adkins Richardson, Modern Art and Scientific Thought (Urbana: University of Illinois Press, 1971), 138–40.

73. Ezra Pound, "Hugh Selwyn Mauberly," in Poems, 1918–21 (New York, 1921), 56, as cited in Robert Wohl, The Generation of 1914 (Cambridge: Harvard University Press, 1979), 1; Wohl, Generation of 1914, 232.

74. Peter Loewenberg, "The Psychohistorical Origins of the Nazi Youth Cohort," 1971, in George M. Kren and Leon H. Rappoport, eds., Varieties of Psychohistory (New York: Springer, 1976), 219–47, esp. 220.

75. Emile Langui, L'Expressionnisme en Belgique (Brussels: Laconti, 1970), 71.

76. Franz Marc, Schriften, ed. Klaus Lankheit (Cologne: M. DuMont Schauberg, 1978), 260.

77. Michel de Ghelderode, "The Ostend Interviews," 1951, in Seven Plays, ed. George Hauger (New York: Hill & Wang, 1965), 3–26, esp. 25; Francine-Claire Legrand, L'Expressionnisme Belge au Musée d'Art Moderne de Bruxelles (Paris: Edition de la Revue Française, n.d.), [2]. Legrand agrees with Langui, L'Expressionnisme en Belgique, 14, who calls Expressionism "essentially a Nordic phenomenon" but who argues that the Belgian variety "escaped . . . the desperate nihilism of the Russians, the ecstatic messianism of the Jews, the dramatic pessimism of the Norwegians, the primitive pathetic passion of the Germans, etc."

78. Catalogue, Decade 1910–1920, ed. Alan Bowness (Leeds: City Art Gallery, 1965), no. 95.

79. Catalogue, David Bomberg, 1890–1957 (London: Tate Gallery, 1967), no. 68.

80. Herbert Read, The Meaning of Art [1931] (Baltimore: Penguin, 1967), 163, 162, 160.

81. Dolf Welling, The Expressionists: The Art of Prewar Expressionism in the Netherlands (Amsterdam: J. M. Meulenhoff, 1968), 18.

82. Elisabeth Lidén, Expressionismen och Sverige: Expressionistika drag i svenskt maleri fran 1910-talet till 40-talet (Stockholm: Raben & Sjögren, 1974), 146.

83. Ibid., 74.

84. Lionel Richard, Phaidon Encyclopedia of Expressionism, tr. Stephen Tint (Oxford: Phaidon Press, 1978), 12, cf. 22.

85. John E. Bowlt, ed., Russian Art of the Avant-Garde: Theory and Criticism, 1902–1934 (New York: Viking, 1976), 285; John E. Bowlt, "Pavel Filonov: An Alternative Tradition," Art Journal 34(1975):208–16, esp. 208.

86. Richard, Phaidon Encyclopedia of Expressionism, 22. The Czech Osma group, mentioned by Richard, was of course a prewar exhibiting group of 1907–08—still pre-Expressionist in direction: see sec. 3.4.

87. For Hungarian art and politics, see Lajos Nemeth, Modern Art in Hungary, tr. Lili Halapy and Elizabeth West (Budapest: Corvina, 1969), 66–79; and John Willett, Art and Politics in the Weimar Period: The New Sobriety, 1917–1933 (New York: Pantheon, 1978), 47–48.

88. Nemeth, Modern Art in Hungary, 128.

89. Daniel-Henry Kahnweiler, Juan Gris: His Life and Work, tr. Douglas Cooper (New York: Curt Valentin, 1947), 97; catalogue, L'Art en Europe autour de 1918 (Strasbourg: A la ancienne Douane, 1968), 232.

90. Werner Haftmann, Painting in the Twentieth Century [1955], tr. Ralph Manheim (New York: Praeger, 1967), vol. 1, 217, 221.

91. Gelett Burgess and A. Clutton-Brock started the practice in 1910; see secs. 4.6 and 5.1. For a summary of American usages in 1934, see Sheldon Cheney, Expressionism in Art (New York: Liveright, 1934), 72. During the 1950s Meyer Schapiro described Paul Cézanne's earliest paintings as "anticipat[ing] expressionist effects of the twentieth century": Schapiro, Paul

Cézanne (New York: Abrams, 1952), 10–11. Also Alfred H. Barr, Jr., in 1955 wrote that Auguste Rodin's 1897 Monument to Balzac "initiated expressionist tradition in modern sculpture": Albert E. Elsen, Rodin (New York: Museum of Modern Art, 1963), 202. And John Golding pointed out in 1959 that Picasso's Demoiselles was nót a Cubist but, rather, an Expressionist painting: "The first impression made by the Demoiselles . . . is one of violence and unrest. Indeed the savagery of the two figures on the right-hand side of the painting (which is accentuated by the lack of expression in the faces of the other figures) would justify its classification as one of the most passionate products of twentieth century expressionism": Golding, Cubism: A History and Analysis, 1907–1914 [1959], rev. ed. (Boston: Boston Art and Book Shop, 1968), 47.

92. Eberhard Roters, Europäische Expressionisten (Gütersloh: Bertelsmann Kunstverlag, 1971); catalogue, L'Expressionnisme Européen (Paris: Musée National d'Art Moderne, 1970).

93. Cheney, Expressionism in Art, 72.

94. Richard, Phaidon Encyclopedia of Expressionism, 14.

95. Louis Vauxcelles, Le Fauvisme [1939] (Geneva: P. Cailler, 1958), 115. It should be noted that, for whatever reason, other non-German Expressionists mentioned were Jewish: Epstein and Bomberg in England, Amos in Hungary, and Scipione in Italy.

96. Maurice Tuchman, Chaim Soutine, 1893–1943 (Los Angeles: County Museum of Art, 1968), 25f.

97. William S. Rubin, Dada and Surrealist Art (New York: Abrams, 1969), 174; William Rubin and Carolyn Lanchner, André Masson, (New York: Museum of Modern Art, 1976), 102, 79; cf. Paul Klee, "Paul Klee," Schöpferische Konfession, ed. Kasimir Edschmid (Berlin: E. Reiss, 1920), 28–40, esp. 32.

98. Rubin and Lanchner, André Masson, 143; André Breton, "Prestige d'André Masson," Minotaure no. 12/13(1939):13, as tr. in Rubin and Lanchner, André Masson, 148; André Masson, "Indésirable expressionnisme?", L'Arc 25(1964):87–88.

99. Cheney, Expressionism in Art, 14, 81–82, 370–71, 113.

100. Ibid., 361; John I. H. Baur, Revolution and Tradition in Modern American Art (Cambridge: Harvard University Press, 1951), 34.

101. Cheney, Expressionism in Art, 11.

102. Charmion von Wiegand, "Expressionism and Social Change," Art Front (New York) (November 1936):10–13, esp. 10.

103. Dore Ashton, The New York School: A Cultural Reckoning (New York: Viking, 1973), 66.

104. John D. Graham, System and Dialectics of Art (New York: Delphic Studios, 1937), 125, 127.

105. Bernard S. Myers, Mexican Painting in Our Time (New York: Oxford University Press, 1956), 42.

106. Ibid., 101–02.

107. Friedrich Nietzsche, Ecce Homo, in On the Genealogy of Morals and Ecce Homo, tr. Walter Kaufmann (New York: Vintage Book, 1969), 327, as cited in secs. 1.5 and 1.6.

108. Cabanas Orphanage, Guadalajara; cf. Myers, Mexican Painting, 162.

109. Francis Valentine O'Connor and Eugene Victor Thaw, Jackson Pollock: A Catalogue Raisonné of Paintings, Drawings, and Other Works, 4 vols. (New Haven: Yale University Press, 1978), vol. 4, 9, no. 925.

110. Alma Reed, ed., José Clemente Orozco (New York: Delphic Studios, 1932), n.p. (section "Paintings"); cf. Diane Waldman, Mark Rothko, 1903–1970: A Retrospective (New York: Solomon R. Guggenheim Museum, 1978), 26, for the dating of the subway series.

111. Jacob Kainen, "Our Expressionists," Art Front (New York) 3(February 1937):14–15.

112. The group exhibited in a conservative Paris gallery in 1936, although the radical Graham showed with The Ten in 1938; Lucy McCormick Embick, The Expressionist Current in New York's Avant-Garde: The Paintings of The Ten, (Ann Arbor: University Microfilms International, 1982), pp. 35, 37, 51.

113. Piri Halasz, "Art Criticism (and Art History) in New York: The 1940s vs. the 1980s; Part One: the Newspapers," Arts Magazine 57(February 1983):91–97, and "Part Two: the Magazines," Arts Magazine 57(March 1983):64–73.

114. Emily Genauer, Best of Art (New York: Doubleday, 1948), 126.

115. Frederick S. Wight, "Under the El," in catalogue, Jack Levine (Boston: The Institute of Contemporary Art, 1955), 3–18, esp. 14–15.

116. Partisan Review 5(August–September 1938):3; 6(Winter 1939):103; 6(Summer 1939):5; W. H. Auden, The English Auden: Poems, Essays, and Dramatic Writings, ed. Edward Mendelsohn (New York: Random, 1977), 245–47 (also cited, with inaccurate reference, in Ashton, The New York School, 109); Friedrich Nietzsche, The Birth of Tragedy, tr. Walter Kaufmann (New York: Vintage Book, 1967), 109–14, sec. 18; Clement Greenberg, "Avant-Garde and Kitsch," Partisan Review 6(Fall 1939):35–36; Clement Greenberg, "Towards a Newer Laocoön," Partisan Review 7(1940):296–310; Samuel M. Kootz, New Frontiers in American Painting (New York: Hastings, 1943), 19; Abraham Rattner, diary entry, as cited in Piri Halasz, Directions, Concerns and Critical Perceptions of Paintings Exhibited in New York, 1940–1949; Abraham Rattner and His Contemporaries, diss., (Columbia University, 1982), 382.

117. Piri Halasz, "Art Criticism (and Art History) in New York: the 1940s vs. the 1980s; Part Three: Clement Greenberg," Arts Magazine 57(April 1983):80–89, esp. 82.

118. Clement Greenberg, "Art," Nation 165(1947):629, as cited in Halasz, "Clement Greenberg," 82; Halasz, Directions, 91, and "Clement Greenberg," 82; cf. Greenberg, "Art," Nation 164(1947):139. For another approach to Greenberg's Forties criticism, less relevant to Expressionist art, see Fred Orton and Griselda Pollock, "'Avant-Gardes' and Partisans Reviewed," Art History 4(1981):305–27.

119. I refer, of course, to the forties Greenberg rather than to the sixties Greenberg who advocated "post-painterly abstraction." Just as the critic once thought the late murals of Delacroix the highpoint of nineteenth century art (1947) so he now prefers Ingres to Delacroix (1981): Halasz, Directions, 87, 478. For Greenberg's early attitudes toward emotion, romanticism, and related topics I follow Halasz's revisionist critique of Kozloff, Sandler, Ashton, Foster, Kuspit, and others ("Clement Greenberg," passim). Nevertheless, a fuller examination of the context of forties attitudes toward emotion in art, including analysis of the writings of T. S. Eliot, Susanne Langer, and others, is still needed.

120. "[Hofmann is] one of the most uncompromising representatives of what some people call the splatter-and-daub school of painting, and I, more politely, have christened abstract Expressionism": Robert M. Coates, "Abroad and at Home," The New Yorker 22(30 March 1946):83. Coates had earlier expressed considerable ambivalence toward Expressionist emotionalism in a piece on "Soutine, Kokoschka, Quirt and O'Keeffe," The New Yorker 19(10 April 1943):40: "Whether you like Expressionism or not—myself, I'm sometimes staggered by its excessive emotionalism—you can hardly afford to disregard it."

121. Rudi Blesh, Modern Art USA: Men, Rebellion, Conquest, 1900–1956

(New York: Knopf, 1956), 253–54; O'Connor and Thaw, *Jackson Pollock,* vol. 4, document D40, 226.

122. Judith Wolfe, "Jungian Aspects of Jackson Pollock's Imagery," *Artforum* 11(November 1972):65–73, esp. 66.

123. Lee Krasner Pollock, as cited in Francine du Plessix and Cleve Gray, "Who Was Jackson Pollock?," *Art in America* 55(May–June 1967):51.

124. Statements by Mary Callery and Meyer Schapiro in Alfred H. Barr, Jr., *Picasso: Fifty Years of His Art* (New York: Museum of Modern Art, 1946), 265.

125. Donald E. Gordon, "Pollock's 'Bird,' or How Jung Did Not Offer Much Help in Myth-Making," *Art in America* 68(October 1980):43–53, esp. 48.

126. Sec. 3.1, though Pollock is far more assertive than the Germans; cf. Clement Greenberg, "'American-Type' Painting" [1955], *Art and Culture: Critical Essays* (Boston: Beacon Press, 1961), 208–29.

127. Cheney, *Expressionism in Art,* 331; Jackson Pollock, "My Painting," in Robert Motherwell and Harold Rosenberg, eds., *possibilities* (New York) 1(Winter 1947–48):78–83, esp. 79, Clement Greenberg, "The Present Prospects of American Painting and Sculpture," *Horizon* 16(October 1947):20–30, esp. 26.

128. John D. Graham, "Primitive Art and Picasso," *Magazine of Art* 30(1937):236–39, esp. 237; Friedrich Nietzsche, *Human All-too-Human* [1878], tr. Helen Zimmern (New York: Macmillan, 1909), vol. 1, 24.

129. C. G. Jung, *The Psychology of the Unconscious,* tr. Beatrice M. Hinkle (New York: Moffatt, Yard, 1916), 28.

130. According to Sanford Hirsch of the Adolph and Esther Gottlieb Foundation, Gottlieb did not purchase the *Tlingit Fringed Blanket* until 1942, after the first pictographs were exhibited.

131. Waldman, *Mark Rothko,* 268.

132. Gottlieb and Rothko, statement, *The New York Times* (13 June 1943), as cited in Chipp, *Theories of Modern Art,* 545; cf. Nietzsche, *Birth of Tragedy,* 61–62, sec. 8.

133. As demonstrated in the opening illustrations to Robert Rosenblum's *Modern Painting and the Northern Romantic Tradition: Friedrich to Rothko* (New York: Harper & Row, 1975).

134. Rothko, "The Romantics Were Prompted," *possibilities* 1(Winter 1947–48):84; cf. Nietzsche, *Birth of Tragedy,* 63, sec. 8.

135. Nietzsche, *Birth of Tragedy,* 60, sec. 7. For Nietzsche as existentialist, see Walter Kaufmann, *Existentialism from Dostoyevsky to Sartre* (New York: Random, 1956), ch. 4.

136. Ashton, *New York School,* 178–82.

137. Harold Rosenberg, "The American Action Painters," *Art News* 51(December 1952):42–43, 48–50, esp. 23.

138. See Rothko's entry in *Current Biography* (New York) (May 1961):42.

139. Harold Rosenberg, "Action Painting: Crisis and Distortion," *The Anxious Object: Art Today and Its Audience* (New York: Horizon, 1966), 39–47, esp. 42.

140. Gail Levin, "Miró, Kandinsky, and the Genesis of Abstract Expressionism," in Robert Carleton Hobbs and Gail Levin, *Abstract Expressionism: The Formative Years* (Ithaca: Cornell University Press, 1978), 27–40.

141. Irving Sandler, *The Triumph of American Painting: A History of Abstract Expressionism* (New York: Harper & Row, 1976), 244.

142. Willem de Kooning, in David L. Shirey, "Don Quixote in Springs," *Newsweek* 70(20 November 1967):80. The phrase "identified with" is Ashton's, *The New York School,* 194.

143. William Faulkner, *Light in August* (New York: Random, 1932), 424–25, 100; cf. Charles F. Stuckey, "Bill de Kooning and Joe Christmas," *Art in America* 68(March 1980):67–78, esp. 72.

144. Thomas B. Hess, *Willem de Kooning* (New York: Museum of Modern Art, 1968), 149f.

145. Rosenberg, *The Anxious Object,* 45–46, 39–40; Embick, *The Paintings of The Ten,* 44, points out that of the seventeen different painters who showed with The Ten, seven had been born in Russia, while others were second-generation Jews. Similarly, there were a number of emigrés among the Abstract Expressionists, including de Kooning, Gorky, Guston, Hofmann, and Rothko, while Pollock and Still brought a strongly rural background to their highly urban art.

146. William C. Seitz, *Abstract-Expressionist Painting in America: An Interpretation based on the Work and Thought of Six Key Figures,* diss. (Princeton University, 1956), ch. 5.

147. Lawrence Alloway in Alloway and MacNaughton, *Gottlieb: A Retrospective,* 57–58.

148. Gottlieb, in Jeanne Siegel, "Adolph Gottlieb: Two Views," *Arts Magazine* 42(February 1968):31.

149. Margit Rowell, "Jean Dubuffet: An Art on the Margins of Culture," in catalogue, *Jean Dubuffet: A Retrospective* (New York: Solomon R. Guggenheim Museum, 1973), 15–34, esp. 21.

150. Peter Selz, *New Images of Man* (New York: Museum of Modern Art, 1959), 16.

151. Seitz, *Abstract-Expressionist Painting,* already mentions the Dadaist impulse in his text of 1956.

152. These generalizations derive from the following table of birth dates, specifically from the middle two dates in each column:

German Expressionists	American Expressionists
Nolde (1867)	Rattner (1895)
Marc (1881)	Rothkowitz (1903)
Heckel (1883)	Gottlieb (1903)
Grosz (1893)	J. Levine (1915)

Abstract Expressionists	European Expressionists
Hofmann (1880)	Soutine (1894)
de Kooning (1904)	Dubuffet (1901)
Gorky (1904)	Bacon (1909)
Pollock (1912)	Jorn (1914)

153. Of Cobra artists Appel was born in 1925, Pierre Alechinsky in 1927. One also thinks of Ernst Neizvestny in Russia, Jan Burssens in Belgium, Bengt Lindström in Sweden, and Fritz Hundertwasser in Austria, all born in the late 1920s, and such others born from 1930 to 1936 as Antonio Saura in Spain, Elizabeth Frink in England, and Luis Noe in Argentina.

154. The older men like Rauschenberg (born 1925) and George Segal (1924) rejected Expressionism before 1960 or, like Edward Kienholz (1927), provided an absurdist twist; younger painters like Jasper Johns (1930), Andy Warhol (1930), and Frank Stella (1936) were uninterested in emotional expression.

155. Kenneth Keniston, "Stranded in the Present" [1961], in Kren and Rappoport, *Varieties of Psychohistory,* 251–56, esp. 252–53.

156. Renato Poggioli, *The Theory of the Avant-Garde* [1962], tr. Gerald Fitzgerald (Cambridge: Harvard University Press, 1968), 230, 233; William C. Seitz, "The Rise and Dissolution of the Avant-Garde," *Vogue* (New York) 142(1 September 1963):182f, and Douglas Cooper, "Establishment and Avant-Garde," *Times Literary Supplement* (3 September 1964):823–84, as cited in Donald Drew Egbert, *Social Radicalism and the Arts: Western Europe*

(New York: Knopf, 1970), 820; Max Kozloff, "The Dilemma of Expressionism," *Artforum* 3(November 1964):32–35, esp. 33.

157. Kozloff, "Dilemma," 32; for "hysteria" as the antidote to solipsism, see E. H. Gombrich, "André Malraux and the Crisis of Expressionism," *Meditations on a Hobby Horse* (London: Phaidon Press, 1963), 84 (Kozloff was reviewing a show prepared by Maurice Tuchman, "Van Gogh and Expressionism," [New York: Solomon R. Guggenheim Museum, 1964]); 32–33.

158. The issue of Expressionist "emotionalism" was discussed, but not resolved, in Gordon, "The Word 'Expressionism' ": 382f.

159. Joseph Beuys, *The Secret Block for a Secret Person in Ireland* (Oxford: Museum of Modern Art, 1974), [8].

160. Günter Grass, *The Tin Drum* [1959], tr. Ralph Manheim (New York: Vintage Book, 1964), 374.

161. Catalogue, *This Fabulous Century: 1960–1970* (New York: Time-Life, 1975), 69.

162. Ibid., 59.

163. Jack Cowart, *Expressions: New Art from Germany* (St. Louis: St. Louis Art Museum, 1983), 85.

164. Jörg Immendorff, *LIDL, 1966–1970* (Eindhoven: Van Abbemuseum, 1981), 13–15.

165. Donald E. Gordon, "Expressionism and Its Publics," in *Beiträge zur Rezeption der Kunst des 19. und 20. Jahrhunderts: Ludwig Grote gewidmet*, ed. Wulf Schadendorf (Munich: Prestel, 1975), 85–97, esp. 96.

166. Ibid., 97.

167. Wolfgang Max Faust and Gerd de Vries, *Hunger nach Bildern: Deutsche Malerei der Gegenwart* (Cologne: M. DuMont Schauberg, 1982).

168. Cowart, *Expressions*, 59.

169. William Barrett, *The Truants: Adventures among the Intellectuals* (Garden City: Anchor Press, 1982), 141.

170. Faust and de Vries, *Hunger nach Bildern*, 34, 36.

171. Cowart, *Expressions*, 35 and fig. 15.

172. John Caldwell, "Anselm Kiefer's 'Dem unbekannten Maler,'" *Carnegie Magazine* 57(January–February 1984):4–7, esp. 7.

173. Susan Rothenberg, in "Expressionism Today: An Artists' Symposium," *Art in America* 70(December 1982):58–75, esp. 65; Sandro Chia, in Carter Ratcliff, "A New Wave from Italy: Sandro Chia," *Interview* (June–July 1981):83–85, esp. 85. Also cited in Diane Waldman, *Italian Art Now: An American Perspective* (New York: Solomon R. Guggenheim Museum, 1982), 10.

174. Chia, statement, in Waldman, *Italian Art Now*, 10: "[W]hat is the most interesting thing in painting is the chasm which divides painting from other things. Considering that the chasm . . . is the most interesting aspect of painting means that between painting and other things there is not bridge a but a jump."

175. Rene Ricard, "About Julian Schnabel," in catalogue, *Julian Schnabel* (Amsterdam: Stedelijk Museum, 1982), n.p.

176. Christian Geelhaar, "Julian Schnabel's 'Head (for Albert),'" *Arts Magazine* 57(October 1982):74–75.

177. "During the '60s, I think people forgot what emotions were supposed to be. And I don't think they've ever remembered": Andy Warhol (1975), as cited in Peter Halley, "A Note on the 'New Expressionism' Phenomenon," *Arts Magazine* 57(March 1983):88–89.

178. Schnabel, in Ricard, "About Julian Schnabel."

179. Their median birthdate is the late 1940s, as can be seen from the middle term in each column of German, Italian, and American/British artists:

Hödicke (1938)	Lüpertz (1941)	
Zimmer (1948)	Fetting (1949)	
Salome (1954)	Dokoupil (1954)	
M. Merz (1925)	Guston (1913)	Morley (1931)
Cucchi (1950)	Bosman (1944)	Salle (1952)
Clemente (1952)	Longo (1953)	Haring (1958).

180. Most provocative was Donald Kuspit's thesis that the German variety was more authentic than the American one: Kuspit, "The New(?) Expressionism: Art as Damaged Goods," *Artforum* 20(November 1981):47–55.

181. Christos M. Joachimides, in catalogue, *A New Spirit in Painting* (London: Royal Academy of Arts, 1981), 14; Clement Greenberg, "To Cope with Decadence," *Arts Magazine* 56(February 1982):120–21; the paper had first been delivered in March 1981.

182. In the West German elections of 1979 Franz Josef Strauss charged that Germany's birth rate was declining, a charge immortalized in Günter Grass' book *Headbirths, or the Germans are Dying Out*, tr. Ralph Manheim (New York: Harcourt, Brace, Jovanovich, 1982). See also the Carter administration's gloomy *Global 2000 Report* of 1980, and the more hopeful rebuttals to it, e.g. in Philip M. Boffey, "Will the Next 20 Years Bring Prosperity or Decline?" *The New York Times* (12 January 1982):C1–2.

183. Inflation dominated the German economy in the early 1920s and the American economy in the later 1970s, while American recessions or depressions occurred in the 1930s, 1979, and 1982—periods we associate with Expressionist art. Yet what matters is not the raw business cycle, but how it is perceived in bourgeois and vanguard circles.

184. See, e.g., Donald E. Gordon, "Ernst Ludwig Kirchner: By Instinct Possessed," *Art in America* 68(November 1980):80–95.

185. In her 1979 exhibition *American Painting: The Eighties*, Barbara Rose remarkably predicted the Expressionist emphasis to come.

186. Gordon, "Expressionism and Its Publics," 97.

187. Arthur Mann, *The One and the Many: Reflections on the American Identity* (Chicago: University of Chicago Press, 1979), 17–18.

188. Paul Cowan, *An Orphan in History: Retrieving a Jewish Legacy* (Garden City: Doubleday, 1982).

189. Patrick Huyghe, "Of Two Minds," *Psychology Today* 17(December 1983):26.

190. Ibid., 26: "[A] child playing with blocks" requires both "wrecker" and "builder," both responsible to "play" and his agent, "play-with-blocks." And yet "play" must ultimately conflict with "I'm getting hungry," etc. See also Howard Gardner, *Frames of Mind: The Theory of Multiple Intelligences* (New York: Basic, 1983).

191. Rudolf Arnheim, *Entropy and Art: An Essay on Disorder and Order* (Berkeley: University of California Press, 1971), 55, 56.

Bibliography

GENERAL WORKS

Arnheim, Rudolf. *Entropy and Art: An Essay on Order and Disorder.* Berkeley: University of California Press, 1971.

Arnold, Armin. *Die Literatur des Expressionismus: Sprachliche und thematische Quellen.* Stuttgart: W. Kohlhammer, 1966.

Auden, W. H. *The English Auden: Poems, Essays, and Dramatic Writings.* Ed. Edward Mendelsohn. New York: Random House, 1977.

Bannister, Robert C. *Social Darwinism: Science and Myth in Anglo-American Social Thought.* Philadelphia: Temple University Press, 1979.

Barrett, William. *The Truants: Adventures among the Intellectuals.* Garden City: Anchor Press, 1982.

Barzun, Jacques. *Darwin, Marx, Wagner: Critique of a Heritage.* Boston: Little, Brown, 1941.

Baudelaire, Charles. *Oeuvres complètes.* Paris: Gallimard, 1961.

Behne, Adolf. *Die Wiederkehr der Kunst.* Leipzig: K. Wolff, 1919.

Benjamin, Walter. *The Origin of German Tragic Drama* [1928]. London: New Left Books, 1977.

Bergmann, Klaus. *Agrarromantik und Grossstadtfeindschaft.* Meisenheim am Glan: A. Hain, 1970.

Bergson, Henri. *Creative Evolution* [1907]. Tr. Arthur Mitchell. New York: Modern Library, 1944.

Bertz, Edward. *Walt Whitman: Ein Charakterbild.* Leipzig: M. Spohr, 1905.

Besant, Annie, and C. W. Leadbetter. *Thought-Forms.* Wheaton, Ill.: Theosophical Publishing House, 1969.

Bett, Henry. *Joachim of Flora.* London: Methuen, 1931.

Biddiss, Michael D. *Gobineau: Selected Political Writings.* New York: Harper & Row, 1970.

Bithell, Jethro. *Life and Witness of Maurice Maeterlinck* [1913]. Port Washington, N.Y.: Kennikat Press, 1972.

Blavatsky, H. P. *Isis Unveiled: A Master-Key to the Mysteries of Ancient and Modern Science and Theology* [1877]. Facsimile ed., 2 vols. in 1. Los Angeles: Theosophy, 1975.

————. *The Secret Doctrine: The Synthesis of Science, Religion and Philosophy* [1888]. Facsimile ed., 2 vols. in 1. Los Angeles: Theosophy, 1974.

Bloom, Harold. *The Anxiety of Influence: A Theory of Poetry.* New York: Oxford University Press, 1973.

Boffey, Philip M. "Will the Next 20 Years Bring Prosperity or Decline?" *New York Times,* January 12, 1982, C1–2.

Bohr, Niels. *Atomic Physics and the Description of Nature.* Cambridge: Cambridge University Press, 1934.

Bourget, Paul. *Essais de psychologie contemporaine* [1883]. 2 vols. Paris: Librairie Plon, 1937.

Brenner, H. *Die Kunstpolitik des Nationalsozialismus.* Reinbek: Rowohlt, 1963.

Bruck, Arthur Moeller van den. *Germany's Third Empire.* Condensed ed. tr. E. O. Lorimer. New York: Fertig, 1971.

Burckhardt, Jakob. *Letters.* Ed. Alexander Dru. London: New Left Books, 1977.

Campbell, Joseph. *The Masks of God: Oriental Mythology.* New York: Penguin, 1977.

Capek, M. *The Philosophical Impact of Contemporary Physics.* Princeton: D. Van Nostrand, 1961.

Chamberlain, Houston Stewart. *Foundations of the Nineteenth Century* [1899]. Tr. John Lees. 2 vols. New York: Fertig, 1977.

Chapple, C. G., and Hans Schulte, eds. *The Turn of the Century: German Literature and Art, 1890–1915.* Bonn: Bouvier, 1981.

Copelston, Frederick. *A History of Philosophy: Schopenhauer to Nietzsche.* Garden City: Doubleday, 1956.

Cowan, Paul. *An Orphan in History: Retrieving a Jewish Legacy.* Garden City: Doubleday, 1982.

Craig, Gordon A. *The Germans.* New York: Putnam, 1982.

Dahlström, Carl E. W. L. *Strindberg's Dramatic Expressionism.* Ann Arbor: University of Michigan Press, 1930.

Darwin, Charles. *On the Origin of Species by Means of Natural Selection, or The Preservation of Favoured Races in the Struggle for Life* [1859]. Facsimile ed. Cambridge: Harvard University Press, 1964.

_____. *The Descent of Man and Selection in Relation to Sex* [1871]. London: Murray, 1909.

Däubler, Theodor. *Der neue Standpunkt.* Leipzig: Insel, 1919.

Deri, Max. *Naturalismus, Idealismus, Expressionismus* [1919]. Leipzig: E. A. Seemann, 1922.

Dostoevsky, Fyodor. *The Idiot* [1868]. Tr. Constance Garnett. New York: Modern Library, 1962.

_____. *Notes from Underground* [1864]. Tr. Ralph E. Matlaw. New York: Dutton, 1960.

_____. *Politische Schriften.* Ed. Arthur Moeller van den Bruck. Munich: R. Piper, 1907.

Durkheim, Emile. *Suicide: A Study in Sociology.* New York: Free Press, 1966.

Edman, Erwin. *The Philosophy of Schopenhauer.* New York: Modern Library, 1956.

Egbert, Donald Drew. *Social Radicalism and the Arts: Western Europe.* New York: Knopf, 1970.

Eisner, Lotte H. *The Haunted Screen: Expressionism in the German Cinema and the Influence of Max Reinhardt.* Berkeley: University of California Press, 1973.

Eliade, Mircea. *Myths, Dreams and Mysteries: The Encounter between Contemporary Faiths and Archaic Realities.* Tr. Philip Mairet. New York: Harper & Row, 1960.

_____. *The Two and the One.* Tr. J. M. Cohen. Chicago: University of Chicago Press, 1979.

Erikson, Erik H. *Childhood and Society.* Harmondsworth: Penguin, 1965.

_____. *Identity: Youth and Crisis* [1968]. New York: Norton, 1978.

_____. "The Problem of Ego Identity." *Journal of the American Psychoanalytic Association* (1956):56–121.

_____. *Young Man Luther: A Study in Psychoanalysis and History.* New York: Norton, 1962.

Faulkner, William. *Light in August.* New York: Random House, 1932.

Fischer, Fritz. *War of Illusions: German Politics from 1911 to 1914.* Tr. Marian Jackson. New York: Norton, 1975.

Forel, August. *The Sexual Question* [1905]. Tr. C. F. Marshall. Brooklyn: Educational Publishing, 1933.

Foucault, Michel. *The History of Sexuality, Vol. I: An Introduction.* Tr. Robert Hurley. New York: Vintage, 1980.

_____. *The Order of Things: An Archaeology of the Human Sciences.* New York: Pantheon, 1970.

Freud, Anna. *The Ego and the Mechanisms of Defense* [1936]. Rev. ed. New York: International Universities Press, 1966.

Freud, Sigmund. "Beyond the Pleasure Principle" [1920]. *Standard Edition,* vol. 18, 7–64.

_____. "The Interpretation of Dreams" [1900]. *Standard Edition,* vols. 4, 5. London: Hogarth, 1953.

_____. "Negation" [1925]. *Standard Edition,* vol. 19, 235–39. London: Hogarth, 1961.

Gardner, Howard. *Frames of Mind: The Theory of Multiple Intelligences.* New York: Basic, 1983.

Garten, H. F. *Modern German Drama.* London: Methuen, 1964.

Gasman, Daniel. *The Scientific Origins of National Socialism: Social Darwinism in Ernst Haeckel and the German Monist League.* New York: Elsevier, 1971.

Gay, Peter. *Freud, Jews and Other Germans; Masters and Victims in Modernist Culture.* New York: Oxford University Press, 1978.

_____. *Weimar Culture: The Outsider as Insider.* New York: Harper & Row, 1968.

"The German Republic." *Encyclopaedia Britannica,* vol. 10, 278–84. Chicago: Encyclopaedia Britannica, Inc, 1957.

Ghelderode, Michel de. "The Ostend Interviews" [1951]. *Seven Plays.* Ed. George Hauger. New York: Hill & Wang, 1965.

Gilman, Richard. *Decadence: The Strange Life of an Epithet.* New York: Farrar, Straus & Giroux, 1979.

Goebbels, Josef. *Kampf um Berlin.* Munich: F. Eher, 1934.

Goethe, Johann Wolfgang von. *Faust: Der Tragödie zweiter Teil.* Munich: Prestel, 1970.

_____. *Goethe's Faust.* Tr. Walter Kaufmann. Garden City: Anchor, 1963.

Gold, Alfred. "Der Krieg und die Bildung." *Kriegszeit,* 16 December 1914, 2.

Goudge, T. A. "Thomas Henry Huxley. "*The Encyclopedia of Philoso-*

phy, vol. 4, 101–03. Ed. Paul Edwards. New York: Macmillan, 1967.

Grass, Günter. *Headbirths, or the Germans are Dying Out.* New York: Harcourt, Brace, Jovanovich, 1982.

_____. *The Tin Drum* [1959]. Tr. Ralph Manheim. New York: Vintage, 1964.

Gross, David. *The Writer and Society: Heinrich Mann and Literary Politics in Germany, 1890–1940.* Atlantic Highlands: Humanities, 1980.

Haeckel, Ernst. *Die Welträtsel: Gemeinverständliche Studien über monistische Philosophie.* People's Ed. Bonn: E. Strauss, 1903.

_____. *The History of Creation: or The Development of the Earth and its Inhabitants by the Action of Natural Cause.* Tr. E. R. Lankester. 2 vols. New York: Appleton Davies, 1876.

_____. *Monism as Connecting Religion and Science: The Confession of Faith of a Man of Science* [1892]. London: Adam & Charles Black, 1903.

_____. *The Riddle of the Universe at the Close of the Nineteenth Century.* New York and London: Harper & Row, 1900.

Hake, Alfred E. *Regeneration: A Reply to Max Nordau.* New York: Putnam, 1896.

Hamburger, Michael, and Christopher Middleton, eds. *Modern German Poetry.* New York: Grove, 1962.

Hanson, Norwood Russell. "Quantum Mechanics, Philosophical Implications of." *Encyclopedia of Philosophy,* vol. 7, 41–49. Ed. Paul Edwards. New York: Macmillan, 1967.

Hatcher, Harlan, ed. *Modern Continental Dramas.* New York: Harcourt, Brace, Jovanovich, 1941.

Hemleben, Johannes. *Rudolph Steiner.* Reinbek bei Hamburg: Rowohlt, 1963.

Hertz, Friedrich. *Race and Civilization.* Tr. A. S. Levetus and W. Entz. New York: Macmillan, 1928.

Hesse, Hermann. "Die Brüder Karamazoff oder Der Untergang Europas" [1919]. *Gesammelte Schriften,* vol. 12. Frankfurt: Suhrkamp, 1970.

_____. *The Glass Bead Game (Magister Ludi).* Tr. Richard and Clara Winston. New York: Holt, Rinehart & Winston, 1969.

Hiller, Kurt, ed. *Das Ziel: Aufrufe zu tätigem Geist.* Munich and Berlin: G. Müller, 1916.

Hingley, Ronald. *Nihilists: Russian Radicals and Revolutionaries in the Reign of Alexander II* (1875–81). New York: Delacorte, 1969.

Hinsie, Leland E., and Robert Jean Campbell. *Psychiatric Dictionary.* 3d ed. New York: Oxford University Press, 1960.

Hitler, Adolf. *Mein Kampf* [1925]. Tr. Ralph Manheim. Boston: Houghton Mifflin, 1971.

Holländer, Felix. *Der Weg des Thomas Truck* [1902]. 10th ed. Berlin: S. Fischer, 1910.

Huxley, Thomas H. "Evolution and Ethics." *Evolution and Ethics and Other Essays.* New York: Appleton Davies, 1898.

Huyghe, Patrick. "Of Two Minds." *Psychology Today* 17(December 1983):26.

Ibsen, Hendrik. *Emperor and Calilean: A World-Historic Drama.* Tr. William Archer. New York: Scribner, 1911.

James, William. *Pragmatism: A New Name for Some Old Ways of Thinking* [1907]. New York: Longmans, Green, 1910.

Jaspers, Karl. *Strindberg und Van Gogh.* Munich: R. Piper, 1949.

Jonas, Hans. *The Gnostic Religion.* Boston: Beacon Press, 1958.

Jung, C. G. *The Psychology of the Unconscious.* Tr. Beatrice M. Hinkle. New York: Moffatt, Yard, 1916.

_____. *Symbols of Transformation.* Tr. R. F. C. Hull. New York: Pantheon, 1956.

_____. *Symbols of Transformation: An Analysis of the Prelude to a Case of Schizophrenia* [1912]. Tr. R. F. C. Hull. Princeton: Princeton University Press, 1972.

_____. *Two Essays on Analytical Psychology.* 2d rev. ed. Tr. R. F. C. Hull. Princeton: Princeton University Press, 1972.

Kafka, Franz. *The Metamorphosis: Die Verwandlung.* Tr. Willa and Edwin Muir. New York: Schocken, 1968.

Kaiser, Georg. *Gas I: A Play in Five Acts.* Tr. Herman Scheffauer. New York: Ungar, 1975.

_____. *Von Morgens bis Mitternachts: Stück in zwei Teilen.* Potsdam: G. Kiepenhauer, 1920.

Kaufmann, Walter. *Existentialism: From Dostoevsky to Sartre.* Rev. ed. New York: New American Library, 1975.

_____. *Nietzsche: Philosopher, Psychologist, Antichrist.* Princeton: Princeton University Press, 1950.

Kecskemeti, Paul, ed. *Essays on the Sociology of Knowledge.* New York: Oxford University Press, 1952.

Kermode, Frank. *The Sense of an Ending.* New York: Oxford University Press, 1967.

Kerschensteiner, Georg. *Die Entwickelung der zeichnerischen Begabung.* Munich: C. Gerber, 1905.

Kidd, Benjamin. *Social Evolution.* Chicago: Charles S. Sergel, 1895.

Kleist, Heinrich von. *Sämtliche Werke und Briefe.* Vol. 2. Ed. Wilhelm Herzog. Leipzig: Insel, 1909.

Kohn, Hans. *The Mind of Germany: The Education of a Nation.* New York: Scribner, 1960.

Kracauer, Siegfried. *From Caligari to Hitler: A Psychological History of the German Film* [1947]. Princeton: Princeton University Press, 1974.

Kren, George M., and Leon H. Rappoport, eds. *Varieties of Psychohistory.* New York: Springer Publishing, 1976.

Kris, Ernst. *Psychoanalytic Explorations in Art.* New York: Schocken, 1967.

Krispyn, Egbert. *Style and Society in German Literary Expressionism.* Gainesville: University of Florida Press, 1964.

Lalande, André. *La Dissolution opposée à l'évolution dans les sciences physiques et morales.* Paris: F. Alcan, 1899.

Langer, William L. *The Diplomacy of Imperialism, 1890–1902.* 2 vols. New York: Knopf, 1935.

Laqueur, Walter. *Young Germany: A History of the German Youth Movement.* New York: Basic, 1962.

_____. *Weimar: A Cultural History, 1918–1933*. New York: Putnam, 1974.

Le Bon, Gustave. *The Crowd: A Study of the Popular Mind* [1895]. Tr. Robert K. Merton. New York: Viking, 1963.

Leibowitz, René. *Schoenberg and His School: The Contemporary Stage of the Language of Music*. Tr. Dike Newlin. New York: Philosophical Library, 1949.

Lewin, Bertram. "Sleep, the Mouth, and the Dream Screen." *Selected Writings*. Ed. Jacob A. Arlow. New York: Psychoanalytic Quarterly, 1973.

Lifton, Robert Jay. *Thought Reform and the Psychology of Totalism: A Study of "Brainwashing" in China*. New York: Norton, 1961.

Lippert, Friedrich, ed. *In memoriam Oskar Panizza*. Munich: H. Stobbe, 1926.

Lipps, Theodor. *Aesthetik: Psychologie des Schönen in der Kunst*. Vol 1. Hamburg and Leipzig: L. Voss, 1903.

Lukács, Georg. *Essays on Realism*. Ed. Rodney Livingstone. Cambridge: MIT Press, 1981.

_____. *Realism in Our Time*. Tr. John and Necke Mander. New York: Harper & Row, 1964.

MacGregor, John M. *The Discovery of the Art of the Insane*. Ph.D. diss., Princeton University, 1978.

Mahler, Alma. *Gustav Mahler: Memories and Letters*. Tr. Basil Creighton. London: Murray, 1968.

Mahler-Werfel, Alma. *Mein Leben*. Frankfurt: S. Fischer, 1960.

Mann, Arthur. *The One and the Many: Reflections on the American Identity*. Chicago: University of Chicago Press, 1979.

Mann, Thomas. *Reflections of a Nonpolitical Man* [1918]. Tr. Walter D. Morris. New York: Ungar, 1983.

Mannheim, Karl. *Ideology and Utopia: An Introduction to the Sociology of Knowledge*. London: Routledge & Kegan, 1954.

_____. "The Problem of Generations." *Essays on the Sociology of Knowledge*. Ed. Paul Kecskemeti. New York: Oxford University Press, 1952.

Men versus The Man; a Correspondence between Robert Rives La Monte, Socialist, and H. L. Mencken, Individualist. New York: Holt, Rinehart & Winston, 1910.

Mencken, H. L. *The Philosophy of Friedrich Nietzsche*. Boston: Luce, 1908.

Merejkowsky, Dmitry. "La question religieuse; enquête internationale." *Mercure de France* 67(1907):68–71.

Meyerowitz, Jan. *Arnold Schönberg*. Berlin: Colloquium, 1967.

Miesel, Victor H. "Paul Cassirer's *Kriegszeit* and *Bildermann* and Some German Expressionist Reactions to World War I." *Michigan Germanic Studies* 2 (Fall 1976):149–68.

Morel, Benedict Auguste. *Traité des dégénérescences physiques, intellectuelles et morales de l'espèce humaine*. Paris and New York: Bailliére, 1857.

Morgenthaler, Walter. *Ein Geisteskranker als Künstler*. Bern: E. Bircher, 1912.

Mosse, George L. *The Crisis of German Ideology: Intellectual Origins of the Third Reich*. New York: Schocken, 1981.

_____. *Germans and Jews: The Right, the Left, and the Search for a "Third Force" in Pre-Nazi Germany*. New York: Fertig, 1970.

_____. *Nazi Culture: Intellectual, Cultural and Social Life in the Third Reich*. Tr. Salvator Attanasio et al. New York: Grosset & Dunlap, 1966.

New Larousse Encyclopedia of Mythology. London: Prometheus, 1972.

Nietzsche, Friedrich. "The Anti-Christ" [1895]. *Twilight of the Idols and The Anti-Christ*. Tr. R. J. Hollingdale. Harmondsworth: Penguin, 1978.

_____. *Beyond Good and Evil*. Tr. Walter Kaufmann. New York: Vintage Book, 1966.

_____. *The Birth of Tragedy and The Case of Wagner* [1888]. Tr. Walter Kaufmann. New York: Vintage Book, 1967.

_____. *The Gay Science* [1882]. Tr. Walter Kaufmann. New York: Vintage Book, 1974.

_____. *Human All-too-Human* [1878]. vol. 1, 24. Tr. Helen Zimmern. New York: Macmillan, 1909.

_____. *On the Genealogy of Morals and Ecce Homo* [1887]. Tr. Walter Kaufmann and R. J. Hollingdale. New York: Vintage Book, 1969.

_____. *Thus Spoke Zarathustra: A Book for All and None* [1883–85]. Tr. Walter Kaufmann. Harmondsworth: Penguin, 1978.

_____. *The Will to Power* [1901]. Tr. Walter Kaufmann. New York: Vintage Book, 1966.

_____. *The Will to Power* [1901]. Tr. Walter Kaufmann and R. J. Hollingdale. New York: Vintage Book, 1968.

Nordau, Max. *Degeneration* [1892–93]. New York: Fertig, 1968.

Orde, Anne. "German Society and Politics, 1900–1933." *Germany in Ferment*. Durham, England: Durham University, 1970.

Otto, Christian F. "Modern Environment and Historical Continuity: The Heimatschutz Discourse in Germany." *Art Journal* 43(1983): 148–57.

Otto, Rudolf. *The Idea of the Holy: An Inquiry into the Non-Rational Factor in the Idea of the Divine and its Relation to the Rational* [1917]. Tr. John W. Harvey. London: Oxford University Press, 1977.

Panizza, Oskar. *Das Liebeskonzil: Ein Himmels-Tragödie in fünf Aufzügen*. Zurich: F. Schabelitz, 1895.

Paterson, R. W. K. *The Nihilistic Egoist Max Stirner*. London: Oxford University Press, 1971.

Petersen, Julius. *Die Sehnsucht nach dem dritten Reich in deutscher Sage und Dichtung*. Stuttgart: J. B. Metzler, 1934.

Poggioli, Renato. *The Theory of the Avant-Garde* [1962]. Tr. Gerald Fitzgerald. Cambridge: Harvard University Press, 1968.

Pois, Robert, ed. *Race and Race History, and Other Essays by Alfred Rosenberg*. New York: Harper & Row, 1970.

Prinzhorn, Hans. *Artistry of the Mentally Ill*. Tr. James L. Foy. New York: Springer-Verlag, 1972.

Przybyszewski, Stanislaus. *Zur Psychologie des Individuums: Chopin und Nietzsche*. Berlin: Fontane, 1892.

Raabe, Paul, ed. *The Era of German Expressionism*. Tr. J. M. Ritchie. Woodstock: Overlook Press, 1974.

———, ed. *Expressionismus: Der Kampf um eine literarische Bewegung*. Munich: Deutscher Taschenbuchverlag, 1965.

———. *Die Zeitschriften und Sammlungen des literarischen Expressionismus*. Stuttgart: J. B. Metzler, 1964.

Raabe, Paul, and H. L. Greve, eds. *Expressionismus: Literatur und Kunst, 1910–1923*. Marbach: Schiller Nationalmuseum, 1960.

Rahv, Philip. "Twilight of the Thirties." *Partisan Review* 50(1983): 3;6(Winter 1939):103;6(Summer 1939):5.

Reinharz, Jehuda. *Fatherland or Promised Land: The Dilemma of the German Jew, 1893–1914*. Ann Arbor: University of Michigan Press, 1975.

Rhodes, Anthony. *Propaganda*. New York: Chelsea House, 1976.

Richard, Lionel. *Phaidon Encyclopedia of Expressionism*. Tr. Stephen Tint. Oxford: Phaidon Press, 1978.

Richardson, John Adkins. *Modern Art and Scientific Thought*. Urbana: University of Illinois Press, 1971.

Richter, Jean Paul Friedrich. *Titan: A Romance* [1800, 1803]. Tr. Charles Timothy Brooks. 2 vols. Boston: Ticknor & Fields, 1863.

Riesman, David. *Individualism Reconsidered*. Glencoe: Free Press, 1954.

Rigby, Ida Katherine. *An alle Künstler!: War—Revolution—Weimar*. San Diego: San Diego State University Press, 1983.

Rilke, Rainer Maria. "Requiem für eine Freundin." *Sämtliche Werke*, vol. 1, 645–56. Wiesbaden: Insel, 1955.

Rothe, Wolfgang, ed. *Der Aktivismus, 1915–1920*. Munich: Deutscher Taschenbuchverlag, 1969.

Ryder, A. J. *Twentieth-Century Germany: From Bismarck to Brandt*. New York: Columbia University Press, 1973.

Sadler, Michael. *Modern Art and Revolution*. London: L. & V. Woolf, 1932.

Samuel, Richard, and R. Hinton Thomas. *Expressionism in German Life, Literature and the Theatre (1910–1924)*. Cambridge: H. Heffer, 1939.

Scheffauer, Herman George. *The New Vision in the German Arts* [1924]. Port Washington, N.Y.: Kennikat Press, 1971.

Scheffler, Karl. *Der Geist der Gotik*. Leipzig: Insel, 1917.

Schickele, René. *Der neunte November*. Berlin: E. Reiss, 1919.

Schlaf, Johannes. *Das dritte Reich: Ein Berliner Roman* [1900]. Berlin: E. Fleischel, 1903.

———. *Walt Whitman Homosexueller? Kritische Revision einer Whitman-Abhandlung von Eduard Bertz*. Minden: J. C. Bruns, 1906.

Schmitt, Hans-Jürgen. *Die Expressionismusdebatte: Materialien zu einer marxistischen Realismuskonzeption*. Frankfurt: Suhrkamp, 1973.

Schnitzler, Arthur. *Reigen: zehn Dialoge geschrieben Winter 1896–97*. 15th ed. Vienna: Wiener, 1903.

Schopenhauer, Arthur. *The World as Will and Representation* [1819]. Tr. E. F. Payne. 2 vols. New York: Dover, 1966.

Schorske, Carl E. *Fin-de-siècle Vienna: Politics and Culture*. New York: Knopf, 1980.

Schreber, Daniel Paul. *Memoirs of My Nervous Illness* [1903]. Tr. Ida Macalpine and Richard A. Hunter. London: Dawson, 1955.

Schuré, Édouard. *The Genesis of Tragedy and The Sacred Drama of Eleusis*. Tr. Fred Rothwell. New York: Anthroposophic, 1936.

———. *The Great Initiates: A Study of the Secret History of Religions*. Tr. Gloria Rasberry. Blauvelt, N.Y.: Steinerbooks, 1977.

Schwarz, Hans, ed. *Das Recht der jungen Völker: Sammlung politischer Aufsätze*. Berlin: Der nahe Osten, 1932.

Shapiro, Theda. *Painters and Politics: The European Avant-Garde and Society, 1900–1925*. New York, Oxford, Amsterdam: Elsevier Scientific Publishing, 1976.

Shaw, George Bernard. *The Sanity of Art: An Exposure of the Current Nonsense about Artists being Degenerate* [1895]. London: New Age Press, 1908.

Simmel, Georg. *The Sociology of Georg Simmel*. Ed. Kurt H. Wolff. Glencoe: Free Press, 1950.

Sington, Derrick, and Arthur Weidenfeld. *The Goebbels Experiment*. New Haven: Yale University Press, 1943.

Slonimsky, Nicholas. *Music Since 1900*. 4th ed. New York: Scribner, 1971.

Sokel, Walter H., ed. *Anthology of German Expressionist Drama: A Prelude to the Absurd*. Garden City: Anchor, 1963.

———. *The Writer in Extremis: Expressionism in Twentieth-Century German Literature*. Stanford: Stanford University Press, 1959.

Spector, Jack J. *The Aesthetics of Freud: A Study in Psychoanalysis and Art*. New York: McGraw-Hill, 1974.

Spencer, Herbert. *First Principles* [1875]. 6th ed. New York: Appleton Davies, 1901.

Spengler, Oswald. *The Decline of the West* [1918, 1922]. Tr. Charles Francis Atkinson. Vol. 1. London: Allen & Unwin, 1971.

Steiner, Rudolf. *Friedrich Nietzsche: Ein Kämpfer gegen seine Zeit*. Weimar: E. Felber, 1895.

———. *Haeckel, die Welträtsel, und die Theosophie* [ca. 1902?]. Dornach: Anthroposophischer, 1926.

———. *Theosophy: An Introduction to The Supersensible Knowledge of the World and the Destination of Man* [1904]. New York: Anthroposophic, 1971.

Stern, Fritz. *The Politics of Cultural Despair: A Study in the Rise of the Germanic Ideology* [1961]. Berkeley: University of California Press, 1974.

Stirner, Max. *The Ego and His Own* [1845]. Ed. John Carroll. London: Cape, 1971.

Strindberg, August. *The Father: A Tragedy in Three Acts*. Tr. Valborg Anderson. New York: Appleton-Century-Crofts, 1964.

———. *A Madman's Manifesto*. Tr. Anthony Swerling. University, Ala.: University of Alabama Press, 1971.

Tierney, B., D. Kagan, and L. P. Williams. *Social Darwinism: Law of Nature or Justification of Repression?* New York: Random House, 1970.

Toller, Ernst. *Die Wandlung: das Ringen eines Menschen.* Potsdam: G. Kiepenhauer, 1919.

_____. *Man and the Masses.* Tr. Louis Untermeyer. Garden City: Doubleday, 1924.

Tönnies, Ferdinand. *Community and Society.* East Lansing: Michigan State University Press, 1957.

Uthmann, Jörg von. *Doppelgänger, du bleicher Geselle: Zur Pathologie des deutschjüdischen Verhältnisses.* Stuttgart: Seewald, 1976.

Viviani, Annaliese. *Das Drama des Expressionismus.* Munich: Winkler, 1970.

Wagner, Richard. *Parsifal: Music Drama in Three Acts.* Tr. Stewart Robb. New York: Schirmer Books, 1962.

_____. *Tristan and Isolde: Opera in Three Acts.* Tr. Stewart Robb. New York: Schirmer Books, 1965.

Weininger, Otto. *Sex and Character* [1903]. London: Heinemann, 1906.

Westheim, Paul. "Der Fetisch." *Künstlerbekenntnisse.* Berlin: Ullstein, 1925.

Whitford, Frank. "Radical Art and Radical Politics." *Germany in Ferment.* Durham, England: Durham University, 1970.

Whitman, Walt. *Grashalme.* Tr. Johannes Schlaf. Leipzig: P. Reclam jun., 1907.

_____. *Leaves of Grass* [1855]. Facsimile ed. Portland, Maine: T. B. Mosher & W. F. Gable, 1942.

Whitrow, G. J. "Albert Einstein." *Encyclopedia of Philosophy,* vol. 2, 468–71. Ed. Paul Edwards. New York: Macmillan, 1967.

Wietek, Gerhard, ed. *Deutsche Künstlerkolonien und Künstlerorten.* Munich: K. Thiemig, 1976.

Wilhelm, Richard, and C. G. Jung. *The Secret of the Golden Flower: A Chinese Book of Life.* Tr. Cary Baynes. New York: Harcourt, Brace, 1962.

Willett, John. *Art and Politics in the Weimar Period: The New Sobriety, 1917–1933.* New York: Pantheon, 1978.

Wohl, Robert. *The Generation of 1914.* Cambridge: Harvard University Press, 1979.

ART AND ARTISTS

Alloway, Lawrence, and Mary Davis MacNaughton. *Adolph Gottlieb: A Retrospective.* New York: Arts Publisher, 1981.

Apollinaire, Guillaume. "Realité, peinture pure." *Der Sturm* 3, no. 138/139 (1912):224–25.

Argan, Giulio Carlo, ed. *Propyläen Kunstgeschichte XII: Die Kunst des 20. Jahrhunderts, 1880–1940.* Berlin: Propyläen, 1977.

L'Art en Europe autour de 1918. Exh. cat. Strasbourg: À la ancienne Douane, 1968.

The Art of Wilhelm Lehmbruck. Exh. cat. Washington: National Gallery of Art, 1972.

Ashton, Dore. *The New York School: A Cultural Reckoning.* New York: Viking, 1973.

Bahr, Hermann. *Expressionism* [1916]. Tr. R. T. Gribble. London: Frank Henderson, 1925.

_____. *Expressionismus.* Munich: Delphin, 1916.

Ball, Hugo. *Flight Out of Time: A Dada Diary.* Ed. John Elderfield. New York: Viking, 1974.

Barr, Alfred H., Jr. *Matisse: His Art and His Public.* New York: Museum of Modern Art, 1951.

_____. *Picasso: Fifty Years of His Art.* New York: Museum of Modern Art, 1946.

Baur, John I. H. *Revolution and Tradition in Modern Art.* Cambridge: Harvard University Press, 1951.

Bayer, Herbert, Walter Gropius, and Ise Gropius, eds. *Bauhaus, 1919–1928.* New York: Museum of Modern Art, 1938.

Beckmann, Mathilde Q. *Mein Leben mit Max Beckmann.* Tr. Doris Schmidt. Munich: R. Piper, 1983.

Beckmann, Max. *Briefe im Kriege.* Berlin: P. Cassirer, 1916.

_____. *Ebbi: Komödie.* Vienna: Johannes, 1924.

_____. *Das Hotel.* Typescript. Ca. 1920–24.

_____. *Schöpferische Konfession.* Ed. Kasimir Edschmid. Berlin: E. Reiss, 1920.

Beckmann, Peter. *Max Beckmann: Leben und Werk.* Stuttgart and Zurich: Belser, 1982.

Behne, Adolf. *Die Wiederkehr der Kunst.* Leipzig: K. Wolff, 1919.

Bemalte Postkarten und Briefe deutscher Künstler. Exh. cat. Hamburg: Altonaer Museum, 1962.

Berend-Corinth, Charlotte. *Die Gemälde von Lovis Corinth: Werkkatalog.* Munich: F. Brückmann, 1958.

Beuys, Joseph. *The Secret Block for a Secret Person in Ireland.* Oxford: Museum of Modern Art, 1974.

Blesh, Rudi. *Modern Art USA: Men, Rebellion, Conquest, 1900–1956.* New York: Knopf, 1956.

Bletter, Rosemarie Haag. "Expressionism and the New Objectivity." *Art Journal* 43(1983):108–20.

_____. *Bruno Taut and Paul Scheerbart's Vision: Utopian Aspects of German Expressionist Architecture.* Ph.D. diss., Columbia University, 1973.

David Bomberg, 1890–1957. Exh. cat. London: Tate Gallery, 1967.

Börsch-Supan, Helmut, and Karl Wilhelm Jähnig. *Caspar David Friedrich.* Munich: Prestel, 1973.

Bowlt, John E. "Pavel Filonov: An Alternate Tradition." *Art Journal* 34(1975):208–16.

_____., ed. *Russian Art of the Avant-Garde: Theory and Criticism, 1902–1934.* New York: Viking, 1976.

Breton, André. "Prestige d'André Masson." *Minotaure,* no. 12–13(1939):13.

Breunig, LeRoy C., ed. *Apollinaire on Art.* New York: Viking, 1972.

Brinkmann, Richard. *Expressionismus: Internationale Forschung zu einem internationalen Phänomen.* Stuttgart: J. B. Metzler, 1980.

Brisch, Klaus. *Wassily Kandinsky (1866–1944): Untersuchung zur*

Entstehung der gegenstandslosen Malerei an seinem Werk von 1900–1921. Ph.D. diss., Bonn, 1955.

Buchheim, Lothar-Günther. *Die Künstlergemeinschaft Brücke.* Feldafing: Buchheim, 1956.

Buenger, Barbara C. "Beckmann's Beginnings: 'Junge Männer am Meer.'" *Pantheon* 41(1983):134–44.

Burger, Fritz. *Cézanne und Hodler: Einführung in die Probleme der Malerei der Gegenwart.* Munich: Delphin, 1913.

Burgess, Gelett. "The Wild Men of Paris." *The Architectural Record* 29(May 1910):400–14.

Busch, Günter. *Max Beckmann.* Munich: R. Piper, 1960.

Caldwell, John. "Anselm Kiefer's 'Dem unbekannten Maler.'" *Carnegie Magazine* 57(Jan.–Feb. 1984):4–7.

Chaumeil, Louis. *Van Dongen: L'Homme et l'artiste; La Vie et l'oeuvre.* Geneva: P. Cailler, 1967.

Cheney, Sheldon. *Expressionism in Art.* New York: Liveright, 1934.

Chipp, Herschel B. *Theories of Modern Art.* Berkeley: University of California Press, 1968.

Clutton-Brock, A. "The Post-Impressionists." *The Burlington Magazine* 18(1911):216–19.

Coates, Robert M. "Abroad and at Home." *The New Yorker* 22(30 March 1946):83.

———. "Soutine, Kokoschka, Quirt and O'Keeffe." *The New Yorker* 19(10 April 1943):40.

Cohn-Wiener, Ernst. *Die Jüdische Kunst.* Berlin: M. Wasservogel, 1929.

Comini, Alessandra. *Egon Schiele.* New York: Braziller, 1976.

———. *Egon Schiele's Portraits.* Berkeley: University of California Press, 1974.

———. *Schiele in Prison.* Greenwich: New York Graphic Society, 1973.

Conrad, Michael George. "Volk und Kunst." *Kriegs-Bilderbogen Münchner Künstler* (September 1914):2.

Conrad Felixmüller: Werke und Dokumente. Exh. cat. Nuremberg: Germanisches Nationalmuseum, 1981–82.

Conrads, Ulrich, and Hans G. Sperlich. *The Architecture of Fantasy: Utopian Building and Planning in Modern Times.* Tr. C. C. Collins and G. R. Collins. New York: Praeger, 1962.

Conzelmann, Otto. "Le Cas Otto Dix." *Dix.* Exh. cat. Paris: Musée d'Art Moderne, 1972.

Cooper, Douglas. *The Cubist Epoch.* London: Phaidon Press, 1970.

Cowart, Jack. *Expressions: New Art from Germany.* St. Louis: St. Louis Art Museum, 1983.

Le Cubisme à Prague et la Collection Kramář. Exh. cat. Rotterdam: Museum Boymans-van Beuningen, 1968.

Daviau, Donald G. "Hermann Bahr and the Secessionist Art Movement in Vienna." *The Turn of the Century; German Literature and Art, 1890–1915.* Ed. Gerald Chapple and Hans H. Schulte. Bonn: Bouvier, 1981.

Decade 1910–1920. Exh. cat. ed. Alan Bowness. Leeds: City Art Gallery, 1965.

Deutsche, Rosalyn. "Alienation in Berlin: Kirchner's Street Scenes." *Art in America* 71(January 1983):65–72.

Dorival, Bernard. "Sources for the Art of Gauguin from Java, Egypt and Ancient Greece." *Burlington Magazine* 93(1951):118–23.

Dube, Annemarie and Wolf-Dieter. *E. L. Kirchner: Das graphische Werk.* 2 vols. Munich: Prestel, 1967.

Dube, Wolf-Dieter. "The Artists Group 'Die Brücke.'" *Expressionism: A German Intuition.* Exh. cat. New York: Solomon R. Guggenheim Museum, 1980.

Dube-Heynig, Annemarie. *E. L. Kirchner: Graphik.* Munich: Prestel, 1961.

Duckers, Alexander. *George Grosz: Das druckgraphische Werk.* Frankfurt: Propyläen, 1979.

Dumont-Wilden, Louis. *Fernand Khnopff.* Brussels: G. van Oest, 1907.

Duncan, Carol. "Virility and Domination in Early 20th-Century Vanguard Painting." *Artforum* 12(December 1973):30–39.

Eddy, Arthur J. *Cubists and Post-Impressionists.* Chicago: A. C. McClurg, 1914.

Edschmid, Kasimir, ed. *Schöpferische Konfession.* Berlin: E. Reiss, 1920.

Edvard Munch: Symbols and Images. Exh. cat. Washington: National Gallery of Art, 1978.

Eichner, Johannes. *Kandinsky und Gabriele Münter: Von Ursprüngen moderner Kunst.* Munich: F. Brückmann, 1957.

Einstein, Carl. *Negerplastik* Leipzig: Verlag der Weissen Bücher, 1915.

Elsen, Albert E. *Rodin.* Exh. cat. New York: Museum of Modern Art, 1963.

Embick, Lucy McCormick. *The Expressionist Current in New York's Avant-Garde: The Paintings of The Ten.* Ann Arbor: University Microfilms International, 1982.

Endell, August. "Formenschönheit und dekorative Kunst." *Dekorative Kunst* (November 1897):75–77.

Ernst Ludwig Kirchner: Zeichnungen, 1906–1925. Exh. cat. Kassel: Staatliche Kunstsammlungen, 1967.

Ernst Ludwig Kirchner, 1880–1938. Exh. cat. Berlin: Nationalgalerie, 1979–80.

Die erste Ausstellung der Redaktion: Der blaue Reiter. Pamphlet. Munich: Moderne Galerie Thannhauser, 1911–12.

"Expressionism." *A New English Dictionary on Historical Principles.* Vol. 3, part 2. Oxford: Clarendon Press, 1897.

Expressionism: A German Intuition, 1905–1920. Exh. cat. New York: Solomon R. Guggenheim Museum, 1980.

L'Expressionnisme européen. Exh. cat. Paris: Musée National d'Art Moderne, 1970.

Faille, J. B. de la. *L'Oeuvre de Vincent van Gogh: Catalogue raisonné.* 4 vols. Paris and Brussels: G. van Oest, 1928.

———. *The Works of Vincent van Gogh: His Paintings and Drawings.* London: Weidenfeld & Nicholson, 1970.

Faust, Wolfgang Max, and Gerd de Vries. *Hunger nach Bildern: Deut-*

sche Malerei der Gegenwart. Cologne: M. DuMont Schauberg, 1982.

Fechter, Paul. Der Expressionismus. Munich: R. Piper, 1914.

Fehr, Hans. Emil Nolde: Ein Buch der Freundschaft. Cologne: M. DuMont Schauberg, 1957.

Fischer, Friedhelm W. Max Beckmann: Symbol und Weltbild— Grundriss zu einer Deutung des Gesamtwerkes. Munich: W. Fink, 1972.

Franciscono, Marcel. Walter Gropius and the Creation of the Bauhaus in Weimar: The Ideals and Artistic Theories of its Founding Years. Urbana: University of Illinois Press, 1971.

_____. "The Imagery of Max Beckmann's 'The Night.'" Art Journal 33(1973):18–22.

Franz Marc, 1880–1916. Exh. cat. Munich: Städtische Galerie im Lenbachhaus, 1980.

Führer durch das Museum für Völkerkunde. Museum guide. Berlin: George Reimer, 1911.

Gabler, Karlheinz, ed. E. L. Kirchner: Dokumente. Aschaffenburg: Museum der Stadt, 1980.

_____. "E. L. Kirchners Doppelrelief: Tanz zwischen den Frauen— Alpaufzug." Brücke Archiv, no. 11(1979–80):3–12.

Gallwitz, Klaus. Max Beckmann: Die Druckgraphik—Radierungen, Holzschnitte, Lithographien. Karlsruhe: Badischer Kunstverein, 1962.

Geelhaar, Christian. "Julian Schnabel's 'Head (for Albert).'" Arts Magazine 57(October 1982):74–75.

Genauer, Emily. Best of Art. New York: Doubleday, 1948.

Gercken, Günther. Ernst Ludwig Kirchner Holzschnittzyklen: Peter Schlemihl, Triumph der Liebe, Absalom. Stuttgart: Belser, 1980.

German Expressionism: Die Brücke. Exh. cat. Charlottesville: University of Virginia Art Museum, 1978.

Golding, John. Cubism: A History and Analysis, 1907–1914 [1959]. Rev. ed. Boston: Boston Art and Book Shop, 1968.

Goldwater, Robert. Symbolism. New York: Harper & Row, 1979.

Gollek, Rosel. Der Blaue Reiter im Lenbachhaus München. Munich: Prestel, 1974.

Gombrich, E. H. "André Malraux and the Crisis of Expressionism." Meditations on a Hobby Horse. London: Phaidon Press, 1963.

Göpel, Erhard, and Barbara Göpel. Max Beckmann: Katalog der Gemälde. 2 vols. Bern: Kornfeld & Cie, 1976.

Gordon, Donald E. "Content by Contradiction." Art in America 70(December 1982):76–89.

_____. "Expressionism and its Publics." Beiträge zur Rezeption der Kunst des 19. und 20. Jahrhunderts: Ludwig Grote gewidmet. Ed. Wulf Schadendorf. Munich: Prestel, 1975.

_____. "Expressionism: Art by Antithesis." Art in America 69(March 1981):98–111.

_____. Ernst Ludwig Kirchner. Cambridge: Harvard University Press, 1968.

_____. "Ernst Ludwig Kirchner: By Instinct Possessed." Art in America 68(November 1980):80–95.

_____. "Kirchner in Dresden." The Art Bulletin 48(1966):335–66.

_____. "Marc and Friedrich Again: Expressionism as Departure from Romanticism." Source: Notes in the History of Art 1(Fall 1981): 29–32.

_____. Modern Art Exhibitions, 1900–1916: Selected Catalogue Documentation. 2 vols. Munich: Prestel, 1974.

_____. "On the Origin of the Word 'Expressionism.'" Journal of the Warburg and Courtauld Institutes 29(1966):368–85.

_____. "Oskar Kokoschka and the Visionary Tradition." The Turn of the Century: German Literature and Art, 1890–1915. Ed. Gerald Chapple and Hans H. Schulte. Bonn: Bouvier, 1981.

_____. "Pollack's 'Bird,' or How Jung did not Offer Much Help in Myth-Making." Art in America 68(October 1980):43–53.

Graham, John D. "Primitive Art and Picasso." Magazine of Art 30(1937):236–39.

_____. System and Dialectics of Art. New York: Delphic Studios, 1937.

Gray, Christopher. Cubist Aesthetic Theories. Baltimore, Johns Hopkins University Press, 1953.

Greenberg, Clement. "'American-Type' Painting" [1955]. Art and Culture: Critical Essays. Boston: Beacon Press, 1961.

_____. "Avante-Garde and Kitsch." Partisan Review 6(Fall 1939): 35–36.

_____. "Towards a Newer Laocoön." Partisan Review 7(1940):296–310.

_____. "To Cope with Decadence." Arts Magazine 56(February 1982):120–21.

_____. "The Present Prospects of American Painting and Sculpture." Horizon 16(October 1947):20–30.

Griffiths, John. The Paintings of the Buddhist Cave-Temples of Ajanta, Kandesh, India. 2 vols. London: n. p., 1896–97.

Grisebach, Lothar. E. L. Kirchners Davoser Tagebuch. Cologne: M. DuMont Schauberg, 1968.

Grochowiak, Thomas. Ludwig Meidner. Recklinghausen: A. Bongers, 1966.

Grohmann, Will. Karl Schmidt-Rottluff. Stuttgart: W. Kohlhammer, 1956.

_____. Wassily Kandinsky: Life and Work. New York: Abrams, 1958.

Grosz, George. Das Gesicht der herrschenden Klasse: 55 politische Zeichnungen von George Grosz. Berlin: Malik, 1921.

_____. A Little Yes and a Big No. Tr. Lola Sachs Dorin. New York: Dial, 1946.

_____. Briefe, 1913–1959. Ed. Herbert Knust. Reinbek bei Hamburg: Rowohlt, 1979.

Grosz, George, and Wieland Herzfelde. Die Kunst ist in Gefahr. Berlin: Malik, 1925.

Güse, Ernst-Gerhard. Die zweite Ausstellung der Redaktion: Der blaue Reiter, Schwarz-weiss. Munich: H. Goltz Kunsthandlung, 1912.

_____. *Das Frühwerk Max Beckmanns: Zur Thematik seiner Bilder aus den Jahren, 1904–1914*. Frankfurt: P. Lang; Bern: H. Lang, 1977.

Gustav Klimt and Egon Schiele. Exh. cat. New York: Solomon R. Guggenheim Museum, 1965.

Hablik, Wenzel. "Schaffende Kräfte." *Dritte Ausstellung: Graphik*. Exh. cat. Berlin: Der Sturm, 1912.

Haesaerts, Paul. *James Ensor*. New York: Abrams, 1959.

Haftmann, Werner. *Painting in the Twentieth Century* [1955]. Tr. Ralph Manheim. 2 vols. New York; Praeger, 1967.

Hahl-Koch, Jelena. *Marianne Werefkin und der russische Symbolismus: Studien zur Aesthetik und Kunsttheorie*. Munich: O. Sagner, 1967.

Halasz, Piri. "Art Criticism (and Art History) in New York: The 1940s vs. the 1980s: Part One: the Newspapers." *Arts Magazine* 57(February 1983):91–97, and "Part Two: The Magazines." *Arts Magazine* 57(March 1983):64–73.

_____. *Directions, Concerns and Critical Percepetions of Paintings Exhibited in New York, 1940–1949: Abraham Rattner and His Contemporaries*. Ph.D. diss., Columbia University, 1982.

Halley, Peter. "A Note on the 'New Expressionism' Phenomenon." *Arts Magazine* 57(March 1983):88–89.

Hartlaub, Gustav F. *Die Graphik des Expressionismus in Deutschland*. Stuttgart: C. Hatje, 1947.

Heller, Reinhold. *Edvard Munch: The Scream*. New York: Viking, 1973.

_____. "Edvard Munch's 'Night,' the Aesthetics of Decadence, and the Content of Biography." *Arts Magazine* 53(October 1978):80–105.

_____. "Edvard Munch's 'Vision' and the Symbolist Swan." *The Art Quarterly* 36(1973):209–49.

_____. "Kandinsky and Traditions Apocalyptic." *Art Journal* 43(1983):19–26.

Herbert, Robert L., ed. *Modern Artists on Art: Ten Unabridged Essays*. Englewood Cliffs: Prentice-Hall, 1964.

Hess, Hans. *George Grosz*. New York: Macmillan, 1974.

_____. *Lyonel Feininger*. New York: Abrams, 1961.

Hess, Thomas B. *Willem de Kooning*. Exh. cat. New York: Museum of Modern Art, 1968.

Heym, George. *Umbra vitae: Nachgelassene Gedichte, mit 47 Original-Holzschnitten von Ernst Ludwig Kirchner*. Munich: K. Wolff, 1924.

Hind, C. Lewis. *The Post-Impressionists*. London: Methuen, 1911.

Hinz, Berthold. *Art in the Third Reich*. Tr. Robert and Rita Kimber. New York: Pantheon, 1979.

Hinz, Renate, ed. *Käthe Kollwitz: Graphics, Posters, Drawings*. Tr. Rita and Robert Kimber. New York: Pantheon, 1981.

Hirsh, Sharon L. *Ferdinand Hodler*. Munich: Prestel, 1981.

Hobbs, Robert Carleton, and Gail Levin. *Abstract Expressionism: The Formative Years*. Ithaca: Cornell University Press, 1978.

Hoffmann, Edith. *Kokoschka: Life and Work*. London: Faber & Faber, 1947.

The Human Image in German Expressionist Graphic Art from the Robert Gore Rifkind Foundation. Exh. cat. Berkeley: University Art Museum, 1981.

Immendorff, Jörg. *LIDL, 1966–1970*. Eindhoven: Van Abbemuseum, 1981.

Internationale Kunstausstellung des Sonderbundes Westdeutscher Kunstfreunde und Künstler zu Köln. Exh. cat. n. p., 1912.

Jack Levine. Exh. cat. Boston: Institute of Contemporary Art, 1955.

Jean Dubuffet: A Retrospective. Exh. cat. New York: Solomon R. Guggenheim Museum, 1973.

Johnson, Ron. "The 'Demoiselles d'Avignon' and Dionysian Destruction." *Arts Magazine* 55(October 1980):94–101.

Jordan, Jim. *Paul Klee and Cubism*. Princeton: Princeton University Press, 1983.

Julian Schnabel. Exh. cat. Amsterdam: Stedelijk Museum, 1982.

Junghanns, Kurt. *Bruno Taut, 1880–1938*. Berlin: Henschel, 1970.

Kahnweiler, Daniel-Henry. *Juan Gris: His Life and Work*. Tr. Douglas Cooper. New York: Curt Valentin, 1947.

Kainen, Jacob. "Our Expressionists." *Art Front* 3(February 1937):14–15.

Kaiser, Fritz, ed. *Führer durch die Ausstellung entartete Kunst*. Berlin: Verlag für Kultur- und Wirtschaftswerbung, 1937.

Kaiser, Hans. *Max Beckmann*. Berlin: P. Cassirer, 1913.

Kallir, Jane. *Austria's Expressionism*. New York: Galerie St. Etienne & Rizzoli International, 1981.

Kallir, Otto. *Egon Schiele: Oeuvre-Katalog der Gemälde*. Vienna: P. Zsolnay, 1966.

_____. *Richard Gerstl (1883–1908): Beiträge zur Dokumentation seines Lebens und Werkes*. Vienna: Mitteilungen der Österreichischen Galerie, 1974.

Kandinsky, Wassily. *Concerning the Spiritual in Art* [1912]. Tr. Francis Golffing, Michael Harrison, and Ferdinand Ostertag. New York: Wittenborn, 1970.

Kandinsky, Wassily, and Franz Marc. *The Blue Rider Almanach* [1912]. Doc. ed. Klaus Lankheit. New York: Viking, 1974.

Kandinsky, Franz Marc, August Macke: Drawings and Watercolors. Exh. cat. New York: Hutton-Hutschnecker Gallery, 1969.

Karpfen, Fritz. *Das Egon Schiele Buch*. Vienna: Verlag der Wiener graphischen Werkstätte, 1921.

Katalog der Neuen Sezession Berlin. Exh. cat. Berlin: W. Baron, 1911.

Kessler, Charles S. *Max Beckmann's Triptychs*. Cambridge: Harvard University Press, 1970.

_____. "Sun Worship and Anxiety: Nature, Nakedness and Nihilism in German Expressionist Painting." *Magazine of Art* 45(1952):304–12.

Kirchner, E. L. *Briefe an Nele und Henry van de Velde*. Munich: R. Piper, 1961.

Klee, Felix, ed. *The Diaries of Paul Klee, 1898–1918*. Berkeley: University of California Press, 1964.

Klee, Paul. "Die Ausstellung des Modernen Bundes im Kunsthaus Zürich." *Die Alpen* 6, no. 12(1912):701.

Kliemann, Helga. *Die Novembergruppe.* Berlin: Mann, 1969.

Kokoschka, Oskar. "Edvard Munch's Expressionism." *College Art Journal* 12(1953):312–20.

———. *My Life.* Tr. David Britt. New York: Macmillan, 1974.

Kollwitz, Hans, ed. *The Diaries and Letters of Käthe Kollwitz.* Tr. Richard and Clara Winston. Chicago: Regnery, 1955.

Kootz, Samuel M. *New Frontiers in American Painting.* New York: Hastings, 1943.

Kozloff, Max. "The Dilemma of Expressionism." *Artforum* 3(November 1964):32–35.

Kramer, Hilton, ed. *The Turn of the Century.* New York: Arts Digest, 1957.

Krüger, Günter. "Die Jahreszeiten, ein Glasfensterzyklus von Max Pechstein." *Zeitschrift des Deutschen Vereins für Kunstwissenschaft* 19(1965):77–94.

Kubin, Alfred. *The Other Side: A Fantastic Novel.* Tr. Denver Lindley. London: Victor Gollancz, 1969.

Kubišta, Bohumil. "Henri Matisse." *Novina* (June 1910):464–67.

Kubler, George. *The Shape of Time.* New Haven: Yale University Press, 1962.

Künstler der Brücke in Berlin, 1908–19. Exh. cat. Berlin: Brücke-Museum, 1972.

Kuspit, Donald. "The New(?) Expressionism: Art as Damaged Goods." *Artforum* 20(November 1981):47–55.

Lackner, Stephen. *Max Beckmann.* New York: Abrams, 1977.

Lamač, Miroslav. *Modern Czech Painting, 1907–17.* Tr. Arnošt Jappel. Prague: Artia, 1967.

Landsberger, Franz. *Impressionismus und Expressionismus: Eine Einführung in das Wesen der neuen Kunst.* Leipzig: Klinkhardt & Biermann, 1919.

Lang, Lothar. *Expressionist Book Illustration in Germany, 1907–1927.* Tr. Janet Seligmann. Boston: New York Graphic Society, 1976.

Langbehn, Julius. *Rembrandt als Erzieher* [1890]. Leipzig: C. L. Hirschfeld, 1922.

Langui, Emile. *L'Expressionnisme en Belgique.* Brussels: Laconti, 1970.

Lankheit, Klaus. *Franz Marc: Katalog der Werke.* Cologne: M. DuMont Schauberg, 1970.

———. *Franz Marc: Sein Leben und seine Kunst.* Cologne: M. DuMont Schauberg, 1976.

Legrand, Francine-Claire. *L'Expressionnisme belge au Musée d'Art Moderne de Bruxelles.* Paris: Édition de la Revue Française, n. d.

Levine, Frederick S. *The Apocalyptic Vision: The Art of Franz Marc as German Expressionism.* New York: Harper & Row, 1979.

Lewis, Beth Irwin. *George Grosz: Art and Politics in the Weimar Republic.* Madison: University of Wisconsin Press, 1971.

Lewis, Ward B. "Walt Whitman: Johannes Schlaf's 'neuer Mensch.'" *Revue de littérature comparée* 47(1973):596–611.

Lidén, Elisabeth. *Expressionismen och Sverige: Expressionistika drag i svenskt måleri från 1910-talet till 40-talet.* Stockholm: Rabén & Sjögren, 1974.

Lindsay, Kenneth C., and Peter Vergo, eds. *Kandinsky: Complete Writings on Art.* Boston: G. K. Hall, 1982.

Löffler, Fritz. *Otto Dix: Oeuvre der Gemälde.* Recklinghausen: A. Bongers, 1981.

Long, Rose-Carol Washton. "Kandinsky and Abstraction: The Role of the Hidden Image." *Artforum* 10(June 1972):42–49.

———. *Kandinsky: The Development of an Abstract Style.* Oxford: Clarendon Press, 1980.

———. "Kandinsky's Vision of Utopia as a Garden of Love." *Art Journal* 43(1983):50–60.

Ludwig Meidner: An Expressionist Master. Exh. cat. Ann Arbor: University of Michigan Museum of Art, 1978.

Macke, August. *Die Rheinischen Expressionisten.* Recklinghausen: A. Bongers, 1980.

Macke, August and Franz Marc. *Briefwechsel.* Cologne: M. DuMont Schauberg, 1964.

Marc, Franz. "Deutsche und französische Kunst." *Schriften.* Ed. Klaus Lankheit. Cologne: M. DuMont Schauberg, 1978.

———. "Das geheime Europe" [1914]. *Schriften.* Ed. Klaus Lankheit. Cologne: M. DuMont Schauberg, 1978.

———. "Ideen über Ausstellungswesen." *Der Sturm* 3(June 1912):66.

Marinetti, F. T. "Tod dem Mondschein! Zweites Manifest des Futurismus." *Der Sturm* 2(May 1912):50.

"Mark Rothko." *Current Biography* 22(May 1961):42.

Martin, Marianne. *Futurist Art and Theory, 1909–1915.* Oxford: Clarendon Press, 1968.

Masson, André. "Indésirable expressionnisme?" *L'Arc* 25(1964):87–88.

Matějček, Antonin. *XXXI. Výstava: Les Indépendants.* Prague: Manes Society, 1910.

Mauner, George. "Amiet und Hodler." *Berner Kunstmitteilungen,* no. 188(April–May 1979):1–5.

McGreevy, Linda F. *The Life and Works of Otto Dix.* Ann Arbor: University of Michigan Press, 1981.

Meidner, Ludwig. *Eine Autobiographische Plauderei.* 2d ed. Leipzig: Klinkhardt & Biermann, 1923.

———. *Im Nacken das Sternemeer.* Leipzig: K. Wolff, 1918.

———. *Septemberschrei: Hymnen, Gebete, Lästerungen.* Berlin: P. Cassirer, 1920.

Meier-Graefe, Julius. *Entwicklungsgeschichte der modernen Kunst.* 3 vols. Stuttgart: J. Hoffmann, 1904.

Miesel, Victor H. "Edvard Munch's Expressionism." *College Art Journal* 12(1953):312–20; (Fall 1953):15–18.

———, ed. *Voices of German Expressionism.* Englewood Cliffs: Prentice-Hall, 1970.

Mitsch, Erwin. *The Art of Egon Schiele.* Tr. W. Keith Haughan. London: Phaidon Press, 1975.

Mochon, Anne. *Gabriele Münter: Between Munich and Murnau.* Cambridge: Busch-Reisinger Museum, Harvard University, 1980.

Modersohn-Becker, Paula. *The Letters and Journals of Paula Modersohn-Becker.* Tr. J. Diane Radycki. Metuchen: Scarecrow, 1980.

Molzahn, Johannes, Karl Hermann, and Jacoba van Heemskerck. "Das Manifest des absoluten Expressionismus." *Der Sturm* 10(September 1919):90–91.

Muller, Joseph Emile. *Fauvism.* New York: Praeger, 1967.

Myers, Bernard S. *Mexican Painting in Our Time.* New York: Oxford University Press, 1956.

Nash, J. M. "The Nature of Cubism: A Study of Conflicting Explanations." *Art History* 3(1980):435–47.

Nemeth, Lajos. *Modern Art in Hungary.* Tr. Lili Halapy and Elizabeth West. Budapest: Corvina, 1969.

Neue Künstlervereinigung München Exh. cat. Munich: Moderne Galerie, 1909.

A New Spirit in Painting. Exh. cat. London: Royal Academy of Arts, 1981.

1909 ars män: Jubileumsutställning. Exh. cat. Stockholm: Liljevalchs Konsthall, 1959.

Nolde, Emil. *Das eigene Leben: Die Zeit der Jugend, 1867–1902.* 3d ed. Cologne: M. DuMont Schauberg, 1967.

———. *Jahre der Kämpfe.* Berlin: Rembrandt, 1934.

Novotny, Fritz, and Johannes Dobai. *Gustav Klimt.* Salzburg: Galerie Welz, 1967.

Obrist, Hermann. *Neue Möglichkeiten in der bildenden Kunst.* Leipzig: E. Diederichs, 1903.

O'Connor, Francis Valentine, and Eugene Victor Thaw. *Jackson Pollock: A Catalogue Raisonné of Paintings, Drawings, and Other Works.* 4 vols. New Haven: Yale University Press, 1978.

Oppler, Ellen C. *Fauvism Reexamined* [1969]. New York: Garland Publishing, 1976.

Orton, Fred, and Griselda Pollock. "'Avant-Gardes' and Partisans Reviewed." *Art History* 4(1981):305–27.

Osten, Gert von der. *Lovis Corinth.* 2d ed. Munich: F. Brückmann, 1959.

Paintings and Drawings by Ernst Josephson. Exh. cat. Portland: Portland Art Museum, 1964.

Paret, Peter. *The Berlin Secession: Modernism and Its Enemies in Imperial Germany.* Cambridge: Harvard University Press, 1980.

Pechstein, Max. *Erinnerungen.* Ed. L. Reidemeister. Wiesbaden: Limes, 1960.

Pehnt, Wolfgang. *Expressionist Architecture.* Tr. J. A. Underwood and Edith Küstner. London: Thames & Hudson, 1973.

Perkins, Geoffrey. *Contemporary Theory of Expressionism.* Bern and Frankfurt: H. Lang, 1974.

Perry, Gillian. *Paula Modersohn-Becker: Her Life and Work.* New York: Harper & Row, 1979.

Pfister, Oskar. *Expressionism in Art: Its Psychological and Biological Basis* [1920]. Tr. B. Low and M. A. Muegge. New York: Dutton, 1923.

Pickar, Gertrud Bauer, and Karl Eugene Webb, eds. *Expressionism Reconsidered: Relationships and Affinities.* Munich: W. Fink, 1979.

Picard, Max. *Expressionistische Bauernmalerei.* Munich: Delphin, 1918.

Plessix, Francine du, and Cleve Gray. "Who Was Jackson Pollock?" *Art in America* 55(May–June 1967):51.

Pollock, Jackson. "My Painting." In Robert Motherwell and Harold Rosenberg, eds., *possibilities* 1(Winter 1947–48):78–83.

Przybyszewski, Stanislau. *Totenmesse.* Berlin: Fontane, 1893.

Raabe, Paul, ed. *Index Expressionismus: Bibliographie der Beiträge in den Zeitschriften und Jahrbüchern des literarischen Expressionismus, 1910–1925.* 18 vols. Nendeln, Liechtenstein: Kraus-Thomson, 1972.

Ratcliff, Carter. "A New Wave from Italy: Sandro Chia." *Interview* (June–July 1981):83–85.

Read, Herbert. *The Meaning of Art* [1931]. Baltimore: Penguin, 1967.

Reed, Alma, ed. *José Clemente Orozco.* New York: Delphic Studios, 1932.

Reidemeister, Leopold. *Künstler der Brücke: Gemälde der Dresdener Jahre.* Berlin: Brücke-Museum, 1973.

———. *Künstlergruppe Brücke: Fragment eines Stammbuches.* Berlin: Mann, 1975.

Reidemeister, Leopold, and Kurt Krieger. *Das Ursprüngliche und die Moderne.* Berlin: Akademie der Künste, 1964.

Reinhardt, Georg. "Im Angesicht des Spiegelbildes: Anmerkungen zu Selbstbildnis-Zeichnungen Ernst Ludwig Kirchners." *Brücke-Archiv,* no. 11 (1979–80):18–40.

———. "Die frühe 'Brücke': Beiträge zur Geschichte und zum Werk der Dresdener Künstlergruppe 'Brücke' der Jahre 1905 bis 1908." *Brücke-Archiv* no. 9/10 (1977–78).

Rewald, John. *The History of Impressionism.* New York: Museum of Modern Art, 1961.

Richter, Hans. *Dada: Art and Anti-Art.* New York: Oxford University Press, 1978.

· Rifkind, Robert Gore. "Wild Passion at Midnight: German Expressionist Art." *Art Journal* 39(1980):267.

Ringbom, Sixten. "Art in 'The Epoch of the Great Spiritual': Occult Elements in the Early Theory of Abstract Painting." *Journal of the Warburg and Courtauld Institutes* 29(1966):405.

———. *The Sounding Cosmos: A Study in the Spiritualism of Kandinsky and the Genesis of Abstract Painting.* Abo, Finland: Abo Akademi, 1970.

Roessler, Anton, ed. *Briefe und Prosa von Egon Schiele.* Vienna: R. Lanyi, 1921.

Roethel, Hans K., and Jean K. Benjamin. *Kandinsky: Catalogue Raisonné of the Oil Paintings. Vol. I: 1900–1915.* Ithaca: Cornell University Press, 1982.

Roh, Franz, *Nach-Expressionismus, magischer Realismus: Probleme der neuesten europäischen Malerei.* Leipzig: Klinkhardt & Biermann, 1925.

Rose, Barbara. *American Painting: The Eighties*. Exh. cat. New York: Grey Art Gallery, 1979.

Rosenberg, Harold. "Action Painting: Crisis and Distortion." *The Anxious Object: Art Today and its Audience*. New York: Horizon, 1966.

———. "The American Action Painters." *Art News* 51(December 1952):42–43, 48–50.

Rosenblum, Robert. *Modern Painting and the Northern Romantic Tradition: Friedrich to Rothko*. New York: Harper & Row, 1975.

Rosenthal, Mark. "The Nietzschean Character of Picasso's Early Development." *Arts Magazine* 55(October 1980):87–91.

Roters, Eberhard. "Beiträge zur Geschichte der Künstlergruppe 'Brücke' in den Jahren 1905–1907." *Jahrbuch der Berliner Museen* 2(1960):204–06.

———. *Europäische Expressionisten*. Gütersloh: Bertelsmann Kunstverlag, 1971.

———. "Wassily Kandinsky und die Gestalt des blauen Reiters." *Jahrbuch der Berliner Museen* 5(1963):201–26.

Rothenberg, Susan. "Expressionism Today: An Artists' Symposium." *Art in America* 70(December 1982):58–75.

Rothko, Mark. "The Romantics Were Prompted." *possibilities* 1(Winter 1947–48):84.

Rowland, Julia. *Kandinsky 1911: The Agitated Style*. M.A. thesis, University of Pittsburgh, 1979.

Rubin, William S. *Dada and Surrealist Art*. New York: Abrams, 1969.

———, and Carolyn Lanchner. *André Masson*. New York: Museum of Modern Art, 1976.

Rubin, William S. ed. *'Primitivism' in 20th Century Art*. Exh. cat. New York: Museum of Modern Art, 1984.

Rudenstine, Angelica Zander. *The Guggenheim Museum Collection: Paintings, 1881–1945*. Vol. 2. New York: Solomon R. Guggenheim Museum, 1976.

Sandler, Irving. *The Triumph of American Painting: A History of Abstract Expressionism*. New York: Harper & Row, 1976.

Santomasso, Eugene A. *Origins and Aims of Expressionist Architecture: An Essay into the Expressionist Frame of Mind in Germany, Especially as Typified in the Work of Rudolf Steiner*. Ph.D. diss., Columbia University, 1973.

Schapiro, Meyer. *Paul Cézanne*. New York: Abrams, 1952.

Schiefler, Gustav. *Das graphische Werk von Ernst Ludwig Kirchner, 1917–1927*. Berlin-Charlottenburg: Euphorion, 1931.

Schneede, Uwe M. *George Grosz: His Life and Work*. Tr. Susanne Flatauer. New York: University Books, 1979.

Schoenberg, Webern, Berg: Bilder, Partituren, Dokumente. Exh. cat. Vienna: Museum des 20. Jahrhunderts, 1969.

Schult, Friedrich. *Ernst Barlach: Das plastische Werk*. Hamburg: E. Hauswedell, 1960.

Secession: Europäische Kunst um die Jahrhundertwende. Exh. cat. Munich: Haus der Kunst, 1964.

Sedlmayr, Hans. *Art in Crisis: The Lost Center*. Chicago: Regnery, 1958.

Seiler, Harald. *Wilhelm Morgner*. Cologne: E. A. Seemann, 1956.

Seitz, William C. *Abstract-Expressionist Painting in America: An Interpretation based on the Work and Thought of Six Key Figures*. Ph.D. diss., Princeton University, 1956.

———. "The Rise and Dissolution of the Avant-Garde." *Vogue* 142(1 September 1963):182.

Selz, Peter. *German Expressionist Painting*. Berkeley: University of California Press, 1957.

———. *Max Beckmann*. New York: Museum of Modern Art, 1964.

———. *New Images of Man*. Exh. cat. New York: Museum of Modern Art, 1959.

Selz, Peter, and Mildred Constantine, eds. *Art Nouveau: Art Design at the Turn of the Century*. New York: Museum of Modern Art, 1960.

Sharp, Dennis, ed. *Glass Architecture by Paul Scheerbart and Alpine Architecture by Bruno Taut*. New York: Praeger, 1972.

Shirey, David L. "Don Quixote in Springs." *Newsweek* 70(20 November 1967):80.

Siegel, Jeanne. "Adolph Gottlieb: Two Views." *Arts Magazine* 42(February 1968):31.

Silver, Kenneth E. "Purism: Straightening up after the Great War." *Artforum* 15(March 1977):56–63.

Spalek, John M., et al. *German Expressionism in the Fine Arts: A Bibliography*. Los Angeles: Hennessey & Ingalls, 1977.

Stuckey, Charles F. "Bill de Kooning and Joe Christmas." *Art in America* 68(March 1980):67–78.

Stutzer, Beat. "Das Stammbuch 'Odi Profanum' der Künstlergruppe 'Brücke.'" *Zeitschrift des deutschen Vereins für Kunstwissenschaft* 36(1982):87–105.

Svenaeus, Gosta. *Edvard Munch: Im männlichen Gehirn*. 2 vols. Lund: Vetenskaps-Societeten, 1973.

Sydow, Eckart von. *Die deutsche expressionistische Kultur und Malerei*. Berlin: Furche, 1920.

———. *Die Kunst der Naturvölker und die Vorzeit*. Berlin: Propyläen, 1923.

Taut, Bruno. *Die Auflösung der Städte oder die Erde eine gute Wohnung, oder auch der Weg zur Alpinen Architektur*. Hagen: Folkwang, 1920.

This Fabulous Century: 1960–1970. Exh. cat. New York: Time-Life, 1975.

Traeger, Jörg, *Philipp Otto Runge und sein Werk*. Munich: Prestel, 1977.

Tuchman, Maurice. *Chaim Soutine, 1893–1943*. Exh. cat. Los Angeles: County Museum of Art, 1968.

XXII, Ausstellung der Berliner Secession. Exh. cat. Berlin: Ausstellungshaus, 1911.

Valintiner, Wilhelm R. "Expressionism and Abstract Painting." *Art Quarterly* 4(1941):210–39.

Van Gogh and Expressionism. Exh. cat. New York: Solomon R. Guggenheim Museum, 1964.

Vauxcelles, Louis. *Le Fauvisme* [1939]. Geneva: P. Cailler. 1958.

Vergo, Peter. *Art in Vienna, 1898–1918: Klimt, Kokoschka, Schiele and Their Contemporaries*. London: Phaidon Press, 1975.

Viennese Expressionism, 1910–1924. Exh. cat. Berkeley: University Art Gallery, 1963.

Vogt, Paul. *Erich Heckel.* Recklinghausen: A. Bongers, 1965.

_____. *Christian Rohlfs.* Cologne: M. DuMont Schauberg, 1967.

Vriesen, Gustav. *August Macke.* Stuttgart: W. Kohlhammer, 1953.

Vriesen, Gustav, and Max Imdahl. *Robert Delaunay: Light and Color.* New York: Abrams, 1969.

Walden, Nell, and Lothar Schreyer. *Der Sturm: Ein Erinnerungsbuch an Herwarth Walden.* Baden-Baden: W. Klein, 1954.

Waldman, Diane. *Italian Art Now: An American Perspective.* New York: Solomon R. Guggenheim Museum, 1982.

_____. *Mark Rothko, 1903–1970: A Retrospective.* New York: Solomon R. Guggenheim Museum, 1978.

Weiler, Clemens. *Alexei Jawlensky: Der Maler und Mensch.* Wiesbaden: Limes, 1955.

Weiss, Peg. *Kandinsky in Munich: The Formative Jugendstil Years.* Princeton: Princeton University Press, 1979.

Wem gehört die Welt: Kunst und Gesellschaft in der Weimarer Republik. Exh. cat. Berlin: Neue Gesellschaft für Bildende Kunst, 1977.

Werckmeister, O. K. "Klees 'kindliche' Kunst." *Versuche über Paul Klee.* Frankfurt: Syndikat, 1981.

Werenskiold, Merit. "Die Brücke und Edvard Munch." *Zeitschrift des deutschen Vereins für Kunstwissenschaft* 28(1974):140–52.

Wiedmann, August K. *Romantic Roots in Modern Art: Romanticism and Expressionism, A Study in Comparative Aesthetics.* Old Woking: Gresham, 1979.

Wiegand, Charmion von. "Expressionism and Social Change." *Art Front* 2(November 1936):10–13.

Welling, Dolf. *The Expressionists: The Art of Prewar Expressionism in the Netherlands.* Amsterdam: J. M. Meulenhoff, 1968.

Willett, John. *Expressionism.* New York: McGraw-Hill, 1970.

Wingler, Hans Maria. *Oskar Kokoschka: The Work of the Painter.* Salzburg: Galerie Welz, 1958.

Wolfe, Judith. "Jungian Aspects of Jackson Pollock's Imagery." *Artforum* 11(November 1972):65–73.

Wölfflin, Heinrich. *Kunstgeschichtliche Grundbegriffe.* Munich: F. Brückmann, 1915.

Worringer, Wilhelm. *Abstraction and Empathy: A Contribution to the Psychology of Style* [1908]. Tr. Michael Bullock. New York: International Universities Press, 1963.

_____. *Form Problems of the Gothic* [1910]. New York: G. E. Stechert, 1920.

_____. *Künstlerische Zeitfragen.* Munich: R. Piper, n.d.

_____. "Zur Entwicklungsgeschichte der modernen Malerei." *Der Sturm* 2(August 1911):597–98.

Index

260